DATE DUE

~~JE 10 '82~~			

DEMCO 38-296

Captain Watson's Travels in America

Captain Watson's Travels in America

The Sketchbooks and Diary of JOSHUA ROWLEY WATSON, *1772–1818*

KATHLEEN A. FOSTER

Commentaries on the Plates by *Kenneth Finkel*

A BARRA FOUNDATION BOOK

PENN

University of Pennsylvania Press

Philadelphia

10 9 8 7 6 5 4 3 2 1

Published by
University of Pennsylvania Press
Philadelphia, Pennsylvania 19104–4011

Library of Congress Cataloging-in-Publication Data
Foster, Kathleen A.
 Captain Watson's travels in America : the sketchbooks and diary of Joshua
Rowley Watson, 1772–1818 / Kathleen A. Foster ; commentaries on the plates by
Kenneth Finkel.
 p. cm.
 "A Barra Foundation book."
 Includes bibliographical references (p.) and index.
 ISBN 0-8122-3384-0 (alk. paper)
 1. United States—Description and travel. 2. Watson, Joshua Rowley, 1772–
1818—Notebooks, sketchbooks, etc. 3. United States—Pictorial works.
4. Watson, Joshua Rowley, 1772–1818—Diaries. 5. Watson, Joshua Rowley, 1772–
1818—Journeys—United States. 6. British—United States—Diaries.
7. Landscape painters—Great Britain—Diaries. 8. Great Britain. Royal Navy—
Biography. I. Finkel, Kenneth. II. Title.
E164.F77 1997
973'.099—DC21 97-15132
 CIP

Contents

vi
Contents

Illustrations

Acknowledgments

The search for Captain Joshua Rowley Watson has been a collaborative adventure. Prime mover and supporter Robert L. McNeil, Jr., of the Barra Foundation deserves first thanks; from beginning to end, this book would not have existed without his help. McNeil's role, like the crucial parts played by several other friends and colleagues, is recounted as part of the unfolding tale of Watson's revelation described in the introduction. Among all the surprises, most delightful and supremely useful has been the assistance of Watson's descendants, who have generously opened their homes, trunks, and scrapbooks; many thanks to three cousins, Pamela Burges Watson Brice, Mary ("Maria") Burges Watson Whinney, Elizabeth Burges Watson Pope, their children, Lt. Col. Julian Pope, Stella Whinney Reeves, Simone Whinney Guest, Sybil Venning, and their families. I am especially grateful to Maria and Patrick Whinney, who have been by turns kind, helpful, patient, and wonderfully entertaining. The transcript of Watson's American diary appears in this book courtesy of Patrick, and in memory of Maria.

Many colleagues on both sides of the Atlantic have also helped. In England, assistance came from Audrey Erskine, at the Exeter Cathedral Archives; P. W. Ellis and Ian Maxted, at the West Country Studies Library; Susan M. Pearce, at Exeter's Royal Albert Memorial Museum; G. Paley, at the Devon and Cornwall Records Society; Lindsay Stainton, at the British Museum; J. M. Dacey and Brian Thynne, at the National Maritime Museum, Greenwich; K. M. G. Stephenson, at the Foreign and Commonwealth office in London; T. R. Padfield and William Foot, at the Public Record Office; D. Mann, curator for the Hydrographer of the Navy; and Evelyn Newby, at the Paul Mellon Centre for Studies in British Art.

In Philadelphia, where this project began, my largest debt is to Kenneth Finkel, who contributed the plate captions to this book. Ken and I can both thank John C. Van Horne, whose admirable work on Latrobe made him a sympathetic guide, Gordon Marshall, Jim Green, and Susan Oyama, all of the Library Company of Philadelphia. We also thank the late Edwin Wolf 2nd. Next door at the Historical Society of Pennsylvania, the staff—particularly Linda Stanley—responded to numerous queries, and the late Nicholas B. Wainwright offered much wisdom. At the Pennsylvania Academy of the Fine Arts, where I was curator while much of this research was done, I found support from Frank H. Goodyear, Jr., Linda Bantel, Judy Stein, Stephen Edidin, Jeanette Toohey, and Helen Mangelsdorf. At the Barra Foundation, Gail H. Fahrner generously retyped the transcript of Watson's diary. Jeffrey A. Cohen found a picture of the Rundle townhouse and an insurance survey of Eaglesfield in the course of his research, and Nancy Carlisle, Kenneth S. Goldstein, Charles Peterson, Darrel Sewell, George Thomas, Richard Tyler, Carol Wojtowicz Smith, and the late Robert F. Looney all offered pertinent advice or assistance.

In New York, I found colleagues to forward the project at the New-York Historical Society. I am grateful for the early assistance of Wendy Shadwell and Richard J. Koke and for the later cooperation of James B. Bell, Elizabeth M. Currie, Annette Blaugrund, and Wendy Haynes. In Washington, D.C., help came from Henry H. Glassie, Sr., who corrected our plate captions for the local views and, with his wife, Betsy, braved traffic on F street to recover Watson's exact sight line; and Edward J. Nygren, then Curator of the Corcoran Gallery of Art, whose *Views and Visions* catalog of 1986 incorporated Watson's work into an excellent new study of American art before 1830. Thanks also go to helpful scholars in other American and Canadian maritime museums and print and drawing collections: Martha Shipman Andrews, Susan Campbell, Stephen Edidin, Janet Flint, Kathy Flynn, Alan D. Frazer, Lila Goff, Sinclair Hitchings, C. M. Kauffman, Lois Oglesby, Robert Rainwater, Bernard F. Reilly, Jr., and Edith Schmidt.

In Bloomington, I was cheerfully assisted at various points by Jacki Anderson, Lois Baker, Lauren Lessing, Terri Sabatos, and Megan Soske, and warmly supported by my colleagues at the Indiana University Art Museum, especially Linda Baden, Nan Brewer, Gwen Bruce, Adriana Calinescu, Heidi Gealt, Ed Maxedon, and Diane Pelrine. Michael Cavanagh and Kevin Montague contributed many superb photographic prints from the negatives made by Henry Glassie or me "in the field." I am grateful to all these people, and to other friends who have made Bloomington such a splendid place to live and work.

Between Philadelphia and Bloomington, this book was produced with the help of old friends at the University of Pennsylvania Press. First supported by Maurice English, the project was nurtured from its inception by Jo Mugnolo Joslyn, who deserves a special prize for patience and persistence.

Watson would agree, however, that families are our most important source of support. I am grateful to my mother, Isabella Chappell, for her early reading of the manuscript and her spirited example as a family historian. In turn, both Ken Finkel and I have enjoyed the wonderful interruption of our own children arriving during this project: we are glad that Ellen Adair Glassie, and Kirk Nathaniel, Benjamin James, and Mack Sigmund Finkel have checked our antiquarian inclinations with happy reminders of the present and future. Ken is grateful to Margaret O. Kirk for her patience and encouragement; I thank Henry Glassie for his inspiring example as a scholar, his love, and his relentless patience. He has always thought Captain Watson's history was important, partly because he believes the conventional record needs to be enlarged and tested by "unknown" artists, and perhaps because he knows what it is like to contain artistic ambitions, as Watson did, within the circle of family and profession. So this book is for Henry. It also salutes the memory of our two fathers, both engaged by the struggle to keep art in life: Wilmot D. (Bill) Foster, a physician (briefly a naval doctor), musician, and amateur watercolor painter; and Henry H. Glassie Sr., a lawyer (likewise once a naval lieutenant), scholar, and watercolor collector.

KATHLEEN A. FOSTER
Philadelphia and Bloomington

Captain Watson's Travels in America

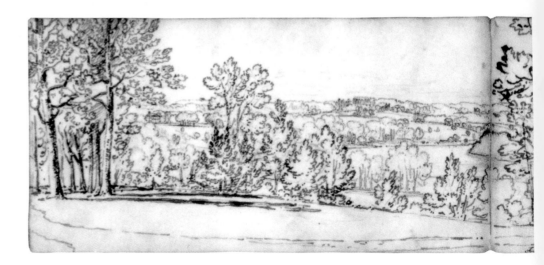

1. Joshua Rowley Watson, *From Eaglesfield looking up the Schuylkill. 1817–*, pen and black wash over graphite, Barra Foundation sketchbook, p. B-75AB.

Introduction:
Discovering Captain Watson

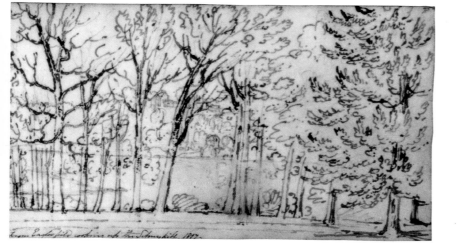

AT THE BEGINNING, there was only one sketchbook. Bound in leather and linen, it held 110 creamy-white sheets of England's finest watercolor paper. Inside, each leaf measured a bit more than five by ten inches, offering an exceptionally panoramic double-page spread when the book was opened. Across this wide field, sometimes from edge to edge, stretched dozens of serene and airy watercolor views of the early nineteenth-century American landscape. As I turned the pages, the itinerary of a picturesque tour unfolded, undertaken with the taste and the attentiveness of a less hurried age. Neat annotations at the base of each image identified scenery between Philadelphia and Washington, D.C., recorded from the fall of 1816 through July of 1817. Some subjects were instantly recognizable — Mount Vernon, the Capitol, the bridges and waterworks of the Schuylkill River — but other scenes, especially the repeated depictions of a country house called "Eaglesfield," were puzzlingly unfamiliar. Known and unknown, these views gained credibility and appeal from the painter's display of skill. Keenly observed and elegantly organized, the pictures showed a special aptitude for long reaches of water, architectural detail, and deep space. The artist appeared well-practiced in a range of techniques: some scenes had been delicately traced in graphite alone; others were built from broad washes of brown, gray, and blue added to a faint pencil sketch; many were further elaborated with lively pen work; and a few were richly built up in opaque and transparent watercolors. Lovely and informative, these pictures

invited careful and pleasant study. They also raised many questions about the artist, presumably identified by an abraded inscription inside the front cover, repeated more lucidly on the back flyleaf: "Joshua M. [?] Watson/ La Favorita/ Guernsey."

In 1975, when Robert L. McNeil, Jr., first showed me Watson's sketchbook, which he had acquired for the Barra Foundation, almost nothing was known about the artist. His name made no appearance in exhibition indexes and dictionaries of British artists. A brief entry under the name J. R. Watson in a dictionary of early artists in America noted only that two watercolors by "Captain Watson (Royal Navy)" had appeared at the Pennsylvania Academy of the Fine Arts annual exhibition in 1829, close to the time that two publishers issued engravings based on his work. The relationship between these prints and the views found in the Barra sketchbook indicated that "Captain Watson" was our man, although the life dates given in this source were only a beginning: his given birthdate was later contradicted, and his death date was unknown.[1]

Such sparse context did not daunt Darrel Sewell, curator of American art at the Philadelphia Museum of Art, who was impressed by the quality of the sketchbook and included it — cautiously "attributed to Joshua M. Watson" — in the celebratory bicentennial exhibition, *Philadelphia: Three Centuries of American Art*.[2] Sewell identified the mysterious Eaglesfield, but the larger questions remained. Who was Captain Watson? Why was he in the United States? How could an artist this good be so obscure?

After the exhibition closed, McNeil invited me to examine the sketchbook again and pursue the elusive Watson. Inquiries about the provenance of the sketchbook hit a dead end in London. His naval identity suggested another line of research, but again the published historical record was slim. Evidently no naval luminary, Watson received only passing notice as the father of a more famous son, Rundle Burges Watson, profiled in a nineteenth-century dictionary of the British navy.[3] To find Watson, more detailed period sources, including primary documents, would have to be inspected. With support from the Barra Foundation, I set off for England, searching for leads in the Admiralty's archives, held in the Public Record Office in Richmond. I found too many Captain Watsons, but after a week, Joshua

Rowley Watson's career in the service began to emerge. Watson's ships' logs were all on file, written in the elegant penmanship I recognized from the sketchbook inscriptions. These official accounts of the ship's business outlined his professional identity, but they revealed almost nothing about Watson's thoughts or his life outside the navy. As my two-week stay came to a close, I began to call up miscellaneous papers from the period of the Napoleonic wars, searching for more personal correspondence. Finally, on my last day at Richmond, Mary Watson's widow's pension application turned up, and with it an affidavit of her marriage, Watson's lieutenancy certificate, and a record of the actual dates of his death and burial, at Exeter, in 1818. I returned to Philadelphia in triumph, convinced that I had the key to Watson "at home."

Audrey Erskine, the archivist at the Exeter Cathedral Library, was kind enough to confirm the details of Watson's burial and grave site, but aside from these mortal remains there was not much of Watson in Exeter. Inquiries at the major maritime museums in England and at every museum, library and historical society in the Exeter area yielded nothing. Most helpfully, P. W. Ellis, the Central Devon Area librarian at the library in Exeter, found entries from the parish records and an obituary clipping that recounted the sad story of his death, giving a first glimpse of the warm family man behind the businesslike Admiralty logs.

Disappointed and puzzled by the thinness of the Devon record, I turned to American sources and canvassed at every likely maritime museum or historical society that might have inherited Watson's drawings. To my delight, Wendy Shadwell at the New-York Historical Society responded with news of *another* Watson sketchbook, acquired by the Society in 1958.[4] It was the mate to the Barra's volume, recording the sights of the first half of Watson's American trip. This book began with mid-ocean views in April 1816; Barra's concluded with vistas of Liverpool harbor in July 1817. I knew I had found Watson's entire trip and effectively doubled the "known" examples of his work.

Elated by the discovery of the second sketchbook, I was transported by another, more astonishing reconnection. The ever-helpful P. W. Ellis wrote again from Exeter, remarking on the recent arrival

of another research inquiry about Watson. The coincidence of interest in this obscure captain struck him as curious; perhaps the two researchers would like to exchange addresses and information? In due course a letter arrived from Capetown, South Africa, from Watson's great-great-granddaughter, Pamela Burges (Watson) Brice, who was simultaneously intent upon reconstructing Watson. She owned letters and watercolors, and knew cousins who had more. To keep Watson's name alive, Brice had recently restored his grave marker in the floor of Exeter Cathedral, hiring carvers to re-cut the letters worn illegible by decades of foot traffic. Brice was open-handed with her own research, pressed her husband into service as a photographer, and cordially offered introductions to her relatives. Delight followed wonder as I was referred to her cousin Maria Burges (Watson) Whinney and Maria's husband Patrick, in Guernsey. Pat and Maria, their nephew, and their three daughters were the other custodians of Watson's legacy. Among them, they had letters, portrait miniatures, and many watercolors. Best of all, they had Watson's diary from the first months of his American trip. From North America, Africa, and Great Britain, the pieces were regathering.

Patrick Whinney, himself an author, gamely undertook the tedious task of transcribing the spidery penmanship of the diary into typescript, for which I remain ever grateful. Cheerfully, the Whinneys sent photocopies of everything. The Barra Foundation agreed that their trove was irresistible, and in 1982 Bob McNeil sent me on another two-week expedition in Britain. Outside London, in the home of Maria's nephew, Lt. Col. Julian Pope, I stood transfixed before the "family museum": a glass case full of Watsoniana, including an exquisite miniature of the Captain himself (fig. 2) and a charming family portrait that brought Watson, his "dear Maria," and their children to blooming life (see fig. 10). Julian Pope kindly helped me take pictures, and then forwarded me to his cousin, Stella (Whinney) Reeves, who took the time to share her set of Watson's coastal profiles and a portrait of his American niece, Fanny Rundle (see fig. 16), painted in Philadelphia by Thomas Sully, and evidently sent to her English relations after Fanny's untimely death.

Mrs. Reeves relayed me to her sister, Simone (Whinney) Guest and her husband Charles, who welcomed me into their home in

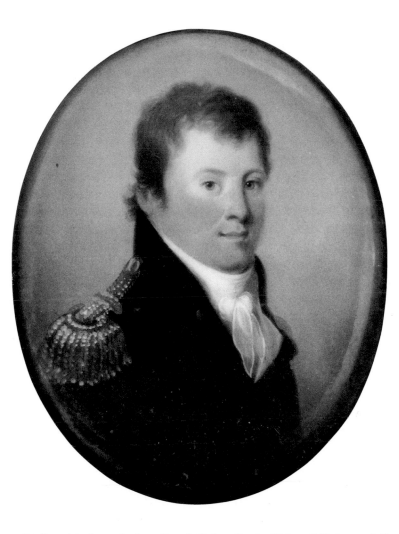

2. Attributed to James Leakey, *Captain Joshua Rowley Watson R.N.* (1772–1818), ca. 1800–1810, watercolor on ivory, 3 × 2½ in. oval, Collection of Elizabeth Burges Pope.

Somerset to examine their portion of the legacy, particularly the transcript of Watson's last diary. The Guests then sent me off to Exeter, where I sought out Watson's marker in the Cathedral and followed his footsteps through the historic districts that had survived the bombing of World War II. His house was gone, but his coffee-house remained. The staff of the Devon and West Country Library again assisted my research into Watson's period and his family tree, in search of the connections that brought him to America in 1816. Then it was on to Guernsey, and the hospitable Whinney home, to pore over old letters and diaries, examine a boxful of watercolors and sketches, and enjoy the family's lore from Pat and its art from Maria, herself a painter and the mainstay of a local gallery. The Whinneys' openheartedness made this research a pleasure, as Watson began to emerge from their collection with a face, a voice, and a family.

Although Watson had by now attained the status of a household member in my own family, diversions forced him to occupy a very distant room. In 1984, seeking help on the iconography of his landscapes, I enlisted the assistance of Kenneth Finkel, then curator of prints and photographs at the Library Company of Philadelphia. Ken's knowledge of the local scene, past and present, has aided me enormously. His imagination and enthusiasm as an historian have made him a good collaborator. He helped me pace out the site of the vanished Eaglesfield, where Watson spent much of his time in Philadelphia, and suggested Parkyns' role in the estate plan as most memorable from the point of view of landscape design. Taking on the cause with spirit, Ken wrote the plate captions, suggested many new lines of research, gently corrected my errors, and then discovered and identified Watson's "lost" exhibition watercolor, *View on the Schuylkill from the Old Water Works* (fig. 40 and color plate 10). Fittingly, this last major revelation came at our doorsteps, concluding the intercontinental chase at Seventh Street north of Chestnut Street in Philadelphia, just a few blocks from my home, Ken's office, and the house where Watson's sister welcomed him in 1816 (fig. 15).

The material gleaned from all these sources is extensive, considering the meager information at the outset. Although patchy, the size of the extant written record is now itself surprising, given the amount that we usually can know about such persons of middling class and small fame, even in a literate society. But Watson appears to have been historically blessed, his record somehow harbored for recovery; otherwise, the survival of his reputation into our own day would seem unlikely. Period sources tell us that he was bright, charming, modest, and well loved by his family and friends on both sides of the Atlantic, but a sterling personality alone will not hold the attention of posterity. His career in the Royal Navy was respectable but likewise unmemorable. Watson joined in many of the events that make up the standard political history of his era, but inevitably his was the ship that stood offshore, dispatching marines and supplies to the battle-front. Such people sustain the larger goals of their culture, and as loyal members of the team they are usually rewarded with obscurity. Although he came from an affluent, literate, and historically-minded class, Watson could well have been reduced, like most of his peers, to an existence in census records, church ledgers, and naval lists.

Why, then—or how—did memories of Watson survive? We can credit the glamor of his own talent and a measure of good fortune. Never famous, Watson was instead favored. Comfortable, successful, and esteemed in his lifetime, he enjoyed after death three important advantages in the erratic process by which the past is saved, sorted, and recomposed into history:

First of all, Watson was historically privileged by his service to a government that kept elaborate records. Having persevered to the rank of post-captain, he was responsible for a sizeable amount of paper work, much of it still safeguarded by the Public Record Office. The Admiralty's documents are only occasionally exciting and very rarely personal, but they do allow us to track Watson's career and his travels, almost day by day, for thirty years. Both Watson and I have reason to be grateful to past and present custodians of these archives.

More fortunate, for history's sake, than the retentiveness of government bureaucracy, were the circumstances of Watson's family tree. One link in a venerable chain of naval officers, Watson had the advantage of following a father and an uncle, both heroes who died in battle, while preceding a distinguished son, also a naval celebrity, whose son and grandson in turn rose to eminence in the same line. Far from being the most brilliant figure in the family's military annals, he was remembered as a part of this uninterrupted sequence,

his mementoes honored by a family that continues to sustain Britain's armed forces.

Still, many families preserve heirlooms that gradually grow mute, and many respected post-captains find their reputations forever entombed in the Public Record Office. Watson escaped such obscurity by leaving to us an ensemble of artifacts—manuscripts and watercolors—too good to discard, too lively to ignore. Although the English art-historical establishment has barely acknowledged Watson's existence, the quality of his watercolors, allied to the picturesqueness of his diaries, made Watson exceptionally memorable to his descendants. Curiously, the preponderance of manuscripts in the family archive are by or about J. R. Watson, not his more celebrated relatives. Was it because he was the family's only diarist? Or did the warmth of his character and the sad circumstances of his early death leave an aura to all his relics? Certainly there is nothing else in the family's collection that approaches the emotional pitch of Mary Watson's tortured letter-draft to her American relatives, recounting her husband's last moments. The vitality that still trembles in this letter (cited at length in the Epilogue) matches the immediacy of Watson's watercolors; magnetically drawn together, the manuscripts and drawings preserved Watson's presence while the memories of his professional accomplishment and cheery personality slowly faded. This time capsule grew richer in the decades after Watson's death, as mementoes owned by his American family were returned to English descendants. Scattered in the mid-twentieth century to eight sites on three continents, the pieces waited, hoping for the serendipitous collision of objects, persons, and facts that lifts historical research into the realm of adventure.

The regathering of these parts adds up to an unexpectedly large and interesting sum, because the quality and diversity of material combined in Watson's record is very unusual. Libraries hold many diaries by people who remain obscure outside of the light of their own testimony, and museums are full of artworks by amateurs and provincials about whom next to nothing is known. Only rarely do we have an ensemble of artifacts that offers the plan of the parlor that held the art originally (fig. 21), introduces the circle of family and friends that met in this room, and shows us the view from all the windows. The navy is also stocked with captains about whom little can be learned beyond the businesslike contents of their ship's logs. Even the most "glorious" heroes in Watson's family are poorly remembered as real people; only the truly exceptional naval stars (for the most part lords and admirals) have made or inspired records that allow a three-dimensional reconstruction of their existence by posterity. Like Horatio Nelson, there were artists of this realm of celebrity—such as Watson's close contemporary, J. M. W. Turner—who were sufficiently talented, successful and eccentric to win a kind of attention in their lifetimes that produced much grist for later historians. A man like Watson, being no match professionally for Nelson or Turner, is by comparison a truly elusive historical quarry: the bottom of the upper class, the periphery of the art world, the middle of the navy brass.

Some would argue that the better-known figures from this period already speak for Watson, who might be dismissed as bearing only the conventional wisdom that trickled down to him from more exalted and accomplished ranks in his society. But, in choosing to gather flowers and shells on the beach during the siege of Trois Rivières, was Watson contemplating events as Nelson would have? Uninterested in selling or exhibiting his watercolors, did Watson paint with the same purpose as Turner? Perhaps, in the witness of this pleasant, well-adjusted man, there is something fresh to be learned, something of the texture of ordinary middle-class life and art in 1816 that cannot be gleaned from the accounts of extraordinary persons. If we believe that history should be more than the story of "leaders" and "followers," Watson deserves this book.

Convinced that the present assembly of artifacts offers more than a charming tour of the early American landscape, I have pressed the surviving fragments of Watson's legacy hard, seeking the larger picture of his life. In Part I, the documentary evidence has been enhanced with research along several lines: naval and political history, to establish a background for his career; genealogical and local history, to map the network of family and professional relationships that supplied his rationale for a trip to the United States; and landscape history, to trace his experience at a time when the itinerary of the picturesque "Grand Tour" of America was still taking shape. In addi-

tion, a literary analysis of his diary seeks to understand more about Watson's values and opinions. These are standard strategies of historical investigation, here used to stitch a patchy assemblage of conventional documents — letters, diaries, wills, institutional records — into a more coherent field.

This written archive, extended by context, bears some attention on its own, especially by Americans, who will find Watson an interesting witness caught between nations during the War of 1812. Married into an American family but professionally pitted against the United States during this conflict, Watson held a perspective shared by many Anglo-Americans during this unpopular war. His opinions, expressed throughout his diary and in the subject-choices of his drawings, give a glimpse of national character on both sides of the Atlantic at this time, and an image of social relations dominated by class and family interests far more than political boundaries.

Social patterns created by family, business and professional life also help us understand why Watson joined the navy, why he came to the United States, who he met when he was here, and how his art has survived. The view from within this network is revelatory, for the redundancy of certain family and professional ties — sisters marrying brothers, sons and brothers becoming naval officers — explains the endurance of social connections across miles, years, and national borders. From within this system, "navy" and "family" became inseparable. These strong ties also connected Watson to a larger social circle. Although he was no celebrity and his American relations do not seem, from our distance, to have been prominent citizens, Watson met an astonishing spectrum of Americans in the course of only fifteen months. His neat list of names at the head of his diary (analyzed in Part I and explicated with brief biographies in Appendix A) demonstrates the extensive circuit open to a man of Watson's class. His diverse roster also illustrates the intimacy at this time of the American elite, whose members all seem to have known one another or at least shared acquaintances. Like Watson's watercolors, this network of friends provides primary data for historians of this period, offering a personalized map of American landscape and society in 1816–17 that is exceptional in both rarity and breadth.

The reconstruction of Watson's social milieu also explains his obscurity as an artist. Always introduced as captain, never as artist, Watson was both harbored and liberated by his status as "gentleman amateur." Basically, he painted to please himself and his family. His artistic motives and opportunities existed within the frame of his primary professional identity, deduced from evidence external to his artwork.

But all the documents in Watson's archive, while enlightening and sometimes quite engaging, have only a limited intrinsic interest; they gain value in relationship to his art, which bears to posterity a much more complex statement of culture and personality. We are fortunate to find *any* written records to interpret Watson's work, since most of the material culture of this period — paintings, houses, bayonets, sausage machines (all described by Watson) — comes to us scantily documented and usually unattributed. But Watson's sketchbooks or his uncle's house offer a far richer expression of period values than all of his manuscripts combined. So, enriched by the discovery of supplementary documents, we turn back to the artifacts that, by their strength, have protected much of Watson's written record and inspired the search for him in the first place.

Three types of material culture come to us from Watson, loaded with messages from his period. The first two — architecture and landscape — are carried indirectly, by representation. Watson's record of the American scene was selective and artistically manipulated, but it was based on visual experience and grounded in the descriptive, topographic tradition of military drawing; surely we can learn much from his sketchbooks about the actual appearance of the landscape he saw in 1816–17. An overview of his tour is given in Part I, and Kèn Finkel's commentaries supply the particular identification and history of sites and landmarks shown in the plates in Part II.

Eaglesfield, the country estate near Philadelphia that belonged to Watson's uncle (fig. 3), has been given special attention, because it appears more frequently than any other subject in the sketchbooks. Probably, Watson lived there during much of his time in the United States. His detailed verbal and pictorial description of Eaglesfield brings to life a house and parklike farm that disappeared more than a century ago. Watson's record helps us reconstruct a lost gem from the necklace of suburban villas that ornamented the Schuylkill valley

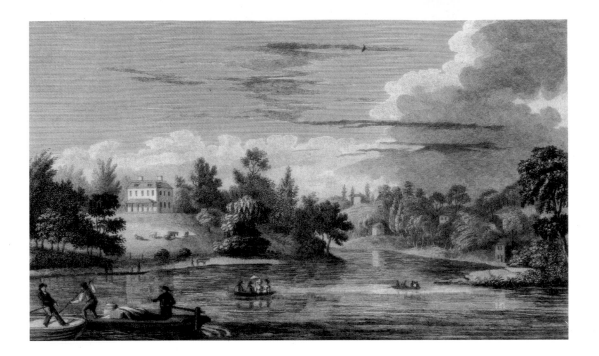

3. Cephas G. Childs, after William Mason, *Eaglesfield*, 1830, etching and engraving on paper, $3\frac{7}{16} \times 5\frac{3}{4}$ in. image, private collection.

in the early nineteenth century, and this recovery is itself interesting to historians of architecture and landscape. But Eaglesfield also reflects upon Watson, who reiterated his approval of the place in both word and picture. In considering the look of Eaglesfield and what Watson liked about it, we discover first the architectural and spatial context of his social life. Naval records and the warships of the period supply his professional environment; Eaglesfield offers a complementary domestic frame, probably very similar to homes he knew in England. As an ensemble of material culture, the buildings and grounds of this estate are also revealed as a work of art no less constructed and self-conscious than Watson's watercolors. From the harmony of values expressed in word, picture, building, and landscape, emerges the complex and integrated aesthetic system of Watson's world.

Finally, we come to the watercolors themselves. In Part III, I have turned to the methods and topics of art history to examine Watson's training, technique, style, subject choices, and organizing principles to set his work within the flow of British and American painting of this period. Scant material for a conventional artistic biography survives, because relatively few paintings outside his American journey are known, fewer still of these are dated, little is known of his education, and no records of exhibition or patronage survive. Some context can be generalized from the experience of his contemporaries and a look at the local art scene in Exeter, but formal analysis must drive in to fill most of these gaps. Ultimately, we can discover Watson's artistic development from sources in contemporary military and fine art traditions, and understand his invention of a personal style that responded to the challenges of his American tour.

Taking a longer view, we can also appreciate Watson's small but notable contribution to the development of the American landscape school. Among the first to take the quintessential "grand tour" of

the eastern seaboard from Lake George to Mount Vernon, Watson contributed to the first generation of widely-circulated prints of the American landscape. As the repertory of picturesque views sought by travelers in his period became canonical, so did the standard tourist's itinerary, and Watson's perspective offers a fresh and early look at these sites that helps explain how, and why, the canon—and the route—took shape.

Looking carefully at Watson's work, we can appreciate his personal artistic development as well as his place in a larger history of art and landscape. But, as we get to know and understand Watson, these insights are only preliminary to the main opportunity presented by his work: to visit the past through Watson's eyes, to imagine the landscape he saw, and to understand how he organized it into art.

Chronology: The Life and Travels of Joshua Rowley Watson

17 April 1772	Born in Topsham, Devon, to Thomas and Mary Watson (d. 1774)
1780	Death of his father in the West Indies
ca. 1780–83	At Auchins Academy, Ewell, near London
ca. 1783–85	Enrolled at the Maritime School, Chelsea
1786	To France
July 1786	To sea, as "Captain's servant," on HMS *Savage*, under his uncle, Captain Richard Rundle Burges
1791	Passed lieutenant's examination
1793	Lieutenant's commission; to the West Indies through 1794
1794–95	Served on the English Channel
1795	Promoted to commander, following his action in the capture of a French frigate
1796	Shipwreck of his command, *La Trompeuse*, off Cork
1797	Death of his uncle and guardian, Richard Rundle Burges, at battle of Camperdown
1798	Captain's commission in March; married 20 November to Mary Manley in Topsham
1804–6	Supervised sea fencibles off southern coast of Ireland
1807	Took command of HMS *Inflexible*; Copenhagen campaign

1809–11	Command of HMS *Alfred*; to Belgium, Spain, and the West Indies
1811–12	Command of HMS *Implacable*; in the Mediterranean
1814	Half-pay listing begins; returns to Devon
18 June 1815	Napoleon defeated at Waterloo
19 March 1816	Leave of absence granted from the navy for 12 months
21 April 1816	Sailed from Liverpool to Philadelphia
11 June	Landfall, Cape Henlopen, Delaware
12 June	Arrived Philadelphia
June–July	In Schuylkill Valley
19 July	Sailed up the Delaware to Trenton; overland to New Brunswick, N.J.
20 July	New Brunswick to New York City
22–23 July	Sailed up the Hudson to Newburgh, N.Y.
25 July	Newburgh to Albany, N.Y.
24 July	From Albany, overland to Fort Miller
28 July	To Lake George
30 July	To Saratoga
31 July	Return to Albany
1 August	To Springfield, Mass.
2 August	To Northampton, Mass.
3–11 August	Boston and Charlestown, Mass.
13 August	In Middletown, Conn.
14–15 August	New Haven, Conn., and return to New York and New Jersey
16–19 August	To Passaic, Paterson, and Weehawken, N.J.
14 September	By this date, back at Eaglesfield
September–3 Dec.	In Philadelphia area; last dated sketch 3 December
4 April 1817	First dated sketch of 1817, in Schuylkill Valley
14 April	Sailed down the Delaware to Newcastle, Del.
15 April	Overland to Chesapeake Bay; steamer to Baltimore, Md.
16 April	Baltimore to Washington, D.C.
17–22 April	Washington, D.C., and Mt. Vernon
23 April	Baltimore
24 April	To Wrightsville and Columbia, on the Susquehanna
26–27 April	To Lancaster and Philadelphia
May–June	Resided Philadelphia and Eaglesfield
14 June	Sailed from Philadelphia for Liverpool
14 July	Landfall, Wales
16 July	Arrived Liverpool; return to Exeter
Spring 1818	Purchase of new home in Dix's Field, Exeter
26 May 1818	Death, age 46, from brain hemorrhage
June 1818	Burial, Exeter Cathedral
1819–20	Publication of Watson's work in Joshua Shaw's *Picturesque Views of American Scenery*
1829	Watson's watercolors exhibited at the Pennsylvania Academy of the Fine Arts
1830	Publication of Watson's work in Cephas Childs's *Views in Philadelphia and its environs*

Watson's World

Raised in the Navy, 1772–1790

AT THE AGE OF NINE—perhaps—Joshua Rowley Watson went to sea with His Majesty's navy, serving in the Caribbean as "Captain's servant" on the ship *Resource*, under Bartholomew S. Rowley. Admiralty records show his sudden appearance on board in June 1781 near Jamaica; sixteen months later he followed his captain to another ship, *Diamond*, where he served until August 1783. It was not unusual for boys to join the service at such an age, to learn a trade or make an early start on the six years of sea duty required of those applying for a lieutenant's commission.

Then again, Watson was probably not on board. A letter from his father, Captain Thomas Watson, who was indeed stationed in the Caribbean in February 1780, to his mother-in-law, Mary Rundle Burges, suggests that young "Rowley" was at home in England all this time, developing the skills of an artist rather than those of a sailor. Thomas asked Mary, who had raised the boy after the death of his mother in 1774, to "put Rowley to a Boarding School," it being the right and "propper time for him to make a beginning." Captain Watson suggested his seven-year-old son commence French lessons and "as he has a turn for drawing let him likewise be instructed in it."[1] His emphasis throughout this letter on the paramount importance of his children's education must have taken on the character of a last will, for Thomas Watson died a hero three months later in the attack on the French at St. Lucia. Probably, his grandmother obeyed these instructions and sent young "Rowley" off to school, not to sea.

The contradictory histories suggested by these documents reveal the friendly network of deceit and support among naval families that quickly encircled the orphaned Rowley after his father's death. Captain Watson's will, penned on board HMS *Conqueror* in anticipation of battle on 10 May 1780, asked that his "young friend Lieut. Bart

Rowley" take notice of his child "in remembrance of me," "should my little son chuse the Navy."[2] Lieutenant Rowley, as Thomas Watson foresaw, was destined to be a powerful sponsor. Son of Vice Admiral Sir Joshua Rowley (1730–90) and grandson of Admiral Sir William Rowley (1690–1768), who had each supported Thomas Watson's career, young B. S. Rowley rose to the rank of Admiral of the Blue before his death in 1811. Honoring his friend's last request, Rowley signed young Joshua Rowley (his father's namesake) on to the *Resource*'s books along with seven other boys, including his own nephew, as soon as he won his captain's post, nine months later. Thanks to this ruse, Joshua began to earn sea time "on paper," gaining a head start on his career, should he later "chuse the Navy."[3]

By the same logic, Watson was introduced into the Admiralty's records as being born 5 October 1770, and he presented an affidavit to that effect, signed by the parish minister, when he applied for his lieutenant's examination in 1790. In fact, his own biographical memorandum declares his birthdate as 17 April 1772.[4] This additional deceit allowed Watson to apply for the examination when he was only eighteen years old, instead of waiting until the usual age of twenty. As young as he was, Watson needed some of his "paper" sea time to show the six years of sea duty needed to qualify for the test. By the time he won his lieutenant's commission in 1793, he had served another year at sea and attained the actual age of 21 (indicating, perhaps, some official recognition of the truth), but the alacrity of his appointment after reaching that age suggests seniority gained by early passage of the examination.[5]

Such bureaucratic intrigues may have gained Watson little, but they demonstrate the power, early in his life, of the supportive culture of the naval community. These maneuvers also illustrate the role of family connections within the navy's system of patronage or "interest." Traditionally, the navy drew almost forty percent of its officers from the aristocracy and landed gentry; in the period of the Napoleonic Wars, another half came from the professional classes, and half of those came from families with a tradition of naval service.[6] Thomas Watson, the only son of the Reverend William Watson (1708?–78), Rector of Ennis in County Clare, Ireland, had been raised with expectations of a career in "Law, Physic or Divinity but he did not like either, & gave preference to the Navy, into which service he entered under the auspices of the Late Sir William Rowley."[7] Lacking great wealth, social position, or a naval background, Thomas Watson had no interest to bring to bear on the Admiralty until Rowley began to look after his career. From his eminence as Vice Admiral of England and Lord of the Admiralty, Sir William Rowley could do a lot for his great-nephew, and Thomas Watson gratefully remembered him as his "benefactor."[8] He accompanied the fleet of Rowley's son, (then) Rear Admiral Joshua Rowley, to the West Indies, and was promoted twice in his service, eventually commanding the Admiral's flagship, *Conqueror*.[9] Thomas Watson proved a brave and loyal member of Rowley's "following"—to use the contemporary term that described younger officers brought along under the patronage of senior captains and flag officers. Naturally, he hoped his son "Rowley" would enjoy the continuing sponsorship of this influential family. In the navy, the selective favor of superiors brought opportunity and promotion; an absence of such interest could stall advancement more effectively than a lack of merit. Rowley interest shone upon J. R. Watson for at least the first six years of his career, consolidating a naval dynasty in the Watson family that would endure for generations.

Whatever the Rowleys failed to supply by way of influence was more than adequately filled by the family network commanded by Thomas Watson's mother-in-law, Mary Rundle Burges, whose father, grandfather, husband, brother, and son were all Devonshire sea captains. By the efforts of the Burges clan, Joshua was raised with a view to the sea, despite the early loss of both parents. Thomas Watson's gallant death made him one of the most memorable citizens in the history of Topsham, the small market town on the River Exe, between Exeter and the channel coast, where the Burges family was based.[10] Rowley was born in Topsham, and two years later his mother was buried there.

His father's death delivered young Watson into the guardianship of the family's other naval hero, his mother's brother, Richard Rundle Burges (fig. 4), who also prospered in the service of Joshua Rowley. Rising to the rank of commander just two years after Thomas Watson's death, Burges was a model officer "of strictest honour and integrity." These qualities "added to a frank and manly deportment

and gentleman-like and conciliatory manner made him respected by all who had the pleasure of knowing him."[11] Uncle Richard joined grandmother Mary to honor the instructions in Thomas Watson's last letter. The boy had been living with Mary Burges in London and at Ewell, near Epsom in Surrey. Per his father's wish, he was enrolled at Auchins Academy, Ewell, when he was eight; ostensibly sailing off Jamaica with Rowley's fleet, he probably began drawing classes at this school or with a drawing master from nearby London.[12]

Art classes notwithstanding, Watson followed his father and all his mother's relations into the navy by the time he was eleven, for in 1783 he entered the Maritime School, Paradise Row, Chelsea, an institution opened in 1778 "with a view to qualify scholars to serve as officers in the Royal Navy." Designed with boys like Watson in mind, the school gave half the places in every entering class to the sons of sea officers, particularly the orphans of men fallen in battle (fig. 5). The managers and benefactors of the Maritime School recognized the importance of naval families as sources for the increasingly professionalized officer class. Loyal and already accultured, boys from such families could not always afford the expense of "public school" education, however, and the school met their needs with scholarships for a quarter of every new class.

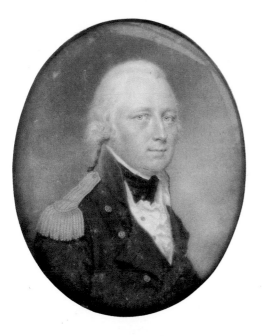

4. Attributed to Sir Martin Archer Shee, *Captain Richard Rundle Burges R.N.* (1754–1797), ca. 1795, watercolor on ivory, $3\frac{3}{4} \times 3$ in., Collection of Elizabeth Burges Pope.

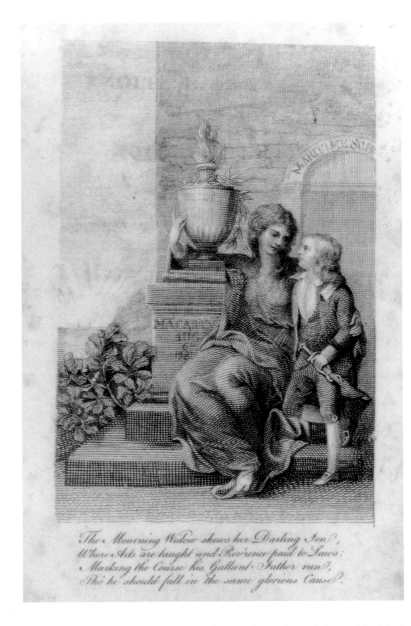

The Mourning Widow shews her Darling Son,
Where Arts are taught and Rev'rence paid to Laws:
Marking the Course his Gallant Father run,
Tho' he should fall in the same glorious Cause.

5. Artist unknown, etched frontispiece from *Rules and Regulations of the Maritime School . . .* , (London 1781). By permission of the Houghton Library, Harvard University. The verse below the image reads: "The Mourning Widow shews her Darling Son, / Where Arts are taught and Rev'rence paid to Laws: / Marking the Course his Gallant Father run, / Tho' he should fall in the same glorious Cause."

Anticipating the commencement of sea service at about the age of thirteen, the boys entered the school at about age eleven, and spent two or three years studying under masters who taught language and writing, navigation and mathematics, small arms and artillery, and—twice a week between three and six—"drawing according to nature, and surveying coasts, &c. as best adapted to service at sea." New students were read a statement of purpose from the manual of rules and regulations that threw an even more practical light on this art training:

We learn to *draw*, as a necessary appendage to our education; and the greater proficients we are, the more we are assured we shall recommend ourselves, when we go to sea, to the kindness and regard of our commanders, who will promote us the sooner.

Additional graces in the curriculum prepared Watson for gentlemanly social and professional occasions: in a letter to "Mama" (grandmother Burges) from this period Watson describes classes in "dansing" and "fensing" as well.[13]

After completing his studies at the Maritime School, followed by a "finishing" trip to France in 1786, Watson really did go to sea.[14] Now fourteen years old and, as his father hoped, made "fitter for life's lot" by a gentlemanly education, he appeared again on the Admiralty's registers as Captain's servant, this time quite logically under the command of his uncle Richard. He joined HMS *Savage* at Woolwich in July of 1786 and was promoted to "able seaman" and "midshipman" within six months—a typical rank for a boy of his age and expectations.[15]

Watson sailed for three years with his uncle on the *Savage*, a small sixteen-gun sloop patrolling shipping and occasionally pressing sailors along the coasts of the English Channel, western Scotland, and eastern Ireland. In August 1789 the ship received a new commander, and Watson was transferred to another sloop, the *Porcupine*, commanded by yet another Rowley family cousin, George Martin.[16] By Christmas 1790, he felt ready to apply for his lieutenant's examination. Presenting his ship journals and letters from his commanding officers testifying to his "Sobriety, Diligence and Qualifications of an

Able Seaman," Watson proved that he could "Splice, Knot, Reef a sail, work a ship in sailing, shift his Tides, Keep a Reckoning of a Ship's Way by Plane Sailing and Mercator; Observe by Sun or Star, and find the Variations of the Compass." On 5 January 1791 he was certified.[17]

An Officer's Life During the Napoleonic Wars, 1791–1815

It was a promising time to begin an officer's career in the British navy, although Watson must have found it dull at first. Exactly two years after his certification the first hostilities with France inaugurated a period of more than two decades of intense naval warfare all across the globe. A sea power for two centuries, Britain would rise to undisputed superiority during this era, drawing on all those willing and able to lead her navy. In the lull before the Napoleonic storm, Watson was called to duty on HMS *Hannibal* without an officer's commission, biding his time in and around Portsmouth and Plymouth for eight months. The *Hannibal*, commanded by Captain (later Admiral) John Colpoys, was a much newer and larger seventy-four-gun ship than Watson had known, but not much was stirring on the channel station. In a moment of calm at Spithead navy yard, Watson drew his ship in pen and ink (fig. 6) in a sketchbook that he would use occasionally until 1815.[18] Competent and informative, if not graceful, this earliest extant dated drawing shows how the nineteen-year-old Watson had profited from—and was limited by—his early drawing classes. His chance to practice and improve increased in October 1791, when he returned home to Exeter and London, still waiting for an officer's commission. Off duty for more than a year, Watson filled his time with a trip to Jamaica in late 1791; by the early summer of 1792, he was back in London.[19] He would not have to wait much longer.

Ten days after Louis XVI was beheaded in Paris in January 1793,

6. Joshua Rowley Watson, *H.M.S. Hannibal, Capt. Colpoys, 1791 at Spithead*, pen and ink over graphite on paper, $6\frac{5}{8} \times 9\frac{1}{8}$ in., Collection of Elizabeth Burges Pope.

and the very day France declared war on Great Britain, Watson was called on board Rear Admiral Lord Alan Gardner's massive flagship, HMS *Queen*, a ninety-eight-gun ship of the line sailing with a fleet of twelve for Prince Rupert's Bay on the island of Dominica.[20] Committed to an older policy of disrupting enemy shipping and assaulting colonial posts, the British navy was flung across the Atlantic to harass French holdings in the Caribbean. The West Indies were the smallest station for both of the major powers and a muddle of strategy and logistics that drained the more critical European campaigns. But for those interested in glory, prize money, and promotion, the islands were full of opportunity. Watson's first sponsor, Captain B. S. Rowley, captured one French ship off Jamaica in April—the first prize taken in the war—and two more in November, off San Domingo. Officers were in demand, and Watson served on the station only six months before winning his lieutenant's commission.

Apart from independent and spontaneous maneuvers, the navy was needed to back up troop landings, such as the intervention in Martinique's rebellion early in 1794, and Watson "distinguished himself" on shore during operations in March and April that won the island.[21] Guadeloupe, Tobago, and St. Lucia soon fell to the British too, but Guadeloupe was lost again in June, and St. Lucia returned to the French by accord in 1795. Pawns in the imperial war game, these islands would all change hands repeatedly in battle and treaty during the next two decades. Watson, who had lost his father in St. Lucia fourteen years earlier on a similar campaign, and who would return to Guadeloupe in 1810 for another "hundred days" of sov-

ereignty, must have understood—perhaps with some bitterness or cynicism—the strategic importance of these sugar islands and their shipping lanes.

The British blockade of the Channel ports was extended late in 1794 to include the coast of Holland, now under French control, and naval resources were reallocated to stretch across this new front. Watson, who had returned to Portsmouth in September, found himself—like Rear Admiral Gardner—reassigned to the channel station in November. As first lieutenant on HMS *Lively*, a brand new thirty-two-gun ship out of Portsmouth commanded by George, Lord (Viscount) Garlies and then George Burlton, Watson played a major part in the capture of the eighteen-gun French sloop *L'Espion* off Brest on 2 March 1795 and the thirty-two-gun frigate *Tourterelle* off Ushant on 13 March. Their first prize, *L'Espion*, surrendered without a fight, but the larger *Tourterelle* fired first and was captured after a ninety-minute struggle. Taking prisoners on board, they "found the Prize very much Cut and all her masts wounded; took her in tow [and]

found our Sails and Rigging very much cut and burnt by his hot shot." As was customary after such triumphs, the captain and first lieutenant—Burlton and Watson—both earned "hero promotions" along with a medal and a percentage of the prize money.[22]

Within two days of the second engagement, Watson rose to the rank of commander and was given charge of *L'Espion*, a ship that was sound enough to enter the British service as *The Spy*. Watson supervised her refitting at Plymouth that summer, when he sketched her in his notebook along with a drawing of the wounded *Lively* and her other prize, *La Tourterelle*.[23] In October he turned over *The Spy* to a more senior captain, but for his efforts he was given command of another sixteen-gun sloop captured the year before, *La Trompeuse* (fig. 7), whose captain had suddenly died. At last awarded his own ship, Watson sailed her into active service off the coasts of Ireland and Wales in November 1795.[24]

Glamorous assignments and sleek vessels were rarely the lot of young commanders, and Watson soon got trouble from *La Trom-*

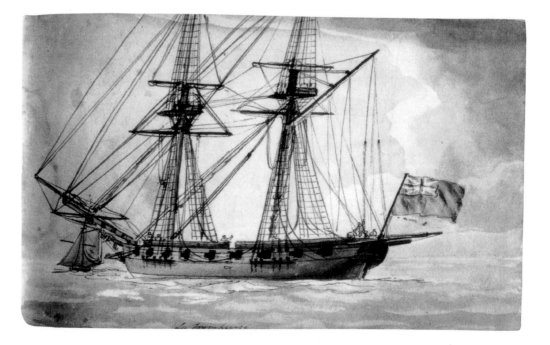

7. Joshua Rowley Watson, *La Trompeuse*, ca. 1795–96, watercolor and pen and ink on paper, $6\frac{5}{8} \times 9\frac{1}{8}$ in., Collection of Elizabeth Burges Pope.

peuse. "Vessel very leaky & people very sickly," he reported, no more than two weeks out. But Watson depicted her gallantly in his watercolor, and bravely she cruised the Irish Station and the channel until returning to Portsmouth for repairs in April 1796. In June, she set out again for the southern coast of Ireland, where Watson witnessed the encounter between HMS *Unicorn* and the captured French frigate *La Tribune*. After sketching a fiery midnight view of the two ships locked in battle, he painted the prize ship in full sail, bearing the victor's flag above her own (see fig. 33).[25]

Misfortune struck Watson just eight months into his first command. On 15 July *La Trompeuse* ran aground attempting to escape the lower cove of Kinsale harbor in an ebb tide. Four days later she was declared a loss "on the Farmer Rock, Kinsale." The subsequent court-martial acquitted Watson and his crew of any wrongdoing or incompetence; the local pilot, who was on board at the time, took blame for failing to advise or warn the young commander effectively. Seeking to mitigate the sense of guilt that nonetheless plagued Watson, his superiors bestowed commendations on him for the rescue of all crewmen and his "indefatigable" efforts to salvage the stores on board, despite heavy weather.[26] He returned home for another, drearier wait.

The "Disaster" of *La Trompeuse*, as Watson described it in his own report, left him out of naval action just before the French fleet sailed toward his station in December 1796 on a mission to "liberate" Ireland. The invasion disintegrated in the stormy seas off Cork, and Watson awaited further news at home ("unemployed—London—Bath—Devonshire," according to family records) through the end of 1796 and most of 1797. While Watson was off duty in April and May, the seamen at the major navy yards of Spithead (off Portsmouth), Plymouth, Sheerness, and the Nore (at the mouth of the Thames) mutinied, refusing to sail against the French until conditions improved.[27] The mutineers were finally subdued in June, and the navy rallied to meet another enemy fleet threatening Ireland.

Intercepting the Batavian (Dutch) forces before their rendezvous with the French fleet, the British navy fought the Battle of Camperdown on 11 October 1797. The victory exhilarated Britain but probably brought mixed emotions to Watson: sidelined himself, he learned of his uncle's "glorious" death in action. Captain Burges's

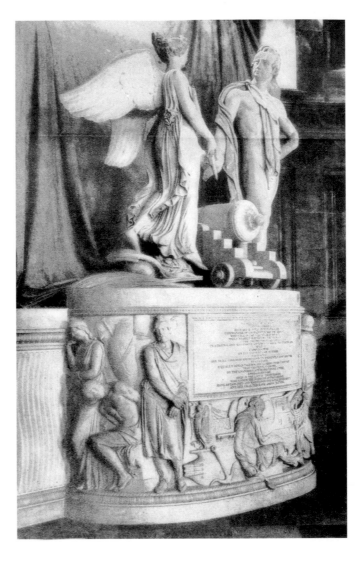

8. Thomas Banks, *Burges Monument*, 1802, marble, St. Paul's Cathedral, London. From a reproduction in *The Sketch*, no. 234, 18 (21 July 1897), Collection of Elizabeth Burges Pope.

valiant efforts at the helm of HMS *Ardent* that day earned him the epithet "The Hero of Camperdown." A grateful nation remembers him still in Thomas Banks' grand and "irresistibly comic" neoclassical monument in Saint Paul's Cathedral (fig. 8).[28] The loss of a guardian and mentor, combined with his own sense of failure and the larger malaise of the navy, made 1796–97 a low point in Watson's life.

The following year—1798—would be different. By no coincidence, a month after his uncle's death Watson was named commander of *La Legère*, a twenty-four-gun French prize captured in 1796. He owed the timing of this appointment entirely to Burges family "interest." Watson's sixty-six-year-old grandmother went into action following Camperdown, seeking to claim her son's pension benefits and her grandson's destiny as the dynasty's next captain. His cousin remembered that "Upon hearing that orders were going off for the Legère to sail for the West Indies," Mary Rundle Burges

immediately though she was ill in bed of the gout . . . got up and had herself carried to the Admiralty where her appearance and representations had such an effect upon Lord [George John] Spencer as in addition to Watson's real claims which certainly were great ones—to draw forth a promise that he should be made [Captain] before he went. She was not satisfied however but renewed her applications till she found his name actually entered as Post Captain.

Convinced that Watson otherwise would not have won this promotion until after he returned to service, Mary Burges "found the Admiralty like the Kingdom of Heaven suffered violence and that the violent took it by storm."[29]

Mary was in high spirits following her conquest of the First Lord of the Admiralty, but Watson's tenure on the *Legère* proved brief. Once again he was put in charge of the tedious repair and refitting that occupied so much of the time of any vessel on active service. In January 1798 he also assumed command of the Plymouth division of gun boats—about fifteen ships, each with twelve guns and approximately fifty men. Finally, on 23 March, his captain's commission became official. Almost immediately, Watson was directed to sail the *Legère* to Cork and turn her over to a new commander. If he returned to England in expectation of a more important post, his hopes were not soon realized. As with his lieutenancy, Watson had to endure for a time the most-junior position on the Captain's seniority listing, which ruled the assignment of new commands. With about 650 ships in service (not counting those in mothballs, under construction, or awaiting extensive repair), there were usually more captains and commanders than posts available. Merit and interest,

with a measure of good fortune, won advancement to the rank of captain, but after that, seniority held sway.[30] Watson returned from Ireland in April 1798 to begin what would be a long wait.

The time passed pleasantly. While Nelson was destroying Napoleon's navy off the coast of Egypt and yet another French fleet fruitlessly prepared to invade rebellious Ireland, Watson was courting pretty Mary Manley (fig. 9), who was barely eighteen when they mar-

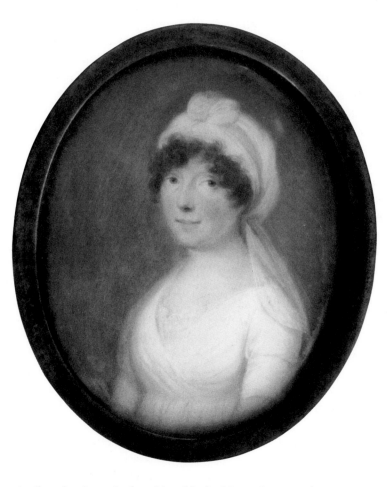

9. Attributed to James Leakey, *Mary Manley Watson* (1780–1852), ca. 1800–1810, watercolor on ivory, 3 × 2½ in. oval, Collection of Elizabeth Burges Pope.

ried in Topsham on 20 November 1798.[31] Although related, through her mother, to the prosperous American merchant Richard Rundle, Mary was raised "from a situation in life rather inferior to" that of her young husband.[32] By all accounts, they were devoted to each other and very happily married, despite the long separations of navy life. Given the wartime circumstances, the young Watsons must have been prepared for a brief honeymoon. As it was, they endured astonishingly little time apart during their first five years of marriage. The couple settled in Dawlish, near the mouth of the Exe, where their first child was born in 1800. This daughter, Louisa, died at birth, as did their first son, Richard Rundle Burges Watson, in 1804. But a family of three older girls—Mary, Frances McKenzie, and Louisa Rundle—and three younger boys—Rundle Burges, Joshua Rundle, and Richard Thomas—soon bloomed to their parents' delight.

In the spring of 1800 the Watsons joined their American relatives, Richard and Mary Rundle, in London. Watson's aunt, Frances Burges, who had visited the Rundles in Philadelphia a few years earlier, set off with them on a tour of England just as Napoleon left Paris to cross the Alps. The Rundles spent parts of 1801 and 1802 in Topsham, with (or near) the Watsons, and the whole family must have gathered in London for the unveiling of the monument to Captain Burges in 1802. While in London, the Rundles apparently visited Benjamin West at the instigation of Samuel Coates (President of Pennsylvania Hospital), to investigate the status of *Christ Healing the Sick*, a painting that West had promised the Hospital in 1801. "Don't forget to call on Benjamin West our countryman in London," urged Coates, "and without seeming to inquire about the painting he is doing for the Hospital, remark the progress he has made in it, and let me know." If Rundle, himself a director of the Hospital, followed up on Coates's suggestion, the news would have been discouraging. Ultimately the directors had to wait fifteen years for receipt of their painting.[33]

More interesting to the Rundles that year would have been the wedding of their nephew, George, and Watson's sister Maria, on 9 March 1801.[34] George Rundle, a young merchant born in North Carolina, managed some of the family's shipping concerns in Liverpool. George and Maria settled in Exeter, not far from the Watsons, who now lived on Alphington Terrace, St. Thomas, across the river from central Exeter. The younger Rundles remained in England until July 1805, when they moved permanently to the United States. As with the Watsons, their first child was stillborn; a second child, their daughter Frances (see fig. 16), was born in Philadelphia in 1806. "Fanny" would be a "fine promising girl" when her uncle recorded their first meeting in his American diary a decade later.

The first five years of marriage were tranquil times for Watson's career, although the navy was not idle, and wartime conditions must have colored civilian life. New fleets were dispatched to the West Indies, and others sailed to Egypt to destroy the remainders of the French army there. Naval activity intensified in the English Channel, where the British worked to blockade enemy ports, divide or subdue enemy fleets, harass almost all shipping, and forestall Napoleon's preparations for the invasion of England. Against the background of such activity, Watson's congenial family reunion in 1800 demonstrates his good fortune to be English, upper class, and on leave during this period. Never the site of battles, never invaded or occupied, even by an army in transit, Britain was a refuge of tranquility compared with the trampled countries of the continent. Press gangs and "recruiting" agents preyed on the lower classes, ruthlessly supplying men to the Royal Navy and Army, and seamen mutinied to protest inhuman conditions, but the relentless conscription and death toll of Napoleon's campaigns struck an even harsher blow on the populations across the channel, where the dreadful impact of the armies themselves scarred the landscape for years. Constriction of trade and the stringencies of wartime economy hurt everywhere, but in Britain least of all, for the sea—and the navy—kept her free. And, if the average British citizen had a relatively less miserable wartime experience, the upper classes—including the families of military officers such as Watson—suffered few inconveniences apart from confinement to their own island and a shortage of French wine. Watson knew the reality of life below decks, for his logs are filled with references to spoiled food, disciplinary measures, and desertion, but from the vantage of even a compassionate officer, the life of a British seaman or laborer took place in another world. Watson's compliments to the American "peasantry," noted in his diary of 1816, reveal his

detached and condescending class perspective with clarity. Although not wealthy, Watson belonged to an insulated elite who could socialize cheerfully in London or tour the countryside "in search of the picturesque" while the less affluent citizens back home in Exeter rioted over the price of bread.[35]

The Peace of Amiens in 1802–3 brought no change to Watson's life, other than reducing his chances for active duty. When war commenced again in May 1803, Britain remobilized the most powerful navy in the world, backed by a prosperous merchant fleet and a corps of trained seamen and officers to inspire fear and envy in all rivals. France, by contrast, had seen its navy shrink, its overseas trade falter, and its caliber of naval leadership and seamanship deteriorate. Overestimating the strength of his navy, Napoleon made no secret of his plans to seize control of the Channel and invade England. The British navy renewed its blockade of French ports with a vigilance fed by near hysteria on the home front. When threats to Ireland were perceived again in 1804, the naval cordon ringing its southern coast was tightened. After five years of waiting, Watson was called to defend the country of his father's birth and the critical western approaches to the Channel.

Before leaving for Ireland, Watson commissioned a portrait of his young family from young James Leakey (1775–1865), the artist of choice for Exeter's upper classes (fig. 10). The appearance of his two daughters, Mary (born in June 1801) and Frances ("Fanny," born in December 1802), must date the painting to early 1804, when Mary was a bit more than two and a half, and Fanny just a year old. In this charming "conversation piece" the conventional grandeur of columns and drapery is domesticated by playful and affectionate human interchange and the lively patterning of the carpet or floor cloth. Since Watson was well past the regulation three years of junior status, he could wear the double epaulets of a senior officer, despite his inactivity. A bicorn hat trimmed in gold braid, which all captains wore sideways, rests behind him. For this portrait Watson chose to appear in his plainer "undress" uniform. Had he chosen to appear in full dress, he would have donned white breeches and stockings and a jacket decorated with more gold trim. The less formal, family mood may have been tailored to please Richard and Mary Rundle, who

10. James Leakey, *Captain Joshua Rowley Watson, his Wife Mary Manley Watson, and their two daughters, Mary and Frances*, ca. 1803–1804, oil on canvas, $14\frac{1}{2} \times 17\frac{1}{2}$ in., Collection of Elizabeth Burges Pope.

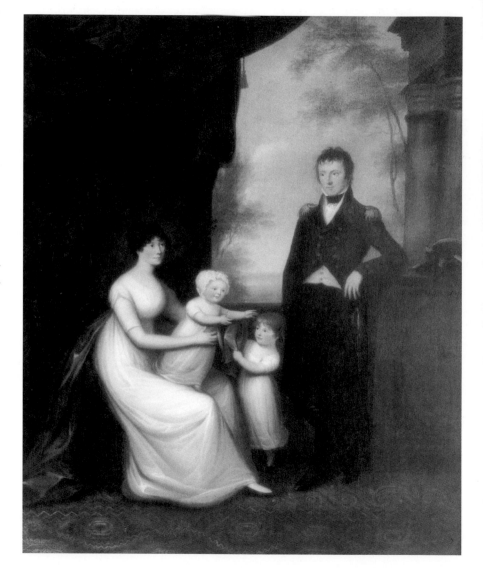

were about to return to the United States. Twelve years later, when he visited Philadelphia, he found "our family picture and several drawings by me" hanging in the parlor at Eaglesfield.[36]

His aunt and uncle sailed from Bristol in March 1804, and Watson reported for duty across St. George's Channel later that month. For the next three years he served at Castle Townsend as superintendent of a squadron of "sea fencibles"—small armed ships capable of swift action in shallow and treacherous coastal waters. The mishap at Kinsale was clearly no liability here; rather, his years of experience in the Irish Sea recommended him, along with his management skills. From Sheep's Head on Bantry Bay to Galley-head, just south of Kinsale, Watson's coast guard patrolled the southernmost tip of Ireland on either side of Cape Clear. More administration than action—for the French invasion never materialized—this assignment surely taught Watson (if his earlier rounds refitting at Portsmouth had not) the bureaucratic reality of a captain's life: commanding twenty-seven ships and almost seven hundred men mostly meant paper work at a desk in Castle Townsend.

Tension rose in the late summer of 1805 as Napoleon joined his troops at Boulogne and poised for the leap across the channel. While Nelson chased parts of the French fleet in the Atlantic, the rest of the British navy gathered in the seas between Ireland and France to defend the western approaches. This massed fleet discouraged the French admirals, and so Napoleon—unable to wrest control of the channel for even 24 hours—broke camp and turned his army east. In October, Nelson's victory at Trafalgar securely established Britain's naval superiority and killed French invasion schemes for good. The British navy maintained pressure on shipping, and Watson remained on defensive duty in Ireland, but the main strength of the fleet could now be applied offensively. For Watson, this shift in strategy ultimately drew him into three controversial naval strikes on the continent.

The first, and most surprising, fell in the summer of 1807. Withdrawn from the Irish station in March, Watson took charge that month of HMS *Inflexible*, the first large warship under his command. With sixty-four guns, the *Inflexible* was a store ship, armed at the level of a third-rate ship of the line but designed to carry troops and

supplies, including a complete forge. She was twenty-seven years old and needed plenty of time for repairs at Chatham that spring before moving on to Blackstakes for the receipt of more stores and marines. The crew, normally about 650 men, was joined on 25 July by 530 Coldstream guards, eighteen women, and one child; on the 30th the ship set off at the head of a convoy of twenty ships, after the officers of the accompanying vessels met on board for instructions. Conducted with both stealth and speed, the *Inflexible*'s preparations surprised the citizens of the neutral nation of Denmark, who woke to find her standing off Elsinore Castle in early August 1807 in the midst of a fleet including twenty-five ships of the line, forty frigates, and 380 transports bearing 29,000 troops.

Learning of Napoleon's intention to force Denmark's allegiance, the British planned to destroy the Danish fleet before it fell into French hands. The commander in chief of the expedition, Admiral James Gambier, came on board the *Inflexible* 10 August. Watson's contingent of marines was unloaded at Wibeck six days later. The noose around Copenhagen, on land and sea, tightened. Watson observed gunfire exchanged between vessels on the 17th, and he began to take on prisoners the 19th, while constantly dispensing supplies to the other ships burning and sinking around him. In the midst of battle, he added to the chaos in the harbor by dumping more than a half-ton of cheese overboard because it was "rotten, stinking & unfit for men to eat." The siege continued until 30 August, when the ship received news of the victory of Sir Arthur Wellesley (later the Duke of Wellington) on shore. Refusing to surrender, the Danes submitted to three days of round-the-clock bombardment, which set off a ruinous conflagration. From the quarterdeck of the *Inflexible*, Watson watched Copenhagen burn. A truce was declared on 5 September, and he was sent on shore "to take command of the Navy Brigade." Back on board by the 7th, he dispatched his prisoners and began to supervise follow-up operations. The ship disbursed supplies to the transports and prizes and finally sailed for England with a convoy of 52 vessels on 28 September.[37]

The Danish navy, both afloat and under construction, had been largely destroyed or captured in this attack. The ruthless British assault on a tiny, neutral country horrified observers on all sides, for

the loss of civilian lives and property was appalling. But militarily, the expedition was awesomely organized and effective, giving proof of Britain's naval resources as well as her determination to allow no threat to rise against her on the seas. When, three months later, the British orchestrated the flight of the Portuguese royal family along with the entire Portuguese navy, Napoleon saw the last available European navy disappear over the Atlantic horizon. More than the defeat at Trafalgar, these two robberies at Copenhagen and Lisbon spoiled French hopes for control of the seas.

Watson held command of the *Inflexible* at the Nore, east of London, until 4 October 1808, when he "put the ship out of commission." He was off duty in Exeter this year, as is proved by an extant drawing of the old city wall, at Southernhay, not far from his new residence on the Barnfield Crescent. The growing Watson family had occupied a townhouse in this newly developed district on the outskirts of Exeter, a few blocks southeast of the Cathedral, since 1804. This new address, probably owned by and shared with his aunt Fanny and her husband, John Green, tells of the middle-class comfort of his family circle. The stylish rowhouses in this quarter, built on crescents facing communal gardens, belonged to merchants, professionals, and gentlemen of independent means "seeking a salubrious and quiet retreat" from the bustle of inner Exeter.[38] The Barnfield Crescent was only a temporary retreat, however, for the birth records of his children show residence (or baptism) in Alphington (1802, 1809), Barnfield (1804), Topsham (1806), and Plymouth (1813, 1815). Evidently, Mary and the children were moving often to be close to Watson when he was stationed at Plymouth or to join other family members, like the Greens, when he was at sea.

The shore leave begun in 1808 ended 21 February 1809. The war was reaching its peak, and Watson would be on duty almost continually for the next four years. The navy's list was approaching a thousand ships and 145,000 men; every able officer was kept busy.[39] Six weeks before the birth of his son Rundle Burges Watson, he was called to the helm of a yet-larger vessel, HMS *Alfred*, at Spithead off Portsmouth. With seventy-four guns, the *Alfred* was classed as a third-rate ship of the line, bearing about 650 men. Two years older than the *Inflexible*, she was nearing her thirtieth birthday, and Wat-

son spent six months getting her in shape for another Baltic expedition that summer. His watercolor of the "Head of HMS *Alfred* when docked at Chatham in May 1809" (fig. 11) gives an informative record of this ship's figurehead and the work in progress. While docked, the ship was overhauled to correct problems with the helm that were responsible for a damaging collision with another vessel in the harbor of Spithead in April. The defect was never rectified, and the lumbering *Alfred* continued to run afoul of other ships, but provisioning began in June: among other items, 20,000 pounds of bread, 425 infantry troops and their officers, with their horses, were brought on board. On 25 July she sailed with the fleet to Folkestone and then crossed to the Belgian coast.

The British landing on the island of Walcheren at the mouth of the Scheldt below Antwerp took place on 30 and 31 July 1809. More ambitious than the siege of Copenhagen two years earlier, it was disastrously mismanaged by comparison. The largest British force mustered at one time during the Napoleonic wars—including some 40,000 troops—crossed the channel and landed at Flushing. Intending to drive a wedge deep into Belgium and draw off Napoleon's army from its destructive campaign in Austria, the army was stopped in the middle of swamps by a coalition of French and Dutch forces. Five months in this muddy trap killed or incapacitated half of those who survived the initial battle. Watson repeated the role he had played at Copenhagen. The *Alfred* never fired a shot after discharging her troops and horses. From the deck, Watson spied gunboats sinking nearby, heard cannons from the shore, received prisoners, and issued a steady stream of provisions and ammunition to the ships on the line. Unlike the less fortunate marines, he was recalled to England quickly. On 23 August, a week after the surrender of the town of Flushing, the *Alfred* sailed for England, running afoul of her sister ships "*as usual* the worst sailer in the squadron."[40]

Watson spent the fall of 1809 refitting the *Alfred* yet again for another Caribbean campaign. He sailed for the Barbadoes on 8 November, before the Belgian expedition stumbled to a conclusion, and remained on station in the Leeward Islands through July 1810. The navy was busy chasing, capturing, and destroying French ships in this region, while supporting the army's maneuvers on land. The *Alfred*

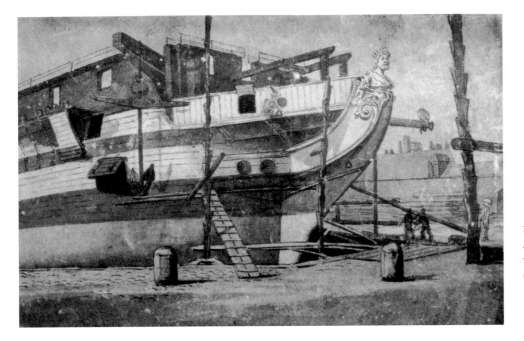

11. Joshua Rowley Watson, *Head of H.M.S. Alfred when docked at Chatham in May 1809*, watercolor on blue paper, $7\frac{1}{8} \times 11$ in., Collection of Elizabeth Burges Pope.

kept constant company with the Admiral's flagship, *Sceptre*, and together they stood off Guadeloupe on 30 January, landed troops, submitted to shelling from the French battery, and "observed our army advancing toward Trois Rivières." Watson had a good view of the troops swarming up the Battery while the French forces retreated to the heights of Palmiste. After the truce of 4 February and the return of the island to British rule, he reported that a medal had been bestowed on the entire army.[41]

Watson's private record of "Memorandums and Observations" in 1810 gives an unofficial account of the same period. On 31 January, the day after the battery was taken, he went on shore before breakfast and "amused myself collecting some Flowers." He returned to the ship, punished a deserter, and then "amused myself drawing. At noon our Troops took possession of the heights on Trois Rivieres."[42] This vision of Watson, putting down his wildflower bouquet to punish a deserter, or looking up from his watercolor sketch-

book to observe a battle, gives a summary picture of his personality and his career as an officer and an artist. Disciplinary incidents occur throughout his logs, in response to the drunkenness, desertion, and insubordination that the navy found both routine and intolerable in this period. In March 1810 a marine captain (evidently commander of the marines on HMS *Alfred*), complained of the "indignities" and "abuse" suffered under Watson's supervision, but evidently Watson was not among the tyrants who inspired the mutinies at Spithead in 1797 or on the *Bounty* in 1789. The court martial investigating these complaints acquitted Watson of all charges and found his directives all "for the good of the service."[43]

Watson's private diary also reveals the texture of a captain's life, even in the midst of a wartime expedition, when boredom threatened more often than combat. Numerous days at anchor, repairing, provisioning, and administering the ship and its company, gave many opportunities for socializing, loafing, or drinking in all quarters. Gre-

garious and curious, Watson made the most of such idle moments in the tropics, collecting flowers and shells on the beach, completing sketches for the admiral, dining with fellow captains, local dignitaries, and visitors (such as the Philadelphia merchant Joseph Dugan and his wife) and writing letters to family and friends in Devon and America. In May he sailed for St. Lucia, on a personal quest for the site at Vighi where his father had been buried thirty years earlier.

In July 1810 the *Alfred*, "still the worst sailer in the squadron," returned to England. By August Watson was reunited with his family in Plymouth. His return that summer occasioned the incident that the indefatigable diarist Joseph Farington recorded in November 1810 as "a genuine & remarkable instance of powerful affection & feeling." Farington's story, heard from Watson's Exeter friend, Rev. Gayer Patch, told of the Captain's return from a long absence at sea.

At the end of abt. two years [his wife] recd. a letter from him informing Her that He expected to be at Plymouth at a certain time & She proceeded to that place to be ready to receive him. It happened that He returned sooner than He had reckoned upon, and while She was walking in the street He suddenly appeared before Her accompanied by an acquaintance, which agitated & affected Her so much that she ran from him to Her Inn whither he followed Her to calm Her spirits which had recd. too great a shock for her reason to bear for the moment.[44]

Mary received another jolt on 23 September, when they awoke at 3 A.M. to find the neighborhood in flames. The Watsons packed and dressed hurriedly and escaped without injury, although five nearby houses were badly burned. As later events would show, this moment of panic left Mary Watson permanently anxious about fire. Two days later, having scarcely enough time to calm her spirits again, Watson "took leave of *all my heart* holds dear" and re-embarked the *Alfred* for Cadiz.[45]

Watson sailed to Spain in the fall of 1810 to support the peninsular campaign that had involved Britain since 1808. Napoleon's brother, Joseph—who would be living in Philadelphia when Watson visited in 1816–17—held the throne of Spain. In Portugal, Lord Wellington waited inside the fortifications of Lisbon, watching the French siege army defeated by hunger and cold. Cadiz, the only port in Spain

that never fell to the French, had become a major base for the British navy. Its harbor received supplies for the inland ventures of the army, launched naval attacks on the captive coastal cities, and offered a haven for repairing or restocking the fleet. As usual, Watson's ship stood behind the lines, feeding supplies to gunboats shelling Fort Catalonia in October and early November. He spent most of the winter in Cadiz, socializing with the delegates to the Cortes that had gathered to draft a new constitution for Spain. Watson and all his "following" officers were transferred to another ship in the harbor in April, a month after the French abandoned the siege of Lisbon and Wellington stepped forth from the city to begin his army's relentless march toward Paris.

Watson may have turned over the helm of the clumsy *Alfred* with some relief, but his new command was another veteran warship. The seventy-four-gun HMS *Implacable*, once known as the *Duguay-Trouin*, had been captured from the French six years earlier, in the aftermath of Trafalgar.[46] Watson sailed her in the Mediterranean through 1811 and 1812; he observed action off Cape Sicie (near Toulon) in June and dispatched his faster attending vessels in chase of French gunboats in July. The *Implacable* took two prizes in tow as a result, and Watson, as commander of the action, received a portion of the prize money for these captures. He cruised the rest of the year between Corsica and Gibraltar, spent the winter of 1811–12 in Mahon (Minorca), and undertook a coastal survey (fig. 12). These off-shore views, like elevations of a map, were standard fare for a naval artist, and Watson may have done them for the Admiralty's use or—as in Guadeloupe—simply to pass the time.[47]

While Watson was posted in the Mediterranean in the summer of 1812, the United States declared war on Great Britain. He returned the *Implacable* to Plymouth that fall and gave up his command on 7 November, perhaps relieved that he was not asked to sail against his American relations. In fact, the *Implacable* was nearing the end of active service, and so was Watson. As he left duty that month, the survivors of Napoleon's army were limping home from Moscow. Time was running out for the emperor, with repercussions for all the military professionals in Europe. Watson would hold no further posts. He entered the half-pay registers in 1814. Briefly re-employed in Feb-

12. Joshua Rowley Watson, *The Gulf of Genoa*, ca. August 1811, pen and ink and blue wash over graphite on two pieces of paper, each $4\frac{3}{4} \times 10\frac{1}{2}$ in. (sight), Collection of Mrs. Stella Reeves.

ruary of that year, a moment when the British navy regrouped and offered many new commissions, Watson was on call when Napoleon fell on 1 April. The ensuing peace of 1814 remained tense for the navy. As the allies negotiated at Vienna, disputes seemed to forecast new battles. The American war escalated as soon as troops and ships were free to be sent to the Canadian front. Not long after Jackson defeated the British at New Orleans in January 1815, Napoleon escaped from Elba and marched on Paris, gathering supporters. In June, his army was crushed at Waterloo. Since Watson was living at Plymouth this year, either employed on shore or awaiting further developments, he would have been nearby when Napoleon was brought to Tor Bay and Plymouth later that summer. Several drawings of Plymouth harbor from May 1815 appear in Watson's sketchbook in the Pope collection; perhaps, before the *Northumberland* sailed for St. Helena in August,

Watson was among the curious spectators on the heights overlooking the sound, or on board the small boats circling the ship at anchor, seeking a glimpse of the man, just three years his senior, who had impelled so many of the events of Watson's career.

Napoleon's final exile precipitated a crisis of peace in the British navy, which now had hundreds of idle ships and almost 6,000 mostly idle officers on its hands. One hundred twenty-five thousand seamen were dismissed in short order, and ninety percent of the commissioned officers joined Watson on the half-pay lists by 1817. Few could expect reinstatement soon.[48] Since Watson's family had survived comfortably on half-pay in the past, a new, more open-ended prospect of gentlemanly leisure unfolded before him.[49]

Watson seems to have enjoyed the return to family life in 1814, for he picked up his old sketchbook and filled some of the empty

pages with new sketches of the Plymouth vicinity (fig. 13). In August 1815 his sixth child, Richard Thomas, entered the world, joining another recent arrival, Joshua Rundle (born in 1813), in their home on Durnford Street, Stonehouse, between Plymouth and the dock yards. Some time that year he visited Ireland, near the headquarters of his old station on the sea fencibles, as shown by the drawing of "Wood Scenery on the grounds of Castle Townsend," dated 1815.[50] Then, with the war in America safely concluded and his newest children sturdily established, he determined to visit the United States.

The American Trip, 1816–1817

On 19 March 1816, Watson applied for a twelve-month leave of absence to visit Pennsylvania. He sailed from Liverpool on 21 April and returned to the same port in July of the following year. His applica-

tion for leave supplies nothing of his intention, so we must accept the meaning of his trip at face value: time off to travel and visit his family. Although he made calls on the members of the British legation in America, inspected naval yards in every city he visited, and made notes on arms and fortifications, Watson seems to have been just a military-minded tourist, with no overt or covert official business.[51]

Like France during the Peace of Amiens, America was invaded after the Treaty of Ghent by curious British tourists, many of them military officers released by the cessation of war.[52] Not all these visitors shared the personal happiness Watson must have felt on the conclusion of this conflict, but the public on both sides of the Atlantic greeted peace with joy and relief; it had been an unpopular, inconvenient, and largely ineffectual war, important to American self-

13. Joshua Rowley Watson, *From Capt. Nashes house Tar Point Looking up the Tamer 18th May 1815*, pen and ink over graphite on two sketchbook pages, each $6\frac{5}{8} \times 9\frac{1}{8}$ in., Collection of Elizabeth Burges Pope.

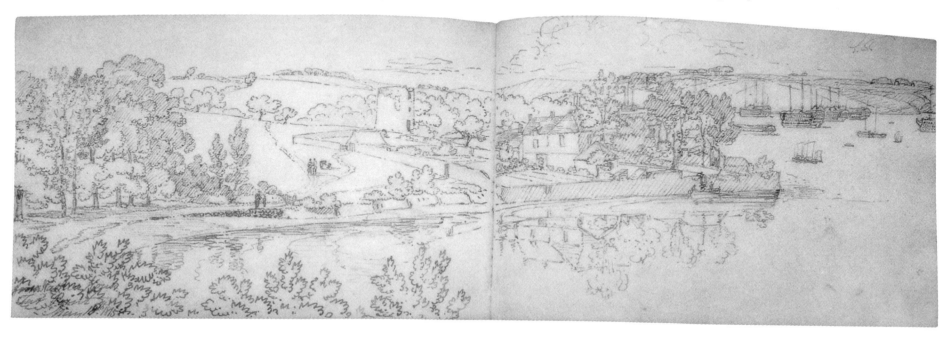

esteem and the rise of Andrew Jackson, but otherwise unproductive. Americans cheerfully restored relations with their natural allies in Britain, and put unpleasant memories behind them. Arriving eighteen months after the signing of the treaty, Watson received nothing but friendship and courtesy. His diary mentions no awkward encounters, even though a British naval officer might have expected a few cool if not gloating remarks, since American victories at sea had provided most of the bright spots in the nation's largely lackluster military showing. But Watson moved into a circle of merchants desperate for the resumption of normal trade, Federalists with pro-British attitudes, and military professionals quick to respect the accomplishments of their recent opponents. He arrived with an unusually positive and receptive attitude and was given a brotherly and collegial welcome.

American Family and Friends[53]

The warmest greetings came, of course, from Richard and Mary Rundle, at Eaglesfield, outside Philadelphia, and George and Maria Rundle, in the city center. All four had been with Watson in England twelve years earlier, and they probably badgered him with invitations once the war was over. Twenty years earlier they had welcomed Watson's aunt, Frances Burges (later Mrs. Green), to Philadelphia, and they must have been happy to maintain the family's tradition of transatlantic exchange.[54] The Rundles (also spelled Rondell, Randall, and Roundell) had been established in Tavistock, in central Devon north of Plymouth, since at least the fourteenth century, and seafaring Rundles found their way to Virginia, North Carolina, Pennsylvania, and New England as early as 1637. The Philadelphia branch was flourishing by the mid-eighteenth century, largely from the enterprise of Daniel Rundle (1725–95), who built a sizable fortune in the shipping business that his nephew, Richard, and grandnephew, George, would cultivate for another century.

The merchant-consortium of Daniel, Richard, and George

Rundle stood within the commercial context of the period much in the way that Captain Watson fit into the navy. Respectable and successful, and to a large degree typical of their class, the Rundles fared less well in history than Watson because the family fortune, impressive in Daniel Rundle's day, dwindled along with the family's ranks. Both Richard and George died without heirs, and the Rundle name disappeared in Philadelphia with George's death in 1859. Daniel, for his part, was neither wealthy nor remarkable enough to earn a lasting reputation in a city of many affluent and resourceful merchants. He evidently emigrated from Devon at midcentury with his older brother, perhaps arriving in Philadelphia by way of Wilmington, North Carolina. The distribution of his considerable estate, as outlined in his will of 1795, reconstructs the resilient network of family connections between Devon and Pennsylvania that remained after two generations of separation and the intervention of the Revolutionary War.[55] Daniel's two sisters married and remained in England, while two (and probably three) of the family's four sons emigrated to America. Their children, either born or raised in America, returned to Devon for long visits—like Richard's—or to marry distant cousins—as did George. Business kept the family together too: both Richard and George tended their shipping concerns from Philadelphia, London, and Liverpool. Certainly any conflict between the governments of the United States and Great Britain made life especially difficult, both personally and financially, for such a family. Daniel Rundle's divided loyalties made him the subject of suspicion during the Revolution; his nephew Richard served in the Continental army but remained loyal to his uncle.[56] Their dilemma, choices, and compromises make a particularly American story.

Richard Rundle (1747–1826), Daniel Rundle's favored nephew and principal legatee, seems to have been raised in Devon, where his father, George, had also been born.[57] His sister Frances (Mrs. William Manley) remained in England, and Richard's long visit to England from 1800 to 1804 must have been occupied by visits with Frances and her daughter Mary (Watson's wife), his great aunt Mary Rundle Burges (also Watson's grandmother), and her daughter Frances Burges Green (who had visited Philadelphia earlier). Watson was thus related to Richard Rundle at least twice: as a distant cousin, united by the "persevering" matriarch Mary Rundle Burges, and as a

nephew by marriage.[58] He needed no excuse to visit Philadelphia.

When Watson embraced his uncle Richard in 1816, he found him close on the age of seventy but almost unchanged since they had parted twelve years earlier. Rundle was in retirement at his country estate, Eaglesfield (see fig. 3), enjoying the fruits of his long career in shipping and real estate. Before departing about 1799 for his extended sojourn in England, Rundle followed his uncle's precedent in supporting local financial and charitable institutions, being a Director of Pennsylvania Hospital (1787–89) and the Bank of North America and a member of the parish of Christ Church, where he was both married and buried. About 1799 he took his young cousin George, based in Liverpool, into a partnership, and not long after he attended George's wedding to Watson's sister, Maria, in Topsham in 1801. Rundle was admired for his character, intelligence, and good business sense. "Remarkable for his urbanity, his cheerfulness and his

hospitality, warm hearted and sincere in his friendship, frank, honorable and courteous in his general intercourse, he was beloved and esteemed by all who knew him."[59]

The older Rundles returned to Philadelphia in 1804, reoccupying the town house in the block bounded by Seventh, Eighth, Spruce, and Pine Streets, left to them by Daniel Rundle in 1797. Times were terrible for American shipping, and after 1806 they grew worse. Routinely harassed by British impressment, American ships were now caught in the cross-fire of French and British trade wars. In an unsuccessful attempt to apply pressure to both sides and regain protection for neutral shipping, Jefferson's embargo in 1807 strangled whatever American trade remained. Rundle, contemplating his retirement, wisely turned to managing his real estate investments.[60] In 1810 he purchased the estate, Eaglesfield, 1.5 miles northwest of the city on the Schuylkill River (fig. 14), and withdrew to enjoy the pleas-

14. Thomas Birch, *Fairmount Waterworks*, 1821, oil on canvas, $20\frac{1}{4} \times 30\frac{1}{4}$ in. Pennsylvania Academy of the Fine Arts, Charles Graff Estate Bequest. Eaglesfield is the distant house seen up the river; at the center is Lemon Hill. Philadelphia's famous waterworks are at the right in this view painted from the center of the Fairmount Bridge.

ant privileges of the "Baron" of the State in Schuylkill, a convivial association whose fishing "castle" stood on his shore.[61]

Meanwhile, George and Maria managed affairs downtown from one of the townhouses their uncle owned in the newly developed neighborhood west of Washington Square (fig. 15). Watson would have found his sister's house familiar, for it resembled their aunt's rowhouse in Exeter and was built about the same time for exactly the same class of prosperous urban occupants. Designed by Robert Mills and built by Richard Rundle's friend, John Savage, the young Rundles' home was a material enactment of the transatlantic ties in this family.[62]

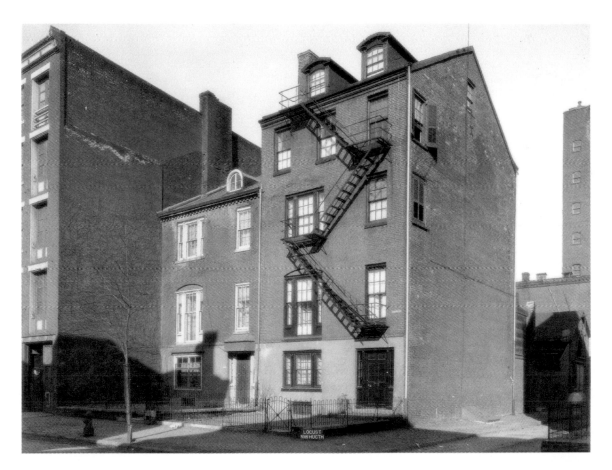

15. The townhouse of George and Maria Watson Rundle, 921 Locust Street (at center) and its neighbor on the right (with a later third story), as they appeared in 1917. These two units, now demolished, were the last of "Rittenhouse Range," a terrace of homes built in 1813 by Meany and Savage from designs by Robert Mills. Photograph courtesy of the Philadelphia City Archives.

Watson went straight to the Rundle home on Locust Street as soon as he disembarked, and he must have spent many hours there with his sister, her husband, and their daughter Fanny (fig. 16), now ten. George Rundle, who was Watson's distant cousin and close contemporary, accompanied him on various social occasions and surely introduced him to a younger circle of friends. George had come to the city from Wilmington, North Carolina, at an "early age" to gain a "commercial education" in the service of his uncle Daniel and older cousin ("uncle") Richard. By 1800 he was established in Liverpool as a merchant and broker, and he remained in England for several years after his wedding to Maria. They moved to Philadelphia permanently in 1805 to join Richard Rundle's enterprises (and perhaps his living space) at 246 High Street. Known for his "zeal and assiduity," George managed the estates of both Watson and his uncle after their deaths, and throughout his own "varied fortunes" in business he remained "emphatically a gentleman of the old school."[63]

George and Richard Rundle held the center of the circle of businessmen and "gentlemen of the old school" that Watson met in Philadelphia. Three quarters of the persons listed at the head of his diary or mentioned within his daily entries (see Appendix A) were from this city, and a third of those were merchants and businessmen engaged in mercantile enterprises. Diary references show that the Rundles' friends, neighbors, and associates on High (now Market) Street included the shipping firms of the Dugan, Emlen, Fisher, Leaming, Murgatroyd, Perot, Savage, Stocker, and Waln families. This group included by no means all of the richest or most fashionable merchants in town. Rundle's crowd was from a more modest, if still affluent, sector. Nonetheless, Richard Rundle was on the periphery of the wealthiest and most stylish circles, if only by virtue of his address at Eaglesfield (see Map I, fig. 17). Most of his neighbors on the river owed their estates to success in business: Henry Pratt at Lemon Hill, Samuel Breck at Sweetbriar, James Fisher at Sedgeley, and Robert Waln at Harleigh. Only two in the vicinity lived truly gentlemanly lives, supported by inherited incomes and estates: James Hamilton at Woodlands and the retired Judge Richard Peters at Belmont. During just the first months of his visit, when Watson's social life can be known from his diary, he made the rounds of these Schuyl-

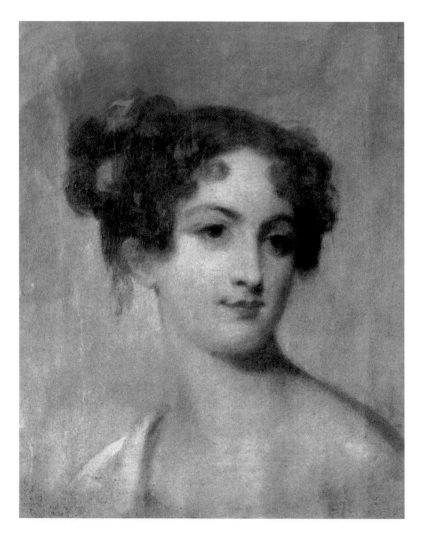

16. Thomas Sully, *Fanny Rundle* (1806–1828), 1859?, oil on canvas, 19 × 15 in., Collection of Mrs. Sybil Venning. The original portrait of Watson's niece, painted in 1828, is in the Corcoran Gallery of Art, Washington; Sully's notebooks indicate that he made three replicas in 1859, probably for the heirs of Fanny's father, George Rundle.

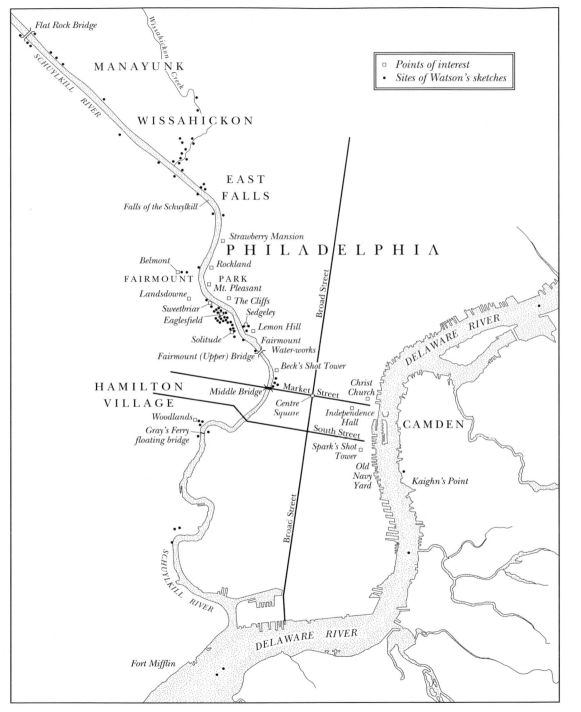

MANAYUNK

Flat Rock Bridge

Wissahickon Creek

SCHUYLKILL RIVER

WISSAHICKON

| Points of interest |
| • Sites of Watson's sketches |

EAST FALLS

Falls of the Schuylkill

Strawberry Mansion

PHILADELPHIA

Belmont *Rockland*

FAIRMOUNT **PARK**

Landsdowne *Mt. Pleasant*

Sweetbriar *The Cliffs*
Eaglesfield *Sedgeley*

Lemon Hill

Solitude *Fairmount Water-works*

Fairmount (Upper) Bridge

Broad Street

Beck's Shot Tower

HAMILTON VILLAGE

Middle Bridge *Market Street*

Christ Church

Centre Square

Independence Hall *South Street*

Woodlands

Gray's Ferry floating bridge

Spark's Shot Tower

Old Navy Yard

CAMDEN

Kaighn's Point

DELAWARE RIVER

SCHUYLKILL RIVER

Broad Street

Fort Mifflin

DELAWARE RIVER

17. Map I: Philadelphia and the Schuylkill Valley.

kill villas, visiting Woodlands, Belmont, Sweetbriar, and Lemon Hill at least twice each. No doubt he saw these homes and their owners again in the remaining ten months of his stay. Such visits suggest that, quite predictably, his uncle's business connections and home address had primary force in shaping the list of people Watson encountered in Philadelphia.

More than a quarter of the identifiable men noted in Watson's diary (that is, twenty-three out of eighty-four) were merchants, bankers, or businessmen. As might be expected in Philadelphia, just as many were lawyers and politicians, mostly of local importance: Breck, Hollingsworth, Hopkinson, Ingersoll, Morgan, the Peterses, Rawles, Dallases and Walns, all active in the state or federal congress and judiciary. While traveling, Watson tended to meet (or record meeting) similar people, the likes of Senator Lloyd and Governor Brooks of Massachusetts.

These two circles of lawyers and merchants, comprising half his list of acquaintances, had a few things in common, beginning with affluence. Most were, like Watson and the Rundles, Episcopalian.[64] (When he remarked on the Quakers — Morris, Shoemaker, Waln — it was usually to note that they appeared no different from the norm.) Most were Federalist in politics. Watson's list included the name of just one church leader, but it was the right one: William White, Episcopal bishop of Pennsylvania and rector of Christ Church. The list of Federalist leaders was longer, including twelve officeholders such as Breck, Hillhouse, Hollingsworth, Hopkinson, Ingersoll, Leaming, Lloyd, Peters, and Rawle. Nationally, Federalism was demoralized, discredited, and declining in strength, but in Philadelphia — and particularly among Watson's friends — the party was enjoying an Indian summer. In the election of 1814 local Federalists, including Samuel Breck, swept the city and county offices away from the Democrats. A few of the party's adherents, such as Judge Peters or Governor Brooks, were of Richard Rundle's generation, veterans of the Revolutionary War who knew Washington personally and upheld his national ideals, usually in terms of the specifically "Federalist" strategies of his brilliant adviser, Alexander Hamilton. Watson listened with delight to tales of Washington from the witty Peters, strolling in the gardens of Belmont; he visited the site of the Hamilton-Burr

duel (see plate 73) and commented remorsefully on the death of "one of Columbia's most able and best men" (23 July 1816), an opinion he likely shared with every Federalist on his list. The gentlemen of the old school among his acquaintances, particularly those with wealth and seaboard business interests to guard, were threatened by Democratic party policies that looked with favor on the western states and vast new territories of the Louisiana Purchase. Certainly Rundle and his friends were hostile to Jeffersonian foreign policy, which had purchased all this new land at their expense, invented the ruinous embargo, and launched an unwanted war with their best trading partner. Only a few Francophiles were in the group, like Samuel Breck, who had been educated in France and enjoyed entertaining such visitors as Lafayette at Sweetbriar.[65] The two lone Democrats, Alexander J. Dallas (Madison's secretary of war and the treasury) and his popular son George, make an interesting exception to the overwhelming Federalist opinion of those on Watson's roster. Regrettably, Watson's diary text leaves off before his mention of these two men and the circumstances of their meeting.

Another quarter of the population in Watson's world held military titles. Predictably, three quarters of these officers were from the navy. By charm or perseverance, Watson managed to meet almost the entire naval pantheon of the War of 1812, including all the most senior and decorated officers: Commodores Bainbridge, Dale, Decatur, and Murray, plus six captains and three lieutenants. Only Commodore Rodgers and Captain David Porter eluded him, though Watson expressed curiosity about the latter. This category of acquaintances differs from the others in being created by Watson's initiative, rather than brought to him through his family. His interest in these men, who had recently fought with great success against the British navy, needs no explanation. Watson found most of them at the various navy yards in Philadelphia, New York, Boston, and Washington that he made a point of inspecting. A few, especially those in Philadelphia, must have been encountered socially, too; Watson and Breck were entertained twice in Washington at the home of Stephen Decatur.[66]

Although this last group of friends was of Watson's own making, its members usually mixed easily with the merchants and lawyers on

religious, political, and social common ground. Commodore Dale was president of the Federalist-flavored Washington Benevolent Society, a member of Christ Church, and a good friend of Judge Peters and Samuel Breck. The tight overlap of these three circles makes it likely that, on certain select occasions, a remarkable percentage of Watson's acquaintances were assembled together: Bishop White's Easter Sunday sermon at Christ Church, for one likely example, or an event Watson described in his diary: the Fourth of July banquet of the Washington Society in 1816, held in concert with the Washington Benevolent Society and featuring an oration by Charles Caldwell.

The remaining quarter of Watson's list was dominated by diplomats, including nine members of foreign legations in Washington and Philadelphia (Denmark, Great Britain, Holland, Russia, Spain, and Sweden). Watson was pleased to find that the Spanish consul, Rengunet, knew his friends in Cadiz; one wonders if remarks passed between Watson and the Danish minister, Pedersen, concerning the obliteration of Copenhagen in 1807. Two other foreigners—Joseph Bonaparte and Emannuel Grouchy—add celebrity glamor to his list, although neither is mentioned in the two months of the extant diary, so it is not known how, or how well, Watson knew them. Both men were in the Philadelphia area almost the entire time that Watson was in America, so he could have encountered them on numerous occasions, perhaps through mutual friends such as Samuel Breck or Joseph Hopkinson, who was Bonaparte's friend and legal adviser.

In addition to these cosmopolitan figures, Watson knew a handful of writers and intellectuals (Breck, Peters, Hillhouse, Caldwell, Vaughan, President Kirkland of Harvard, Professor Ellicott of West Point) and a few men of science (Hosack, Wistar, Peale). Remarkably, Charles Willson Peale was the only American artist mentioned in his diary other than John Vanderlyn, whose work was seen in New York during a brief visit, and neither was listed among the persons Watson actually met. Peale was sequestered at his Germantown farm during this period, but Watson must have encountered Rubens Peale, who was managing the family museum in Independence Hall described in the diary on 5 July 1816. Watson's critique of Vanderlyn's work (see fig. 61) was enthusiastic, his description of Peale's museum was appreciative, and he noted with admiration James Hamilton's

collection of paintings at Woodlands. Surely he visited the Pennsylvania Academy of the Fine Arts and many homes where American portraits or landscapes were displayed. His next-door neighbor at Sweetbriar, Samuel Breck, owned family portraits by Gilbert Stuart and Bass Otis, "a young artist rising to eminence" in Philadelphia.[67] Yet the closest Watson got to a painter seems to have been in Boston, where he met John S. Copley's son-in-law, the very wealthy and socially acceptable Gardiner Greene.

Architects received even less attention, but there were fewer of them to encounter. Watson noted only his meeting with William Thornton, who was supervising the patent office in Washington. He failed to record the name of Benjamin H. Latrobe, the architect whose elevations of the new Capitol he copied (see Plate 76), and when he visited Sedgeley, also designed by Latrobe, he remembered only that it was laid out by some "French architect." Attentive to actual architecture, Watson included many sketches of houses in his notebooks and frequently commented on building materials. His indifference to architects becomes poignant in consideration of Latrobe's interests and his contemporary views of America, which are astonishingly kindred.[68]

Sculptors made no impression on Watson whatsoever, notwithstanding the loving attention he had given to the figurehead of the *Alfred* (see fig. 11) and the high profile in Philadelphia of the figurehead carver-turned-"sculptor," William Rush.[69] The one sculpture that he confronted and described, a monument to James Lawrence in New York City (see fig. 62; see Diary, 22 July 1816), received a confidently scathing review, indicating Watson's readiness to judge in such matters. But his visit in April 1817 to the Baltimore studio of the "very celebrated Italian sculptor" Antonio Capellano, described in Samuel Breck's diary, failed to make an impression on Watson at all.[70] Perhaps, as the inconsistencies in Watson's list of acquaintances suggest, people he met at the end of the trip were not recorded with the rigorousness maintained at the beginning of his visit.

Watson's failure to meet or remember *any* artists other than Thornton, who actually held a bureaucratic post, speaks eloquently for the social position of most artists in American society, just as it comments on Watson's professional priorities. Generally, painters

were not at dinner parties with the merchants, bankers, lawyers, politicians, diplomats, and sea captains in Watson's crowd, although many of these men—particularly Hopkinson, Vaughan, and Hosack—knew many artists well. Watson, for his part, seems to have made no effort to meet such people. He was evidently most interested in other officers and gentlemen; he must have presented himself first—if not only—as a Captain, R.N. The speed of his travels through Boston, Washington, and New York did not prevent him from contacting every major naval commander nearby, but eight months (at least) in Philadelphia was not enough time to seek out the Peales, Rush, Birch, Sully and his private gallery of paintings, or any other established artist in the city. It may be that Watson was genuinely modest about his accomplishments and too self-deprecating as an amateur to muster even a vestige of the collegiality that inspired his many calls on strange naval officers. Perhaps, too, his silence expresses condescension or disapproval. Certainly he had seen better art in London and Paris; probably he had seen the equivalent, or worse, in Plymouth and Exeter. At last, he may simply have been indifferent, or adequately entertained by the circle of friends supplied by the Rundles and the U.S. Navy.

Another lesson in social segregation comes from the total of three women on Watson's list of acquaintances. None is given a full name. The diary mentions a dozen more women, all wives and daughters described by last name only, and it refers occasionally to groups like the "Rawle family" that imply mixed company. Watson surely held the prejudices of his period that both exalted and subordinated women while expecting men to supply political, commercial, "public" leadership. He remarked on accomplished women when he met them, but his compliments were sometimes backhanded (as in admiring Judge Peters's "amiable daughter" but forgetting her name) and likely to stress physical appearance. Watson's tendency to overlook women might have been encouraged by the navy, where he grew up with the camaraderie, freedom, and competitive conventions of an officer's life. But the navy also taught him the bitterness of leaving women and children at home. Watson adored his family and, as his diary of 1818 shows, surrounded himself with women in Exeter. He spent much more time reading with his teenage daughters, tending his invalid aunt, or calling on other family groups than he spent in

the local coffeehouse consorting with brother officers. By his own admission, Watson preferred mixed groups and found the American custom of segregating the sexes at social events odd and detrimental. Only two weeks into his visit he noted with pleasure an "uncommon" dinner party at Eaglesfield, where "Ladies formed a part of it" (2 July). Even at Saratoga, where the social life was at least as attractive to visitors as the mineral waters, Watson

remarked here as I have elsewhere in America, that Ladies assemble together, and the Men in separate conversation lose the delight of female society, which so much improves the manners of those who mix much in their company. (30 July)

If Watson knew few women in America, it was not entirely his fault.

Philadelphia

Watson stayed in Philadelphia at least three quarters of the year he spent in America. He found the city "built on a scale of magnificence I had no idea of" (13 June). Although the federal capital had been moved to Washington in 1800 and the city's statistical superiority in shipping and population had been lost to New York City, Philadelphia was still the "Athens of America."[71] Watson appreciated its orderly plan, broad shady streets, and handsome architecture, built in brick with white marble trim.

The clay for making bricks in [and] about Philadelphia is uncommonly fine, and their bricks particularly good—the neighborhood also abounds with a light coloured grey granit and grey Marble, with such materials, and an abundance of the choisest woods for building, easy to be procured, 'tis no wonder that this city is the boast of its inhabitants. (19 June)

The public buildings and homes were all so "neat," he wrote, "that it looks as if it was just out of the hands of the workmen."

Philadelphia's city plan, foretold by William Penn, remained half-

filled in 1817. Most of the population of 112,000 clustered on the Delaware, between Spring Garden and South Streets, and west from the river to the distance of Seventh or Tenth Streets. Wharves and commercial buildings crowded the shores of the two rivers that flanked the city, but the center of Penn's map was still undeveloped pasture land. Watson found Market and Chestnut Streets paved in brick or cobblestone all the way to Broad Street, with plans under way for paving Vine Street, but the grand Centre Square at the intersection of Market and Broad (see fig. 52; now occupied by City Hall) remained a park on the edge of the city proper. Farther west, along the Schuylkill, only a few streets had pressed inland toward Broad. To the south, along Spruce, Locust, and Pine, urban development was creeping toward Pennsylvania Hospital, built after 1757 between Ninth and Tenth Streets, where it was assumed the occupants could escape the clutter of downtown and enjoy salubrious rural air. Watson's sister and brother-in-law, who lived at Ninth and Locust, were on the expanding edge of this neighborhood, on a frontier that was marching year by year westward toward the Schuylkill, claiming Penn's geometrical scheme with brick row houses where there had been gardens, cowpaths, and scrub.

Within the first two months of his visit, in the period described by his diary, Watson visited many of the institutions that were the pride of the city: Pennsylvania Hospital, the State House (which held Peale's museum), Athenaeum, Jail, Bettering House, Navy Yard, and major banks. We can only speculate about what he visited after August 1816, though his sketches document an expedition to the top of Beck's shot tower in December (see plates 7, 9) and a trip to Camden to get a perspective of the city from the far shore in May (see plate 3, color plate 2). Probably he visited the Pennsylvania Academy of the Fine Arts[72] and the new Fairmount Waterworks (see plate 10), the two other landmarks of civic pride that no tourist failed to see. The stone pumphouse by Frederick Graff (see fig. 14), with its turbines that lifted the water to the reservoir on top of Fairmount, had been completed in September 1815. Gravity distributed this water into center city, fulfilling a plan that was a model of efficiency and picturesqueness.

After a day visiting local sights, Philadelphians of this era, and particularly men of Richard Rundle's class, ate at home, not in restaurants. Most had a favorite coffeehouse where they mingled with other men, read newspapers, smoked, and conversed. Such establishments often drew from particular professions or trades, such as merchants or military personnel, like Watson's own "local" at Exeter. Philadelphia city and county boasted 4,000 taverns and 1,800 "tippling houses" in 1816, and doubtless Watson saw the inside of several. The ubiquity of the taverns must have added to the liveliness of street life, which in any port city such as Philadelphia was daily surging with carriages, wagons, stevedores, pedestrians, and animals of many kinds. To the predictable bustle of Market or Front Street might be added the unexpected "public nuisances" of 1816, all denounced and forbidden by the mayor that year, including offenses such as

the flying of kites, the rolling of hoops, the ringing of bells by vendors of muffins, the sweeping of gravel from the interstices of stone pavements, and the placing of merchandise in the footways.[73]

The liveliness in the streets in 1816 would not have obscured the depression that lurked in postwar Philadelphia and the struggle to overcome difficulties recently endured. The city's shipping industry had been dealt a bad blow by the War of 1812 and the decade of harassment, embargo and nonimportation treaties preceding it. Two years after the peace was made at Ghent, it was still true that unemployment was high, "times were hard, business was dull."[74] But the business community pressed for, and won from the U.S. Congress, funds for a new custom house in 1816. A new fish market, which Watson admired, was in operation on High Street. Two splendid new bridges, opened in 1805 and 1813, spanned the Schuylkill (see plates 7, 8, 9, and 14, and color plates 4 and 10), joining turnpikes that radiated west and south to Lancaster and Baltimore. After 1810, new steamboats churned up and down the Delaware between Bordentown and Wilmington, and a steam ferry made crossing to Camden a swift and modern passage (plate 3, color plate 2). Such progress was too hasty for some; a series of disastrous steamboat fires and explosions on the Delaware led to a round of public investigations into the safety of steam travel in the year Watson visited.[75] With typical optimism, Watson failed to mention such accidents, commenting only on the speed and convenience of steam travel. Insulated by

the affluence of his friends and the buoyancy of his own nature, he noted little hardship in Philadelphia. Instead, Watson saw enterprise, prosperity, "magnificence." If we reconstruct the delightful perspective from the veranda of his uncle's estate, Eaglesfield, such a vision of Philadelphia in 1816 becomes not just understandable, but believable, even real. Although the imaginative recovery of a lost mansion and its landscape presents more difficulty than the construction of Watson's biography or his social network, fortunately we can turn to his sketchbooks for help in rediscovering the place called Eaglesfield.

Eaglesfield: A Gentleman's Villa on the Schuylkill

"Among the various country seats which adorn the banks of the Schulkill for some miles above Philadelphia, no one surpasses [Eaglesfield] in beauty of situation," asserted the text accompanying the 1830 etching by Cephas Childs (see fig. 3).

From the portico of the house the eye looks down upon the sloping shores of the river, upon its placid lake-like bosom, and upon a prospect adorned with all that taste, high cultivation, and natural scenery, can conspire to make lovely. From the pier of the dam at Fairmount, whence the present sketch was taken, the scene is not less picturesque; the house itself forms the prominent object, resting as it does on the summit of a rising and verdant lawn; and the proportions of the edifice, and the disposition of the grounds around, display a taste adapted to the natural advantages of the place.

Ten years earlier, Watson had been equally charmed. "Eaglesfield is about 3 miles from Philadelphia, situated on the right shore of the River Schuylkill," he wrote on 13 June 1816. "The estate consists of 130 acres of which 50 are wood, the rest in pasture and arable, including the Garden & pleasure ground. It is one of the most beautiful places, for its size, I ever saw." Watson spent the greater part of his time in Philadelphia at Eaglesfield, and the many views of it he painted in his sketchbook made the estate the centerpiece, in more than one way, of his American experience.

As Watson noted, the house was "well situated on a rising ground, sheltered from NW to NE by lofty trees, and commanding most picturesque views up and down the river." (see fig. 2 and plates 14, 24) The estate held the west bank of a knobby bend in the river, land that had been granted by William Penn to William Warner, who settled Blockley Plantation (later Blockley Township) about 1680–81.[76] Warner's great-grandson, Isaac, sold a southern parcel of the land in 1784 to John Penn, Jr., who immediately built his country retreat, Solitude, overlooking the river (see plate 13). Upon Isaac Warner's death in 1794, the remaining 132 acres went to his widow and sons. Four years later, Warner's heirs sold this property to the merchant Robert Egglesfield Griffith. The new owner gave his middle name to the estate (which was occasionally spelled "Egglesfield" throughout the nineteenth century) and hired the English artist and landscape designer George Isham Parkyns (1749–1820) to help him build a country house on the site. If the Warners had any buildings on this parcel of land, they were soon replaced, remodeled or obliterated by Parkyns's design; the estate as Watson knew it in 1816–17 seems to have been largely the creation of the Griffith era.[77] Proud of his new home, Griffith probably commissioned its first portrait, by William Groombridge, in 1800 (see fig. 42).

Griffith did not enjoy Eaglesfield for long. In December 1807 the land was sold by the sheriff, who saw it taken up as settlement on a debt owed to Benjamin Chew (1722–1810). Six months later, Chew and his wife, Elizabeth, rendered the estate over to William Tilghman (1756–1827), in trust for Ann Penn (Allen) Greenleaf (1769–1851). Most likely, Ann and her husband, James Greenleaf, commissioned Thomas Birch to paint a view of their new estate (fig. 18) in 1808. They may have used Eaglesfield as a summer house or rented it to tenants during Ann's brief ownership, which ended 13 January 1810, when she directed Tilghman to sell it to Richard Rundle. She received thirty thousand dollars for the estate, realizing a tidy 15 percent increase on the value of her investment eighteen months earlier.[78]

In agreeing upon this price, both buyer and seller realized that land along the Schuylkill was very fashionably situated. The district was enjoying its golden age, when the year-round attention Rundle devoted to the "amusement and interest of his farm" joined similar efforts up and down the river (27 June). Rundle's nextdoor neighbor,

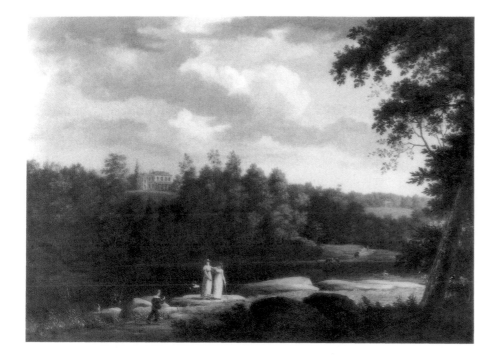

18. Thomas Birch, *Eaglesfield*, 1808, oil on canvas, 26 × 36¼ in., private collection.

Samuel Breck, had been one of the first to become a permanent resident of the neighborhood—as opposed to just a summer visitor or a yellow-fever refugee—when he built Sweetbriar in 1797. In his retirement, Rundle followed Breck's example and brought Eaglesfield to a peak of comfort and beauty in the years of his tenure, from 1810 to 1826.

THE ARCHITECT: GEORGE ISHAM PARKYNS

It is no wonder that Watson found Eaglesfield entirely to his liking, for it was planned by a man with very similar tastes and background. George Isham Parkyns also led a military life, as commander of a company of Nottinghamshire militia. He began to paint as a young man and exhibited his own landscape engravings at the Society of Artists in London the year Watson was born. While serving in

the army, between 1782–87, he occupied leisure moments designing estate layouts and landscaping. By the early 1790s, he was busy engraving picturesque views of British abbeys and castles. Evidently a man of independent means, Parkyns came to America in 1794 to clear the title on lands he had purchased speculatively while in England. He established himself in Philadelphia and lent a hand in the formation of the short-lived artists' society, the Columbianum (1794–95), a group composed mostly of emigré British artists like himself.[79] According to William Birch, who was soon to publish two sets of his own Philadelphia views, Parkyns "when he favoured this country with his celebrated talents, made a sett of drawings" of local country retreats "which he called the Tour of Schuylkill." Birch also recalled that "Mr. Greenleaf had a very engaging spot of much beauty laid out by Mr. Perkins near Solitude." Recollecting only the Greenleafs' brief ownership of the estate from 1808 to 1810, when Thomas Birch painted his view, William Birch was surely referring to Parkyns's

work at Eaglesfield, the estate bordering Solitude on the north.[80]

When approached by Griffith in 1798, Parkyns was working on a projected series of twenty-four aquatint views of American cities. Only four of these prints were published (fig. 19) before the portfolio failed for lack of subscriptions, driving Parkyns back to England not long after completing Eaglesfield.[81] These American views show a style remarkably like that of both Watson and Benjamin H. Latrobe. A masterful architectural draftsman, partly owing to his apprenticeship with Sir John Soane, Parkyns displayed his skill in a watercolor rendering of Pennsylvania Hospital about 1801.[82] With rural subjects, Parkyns showed himself securely in control of the vocabulary and

syntax of the "picturesque" landscape, employing a darkened foreground with framing masses of trees, alternating planes of dark and light into the distance, and a graceful and varied repertory of linear conventions to describe texture and foliage. Watson and Latrobe, only a generation younger, used the same recipes with the addition of a slightly less generalized, more detailed and observant topographic sensibility. The compositional format of Watson's *Looking up the Schuylkill from the Hutt* (see plate 23) parallels Parkyns's solution in his view of Washington, immediately suggesting the artistic fraternity of well-educated provincial gentlemen that embraced both painters and Latrobe as well. Parkyns's views of Mount Vernon, Passaic Falls, and the Falls of the Schuylkill indicate that he, Watson, and Latrobe covered much of the same picturesque territory too.

Parkyns's talent as a landscape painter was not the only thing to recommend him as a landscape architect. Two years before coming to America he had published six plans for "improving and embellishing" estates in a fashion attuned to current English theory and practice of landscape design. Appended to Sir John Soane's *Sketches in Architecture*, Parkyns's plans harmonized with the newest taste in English country villas. All six layouts were based on actual sites Parkyns had observed during his military encampment in Nottinghamshire in the 1780s, and the descriptive text emphasized the responsive nature of his "embellishments" to the particular opportunities of each site. Denying "the mere sportive effusions of creative fancy, nor the prescribed operations of an established system," Parkyns attempted "to assist nature, and, whenever she has failed in beauty, to supply the deficiency without suffering the appearance of art to intrude itself."[83] In Parkyns's spirit, Eaglesfield was conceived as a totality that enhanced the natural beauty of the site and balanced human presence harmoniously against nature.

19. George I. Parkyns, *Washington*, ca. 1800, aquatint on paper, $13\frac{1}{2} \times 15\frac{5}{8}$ in. sheet size, Library of Congress, LC-USZ62-15170.

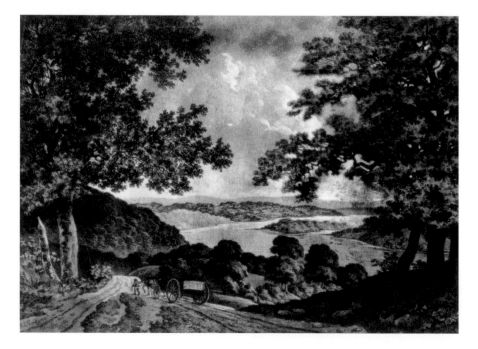

THE HOUSE

One of the first of the new generation of Schuylkill villas, the house at Eaglesfield was—according to Samuel Breck, who lived next door—an "elegant and spacious mansion."[84] Compared with its neighbors

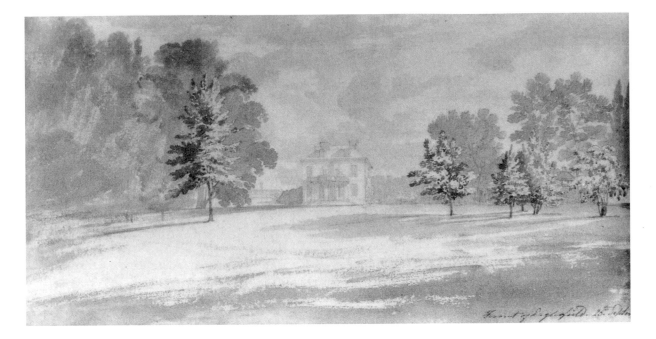

20. Joshua Rowley Watson, *Front of Eaglesfield. 20th September* [1816], ink wash over graphite, Barra Foundation sketchbook, p. B-107A.

just across the river — Lemon Hill and Sedgeley (see fig. 14 and plates 12, 14), both built the following year in 1799 — the design was downright old-fashioned. The architect of the house is not known, but Parkyns's association with Soane surely prepared him to design both house and landscape as a unit. Parkyns's genteel provincial background put him on understanding terms with a conservative American of similar station; neither one may have cared for modish architecture. Instead, Parkyns's preference for landscape design allowed the site to dominate the design.

The house, although not massive, was nonetheless a beacon; its pale and geometrical form organized human sight lines in the landscape for miles up and down the river (see figs. 14, 18). From far and near, the house read crisply as a statement of human enlighten-

ment. Resolutely artificial and rational, Eaglesfield stood apart from nature, exactly like the houses in Parkyns's *Six Designs*. The tripartite, bilateral symmetry of both major facades and the light color and squarish proportions of its mass all demonstrate the neoclassical architectural taste of mid-eighteenth-century Georgian England and its imperial sphere. Only a few bits of exterior detailing, such as the flattened, delicate trim or the "Palladian" configuration of the entrance porch and its overhead window (fig. 20), proclaim a measure of 1790s fashion consciousness. This second-floor window, stylishly inscribed in a shallow half-circle, is the one piece of design that announces the Federal or Adamesque date of the house. However, the tall chimney stacks, dormers, and hipped roof, raised enough to admit a third story, show the taste of an earlier generation; such ele-

ments would have lost favor among modish clients and builders by 1798. Watson's drawings show us that, in standard Georgian fashion, Eaglesfield was set on a contrasting stone basement, with a string course belting the house between the stories and slender pilasters articulating the corners. An insurance survey of 1832 tells us that the fabric was stone, like Sweetbriar next door, probably stuccoed to give the smooth, crisp surface that Watson depicts.[85]

The plan of Eaglesfield was indeed elegant and spacious, as Breck declared, but hardly progressive, showing aspects of Georgian layout common in larger American homes from the early eighteenth

21. Floor plan of Eaglesfield, based on Watson's sketch in the New-York Historical Society sketchbook, p. NY-132A. Lightly sketched lines in his plan (shown here as dotted lines) seem to indicate the placement of closets and furniture.

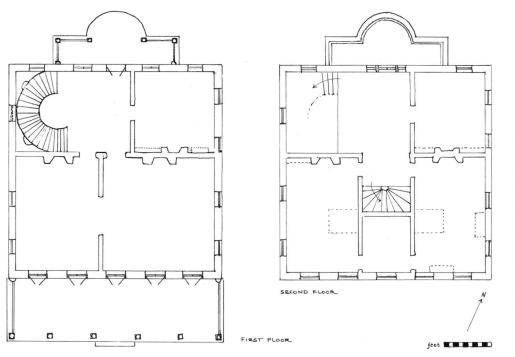

SECOND FLOOR

N

FIRST FLOOR feet ▪▪▪▪▪▪

century (fig. 21). The first-floor rooms echoed, on a smaller scale, the plan of Shirley Plantation in Virginia, built three quarters of a century earlier, with generous reception and entertainment spaces asymmetrically arranged within a strictly symmetrical exterior. As at Shirley, a large, squarish entrance and stair hall in the corner of the house gave access to all three first-floor rooms: the smaller "Breakfast Parlor" at the left of the entrance (16 feet 8 inches square, according to Watson's sketch plan) and two larger salons, connected by double doors, that opened onto the veranda.[86] Probably the smaller of these rooms (23 feet × 17 feet 4 inches × 13 feet) was a formal dining room; the larger one (23 feet × 23 feet × 13 feet) may have been a parlor. This asymmetrical organization of rooms, lacking the center hall of the most typical Georgian plan, provided more open and informal circulation; such a plan may have been perceived as appropriate to a country residence.

Upstairs, three large bedrooms opened into the upper hallway, flooded with light from the tripartite window that opened on to the balustraded balcony. A dressing room, shared by the two front bedrooms, was tucked behind curling stairs to the third floor. This top floor of "garretts," lit by dormers, evidently held servants' bedrooms and storage. The basement, entered from stairs beneath the main spiral staircase or from steps descending along the same wall on the exterior, contained "the kitchin etc.," and probably other service and storage rooms. Nothing about this arrangement seems out of the ordinary for buildings of this class and period.

Little can be learned about the interior of Eaglesfield from Watson's drawings, but an insurance survey of 1832 provides suggestive details: marble neoclassical mantels, stuccoed cornices in the parlors, decorated surbase moldings, pine floors and woodwork, mahogany rail, brackets, and skirting on the front staircase. Such trim is in keeping with the discreet affluence of the entire house, which was elegant but not extraordinary.

The novel and appealing aspect of the house lay not in plan or detail but in the extension of its interior spaces into the landscape, via porches on each major facade. The "back front piazza," extending along the three central bays of the house facing the northwest approach of the drive (see fig. 20; plates 15, 16), welcomed visitors with

an extended half-circular porch that echoed the shape of the window above. This "piazza" operated in the way of a traditional British porch, by providing shelter for the doorway and a transitional space for those arriving or leaving by carriage. A similar-shaped porch, serving similar purposes, still ornaments the facade of the smaller, slightly newer Schuylkill villa, Rockland, on the other bank of the river.[87]

The other "piazza," overlooking the view downstream to Fairmount, ran the entire length of the southeastern facade (46 feet × 13 feet) and served a different purpose. "This is a delightful place," wrote Watson on encountering this "front" piazza; it "affords shelter in the summer from the intense heat, and in rainy weather and winter, from damp and extreme cold" (13 June). After viewing other examples in the neighborhood, Watson remarked that "all the [American] Country houses" had such piazzas. "I don't see why those in England should not have the same, which would secure a fine airy walk in all weathers, besides being ornimental (sic) to the buildings" (17 June). Watson's remarks reveal the freshness of his encounter with an authentically New World hybrid of vernacular architecture: the Caribbean (ultimately African) tradition of the encircling porch married to the Georgian plan.[88] The utility of this veranda in the extremes of North American climate was clear to Watson; his drawings, showing Windsor chairs and potted plants (see plates 17, 18), show that Eaglesfield's piazza was indeed used as an outdoor sitting room—halfway between nature and parlor.

More remarkable than the piazza itself was its integration with the house. Five French doors shaded by sets of louvered shutters gave the parlor and dining room an easy and pleasant flow of light, air, and traffic to and from the veranda and the outdoors. These "windows" (to Watson), reaching "from near the top of the room to the floor" were extraordinary in Philadelphia; although most of the local villas had piazzas, the neighboring examples were either enclosed on three sides by the house (Woodlands, Sedgeley), or entered from clumsier double-hung sash windows (Sweetbriar, Sedgeley, Lemon Hill). Even considering those houses with more extensive verandas, encircling three sides of the building (Belmont, Lemon Hill), no other villa enjoyed such a bank of five doors en suite. Together, they effectively dissolved the southwest wall of the house and opened the interior space into the landscape, giving a truly modern effect. The veranda had balustrades only on the sides, with a single marble step south on to the lawn, and an uninterrupted view down the hill to the river. "The view from it is beautiful, looking over a lawn of 25 acres, well-planted with trees and shrubs" framing a prospect of the Fairmount Bridge, the city skyline, and the distant New Jersey shore of the Delaware (13 June; see plate 14). And, viewing Eaglesfield from a distance, this veranda indeed became "ornimental to the building," breaking up the box of the house and distinguishing it from all its neighbors. Artists often confused details, but they always got the basic configuration of house and veranda correctly; it was Eaglesfield's signature element (see figs. 3, 14, 18, 42).

THE LANDSCAPE DESIGN

Watson considered the southern river facade, with its generous piazza, to be the "front" of Eaglesfield, notwithstanding the actual carriage entrance on the northwest, or "back front" of the house. This orientation, inspired by the splendid views to and from the facade in this direction, points to the larger talents and intentions of the designer, Parkyns, and his client, Griffith. The pleasant but modest innovations in the union of interior and exterior space functioned well, and indeed became memorable, because of the spectacularly successful siting of the house. The charm of Eaglesfield from within and without depended to a large degree on Parkyns's skill as a landscape designer. Clearing trees and arranging new plantings, Parkyns made the house at Eaglesfield a landmark, despite its relatively small size and fundamentally conservative appearance.

Parkyns's principles are well outlined in Watson's drawings of 1816–17, when the landscaping strategies of 1798 had ripened across almost two decades of careful maintenance and growth. Major allées of lawn, on axis with the principal views up and down the river, led up to the main facades, following the configuration invariably seen in Parkyns's published designs, where hilltop houses command long vistas across water. Framing these views, like *repoussoir* foli-

age in Claude Lorrain's paintings, trees and shrubs stood in curving and irregular ranks. In keeping with British landscaping theories of the period, Parkyns sought a "natural" and informal, rather than geometrical, effect. The revolutionary practices of "Capability" Brown, who transformed the design of the English country estate in the 1760s, lie beneath Parkyns's arrangement of curving drives, massed foliage, and parklike meadows. The critiques of Brown's work that ensued from Humphrey Repton, Uvedale Price, and Richard Payne Knight brought greater refinement and sensitivity to a system accused of heavy-handed, formulaic solutions. Selectively weeding more than planting, and disavowing "the prescribed operations of an established system," Parkyns showed himself to be a man of this second generation, alert to the particular beauties of the site. He contrived a more dynamic and surprising experience, expressing theories of the picturesque that would enliven Brown's smooth, orderly, and beautiful effects. While opening out certain vistas, Parkyns deliberately blocked others, creating winding paths and drives that discovered views suddenly (as Watson recounted in his approach to the house; 13 June) or sought, in Parkyns's words, "internal variety; a circumstance which never fails to cheer the imagination, and to relieve the eye." [89]

These principles of variety and informality extended to the dynamic relationship of the house and its setting. Parkyns made every view from within an inviting picture. He dropped the basement, to bring the principal floor close to the level of the lawn, and opened large doors to the exterior, while maintaining the crisp articulation of the house from its setting. Following Brown's earlier practice, Parkyns drew the park up to the edge of the house, adding no plantings to obscure or soften the contours of the building, which sits in pristine geometrical detachment, despite its welcoming porches and doors. Sheltered and framed by trees from a distance, the house felt free and open close at hand.

Watson disliked the more progressive efforts at Sedgeley, across the river (see plate 12), where "the views . . . are confined, and the Trees are allow'd to grow too near the house" (29 June). Latrobe's more modern sensibility at Sedgeley, akin to the theories of Humphrey Repton, nestled his "modern Gothic style of Cottage" amidst foliage.[90] The encroaching garden with its "trim'd up" trees felt too "artificial" to Watson, who preferred the no less artificial openness of Eaglesfield, where plantings had been cleared on three sides of the house. Latrobe's own view of his work (fig. 22), made when Sedgeley was new or imagined, confirms Watson's account, although the architect's drawing clearly stressed the house, giving less attention—and therefore less credibility—to his description of the grounds. Sixteen years later, Watson's sketches show how much the foliage had thickened, closing the possibility for dramatic long views like those that made Eaglesfield so noticeable (see plate 12). The contrast between these two estates, expressed in Watson's pictures and text, summarizes the territory between moderate and avant-garde taste in the spectrum of progressive Anglo-American landscape design around 1800.

Eaglesfield did have a more formal, eighteenth-century "pleasure garden," according to Watson, but it appears nowhere in his sketches. Obviously he had little interest in describing it, and Parkyns evidently had no interest in intruding such a formal garden into the "natural" landscape composed around the major vistas to and from the house. Such a garden was to be experienced from within its hedges, not from a distance. It held the sunny southwest side of the house, sheltered between trees and adjacent to the "pavillion" (see plate 18 and fig. 42), the only quadrant of the house inaccessible to long views and not depicted in Watson's sketches. The retention, but powerful subordination, of this old-fashioned garden may tell something about the American—and particularly Philadelphian—attachment to flower gardening.[91] However, Parkyns did include such gardens, always somewhat hidden and detached from the house, in his landscape designs of 1793. Like the contrast between Eaglesfield and Sedgeley, the presence of this garden fixes the estate plan in a period between the period of regimented gardens (as at Mount Vernon or Williamsburg) and the more informal, "romantic" landscaping that would creep up to ring the house with flower beds and bushes in the nineteenth century.

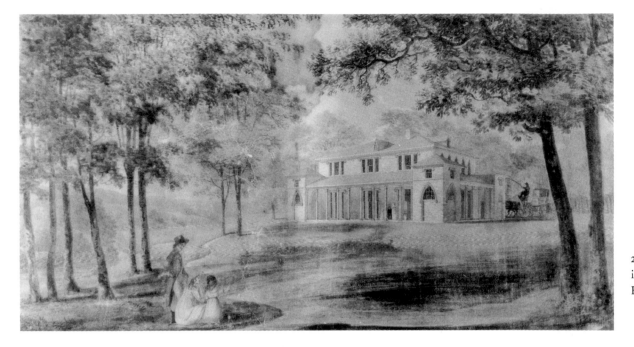

22. Benjamin H. Latrobe, *Sedgeley*, ca. 1800, watercolor, ink, and pencil on paper, 13 × 24 in., Commissioner of Fairmount Park, Philadelphia.

AFTER THE GOLDEN AGE

Eaglesfield flowered under Richard Rundle's stewardship, and it suffered after his death in May 1826. "Universally beloved by his Friends and acquaintances," Rundle was buried in the family vault just outside the south door of Christ Church.[92] Having outlived his wife and his favorite nephew, he bequeathed most of his estate to Watson's widow, Mary, and their children—all still in England—while appointing his nephew George Rundle executor of his will. George managed the estate's investments for years, sending Mary annual stipends and maintaining friendly contact.[93] She welcomed this income, but her expectations of a grand inheritance were disappointed. Her uncle's generous annual support before his death, added to the failure of his bank stock, had much diminished his wealth. The value of Eaglesfield had dropped after the construction of the new dam at Fairmount, which lifted the Schuylkill's shoreline after 1822 and slowed its flow, flooding the lowland meadows with stagnant water. Once a salubrious retreat from the city's feverish summers, the valley just north of Fairmount became itself a place of rank air and mosquitoes. When Samuel Breck's adored only child died of yellow fever in 1828, the heartbroken Breck closed up Sweetbriar and moved into town. The neighboring Eaglesfield, which Richard Rundle had conservatively estimated as worth forty thousand dollars in 1818, remained unsold in the summer of 1828 after two years on the market. To pay off the mortgage and taxes, George Rundle had to accept the only offer: twenty-two thousand dollars. "Such is the depreciation in the Value of County Seats in the neighborhood of the City—especially since the prevalence for a few years past of the intermittent fever in the country generally—that notwithstanding its superior attractions for beauty, and the increased intrinsic value of the place

from its proximity to the city,"[94] Eaglesfield sold for 25 percent less than it had cost in 1810.

The lone offer came from John J. Borie (1776–1834), a French-born merchant in Philadelphia who kept up the house and farm sufficiently to mark Eaglesfield as Borie's Place to later visitors and earn him credit for its building.[95] After Borie's death in 1834 the house suffered from intermittent tenancy and absentee landlords.[96] Depressed by the unhealthy change in the environment, the suburban neighborhood of Eaglesfield was further assaulted by the intrusion of commercial buildings such as ice houses and breweries along the river bank. The final attack, pressed forward by the interests of an expanding city, came from carriages and trains. Girard Avenue and its adjacent railroad bridge crossed the river and plowed through Eaglesfield's sweeping lawn, blocking the vista down the river and rattling the windows of the house with traffic. Thomas Eakins, wandering on the east bank of the river, sketched the house poking above the bridge and icehouses, about 1860.[97] David J. Kennedy, the self-appointed topographer of Philadelphia's changing landscape in the nineteenth century, recorded the house with a midcentury addition on the east and the new avenue in its front yard (fig. 23). A last view of Eaglesfield in the photographic era (fig. 24) documents its uncomfortable old age as the Egglesfield Hotel, a rooming house listed in city directories only in 1867–68.

The proximity of Girard Avenue and the railway line doomed Eaglesfield, even while the rest of the neighborhood was revived by the creation of Fairmount Park. In 1844 the acquisition for park use of Lemon Hill, a mansion built on the east bank of the river in the same year as Eaglesfield, inspired the concept of a watershed and public park along both sides of the Schuylkill. Included within the district "condemned" for this purpose in 1867, Eaglesfield was acquired by the park in 1869. Rumors of demolition plans spurred preservationists to petition the park commission in July 1869, suggesting the refurbishment of the house "for a reasonable sum" as a "temperance restaurant" and park shelter.[98] But the house vanished soon after, the victim of the widening of Girard Avenue and the reconstruction of its bridge, completed just in time to carry traffic to and from the Centennial fairgrounds in 1876. The park's man-agers adapted other old mansions within the district, such as Lemon Hill, for practical use as storage and offices, so it must be assumed that Eaglesfield was too derelict, too altered, or—most likely—too crowded by neighboring improvements to survive. Sweetbriar, a few hundred yards to the north, and Solitude, an equal distance to the

23. David J. Kennedy, *Egglesfield Mansion F[airmount]. P[ark]., Residence of R. E. Griffith [prior?] to its being demolished by the Park Commission*, ca. 1870, watercolor on paper, Historical Society of Pennsylvania.

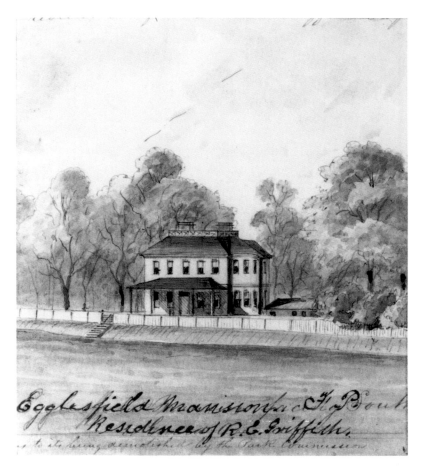

south, stood just far enough from the traffic to escape destruction. The identity of the estate was remembered, briefly, in the construction of the Egglesfield Gate (since destroyed) to the park, at the intersection of Lansdowne Drive and Girard Avenue. Perhaps a recollection of the old house inspired those who saved from demolition the so-called William Penn house on Letitia Court and moved it to the empty site in 1883. This small brick urban rowhouse now stands incongruously at the edge of Eaglesfield's grassy knoll, a lonely city dweller amid the trees that still circle respectfully around the ghost of another, larger house that once commanded the site with far greater elegance and ease.

Travels in the United States

During the warmer months of his stay, Watson explored the Atlantic seaboard north and south of Philadelphia. A summary of his itinerary, deduced from diary and sketchbook notations, appears in the Chronology. He made two extended excursions: the first, lasting seven and a half weeks in the summer of 1816, took him to New York City, Albany and other Hudson River sites, Lake George, Springfield, Boston, New Haven, and back to Philadelphia (see Map II, fig. 25); the second, for two weeks in the spring of 1817, included visits to

24. Photographer unknown, Schuylkill River, Girard Avenue Bridge, Eaglesfield, 1867, Historical Society of Pennsylvania, Penrose Collection.

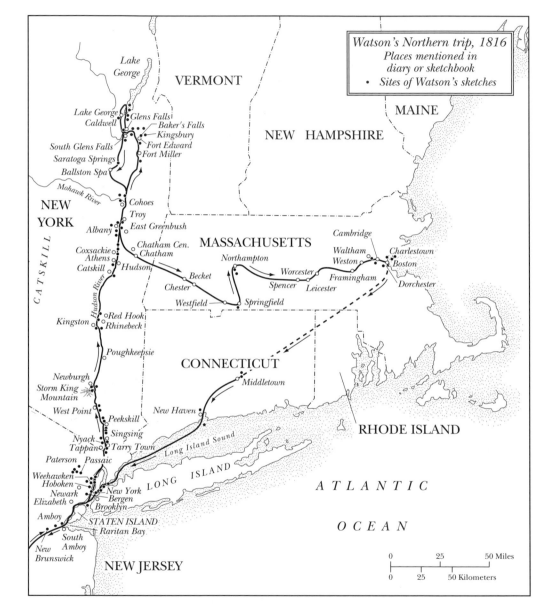

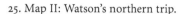

Watson's Northern trip, 1816
Places mentioned in
diary or sketchbook
• Sites of Watson's sketches

VERMONT

MAINE

NEW HAMPSHIRE

Lake George

Lake George
Caldwell
Glens Falls
Baker's Falls
Kingsbury
South Glens Falls
Fort Edward
Saratoga Springs
Fort Miller
Ballston Spa

Mohawk River

NEW YORK

Cohoes
Troy
East Greenbush

Albany

Chatham Cen.
Chatham

MASSACHUSETTS

Cambridge

Coxsackie
Athens
Catskill
Hudson

Waltham
Weston
Charlestown
Boston

Northampton

Becket
Chester

Worcester
Spencer
Leicester
Framingham

Dorchester

Westfield
Springfield

Kingston
Red Hook
Rhinebeck

Poughkeepsie

CONNECTICUT

Newburgh
Storm King
Mountain
Middletown

West Point

Peekskill
New Haven

Nyack
Singsing
Tappan
Tarry Town

RHODE ISLAND

Paterson
Passaic

Long Island Sound

Weehawken
Hoboken
Newark
New York
Bergen
Elizabeth
Brooklyn

LONG ISLAND

ATLANTIC

Amboy
STATEN ISLAND
Raritan Bay

South
Amboy
New
Brunswick

OCEAN

NEW JERSEY

CATSKILL

Hudson River

0 25 50 Miles

0 25 50 Kilometers

25. Map II: Watson's northern trip.

Baltimore, Washington, D.C., and Wrightsville or Columbia, Pennsylvania (see Map III, fig. 29). A print, made after a watercolor attributed to Watson, depicting Saint Anthony's Falls on the Mississippi (see fig. 46) raises the possibility that Watson also visited the frontier sometime in 1816–17, although this major side trip has been confirmed nowhere else. Putting this extraordinary (and unlikely) trip aside for the moment, the remainder of his travels in America amount to a classic grand tour, for Watson saw the sights and traveled the routes that most foreign visitors sought in his day and in decades to come. The canonization of this route in guidebooks such as Joshua Shaw's *U.S. Directory for the Use of Travellers and Merchants* (1822) was just a few years away. Steam travel, which was in its first decade of regular service in Watson's day, had just made this tour swifter, more reliable, and more accessible, and Watson—although by no means a pioneer on this route—was among the first to enjoy all the "modern" amenities of the dawning tourist circuit. No extant combination of diary and sketches so thoroughly documents the American grand tour in its infancy.[99]

NEW YORK AND NEW ENGLAND

Watson's first and longest journey was well documented in his diary, even though the account breaks off on 3 August, midway through the trip. He traveled in the company of his young bachelor friend Thomas Fisher Leaming. The trip commenced by steamboat, up the Delaware River to Trenton, and then overland to New Brunswick, where, after an overnight stay, they boarded a second steamer that traveled down the Raritan River and across New York Bay to Manhattan. Watson found the stagecoach ride boring and uncomfortable but the steamboat accommodations "excellent" and the river views "delightfully diversified" (19 June). The men spent two and a half days visiting in New York City and then embarked on another steamboat up the Hudson (figs. 26, 63).

Steam travel was a novelty to Watson, as it was to most Americans; Fulton's *Clermont* had first ascended the Hudson in 1807, revolutionizing shipping as well as tourism in the valley. The day trip up to the Highlands would later become a holiday outing for the middle

class, but in 1816 there was still only one departure each day and the fare was relatively expensive, making the experience an exotic one, especially for artists. Watson's serial sketches of the landscape on this trip (see fig. 34 and plates 44–53) are preceded by only one extant suite of views, by George Heriot, in 1815.[100] Unfortunately for artists, the boat pressed on relentlessly, without regard for the darkness, thereby denying a good view of West Point to northbound passengers like Watson, who passed this turn in the river after sundown.

The steamboats were new, but the tourist trail up the Hudson was already well paved, and Watson found inns awaiting him at convenient intervals along the river. He was disappointed at Newburgh to find no boats or carriages available for hire to take him back down to West Point, proving that one step off the main route led to a dramatic difference in amenities for travelers. Returning to the standard

26. Pavel Petrovich Svinin (1787–1839), *Deck Life on the "Paragon," one of Fulton's Steamboats—Fort Putnam and West Point in the Background*, ca. 1811–13, watercolor on paper, $9\frac{7}{8} \times 14\frac{5}{16}$ in., The Metropolitan Museum of Art, Rogers Fund, 1942.

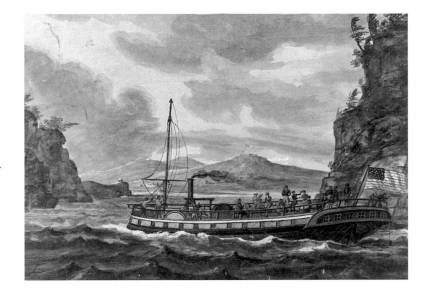

itinerary, which touched down at the spas at Saratoga and Ballston and at various waterfalls en route to Lake George, Watson encountered other tourists like himself, including family groups. The hotels in these places were young and the settlements somewhat raw, but tourism had already etched lasting patterns in the landscape.[101]

He cut short the grandest possible tour by turning back from Lake George and Saratoga instead of pressing on to Niagara. A trip to the falls must have tantalized Watson, who visited every other major waterfall between Washington and Boston, but evidently he could not spare the extra week's time it would have taken to cross New York State and return. Instead, he doubled back to Albany and traveled quickly—too quickly, by his account, given the "romantic" beauties of the scenery that he passed—to Springfield and Boston.

Watson arrived on the outskirts of Boston on 3 August, the last day recorded in his diary. His dated drawings indicate that he remained in this area until at least the eleventh. The longer stay in Boston is reflected in the larger number of acquaintances from this city on his diary list (17) than the group encountered in New York (4). Some of these people may have been friends of Samuel Breck, whose brother-in-law was Senator James Lloyd, or merchants known to the Leamings and Rundles. A sketch of the Harrison Gray Otis house dated 8 August (NY-96B) hints at the excursions and social contacts that took place. Many of Watson's new friends in Boston were connected to the Navy Yard, which was the most active American naval base in 1816. His visit there must have been engrossing: he sketched the *Congress* and Commodore Bainbridge's *Independence* at moorings (see plate 39, 68 and NY-16A), and he could have observed the veteran *Constitution* ("Old Ironsides"), now safely harbored after several victorious encounters against the British in the recent war. Watson would have wanted a close inspection. The tiny American navy, which held only sixteen ships at the outbreak of the War of 1812, had given the British their match for gunnery and seamanship. The American ships carried fewer guns, but their range was longer, and the swift and responsive design of their hulls carried reinforced framing capable of withstanding heavy fire. Exasperated by the clumsy handling of his own warship, the *Alfred*, Watson must have studied the American ships with lively interest.

By 13 August Watson was headed south on the route of the regular stagecoach that passed from Boston to Worcester and then descended the valley of the Connecticut River from Springfield, Massachusetts. He passed through Middletown (fig. 27) spent one evening in New Haven, where he was evidently entertained by James Hillhouse, and then departed on a coastal packet to New York. Several days in northern New Jersey visiting Passaic Falls, Paterson, and the dueling ground near Hoboken concluded the trip (see plates 70–73; fig. 28; color plate 17). The last dated view in his first sketchbook was inscribed 19 August 1816.

When Watson opened a fresh sketchbook, he dated his first views a month later, near Eaglesfield. His drawings of the Schuylkill Valley that autumn conclude with the perspective from the top of Paul Beck's shot tower, recorded 3 December (see plate 9). After that day we lose sight of Watson until the recommencement of dated drawings on 4 April 1817, again depicting landscapes of the lower Schuylkill.

Where was Watson during this four-month period? Most likely he retreated in the cold weather to the warm hearths of the Rundles at Eaglesfield or in Center City. The aquatint by John Hill, *Falls of St. Anthony on the Mississippi* (see fig. 46), based—according to the publisher, Joshua Shaw—on a watercolor by "Captain Watson, R.N." suggests another use for this time: a trip to the Northwest Territory. There are no other unaccounted-for gaps in Watson's calendar sufficient for a two thousand mile expedition to the upper reaches of the Mississippi and back, a trip much longer and more adventurous than his New England tour. However, the likelihood of such a visit to Fort Snelling (near St. Paul, Minnesota) seems small, given the time of the year, when travel would have been most uncomfortable, even perilous. The silence respecting this journey in extant manuscripts and the absence of related sketches made en route further diminish the possibility of such a trip.

Shaw's view may be fictitious, anyway. The land forms do not resemble other contemporary pictures of the area, and the artist's placement of the falls in the distance seems to dodge specifics deliberately.[102] The questions raised by the Shaw-Hill aquatint are discussed in Part III, for they involve personalities and events in Philadelphia

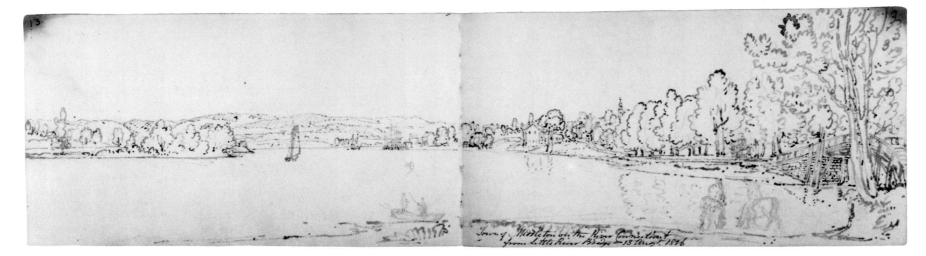

27. Joshua Rowley Watson, *Town of Middletown on the River Connecticut from Little River Bridge 13th Augt. 1816*, pen and black wash over graphite, New-York Historical Society sketchbook, p. NY-13AB.

28. Joshua Rowley Watson, *Patterson, [New Jersey] 16 Augt.* [1816], pen and black wash over graphite, New-York Historical Society sketchbook, p. NY-4AB.

at least two years after Watson's departure. But in terms of his itinerary in America, we can initially conclude that the print is misleading. Watson probably stayed in Philadelphia all that winter. When he found the weather pleasant, in April, he began to sketch again in the vicinity of Eaglesfield and soon began to plan a trip to the nation's new capital.

WASHINGTON, D.C. AND THE SUSQUEHANNA VALLEY

Watson's southern trip was much briefer than his New England tour, and the distances were much shorter (Map III, fig. 29). He traveled with Samuel Breck, who had congratulated himself the previous spring by making the 360-mile round-trip to Washington in just five days, including a day spent conducting business in the capital. Breck's diary, in conjunction with Watson's sketchbook, provides an outline of the places and persons visited during their twelve-day tour.[103]

At noon on 14 April 1817, Watson and Breck sailed from Philadelphia on a steamer bound for Newcastle, Delaware, where they spent the night. The next day a stage carried them sixteen miles overland to Frenchtown, Maryland, where they boarded another steamer that crossed Chesapeake Bay to Baltimore. After a night at Barney's Inn, they took a coach to Washington in the morning and arrived in the capital by 2:00 P.M. on 16 April. Without delay they proceeded to the Navy Yard "and went through a fine line of battle ship then on the stocks." The shipyard, along with the Capitol, White House, and various other major buildings, had been burned by the British three years earlier, and the scars of this occupation would have been still visible, despite intense rebuilding activity.

According to Breck, Watson called on the British ambassador, Charles Bagot, and returned with an invitation for them both to dine. That evening Bagot, Watson, and Breck also visited Commodore Stephen Decatur's home, "where we spent a charming evening. Mrs. Decatur is a fine woman, the Commodore a soldierly, accomplished gentleman."

The following day, 17 April according to Breck, they rode the sixteen miles to Washington's estate, Mount Vernon. "Everything looked shabby," noted Breck, "except what depended upon nature,

such as prospects etc, and they were fine." Watson evidently agreed, for he sketched views up and down the Potomac (dated 18 April; see plates 78, 79), as well as the deteriorating tomb (see plate 80, and color plate 18). Breck condemned the "slovenly" appearance of the place under Bushrod Washington's custody, recollecting that "the General kept the house and grounds in a style of great neatness." Watson could have reminded Breck that the survival of Mt. Vernon in any condition was owed to the protection given it by British troops in August 1814; alone among the major buildings in and around the capital, Mt. Vernon was not burned.

That day Watson also sketched the Capitol under construction and somehow copied Latrobe's elevations of the building, as it was intended (see plates 75–76). The same day or the next the two travelers visited the U.S. Patent Office, "under the care of Dr. Thornton, who was excessively civil to us." That night they "took tea with Mrs. Bland Lee." The next day (the twentieth according to Breck but the twenty-first per Watson's sketches), they drew the views along the Potomac near Lower Falls before visiting the Decaturs again (see plates 81–82).

Watson returned to Baltimore alone on 21 or 22 April, bearing a letter of introduction to "Mrs. Wirt . . . where he was desirous to lodge." Breck remained in Washington on business for two more days, then joined Watson in Baltimore on 23 April. After dinner that evening they visited the "work shop" of the "very celebrated Italian sculptor" Antonio Capellano, from whom Breck purchased portrait medallions of Napoleon, Maria Louisa, Franklin, and Washington.

Breck and Watson left Baltimore on 24 April to travel up the Susquehanna's shore to the point at Wrightsville and Columbia where the major east-west turnpike between Pittsburgh and Philadelphia intersected the river at the head of shipping. The felicitous location had made Columbia (earlier known as Wright's Ferry) a contending site for the national capital (see plates 83–90). A bustling crossroads of trade, if not the cultural center it had once promised to be, the area also offered many picturesque compositions of river, shoreline, and mountain. Watson was "so pleased" by the wealth of views on the Susquehanna that the two men "staid sketching on its beautiful banks until the evening of the 26, when we set off for Lancaster and reached home the next day."

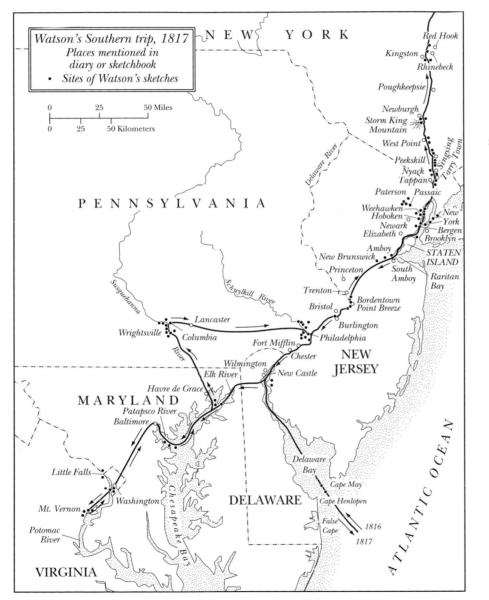

Watson's Southern trip, 1817
*Places mentioned in
diary or sketchbook*
• *Sites of Watson's sketches*

0 25 50 Miles
0 25 50 Kilometers

NEW YORK

Red Hook
Kingston
Rhinebeck
Poughkeepsie
Newburgh
Storm King
Mountain
West Point
Peekskill
Nyack
Tappan
Paterson Passaic
Weehawken
Hoboken
Newark
Elizabeth
Amboy
New Brunswick
Princeton
Trenton
Bristol
Bordentown
Point Breeze
Burlington
Philadelphia
Fort Mifflin
Chester
Wilmington
New Castle
Elk River
Havre de Grace
Patapsco River
Baltimore
Little Falls
Mt. Vernon
Washington
Potomac
River

Sing Sing
Tarry Town
New
York
Bergen
Brooklyn
STATEN
ISLAND
South
Amboy
Raritan
Bay

PENNSYLVANIA

Delaware River
Schuylkill River
Susquehanna River

Lancaster
Wrightsville
Columbia

NEW
JERSEY

MARYLAND

DELAWARE

Chesapeake Bay

Delaware
Bay

Cape May
Cape Henlopen
False
Cape

1816
1817

ATLANTIC OCEAN

VIRGINIA

29. Map III: Watson's southern trip.

Watson returned to Philadelphia for a final seven weeks, during which time he launched a last series of views in the vicinity of Eagles-field (fig. 1, plates 6–20, 22, 27, and color plates 3–5, 11). His round of farewell calls and sketches must have been enlivened on 6 June by the memorable visit to Philadelphia of President James Monroe. Monroe's party rowed up the Schuylkill to Gray's Ferry (see plates 4, 6, and color plate 9), crossed the Market Street Bridge (see plates 7, 8, and color plate 3), and then proceeded with pomp through the city, visiting most of the famous sites that Watson had first inspected the previous summer. Although Monroe had won the election the previous fall by a landslide and had taken the state of Pennsylvania overall, he had not swayed the city of Philadelphia. Watson's friends would probably have been divided in their opposition, however, for Monroe owed his victory to support from all quarters. Old divisions were softening, the Federalists were fading away (or transforming themselves into "Independent Republicans"), and the Republicans and Democrats were growing harder to tell apart, especially as their names began to change. In this moment of flux, Monroe was given a warm welcome befitting the commencement of "the era of good feelings." Before the president departed on 7 June for Trenton, Watson and the Rundles probably got at least a glimpse of him from afar. A week later, Watson received his own, more private send-off and embarked on one last trip: back across the Atlantic to Liverpool, and home to Exeter.

Watson's American Diary

Captain Watson was in the United States from 11 June 1816 until 14 June 1817. His diary (published in its entirety in Appendix A) covers only the first three months of his visit: it begins with his embarkation at Liverpool on 21 April and ends with the date "Aug. 4,"

followed by blank pages. The abruptness of this conclusion suggests an interruption while Watson was copying or elaborating notes from an earlier diary, now lost.[104] Other clues support this thesis: the handwriting in the present text is firm and continuous, without changes in pen or alterations in penmanship, as if it were done all at once, or in several steady campaigns; few deletions or false starts mar the pages; and the book itself, bound in red morocco, is clean and crisp, hardly looking as if it had survived three months of travel and daily handling (fig. 30). The text also includes interior evidence, such as an occasional prospective remark ("I shall have occasion to speak more fully on Steam Boats when I take a trip on them"), hindsight observations (see 12 June), and errors in dating that could have been caused by absentminded copying. Certain names and dates are left blank, awaiting the insertion of information that had slipped Watson's memory by the time of his copy. (Such blanks are bracketed in the present text.)

Most telling, however, is the list of names Watson prepared at the head of the diary. Obviously, such an alphabetical list could only have been organized at the end of his trip, but the appearance of names of persons from Boston, New Haven, and Washington—such as Stephen Decatur—who are *not* discussed in the extant diary implies the existence of later manuscript that Watson never copied into his fresh volume. His sketchbooks confirm his visits to these cities later in the summer of 1816 and the spring of 1817. Apparently, his list was made from a much longer diary that recounted events through June 1817.

THE LIST OF NAMES

At the head of his text Watson composed a list of eighty-seven names of persons he met in America. The list includes many people not discussed in the diary, evidently because he met them after 3 August 1816, when the present text ends. The list also fails to include many names mentioned only briefly (usually women whose husbands or fathers do appear on the list) and a few persons too familiar to need an entry, such as his uncle, aunt, sister, and brother-in-law. Such

30. *Josiah White's wire bridge over the Schuylkill River*, pen and ink, from Watson's diary, June 15, 1816, Collection of Elizabeth Burges Pope.

omissions make Watson's list only a partial census; complete references to names mentioned in the diary must be sought in the index.

The total roster, composed of names on Watson's list and living persons mentioned in his text, comes to ninety-seven men and seventeen women. The women are identified by family name only; half the time they come described simply as someone's wife or daughter. Joining these women in a realm of murky identity is a group of thirteen men whose full names, addresses, or occupations eluded discovery. With 15 percent of the men removed into historical limbo, most of the remaining eighty-four men gather into a few major occupational groups: merchants, bankers, and businessmen (23); lawyers, judges, and politicians (22); military officers (20); diplomats (9); and those in the arts and sciences (8). The character of this list, and what it tells us about Watson's experience in America, has been more fully discussed earlier (see "American Family and Friends"). Individual biographical summaries appear at the foot of the complete diary text, in Appendix A.

Supplementary sources, written by those who attended events with Watson, indicate a wider circle of acquaintances outside the roster of those mentioned in his diary. Certainly Watson could not be expected to record every single person he met, even among his own clan. Selective memory can be understood in the context of large parties, such as the convivial dinners with the State in Schuylkill that Watson joined twice but never mentioned in his diary.[105] But his oversights become more curious in consideration of events described in Samuel Breck's diary, such as their visit to Antonio Capellano's sculpture studio in Baltimore or dinner with the British ambassador, Charles Bagot, in Washington, a few days later in April 1817.[106] Such omissions suggest that Watson's "lost" diary entries grew cursory or

irregular at the end of his visit, and at the very least they indicate that Watson knew more people than his diary describes.

The Character of the Text

The content of Watson's diary ranges widely, showing a curious and educated mind attracted by diverse subjects. The text maintains a remarkable tone, being consistently positive and open-minded. Unlike many of his British contemporaries, Watson arrived predisposed to like the United States and enjoy himself; evidently he shared the attitude of Benjamin H. Latrobe—an artistic fellow countryman who also came from a mixed transatlantic family—in seeking "more to commend than condemn the state of things and the character of individuals here." [107] The diary is full of compliments and almost free of complaints, even on the well-worn topics of bedbugs, roads, food, and manners. Criticisms, when they occur, are delivered bluntly but without arrogance or spite. Watson's calm and friendly tone suggests a trustworthy opinion in these moments of judgment; if he habitually wore rose-tinted glasses, he could nonetheless see clearly through them.

The happy tint pervading his account came from two sources: the fortunate circumstances of his social milieu, which surrounded him in pleasant, upper-middle-class comfort and civility, and the cheerful quality of Watson's own personality. "Enemies he had none—for he knew not how to make one," wrote his uncle Richard Rundle. [108] Carrying no bitterness, negativity, or malice, Watson discovered goodness in the world around him. His vision remained steadily extroverted, rarely turning inward to discuss his own health or feelings, nor did his prose drift into speculation. Politics, religion, literature, and philosophy find no place in this diary. [109] Aside from his enthusiastic comments on Vanderlyn's paintings, he made no pronouncements on the state of American art. His mission in his journal seems to be the documentation of daily events and the brisk observation of a new and picturesque landscape. Without pretext or ideology other than a faith in empirical method, Watson's text is a remarkably straightforward and accessible document.

As if simple candor needed explanation or defense, the motives behind Watson's diary can be imagined and scrutinized, with conclusions quite akin to those reached about the nature of his entire trip. Watson was an inquiring person with time on his hands and a professional habit of journal keeping, instilled since his days as a midshipman. Like a naval log, every day's commentary begins or ends with observations on the weather. The entries themselves are much more detailed and conversational than his ships' logs, however, and more elaborate than the two extant private journals that he kept for his own pleasure at sea and on shore. Clearly, he found more to remark on in America, and he made a special effort to record these observations. Did he plan, as so many others did, to publish an account of his trip for interested readers in Britain? Perhaps, although the incompleteness of the text shows that such plans remained undeveloped. Certain expository passages, like his observations on American character and social life, sound as if they were addressed to an audience larger than himself. This audience may have been his family or posterity. Or, at the simplest level, he was speaking to himself in years to come, refreshing memories for later reconsideration. His careful copying of his notes into a fresh book tells us that, at the very least, he wanted to preserve these remarks. [110] His family did not disappoint him.

The content of the diary confirms this basically private mission, for it emphasizes Watson's particular interests rather than obligingly attending to the curiosity of armchair tourists. Peale's "Philadelphia Museum" (see fig. 54) is catalogued with some detail, but the State House ("Independence Hall") in which it was housed, and other nearby shrines of national import, receive neither historical nor architectural comment. None of the major buildings in Philadelphia is given a fraction of the space in the diary devoted to Josiah White's novel wire bridge across the Schuylkill (see fig. 30) or Robert Fulton's steam frigate (see fig. 60). Fascinated by bridges and ships, he was clearly less interested in gossip or celebrity anecdotes. Few of the people he met were given more than a brief introduction; the mere record of their names sufficed as an aide-mémoire. He rarely essayed a deliberately entertaining description of persons or social events, the exceptions coming as a pleasant surprise, such as his accounts of

Judge Richard Peters, the State in Schuylkill, or the Fourth of July celebration, when "the whole population of the Country appeared to be in motion." [111]

Predictably, Watson attended first to military matters. He liked to comment on battle sites, monuments, fortifications, and military facilities. Espionage was probably not part of his mission, for his observations were generally too brief to be practically useful, but his professional instincts drew him to measure, simply for his own satisfaction, the strength of the American armed forces. He visited every naval base or shipyard within his range, noting the vessels, their condition, and the special features of the newly built warships, such as the *Franklin*, that seemed especially superior or vulnerable. The "destructive and dreadful" Fulton Steam Frigate, which shot a column of boiling water from its engine in addition to carrying conventional guns, inspired Watson to sketch its plan. He was impressed by an experimental machine gun (but, as a polite tourist, could not learn the "secret" of its loading) and admired "clever" reinforced boarding helmets (see fig. 57) and convenient new bayonet mounts (see fig. 68), all of which earned sketches in the margin of his diary (see also figs. 55, 56).

Ingenious machines, daring engineering, and modern improvements arrested Watson frequently. American ice houses, fire departments, and shad fishing reels all struck him as progressive. The drawing of a sausage machine that covers the flyleaf of his second sketchbook must have been inspired by personal interest, but on most occasions, such as his encounter with the wire suspension bridge, the military applications of American technology lept to his mind immediately. "Such a flying bridge as this might easily be made . . . so as to enable a body of troops to secure an opposite shore," he surmised (15 June). Watson hardly passed a bridge without commenting on its construction, and his sketchbooks reconfirm this interest in engineering. From such a connoisseur, his description of the new "Colossus" at Fairmount (see plates 8, 9, 13 and color plate 3) as "the most beautiful and gigantic Bridge of One Arch in the World" comes as praise indeed.

After military installations and bridges, Watson studied American architecture with varying levels of attention. Though he men-

tioned no architect by name, he felt free to deliver summary judgments on the public buildings he inspected. In Philadelphia, he admired the banks, suggested the improvement of the old water works, and complimented the "magnificent" hospital. The new City Hall in New York "has a very imposing appearance," he wrote, "but the proportions are bad." The total effect of New York, with its "handsome" steeples, drew more praise than any single building. "Broad Way," remarked Watson, "would be considered a fine Street in any part of Europe."

Watson's sweeping comments about most of the American towns and cities he saw indicates a low level of interest in the urban landscape, consistent with the absence of such views in his sketchbooks. Domestic architecture interested him, however, especially the country homes of persons from his own class or the more lavish estates of the wealthiest Americans (fig. 31). He described his uncle's estate, Eaglesfield, at some length and commented frequently on

31. Joshua Rowley Watson, *House Springfield Connecticut 1st August 1816*, pen and black wash over graphite, New-York Historical Society sketchbook, p. NY-87B.

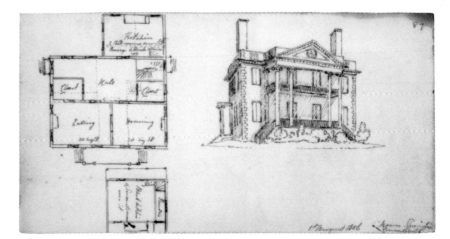

the neighboring "gentleman's villas." More modest homes glimpsed while traveling were also noticed, usually in terms of their building materials or technology (fig. 32). He described the "durable and warm" country houses of upstate New York, built "in the Old style of Logs," and exclaimed over the "strange" habit of the New Englanders, who built in wood when they had so much stone at hand. The quality of local brick and stone, and its artistic effect, almost always engaged him. Overall, he was "astonished to see so many houses building," in so many different quarters. From the heights above Albany he surveyed the humming construction sites in the city and commented as follows:

This like all the American Cities & towns I have seen, has a degree of neatness and comfort, with which every European must be astonished, for they all have the appearance of being just put out of the hands of the Bricklayer & Carpenter. (26 July)

Perhaps his astonishment was the product of overturned expectations, having imagined primitive squalor or, at best, provincial pretension. The "magnificence" of Philadelphia and the prosperity of the Hudson Valley were—as he admitted—surprising.

Watson was also impressed by the quality of transportation used in all parts of the country he visited. As with the architecture, he may have expected worse. Being from Devon, he knew one of the most dreadful road systems in England; in America, he gratefully remarked on enormous turnpikes, daring bridges, comfortable wagons (the Dearborn, see fig. 69) that he could scarcely praise enough, and a new system of steam navigation that simply charmed him.

Now for the small sum of $12 you can in the course of 48 hours, be set down at the City of Albany in the State of New York on the River Hudson, with only a land carriage of 27 miles from Philadelphia, and with no other fatigue than is occasioned from being so long confined to the vessel, but which is relieved by the great variety of scenery and the company on board. (19 July)

Watson complained only once, to remark on the bad roads and stage coaches between Trenton and New Brunswick, New Jersey: "the stages are amongst the worst contrivances in America," he declared flatly, "being *very* uneasy" (19 July).

Most of his traveling seems to have been pleasant, including the overnight accommodations. Again, he may have been prepared for backwoods conditions, but he found the inns along his route ranging

32. Joshua Rowley Watson, *Cottages in the Northern parts of [the] State of New York*, pen and black wash over graphite, New-York Historical Society sketchbook, p. NY-28AB.

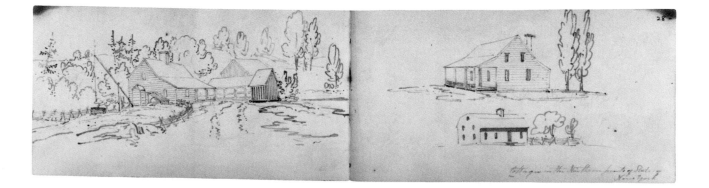

from "very tolerable" (at New Brunswick and Albany) to "very good" (at Lake George) and an ecstatic *most comfortable* at the Indian Queen in Springfield, Massachusetts. "Tis necessary to examine your beds before you turn in, as they are not so particular in furnishing them with clean linen," he admitted in Newburgh. "I had made up my mind to be roughly handled by Bugs, but I must say, in most of my nights lodging, I was agreeably surprised to find I had been allowed to slumber in quiet" (24 July).

Food rarely earned a mention from Watson, but he did comment on the average quality of his meals on the road.

The two meals of Tea & Supper are blended in one, and the traveller has no reason to complain of the fare—he will in general find some excellent fish, beef steaks, Mutton chops, eggs, grillade fowl's, with several sorts of preserves, a variety of cakes & good Coffee & Tea. Breakfast on most of the rout[e]s is served up in the same abundant manner. (24 July)

More interesting to Watson was the social life entered in these tavern or steamship meals. "It is their general plan to have a public table, at which both Ladies and Gentlemen assemble at Breakfast dinner and Supper," he wrote. "For a single man this is not unpleasant, as he has an opportunity of seeing the manners of the people, and from all thinking themselves on a level there is very little ceremony" (26 July). Remembering his complaints about the segregation of the sexes at most social events,[112] we should not be surprised that Watson enjoyed these public meals as well as the "great mixture of company" on the steamboats (see fig. 26). Not all British tourists found the opportunity pleasant, but Watson used these moments of interchange to gather material for a few broad generalizations about American character. "They are very inquisitive, accute, much cunning, quick in comprehension, ingenious, moderate in their living and laborious," observed Watson; " 'tis a man's own fault if he is not in easy circumstances" here. He also found Americans more courteous than he had expected. Civility was always returned in kind, and "by humouring them and appearing to request what you may want, they will be found to be a very different character to what strangers in general have imputed to them" (26 July). Such a comment tells more about the typical arrogance of British milords on the Ameri-

can grand tour or conventional opinion of American manners than it tells about American people, and Watson betrays his own condescending attitudes in this remark, but it seems that he made the effort to "appear" polite successfully.

Watson often complimented the appearance of the citizens seen in the small towns and farming areas he traveled through, remarking on the "fine well grown healthy race of people" he encountered. Pretty women—or their absence—never failed to gain his notice. But even more than the physical appearance of particular individuals, Watson admired the general well-being of the populace. Except for a "filthy" Mohawk Indian family glimpsed near Albany, he found that "the appearance in every town that we pass'd all denoted comfort, contentment & ease, nor did we see a begger or person badly dress'd since we left New York."[113]

The prosperity of the countryside depended on the efforts of farmers and small industrialists, and Watson frequently commented on the development of the rural landscape. As he noted, the exhausted soil and "redundancy of population in the New England states" were inspiring an exodus into the rich and empty western states and territories. He described with concern the idle mills in Massachusetts, built during the nonimportation period but now superseded by the return of high-quality goods from Europe. The vacant mills would soon be rejuvenated to employ those who remained, but these harbingers of industrialization had not altered substantially what was still an agricultural or pastoral landscape. As he passed through farmland, Watson noted outbuildings, fence types, and crops, particularly in Pennsylvania. His uncle and his near neighbors, Breck and Peters, were all enthusiasts—even scholars—of modern horticulture, and the conversation at Eaglesfield turned frequently to the subject of useful grasses, harmful weeds, and good livestock breeds. Watson was himself interested in botany and listed the American tree species he encountered. Judge Peters promised to send him a seedling from a tree at Belmont planted by Washington, and, when he returned to Exeter, Watson in turn made up a packet of seeds to send to Richard Rundle.[114] More impressive than new grasses or trees, however, was the news that American farmers were willing to work on Sundays during harvests, if weather threatened the crops.

"I have often lamented the loss of a fine day to our Farmers in England, in a bad season, when it fell on a Sunday," he wrote. "It surely would not be considered by the Almighty as a breach of the Commandments, were they to do the same" as their American cousins (30 June; 7 July).

The improvement of the countryside by farming, gardening, industry, or engineering drew most of Watson's attention while he was on tour. True to the aesthetic canon of his day, he found the greatest beauty in the civilized landscape. He approved of "well-cleared and cultivated" land, and praised the "rapid advances made by an industrious and high minded people, in overcoming the dreariness of the wilderness, and making the land smile with plenty" (24, 25 July). This pre-Romantic statement of conquest and progress was elsewhere modified by appreciative comments on wilderness, but usually as a foil to civilization. In Massachusetts, he observed with approval that the woods were "not too much cleared away," allowing a landscape of contrast and harmonic interaction between man and nature. This desire for pleasing contrast, based on the search for paired opposites (such as roughness and smoothness) that defined the contemporary aesthetic category of the "picturesque," emerges even more clearly in Watson's drawings. His idea of "interesting" scenery in the Hudson River valley summarizes the syntactical structure of his watercolors, where "the eye is carried over hills well diversified with woodland and cultivation" into an airy distance (25 July).

Watson was more ambivalent about the role of industry in the landscape. Certainly the mills clustered around the falls and rapids were signs of human enterprise and progress, but he was disappointed at Glens Falls to find that the mills diverted so much water "that the falls are lessened and the scenery far from improved by the buildings" (28 July). He satisfied himself by turning his back on the mills and enjoying the view downstream. Watson was more likely to remark on industrial buildings without criticism, however, and he often organized his sketchbook views around mills or bridges that become proud points of human "improvement" and contrast in the midst of nature.

A small, but significant portion of Watson's time was spent in consideration of unrelieved wilderness, which he evidently failed to find "dreary." "The passage up the North or Hudson River is grand beyond anything I had ever seen before, and the varied beauty of its scenery requiring the pen of a Gray or Eustace to do justice to its discription." His "humble attempt" in words was less successful than his efforts with brush and pencil, but he gave a fairly well-informed outline of the geological structure and striking appearance of the Palisades and Highlands. Evidently well prepared for the grandeur of the Hudson, he was caught completely off-guard by the Berkshires.

The road from Becket through the defiles of the River Agawam to Westfield is more beautifully grand than I can find language to give an idea of—the road in several places nearly overhanging the river, and precipices so grand and varied with wood scenery, that would occupy the time of an Artist for a week at least. (1 August)

He regretted that the pace of his commercial stagecoach did not allow for stopping, with the result that neither his diary nor his sketchbook could do justice to his impressions of "one of the most romantic spots I have seen in America" (1 August).

Watson's language in these passages draws upon the aesthetic vocabulary of his period: "grand," "magnificent," "varied," "abrupt," "romantic,"—all the terms of the picturesque and sublime landscapes categorized by English writers since the publication of Edmund Burke's *Philosophical Enquiry into the Origins of Our Ideas of the Sublime and Beautiful* in 1757, and popularized by the Reverend William Gilpin's travel guides in the 1780s. Watson used the term "picturesque" himself on several occasions, referring to views such as the pleasantly irregular and varied landscape of the Schuylkill Valley. He never employed the word "sublime," substituting "grand," "magnificent," or "romantic" to express the awe-inspiring quality of this landscape experience. The towering Highlands of the Hudson, or the precipices of the river gorge near Westfield supplied the scale necessary to a sublime landscape, and Watson was appropriately breathless in both circumstances. More frequently his descriptive vocabulary turns to "pretty" and "beautiful"—words signifying neatness, orderliness, elegance, or regularity. The towns and houses he admired are almost always "pretty," whereas "beauty" appeared in settled landscapes and in Vanderlyn's *Ariadne* (see fig. 61). Watson's

all-purpose, ubiquitous word of praise was "fine," applied to persons, weather conditions, and a variety of landscape views. Equally vague, and indicative of Watson's genteel (rather than rigorous) literary education and positive frame of mind, are his other favorite words: "pleasant," "admirable," "agreeable," "delightful," "interesting." Without seeming to be a propagandist, Watson nonetheless scatters such words on every page of his diary, building his happy effect. Such appreciative descriptions of landscape take up the largest part of his diary, and, aside from his notes on new acquaintances and customs, must be assumed to be the major inspiration and raison d'être for his journal.

Landscape is likewise the centerpiece of Watson's sketchbooks, wherein he shows a visual vocabulary far richer and more precise than his verbal skills. Nonetheless, the reiteration of themes, the expression of values, and the substantiation of Watson's character and milieu found in his diary add invaluably to our appreciation of his drawings. Words unite with pictures to describe the central experience of his trip: the American landscape.

Selections from Watson's American Sketchbooks

with Commentaries by Kenneth Finkel

Introduction

THE PLATES THAT FOLLOW reproduce a selection of views from Captain Watson's two American sketchbooks. A complete facsimile was not feasible for several reasons. Many of Watson's sketches are in pencil only and too faint to reproduce clearly. Some drawings are incomplete or are false starts for other, more coherent images. Numerous pages are blank. A few images appear upsidedown in the general order. Most confusing of all, the sketchbooks seem to have been used from back to front, with the latest drawings on the first pages. For these reasons, as well as for the sake of quality and interest, fewer than half the drawings in these books have been reproduced. However, a complete list of every view, in the order in which it appears in each volume, appears in Appendix B, for the use of those curious about additional material.

Since the physical order of Watson's sketchbooks has been dismantled by the selection process, we have reorganized the views slightly to follow the chronological and geographical sequence of his travels, described in Part I. Many views of Philadelphia, the Schuylkill Valley, and Eaglesfield have been gathered together from different dates to create a tour of this region. The sketches from the New England and Washington journeys have been maintained in close to their original order within the sketchbook. The actual sequence can be reconstructed by consulting the Chronology.

Watson, or perhaps someone in his family, numbered the pages of these books, giving each double-page spread a single number. Usually one image appears on this spread, so we have maintained this numbering system, adding the letters "A" and "B" to designate left and right leaves. The two volumes are coded "NY" for the first one, in the New-York Historical Society, and "B" for the second volume, in the Barra Foundation. Thus, "B-104AB" will identify pages 104 A and B (a double-page view) in the Barra's sketchbook; "NY-92A" indicates a single page drawing, appearing on the left side of spread 92 in the New York book.

The New York sketchbook page measures $4\frac{1}{2}$ inches by $8\frac{1}{2}$ inches (11.43×21.6 cm); the Barra page is slightly larger, at $5\frac{3}{8}$ inches by $10\frac{1}{2}$ inches (13.65×26.67 cm). Both are prebound sketchbooks of excellent English watercolor paper with a watermark of "J. Whatman/1813" (NY) and "Ruse and Turner/1813" (Barra). Most of the sketches begin with a graphite sketch, often washed with gray, brown, or blue washes and occasionally touched with additional color. Watson's method and palette are discussed in Part III, "Watson's Art"; the specific materials used in each view are described as a part of the complete list of views in Appendix B.

Whenever possible, titles are taken verbatim from Watson's inscriptions. These inscriptions are usually in graphite and are not always legible. Watson seems to have gone over them in ink, sometimes confusing them further. Questionable words, newly invented titles, and dates supplied by external documentation appear in brackets.

All quotations, unless otherwise noted, are from Captain Watson's diary, Appendix A. Other sources used in the commentaries are listed in the Notes (numbered by plate number).

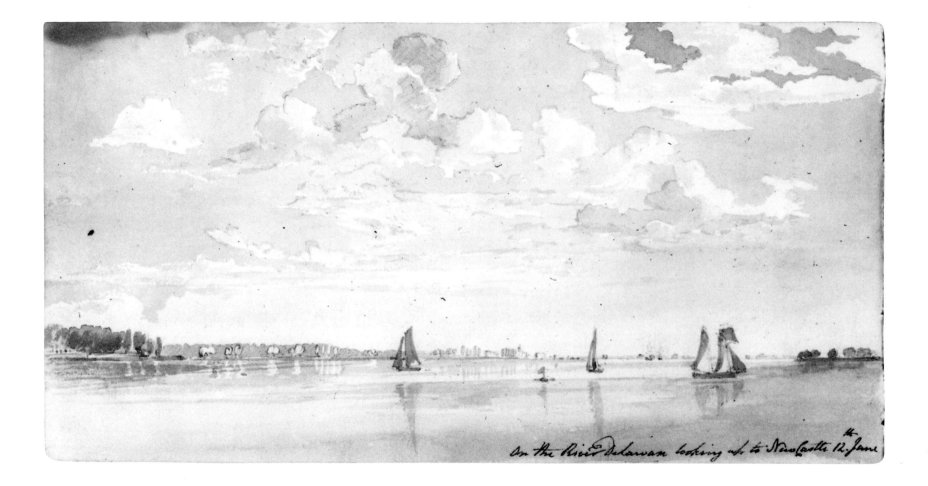

On the River Delaware looking up to Newcastle 12. June

1. *On The River Delawar Looking up to New Castle*
12th. June [1816]
Pen and blue and black wash over graphite (NY-135A; color plate 1)

The *Mercury*, a 364-ton "sharp-built ship," set sail from Liverpool on 21 April and gained North American landfall at Cape Henlopen on 11 June. The following day, after entering Delaware Bay at 3:00 P.M., a pilot boarded the ship and guided her through the maze of shoals, past the oyster beds off Nantuxet Bay to Reedy Island. At the top of the bay, and in view of Newcastle, Delaware, they laid anchor for the night.

When William Penn landed at Newcastle on 28 October 1682, it promised to become the largest port on the lower Delaware. Fort Casimir, built by the Dutch thirty years earlier, was in ruins, but a new Court House and a host of other buildings of mixed Dutch and English ancestry showed promise. Newcastle's metropolitan potential continued as a theme to Watson's time. Architect Benjamin Henry Latrobe, with assistants Robert Mills and William Strickland, made a block-by-block survey of the street facades in 1805, which was published along with an essay on the hoped-for growth of the town. But Newcastle never burgeoned as a seaport. Rather, it became important as a part of an overland connection between Philadelphia and Baltimore.

2. Philadelphia 14th April(?) 1817
Black wash over graphite (B-69B)

Only after a ship sailed around the bulge of South Philadelphia was the first glimpse of the city to be had. Arriving for the first time at dusk, when it was too dark to see well, Watson did not make a sketch from this vantage in June 1816. Rather, he revisited the scene almost a year later, while en route to Washington. From this angle, the city skyline stretches northward from a point near the present Walt Whitman Bridge, until the view is interrupted by the tree-covered Windmill or Smith's Island (removed in the late 1890s). Sparks's shot tower and the nascent Navy Yard appear on the left. Beyond rises the lone, glistening Georgian tower of Christ Church.

The paucity of spires in Philadelphia—the Friends had none on their meeting houses—was often noted by artists wishing to find a good view. "Philadelphia at a distance does not make much show," Watson remarked, "and was it not for the Towers of the two shot Manufactories and the Steeples on one of the Episcopal Churches & Free Masons Hall, a stranger might enter it without knowing he was in town" (Diary, 29 June 1816). Before the famed Treaty Elm at Shackamaxson was blown down in 1811, the city was most often presented from a northern perspective. The enormous branches of this ancient tree projecting over the bank of the Delaware suggested an appropriate and a symbolic frame for the city: it was the site where, according to popular legend, Penn had met with the Indians. Only in the 1830s, when the Navy Yard built a 103-foot tall building for the construction of the ship of war *Pennsylvania*, did the southern view gain interest.

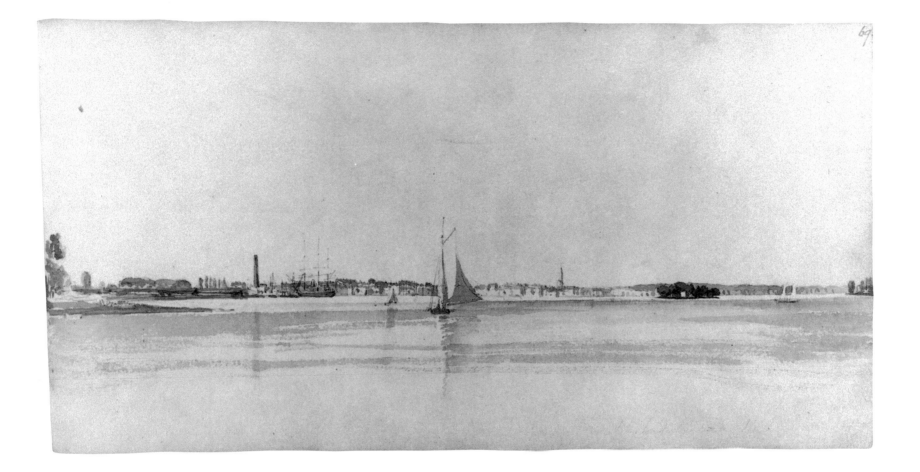

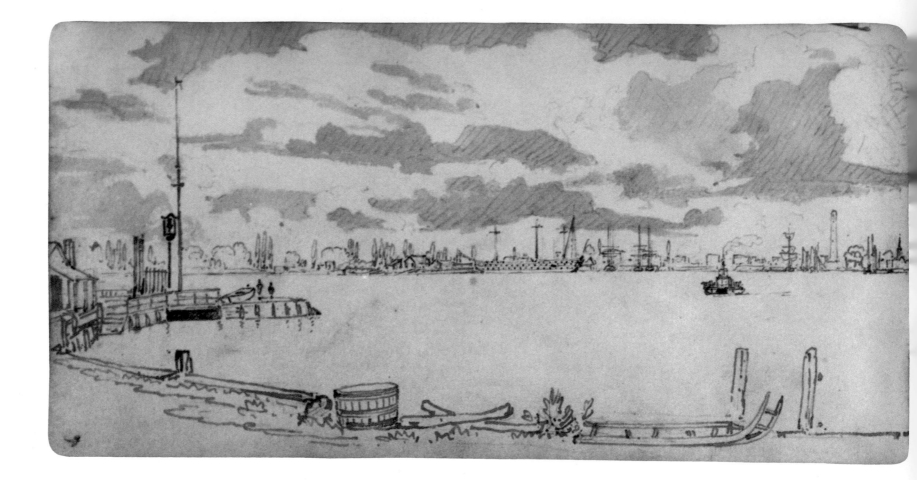

3. *View of Philadelphia from Keans Ferry on the Pontuxat or Delawar River 12th. May 1817.*

Pen and brown wash over graphite (B-41AB; color plate 2)

The New Jersey side offered the most advantageous prospect of the Philadelphia skyline. Peter Cooper chose that frontal view for his painting circa 1720; Scull and Heap did likewise for their monumental engraving of 1754. To the left of center in this view is the Philadelphia Navy Yard, where Watson visited the recently finished *Franklin*. Moving to the right, or north, is seen a ferry at midstream, and Sparks's shot tower. Windmill or Smith's Island blocks the view of the most built-up part of Philadelphia. The shaded foliage of the island is flanked by the steeples of St. Peter's and, to the right, Christ Church.

The ferry slip at the far left tells of the development of transportation since 1695, when the first ferries had plied the Delaware between Phila-

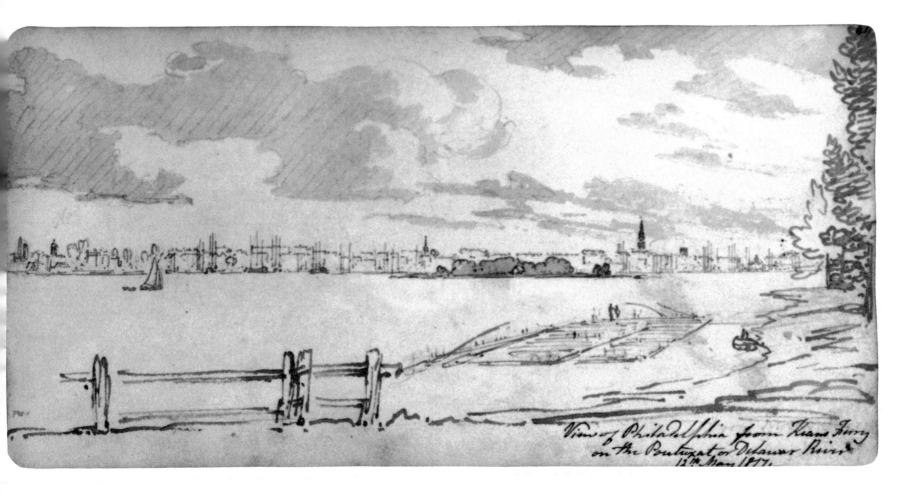

View of Philadelphia from Keans Ferry
on the Pontuxat or Delaware River
15th May 1857.

delphia and Camden. Initially, there were wherries, for twelve to fifteen persons, horse-boats, and team-boats. On the last, as many as ten horses would power a treadmill. Colder months were especially hard on ferrying and the rates of passage doubled between December and March. Steam-boats, which were introduced a few years before Watson's visit, made crossing the Delaware more speedy, somewhat more reliable, and, poten-tially, more profitable.

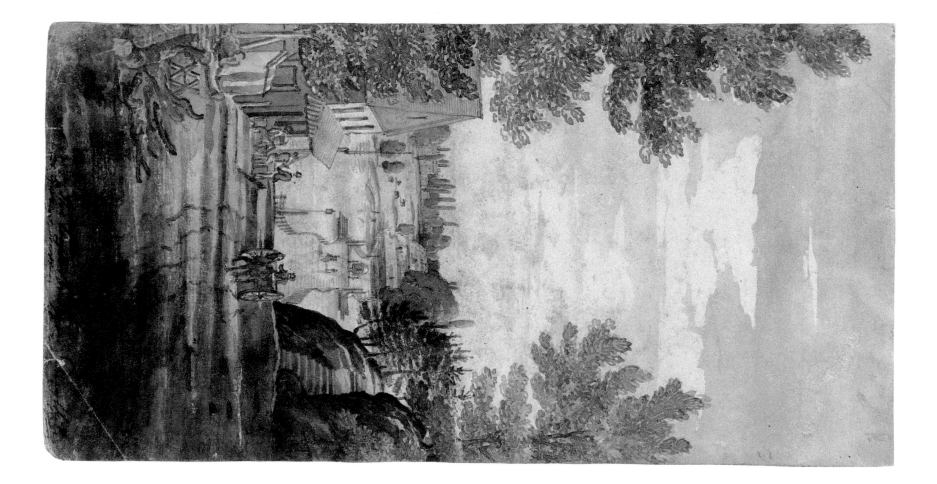

4. The Lower Bridge on Schuylkill at Gray's Ferry
5 [. . .]ber 1816
Watercolor over graphite (B-110A; color plate 9)

The Schuylkill River formed Philadelphia's western boundary, providing parklike suburban entrances to the city from inland districts. During the British occupation of Philadelphia in 1778, the southwestern approach to the city was upgraded from a ferry to a floating bridge. Eleven years later, when George Washington was making his way to his inauguration ceremony in New York, he entered the city by crossing the Schuylkill River at the same Gray's Ferry Bridge.

Washington's return was anticipated. There were patriotic banners, emblems, and spectators everywhere. "The whole railing, on each side of the bridge, was dressed with laurels interwoven with cedar," reported the *Columbian Magazine* of May 1789. "A triumphal arch, 20 feet high, decorated with laurel and other ever-greens, was erected at each end, in a style of neat simplicity: under the arch of that of the west end hung a crown of laurel, connected by a line which extended to a pine tree on the high and rocky bank of the river, where the other extremity was held by a handsome boy, beautifully robed in white linen; a wreath of laurel bound his brows, and a girdle of the same his waist." The crowd was informed of the general's approach when a flag was raised in Gray's gardens on the west bank. "About noon, the illustrious Washington appeared, and as he passed under the first triumphal arch, the acclamations of an immense crowd of spectators rent the air, and the laurel crown, at that instant, descended on his venerable head."

Later that year, the floating bridge was washed away in a flood and immediately replaced. The landscaped grounds on the east bank surrounding Gray's Inn, at the left, evolved into a pleasure garden. Fourth of July crowds picnicked during the day and were entertained in the evening by illuminated classical and presidental statuary along the steep walks of the garden, and, in the river below, an illuminated artificial island complete with a miniature farm house.

Traffic was steady on bridge and river. Bridge users frequently complained that they could not cross for all the openings. Boatmen complained that they could not conduct their business for all the time they had to wait. A bridge was wanted by all, but the minimal rise of seventy-five feet (so that the tallest masts could pass below) made its cost prohibitive. Only with the advent of the railroad, in the 1830s, was it absolutely necessary to replace the floating bridge with a permanent one.

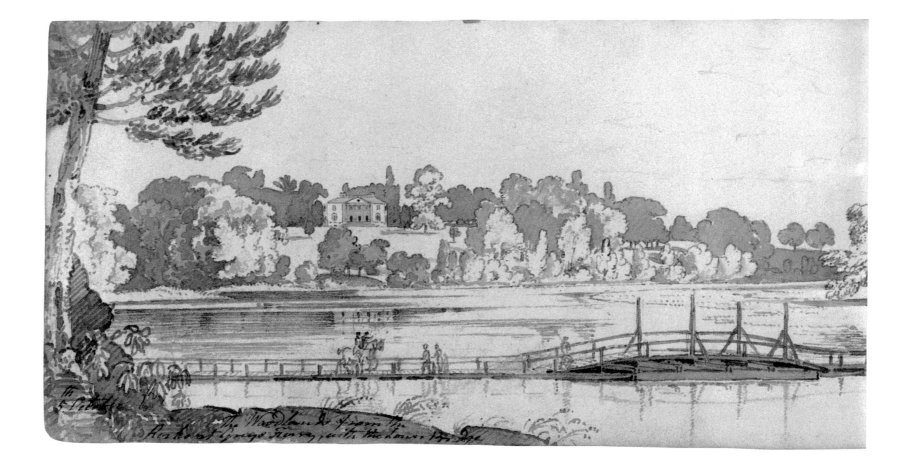

The Woodlands from the
Ferry at George's Ferry, with the Lower Bridge

*5. The Woodlands from the Rocks at Grays Ferry, with the
Lower Bridge 5th October [1816]*
Pen and black and brown wash over graphite (B-105A)

Senator Timothy Pickering and Representative Dr. Manasseh Cutler, both of Massachusetts, were making their way to Washington when Dr. Cutler fell and injured his side. It was midafternoon, on an autumn day in 1803, and they stopped at the nearest place, Gray's Inn. Ten were already there for the night, and the innkeeper had only blankets and a hard floor to offer.

Just across the Schuylkill, in plain view, was William Hamilton's Woodlands. Senator Pickering had known William Hamilton for some time; hoping to find him in and in a hospitable mood, they crossed the floating bridge. Watson's watercolor, made from the southwestern bank of the river, looking upstream, captured the view of Woodlands that enticed such travelers. "In the front, which commands an extensive and most enchanting prospect," wrote Cutler, "is a piazza supported on large pillars, and furnished with chairs and sofas like an elegant room. There we found Mr. Hamilton at his ease, smoking his cigar." They toured Hamilton's grounds, admired walks bordered with flowers, lawns with artificial groves, trees from all parts of the world, and greenhouses with exotic tropical trees, decorative plants, and spices. Discussions continued back at the house, where tea was served and several of Hamilton's botanical plate books were examined. If a specimen in an illustration was in the greenhouse, Hamilton would have a gardener fetch the plant for his guests to compare. Cutler was constantly bothered by his pain through this unexpected treat. "When I had time to think of it, while I sat at the table, I was obliged to bite my lip to supress my groans. . . . O! That I had been well!"

Later Cutler and Pickering admired the oval rooms with niches occupied by statues and, on the walls, portraits by Benjamin West, Dutch landscapes, and Flemish religious pictures. Its stylish plan, notable art collection, and lavish gardens made Woodlands one of the most-visited houses in Philadelphia and one of the most-often painted. Watson found the whole place "*very* pretty" (Diary, 9 July 1816) and in his watercolor balanced interests in the house and its landscaped setting, a formula he found satisfactory for the many Schuylkill mansions.

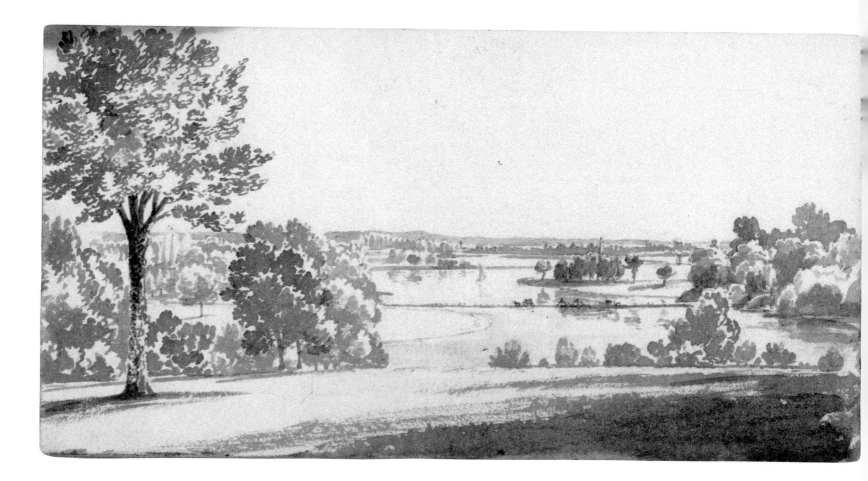

6. [The Lower Bridge at Gray's Ferry, from the lawn of Woodlands, 9(?) July 1816]
Blue and black wash over graphite (NY-120AB)

An Anglophile, William Hamilton laid low during the Revolution, and in 1784 he left his modest farmhouse for a grand tour of Europe. He soon learned that what constituted wealth in America did not in England. Instead of touring, Hamilton spent time imagining the rebuilding of Woodlands. He studied contemporary British architecture, became expert in matters of landscaping, and sent to Philadelphia for samples of local stone.

The income, and perhaps the inspiration, for this project was the legacy of William's grandfather, Andrew Hamilton. He had been the architect of Independence Hall and had the good fortune to own the land on which Lancaster, Pennsylvania was built. The ground rent grudgingly paid to the younger Hamilton handily covered the expenses incurred at Woodlands. And it was from his grandfather's estate, Bush Hill, that the young Hamilton directed the early stages of construction after his return from England. When the conversion was finished, in 1789, the farmhouse had transformed into a prominent and influential country house in the Adamesque-Federal style.

"The house is planned with a great deal of taste," wrote an unidentified woman in June 1788:

The front is divided into a spacious hall with a room at each end, the back part is composed of a large dining-room, separated by an entry leading from the hall to the back door, from a very handsome room, which, when finished will form a complete oval — The prospect from every room is enchanting, as you enter the hall you have a view of a remarkably fine lawn, beyond that, the bridge over which the people are constantly passing, the rough ground opposite to Gray's, four or five windings of the Schuylkill, the intermediate country & the Delaware terminated by the blue mist of the Jersey shore — . . . The whole of this is heightened by mirror doors which when closed repeats the landscape & has a very fine effect it appears, indeed, like a fairy scene. . . .

The vista was remarkably similar thirty years later, when Watson made repeated visits to Woodlands. Upon the death of William in 1813, his unmarried nephew James inherited the estate and occupied Woodlands with his brothers, two sisters, and a brother-in-law, James Lyle. In 1845 the house became the centerpiece of Woodlands Cemetery, and the lawns were soon built up with Victorian monuments in white marble.

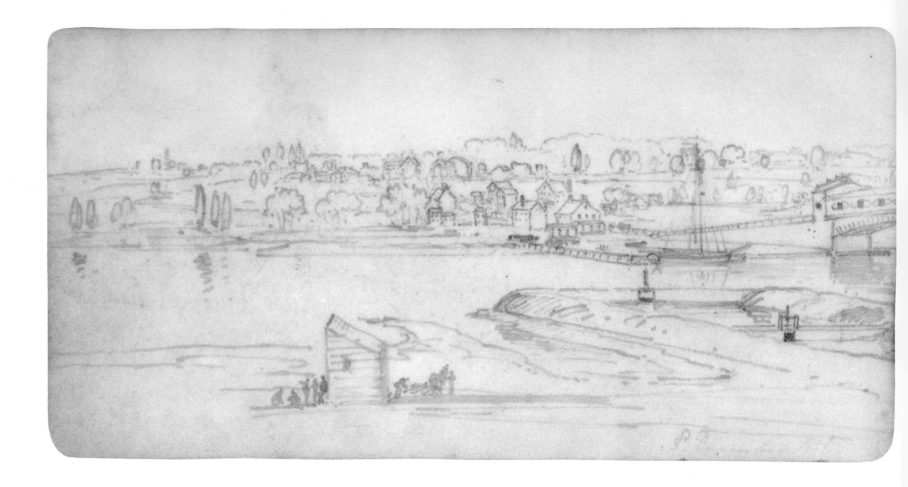

7. *[West bank of the Schuylkill below the Market Street bridge] 3d. December 1816; The Shot tower . . . December 1816*
Pen and black wash over graphite (B-104′AB)

In his plan for Philadelphia, William Penn intended that the Delaware riverfront become an international port and that the Schuylkill riverfront become a provincial one. Citizens of the two halves of the city would meet at the center in public buildings along Broad Street—out of the sight, sound, and smell of commerce. This plan remained more hope than reality. By Watson's time, the Delaware side of the city had grown beyond the bounds set for it and the Schuylkill front had not yet approached its commercial potential. From his vantage point, adjacent to the Old Waterworks building at Chestnut and Schuylkill Second (now Twenty-first) Streets, Watson sketched these two views. On the left, looking across

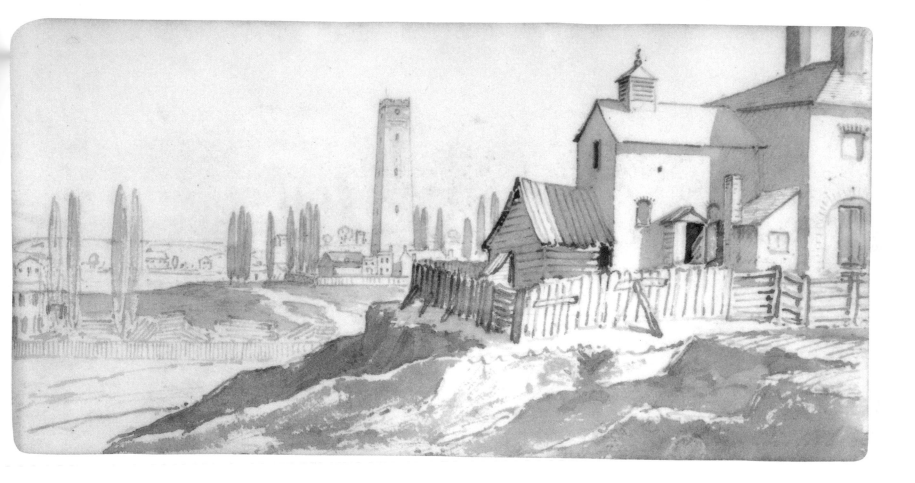

the Schuylkill just below the permanent bridge at Market Street, is the beginning of West Philadelphia. On the right, Watson sketched the view northward from the Old Waterworks building, in the foreground, to Paul Beck's shot tower.

These sketches and the following one (plate 8) led up to Watson's only known major work, *View on the Schuylkill from the Old Water Works* (see fig. 40 and color plate 10). After Watson's departure from Philadel-phia, it was published twice as a wood engraving, and, soon after, Cephas Grier Childs engraved it for his *Views in Philadelphia and its Vicinity* (see fig. 47). The large watercolor may have been exhibited at the Pennsylvania Academy of the Fine Arts in 1829 over the title *View from the Porcelain Factory, near the Schuylkill Permanent Bridge*. The change in title reflected a change in the use of the waterworks building: in the late 1820s, William Ellis Tucker converted the building into the first American porcelain factory.

8. View of the Middle and Upper bridges on the River Schuylkill taken from the Old Waterworks Philadelphia 5th October 1816
Watercolor over graphite (B-104"AB; color plate 3)

In his *Picture of Philadelphia*, published in 1811, James Mease anticipated travelers' wants by suggesting several tours. One took the visitor over the new thirteen hundred-foot permanent bridge over the Schuylkill at Mar-ket Street seen at the left in Watson's view. "From the middle of this bridge, especially if the tide be up," wrote Mease, "the eye will be gratified by a fine prospect of both shores, some handsome country seats being on the bank, and the land agreeably undulated. . . ." Watson illustrated this point, showing the upper bridge at Fairmount, which he found to be "the most beautiful and gigantic Bridge of One Arch in the World," framing the estate Lemon Hill beyond.

The western half of the city appears just as it was on the rise. Heavy

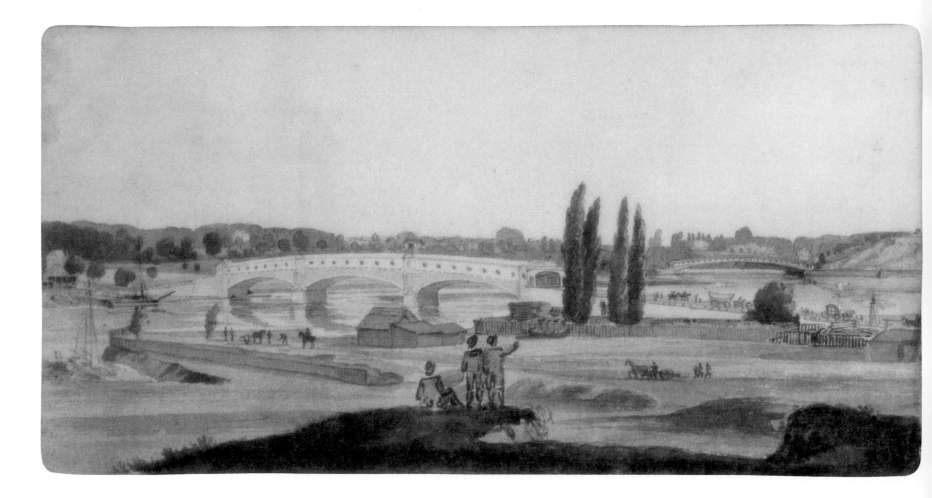

traffic leading up to the middle bridge was changing its suburban character; overgrazing by livestock and meandering streams caused erosion. By the 1830s, nearly twenty-five thousand vessels were passing through the locks at Fairmount each year, assuring an annual increase in the amount of coal and industrial and agricultural goods brought to Philadelphia from throughout the commonwealth.

Watson emphasized the breadth of the Schuylkill Valley and simplified the urban elements of this scene by removing a lumber yard (present in plate 7), diminishing several buildings in the middle ground, and omitting details of the Water Works. He chose to eliminate the shot tower, although it did appear as a distant element in the large version of the watercolor (see fig. 40 and color plate 10). Even with these changes, Watson's view differs from the boosters' image of Philadelphia, seen in views such as those of William Birch, whose engravings from 1800 depict the banks, churches, and markets far from the ragged expanding edge of the city.

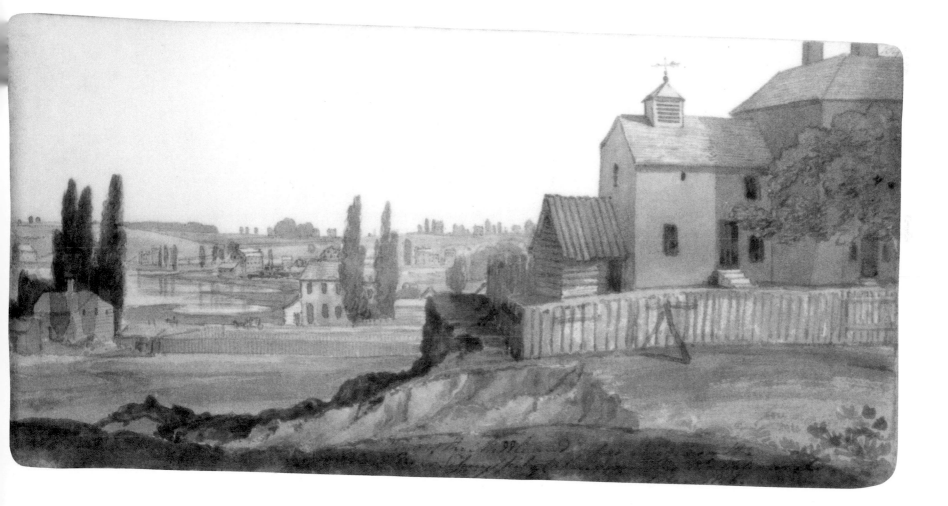

9. This View looking up the River Schuylkil is taken from the top of the West Shot tower at Philadelphia. 3rd Decembr. 1816.
Pen and black wash over graphite (B-76A)

Shot was made by pouring molten lead into a bed of sand from extreme heights. Philadelphia's first shot tower, 142 feet tall, was built in 1807 by John B. Bishop and Thomas Sparks. It is still extant at Carpenter near Front Street. A second shot tower, built the following year by Paul Beck, was represented in *The Portfolio* of December 1812. Engraver Thomas Birch showed the tower from just below Fairmount. Four years later, Watson made his view of the river valley from its castellated top, 166 feet high. "From all the neighboring country seats, it forms a beautiful object," reported *The Portfolio* in an accompanying article, "while on its top, may be enjoyed the most comprehensive view of the city, and all the surrounding scenery." Watson's attention was drawn northwest, up the river, to the bridge at Fairmount, which "forms a most striking object" and to his uncle's estate, Eaglesfield, seen above the bridge span.

The distant pastoral beauty must have been a poignant contrast to the busy industrial scene below. Beck's tower produced ordnance—up to five tons of shot each day—enough for the entire nation. And Watson would have known that the buildings in the foreground included Foxhall and Richard's Eagle Foundry, where cannons used by the American navy were made. But the clashing of munitions manufacture and country life ended before long. The foundry fell into ruins not long after its management turned to less lucrative peacetime work—parts for the Fairmount Waterworks were cast there. And competition forced the abandonment of Beck's shot tower in 1828.

A view looking up the River Schuylkill taken from the top of the West Front tower of Philadelphia Penna 1816.

10. Looking up the Schuylkil from the Upper Bridge
9th October 1816

Pen and black wash over graphite (B-108AB)

A window of the four-hundred-foot bridge at Fairmount, called "The Colossus," provided Watson with a view of suburban Philadelphia to the northwest. Looking upriver from the four-year-old span, he could see the Fairmount Waterworks in the foreground at right. Its engines and turbines were clothed in a genteel Classical Revival pavilion, not as bold as the earlier pumphouse at Center Square (see fig. 52). The waterworks and its adjacent gardens attracted admiring tourists and strollers who also enjoyed views of the newly built country seats.

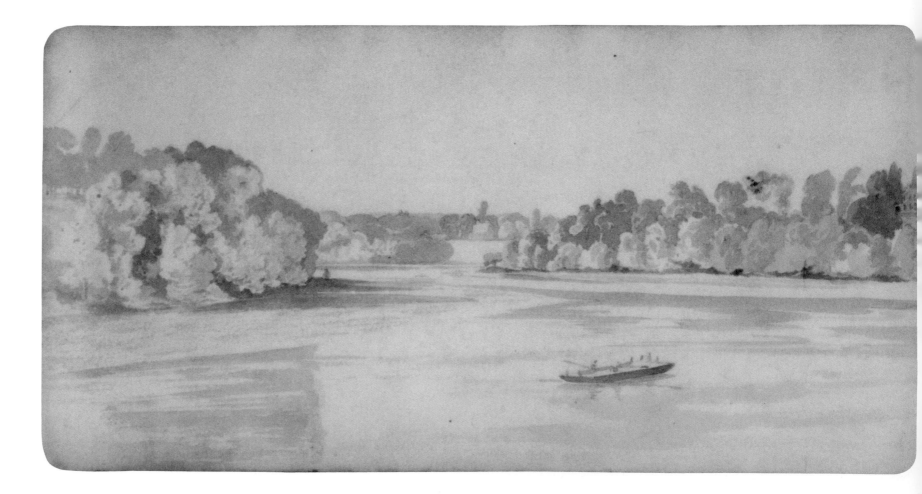

The notion of spending one's summers on the bluffs of the Schuyl-kill gained popularity after a yellow fever epidemic killed ten percent of Philadelphia's population in 1793. What started as a flight from pestilent air and water took delightful wings when combined with the tradition of the English country house. Before the end of the decade, several notable "gentlemen's villas" were complete. In 1799, Henry Pratt built a new house, Lemon Hill (seen at the centerfold of Watson's sketch) named after the extravagant greenhouses (to the right of the house) built by the estate's

previous owner, Robert Morris. Benjamin Henry Latrobe's Gothic Revival Sedgeley, just north of Lemon Hill on the east bank, was begun the same year for William Crammond. Further upstream, on the west bank, appears Eaglesfield, built in 1798. This was the home of Watson's uncle, Richard Rundle.

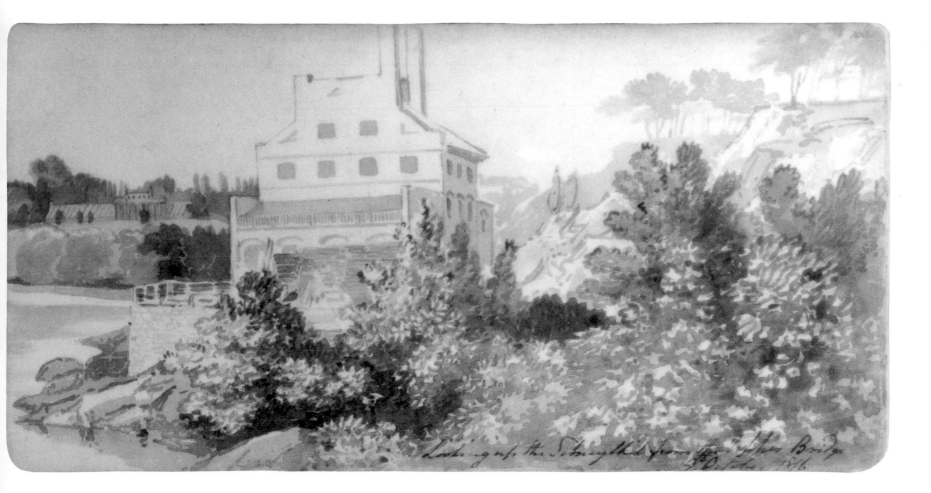

11. *[View up the Schuylkill toward Eaglesfield, from the west bank opposite Sedgeley Point; April 1817]*
Black wash over graphite (B-70AB)

"A most delightful ride is offered by pursuing the following course," wrote James Mease in his *Picture of Philadelphia* in 1811. "Having crossed the Schuylkill bridge (High Street) take the first right hand road, this will conduct you along the river Schuylkill, sometimes on its margin, at others on its high banks; the tasteful villas scattered on both sides of this beautiful stream, added to the variegated decorations of nature, cannot fail to gratify." Watson stopped on this road to sketch the first uninterrupted view north to his uncle's country estate, Eaglesfield. From this same spot

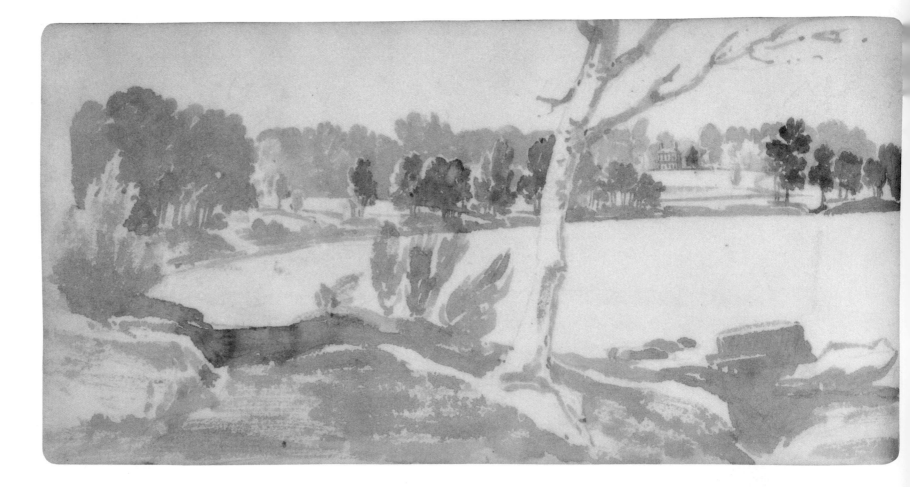

he could see the roofline of Sedgeley (plate 12) rising above the rocks and foliage at the right; Lemon Hill would have been visible farther to the east. The dark clump of trees and sunlit lawn on the west bank, to the far left of Watson's composition, encircled John Penn's country retreat, Solitude (plate 13).

Throughout the nineteenth century, artists gravitated to this spot. Swiss naturalist Charles Alexandre Lesueur visited it in the early 1820s and depicted pleasure boaters there. Through the works of artists such as engraver William Birch, lithographer Augustus Kollner, photographer John Moran, and painter Thomas Eakins, the Schuylkill upstream from Fairmount—and a stretch now called Boat House Row—became particularly Philadelphian. As the distant view of the river turns behind Eaglesfield it is now closed by a pair of bridges at Girard Avenue.

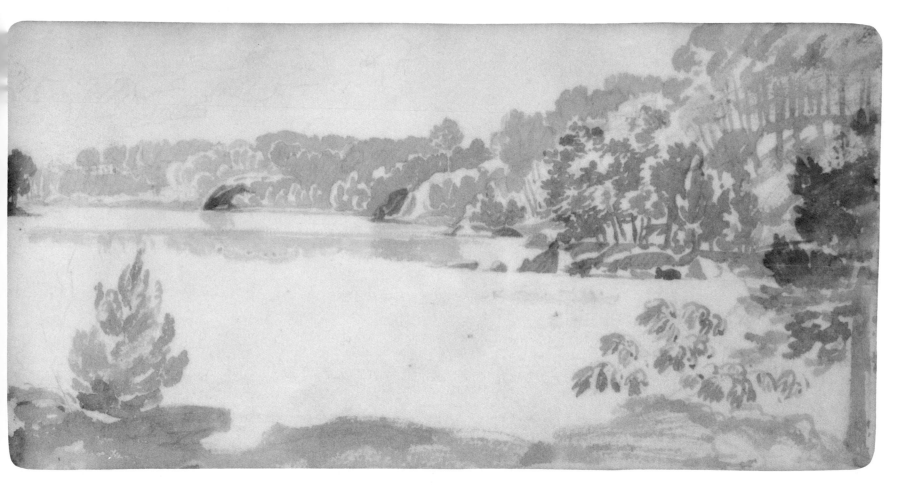

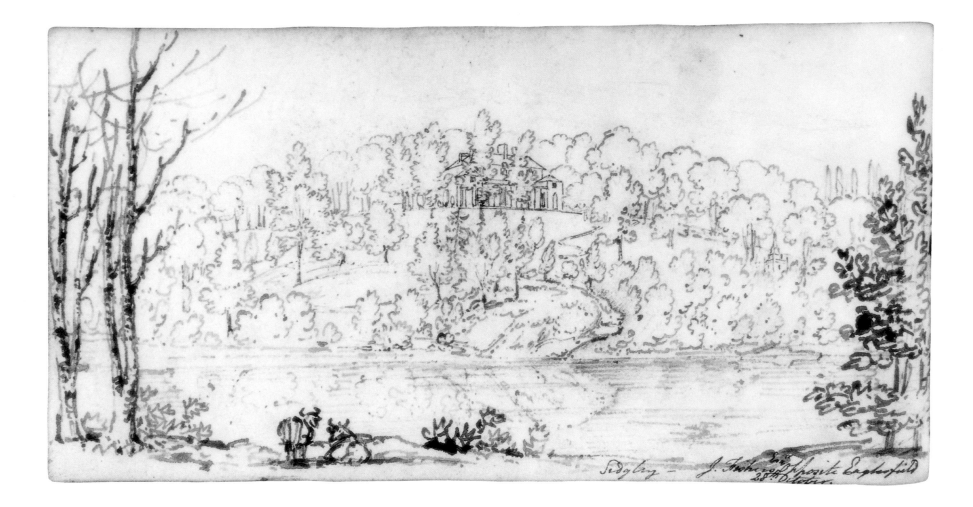

Sidgley — J. Fisher opposite Eaglesfield
28th October.

12. Sedgley—J. Fishers Esqr. opposite Eaglesfield 28th.
October. [1816]

Pen and black wash over graphite (B-78A)

America's first Gothic Revival house, featuring pointed windows and drip mouldings, was built in 1799 on an eighty-foot bluff on the Schuylkill's east bank. Opulence set Sedgeley apart from the other river houses, and its eventual demise was caused, in part, by its showiness. As the fortunes of the flamboyant merchants it attracted waxed and waned, so Sedgeley flourished and teetered.

Robert Morris's land holdings, including Lemon Hill, were liquidated at sheriff's auction in the spring of 1799. William Crammond bought a twenty-five acre parcel to the north and planned for it a state-of-the-art country house. He hired architect Benjamin Henry Latrobe, known in town for his propensity to employ white marble and the Greek Revival style. Here, beyond the city limits of the "Athens of America," Latrobe chose the picturesque and playful "modern Gothic" style. Watson thought the house itself "well-contrived," but he found the landscaping both artificial and confining (Diary, 10 and 15 July 1816). He sketched no views from Sedgeley, preferring to descend to the rocks below to draw Eaglesfield, as it appeared across the river (see NY-122AB). Sedgeley and its towerlike garden pavilion, seen poking above the foliage at the right, also appear in Watson's sketches from Eaglesfield's verandah (plate 14, color plate 4).

William Birch credited Sedgeley to Crammond in his *Country Seats of the United States* in 1808, although it was Samuel Mifflin's by then; Crammond had been forced to sell it while beset by financial difficulties. James Cowles Fisher owned Sedgeley as his summer house when Watson sketched it, and by the 1830s both Sedgeley and the adjacent Lemon Hill were too close to the creeping industrial fringe of the city to be considered desirable country seats. Land speculator Isaac S. Lloyd bought both and, while awaiting an opportunity to sell the property for industrial use, sold the plantings as timber. By 1857, when the city bought the land, its protection as Fairmount Park was imminent but so was the demolition of the once-sublime Sedgeley.

*13. Upper Bridge with the Waterworks on Schuylkill fm
Solitude 28.th October; Solitude Jno. Penn Esqr. 28th.
October [1816]*

Pen and black wash over graphite (B-77AB)

Further upstream, along the west bank, Watson paused to delineate the classic view down the river to the Fairmount bridge, waterworks, and reservoir. Evidently, he took a position on the grassy clearing below Solitude, visible in plate 11, where he could simultaneously sketch the river view and then turn to consider the prospect of the house on the slope to his right. The small, hipped-roofed residence was built in 1784 by the grandson of William Penn, statesman and poet John Penn. When Watson visited Philadelphia, according to Samuel Breck, the house was occupied by Mrs. Benjamin B. Howell, and the following summer, by Penn's agent, General Thomas Cadwalader (1779–1841), his wife, and her relative Rebecca Bond. This house still stands today, tucked neatly, if somewhat incongruously, within the grounds of the mostly Victorian Philadelphia Zoological Gardens.

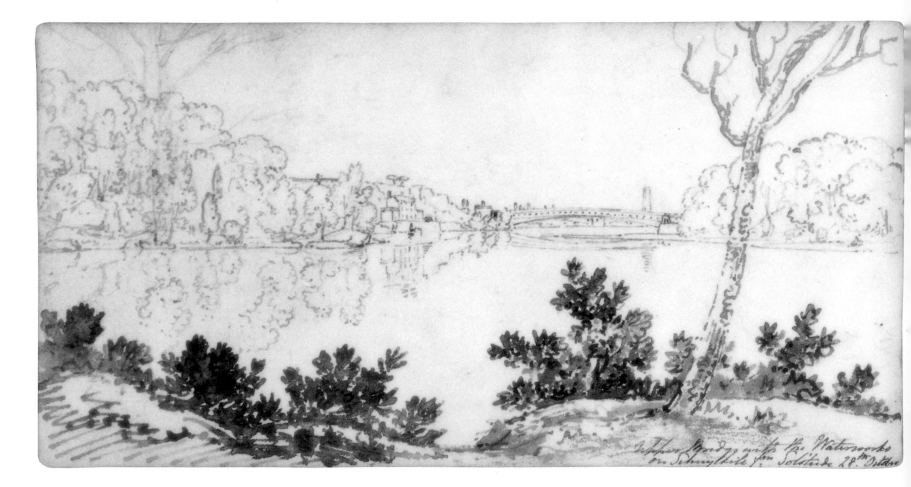

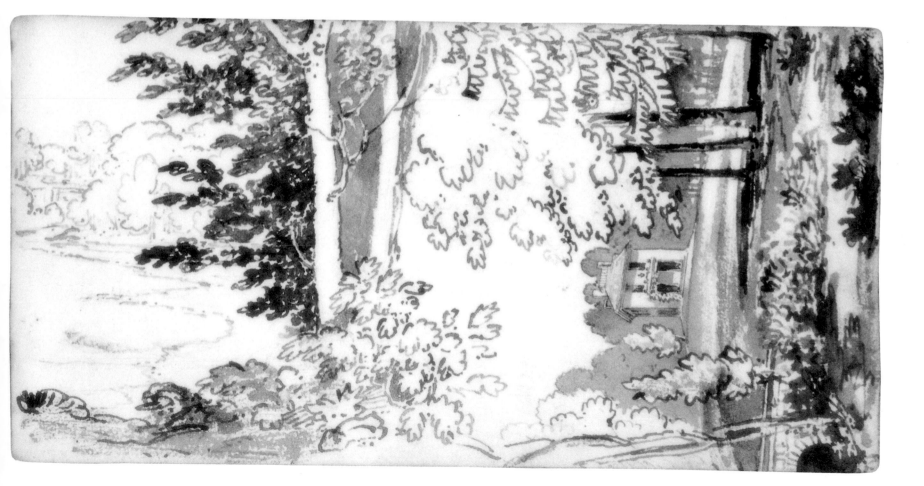

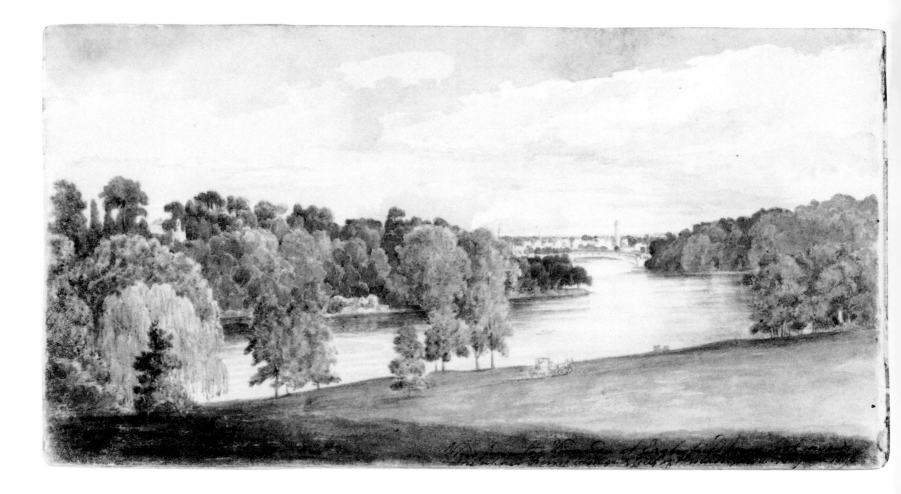

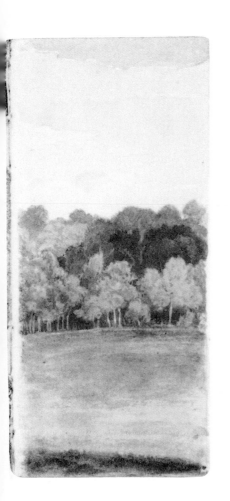

14. View from the Veranda at Eaglesfield house look[ing]
towards the Upper Ferry Bridge & City of Philadelphia
13th June 1816
Watercolor over graphite (NY-133AB; color plate 4)

Still farther upstream, at Eaglesfield, the commanding view of the river
and the city's fledgling skyline beyond the bridge at Fairmount made it
one of the finest prospects along the Schuylkill. Excited by the panorama
extending from the roof of Lemon Hill and the pavilion of Sedgeley, at the
left, to the shot tower in the distance and then across to Solitude (hidden
by trees at the right), Watson sketched this view on the first day he came
to Eaglesfield and twice again in September 1816 (see B-109AB).

Eaglesfield stood on the remainder of an estate owned by the Warner
family since William Penn's time. Adjacent parcels had been sold off, and
after William Warner died in 1794 this knobby rise around which the
Schuylkill gently flowed was purchased by Robert Egglesfield Griffith. Rec-
ognizing the unique opportunity to improve upon Warner's modest sum-
mer house, Griffith sought out the latest talent in landscape architecture
and saw an elegant new mansion rise amid well-planned grounds in 1798.

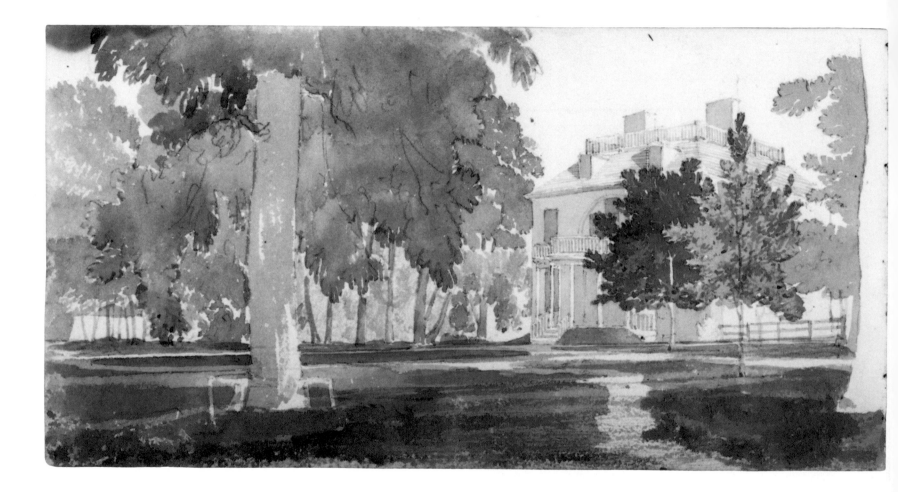

15. Front [at?] Eaglesfield 4 July [1816]
Green and black wash over graphite (NY-127)

Watson's first visit to Eaglesfield was on 13 June 1816.

We left Town at 1 PM in his [Richard Rundle's] Chariottee, drawn by a very fine pair of Bay horses—We proceeded through a part of the City, which is built on a scale of magnificence I had no idea of, through Walnut Street to the Old Waterworks . . . and so on to the Center or Permanent Bridge across the river Schuylkill. . . . On passing over the former we turned to the right along the banks of Schuylkill, to the Old ferryhouse . . . the road is prettily diversified by Country houses and small boxes laid out with good taste. I was all eyes looking out for a view of Eaglesfield, but afraid to ask questions, tho we pass'd one or two places I thought might be it. By the approach through a good road with trees on either side, and the beautiful flowering plants, the wild Laurel and Rhodedendrums &ca. in great profusion, we enter'd the North Gate of Eaglesfield near the Dairyhouse and Bath: and drove about 300 yards amidst fine timber trees of Oak, Cedar Hickory, Chesnut and Tulip, nor could I get even a peep at the house till we were close up at the door.

Although romantic suspense and surprise played a part in the approach to the house, the building itself enacted the neoclassical taste for pale colors, square plans and symmetry from all angles. The flattened Palladian window, hipped roof with dormers and balustrades read as English Georgian and American Late Colonial intermingling as the newer Federal style.

In 1798, Robert Egglesfield Griffith had named Englishman George Isham Parkyns as architect for his country retreat. Just the year before, Parkyns' *Six Designs for Improving and Embellishing Grounds* was issued as an addendum to John Soane's *Sketches in Architecture*. In detailed cross-sections, Parkyns placed relatively modest residences with commanding vistas contrived to look natural. If Griffith was impressed by this publication, a copy of which was available at the Library Company of Philadelphia, he was not the only American to feel this way. Thomas Jefferson invited Parkyns's to work at Monticello. At Eaglesfield, Parkyns's sensibility was played out in the sweeping lawns and massed foliage that dramatically framed the house as well as the views from its veranda and windows.

16. *[Eaglesfield from the northeast] May 11th. 1817*
Watercolor over graphite (B-43AB; color plate 5)

Eaglesfield was at its best during Richard Rundle's ownership, from 1810 to his death in May 1826. Rundle lavished attention on the house, outbuildings, and grounds, making it all a showplace. The well-executed plans of Parkyns had seasoned and matured after almost twenty years. Watson delighted in the estate, sketching and painting every grove and vista.

The comfortable, domestic Schuylkill changed after the dam was completed at Fairmount. With the water stilled, healthful country retreats gave way to mosquitoes and industry. After 1834 and the death of Eaglesfield's next owner, John J. Borie, ice companies, breweries, and other industries dominated the riverbanks. Once quiet paths became throughfares to and from a burgeoning city. In the spring of 1840, Sidney George Fisher wrote in his diary:

Went up to the house at "Eaglesfield," Borie's old place, one of the most beautiful seats on the now deserted Schuylkill. The house was open & I went in, as no one

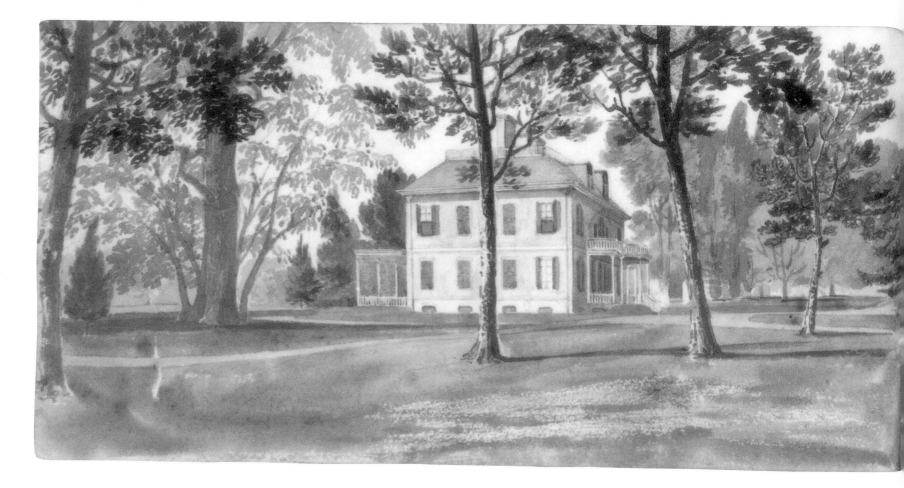

was living there. It is a very handsome and convenient mansion, or a plan that I like much & very well finished. The situation is fine, commanding a view up and down the river. It is surrounded by fine old trees. It is to be occupied this summer by a tenant.

Eaglesfield became a hotel, too, for a time, but there were no further permanent residents (see figs. 23, 24). The land was acquired by the city early in 1869, as an addition to Fairmount Park, and the future of Eaglesfield, like that of any other building in the growing park, was likely demolition. A few months after the acquisition, forty-two prominent petition-ers signed and presented to the Fairmount Park Commission a document contending that "the Egglesfield Mansion is a substantial and good building and can be put in good order for a reasonable sum; that the convenience of citizens especially pedestrians will be much promoted by having the same retained and rented as a temperance restaurant and place for rest and shelter in case of sudden storms, as it will probably be the only place for such purposes between the Mansion House on Lemon Hill and the Belmont Mansion." To no avail. By the time Girard Avenue Bridge was widened, in anticipation of the Centennial Exhibition, Eaglesfield was gone.

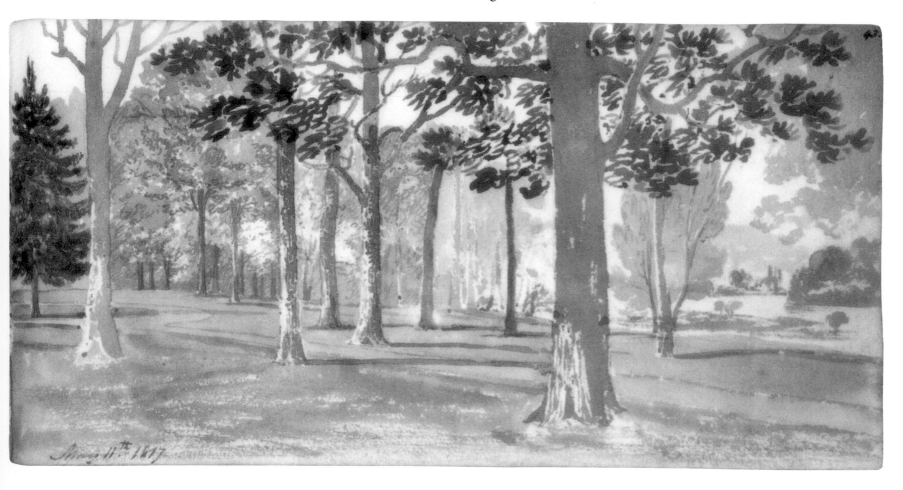

*17. From the Piazza Eaglesfield looking towards Mr. Morris's
29th. May 1817*
Pen and brown and black wash over graphite (B-38AB)

The front windows of the drawing and eating rooms reached floor to ceiling and opened onto Eaglesfield's piazza, forty-six feet wide and sixteen feet deep. "This is a delightful place," wrote Watson, and from it he sketched every view. The southeast prospect of Philadelphia, beyond the lawn and river, was the one most featured. On a clear day the Delaware was visible, and New Jersey stretched along the hazy horizon. The middle ground, in good picturesque fortune, was soon occupied by the bridge and waterworks at Fairmount (plate 14). But architect Parkyns was not

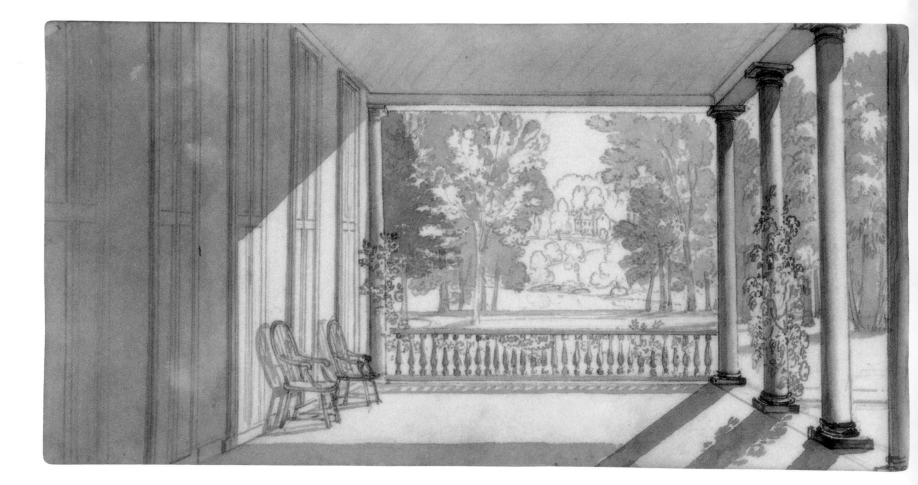

one to miss additional visual opportunities. At right angles to this main axis, he used the end of the piazza and a careful clearing of trees to gently frame The Cliffs, a house on the opposite side of the river. With such visual connections, the Schuylkill Valley and its new inhabitants became artfully entwined.

The Cliffs, a mid-eighteenth-century stone house with soapstone steps and wood-paneled interiors, was fled by its Tory owners during the Revolution. During the war, Sarah Franklin Bache, Benjamin Franklin's daughter, converted the house into a bandage workshop for Washington's army. The building survived in obscurity as part of Fairmount Park and was preserved as a residence for park employees into the middle of the twentieth century. In the 1970s, The Cliffs was emptied and soon vandalized. The adjacent gorge became a dumpsite for fill excavated for a commuter tunnel in Philadelphia's center. Neglect and disrespect brought near total destruction by fire in February 1986.

From the Piazza Eaglesfield looking towards Mr. Morris's
28th May 1809

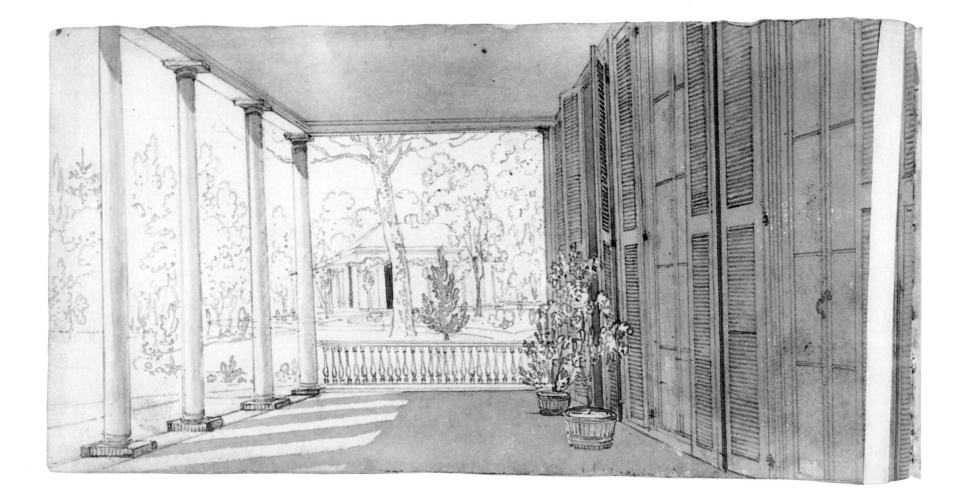

18. From the Piazza looking towards the Pavilion 21st
May 1817—
Pen and black wash over graphite (B-40A)

"Near the house is a pavillion with a Piazza all round it, it consists of two rooms and [is] well situated for privacy," wrote Watson. Its peaked roof reappears in a view from across the river, recorded in William Groombridge's painting of 1800 (see fig. 42). What appeared to be a casual placement at the edge of the woods was another illusion by architect Parkyns. The modest building, an integral part of any proper gentleman's country estate, offered summer lounging in shade amidst breezes from the nearby shaded thickets. It also provided visitors with a truly grand view of the city.

At the foot of Eaglesfield's southeastern bank, the oldest social organization in the world, as the Schuylkill Fishing Company calls itself, had rented an acre of land since the middle of the previous century. By mutual agreement, the landowner was paid the first two sunfish caught by the company each season. In an annual procession, these fish were escorted from the clubhouse on the river bank, up the slope to the "Baron" on his veranda. The ritual, begun in William Warner's day, continued through Griffith's ownership and, after 1810, under the bemused lordship of Richard Rundle. "Baron" Rundle and his guests were welcome at the company's celebrated dinners; he and Watson attended the festivities at their Fish House at least twice in 1816–17 (*Diary* 13 June 1816). When the dam of the Waterworks at Fairmount was completed in 1822, the quantity and variety of fish were diminished and the "State in Schuylkill" relocated downstream near Gray's Ferry.

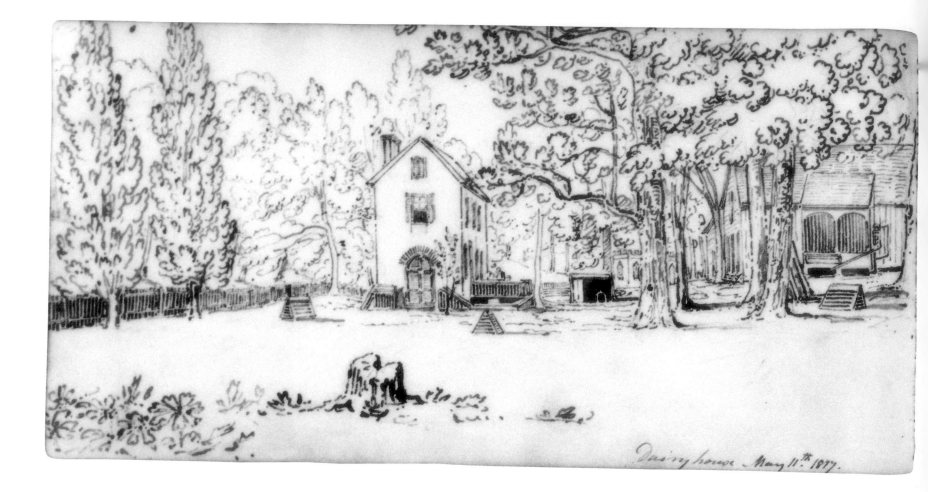

Dairy house May 11th 1817.

19. Dairy House. May 11th. 1817.
Pen and black wash over graphite (B-42AB)

"The Dairy house Cow house, Bath &ca are at a short distance from the house—in the former the pans of milk are placed in a cooler in summer, through which a stream, issuing from a fine spring is constantly running. It also supplies the Bath and fills a pond for the Horses and ducks" (Diary, 13 June 1816). "Its stream is so contrived as to pass round the room, into which the Milk in pans are placed, and kept in the nicest Order. An old Woman (in general calld Aunt Fanny) has the charge of this house, at

which the People employd on the farm reside." The stone, eighteen by forty-four foot Dairy House, on the left, was part of the complex of service buildings located approximately three hundred yards from the house, "near the Northgate, and is a good object on entering the grounds on that side" (Diary, 3 July 1816).

20. Stables & Barns 21st. May 1817—
Pen and brown wash over graphite (B-39AB)

Pomposity, symmetry, and a dash of theatrics characterize gentlemen's country villas of the Regency style. The outbuildings of Eaglesfield depicted in this and the previous drawing (plate 19) indicate a prosperous farming complex started by Griffith and maintained by Rundle. False fronts with details worthy of residences, if not public buildings, greet the

visitor as he is whisked from the entrance gate to the formal semicircular entrance of the house (see plates 15 and 16). It is all of a piece, composing an elegant parklike ambience for the business of stabling horses and storing carriages, wagons, and other farming gear.

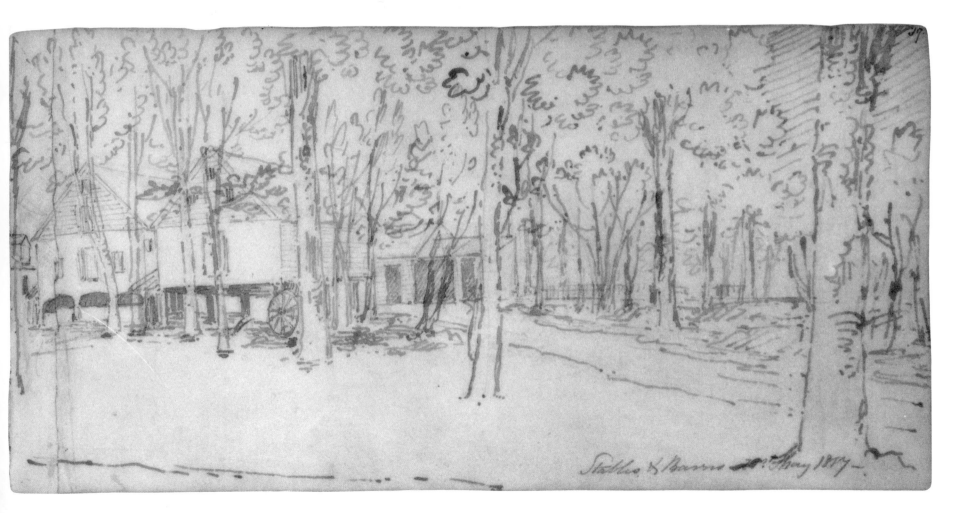

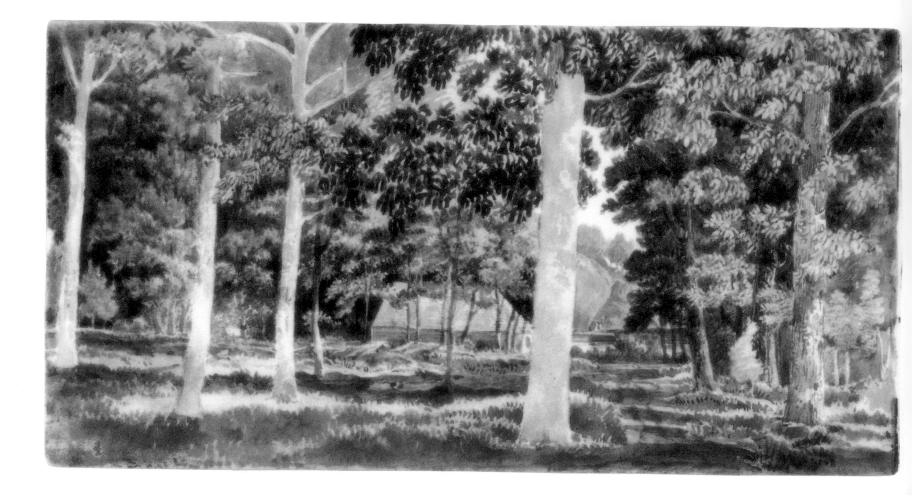

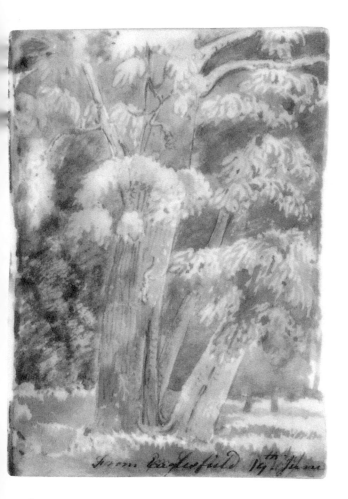

21. From Eaglesfield 19th June— [*1816; view through woods to river*]

Watercolor over graphite (NY-130AB; color plate 7)

Watson's diary records "several sketches" made "about the house" on the fine day of 19 June 1816. This view shows how the landscapes and vistas of Eaglesfield were maintained far from the house at the river's edge as well as at the farm's center. The barnlike building in the middle ground may have served the lowland pastures.

22. Banks of Schuylkill looking up the River 4th. April 1817—
Pen and black wash over graphite (B-73AB)

Watson halted on the road below Eaglesfield to enjoy this view toward Peters Island, opposite Belmont, the estate of Richard Peters (see plates 24, 25). The island was a prominent feature of Schuylkill life early in the nineteenth century, serving as a resort for rowboating picnickers. Groceries were sold, and a card game was always being played in a small frame building there. The size of the island was abbreviated after the dam at Fairmount raised the level of the river, and repeated freshets kept island life from getting a stronger foothold. During the freshet of February 1822,

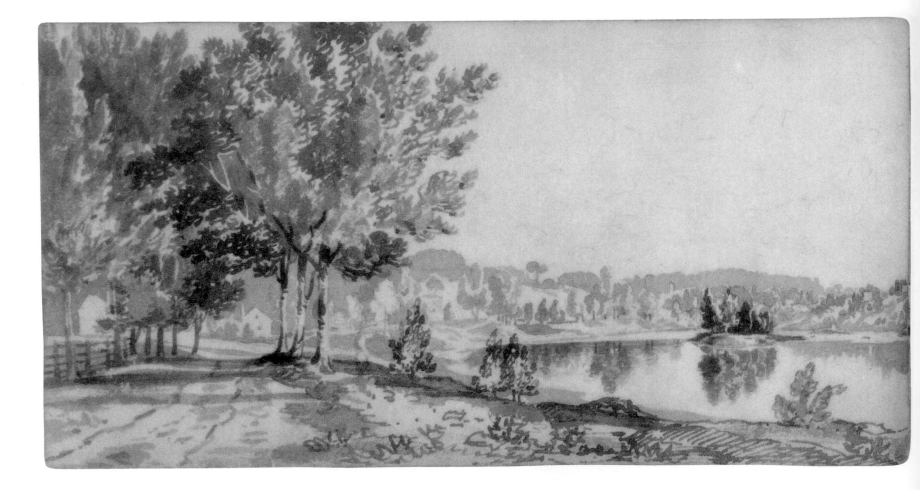

ice lifted the bridge at the falls of the Schuylkill off its piers and carried it miles downriver, decimating the island. By midcentury, there had been five more floods, each more destructive than the last.

"The River was black with vast quantities of drift wood, wrecks of boats, fragments of bridges, portions of houses & c., and upon the surging billows were borne numbers of hogs and other animals," reported a newspaper after a September 1850 freshet. "A great many barrels of flour floated down. Both sides of the river presented lively sights all the morning; hundreds of men, women and children reaped a harvest by catching wood, flour from the mills of the Schuylkill, and other things that the freshet had yielded as God-sends to them. The Market street and Wire Bridges were crowded with spectators, not a few of whom were well-dressed ladies and gentlemen, looking at the flood and its exciting accompaniments."

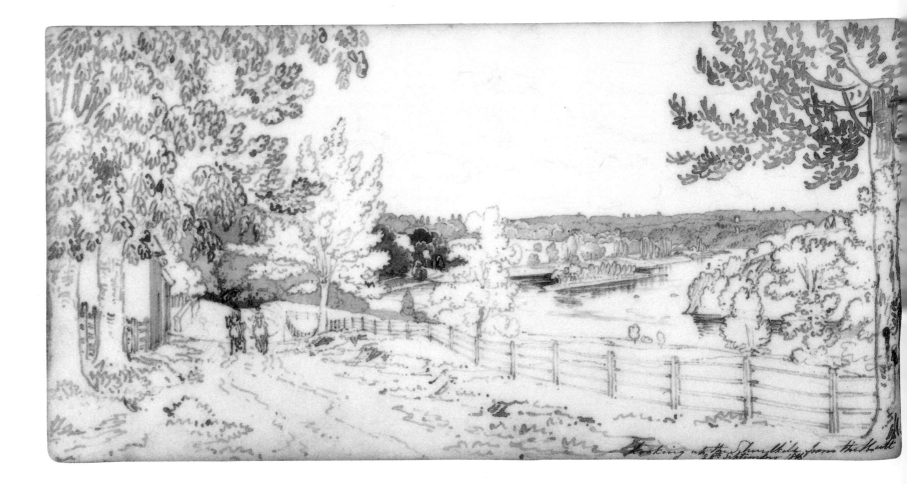

Looking up the Schuylkill from the Mill
September 1846

23. *Looking up the Schuylkill from the Hutt*
24th September 1816

Pen and black wash over graphite (B-103AB)

Leaving town by High Street and then Lancaster Road, one would soon be at the beginning of River Road, now Forty-First Street. On it, one gradually converged with the Schuylkill, passing by Landsdowne, the late William Bingham's estate, and catching sight of the river at Peters Island (plate 22) from an eminence just above Eaglesfield. Before arriving at the road along the river bank (now West River Drive), one more estate, Sweetbriar, would come into view.

During Watson's visit, Landsdowne was being leased to Joseph Bonaparte, Napoleon's exiled brother. It had been built by Governor John Penn in 1777 and was anything but an understated country house. During their rental of Landsdowne and after their purchase of it in 1795, the Binghams entertained lavishly both there and in their mansion at Third and Spruce Streets. When daughter Ann Louisa married Alexander Baring, Bingham built a house for them on River Road. He named it The Hut. A second daughter, Maria Matilda, eloped with a French adventurer who called himself Alexander, Count of Tilly. Bingham's fury—and his influence—was enough to produce an act of the Pennsylvania legislature divorcing the Frenchman and his estranged daughter.

Landsdowne was destroyed on 4 July 1854, when stray fireworks lodged in its cornice. The mansion burned while the Western Hose Company, drawn by a tired team borrowed from a nearby furniture shop, made its way from downtown. Landsdowne's charred ruins stood for another twenty years before they were replaced with the Centennial Exhibition's Moorish-style glass and iron Horticultural Hall. The Hut had deteriorated beside a deeply rutted River Road; it, too, became a casualty to the exhibition celebrating industrial progress.

24. Looking towards Bellmont from Eaglesfield 16 June [1816]
Watercolor over graphite (NY-131AB; color plate 6)

With his back to the entrance of Eaglesfield, (see plate 16) Watson looked upstream at the sprawling Schuylkill Valley to the northwest. Beyond Edgeley Point, now known as the Columbia Avenue curve, he saw "the innumerable spots for building villas which might be laid out to great advantage" (Diary, 18 July 1816). Many of the best sites were already taken. On the eastern bluff, visible through the trees at the right, sat the grand, Georgian Mount Pleasant, known then as Point Pleasant. Along the gentle western slopes was William Bingham's Landsdowne, Samuel Breck's Sweetbriar, visible at the far left, and Judge Richard Peters' Belmont, set back from the river in the distant center. Much entranced by this view (see also fig. 1), Watson sketched it from the river bank below (plate 22) and from the heights of River Road (plate 23), a bit upstream to his left.

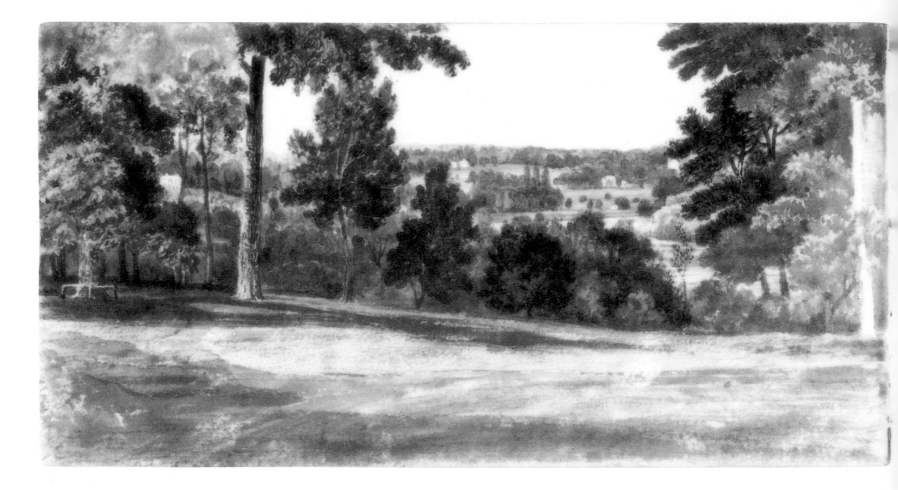

As Watson painted this view toward Belmont, its owner was visiting Eaglesfield. Judge Richard Peters was probably at the artist's elbow, recalling stories of the valley in which he was born and raised. The "wonderful old gentleman," as Watson referred to Judge Peters in his diary that day, charmed the company with "wit and bon mots through dinner." Having put everyone at ease, Peters gave the conversation a more serious turn and condemned the United States government for its recent war with Britain.

Peters' opinions were well taken, even sought after. He had been secretary of the Board of War during the Revolution and a confidant of General Washington. In peace, he held elective offices in Congress and the Pennsylvania Assembly and Senate and served on the Federal bench until his death in 1828. At Belmont, the energetic Peters became an advocate of progressive farming; his *Discourse on Agriculture* was fresh off the presses.

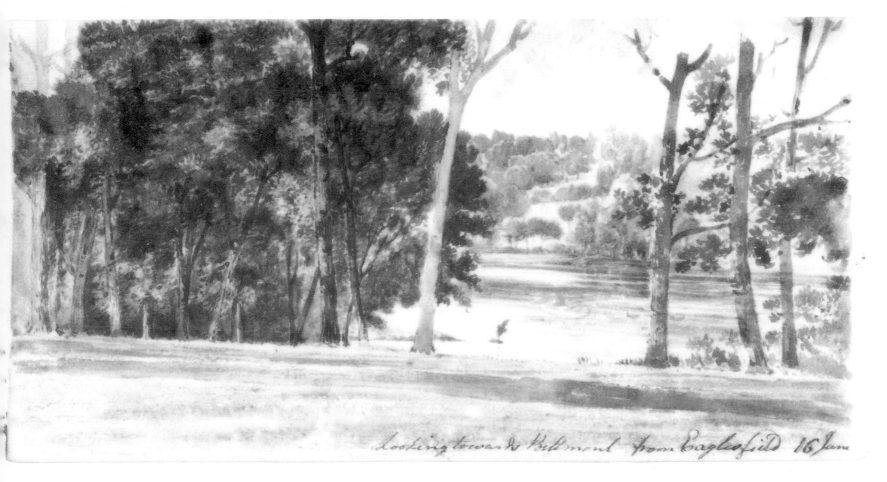

looking towards Belmont from Eaglesfield 16 June

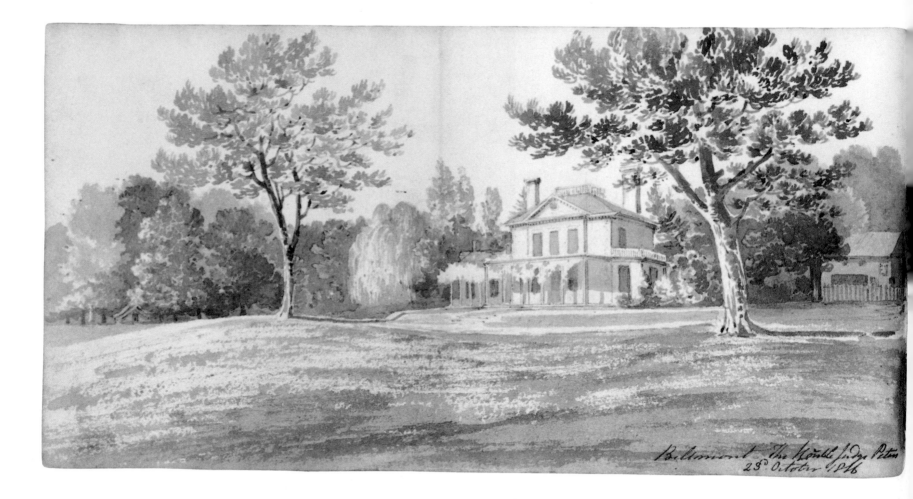

Bellemont The Hon:ble Judge Peters
23 October 1816

25. Bellmont The Honble Judge Peters 23rd. October 1816
Black wash over graphite (B-82A)

William and Richard Peters, father and son, took opposite sides during the Revolution. The elder Peters returned to England, leaving the elaborate estate behind. It was not long before George Washington and Richard Peters became friends and Belmont became the object of Washington's country rides. Years later, on what turned out to be their last walk together, "the Judge handed the General a large chestnut (a Spanish nut). Washington suggested planting it; thereupon the Judge, who carried a cane (Washington never carried a cane), made a hole with it in the ground, Washington dropped the nut, the Judge earthed it over. . . . It grew to be a large tree." During Watson's first visit to Belmont the previous June (17th), Peters told Watson the story of his collaboration with Washington in front of the maturing tree, perhaps one of the two seen here. Peters also promised Watson nuts and a sapling from it.

Hannah Callender wrote of Belmont's ornate interior after her visit in 1762, but the views from the house impressed her more.

From the front hall you have a prospect bounded by the Jerseys like a blue ridge. A broad walk of English cherry trees leads down to the river. . . . From the windows a vista is terminated by an obelisk. On the right you enter a labyrinth of hedge of low cedar and spruce. In the middle stands a statue of Apollo. In the garden are statues of Diana, Fame and Mercury with urns. We left the garden for a wood cut into vistas. In the midst is a Chinese temple for a summer house. One avenue gives a fine prospect of the City. With a spy glass you discern the houses and the hospital distinctly. Another avenue looks to the obelisk.

Such a view of the city from Belmont appeared in Birch's *Country Seats* in 1808, and Watson had sketched a similar prospect on 1 July 1816 (fig. 53). As Philadelphia's skyline rose, the view became even more popular.

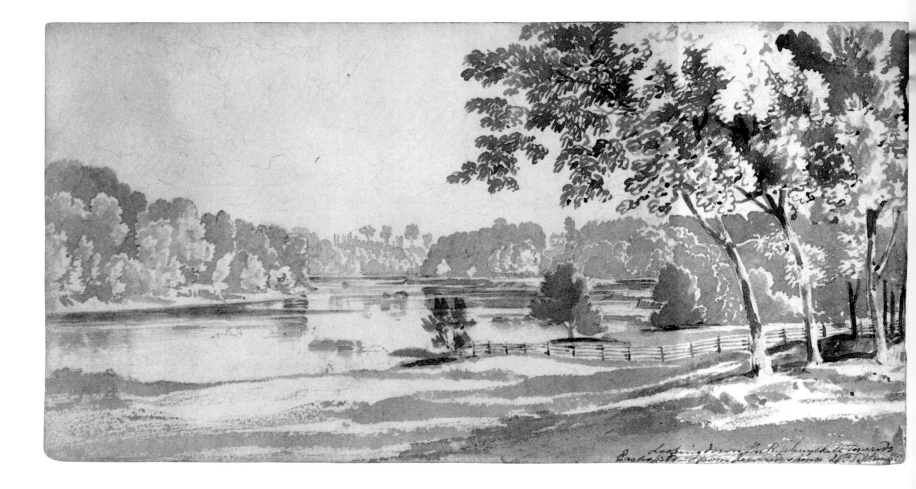

Looking down the R. Schuylkill towards East to [...] from [...] river shore [...]

26. *Looking down the R. Schuylkill towards Eaglesfield—from Kennedys House 24th. Septembr. [1816]*

Black wash over graphite (B-102AB)

Descending Belmont plateau to a point on the west bank near Peters Island, Watson looked downstream to Eaglesfield along the same sightline employed in plate 22. "Kennedy's house" (probably not the small building seen here at the road's edge) may have been the home of the entrepreneur Robert Kenedy, one of several developers of the falls, upriver of this site. He was living at the Falls Hotel in 1807 when the Pennsylvania legislature vested in him the rights of water power at the falls. The only condition was that Kenedy also build locks for the passage of boats. No other speculator had been willing to risk an investment, knowing that ice "would come down in immense large fields, with great momentum" possibly destroying all in its path.

With Conrad Carpenter of Germantown, Kenedy built a bridge at the falls in 1808, which survived ice but succumbed to the weight of cattle two years later. The third bridge fell under the weight of snow six months before Watson's visit. By then, much of the labor for manufacturer Josiah White's factory lived on the opposite bank of the Schuylkill. To bring them over, White installed a foot bridge, eighteen-inches wide, from the windows of his wire mill on the eastern side to a large tree on the western side. It swayed gently, fifty feet above the rapids, as workmen crossed its 407-foot span (see fig. 30 and Diary, 15 June 1816).

White and his partner, Erskine Hazard, had a grandiose industrial vision for the falls of the Schuylkill. They opened a lumber mill and a white lead plant across from their wire factory. They promoted anthracite coal and canal transportation on the Schuylkill and Lehigh Rivers. Hazard even lobbied that Philadelphia build its waterworks at the falls rather than at Fairmount (see plates 28 and 29).

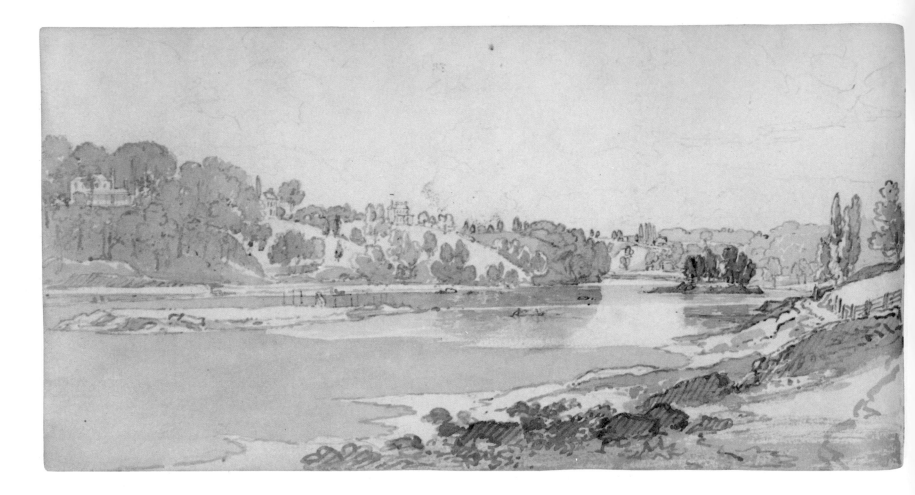

27. Banks of Schuylkill looking down the River near the Ford below the Falls—4.th April 1817; [steamboat] Memo The Indian name of the River Schuylkill was the Manaiunk—

Pen and black and brown wash, pen and black ink over graphite (B-74AB; color plate 11)

Looking back at Peters Island from Mendenhall's Inn, Watson could see the mansions of Ormiston, Laurel Hill, and, nearest at left, Somertown, where Judge William Lewis lived during Watson's time. After his death in 1819, it was occupied by the Hemphill family, whose son Coleman raised cows and cultivated strawberries imported from Chile. The steward of the Philadelphia Club bought the house in 1846 and opened a restaurant there in which he served fresh-grown strawberries and home-churned cream. Some of his clientele arrived over land. Others were brought up the river by steamboat to Strawberry landing, which eventually provided a new name for Somertown: Strawberry Mansion.

Memo The Indian name of the River Schuylkill was the Manaiunk —

Banks of Schuylkill looking down the River near the Ford below the Falls — 4th April 1847

In the middle of the nineteenth century, weather permitting, the steamboats *Mount Vernon*, *Washington*, and *Frederic Graff* left hourly from Fairmount for the Falls of the Schuylkill. The first stop was the Belmont landing, close to the site shown in plate 26. Mill commuters and weekend sightseers would commute to work, visit the cemetery at Laurel Hill, or the Fountain Park Hotel. As William I. Cline's *Frederic Graff* plied toward the picturesque Wissahickon, his black and tan terrier entertained tourists by fetching quarters from a barrel of water.

Some Philadelphians had grown accustomed to river travel, but during the Civil War, they were forced to make their way on land. The federal government had moved the Schuylkill steamboats to the Potomac for troop transportation. When the boats were returned after the war, much of the Schuylkill Valley was claimed as parkland, and steamboats operated almost exclusively for weekend sightseers.

28. Looking up the Schuylkill to the Mills at the Falls from the Fishermans Hut Alphington[?] 24th. Septembr. 1816

Black and brown wash over graphite (B-101AB)

In his memoirs of 1869, Charles V. Hagner recalled that the rocks in the river "extended from the foot of the hill to about two-thirds the distance across the river, forming a complete natural dam." Depending upon the water flow and wind direction, the sound of the rapids could be heard as far as five miles away. Since 1821 and the rise of water behind the Fairmount dam, all but a few of the rocks were submerged and the Falls became a relatively silent place.

In the eighteenth century, a species of catfish whose numbers darkened the river each May were caught in legendary quantities. Godfrey Schronk claimed that he had netted 3000 catfish in one night and hooked as many

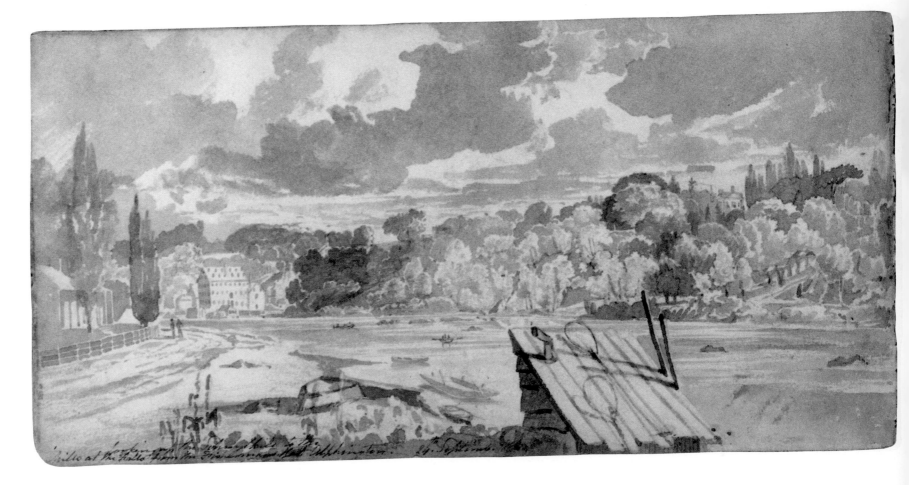

as 80 pounds in a morning. Schronk would fry no less than forty dozen at a time for the members of the Fishing Company of St. Davids, a group akin to the Colony in Schuylkill downstream at Eaglesfield.

According to Hagner, Schronk's legendary catfish haul was nothing special. He remembered dip nets so full of catfish that several men could not lift them into their boats. By the 1860s, that species of catfish was nearly depleted, and the inns along the Schuylkill drained their pools in which the trapped fish were kept alive. Still, the Falls Tavern continued to serve catfish and coffee, waffles, and ice cream to a nostalgic clientele.

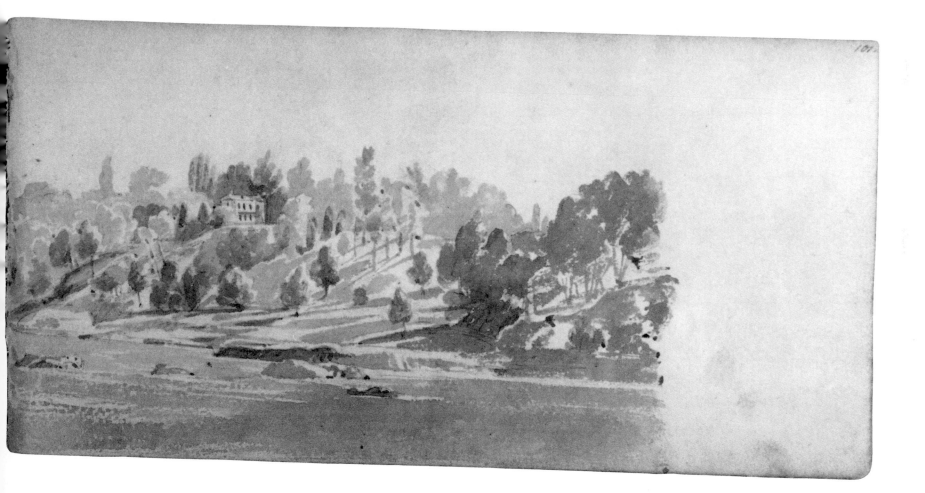

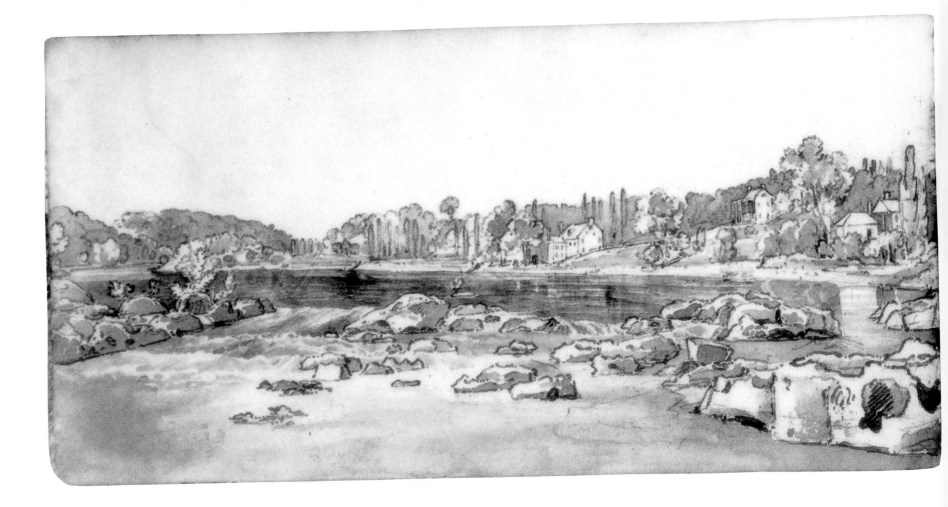

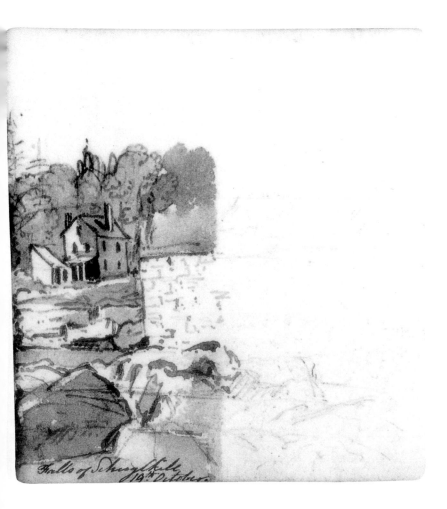

Falls of Schuylkill
19th October

29. Falls of Schuylkill 19th. October. [1816]
Pen and black wash over graphite (B-100AB)

Until Josiah White and Joseph Gillingham finally built a canal in 1815, the narrow Reading boats shot the Falls when the water was high. "It was an exciting and beautiful sight to see these boats descending the Falls, which they did with great rapidity. Sometimes, they would be almost lost to sight, and the next instant mounted high on the waves; in some instances they were wrecked."

Watson visited the Falls soon after the canal along the west side had been completed and prosperity seemed a certainty. He invited his neighbor, Samuel Breck, at Sweetbriar to join him on the excursion, and, according to Breck's diary, the two men "drew the fine scenery around [the falls], and visited the wire works, nail factory, crossed the wire bridge and viewed the great canal & lockwork now going on." Watson sketched the modest townscape from a rock just above the White and Hazard Mills or perhaps from a less comfortable perch on their new wire bridge (see text, plate 26). From right to left is the saw mill at the mouth of Falls Creek, Watkin's Falls Hotel, the Mifflin mansion (birthplace of Governor Thomas Mifflin) on the hill, and the Fountain Park Inn.

Between 1808 and 1813 the Falls had an innovative school run by Joseph Neef, a student of Johann Heinrich Pestalozzi. Neef made a call for youngsters soon after his arrival from Paris. "Well, then, father or mother, have you got any little hobble-de-hoy, gay, full of tricks and quibbles, very mettlesome, inquisitive, sprightly, smart, gay, bustling, teasing, little fellow, every moment putting your patience to the test; this is just what I want." Neef wanted as many as forty boys between the ages of six and eight. "If they are totally ignorant, so much the better! for they will be obliged to forget it, in order to learn it again in my own way." Neef's students were permitted to wander from their octagonal schoolhouse the distance the sound their teacher's powerful two-fingered whistle would travel, about half a mile.

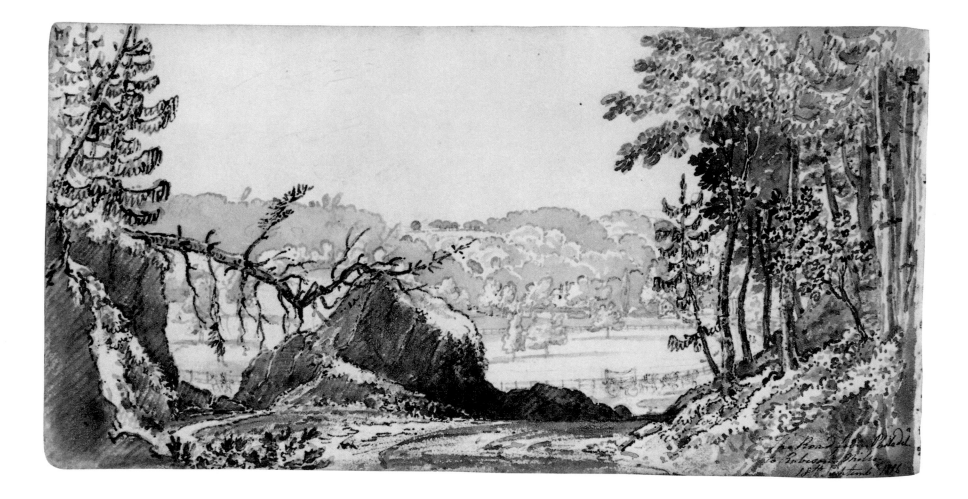

30. The Road from Philadela. to Robisons Mills
18th Septembr. 1816
Pen and black wash over graphite (B-99A)

"You are now on the Ridge Road," reads James Mease's tour up the Schuyl-kill in 1811, "and may either return by it to the city, go up to Germantown, or proceed upward, passing Robeson's flour mills on the Wissahickon creek near its confluence with the Schuylkill. . . ."

The Duke de la Rochefoucauld Liencourt had made his way up the Schuylkill River from Philadelphia on horseback about twenty years before Watson's visit. "This road, like all the roads in Pennsylvania, is very bad, for provision is brought to that city from all parts in large and heavily laden wagons. The constant passing of these wagons destroys the roads, especially near the town, where several of them meet. Ridge Road is almost impassable." Although straightened in 1799, and again five years later, transportation by Conestoga wagon and team on Ridge Road remained difficult and, for Watson, picturesque.

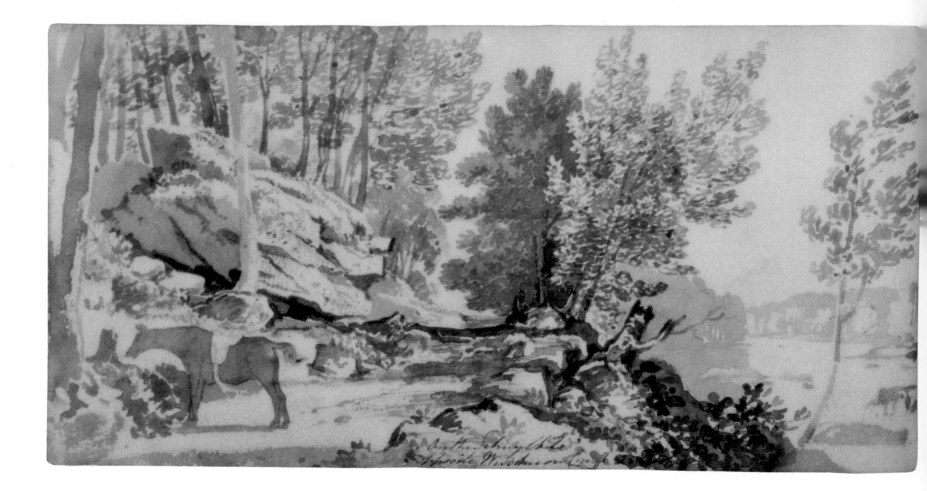

*31. On the Schuylkill opposite Wissihicon Creek 25th Octobr.
[1816]; Looking up Wissihicon Creek 25.th October [1816]*
Black wash and watercolor over graphite (B-81AB; color plate 12)

Mease tempted his readers to make the trip up the Wissahickon: "The scenery up this creek is very romantic, the creek passes in a serpentine course along majestic hills, from the sides of which rocks in rude disorder, impend over the stream."

The name Wisaucksickan, as the Indian name sometimes appeared, meant "yellow-colored stream." Surveyor Thomas Holme changed it to Whitpane's Creek in his map of 1687, naming it after a new landholder, but

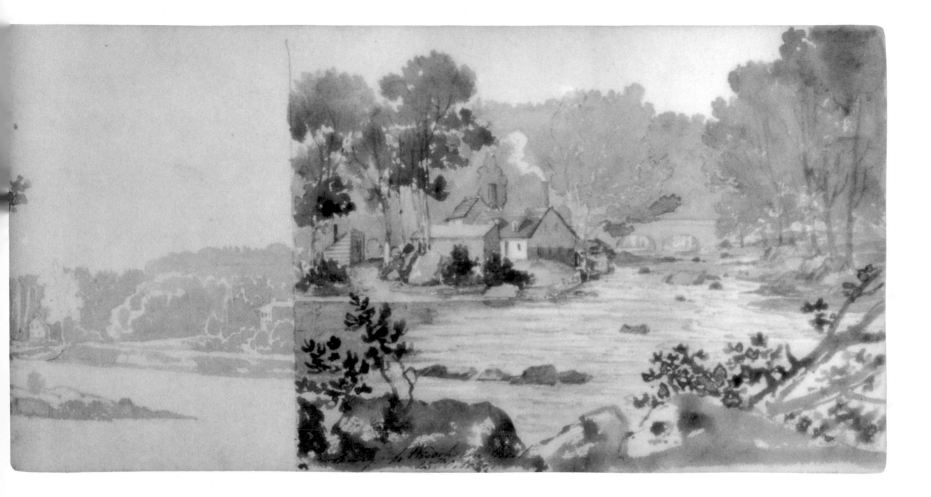

a version of the Indian name was soon restored. It was written as Wisahiccon or Wisamickan, meaning "catfish creek," before the spelling was finally set.

However romantic in name and in scenery, the Wissahickon was seen from the beginning for its practical possibilities. Mathew Holgate had a fulling mill in 1698, about the time William Rittenhouse's paper mill started up. William Dewee's and Daniel Howell's started in 1710. Thomas Shoemaker's or Livezey's "Great Mill" was considered the largest in the colonies in 1745. Nearly twenty-five mills greeted Watson, and by the middle of the nineteenth century there were about twice that number, nearly one at every turn of the creek.

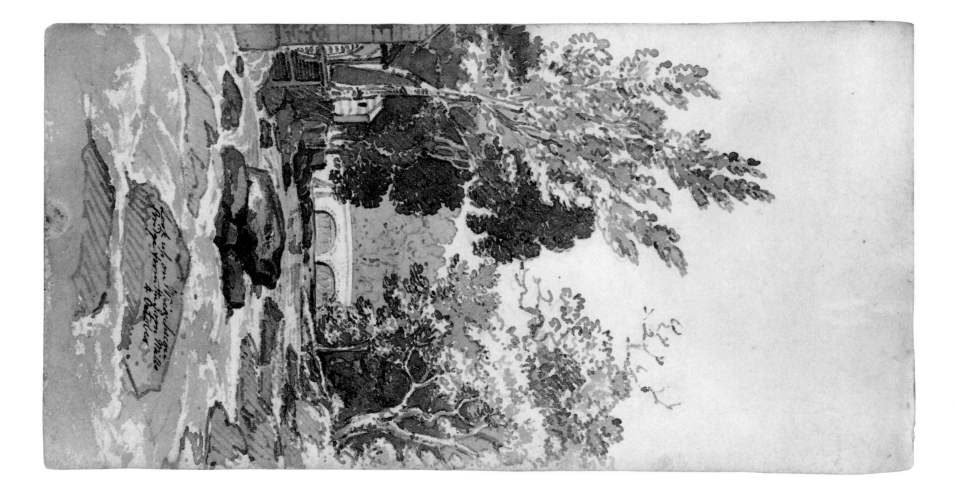

32. Look[ing] up on Whissihicon Bridge from the Iron Mills
4 October [1816]
Pen and black wash over graphite (B-93A)

America's first locomotive, built by Matthias W. Baldwin, pulled cars that looked like stagecoaches from Philadelphia to Germantown beginning in November 1832. Two years later, the Philadelphia, Germantown & Norristown Railway was extended to Manayunk via wooden trestle, seventy-five feet high and three hundred feet across, spanning the Wissahickon Valley above the old Robeson Mill.

What was done in the first half of the nineteenth century was undone in the second half. Both trestle and mill below were destroyed by fire in 1863. And within a decade, the Wissahickon Valley was transformed by an act of the state legislature. To continue to protect the purity of the Schuylkill River water, the Fairmount Park Commission was authorized to buy up the banks of the creek. A stretch of six and a half miles, varying in width from 350 to 2000 feet, was soon protected. The mills were systematically demolished, and picknickers replaced millworkers.

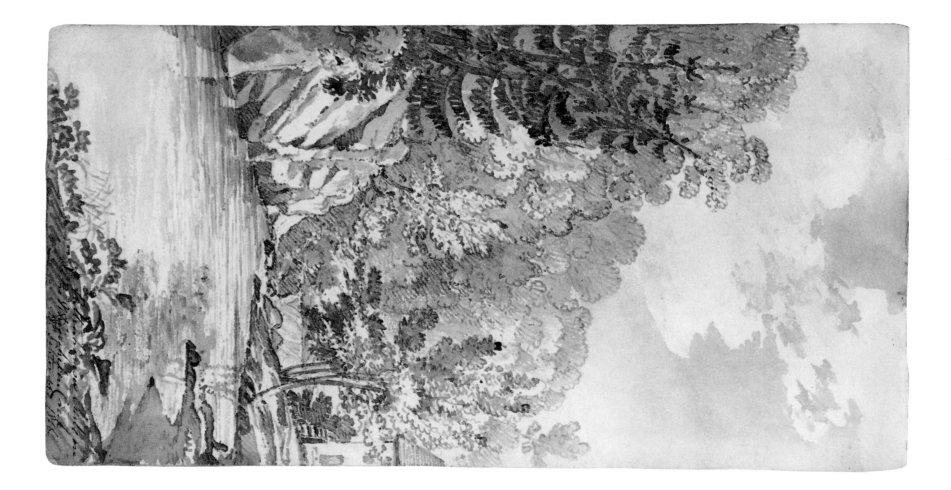

33. Rittenhouses Mill on the Whissihiken Creek
18th September 1816.
Pen and blue and brown wash over graphite (B-95A)

John Holmes's quaint poem of 1696 "True Relation of the Flourishing State of Pennsylvania" mentions the presence of a paper maker along the Wissahickon:

> Here dwelt a printer and I find
> That he can both print books and bind,
> He wants not paper, ink nor skill
> He's owner of a paper mill
> The paper mill is here hard by
> And makes good paper frequently
> . . .
> Kind Friend, when thy old shift is rent
> Let it to th' paper mill be sent.

Perhaps Holmes neglected to include the name of the paper maker because it was still evolving into its final anglicized form. William Rittenhouse was also known as Willhem Ruddinghuysen, Rittinghausen, or Rittenhausen. He was a Mennonite minister from Rhenish Prussia, who moved to Arnheim in the Netherlands and then to Philadelphia in 1688. There he joined a group of thirteen Dutch-Germans, mostly weavers, who were led by a brilliant young lawyer, Daniel Francis Pastorius, to Germantown.

Samuel Carpenter leased twenty acres at the Wissahickon and Paper Mill Run to Rittenhouse and three partners for 999 years. One partner was William Bradford, whose Philadelphia press consumed all the paper produced at the mill. The above poem was issued on Rittenhouse paper, as was the *American Weekly Mercury*, Philadelphia's first newspaper. By the date of the first issue, 22 December 1719, Andrew Bradford, William's son, was the printer and Nicholas (or Claus) Rittenhouse milled the paper.

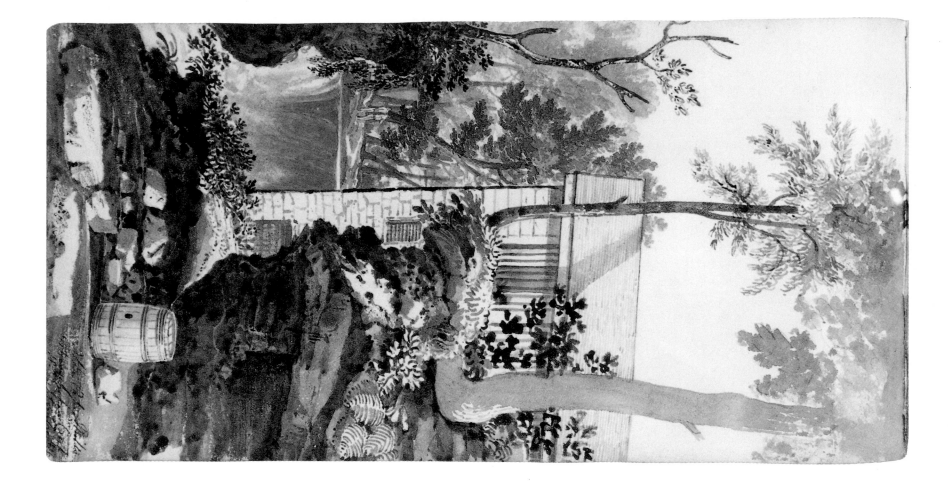

34. At the Paper Mills Whissihikon Creek 18th September 1816
Pen and blue and brown wash over graphite (B-96A)

The most distinguished member of the Rittenhouse family was William's great-grandson David, born at the house along the creek in 1732. He was a mathematical prodigy who was an instrument maker at nineteen and later succeeded Benjamin Franklin as president of the American Philosophical Society. David Rittenhouse's orrery was his masterpiece; it predicted celestial events for five thousand years, backward or forward.

The Wissahickon Valley spawned a mystical tradition both equal and opposed to the pragmatic and rational Rittenhouse legacy. Transylvanian Johann Kelpius intended to study law, but he studied theology instead and became a follower of Johann Jacob Zimmerman. The group of Pietists, as they called themselves, believed that the savior would return in the autumn of 1694 in the form of a woman. She would appear, they were certain, in the woods of Pennsylvania. Zimmerman died, and Kelpius led his group to the Wissahickon, where he lived in a cave on the bluffs of the creek and prepared himself by study and alchemical experiments. The savior did not make herself apparent to the group, and Kelpius continued his preparations until his death in 1708.

The romantic appeal of the Wissahickon grew, particularly after the commercial elements fell into picturesque ruins or gave way to parkland. Edgar Allan Poe, Fanny Kemble, and George Lippard wrote of its dells and shaded bowers later in the nineteenth century, and local artists such as Thomas Moran, William Trost Richards, and Thomas Eakins grew up sketching its wooded banks.

*35. On the Schuylkill a mile above Wissihicon creek
25th. October [1816]*
Black and brown wash over graphite (B-87AB)

"Perhaps the most romantic walk, to be found in this country," wrote Eli Bowen in 1839, "is along the banks of the Schuylkill, beside the canal, or on the opposite shore to Manayunk village; and in the verdant season crowds of citizens and strangers do themselves the delight thus, to walk out, to drink the balmy air borne in sweetest fragrance from the golden fields and blushing gardens of the surrounding hills."

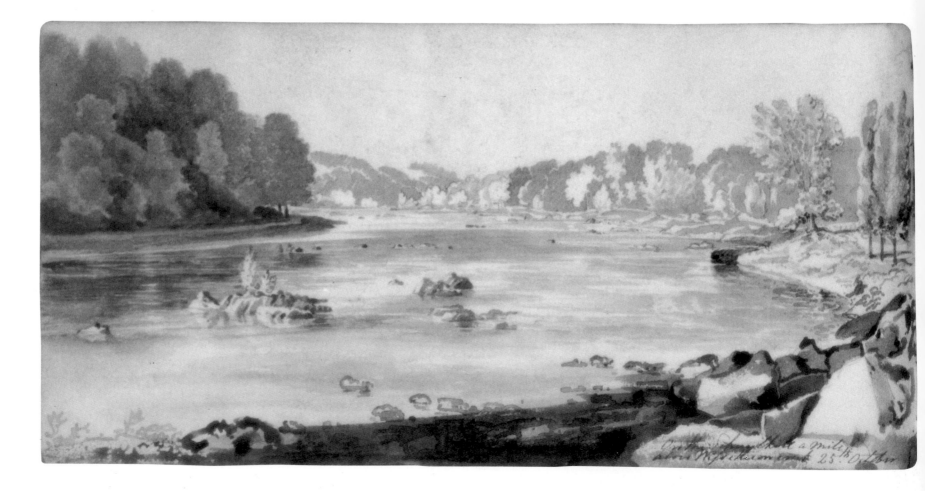

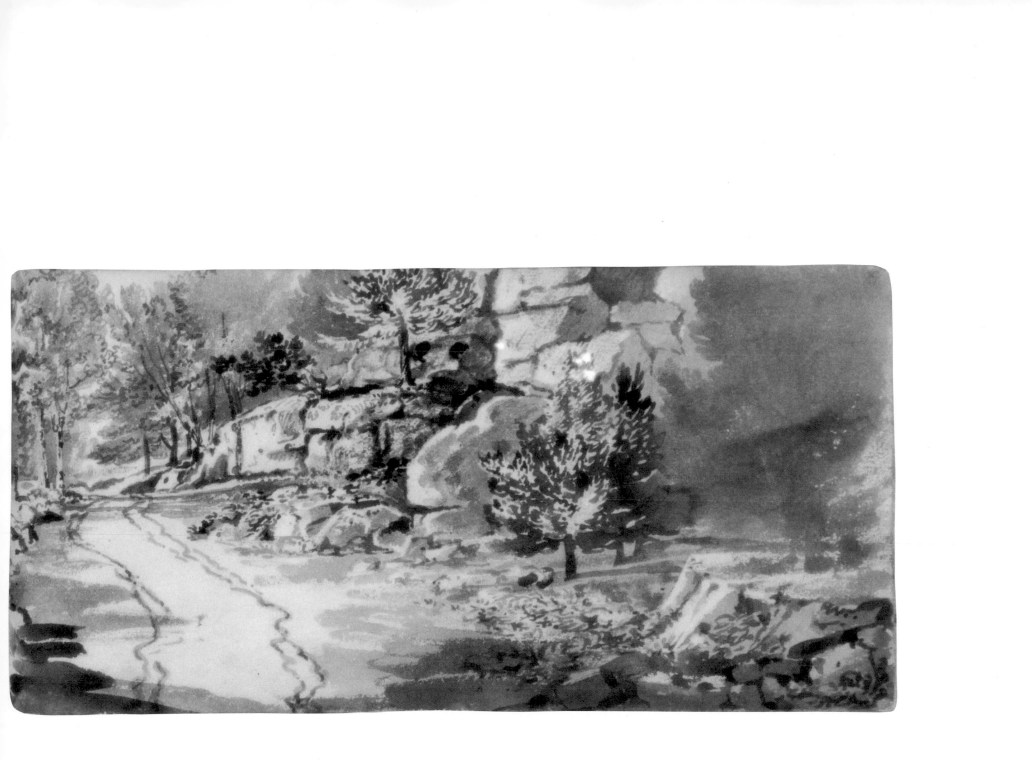

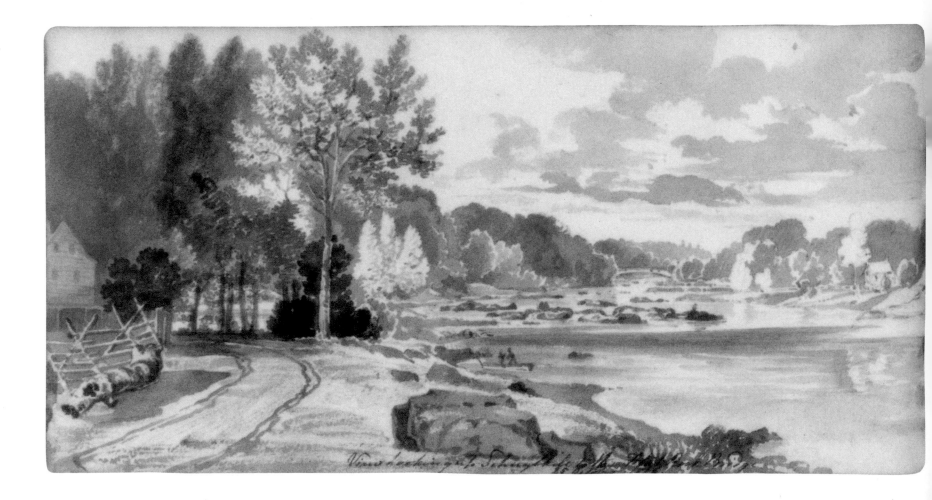

36. View Looking up Schuykill to the Flat Rock Bridge
25 October 1816.

Black wash over graphite (B-80AB)

Manayunk was a village of fewer than a thousand persons in 1816. Watson knew it as Flat Rock, a place of rough-cast houses and mills built of mica schist. Still largely undeveloped in his day, this reach of the river was about to become an industrial center far greater than the falls ever was.

The rocks in the river suggested the original name of Flat Rock. But in 1824, after the Fairmount dam covered many of them, its residents began to campaign for a new name. Udoravia (from *udor*, ancient Greek for "water") was suggested and adopted at a community meeting. A sign with the new name was hung in the center of the village.

The mill owners, who were not present at the meeting, opposed Udoravia. Although the name "Schuylkill" had been derived from the Dutch, the original natives had referred to the river as "the place where we drink" or "Manaiunk." And although this name had persisted in local lore, it had never been attached to a particular place. (Watson himself noted this on his drawings. See plate 27.) The mill owners were almost in complete agreement: Udoravia would be called Manayunk. The only holdout was Captain John Towers. Unrelenting, he had stationery printed bearing the name of his choice: Bridge Water.

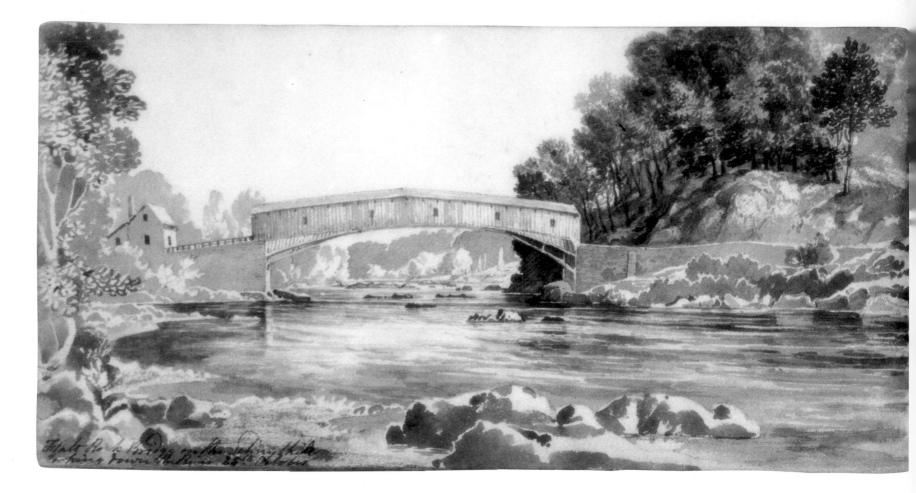

*37. Flat Rock Bridge on the Schuylkill looking down the River
25th October [1816]*
Pen and black wash over graphite (B-88AB)

Flat Rock Bridge, the second permanent bridge in Philadelphia County, spanned the Schuylkill at the foot of what is now Domino Lane. It was opened in 1810 and survived without damage until 1833, when two teams hauling marble attempted to cross simultaneously. Even then, repairs kept Flat Rock Bridge whole until 1850, when the flooded river carried the bridge upstream at Conshohocken off its piers and crashing down to Flat Rock.

If the bridge had been otherwise adequate, Flat Rock dam was not. Late in 1818, Ariel Cooley came from New England to build the dam, canal, and locks. He did so on time, to the surprise of everyone and to the profit of a few, but his engineering was hasty. Eventually, Cooley's works had to be rebuilt.

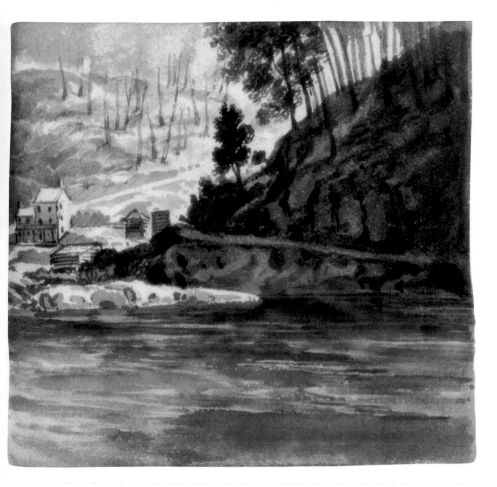

Progress brought all kinds of perils. As at Fairmount, the new dam brought still water and health problems. Flu gripped Flat Rock in 1821 and stayed for several years. No one escaped the "chills and fever" as it became known. Dogs shook as they ambled down Main Street. Businesses closed; the wealthy retreated. The reputation the Schuylkill Valley had gained for salubrious country living since the yellow fever epidemics in the 1790s suffered a serious blow.

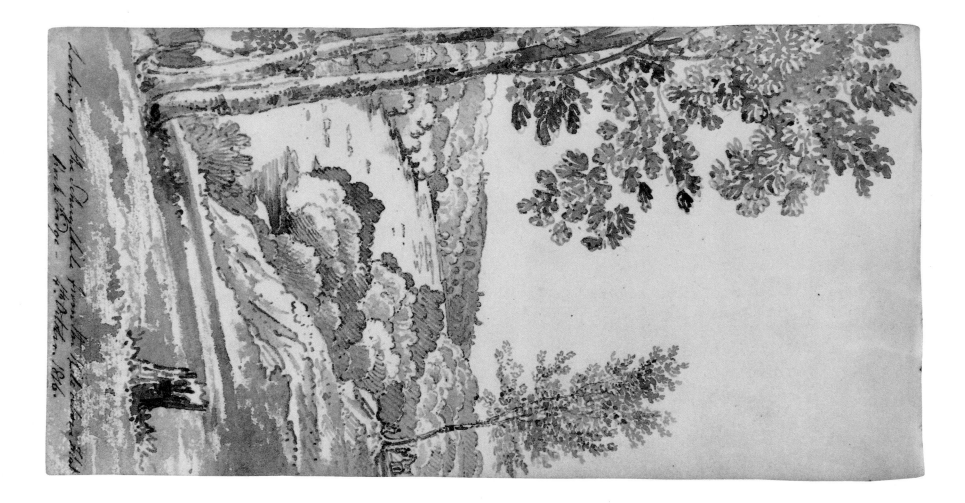

38. Looking up the Schuylkill from the Hill above Flat Rock Bridge — 4th October. 1816.

Pen and black wash over graphite (B-89A)

Mease recommended a visit to the soapstone quarry, a little upstream among the hills to the northwest. Travelers would "likewise be interested by witnessing twelve saws ingeniously contrived to move by water, for cutting large blocks of marble."

The Schuylkill continued up past Conshohocken, Norristown, Pottstown, Reading, through the first ridge of the Alleghenies at Port Clinton, 120 miles into the eastern half of Pennsylvania to the coal regions beyond Pottsville. However, Watson pressed no farther in this direction, choosing to explore points north and south via the Delaware River.

39. The Landing at BordenTown with Point Breeze now belonging to Joseph Buonaparte. U.S. Frig.te Congress at Boston Mr. Sayre, [19 July 1816]
Black wash over graphite (NY-113AB)

After a month in Philadelphia, Watson embarked on an American Grand Tour. With Thomas Fisher Leaming as traveling companion, he left aboard the steamer *Philadelphia*, known as "Old Sal" for the figurehead on its bow. It was an efficient and pleasant trip between the 7 AM departure and the noon arrival at Trenton, New Jersey.

Joseph Bonaparte lived near Bordentown, New Jersey. Here was a spectacle in America: a recently exiled king of Spain, former king of Naples, and would-be king of France. Bonaparte, who resembled Napoleon in no

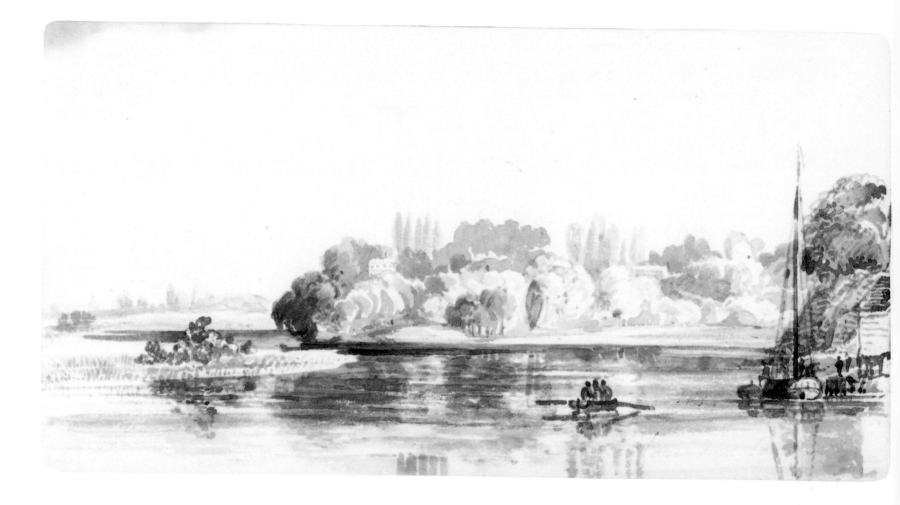

way other than appearance, had come to power by virtue of his brother's ambitious campaigns. Procrastinating with his futile plan to rescue Napoleon from exile on Saint Helena, Joseph adopted the title Compte de Survilliers — derived from his vestigial holdings in Switzerland — and lived elegantly in New York, New Jersey, and Philadelphia. He installed a remarkable art collection in his Bordentown mansion and succeeded, if at nothing else, in making the site a nineteenth-century tourist attraction. The region, wrote an observer, "only wants a castle, a bay, a mountain, a sea, and a volcano, to bear a strong resemblance to the bay of Naples." As Watson's sketch and diary note, "Point Breeze" was purchased from a "Mr. Sayre," formerly Sheriff of London (Diary, 19 July 1816). Bonaparte stayed there for only a few years.

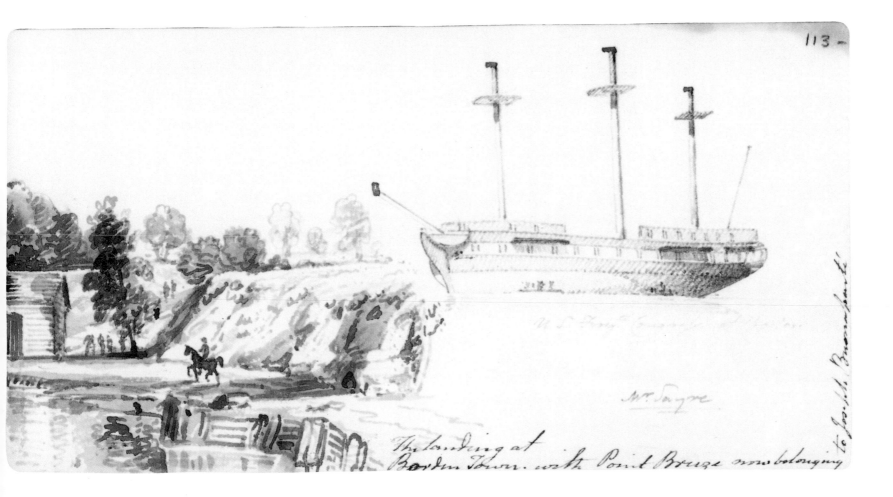

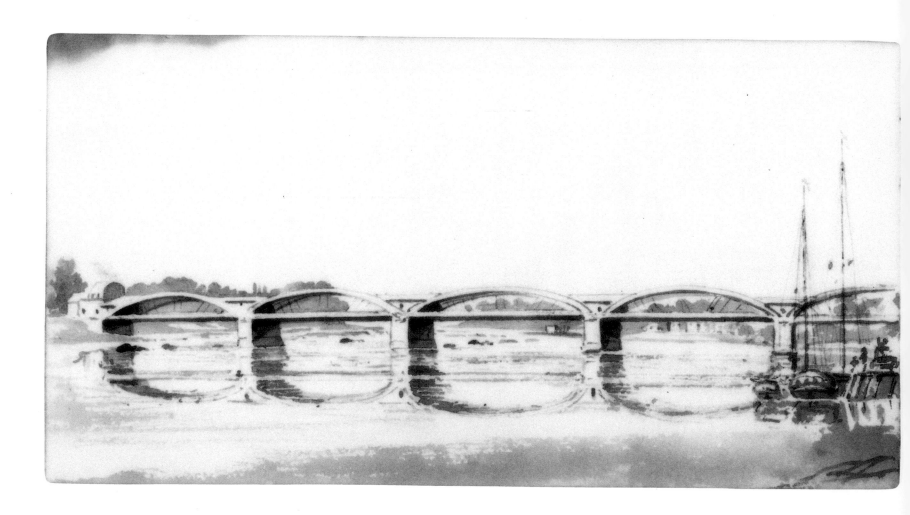

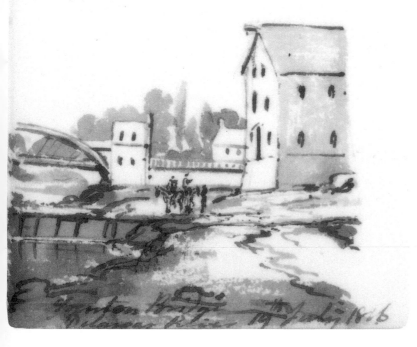

40. *Trenton Bridge Delawar River 19th July 1816*
Black wash over graphite (NY-110AB)

At Trenton, the head of navigation on the Delaware, the leisure of the steamer was exchanged for less comfortable overland transport. As the stagecoaches prepared to traverse "27 miles over bad roads," Watson only had time to sketch the first bridge across the Delaware, completed ten years before by Theodore Burr. He was intrigued by the "peculiar construction" of the bridge, which carried its roadbed on chains suspended from the arches (Diary, 19 June 1816). The Delaware River at Trenton was regarded as a dividing line between northern and southern colonies. The lack of a bridge between New Jersey and Pennsylvania had been, in 1783, the primary argument against locating the nation's capital at Trenton.

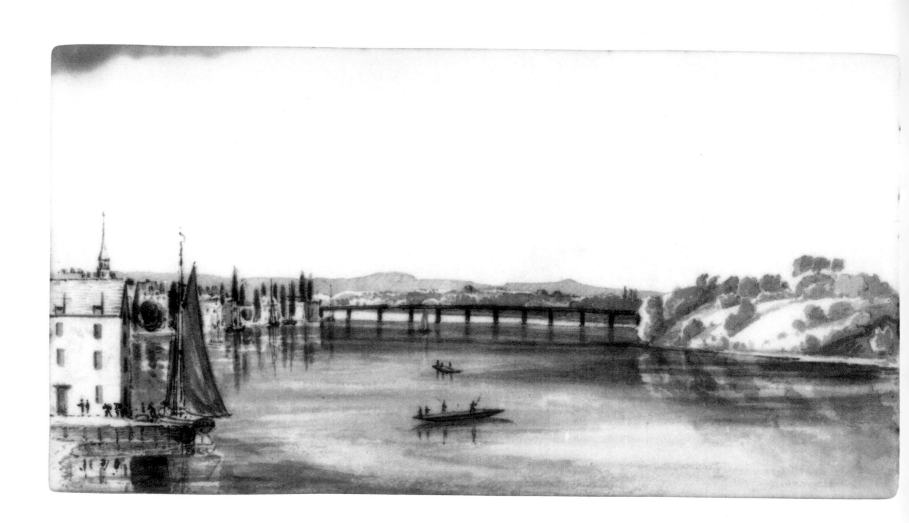

*41. [Two views of] Brunswick 19th July 1816 Kittateny
Mountains*
Black and blue(?) wash over graphite (NY-109AB)

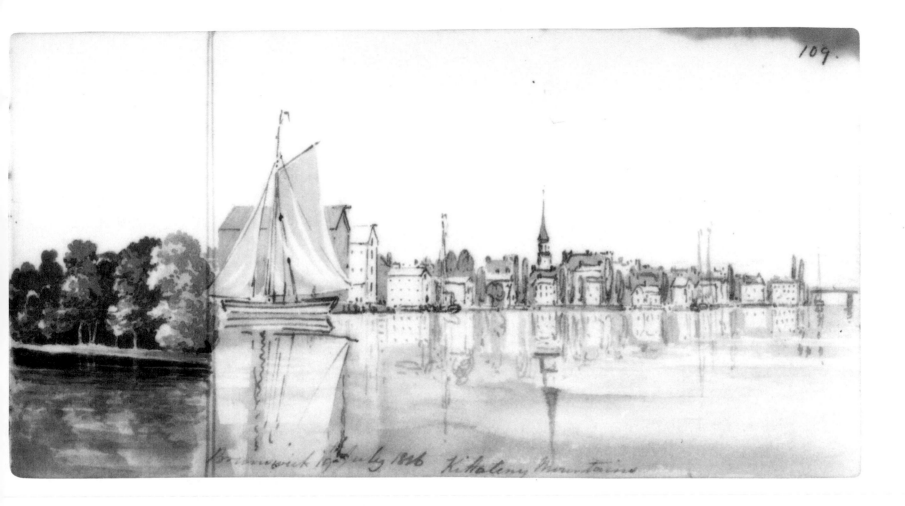

Watson spent his first night out of Philadelphia at a "very tolerable" New Brunswick Inn. From it, he made two sketches of the town "delightfully situated" on the Raritan River with a view of the distant Kittatinny Mountains. As the river "empties itself into the Bay of New York," Watson wrote, "and large Sloops and Schooners come up to it, the inhabitants partake of the lucre of trade. It has a population of 6,312 souls. There is a Wooden bridge over the river and the scenery on the banks on either side [is] interesting" (Diary, 19 July 1816).

New Brunswick was very much on the beaten track of travelers, and its scenery impressed each one. "At New Brunswick," wrote Sir Augustus John Foster a few years before, "there is a fine extensive view of a long level plain, across which the road is carried to the Bay of Amboy, where there is one of the finest harbours on the continent and hills show themselves in the background."

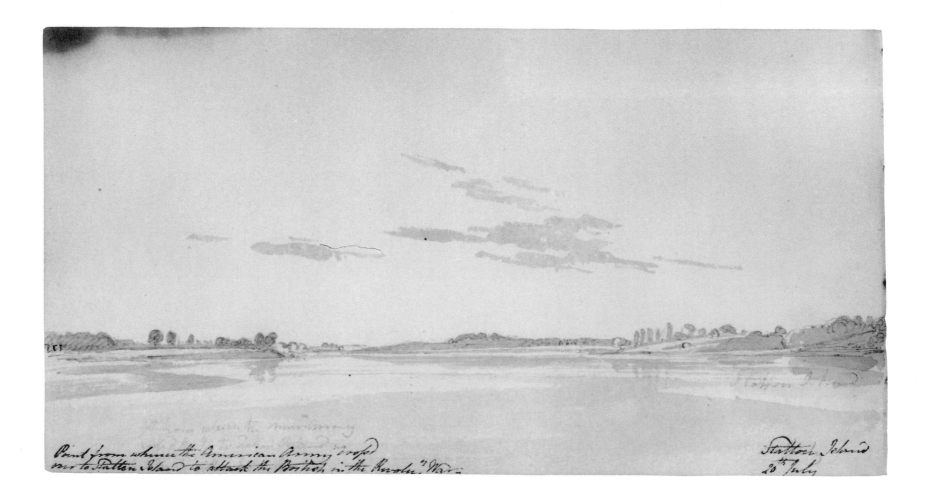

Point from whence the American Army cross'd
over to Statten Island to attack the British in the Revolu.y War

Statten Island
20.th July

*42. Point from whence the American Army crossed over to
Statton Island to attack the British in the Revolu.n War.
Statton Island 20th July [1816]*
Black wash over graphite (NY-103A)

What is now the heart of Jersey City once was "an Island of sand and marsh bounded by the coves of Ahasimus and Communipaw . . . separated from the mainland by salt meadows [which] flooded at every tide." The commanding view of New York Harbor gave strategic importance to Powle's or Paulus Hook, a point of high ground along the shore just north of Ellis Island. Three blockhouses and a chain of breastworks with four cannons were built. When the British arrived in force in 1776, they took charge of the fortifications.

Until the expedition led by Major Henry "Light Horse Harry" Lee of Virginia, the site was thought to be impregnable. On 19 August 1779, between four hundred and five hundred men, mostly Marylanders and Virginians, trekked across Staten Island and north through the Bergen Woods to the British fort. Some of Lee's men were lost in the swamps; others became entangled in the forests; still more deserted. Those who rejoined for the attack had lost their ammunition to water. Nonetheless, the sleeping British were surprised, and Lee's forces took 159 prisoners, earning Lee a congressional medal.

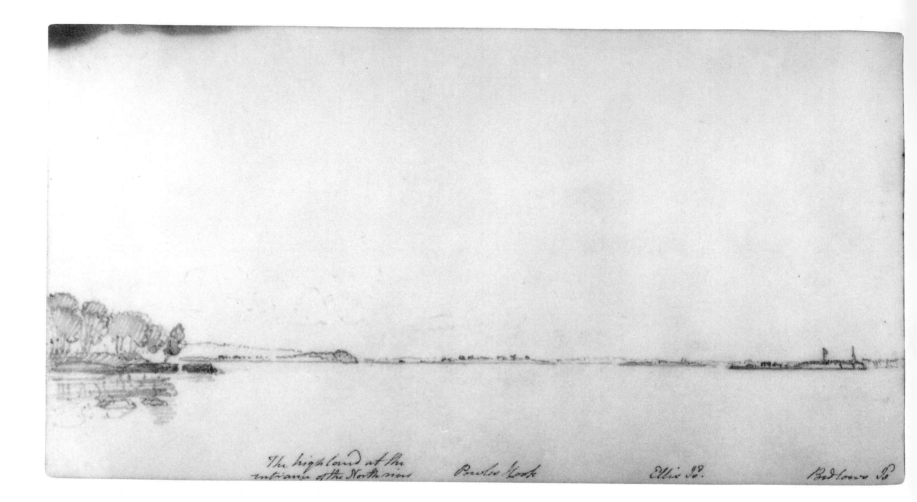

The highland at the
entrance of the North river Powles Hook Ellis Is. Bedlows Is

43. *The highland at the entrance of the North River Powles [?] Hook Ellis Isd. Bedlows Isd. New York from Kill Sound 20th July [1816] Williams Battr & Governors Island. Land of Long Island in the distance.*

Pen and black wash over graphite (NY-101AB)

The trip by steamboat from New Brunswick to New York City by way of Elizabeth Town took seven hours. Watson marveled as the Kill van Kull emptied into the Bay of New York at Bayonne. Of all the harbors he had seen, few were so militarily perfect. He noted the impressive fortifications with a characteristic interest and neatly labeled his sketch (Diary, 20 July 1816). Looking northeast toward Manhattan, his view swept from the shore below Jersey City at left, across Oyster Bay to the Batteries on Governor's Island, with south Brooklyn in the far right distance.

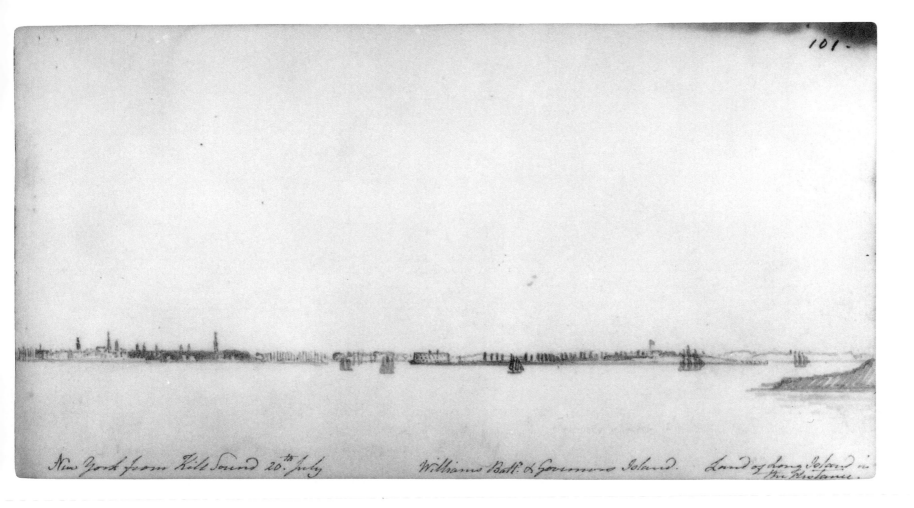

New York from Kill Sound 20th July *Williams Batt: & Governors Island.* *Land of Long Island in the distance.*

"The grand Hudson rolls its waters on one side [of Manhattan], wrote William Cullen Bryant, the swift and deep tides of the East River wash it on the other; both unite at its southern extremity, where they expand into a broad bay; and this bay is practically a land-locked harbor, that, by a narrow gateway, opens into the expanses of the Atlantic."

Commercial rather than military advantages had brought sustained admiration to the harbor of New York. No American port was more productive; it generated about one quarter of the revenue of the United States.

Annual tonnage in 1809 was 243,539 compared with Philadelphia's 121,443, Boston's 133,257, and Baltimore's 102,434. But for this success, a price was being paid in another currency. "In the mass of the mercantile community," observed Adam Hodgson, another British visitor, "there is less mental cultivation than in Boston, and less refinement than in Philadelphia."

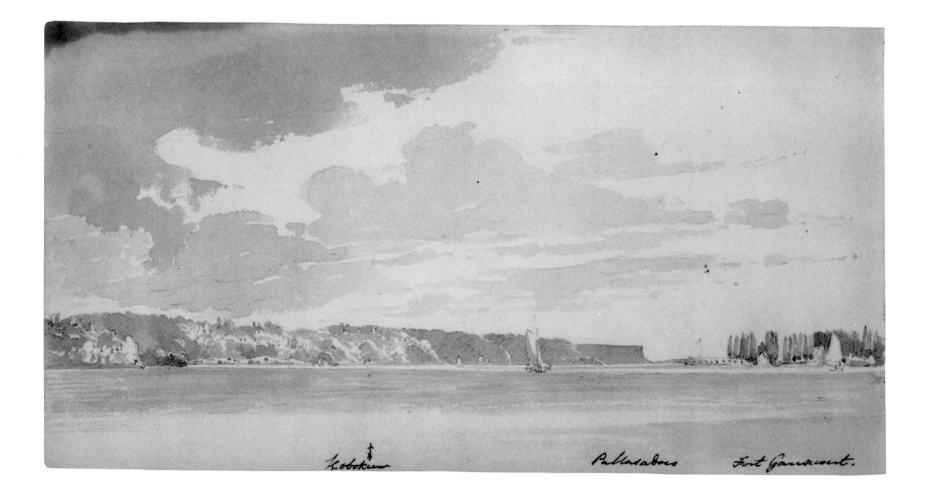

Hoboken Pallasadoes Fort Gansevoort.

44. Hoboken Pallasades Fort Gansewert. [22 July 1816]
Blue and black wash over graphite (NY-93AB)

Watson left New York City at nine o'clock in the morning aboard the steamboat *Firefly*, bound up the Hudson River for Newburgh (see fig. 63). The first advantageous view was of the resort Hoboken, New Jersey, and the basaltic cliffs, the Palisades. "The passage up the North or Hudson River is grand beyond anything I had ever seen before," wrote Watson, "and the varied beauty of its scenery requiring the pen of a Gray or a Eustace to do justice to its description. My humble attempt will fall very far short, and I fear will scarcely give an idea of what it really is" (Diary, 23 July 1816).

As was often the case, Watson balanced his interest in natural wonders with attention to military landmarks. At right appears Fort Gansevoort or the "White Fort," built during the War of 1812 at Twelfth and Gansevoort Streets. Watson's interest in this prospect was piqued by additional historical associations. He would, on his return trip a month later, visit the "romantically interesting spot" of the Hamilton-Burr duel, atop the Palisades at Weehawken (see plate 73).

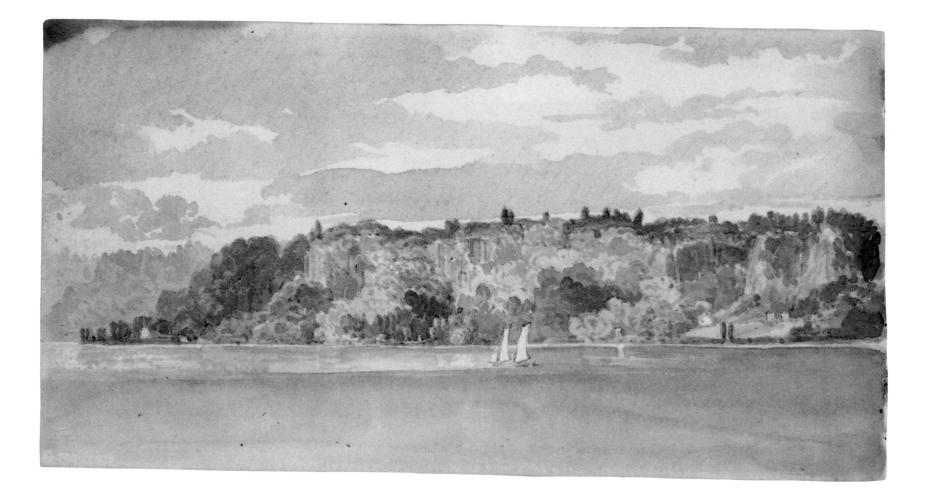

45. [The Palisades, 23 July 1816]
Watercolor over graphite (NY-91A)

Watson noted the contrast between the "York Island side well cultivated and spot[t]ed with Gentlemens villa's," and the Jersey shore opposite, "forming abrupt cliffs in vertical shafts from 250 to 300 ft. high of Basaltic rock; from their base to the water is a steep composed of fragments which have from time to time faln off from the cliffs; and trees with a variety of under wood having formed a soil, adds much to the picturesque beauty of the Palisado's" (Diary, 23 July 1816).

"At its base are many little sheltered nooks," wrote the author of a later guidebook, "with here or there an isolated cottage or patch of cultivation; and here or there may be seen on shore some tiny sloop loading with building-stone from the cliffs above." Deforestation and quarrying, begun in the late eighteenth century, took a toll at the Palisades until the Hudson-Fulton Tricentennial in 1909, when the Palisades Interstate Park was dedicated.

46. Part of the Pallisadoes with the highlands of the Hudson in the distance. 23rd July 1816.

Watercolor over graphite (NY-85AB)

Beyond Yonkers, wrote Paul Wilstach,

the natural aspect of the river presents its first marked change. The Palisades rise in one final lofty reach and then dip, almost abruptly, and disappear in the billowy greenery below Sneden Landing. Opposite, the higher hills lift their summits nearly two miles east from the water. The beauty of the scene is milder as the banks lose their abruptness, the surface of the water widens, and we sail into what appears to be a hill-cinctured lake, but what in that part of the Hudson is known as the Tappan Sea.

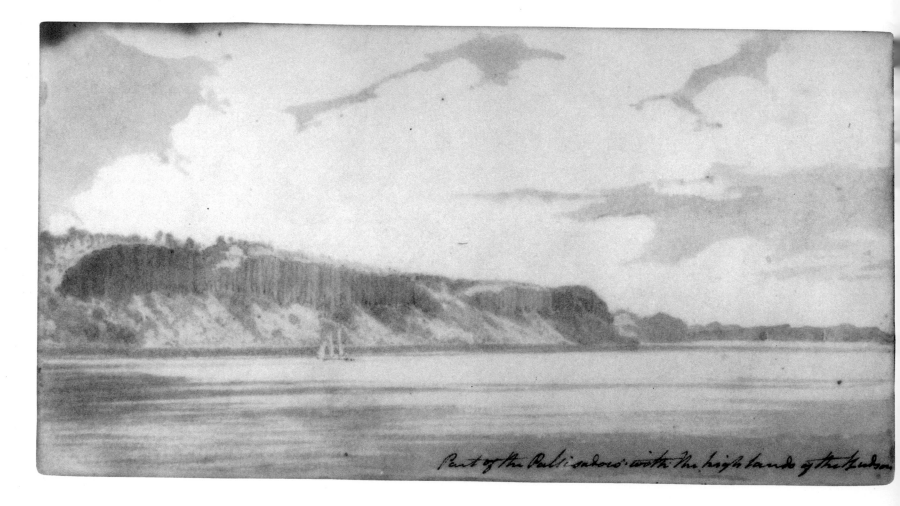

Beyond the Palisades, the first village on the west bank (left) is Nyack, currently linked to Tarrytown, on the opposite shore, by the Tappan Zee Bridge. In the distance appears Hook Mountain, the highlands, and Teller's Point. Watson turned his back on this view to paint the prospect down the Hudson from this same point (see fig. 64).

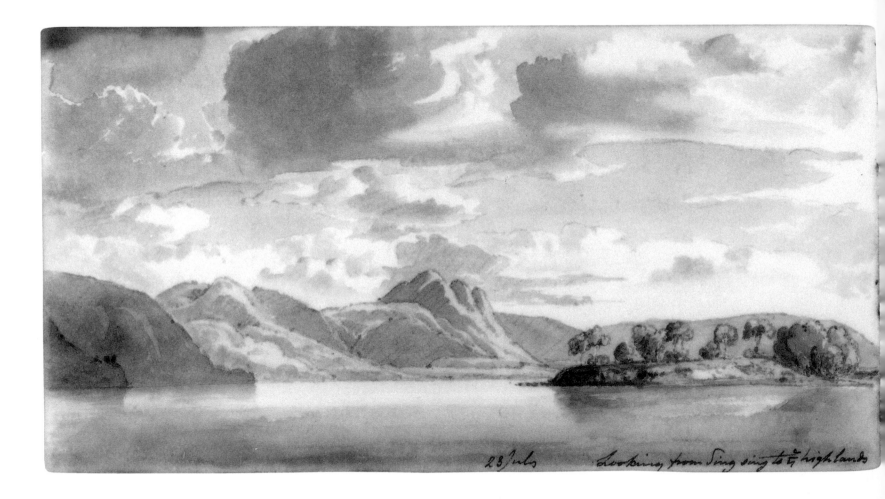

23 July Looking from Sing sing to ye highlands

47. Looking from Sing sing to the highlands 23rd July [1816]
Watercolor over graphite (NY-82AB)

Less than five miles above Tarrytown, about thirty-three miles north of New York City, "the riverside green has been shaved away and the shore is stark as sterile rock. In this bleak patch rises a heterogeneous of bold, angular, garish, high-walled, fortresslike buildings, which are the prison known as Sing Sing." The name was derived from the Indian name *ossining*, meaning "place of rock." Watson looked between the foot of Hook Mountain, at the left, and the wooded Croton Point, at right, to Haverstraw Bay, with Dunderberg in the distance.

Like many British tourists passing Sing Sing, Watson sadly noted that the "much lamented and unfortunate" Major André was taken captive by American troops here. And the spot farther up the river, where André met with the traitorous General Benedict Arnold, was likewise brought to his attention, and recorded (Diary, 23 July 1816).

48. The reach, calld The Horse race 23 July [1816] Antonies Nose 935 ft. in height.

Black wash over graphite (NY-78AB)

Upstream from Haverstraw Bay, the Hudson turns east and narrows. "At Verplanks Point (directly opposite to which is Stoney Pt. and on which there was formerly a strong Redoubt) the rocks all at once change from the Granit to Limestone," wrote Watson.

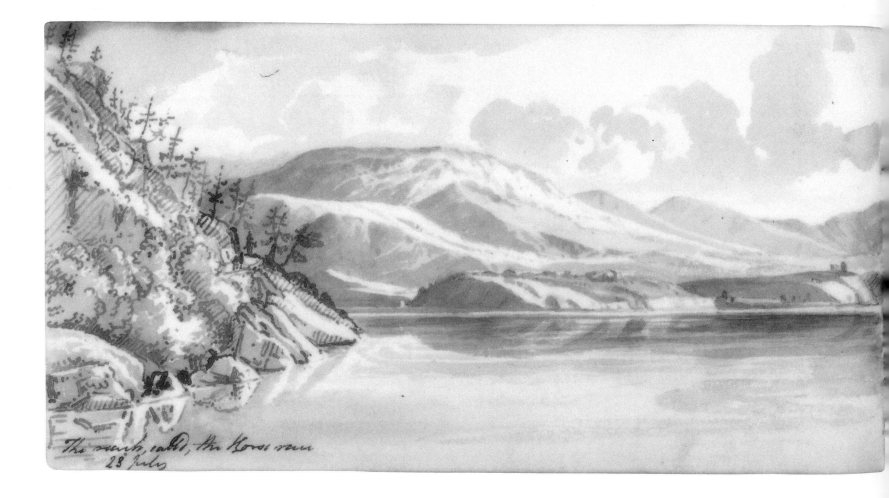

The reach, calld, the Horse race
23 July

On turning the Point you become completely land locked, and so abrupt & deceiving is the shore, that you are at a loss to find out the passage through which you have to pass; but on arriving abreast of Peeks Kill, you turn short around a Point on the left, when the scenery becomes magnificent; the ranges of Mountains hanging over the river to the height of 900 ft. In this reach calld the Horse race the Hudson becomes narrower and from Antonies Nose to West Pt. I should not take it to be more than 900 yards wide.

Looking upstream from that elbow in the Hudson, the base of Dunderberg, or Thunder Mountain (eleven hundred feet) is in the foreground on the left. The precipitous rise of the mountain called Anthony's Nose is off to the right. Across the river, beyond the low hills of Iona Island, Bear Mountain rises gently.

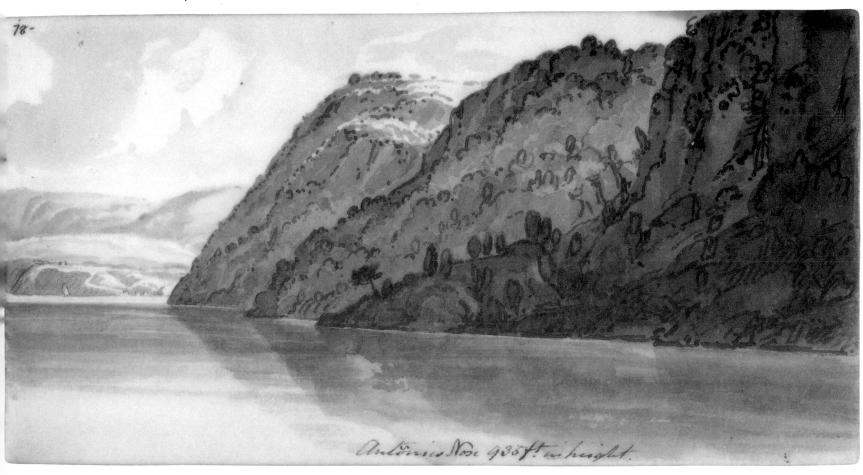

78-

Antonies Nose 935 ft in height.

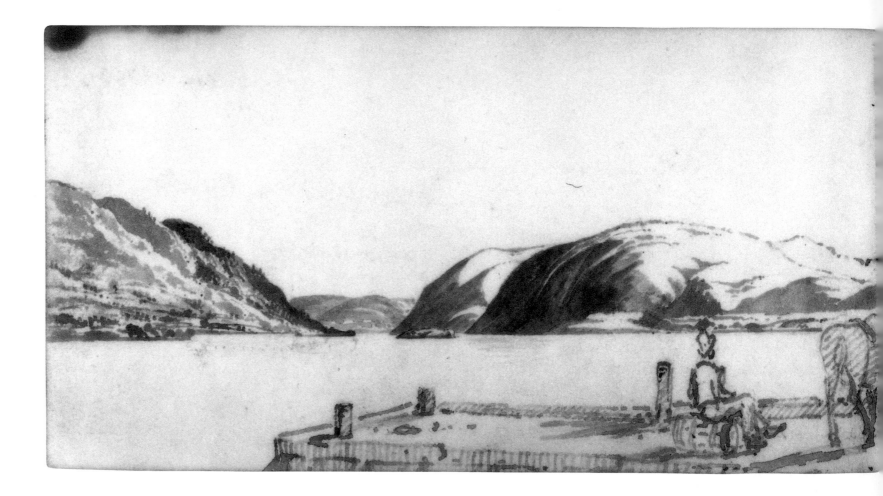

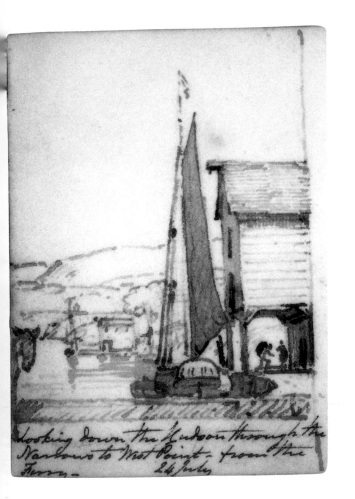

49. Looking down The Hudson through the Narrows to West Point—from the Ferry—24 July [1816]

Black wash over graphite (NY-75AB)

As they steamed toward Newburgh late in the evening, "gliding along over the smooth surface of the Hudson like a Swan," Watson sketched Buttermilk (Highland) Falls (NY-76) in the twilight and "lamented" that nightfall obscured the "grand scenery" around West Point. The following day he went down to the ferry launch and sketched what the darkness had hidden. "A little above W[es]t Point the Hudson is confined between the Mountains for about two miles to the width of 900 Yards when it opens out to a fine wide expanse of water near two miles over, and has the appearance of a beautiful lake—the buildings on Wt. Point closing the distance to the Southward, with Polypus [Polopel's] Island in the Narrows & the highland on either side forming a fine outline of beauty" (Diary, 23, 24 July 1816). Breakneck Mountain and Bull Hill (Mt. Taurus) slope into the river from the east, across from the shadowed face of Butter Hill (Storm King).

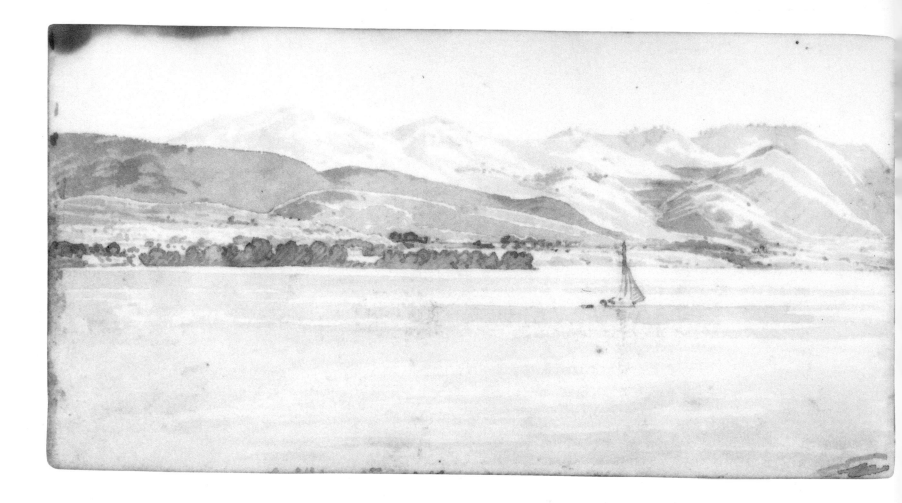

50. Looking down the Hudson from Newburg at Butter Hills Through the narrows to Pollipero[?] Island, with the Military Establishment on West Point in the distance 24th July [1816]

Black wash over graphite (NY-73AB)

The "Gibraltar of America," first known as Butter Hill and then renamed Storm King in the romantic period, topped out at 1,529 feet on the western bank (right) upstream from West Point. Opposite is the even higher Bull Hill (likewise renamed by the poet Nathaniel Parker Willis, as "Mt. Taurus"). Between, off the village of Cornwall, was the eerie and barren Polopel's Island.

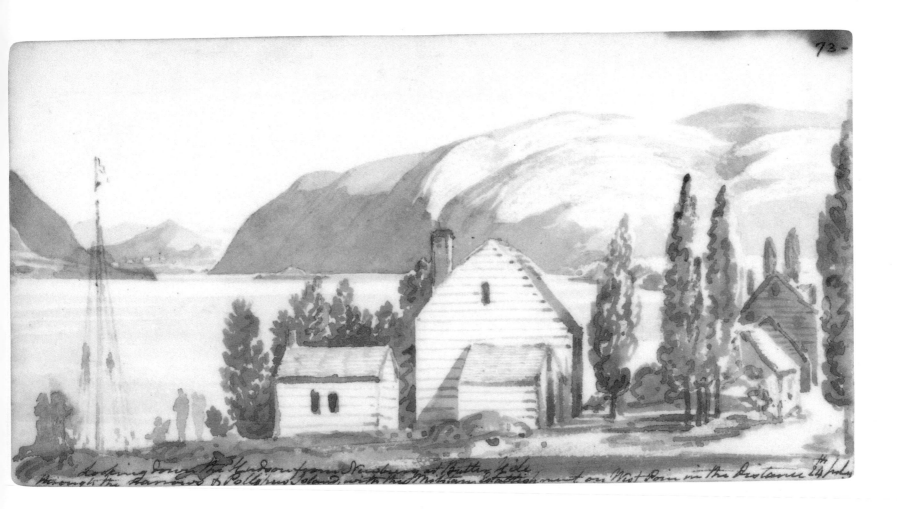

Looking down the Hudson from Newburg at Butter Hill through the Narrows & Pollopos Island, with the Military establishment on West Point in the Distance 24 July

The area had a vital role during the American Revolution: the Continental army was encamped near Newburgh from 1779 through the end of the war in 1783. Washington spent some of his most anxious times there, in headquarters not far from Watson's vantage in this sketch. Soldiers threatened to revolt for back pay. And it was suggested at Newburgh that Washington be made king. As Watson passed through, he doubtless heard these stories, which provided some background for the neighborhood of West Point Military Academy, begun in 1802 on a plateau above the river just south of Storm King.

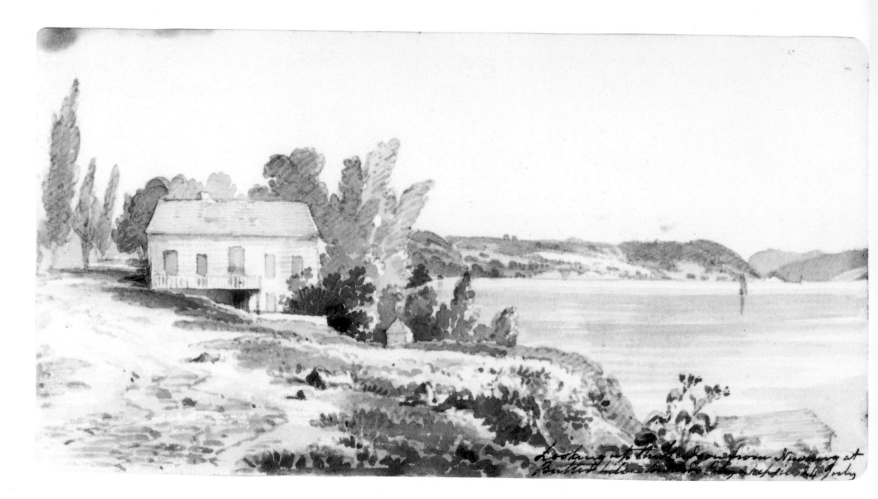

51. Looking up the Hudson from Newburg at Butter Hills towards Poughkepsie 24 July [1816]
Black wash over graphite (NY-74AB)

Newburgh rises from the river on a series of terraces to a height of three hundred feet. Watson noted that "only twelve years since [Newburgh] had but 3 houses, is now growing fast into consequence, having at this time a population of 5000 souls, many good houses," and an advantageous location for trade. True to his predictions, the town, founded by Palatine Germans, doubled its size again by midcentury.

Upstream from Newburgh Bay was the point known as Teufel's Danskammer or Devil's Dance Hall, so named by Henry Hudson's men who, legend has it, observed Indian rituals there. A lighthouse was built at that bend where the river turned northward. Beyond, the land flattened out, and the Hudson reverted from its appearance as a series of lakes back to a river again. The view south from Newburgh was more dramatic, but Wat-

son also found this northern prospect "very interesting, and the eye is carried over hills well diversified with woodland and cultivation as far as the town of Poughkeepsie," nine miles away (Diary, 24 July 1816).

52. City of Albany, taken on the Bathside of the River
26th. July. [1816]
Black wash over graphite (NY-55AB)

Two hours after midnight, the Albany-bound steamboat *Car of Neptune* stopped at Newburgh. "We went below on getting on board and took possession of a bed," wrote Watson. Naturalist Jacques Gerard Milbert, who made a contemporary trip up the Hudson, compared the steamboats to "little frigates with a convenient, though rather complicated layout.

Between-decks, there are two large and well-decorated drawing rooms that serve as a meeting place and dining room. Around the walls stretch two tiers of immaculate beds, and, if these do not suffice, sofas, chests, tables and even the dining room floor are pressed into service."

Watson arose at six, by which time they had passed Poughkeepsie, and, from the deck, there was a distant view of the Catskills. As the *Car of Neptune* moved rapidly up the river, Watson made numerous quick sketches of the shoreline near Esopus, Kingston, Athens, Hudson, and Cocksackie Landing, with the Catskill Mountains in the distance (NY-72–60; see figs. 34, 65).

"Albany makes a very good appearance from the river," wrote Watson of his first view of it, 6:30 that evening. "The Capitol on the Hill, the State House, with its Churches and many Villas near the town, give it an air of consequence." Other contemporary visitors agreed. Milbert praised Albany's institutions and noted the similarity of its commercial part to towns in Lower Normandy. "Huddled together in a small area are hat and tobacco factories, smithies, tallow factories, breweries of a well-known beer, and shops for all kinds of salted foods," wrote Milbert. Watson was impressed by the new-world aspect of Albany and amazed by the amount of new construction: "This like all the American Cities & towns I have seen, has a degree of neatness and comfort, with which every European must be astonished."

During the second day of the visit, Watson crossed to the opposite side of the river to gain the view from Bath, near Greenbush. "We walked two miles down the river, and on my way back made a sketch of the City from a point fm. which you see it to the greatest advantage" (Diary, 25, 26 July 1816).

Military Depot of Artillery.

Town of Troy. This view is taken near the depot 17 July

53. Military depot of artillery. Town of Troy, this view is taken near the depot 27 July [1816]
Pen and black wash over graphite (NY-54A)

A coach was hired for the trip to Lake George, and they left Albany at daybreak. Traveling north, they "passed by an Artillery depot opposite to the pretty town of Troy and which is the advanced station at present in front of Albany, at which, during the War, was their Head Quarters" (Diary, 27 July 1816). This depot, at left, was one of six new and massive United States arsenals, where up to six hundred workers made the arms and munitions for war.

Farther north was Watervliet and on the opposite shore Vanderheyden, two towns that became West Troy and Troy, respectively. Vanderheyden (the name of its first European proprietor) had been known earlier as Ferry Hook and Ashley's Ferry and was incorporated as Troy the same year Watson depicted it rising from the river up the slopes of Mount Ida.

"It has crept up that hill in some places," wrote Benson J. Lossing, "but very cautiously, because the earth is unstable, and serious avalanches have from time to time occurred." But it was fire, not earth, that destroyed the town in 1820. Troy rose again; by the middle of the century the population was nearly fifty thousand.

54. The falls of Cohoes on the Mohawk River 62 feet
27 July 1816
Watercolor over graphite (NY-53AB; color plate 13)

The largest tributary of the Hudson, the Mohawk River, flows through more than a hundred miles of rich agricultural land. Not far from its mouth was the popular Cohoes Falls, seventy feet high, which received its name from the Iroquois word for a falling canoe. (Watson recorded the local Indian legend bound into this place name [Diary, 27 July 1816].) Although the river was low and the effect of the falls reduced, Watson was not disappointed. "Actually there is no solid sheet of water," wrote Milbert, "for it is broken and divided by several large clusters of rocks no less

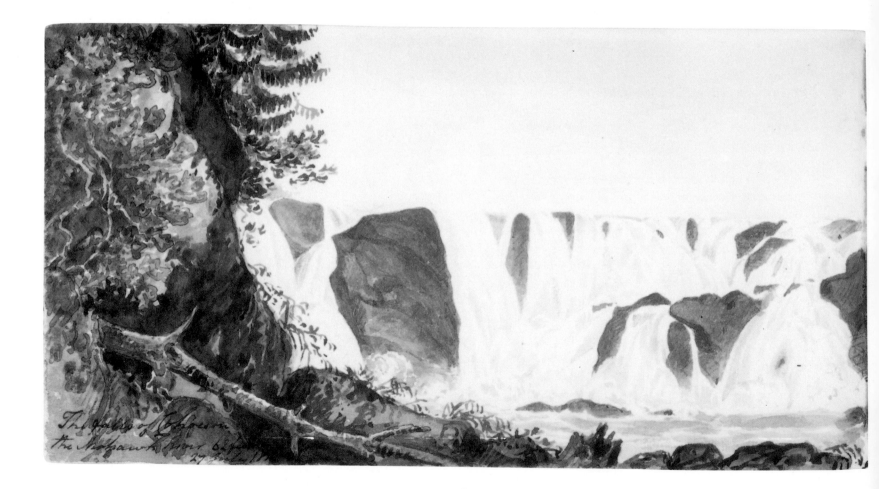

than by a number of projections. The water boils along, darting in every direction columns of snow-white spray, which cross one another, are re-united and separate once again before mingling in the lower basin of the river." They returned to the rickety bridge across the Mohawk, just down from the falls (NY-51A), where Watson paused again to sketch the view upstream (NY-49A).

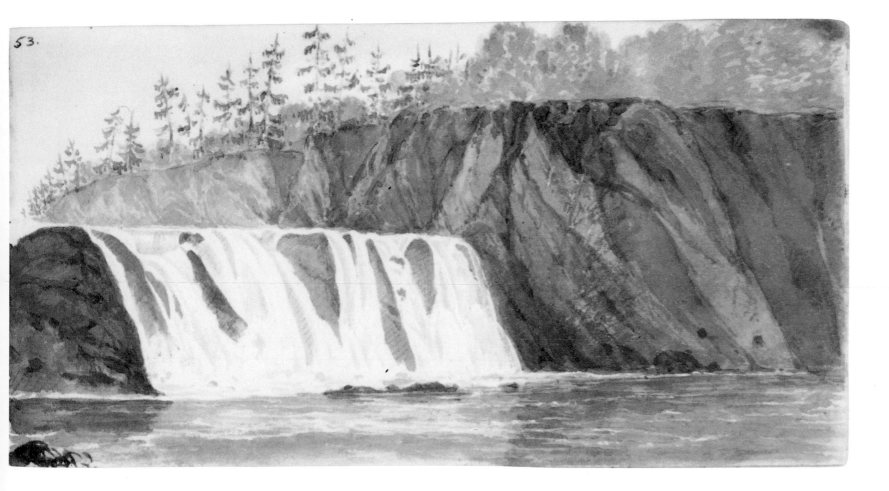

55. Fort Edward or Millers Falls 28th. July [1816]
Black wash over graphite (NY-44AB)

Farm wagons were a common sight during Watson's visit. A half-century earlier, artillery wagons had clogged the same roads. This part of New York, west of the wedge of lakes reaching down from the north, had been the buffer between British and French land. The English built Fort Edward to control both road and river traffic to and from French Canada. Battles

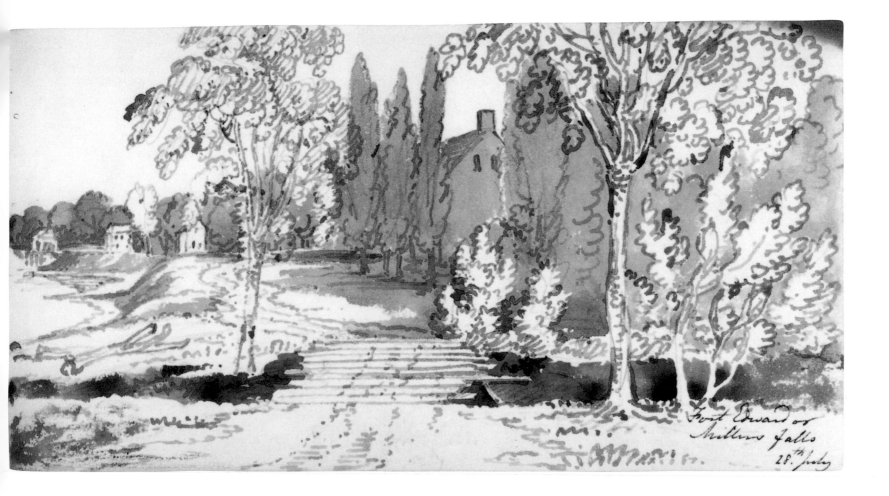

Fort Edward or Millers falls 28th July

were fought there in the 1750s, but by the time of the American Revolution, Fort Edward no longer had strategic importance. The fortress was soon in ruins, and farmers reclaimed the parade grounds with their plows.

Watson noticed the "fine well grown healthy race of people" and "well cultivated country" in the vicinity of Fort Miller, eight miles south of Fort Edward on the east bank of the Hudson. He might well have seen a copy of Horatio G. Spafford's *Gazetteer of the State of New York* when he concluded that the region would grow in coming years. According to Spafford, the population of the county (Washington) had been less than forty-five hundred in 1786; by 1810, residents numbered more than forty-two thousand.

56. *Bakers falls, Kingsbury 28th. July [1816]*
Watercolor over graphite (NY-42AB)

Watson, Leaming, and the Hammond family crossed paths at Fort Miller and, liking their mutual company, joined together for an excursion to Lake George. They left shortly after daybreak and traveled thirteen miles up the west bank of the Hudson, arriving at Sandy Hill (now Hudson Falls), a village near the larger town of Kingsbury. Between Sandy Hill

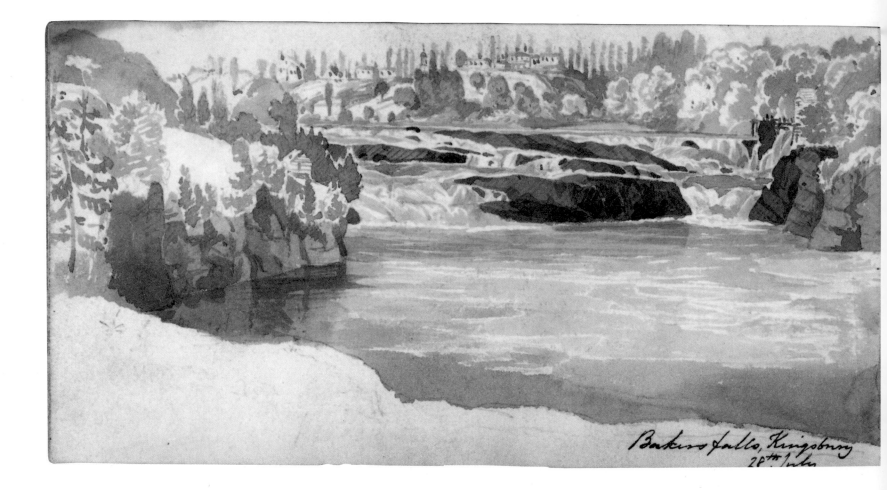

Bakers falls, Kingsbury 28th July

and Fort Edward, at the wooded Baker's Falls, the rocky bed of the Hudson dropped off in a dramatic falls. "The Scenery here is very beautiful," wrote Watson, "and the falls of Baker worthy [of] notice. There is a long wooden bridge over the river of 26 arches. The best view of the falls is on the opposite shore. They tumble over a dark rock with great force about 40 ft. Part of the stream is turned off, and works a sett of saw mills on either side" (Diary, 28 July 1816). By 1810, the water powered twelve sawmills, six grain mills, several fulling mills, and a woolen manufactory.

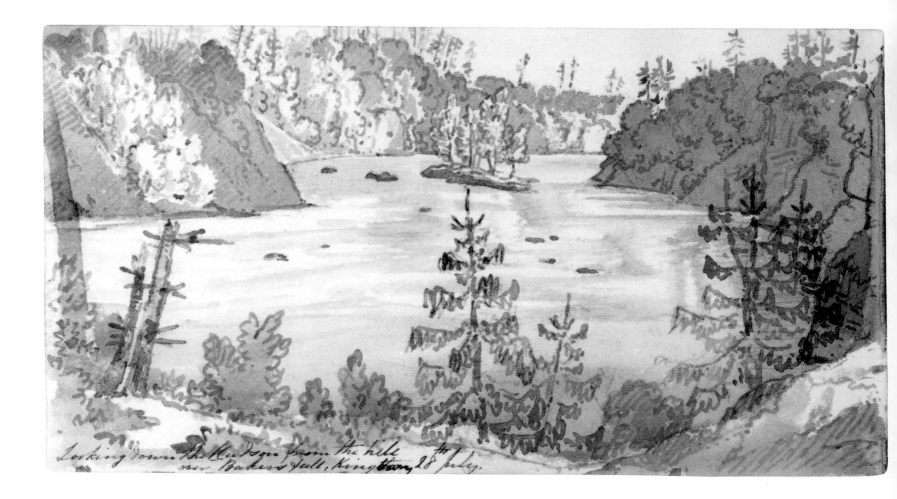

Looking down the Hudson from the hill
nor Bakers fall, Kingtown 28 July.

57. Looking down the Hudson from the hill over Bakers Fall, King[s]bury, 28th July. [1816]
Blue and black wash over graphite (NY-41AB)

"The view looking down from this spot is also pictoresque, the rocks in some places perpendicular, and the woods of Pine, Elm and Oak add much to its beauty," noted Watson. To get close to the falls, named for Albert Baker, a miller and early settler of Kingsbury, one had to descend a shaky eighty-foot ladder fixed only with an occasional stake. Such a place fueled the romantic conception of the Hudson Valley. James Fenimore Cooper and Walter Scott set their scenes in these hills, and before long, their impenetrable recesses were familiar in the American literary imagination.

58. Glens Falls 28 July [1816]
Watercolor over graphite (NY-37AB; color plate 14)

The party left Kingsbury for Glens Falls at noon. A sandy road made the short trip through some "Pine Barrens" slow and difficult, and the falls were generally a disappointment. Watson complained of having heard "exaggerated descriptions" of Glens Falls, and the effect was diminished by the inroads of industrial development. "There is a bridge over the Hudson," wrote Watson, "which in the center rests on the rocks, where they have a saw mill, and a large establishment of the same, on the left shore: but which requires so much of the water to work them, that the falls are lessened and the scenery far from improved by the buildings." The place with the best view—the toll house on the bridge—had a souvenir stand

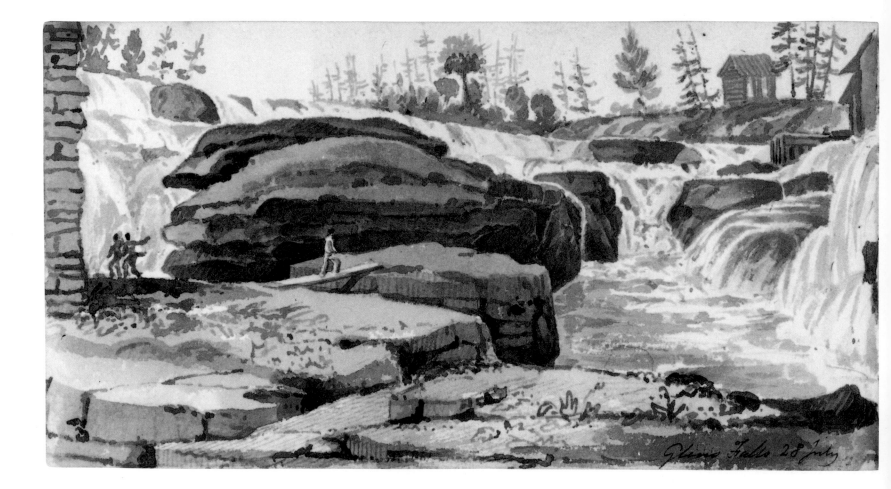

purveying fossils. Watson painted this view upstream and then turned his back on the cluttered and diminished falls to the more "interesting and beautiful" view downstream with high, blue limestone banks and undulating underwater rocks (NY-38AB; see fig. 67).

The travelers wound their way up the Hudson through a rich plateau bordered, as Milbert noted, by "bluish, gracefully wavy line of summits overlooking Lake George." Pressing on to the lake, they enjoyed "a most varied & interesting country . . . looking back on Vermont is magnificent —the Mountains lofty and their outline beautiful" (Diary, 28 July 1816).

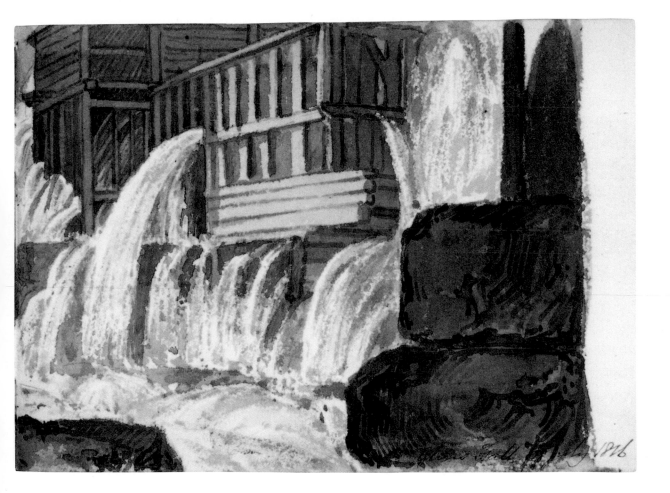

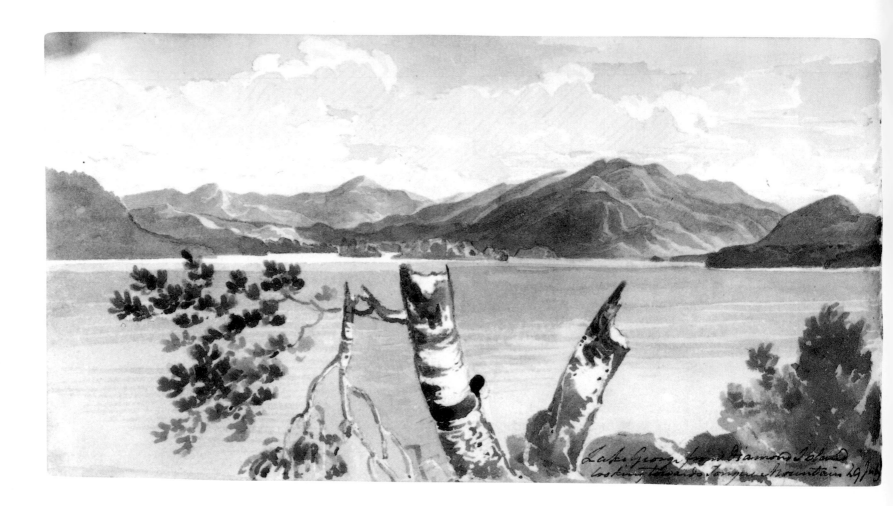

59. Lake George from Diamond Island looking towards
Tongue Mountain 29 July [1816]
Watercolor over graphite (NY-36AB; color plate 15)

"The first peep we got at the lake was very fine, and I think the best we had of it from any point—indeed we only saw as far down as the Tongue Mountain . . ." (Diary, 28 July 1816). Aboard a hired steamboat, they started the next morning on the thirty-six-mile lake with the "inten-

tion of going down as far as the Narrows, where the traveller has a fine view of the whole expanse of water." A stiff wind limited their progress at Diamond Island, where, in spite of an infestation of rattlesnakes, Watson sketched and his friends "amused themselves in picking up from amongst

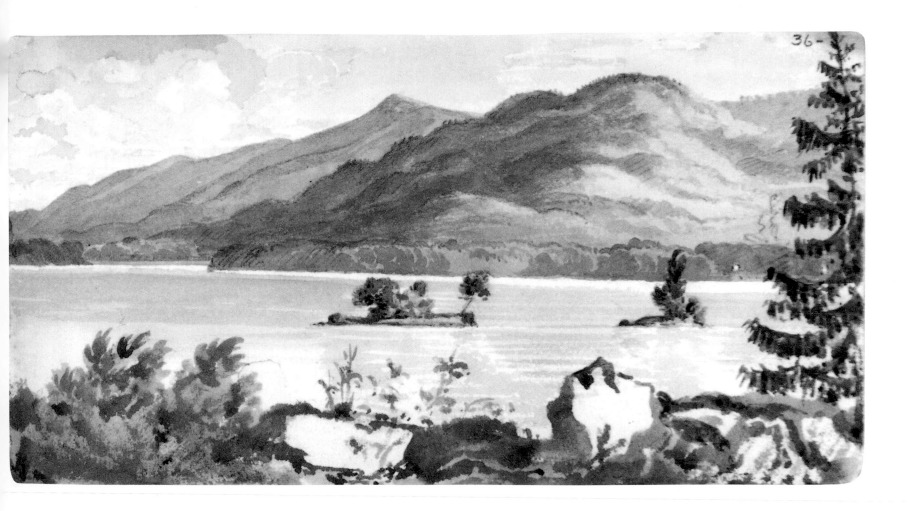

the sand and gravel on the beach, crystallized quartz commonly calld Lake George Diamonds." While his companions rambled, Watson painted the view north to Tongue Mountain (at left center). See also fig. 66.

60. Lake George & Islands from the Point of Land under
Frenchmens Mountain 29th July 1816
Watercolor over graphite (NY-35AB)

"Finding out we could not advance down the lake without much inconvenience, we landed in our way back, on the point under French Mountain so calld from the French forces having landed there from Canada when they advanced and took the Fort" (Diary, 29 July 1816). Fort George replaced Fort William Henry, which the Marquis de Montcalm destroyed in his fourth attack in August 1757. Six thousand men and powerful artillery

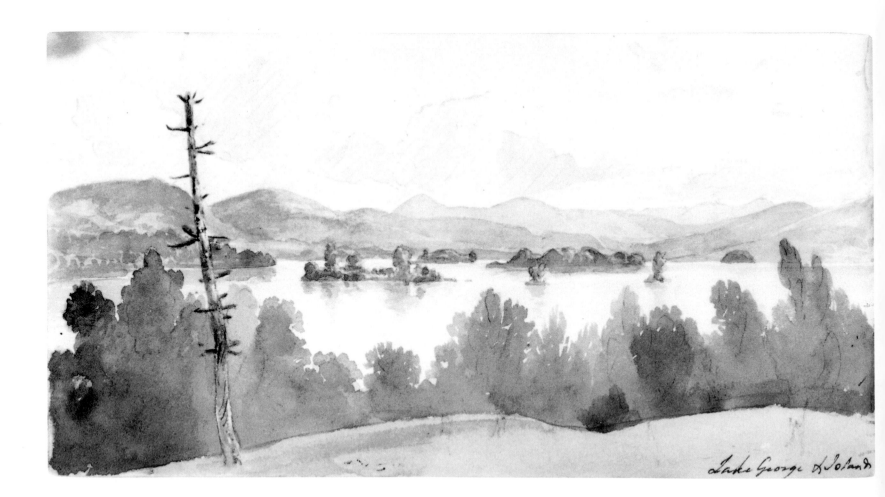

under his command took the three thousand British led by Lieutenant Colonel George Monroe. After the battle, prisoners were escorted to Fort Edward, and many were massacred as they marched.

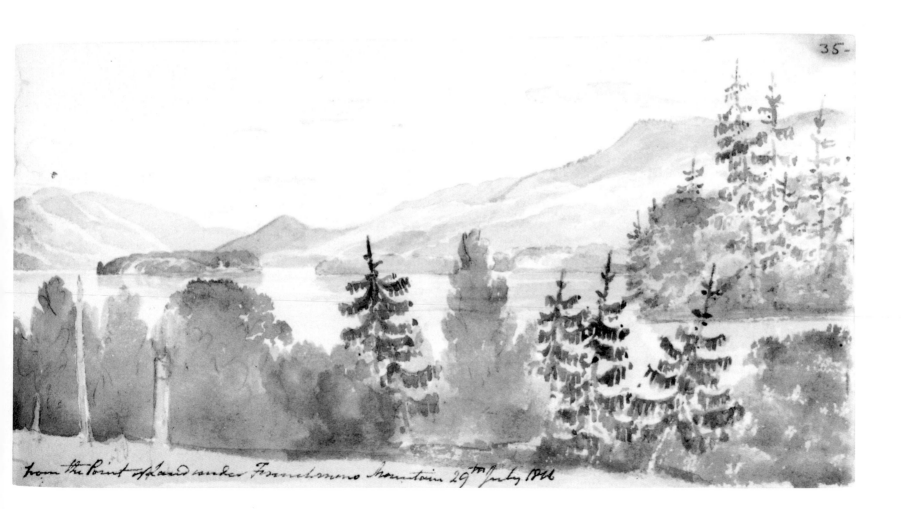

from the Point of Island under Frenchmans Mountain 29th July 1846

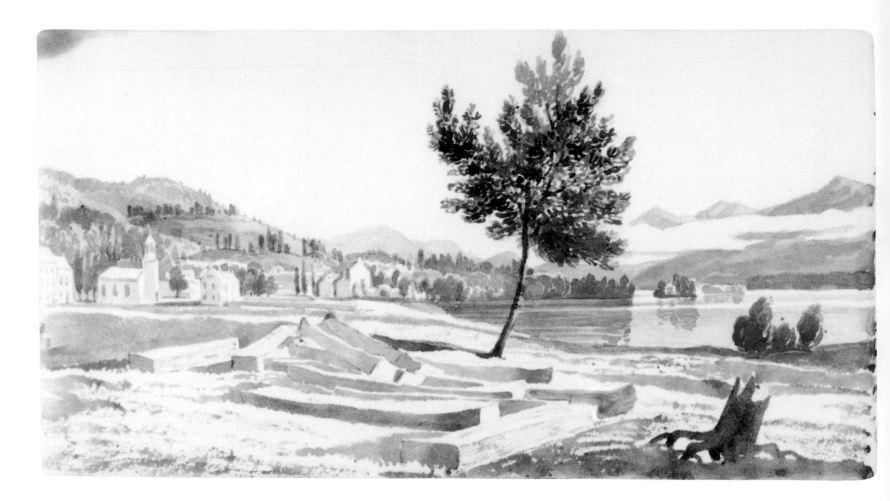

61. [Caldwell, New York, shores of Lake George, 29 July 1816]
Blue, brown, and black wash over graphite (NY-34AB; color plate 16)

The town of Caldwell, later renamed Lake George, had 560 residents in 1810. It "presents a pleasing spectacle," wrote Horatio Gates Spafford, "and beyond it are farms, fields and forests, as far as the eye can reach." Caldwell was built on the western shore, where the land was arable and even welcoming. It was hoped, as Watson noted, that some of the farming families making their way from New England to the fertile Ohio River Valley might settle instead in Caldwell. But the attractive scenery was little consolation for a paltry wheat harvest. Instead of becoming a farm community, the town burgeoned only in the summer months, when its two inns supported a fledgling tourist industry (Diary, 29 July 1816).

After two days at the lake, Watson and party returned to the town at Glens Falls by the road to Caldwell, admiring along the way "the Coun-

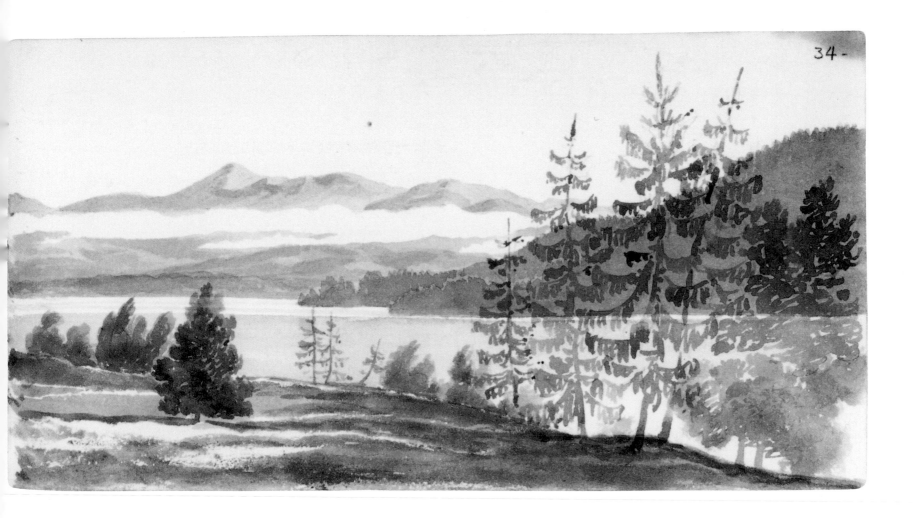

try houses . . . built with wood, some in the Old style of Logs, placed over
each other, & their ends locked in by a sort of mortice. They are plastered
inside or lined with plank and are found to be very durable and warm"
(see fig. 32).

62. *[Saratoga, 30 July 1816]*
Black wash over graphite (NY-29AB)

"Saratoga is a place in its infancy and has nothing attractive but the salubrity of its mineral waters," wrote Watson. The springs had drawn crowds, however, for, as Spafford attested in 1813, "No Medicinal Waters of the Eastern Continent possess equal claims to celebrity, with those of Saratoga." The place was becoming increasingly popular among persons with ulcers, rheumatism, dysentery, hives, hypochondria, dropsy, paralysis, fevers, and scrofula. Visitors imbibed large doses of naturally carbonated water from Saratoga's five springs.

Several quarts would probably cause no harm and might actually do

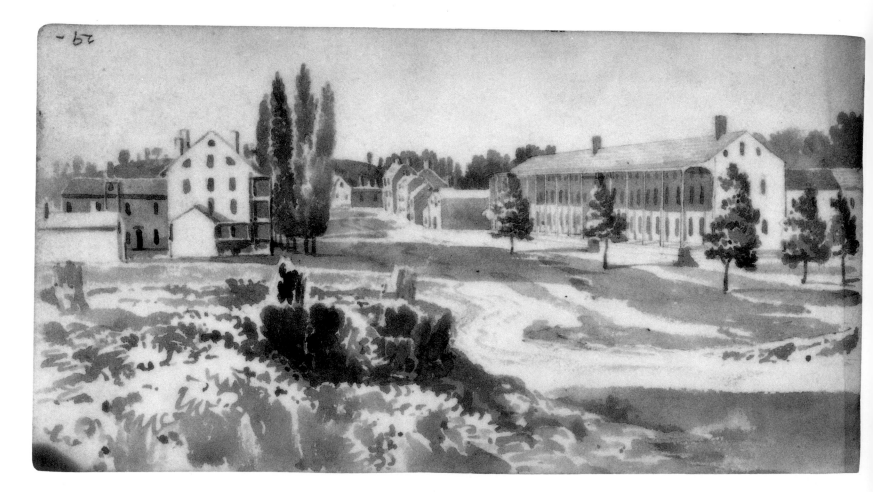

some good, according to Dr. Valentine Seaman's *Dissertation of the Mineral Waters of Saratoga* (1st ed., 1793; 2nd ed., 1809). To house the health seekers, according to Watson, several hotels on "a *very* large scale" were built. In addition to the Pavilion and Union Hall, Congress Hall was built with a colonnade that became a trademark for Saratoga Springs.

Wellness prevailed. "In the morning everyone drinks the water religiously," wrote Milbert, "at night they make fun of it." Milbert and about a hundred and fifty others passed an evening in the large salon "where . . . some of the guests gather to converse, and people staying at other estab-lishments come to call. . . . Several ladies take turns at the piano and, despite a noisy obligato of arrivals, departures and animated discussions, they pursue their sonatas unperturbed and receive the applause of the whole gathering. The evening is usually concluded by a walk in the woods."

Accustomed to the society of English "watering places," Watson remarked on the segregation of the sexes at Saratoga. He noted with disappointment this particularly American practice, which denied men "the delight of female society" (Diary, 30 July 1816).

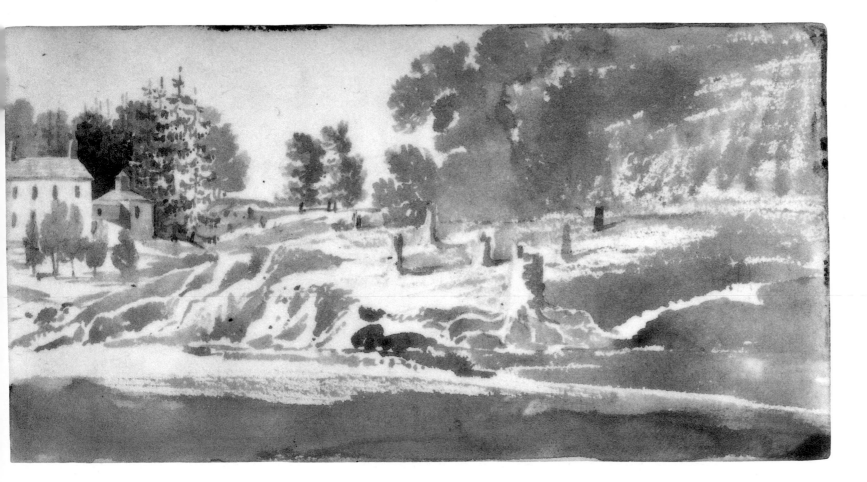

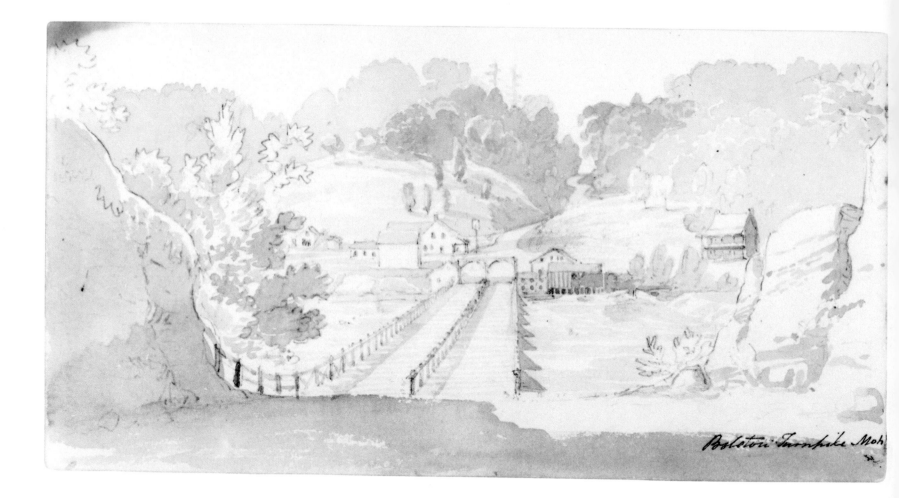

Ballston Turnpike Moh

*63. Bolston Turnpike Mohawk Bridge It is 93 ft. over, & has
9 arches [31 July 1816]*
Black wash over graphite (NY-26AB)

In the very book that made the springs at Saratoga and Ballston famous, Dr. Seaman cautioned that popularity would be their ruin. He feared that vacationers, not patients, would flock to a resort that offered so much more than curative waters. Seaman wrote:

We cannot be surprized that these, like most other celebrated Medicated Springs, having at first been the refuge of suffering humanity, the comfortable asylum of the afflicted invalid, should become the seat and empire of luxury and dissipation, the rallying point of parties and pleasure. Where one person *now* applies there to repair a disordered constitution, twenty go, in the gaity of health, to sport a sound one, against the enervating influence of revelry and riot.

Watson and Leaming left Saratoga for Albany by way of Ballston, where the horses were watered. Farther along, on the road to Schenectady, they dined near the Ballston Mohawk Bridge, where Watson made his last sketch of the region. He showed the 1100-foot-long iron and wood bridge, which shook and clanked as they crossed over.

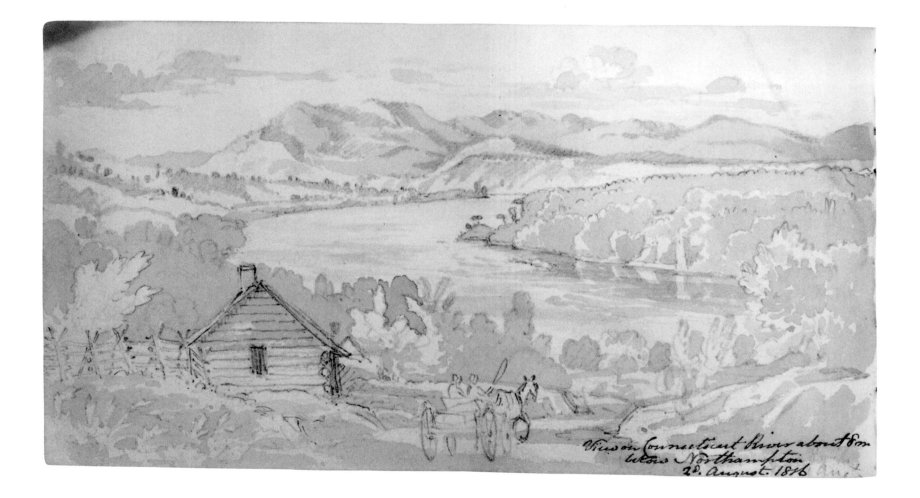

View on Connecticut River about 8 m.
below Northampton
2d. August. 1816

64. View on Connecticut River about 8 m below Northampton
2d. August. 1816
Black wash over graphite (NY-23A)

Watson left Albany on 1 August at 2:00 A.M. in the eastbound mailcoach, which crossed the Hudson in a scow. After eighteen miles it reached Chatham and, after breakfast, continued through western Massachusetts. "The road from Becket through the defiles of the River Agawam to West-field is more beautifully grand than I can find language to give an idea of," wrote Watson, who regretted traveling so quickly through "one of the most romantic spots I have seen in America." They had to press on through the Green Mountains to Springfield. There, before nightfall, Watson inspected the government arms manufactory and made sketches of new bayonet mountings (see figs. 31, 68).

The next morning, they set out for Northampton. "We drove along the shore of the Connecticut river for 21 miles, the country rather flat, but near Northampton it is mountainous the scenery rich and beautiful." Remarking on the exodus from this area into "Ohio and the Western states," Watson also commented on the unfailing courtesy and "propriety" of the citizens he passed on the road (Diary, 1 and 2 August 1816).

As they passed through this countryside, Watson noted the increased population, the idle textile mills, the rocky fields, and the exhausted soil. He expressed fondness for the Dearborn wagon in which they traveled. "It will take 4 people with ease, and tho not suspend'd on springs, the seats are so elastic being on angular pieces of wood that the motion is not unpleasant" (fig. 69). Not long before their arrival in Northampton, they stopped to make this sketch.

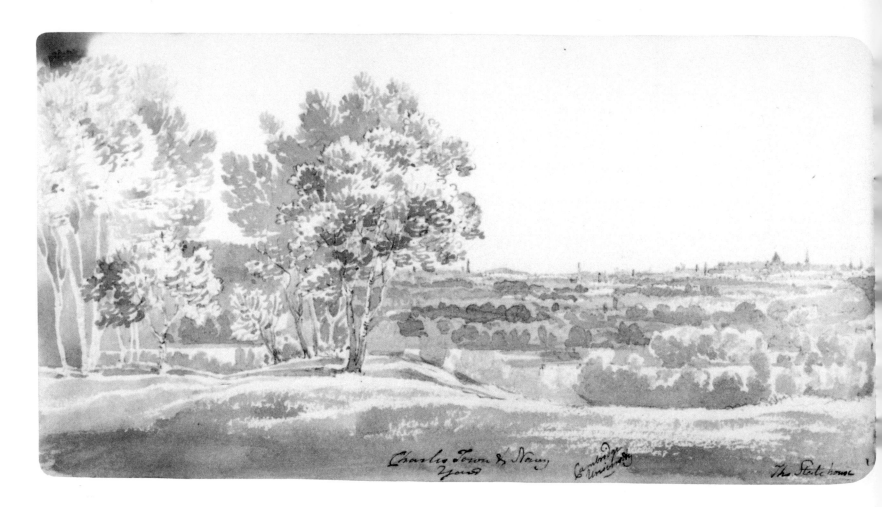

Charles Town & Navy Yard Cambridge University The Statehouse

65. *Charles Town & Navy Yard Cambridge University The Statehouse The City of Boston from Walnut Grove near Watertown. E. Preble's Esqr. 8 Augt. 1816 Gloucester heights Rocksbury*

Black wash over graphite (NY-21AB)

The ninety-three-mile trip from Northhampton to Cambridge began at four o'clock the next morning. The travelers made their way through darkness, fog, and "the very offensive smell exuding from a Skunk," before

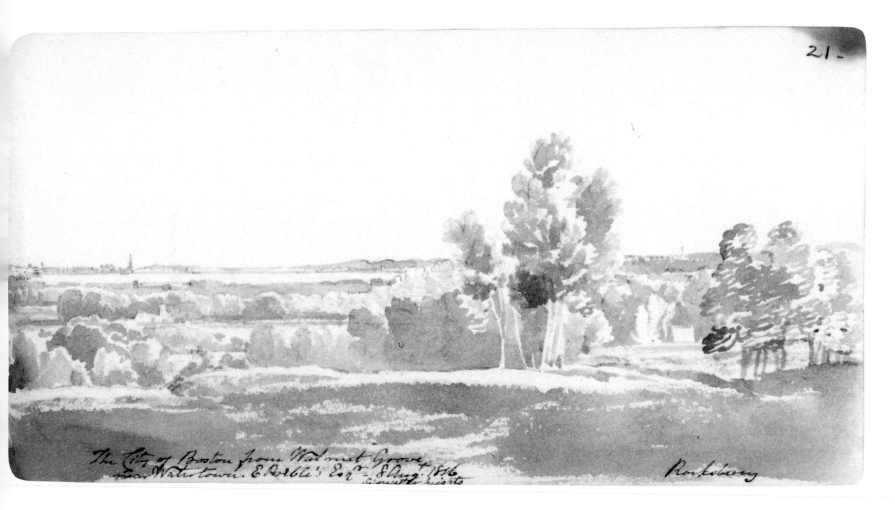

The City of Boston from Walnut Grove near Watertown. E.Preble's Esqr - 8 Augt 1816

Roxbury

reaching Belchertown for breakfast. Afterward, they proceeded through Western Brookfield, Spencer, Leicester, and Worcester. In the area covered by this final leg of the trip, the population was double what it had been in the western part of the State. Likewise, the stage was crammed with passengers as they passed through Worcester, Framingham, Waterford (Watertown), and Cambridge. At eleven o'clock that night they arrived at Boston.

Five days later, Watson returned on this path to stop at the estate Walnut Grove, near Watertown, to paint this view of the Boston skyline from Charlestown to Roxbury, including the spires of Harvard, which he re-ferred to as "Cambridge University." The diary entries end on August 3, although while in Boston, Watson made the acquaintance of President John Thornton Kirkland of Harvard, Governor John Brooks, Chief Justice Isaac Parker, Gardiner Greene (J. S. Copley's son-in-law), and others listed at the front of his diary.

66. Boston from the Road under Dorchester heights 10th.
August 1816; [inscribed] Williams Island
Black wash over graphite (NY-20AB)

Boston was a "very pleasant" hilly peninsula in 1634 when William Wood described it as "hem'd in on the South-side with the Bay of Roxberry, on the North-side with the Charles-river, the Marshes on the backe-side, being not halfe a quarter of a mile over. . . ." There were no woods to speak of, which all but eliminated the nuisance of "Wolves, Rattle-snakes and Musketoes."

The population of the city grew slowly at first. By the middle of the eighteenth century there were little more than sixteen thousand residents.

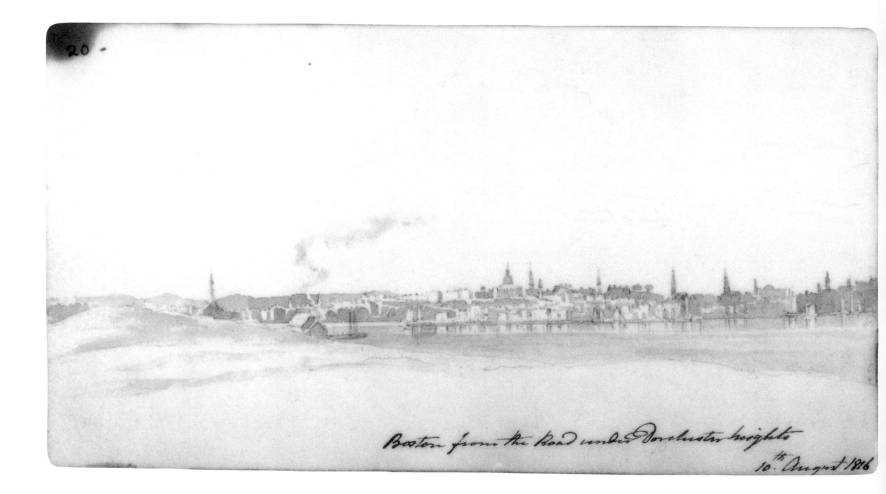

Boston from the Road under Dorchester heights
10.ᵗʰ August 1816

An additional fifty years brought only two thousand more. But in the first two decades of the nineteenth century, the number of Bostonians had more than doubled. Space, which was never in abundance, had run out.

South of town, just across mud flats and a narrow channel, was the peninsula of Dorchester. In 1804, Boston land speculators engineered its annexation and, at the same time, passage of the South Bridge Act. Dorchester became the new South Boston and a toll bridge to it opened a year later. New settlers were not attracted, as was hoped, but for some years it at least furnished a fashionable promenade for Boston residents who enjoyed the agreeable view of the town.

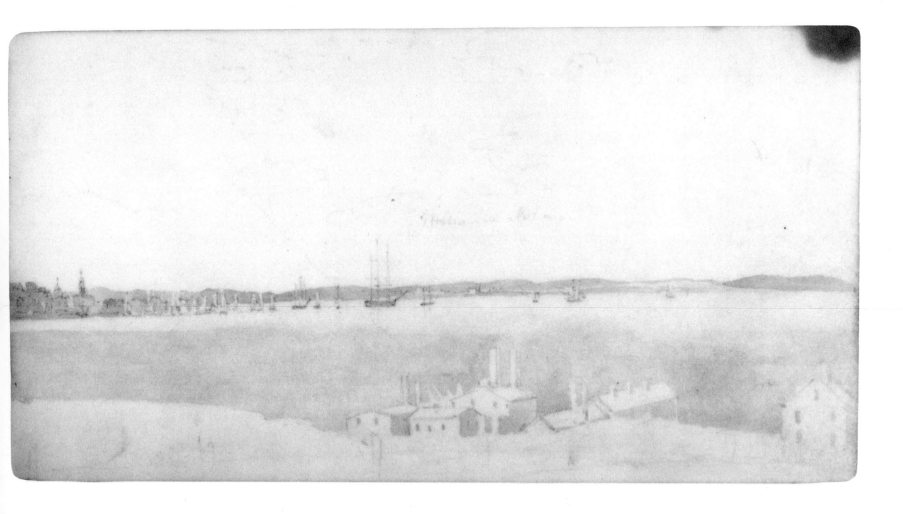

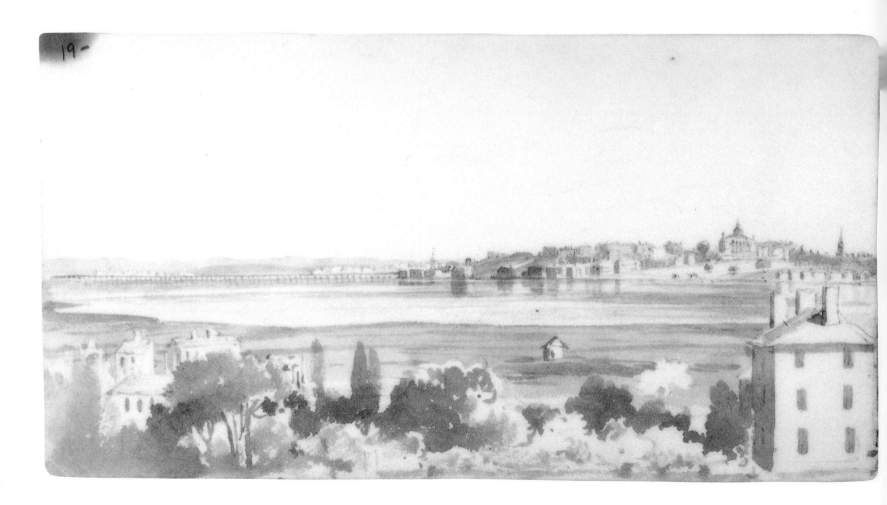

67. Roxbury—Boston fm Church 10th Augt. [1816]
Black wash over graphite (NY-19AB)

Across the Great Bay or Back Bay, just to the west of Dorchester, was the village of Roxbury. Watson visited one of its churches on Sunday and made this view facing Boston. Great changes were in progress: the Boston and Roxbury Mill Corporation was chartered two years earlier, and engineer-entrepreneur Uriah Cotting proposed a 1.5-mile dam to power

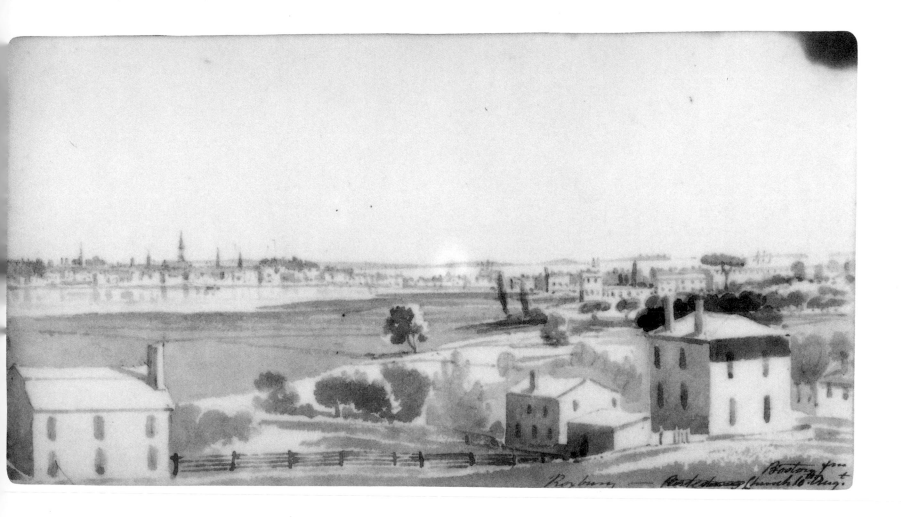

Roxbury — Roxbury Church 16 Aug.

scores of mills. The prospectus was well received by investors who crowded Cotting's office. One eager applicant was so motivated that he resorted to climbing in by the window.

There was an added attraction to the dam: Roxbury and Boston would be connected by a toll road atop its fifty-foot breadth. As the new road did not open until 1821, Watson was obliged to visit Roxbury by the comparatively circuitous route along Boston Neck, the narrow strip of land that attached Boston to the mainland. Later in the nineteenth century, most of Back Bay was filled in for residential development.

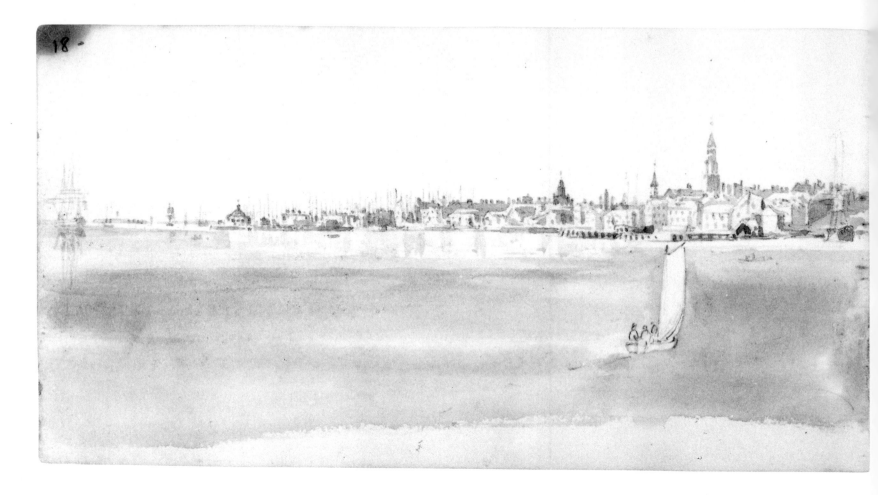

68. Boston from the Navy Yard at Charlestown
10th. Augt. [1816]
Black wash over graphite (NY-18AB)

The most easterly part of Charlestown's waterfront, just across the channel from Chelsea, had a long association with military aspects of seafaring. An early name was Moulton Point, after ship carpenter Robert Moulton. Howe had landed his forces there bound for Bunker Hill. In 1799 a new naval yard was begun, and, at the time of Watson's visit, forty-four officers and numerous men were stationed there. Their frigates *Congress*, *Macedo-nian*, and *Constitution* as well as the ships *Washington*, *Independence*, and *Chippewa* attracted Watson; he attentively sketched Commodore Bainbridge's *Independence* (NY-17B, 16A) and *Congress* (see plate 39).

If the profile of Boston was impressive, crowned by the dark bulk of the State House, it had been even more substantial a few years earlier. Real estate entrepreneurs were busily reclaiming the marshes and ponds on

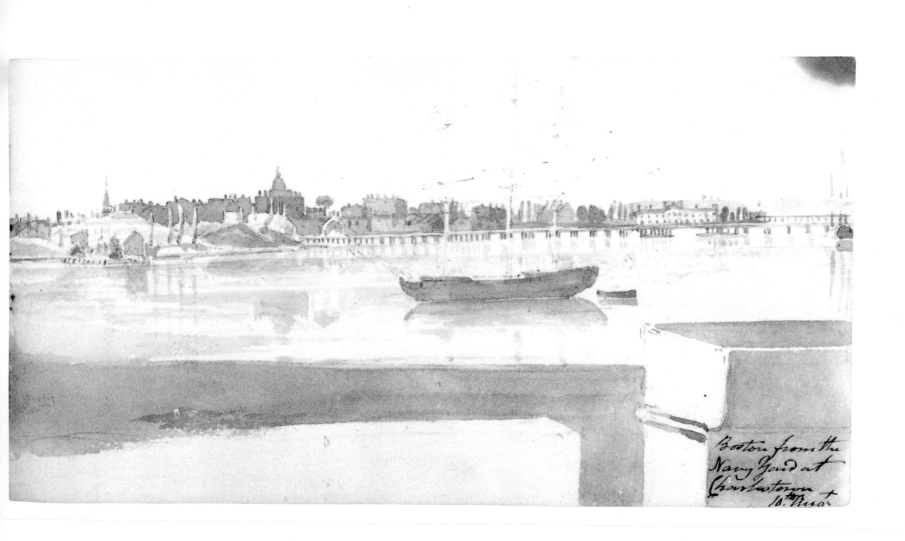

Boston from the
Navy Yard at
Charlestown +
16th Nov.

Boston's edges. Architect Charles Bulfinch had already planned the location of streets on the triangular Mill Pond, between Craigie's Bridge and the Charles River Bridge (to the right). Landfill for these low areas was obtained by whittling down Boston's hills.

For several years, preservationists postponed the excavation of Beacon Hill, adjacent to the State House. But the Hancock heirs, who owned all but its summit, prevailed in 1810, and soon Bulfinch's sixty-foot Doric monument was left sticking out of a cliff-sided grassy nub. The following spring, the six-rod square summit was sold, the monument moved, and the land on which it stood carted away.

69. Charlestown Boston from The Wt. Bridge
11th August [1816]
Black wash over graphite (NY-15AB)

From the Cambridge or West Boston Bridge, which traversed the Back Bay near the mouth of the Charles River, Watson found a panoramic view of the seven-year-old Canal or Craigie's Bridge. It spanned the Charles River, connecting Barton's Point in Boston (right) to Lechmere's Point in Cambridge (left, out of view) and intersected with the Prison Point Bridge, which led to Charlestown (distant left). "All these bridges are well-lighted by lamps when the evenings are dark," wrote Caleb H. Snow in 1825, "and the lights, placed at regular distances, have a splendid and romantic appearance."

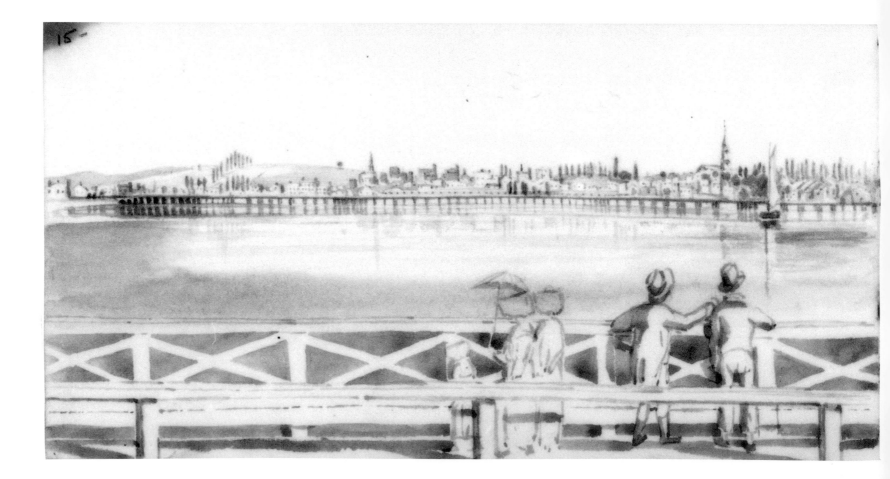

The largest of Boston's nine bridges was Craigie's Bridge, pictured here. It spanned 3,484 feet. Milbert noted during his visit in 1817:

Nearly all of the bridges are of wood and follow the same design; they rest on a mass of piles separated by arches 18 to 20 feet wide and rising to about the same height above the water. The flooring, which measures 25 to 30 feet in width, including the sidewalks, is formed of pieces of wood five to six inches thick and of a length equal to the floor's width. The largest are opened by means of a very ingenious mechanism that makes it possible for every kind of vessel to sail around the city, from the end of the inner bay to the sea. Most of these bridges belong to private contracting companies that have a concession from the Government to collect a toll. Their Maintenance is subject to rigid inspection, since negligence could easily cause terrible accidents, and any company found guilty of such a misdemeanor would certainly lose its license.

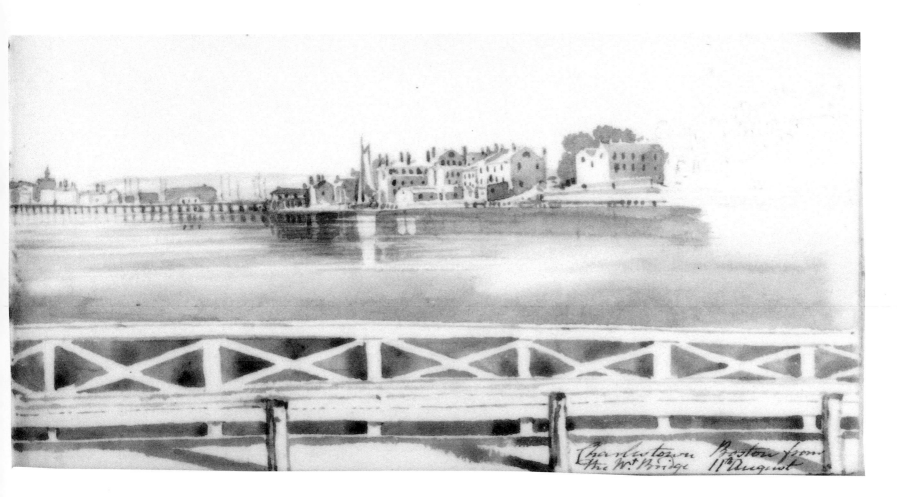

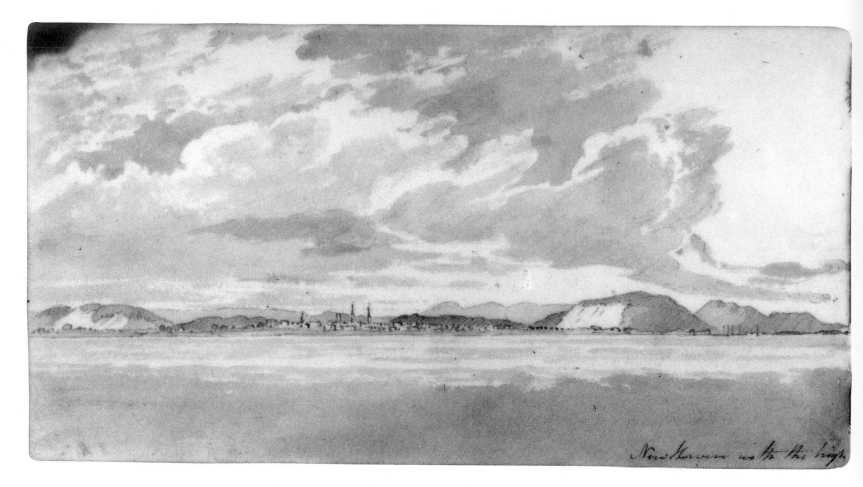

70. New Haven with the high lands of the Et. & Wt. Rocks
15th. August 1815 [1816]
Black wash over graphite (NY-12AB)

Watson probably left Boston by stagecoach, for his next drawings show the Little River Bridge, near Middletown, on the Connecticut River (see fig. 27). Evidently, he was bound for New Haven, where he would board a boat heading for New York. New Haven appears in Watson's sketch from a vantage at the outermost point of the harbor, near Fort Hale. The Connecticut town sits on a two-mile plain between West Rock (far left) and East Rock (middle). When Watson passed through New Haven, the city's architectural and intellectual Golden Age still lay a generation ahead, its future resting in the hands of such men as James Hillhouse, whose name appears on the roster of acquaintances in Watson's diary.

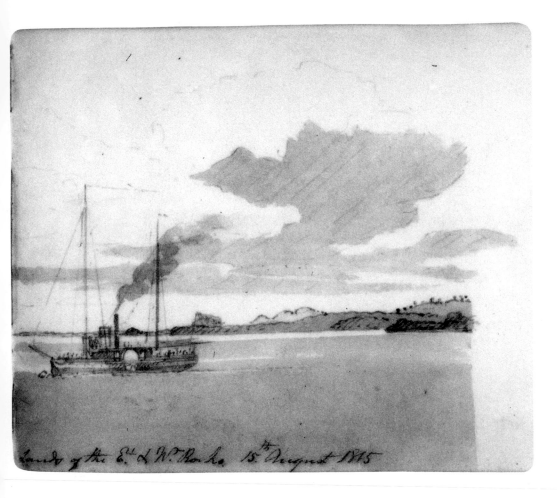

Lands of the E.d & W.m Banks, 15th August 1815

Visitors of this period agreed that New Haven, in spite of the presence of Yale College, then more than a century old, had "a country-village look quite different from what one expects to find in a big city." Approximately seven thousand resided there in 1800. This population supported six churches, eighteen blacksmiths, nine coopers, six drug stores and shoe stores, five printing offices, and four each of bakers, hardware stores, book stores, and barber shops. Two crockery stores, paper hanging stores, sail lofts, and distilleries were in business. There was a nail factory and a public market.

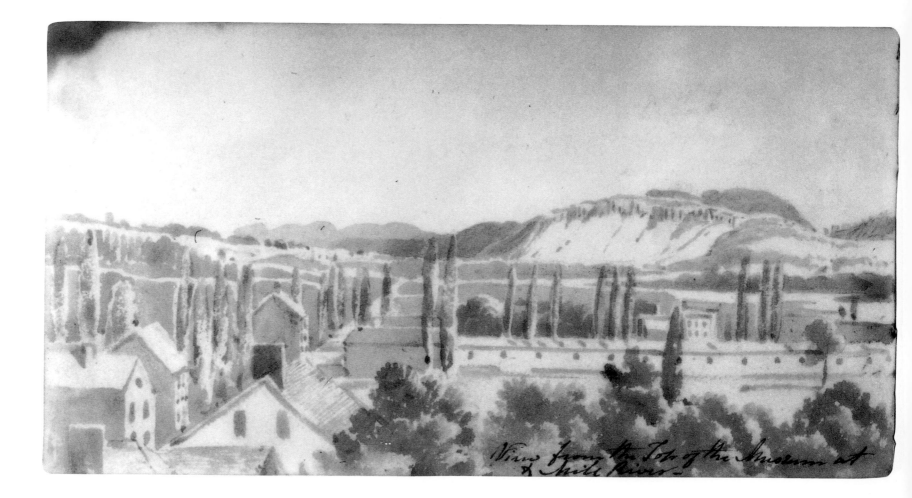

John Mix's Museum and Columbian Garden opened 4 July 1807, on Olive Street, at the east end of Court Street. "It contains a tavern," wrote Milbert, "a natural history collection, a picture gallery of very doubtful value, and, in the attic, a dark room where one may contemplate a panorama of the city, the surrounding region, and the ocean." In that room, Mix installed a large camera obscura, which pointed outward to the town. Upon its ground glass were projected views of New Haven that would have been enjoyed by visitors and even traced by aspiring amateur artists. Watson bypassed the device and made this sketch on his own.

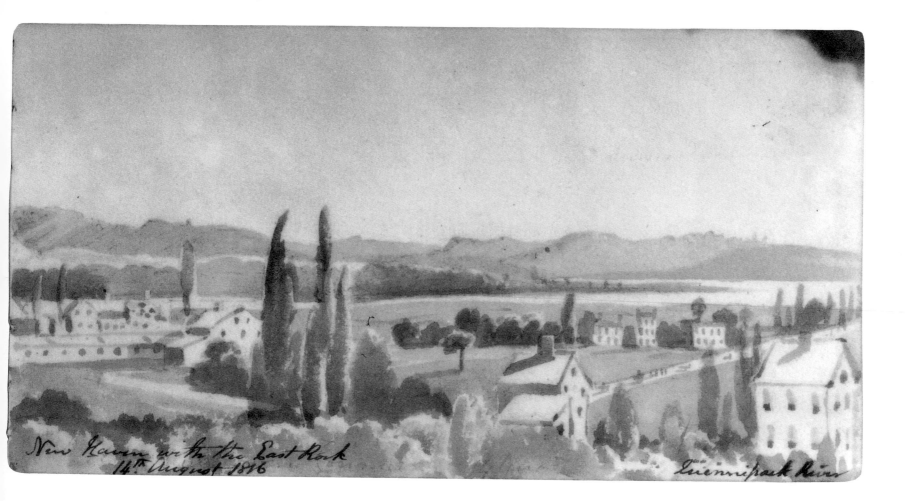

New Haven with the East Rock
14th August 1816 Quinnipack River

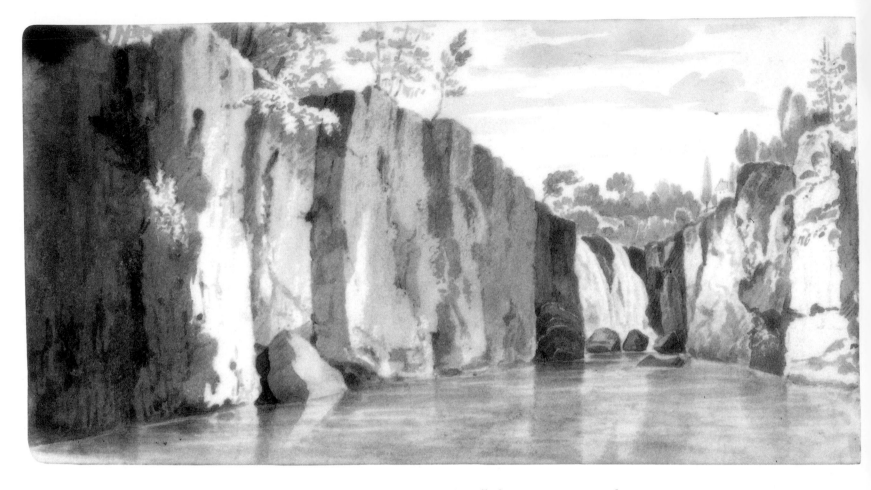

72. Passaic Falls [15 or 16 August 1816]
Black wash over graphite (NY-5AB)

Watson left New Haven on 15 August, and by the next day he had rounded
New York harbor and regained the New Jersey shore. To the northwest of
New York City was the growing industrial village of Paterson, New Jersey,
(fig. 28) and Passaic Falls.

 "It seems to me impossible to give an idea of this waterfall, except by
a drawing," wrote François Jean Chastellux during his visit in the 1780s.
Others shared this sentiment, and it was not long before the falls had ac-

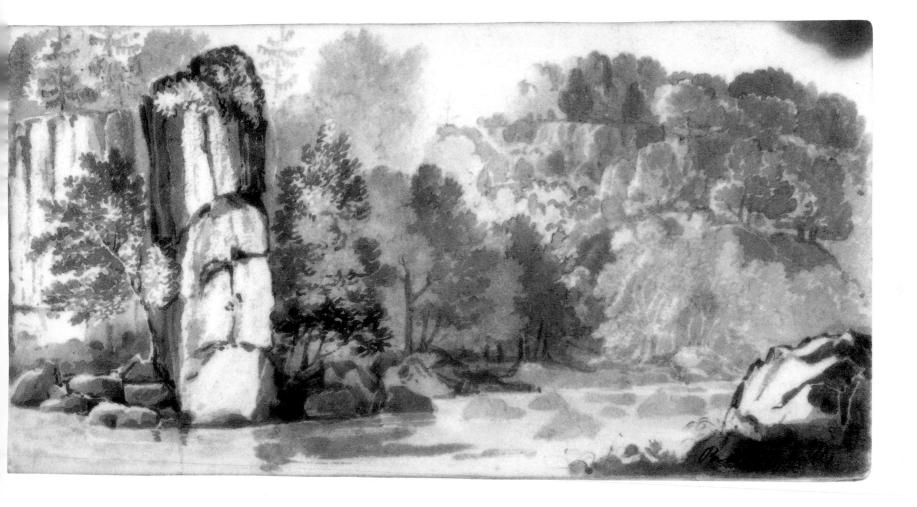

quired a respectable iconography. Even after Pierre Charles L'Enfant was retained in 1791 by Alexander Hamilton and the other planners of Paterson, visitors rarely noted the town. "The Cataract itself presents so many and so different points of view, that it affords a new picture at every Step," wrote Benjamin Henry Latrobe, who made ten views of the falls during visits in 1799 and 1800. Watson, too, kept his back to the cotton mills when he made his sketches.

Paterson was larger, about ten thousand strong, and the falls still wild when Frederick Marryat visited thirty years later. "But turn around with your back to the fall—look below, and all is changed: art in full activity—millions of reels whirling in their sockets—the bright polished cylinders incessantly turning, and never tiring."

*73. New York from Whehauken [monument at the dueling
ground] 19th August 1816 J. R. Watson Delt.*
Watercolor over graphite (NY-2″AB; color plate 17)

Watson went down the long and rocky path in Weehauken to the pictur-
esque spot "stained with the blood of one of Columbia's most able and
best men, Maj. Genl. Hamilton" (Diary, 23 July 1816). Twelve years earlier,
Hamilton's charge that Vice-President Aaron Burr was "a dangerous man

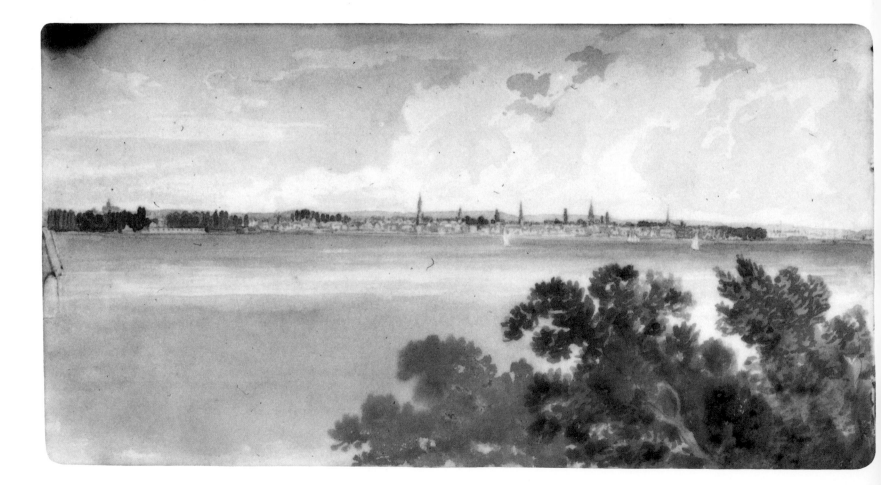

and one who ought not to be trusted with the reigns of government" turned their long political rivalry into a duel. Across the Hudson River from New York, on the morning on 11 July 1804, Burr fired a bullet that wounded Hamilton. The next day, Hamilton died.

The site became a shrine. In 1806, a fourteen-foot obelisk topped with a carved urn and flame was installed by the St. Andrew's Society of the State of New York for their fallen brother. It stood until a few weeks before Watson's visit, when "nearly every projecting corner of the stones has been broken off and carried away by curiosity hunters." The site also attracted duelists. What was left of the monument was finally removed in 1831 "because it was believed to have a bad moral effect, by encouraging others to go and expose their lives on the spot. . . ."

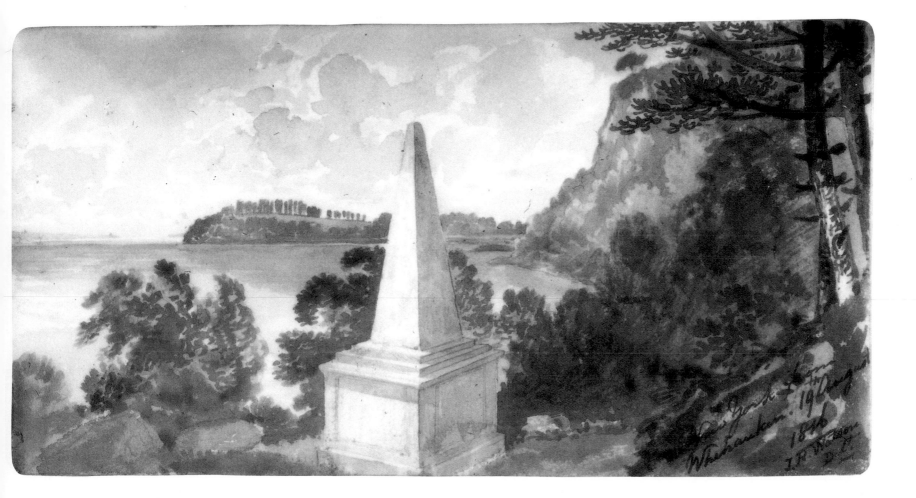

74. [Two views of the] Entrance into Baltimore between Battery Island and Love Point 15th. April 1817.

Black wash over graphite (B-65AB)

Back in Philadelphia after his Northern trip, Watson spent the next several seasons at Eaglesfield. He began a new sketchbook on September 14, 1816 with views from the piazza of the house. By the end of October, Wat- son had made thirty-five sketches and watercolors of the Schuylkill and Wissahickon valley.

The following April 14th, Watson and Samuel Breck left for Washington, D.C.. Breck was a neighbor of the Rundles at Sweetbriar, a merchant, a politician and a diarist. "We embarked on board the New Castle Steamboat at 12 O'clock and slept that night at New Castle," he wrote. "Capt. W. sketched on his passage down the Delaware all the principal views. This

he does inimitably well. We crossed the Chesapeak bay from Frenchtown the next day in a very pleasant manner . . ."

One day after that, Watson and Breck "arrived at Baltimore about 5 o'clock. After sauntering through this flourishing city, we retired to rest at Barney's Inn. . . ."

The British burned both Havre de Grace and Washington, D.C., in the War of 1812, but Baltimore, situated about ten miles from the body of the Chesapeake, was spared. According to a contemporary atlas, its well-guarded entrance between Fort McHenry and the Lazaretto and light-house, was "scarcely a pistol shot across."

Tucked in its safe harbor and unscathed, Baltimore nearly quintupled in population from 1790 to 1820: 13,503 to 62,627. Whereas Philadelphia had been the undisputed leader in value of exports during the first decade of the nineteenth century, in the second it was in a dead heat with Baltimore.

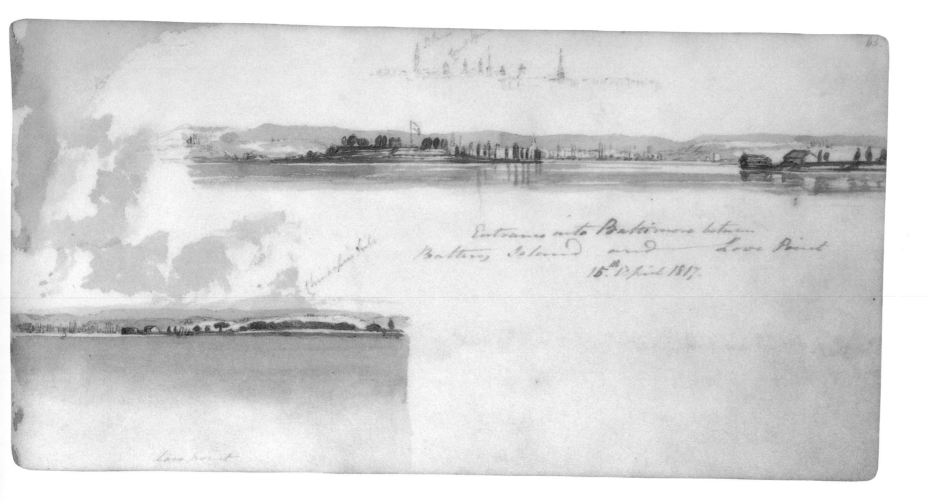

75. [Washington, D.C.: Pennsylvania Avenue from Capitol Hill, Elevations of the U.S. Capitol, after drawings by B. H. Latrobe, April 1817]

Pen and black wash over graphite (B-64AB)

"The next morning," wrote Breck, he and Watson hired a hack in Baltimore and "had a pleasant ride to Washington, where we arrived at 2 o'clock." The young capital was on the threshold of its first "era of good feeling." Exuberance had mounted throughout reconstruction after the War of 1812, and another fresh start had been made only a month before with the inauguration of James Monroe.

Acceptance of Washington, D.C., as the permanent capital had been slow in coming. The decision to build on the Potomac was a compromise made at a dinner in 1791 between Secretary of State Thomas Jefferson, Secretary of the Treasury Alexander Hamilton, and two congressmen from Virginia. In return for Hamilton's support of a southern capital, the Virginians agreed to a federal assumption of the state debts incurred during the American Revolution. Ever since, there had been endless and seem-

ingly hopeless efforts to convert swamps, orchards, and fields of tobacco and corn into a capital city.

More than new building, the reconstruction of the Capitol, White House, War Department building, Treasury Department building, and bridge—all burned by the British in 1814—proved to be a rallying point. As a visitor the year before, Breck had been shown the Capitol and was introduced to its architect, Benjamin Henry Latrobe, the commissioner of public buildings, Colonel Samuel Lane, and the sculptors. Breck must have made a return visit to their offices in 1817: Watson's front and rear elevations were copied from Latrobe's drawings, showing aspects of the Capitol

that were not yet executed. They must have also visited the construction site, for Watson's pencil sketch shows the view of Pennsylvania Avenue from Capitol Hill, with the Tiber Creek wandering behind the scattering of buildings in the vicinity of the White House. The heights of Arlington and Georgetown form the horizon at right.

Despite the jests, Washington grew. The Tiber's marshes were drained, and Jefferson's lombardy poplars lining Pennsylvania Avenue (at left) made an elegant effect. The city was hardly imaginary. It had more than sixty-seven hundred residents by 1810, and soon the Mall would begin to unfold along Watson's sightline from Capitol Hill.

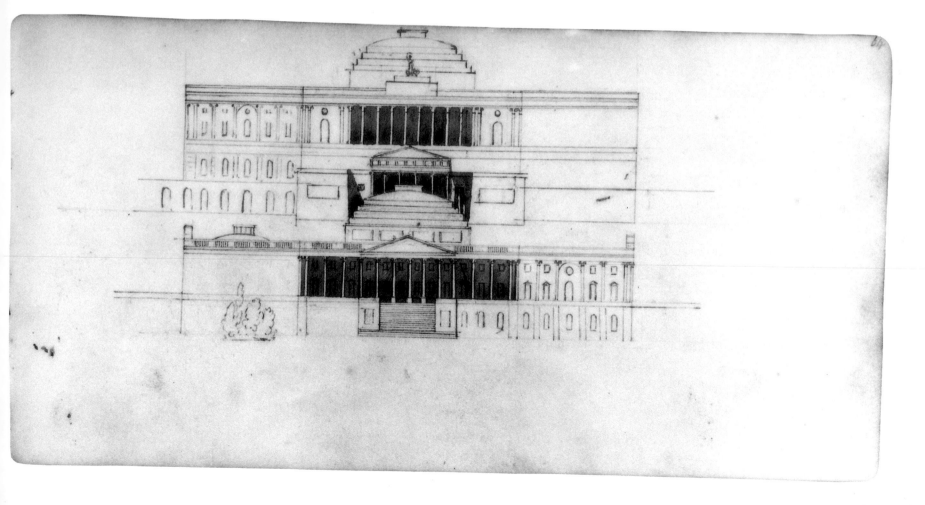

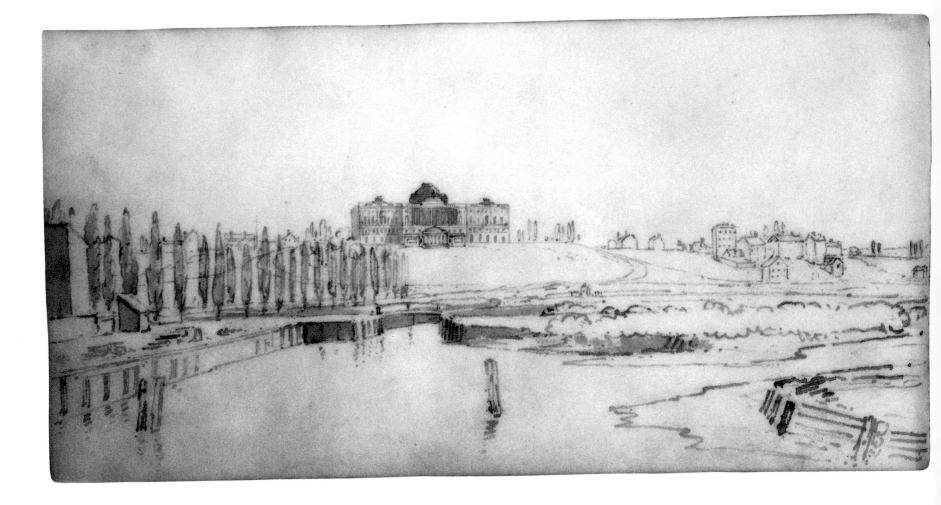

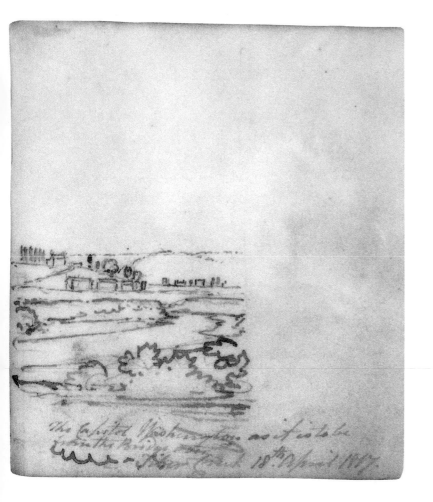

76. The Capitol Washington as it is to be from the Bridge over Tiber Creek 18th. April 1817.

Pen and black wash over graphite (B-58AB)

A man named Pope owned this land in the seventeenth century. He named his plantation "Rome" and its creek "Tiber." No less presumptuous was the vision of Pierre Charles L'Enfant in the 1790s. L'Enfant planned a grand capital but stalled when it came to publishing a map. It would, he feared, lead to the premature sale of land and result in uncontrolled development. Baltimore surveyor Andrew Ellicott was hired to publish a map, and the enraged L'Enfant was dismissed.

Just as L'Enfant had predicted, the sale of lots along Washington's unpaved boulevards went from boom to bust. The vast undeveloped tracts adjacent to the boardinghouses that served as temporary homes to the members of Congress and the administration (seen on the southern slopes of Capitol Hill in Watson's view) were soon sprinkled with speculators' unfinished dwellings.

Thomas Moore visited Washington, D.C., in 1804, and, like many visitors, both foreign and domestic, he was amused by the contrast between vision and reality. He wrote:

This embryo capital, where Fancy sees
Squares in morasses, obelisks in trees;
Where second-sighted seers e'en now adorn
With shrines unbuilt and heroes yet unborn
Though now but woods—and Jefferson—they see
Where streets should run and sages ought to be.

In a similar spirit of fancy, Watson looked back on the spot where he had stood earlier to sketch plate 75 and envisioned the hill crowned by Latrobe's finished Capitol. In fact, the building he saw needed two years' work before its rooms were ready for occupancy and eight years before it was finished.

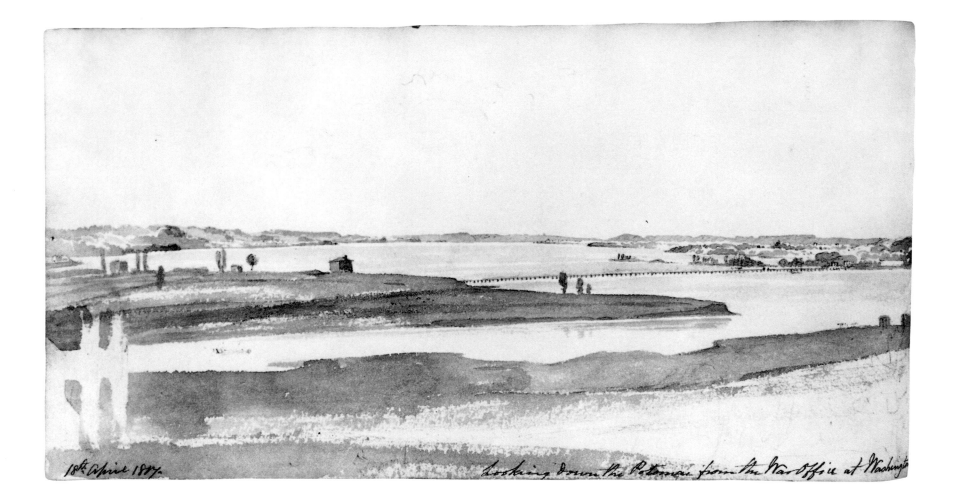

18th April 1807. Looking down the Potomac from the War Office at Washington

*77. Looking down the Potomac from the War Office at
Washington 18th April 1817*
Black wash over graphite (B-63A)

Watson and Breck "went through a fine line of battle ship then on the stocks" at the Navy Yard before visiting the new War Department building. The old War Department office just west of the White House was first built in 1801, burned by the British in 1814, and rebuilt on the same site by James Hoban. Watson paused at an upper-story window to sketch the southerly view of the Potomac that included the mile-long Washington Bridge, also reopened in 1816 after war damage. Today, the same prospect from Seventeenth and F Streets would encompass the Washington Monument, the Jefferson Memorial, the Fourteenth Street Bridge, and, on the opposite filled-in shore, the Pentagon.

That evening, Watson and Breck dined with the British ambassador, Charles Bagot. "Mr. Bagot accompanied us to Commodore Decatur's where we spent a charming evening," wrote Breck of their introduction to the whirl of Washington society. "Mrs. Decatur is a fine woman, the Commodore a soldiery, accomplished gentleman."

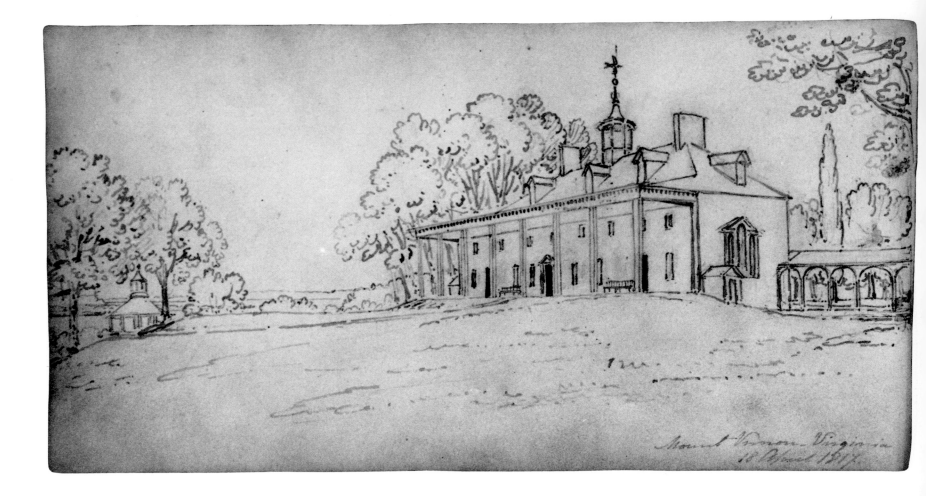

Mount Vernon Virginia
18 April 1817.

78. Mount Vernon, Virginia 18 April 1817.
Pen and black wash over graphite (B-59AB)

"Everything looked shabby at the late seat of great Washington," wrote Breck, "except what depended upon nature, such as prospects etc., and they were fine. Judge [Bushrod] Washington with 20 servants has everything in a slovenly way. The General kept the house and grounds in a stile of great neatness."

The home and tomb of the first president was an appealing side trip for visitors to the capital. The popularity of Mount Vernon, which was under the generous and casual stewardship of Bushrod Washington until his death in 1829, nearly led to its demise. As many as ten thousand souvenir-hungry visitors roamed the mansion's overgrown grounds and ramshackle halls each year.

In 1840, a French minister, the Chevalier de Bacourt wrote: "All is shabby as possible; the park is grown over with weeds; the house is tumbling down; everything dirty and in a miserable condition. The whole country ought to do something for a place which gratitude should make sacred in their eyes. . . . The United States owe their existence and prosperity to his genius; and he lies forgotten amidst uncultivated bushes, and near his house, which will soon be in ruins."

*79. Looking down the River Potomac from the Summer house
at Mount Vernon 18th. April 1817*
Pen and black wash over graphite (B-61AB)

The state of Mount Vernon had become a notorious public shame. And the longer it went unresolved, the more complicated it became. Negotiations with the federal government and the state of Virginia had fallen through, and the family set out to sell the estate privately for $200,000.

That decision inspired ideas in many an entrepreneur. It appalled South Carolina's Ann Pamela Cunningham.

"Ladies of the South," wrote Cunningham in 1853, kicking off her campaign to rescue Mount Vernon, "Will you, can you, look on passively, and behold the home and grave of the matchless patriot, who is so completely *identified with your land*, sold as a possession to speculators without such a feeling of indignation firing in your souls as shall cause you to rush with one heart and spirit to the rescue?" Newspaper editors supported the idea.

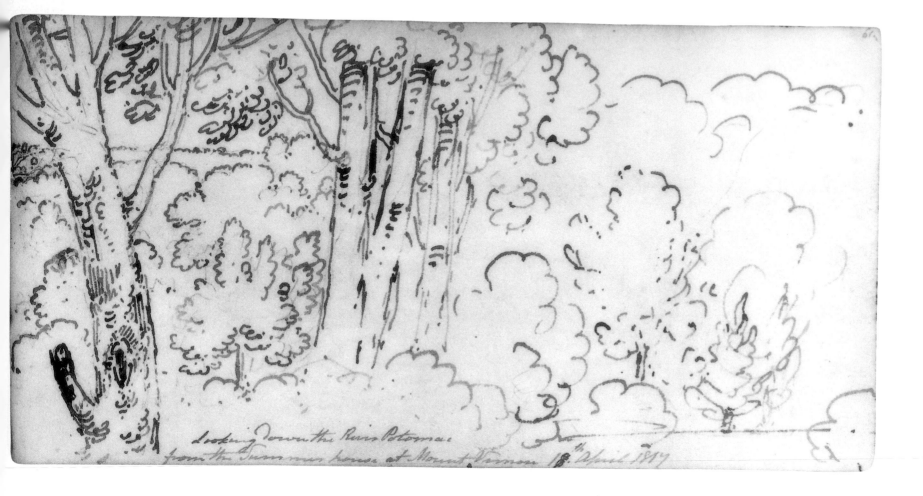

looking down the River Potomac
from the Summer house at Mount Vernon 18th April 1847

Cunningham's letter, first printed in the *Charleston Mercury*, was soon re-printed throughout the South, generating much interest and sympathy and some funds.

Northern Women responded. "Ladies to the rescue!" read a letter in the *Philadelphia Bulletin*, 18 September 1855: "Manufacturing speculators have offered $200,000 for Mount Vernon—that spot, dear, as it *should be*, to all *American hearts*, is to be sold to the highest bidder! . . . Let us rise as *one* woman, and, in the strength of our united womanhood, decide that this shall not be. The sum which is required to save it, seems large—startling at first—but what is a *nation* of women?"

In the spring of 1858, John A. Washington accepted eighteen thousand dollars from the Mount Vernon Ladies Association with the understanding that the remaining $182,000 would be paid over the next four years. The action ensured the preservation of the house, grounds, and the scenic overlooks down the Potomac from the summer pavilion (at the left in plate 78).

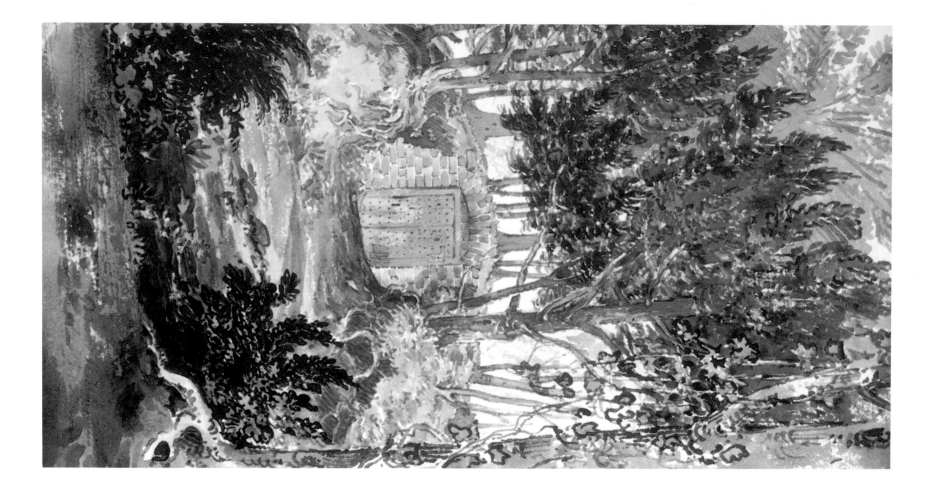

80. General Washingtons Tomb at Mt Vernon [18 April] 1817
Pen and ink and watercolor over graphite (B-62A; color plate 18)

Washington planned to be interred in the old family vault after a funeral "without parade or oration." It was not to be. Four days after his death on 14 December 1799, a procession of troops marching to a dirge with muffled drums was followed by his saddled horse and the officers and Masons bearing his coffin. They marched from the house to the vault near the Potomac, where an anchored schooner fired a salute.

Seventeen years later, Watson and Breck visited a modest brick shrine overgrown with trees planted by patriots paying their respects. Watson's watercolor served as a model for the first plate in Joshua Shaw's lavish *Picturesque Views of American Scenery* (Philadelphia: M. Carey & Son, 1820). John Hill's aquatint, *Washington's Sepulchre Mount Vernon*, (fig. 45) became an illustration of the inadequacy and neglect at the tomb. "This rude and decaying tomb of the most pure and faultless of patriots has long been the subject of reproach to his countrymen," read the accompanying admonition. "Not a stone tells where the hero is laid. No proud column declares that his country is grateful." By 1831, a more stylish and substantial Gothic Revival mausoleum was built, and Washington's remains were moved.

81. From the Gun Foundry near Washington on the River Potomac. 21st. April 1817.

Pen and black wash over graphite (B-56AB)

Henry J. Foxhall owned two military works in Washington: one on Rock Creek and another on the Potomac. During their last day in the capital, Watson and Breck passed it by as they made their way upstream (west) on the Potomac from Greenleaf's Point, where the two branches of the river joined, to the chain bridge.

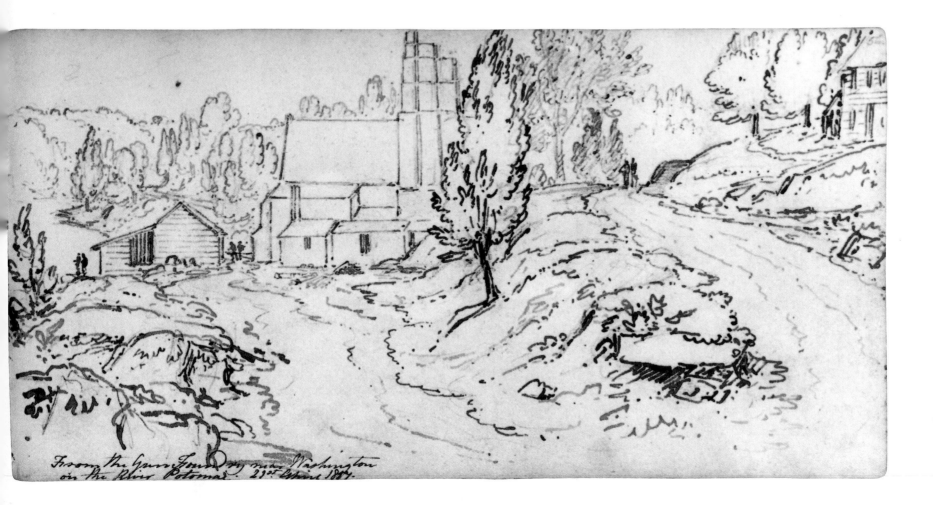

From the Gun Foundry near Washington
on the River Potomac. 23rd April 1827.

82. *Bridge at the Lower [Little] Falls of Potomac 21st.*
April 1817
Pen and black wash over graphite (B-57AB)

The Potomac narrows toward the northwestern edge of Washington. When Watson and Breck traveled upstream the half-mile from the gun foundry (plate 81) toward the Little Falls, they saw the seven-year-old

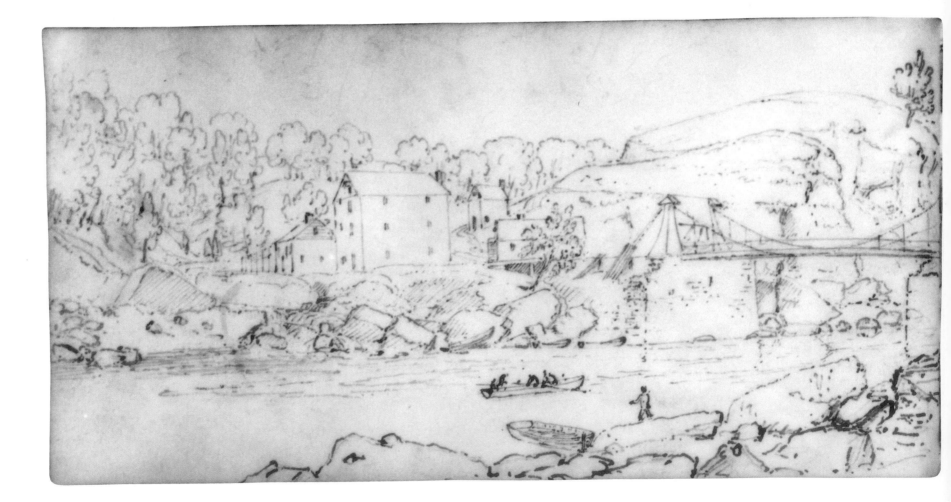

chain bridge, which replaced a covered bridge, built in 1797, the first across the river. A new woolen manufactory stood on the opposite shore. Today the site is part of Palisades Park.

Back in town by evening, Watson and Breck were invited to Commodore and Mrs. Decatur's house one last time. The following morning, Breck sent Watson off to Baltimore. "I furnished my friend Watson with a letter for Mrs. Wirt of Balto. where he was desirous to lodge and being obliged to stay a day or two in Washington, I bade him goodbye." The friends rejoined there on 23 April and took a roundabout route home, traveling up the Susquehanna River to Columbia, Pennsylvania, before turning east to Philadelphia.

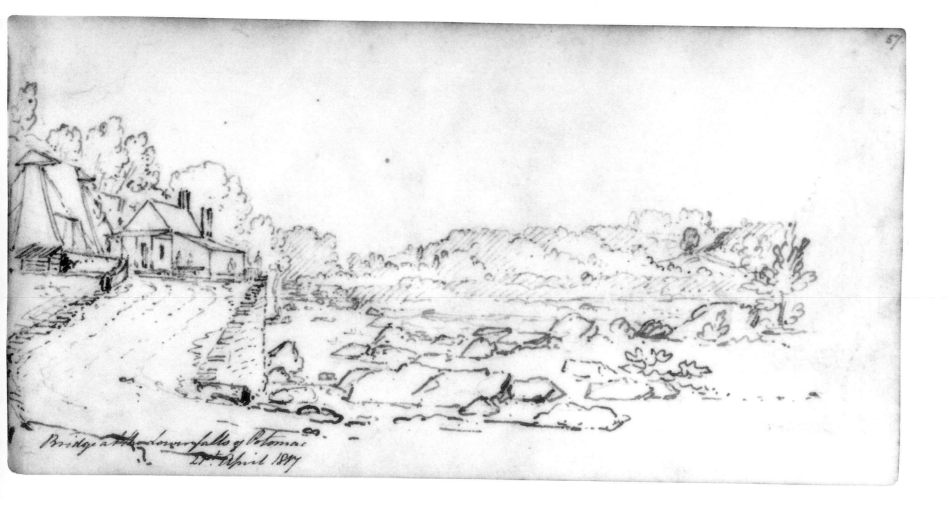

Bridge at the Lower falls of Potomac
21st April 1817

83. Looking up the Susquehannah from the Point below Cryts Creek with Columbia Bridge of 51 Arches being 1 mile & 25 Rods long 25th. April 1817.

Black wash over graphite (B-51AB)

The major river crossing for traffic moving between Lancaster and Pennsylvania's western counties was over the Susquehanna between Columbia (right) and Wrightsville (left). Before the one-and-one-eighth-mile-long bridge was finished in 1814, travelers crossed the river in the fashion elegantly depicted by Pavel Svinin circa 1811–13 or prosaically described by Joshua Gilpin in 1809:

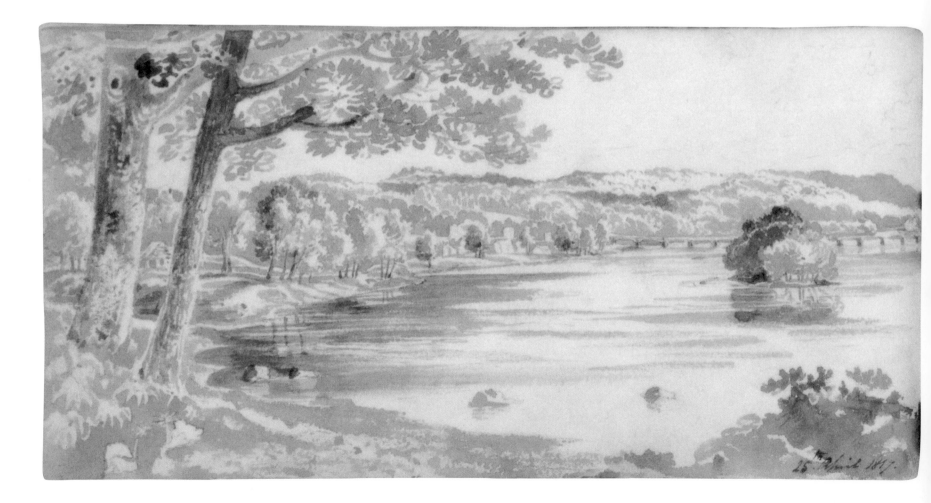

We crossed the Susquehanna at Columbia about 8 o'clock, the carriage & horses in a long scow: as the river abounds in rocks & flats to avoid accidents. Mr. G. Henry & myself took a small batteaux with a man to row it, in which we crossed in about 20 minutes & the Scow in about half an hour, the water not being high & the current by no means rapid, we could everywhere see the bottom the water being quite clear . . . the deepest part was not more than 5 or 6 feet but so shallow in many places that our boat which drew almost 5 or 6 inches of water almost touch'd some of the rocks. . . .

Governor Simon Snyder granted a charter to build a bridge between Columbia and Wrightsville in 1811 (see plate 84). This bridge was carried away by ice in 1832. Its replacement was destroyed three days before the battle at Gettysburg on 28 June 1863, burned by the northern army as a defense against encroaching southern troops.

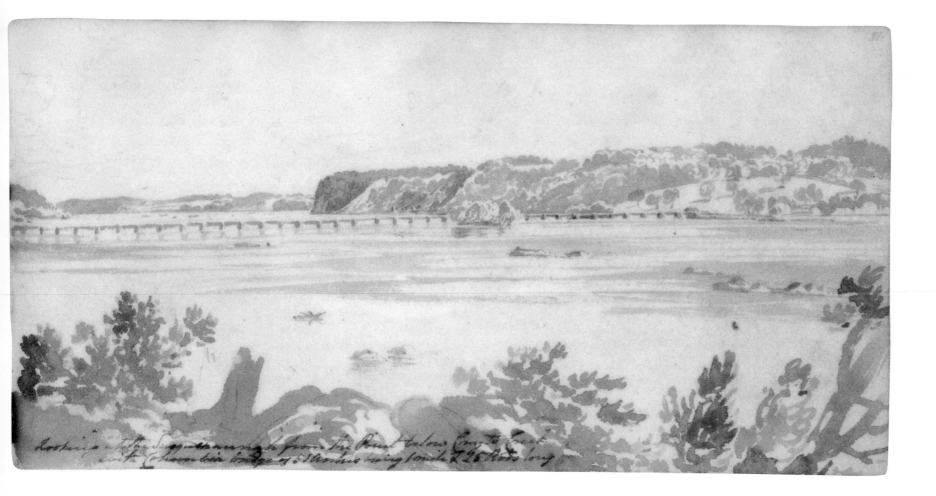

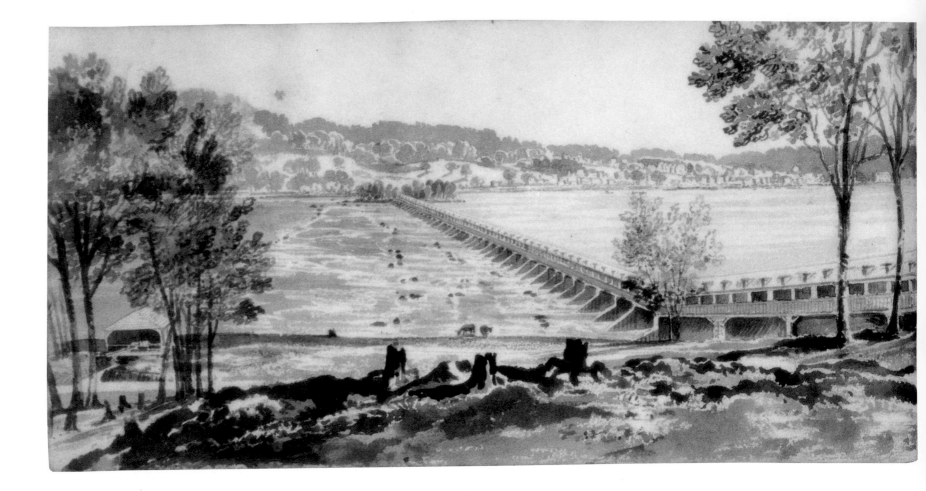

84. View of Columbia Town & Bridge over the Susquehannah looking down the river—25th April 1817.

Black wash over graphite (B-52AB)

If William Penn had gotten his wish, a second Pennsylvania metropolis would have been planned on the shores of the Susquehanna. By the end of the eighteenth century, Wright's Ferry, as the town of Columbia was first named, had grown into a regional commercial center, although the town retained the "air and shade and leisure" of the countryside, as Watson's view from across the river at the Wrightsville toll house shows.

"I languish for the country, for air and shade and leisure and converse," wrote Benjamin Franklin to Susannah Wright, "but fate has doomed me to be stifled and roasted and teased to death in a city." Despite her isolation, the daughter of John Wright, the first ferry owner, maintained friendships with the literati back in Philadelphia. When Benjamin Rush passed through on his way to Carlisle in 1774, Susannah Wright told him

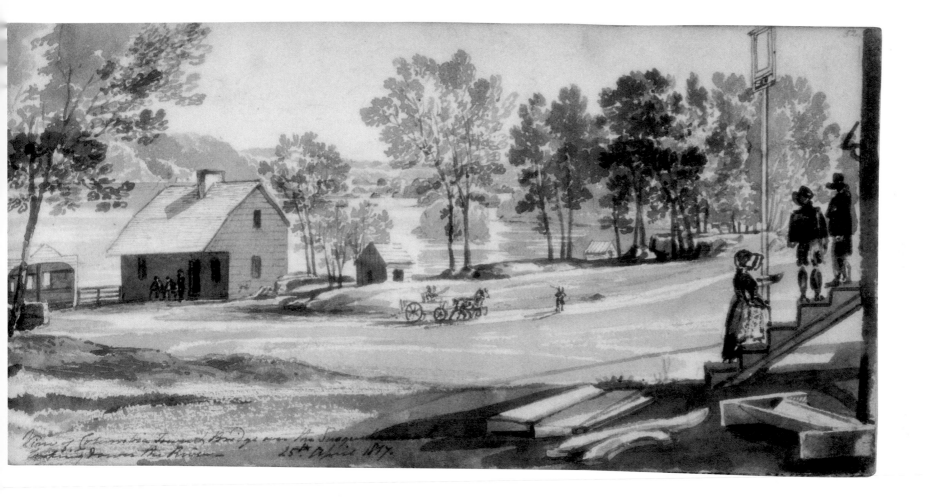

that books had been "a tremendous blessing" during her sixty-two years on the Susquehanna.

The Susquehanna's second chance to bear a metropolis came in the late 1780s, when Wright's Ferry was suggested as a permanent site for the United States capital. As Congress was hearing Pennsylvania Senator William Maclay propose Wright's Ferry, Harrisburg, York, Lancaster, or Germantown as the capital, Susannah Wright's nephew Samuel began promoting the idea back home. The name of the town was changed to Columbia and Wright engaged speculators by selling lottery tickets for 160 parcels of land. But Alexander Hamilton dashed all hopes by engineering a deal with southern legislators, who landed the capital on the Potomac, at "Washington, District of Columbia."

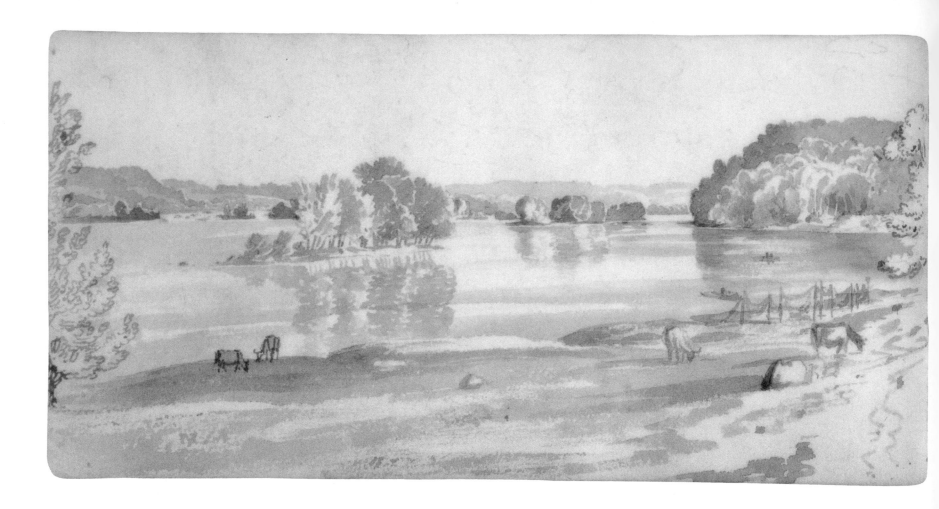

85. Looking down the Susquehannah fm Wrightsville ferry
25th April 1817
Pen and black wash over graphite (B-50AB)

Ambitious Pennsylvanians considered the Susquehanna a connection with Pittsburgh and a gateway to the west. In 1789, the newly formed Society Promoting the Improvement of Roads and Inland Navigation lobbied with the state Legislature for an internal commercial network of rivers and canals. Conservatism prevailed. Two years later, the society again made the case that canal building and river clearing would result in "an almost unbounded prospect of future wealth." Legislators were not convinced. A more hesitant and piecemeal approach to canal building was taken.

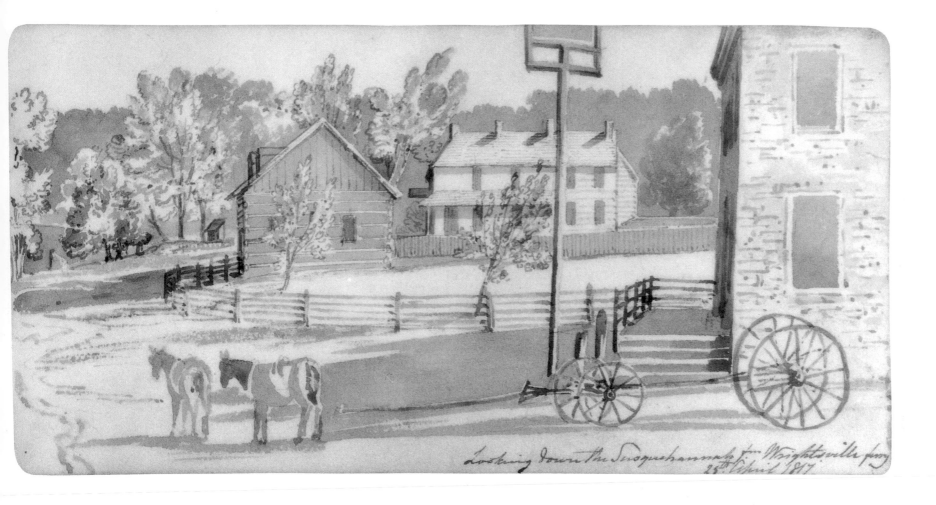

Looking down the Susquehanna from Wrightsville ferry 25th April 1817

Until canals were completed along the Susquehanna from the mouth of the Juniata River to the Chesapeake, boatmen learned to navigate the river (see plate 86). During 1801 and 1802, architect-engineer Benjamin Henry Latrobe and a Maryland team surveyed and supervised the clearing of natural obstacles from Columbia, where the river became especially treacherous, to Havre de Grace, forty miles downstream.

Watson was attentive to the commercial bustle and enjoyed the picturesque scenery. He sketched views from Wrightsville that emphasize the ambitious engineering of the bridge (plate 84) and the substantial log and masonry structures that served the traffic on the river and the roads. The tall signs posted in front of the buildings at the right in this view (and the previous one) indicate inns or taverns where Watson and Breck doubtless paused in their journey.

86. Looking down the Susquehannah from the end of the Town of Columbia—24th. April 1817.

Pen and black wash over graphite (B-55AB)

Philadelphian Joshua Gilpin wrote in 1809 of the barges on the Susquehanna:

They are in fact nothing more than a cast, rough, and unwieldy box, being flat bottomed & perpendicular at the sides, about 60 to 90 feet long—from 15 to 20 wide and about five feet deep—they are so rough as to be put together only with wooden pins or dowells—they carry an immense quantity and draw about 2 feet of water—these are built at the places of embarkation on the upper parts of the river, & loaded at the time of freshets only, as they cannot be navigated in any other sea-

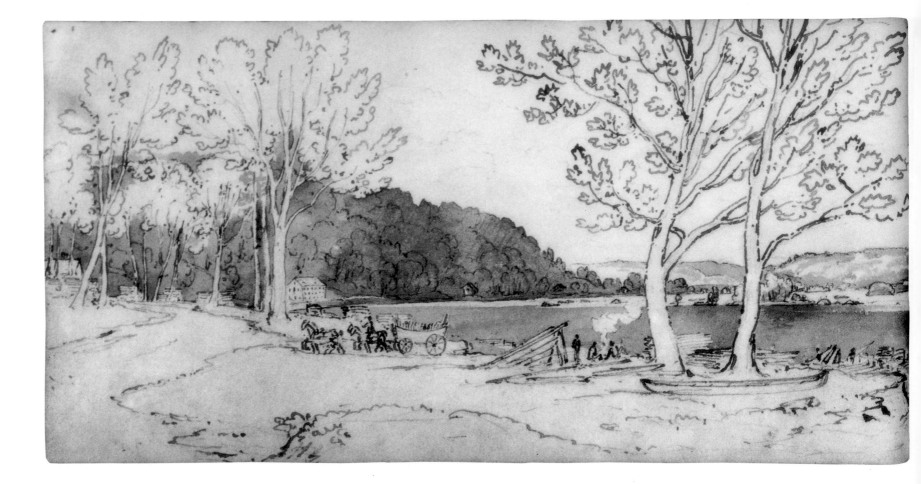

sons they have neither oars or sails but depend soley on the velocity of the current and are guided by one long oar for a rudder at each end—thus strong, they bounce & tumble over the falls & rapids it being only necessary to keep them from running aground as they are then knocked to pieces. . . . the boatmen are so expert however that these accidents do not often happen; when they arrive at Columbia they are unload'd broke up & sold as lumber—several we saw at Columbia had a vast quantity of coal on board.

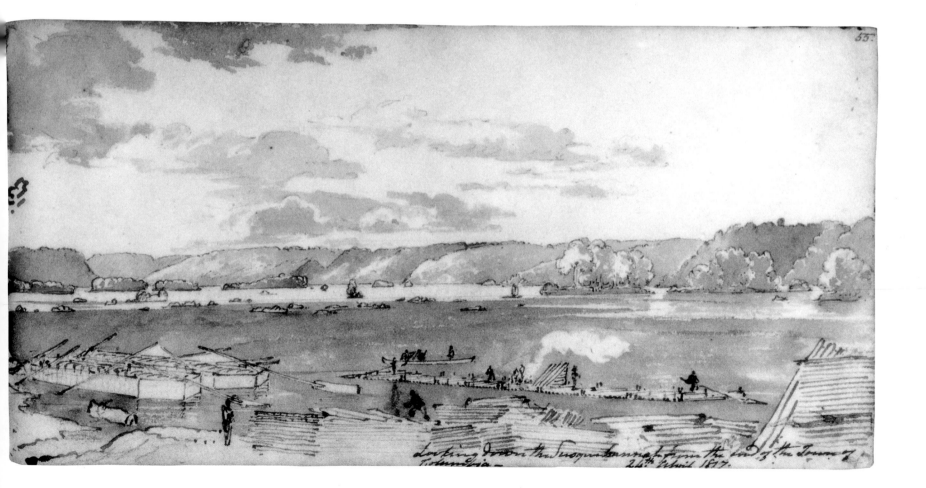

87. Looking up the Susquehannah a little above Columbia Bridge—26th. April 1817.

Pen and black wash over graphite (B-45AB)

Tales of natural history on the Susquehanna mingled with tales of human history. One popular local legend told of bargeman Kryder, whose mill was eighty-six miles up the Juniata River. In the spring of 1795, Kryder heroically "came down from his mill . . . with one hundred and seventy barrels of flour. He passed Wright's ferry [Columbia] in the morning, and was at Havre de Grace time enough in the evening of the same day, to put his flour on board a shallop, which delivered it at Baltimore, the next day at twelve o'clock." Perhaps the water was high enough in April 1817 to inspire the boatmen in this view to similar feats of navigation.

Watson was "so pleased" with life on the Susquehanna and its shores, that, according to Breck, they "staid sketching on its beautiful banks." In two and a half days Watson made eleven different views. The very morn-

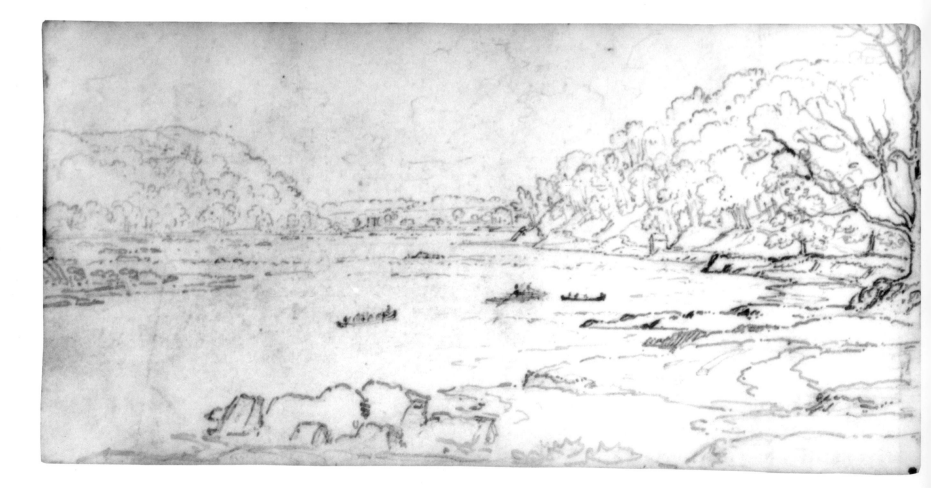

ing Breck and Watson were to leave, they made an early jaunt upstream to Chickies Rock, traveling along the river road on the eastern shore above Columbia Bridge. Watson made five drawings on this one stretch of the river (plates 87–90; B-49–45).

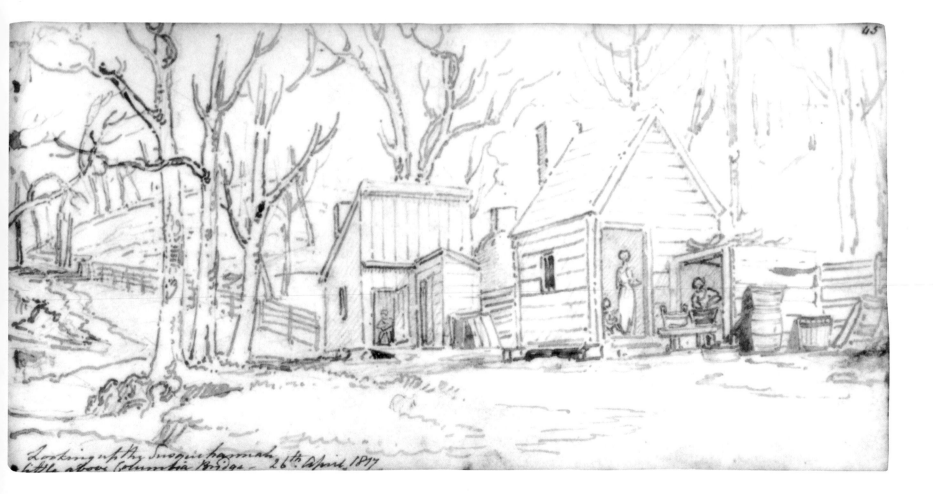

88. Halfway houses near Chickey's Rock—On the Susquehannah 26th. April 1817.

Pen and black wash over graphite (B-49AB)

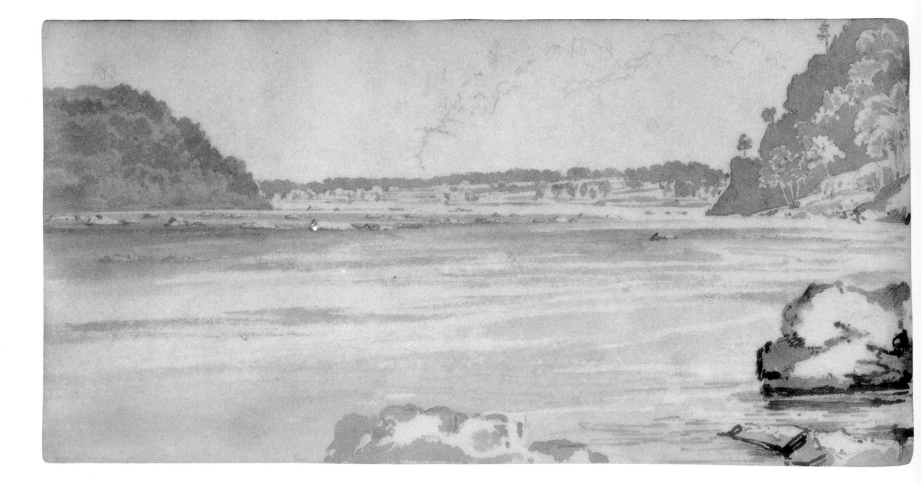

Trade on the Susquehanna between the Juniata and the Chesapeake was substantial enough to support a community at the halfway point, upriver from Columbia, in the shadow of Chickies Rock. But the network of rivers and canals making this trade possible was quickly becoming outdated. Only late in 1824, a year before the Erie Canal gave New York the upper hand in trade, did Philadelphians realize that the economic future of their city was linked to comprehensive, up-to-date transportation to the west. The Pennsylvania Society for the Promotion of Internal Improvements was founded with the anxious admission that "a large proportion of the western trade has been withdrawn from this city, and the present exertions are calculated not merely to regain what is lost. The struggle assumes a more serious aspect. It is to retain what is left."

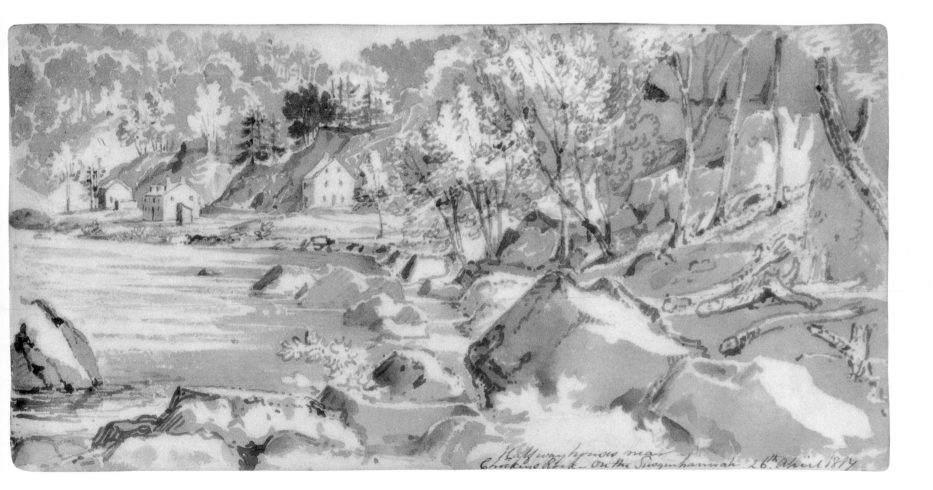

89. Mill at the Half way Houses near Chickeys Rock on the Susquehannah 26th. April 1817.

Black wash over graphite (B-48AB)

Watson stood on the shore under Chickies Rock and turned his gaze south along the row of buildings already depicted from downstream in plate 88. These mills and "half-way houses" serving traffic on the Susquehanna were a community with only meager prospects in 1817. As long as there was no more modern linkage to the west, what came down the river was, increasingly, of regional rather than of national importance.

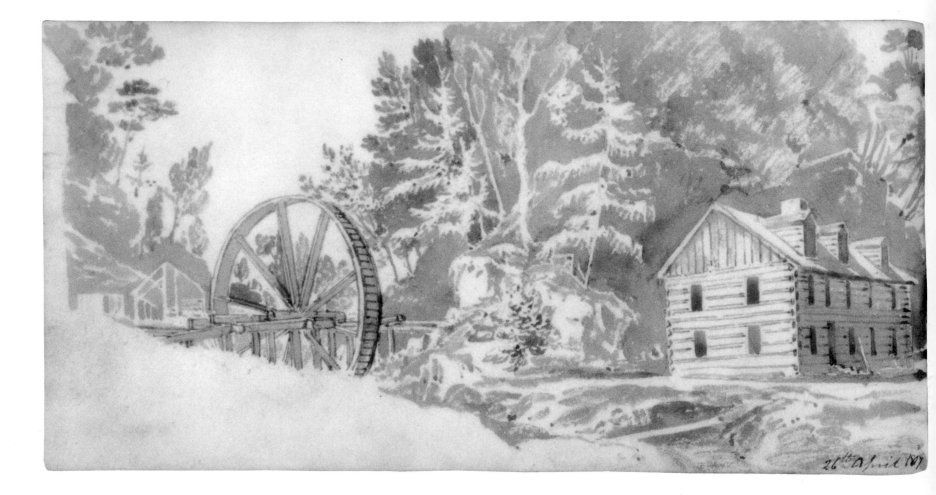

Plotting to catch up, The Pennsylvania Society for the Promotion of Internal Improvements hired architect William Strickland to study the trends in commercial transportation. It was no surprise that his 1826 *Reports on Canals, Railways, Roads and other Subjects* found Pennsylvania's three thousand miles of turnpike obsolete. But Pennsylvanians expecting the proposal of another canal project instead learned that the future was on land, in railroading. Susquehanna barge traffic was more out of date than anyone had guessed.

The completion of the Columbia Railroad in 1834, the first link in the Philadelphia-to-Pittsburgh "main line," revitalized commerce between east and west. Watson returned to Philadelphia along this same trajectory but at the slower pace of the stagecoach.

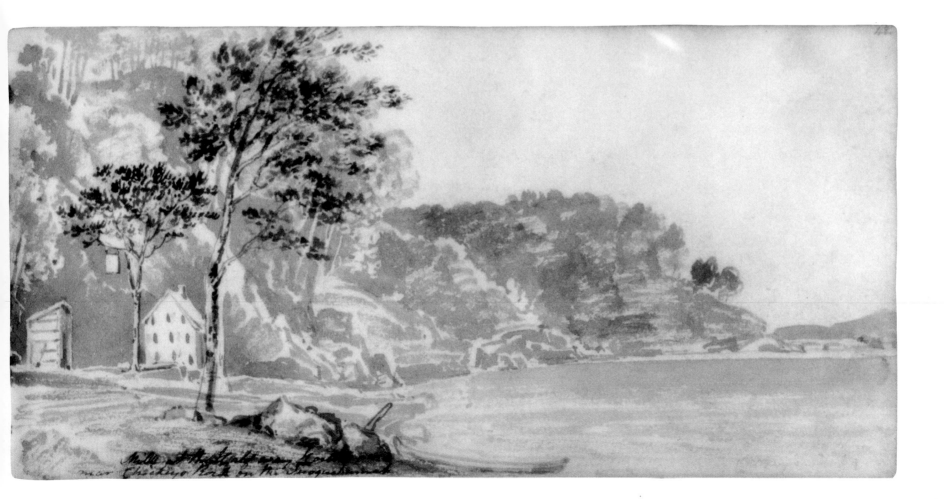

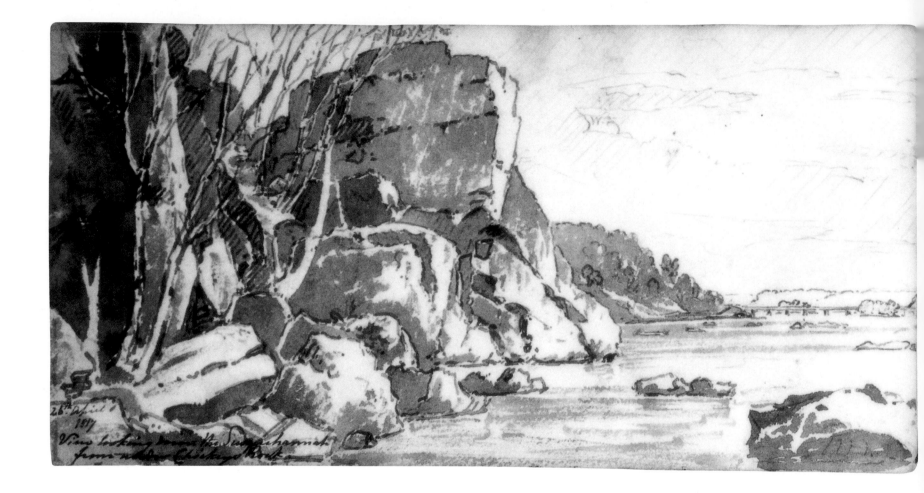

90. View looking down the Susquehannah from under Chickeys Rock. 26th. April 1817
Pen and black wash over graphite (B-46AB)

A ridge of quartzite called Chickies Rock abuts the Susquehanna, not far upriver from Columbia (see plates 83, 88). It was named for the nearby Chiquesalunga Creek (from the Indian word *chickiswalungo*, mean-ing "place of crawfish"). Nineteenth-century railroad construction cut through parts of the ridge, but the twentieth century had a kinder treat-ment. Today it is protected in a county park known for the migrating birds that rest there. With the mills seen in plate 89 now hidden by the rock, Watson's view again takes in the Columbia Bridge and Turkey Hills, six miles beyond. Having gained his highest point on the river, Watson re-turned to Columbia and boarded the stage for Lancaster, where he spent

the night. The following morning, he continued on to Philadelphia and ended this two-week tour back at Eaglesfield, where he stayed for an additional six weeks.

On the fourteenth of June, after almost precisely a year in America, Watson departed aboard the *Rebecca Sims* to return to England. "I shall ever feel attached to this good hearted gentleman," wrote Samuel Breck. A month and a day later Watson arrived back in Liverpool.

PART III

Watson's Art

Inventing a Personal Style in Watercolors

Joshua Rowley Watson showed "a turn for drawing" before the age of eight, and his father encouraged this talent by arranging for his son's art instruction, either at boarding school in Surrey or from a drawing master nearby. In doing so, Thomas Watson probably did not expect his son to become a professional artist, for drawing was seen as a gentlemanly accomplishment, akin to the skills in dancing and fencing that Watson also acquired at school. Perhaps Captain Watson also thought that expertise in drawing might prove useful to his son, "should he chuse the navy" as a career. To young men with such expectations, training in art offered two possibilities: the pleasant, self-rewarding practice of the amateur "fine" artist or the more practical application of skills to military purposes. The two paths were not mutually exclusive, and Watson, like many another military officer, pursued both in alternation.

Until he arrived in America, Watson managed to keep his two types of art work apart in both appearance and intent. The subjects, media, and, to a degree, techniques remained distinct in each genre. The separation was never very tidy, for the military draftsman shared many qualities of period style with the "artistic" watercolor painter. But such separation as Watson had maintained ceased when he landed in the United States. The excitement and pressure of travel in a picturesque new landscape confused and altered his earlier categories, producing a new personal style fit to the occasion. The two contributing strands in Watson's work remained present and recognizable, however, and their sources and characteristics deserve analysis.

First, and surely earliest in Watson's consciousness, was his sense of the military utility of drawing. He was born to be a naval officer, and it seems no coincidence that his earliest extant sketches are of

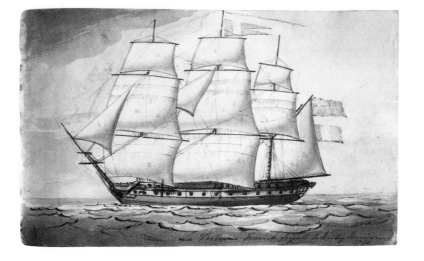

33. Joshua Rowley Watson, *La Tribune, French frigate taken by Unicorn, 1796,* watercolor, pen and ink on paper, $6\frac{5}{8} \times 9\frac{1}{8}$ in., Collection of Elizabeth Burges Pope.

ships (figs. 6, 7, 33). As a military artist, he would have seen his mission as descriptive; like the British topographical landscape painter, who held a similar position in the ranks of professional artists, his work stressed detail and accuracy. Drawing was taught to students at the Royal Army and Navy academies at Woolwich and Portsmouth and at other military schools including West Point (beginning in 1803) and at Watson's own Chelsea Maritime School.

Although these classes were usually supervised by a "fine" artist, such as Paul Sandby, who taught at Woolwich when Watson was a boy, or John F. Weir, who taught at West Point, drawing was taught in these schools as a communication skill. Officers might need to supply reconnaissance sketches, read and draw maps, or undertake engineering projects that required visual literacy. At the very least, drawing exercises were understood to sharpen observation. Watson may have learned a bit of perspective and mechanical drawing from this tradition, and he absorbed attitudes that kept his American sketches honest. In this mood, Watson drew plans and diagrams,

ships and wagon types, mills and bridges, forts and bayonet mounts. We can assume that, when he sketched the USS *Independence,* he got the number of gun ports right.[1]

But Watson was not the usual military artist; he may never have served officially as one. Talented draftsmen who showed an inclination were made into specialists, serving the Ordnance Board or the Admiralty's hydrographic archive. Watson, by choice or family pressure, followed his father and uncle to the more gentlemanly station of post-captain. Typically, a captain would not be assigned work on maps and views; he had other work to do and other men to supply such reference material. Watson's private journal in the Caribbean notes the preparation in 1810 of watercolors "for the Admiral," but it is not clear whether he undertook these views as a task or as a personal favor.[2]

Personal rather than professional interest also may explain why Watson retained for himself a series of coastal surveys made on his next station, in the Mediterranean (see fig. 12). None was filed with the Admiralty (although these could be drafts prepared before more finished views), but they represent Watson's landscape work at its most businesslike, military pole. Such drawings, made from the deck of a ship standing a mile or two off shore, were the stock in trade of a naval artist, who would render an elevation of the seacoast that complemented the navigational charts and maps of the same area. As early as age eleven, as a student at the Chelsea Maritime School, Watson had been making such coastal surveys. Painted on double sheets of sketchbook-sized paper, his images appear on one side of the page only, as if intended for mounting. Restrained and spare, with less color and fewer artistic contrivances than the watercolors made for his own private purposes, these coastal profiles cover the page uniformly from edge to edge. The watercolor washes are pale and transparent, leaving the linear network of the pencil underdrawing crisp and legible. Annotations identifying major landforms announce the priority of information over art. Straightforward tools for naval business, these drawings are frequently striking and beautiful too.[3]

Watson produced nothing quite like these Mediterranean surveys when he was in the United States, although the tradition organizes his harbor views of Philadelphia, New York, Boston, Baltimore, and

New Haven and the running shoreline profile of the Hudson River that occupies so many pages in his first sketchbook (fig. 34; see plates 42–48). As in the earlier views, Watson used the double page of his American sketchbook from margin to margin to grasp the widest possible panorama. When he had more time and was seeking a consciously artistic effect, he would crop his compositions at midpage, seeking an appropriate framing border within the subject. Certainly his earlier experience made him comfortable, even graceful, within the strange horizontal format of his open sketchbook. Only occasionally, as at Passaic Falls (plate 72), does this narrow page seem confining. Watson's adjustment to these proportions is so complete, one finds a surprising emptiness in his larger essay, using a more conventional sheet, *View on the Schuylkill* (see fig. 40).

Watson was not alone in favoring this horizontal format, although his taste in proportions was more extreme (1:4) than the usual (1:3). English topographers had used this format since the late seventeenth century, and in Watson's day other painters had been drawn by the panoramic possibilities: John Vanderlyn was at the same moment planning his enormous walk-in "cyclorama" of Versailles. With this same impulse, Thomas Girtin had exhibited a circle of watercolor

views of London from an overlook on the Thames in 1801–2. Closer to home, Watson could have found Francis Towne in Exeter using his sketchbooks in exactly this way.[4] Excepting Towne, the difference between these efforts and Watson's was largely a matter of scale and finish; the difference between his American sketchbooks and his own earlier coastal profiles was largely a question of time. The watercolors of 1811–12 were done slowly and carefully, over hours, from a stationary position at anchor off shore; the sketches of 1816 were made from the deck of a steamboat sailing relentlessly upstream. The schematic brevity of Watson's upper Hudson River drawings may be disappointing when compared with his more studied views, but they in fact represent an impressive athletic feat of observation and record. With steam travel on the river barely ten years old, Watson — along with George Heriot (see fig. 43) — was one of the first painters to accept the challenge of such modern conditions. Others would stop and work selectively. The topographer in Watson tried to capture it all.

Consistent, perhaps, with the energy of Watson's "military" art was the modesty of his posture. His skill was known to his contemporaries, such as Samuel Breck in Philadelphia and Joseph Farington in England, but Watson never pressed for recognition as a painter.[5]

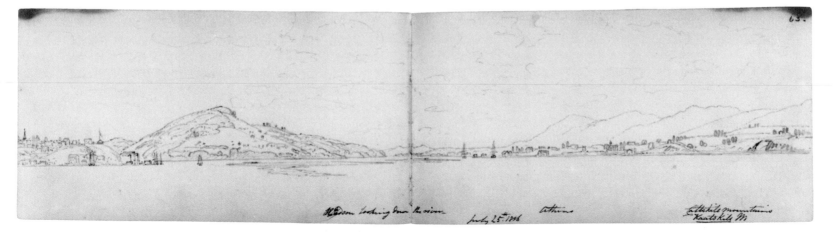

34. Joshua Rowley Watson, *Hudson looking down the river. July 25th. 1816 Athens Cattskill Mountains. Kaatskill M*, pen and black ink over graphite, New-York Historical Society sketchbook, p. NY-63AB.

In America he made no effort to meet other artists; in England he never exhibited his work outside the circle of his family and friends. This attitude, combined with the integrity of his naval identity and the documentary qualities of his drawings, invites us to categorize Watson as a military draftsman, whether or not the Admiralty actually employed him.

But to confine Watson to this category is to overlook the coexisting qualities in his work that lift it above draftsmanly competence and beyond antiquarian interest. His handling of line, color, modeling, and composition was unnecessarily elegant for strictly utilitarian purposes. An assertive aesthetic sensibility organized all his views, even the most documentary ones. These artistic conventions did not come from his military experience; instead, they show familiarity with the most sophisticated professional landscape painting in watercolors of his day. The military tradition occasionally produced artists of wider ambition and accomplishment—such as Paul Sandby's student George Heriot—who consistently exceeded the demands of reportage to engage the issues and conventions of contemporary painting. Like Heriot, Watson maintained an exceptionally high level of progressive, artistic consciousness.[6]

This aesthetic sensibility must have been as old in Watson's experience as his "turn for drawing." Certainly his artistic indoctrination began in earnest with the commencement of formal instruction, about the age of eight. Most of the military-gentleman-artists like Heriot and Watson who showed special competence had received such training from sources outside the professional military schools—a circumstance that accounts for the difficulty in isolating purely "military" or topographic qualities in the naval draftsmanship of the day.[7]

Without knowing anything about the drawing lessons Watson took as a boy, we can imagine a course of study for him based on mainstream British practice in the 1780s. He probably learned to sketch in both pencil and pen, for crisp outline dominated the drawing style of the period. His earliest extant drawings are done with a fine stiff pen, in very black ink (see fig. 6), a technique that endured in a more fluid style in his American sketchbooks. He must have been taught to handle brush and ink, or a few pale colors and neutral washes, to add modeling tones and light tints to his outlines. Until early in the nineteenth century, most British watercolors had the character of a shaded and tinted pen drawing or print; artists and amateurs of all persuasions, from Rowlandson to Blake, shared this effect for a time, but military draftsmen and topographers retained it the longest, partly because "etched outline" was stressed in the work and in the teaching of Sandby, the Royal Army College's influential drawing master. Sandby, an army draftsman who rose to an important position in the Royal Academy, demonstrates to us, as he did to hundreds of painters in his own day, the interpenetration of the descriptive tradition and the more self-consciously artistic landscape painting of his time.[8]

In North America, Sandby's pen style manifested itself awkwardly in the landscape drawings of Charles Willson Peale, more fluently in the sketches of John Trumbull, and most effectively in the watercolors of Thomas Davies, who used the technique more frequently than his two contemporaries. Davies, a British army officer trained at Woolwich, preceded Watson on the shores of Lake George and the Hudson by more than fifty years.[9] Like Watson, Davies made watercolor a leisure-time avocation as well as a professional duty, and—like Watson—he mixed military and artistic purposes freely, submitting his topographical subjects to a highly developed aesthetic sensibility. Although their differing techniques and visual conventions reflect generational changes, both painters developed two styles: one more straightforward documentary (albeit artificial) manner for sketching and another more contrived and polished manner for finished "exhibition pieces." In this latter, elaborate style, Davies's pictures showed the richer coloristic effects pioneered by his contemporary Sandby, whose work left no British watercolorist in this period unaffected, but the idiosyncratic and charming stylization of these finished pieces took Davies somewhat out of the mainstream. However, his sketchbook of 1773–97, analogous in purpose to Watson's, demonstrates the standard sketching tradition of about 1780 with clarity. In *View near Morris House* (fig. 35), Davies's lively, wiry pen line organizes his clean and relatively simple washes throughout; often, such pen drawing lay both above and below the tints. This style held sway when Watson was a boy, and whether he

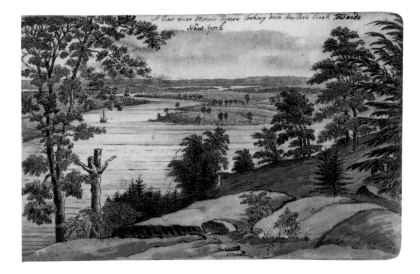

35. Thomas Davies, *A View near Morris House looking Down Harlem Creek towards New York*, ca. 1773–1797, watercolor, black wash, pen and ink, and graphite on paper, $4\frac{7}{16} \times 7\frac{1}{4}$ in., from a sketchbook in the National Gallery of Canada, Ottawa.

learned it from Davies (who was for a time stationed in Plymouth with Watson) or Sandby or the Devon watercolor painter Francis Towne, who enacted an expressive version of this mode, the traces of its linearity endured to the end of Watson's career.

Although his overall effect seems soft, atmospheric, and painterly compared with Davies's, Watson's practice followed essentially the same late eighteenth-century method. He always worked first (sometimes only) in black and white. Sketched in pencil and then traced with a pen or the tip of the brush for an overall linear network (see fig. 1 or color plate 2) or blocked in with broad washes (plate 11), his drawing began in light and dark. To a watercolorist of this period, color was something to be added later, at home, either on top of the original sketch or over a more careful, finished replica based on field notes.

This secondary application of color responded to both conceptual and technical demands on the medium in this period. First, it

showed the aesthetic priority given to line or value structure, usually established in pen, ink wash, or "neutral tint" over a graphite sketch.[10] As often as not for Watson, this formed a sufficiently complete effect without color. Second, the division of value and hue allowed—or demanded—a moment for the tonal underlayers to dry before colored glazes could be superimposed cleanly. Watson's habit of sketching while the stagecoaches were changing teams or the steamboat paused to take on new passengers hardly gave him time for sequential watercolor washes. While on the road, he probably worked mainly in pencil. A few such sketches that he never developed with ink or wash remain in his sketchbook as records of this initial phase.[11]

Although this technique was expedient for a topographical artist, it was also the most common practice for amateur and professional landscape painters in this period. Outdoor sketching in colors grew popular only in the generation after Watson's death; pocket-sized portable equipment was not common during his lifetime, and even the most inveterate and revolutionary watercolorists before 1820, such as J. M. W. Turner, usually sketched outdoors in pencil with quick washes and at home in full color. American painters did not take watercolor paints into the field with them regularly until after the Civil War.[12]

Evidence in his diary also suggests that Watson rarely took brush or pen into the field. The diary of his first weeks at Eaglesfield contains several references to rainy days spent "filling in" views at home.[13] Confined to the house by an ailment on 25 June, he amused himself writing letters and drawing: "Indeed from the great variety, and new matter occuring every ride or drive I take, 'tis necessary to make good use of my time in filling in my sketches."

To keep up, he experimented with new techniques for developing a sense of color and space efficiently. "A reed pen makes quick work," he wrote, "and by using licquid Scipia for the front & second ground, and licquid Indigo for the distance, a good effect is produced and an easy sketch composed." The choice of this blunt reed pen, rather than a sharper metal point, and the use of watery sepia, blue, and gray, softened Watson's contours and set his style apart from the crisper division of line and wash held by earlier generations. Many of Watson's most fluid and beautiful American drawings demonstrate

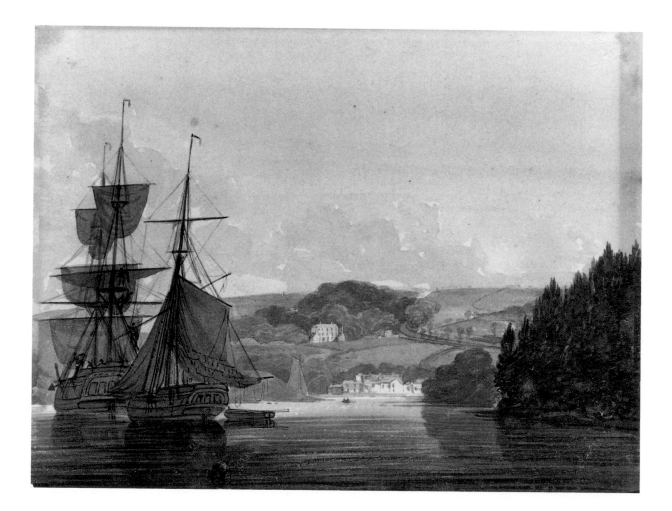

36. Joshua Rowley Watson, after William Payne, *Bell Vue near Hoo Cattwater*, ca. 1798–1804, watercolor on paper, $5\frac{7}{8} \times 6\frac{1}{4}$ in. (sight), private collection.

the development of this method, which does not appear in his work before 1816 (color plate 8). Although only a few pages in his sketchbook use both blue and brown together, as he suggests (see plates 33 and 34), the majority of his views combine one of these colors with gray to produce Watson's "good effect."

Plates 33 and 34, from a suite of six sketches (B-94–99; see also plate 30) all made on 18 September 1816, were done on an artistic outing with Samuel Breck, who noted in his diary that day: "We brought home several romantick views."[14] Because the two friends dedicated the whole day to sketching, it seems likely that Watson produced his six views entirely out of doors. Some remain undeveloped, others are more finished, but all depend on a restricted palette of black, brown, and blue applied in washes with a brush or a broad pen over a graphite sketch. This series probably illustrates the tools that Watson took into the field and the range of effects he was willing to essay on the spot.

Watson invented this style to suit the circumstances of his American trip; there is nothing as bold and suggestive in his earlier sketchbooks, although the confident pen manner and expansive compositions appear in a few drawings of the Plymouth area in 1815 (see fig. 13). His new style came quickly to him in America, where he had the time and inspiration to sketch frequently. Like Watson himself, this sketching manner stood between the eighteenth century and the modern period: based on a linear, intellectual tradition, it was altered to grasp more atmospheric effects, more "romantick" landscape sentiments, in addition to topography. The pale, restricted palette, blunt pen, and network of linear activity in Watson's style link it clearly to the work of his contemporaries in the generation after Sandby, who sought to relax and soften earlier linear conventions with broad, suggestive washes in subtle hues.

Watson could have looked to Sandby again when he expanded his palette and the scale of his work, as happened occasionally in America. The dominant tendency in British watercolor painting during Watson's lifetime was toward denser, more saturated color and larger size, building to work that competed visually, on exhibition, with oil painting. Usually a low tone prevailed in such work, emphasizing earth colors, blue, gray, and contrasts of light and dark (as seen in Thomas Girtin's oeuvre or Turner's early watercolors), but effects of brighter, more opaque or intense color began to appear. Watson had essayed full-color effects long before his American tour, as seen in a dated watercolor of 1795 showing Pembroke Castle, Wales (Pope coll.). While this early view betrays a clumsiness in drawing and an uninspired notion of the picturesque, it also demonstrates familiarity with the superimposed color-wash technique of the period. Equally conventional, but more proficient—probably because closer to his heart—were watercolors from the following year when Watson was twenty-four: the captured *La Tribune* (see fig. 33) and his own ill-fated command *La Trompeuse* (see fig. 7). These little ship portraits show a lively competence akin to that of contemporary professionals in this genre. Watson was earnest enough in this decade to note recipes for color preparation in his sketchbook; although pigment in cakes had been available to watercolorists since about 1780, he apparently experimented with available materials and dubious new concoctions before arriving at the very simple palette seen in the majority of his American views.[15]

A watershed in Watson's development as a painter occurred a few years after the ship portraits of the mid-1790s, when he turned his attention to west country landscape watercolors in the most up-to-date style. Some time during the period from 1798 to 1804, while Watson was in the Exeter area awaiting active duty, he began an ambitious watercolor tutorial, copying some forty-odd Devon views (figs. 36, 37) by the fashionable painter and drawing master, William Payne (1760–1830). Only one of Watson's copies is dated—1803—to suggest the period for all these related works and the hopeful circumstances of his project; perhaps the brief Peace of Amiens freed Watson to contemplate other endeavors, including the improvement of his art.[16]

These watercolors stand apart from Watson's earlier harbor scenes and ship portraits in several ways. More remarkable than the use of second-hand sources is the skill of these copies, which show an improvement in the range and subtlety of Watson's technique and a dramatic departure from his earlier habits. All have been trimmed to a standard size (close to 5″ × 6½″) that is smaller and more squarish than his other formats. All are true watercolor paintings, as opposed to tinted drawings or sketches; each one is built upon a foundation of gray wash that has been overlaid with color and then delicately finished with fine pen or brushwork. Although small, they are

densely worked and contrived for high visual impact from both far and near. Most are identified as particular places, typically harbors, rivers, or estates in south Devon, but the topographical content has been artfully organized to create an effect more picturesque than documentary.

The pictorial conventions in these works, derived from baroque painting and formalized by British artists and theorists of the eighteenth century, comprise a catalog of devices to construct a picturesque landscape. Payne was a master of this repertory at a petite scale: a darkened foreground with flanking forms bracketing a view into a well-lit middle distance; progression into space along a curving diagonal from lower right to center; overlapping planes alternating from one side of the picture to the other to establish distance; strong oppositions of massed darks and lights with accompanying contrast in texture; and architectural forms (usually medieval in style) harmoniously set within nature.

While absorbing Payne's lessons on motif, composition, and lighting, Watson also showed himself to be an adept student of Payne's brush handling, his fine penwork, and his characteristic arsenal of technical tricks. Watson ably commanded Payne's signature devices—drybrush dragging and patterning produced by pressing scraps of textured cloth saturated with color against areas of foliage (see fig. 37)—although his use of these techniques was more restrained than Payne's. Conversely, Watson felt free to revise and embellish areas of foliage (as in the foreground and left edge of fig. 37) and "improve" Payne's detail, adding an anchor, new rigging, and five figures to the ships at the left in fig. 36. Some of Payne's stylish mannerisms, such as an exaggeratedly dark foreground and a tendency to draw with the brush, rather than with a pen, remained with Watson and emerged in his later work (as in fig. 40, color plate 10). Later, Watson may have been encouraged to experiment with simple combinations of blue, black, and brown in his American sketches, following Payne's habit of working with a few multi-purpose tints such as the mixed color, "Payne's Grey," that he invented and advocated as a neutral tint.[17]

Payne's mastery of technique or his selection of west country subjects must have recommended his work to Watson, who also

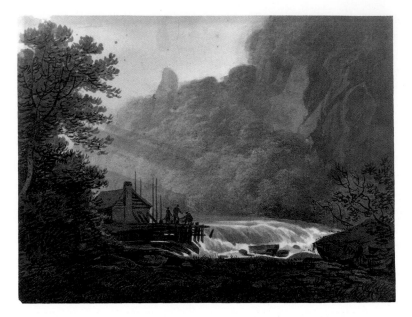

37. Joshua Rowley Watson, after William Payne, *Weir on the Tamar*, ca. 1798–1804, watercolor on paper, $5\frac{7}{8} \times 6\frac{3}{8}$ in. (sight), private collection.

may have responded to Payne's Devonshire connections or his military background. A dozen years older than Watson, Payne had been trained, like Paul Sandby, in the "Drawing Room" of the Ordnance Board at the Tower of London, rendering plans and elevations of fortifications. He had been stationed at the Plymouth dockyards in the 1780s, working as an engineering draftsman while sending landscape watercolors to the exhibitions at the Royal Academy in London. Watson was in school or on station in the Caribbean during this decade, so it is unlikely that the two met, and Payne returned to London in 1790 to launch a more single-minded career as an artist and teacher. The appeal of his work to upperclass amateurs soon made Payne London's most sought-after and prosperous drawing master; Watson, who was in London at least twice in the period between 1797 and 1804, when Payne's reputation was nearing its zenith, could have received personal instruction from him, too. Payne's "classes," usually

conducted in the student's home, involved observation of the master at work and then copying or completing his sketches.

Such a teaching session also could have taken place in Devon. Payne's wife was from Plymouth and his reputation had been established by views of the west country, so he returned to the area periodically after 1790 to visit and sketch. He also found enthusiastic patronage in the region from the Reverend John Swete (1752–1821), an amateur poet, watercolorist, and avid seeker of the picturesque who compiled twenty albums of west country views and commentary in the period between 1790 and 1802. In addition to Swete's albums were two volumes containing 87 watercolors by William Payne "(in small) of scenes of Devon" from which the majority of Watson's copies (ca. 36–39) seem to have been taken. Payne visited Swete at his country estate, Oxton House, seven miles south of Exeter, in 1790, 1793, and 1795, and the two men may have toured and sketched together between 1793 and 1795, when many of Payne's views in Swete's collection were done.[18]

Swete was happy to share his albums with the visiting artist Joseph Farington in 1809, and he must have opened them to Captain Watson as well, whether or not Payne was on hand.[19] Watson was living at Dawlish, just five miles south of Oxton House, in 1799–1800, and at Exeter and Topsham, an equal distance northeast, from 1801–1803. The profusion of Watson's copies and their high quality implies many hours of work and extended access to Swete's albums. Perhaps, like the London collector Dr. Thomas Monro, who from 1794 made his parlor an informal academy for student-copyists such as Turner and Girtin, Swete enjoyed sharing his watercolors while promoting the advancement of earnest and talented students.

Watson's practice does not seem unusual in the context of Turner's copy sessions at Dr. Monro's, and his method becomes more comprehensible when the opportunities for study in Devon at this period are considered. Exeter, the cathedral town, held 16,827 people in 1800, making it the fourth-largest city in England, but its ancient cultural and political hegemony was crumbling as Plymouth's commercial and industrial power expanded.[20] Always conservative and somewhat behind-the-times, Exeter's gentility rallied to reassert the city's artistic and intellectual leadership, founding the Devon and

Exeter Institution in 1813 to answer the challenge of the Plymouth Institution, organized the year before. Both groups pledged to support local artists and scholars after the fashion of the Royal Academy, the Royal Society or—in Philadelphia—the Pennsylvania Academy of the Fine Arts and the American Philosophical Society. Gentlemanly and clubbish, both of these Devon institutions were slow to organize classes or exhibitions for artists. Watson was stationed in the Plymouth area in 1812 and 1813, so it is possible that he collaborated in the founding of these societies. The Plymouth Institution mounted its first exhibition in the fall of 1815, when his sketchbook shows that he was nearby (see fig. 13), but the dearth of contemporary documents and catalogs makes it impossible to know if he participated. He returned from America in 1817 to settle in Exeter, where the local Institution would not muster an exhibition until after his death. Arriving back in Devon at the dawn of such organized activities for local artists, Watson may have imagined a future liberated from active service in the navy and supported by new groups such as the Plymouth Society of Artists and Amateurs. Sadly, his death in 1818 came just as the local network of art education and patronage became more supportive, as well as easier to trace.[21]

Before 1815 and the establishment of annual exhibitions in Plymouth, patterns of teaching, collecting, and practicing painting in Devon are also made obscure by the peripatetic lives of the artists themselves. In Watson's lifetime, Devon—like the United States—lost her most ambitious native painters to London. Most of the local stars—Reynolds, Cosway, Haydon, Northcote, Eastlake, Prout—kept strong home ties, however, and the landscape invited a calvacade of visiting painters, such as Girtin and Turner, who later welcomed local artists into their London studios. But few painters were permanent residents before 1820, save a scattering who earned their living as portraitists, or those who claimed amateur status.[22]

In Plymouth and Exeter, the native artists departed for London or suffered by remaining. Exeter's principal drawing master in 1810 was deemed unqualified, and James Leakey, the major local portrait painter (see figs. 2, 9, 10), discouraged students by repeating the earlier opinion that the town was "no place for an artist."[23] The city's two local landscape watercolorists of some fame today, Francis Towne

(1740–1816) and his student John White Abbott (1763–1851) labored under the limitations of their audience; Towne left in 1800, claiming never to have exhibited his work publicly, and Abbott, a surgeon, admitted that he had never sold one of his watercolors. Neither one received much credit in his own day, and inspection of their work, with its energetic pen contours, bright washes, and broad planes, shows that Watson paid them little attention, too, unless traces of their simplifying style can be read in his coastal profiles.[24]

With few resident artists to learn from, Watson completed his education by copying examples in local collections. The study of Payne's work brought Watson a more graceful hand, a working knowledge of picturesque composition, and an eye for promising landscape subjects. In addition to these skills, his attitudes—such as interest in Devon views or travel albums—may have been shaped by Payne or Swete, or by the larger context created by the Rev. William

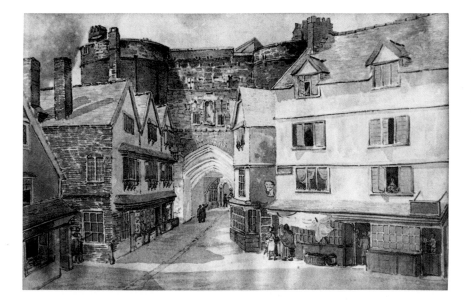

38. Joshua Rowley Watson, *Southgate, Exeter*, ca. 1808, watercolor on paper, 6 × 9½ in. (sight), Collection of Elizabeth Burges Pope.

Gilpin, whose influential tours provoked new appreciation for the British landscape in the late eighteenth century. Gilpin, who held "a virtual dictatorship of taste between 1780–1820," discovered Devon as a picturesque landscape in his *Observations on the Western Parts of England*, published in 1798.[25] Following Gilpin's lead, but more progressive and inclusive in his sense of subject matter, Payne was among the first to specialize in Devon scenery. Watson, stimulated by Payne, Swete, and the popular culture of Gilpin, was ready to set out on his own.

Four years of active duty delayed Watson's first independent forays. He returned to Devon in 1808 prepared to produce a more extended series of picturesque views based on his own observation. Relaxing in the seaside town of Teignmouth that August, Watson took out his watercolors to paint at least six views. He began a series of views of Exeter (see fig. 38) more in the vein of Samuel Prout than William Payne, including a panoramic landscape from the southwest, *Exeter from the Havre Banks* (Pope coll.). This sketch of May 1808 may have formed the basis of a major, finished composition, *View of the City of Exeter, Cathedral, and River* (now lost) exhibited in Philadelphia in 1829.[26]

Watson returned to duty in 1809, leaving a version of his Exeter view in the hands of the Rev. Gayer Patch (1755–1825), another local clergyman who collected the work of both nationally and regionally known watercolor painters. Patch cheerfully shared his portfolios with visitors and enjoyed promoting local talent to Farington, who was again touring Devon in search of the picturesque. "Mr. Patch shewed me a view of Exeter drawn with some ingenuity by Captn. Watson of the Navy, of whose character He spoke very highly," wrote Farington in his diary on 28 November 1810, about a year after his visit to Rev. Swete.[27] Farington met the painters Leakey and William Traies at this time, and later helped them forge connections in London; he made it his business to know the gossip of the art world and record it in his voluminous diaries. If Farington knew Watson only from this distance, it is safe to assume that Watson's reputation extended only to the limits of Gayer Patch's circle. Admired within that community, Watson evidently had opportunities to meet local artists and study their work, but held no ambitions as an artist beyond those of a well-respected amateur.

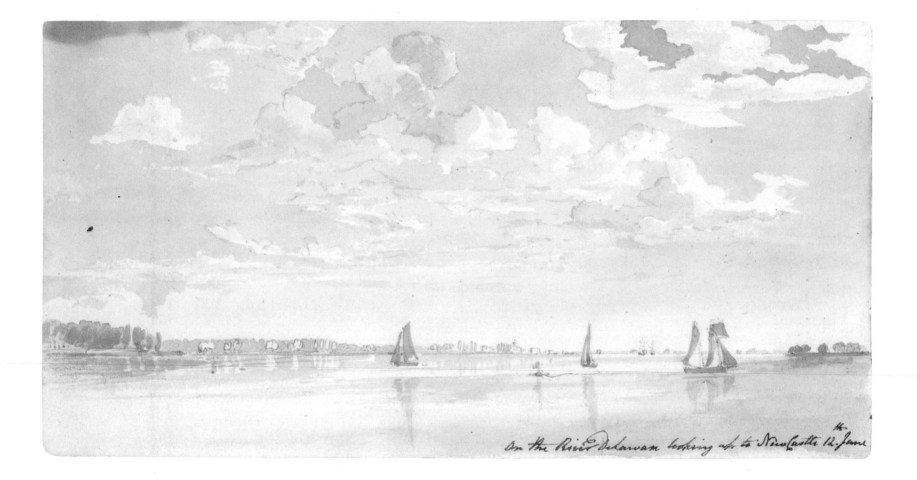

1. *On the River Delawar Looking up to New Castle 12th. June* [1816]
Pen and blue and black wash over graphite (NY-135A; see plate 1).

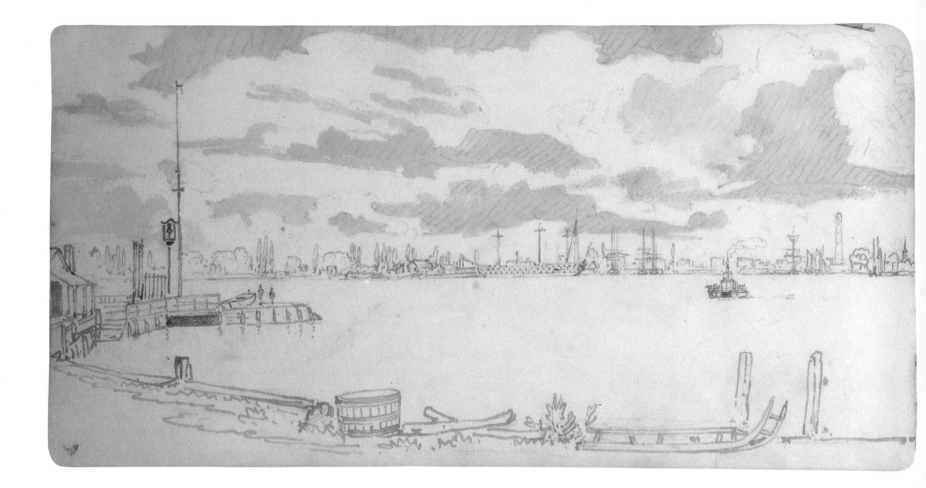

2. *View of Philadelphia from Keans Ferry on the Pontuxat or Delawar River 12th. May 1817.*
Pen and brown wash over graphite (B-41AB; see plate 3).

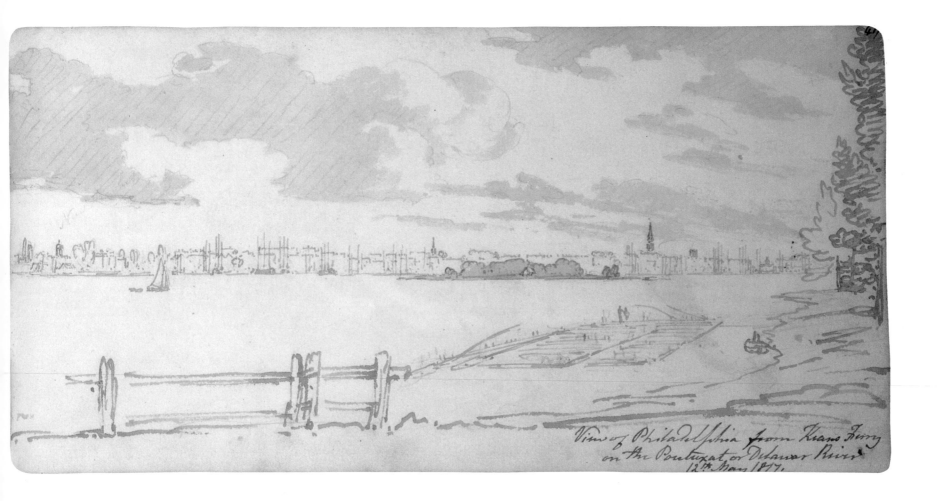

View of Philadelphia from Kears Ferry
on the Pontuxat or Delaware River
12th May 1817.

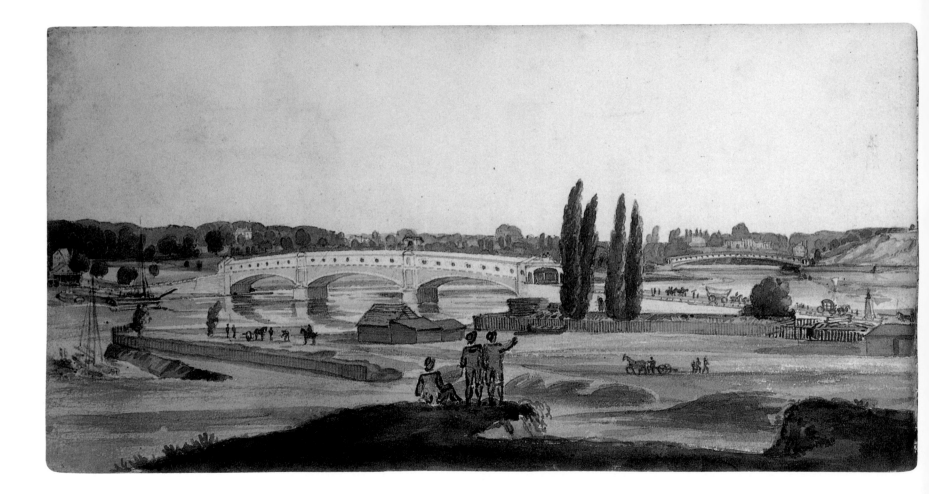

3. *View of the Middle and Upper bridges on the River Schuylkill taken from the Old Waterworks Philadelphia 5th October 1816*
Watercolor over graphite (B-104"AB; see plate 8).

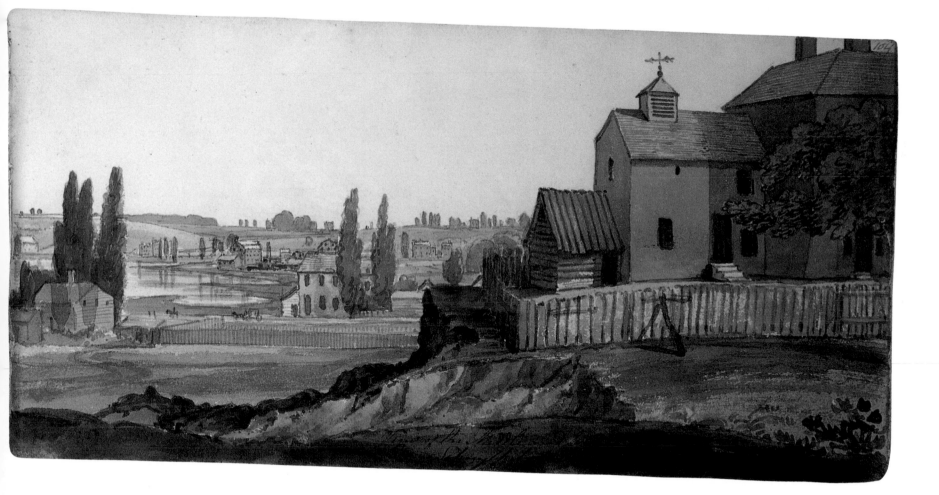

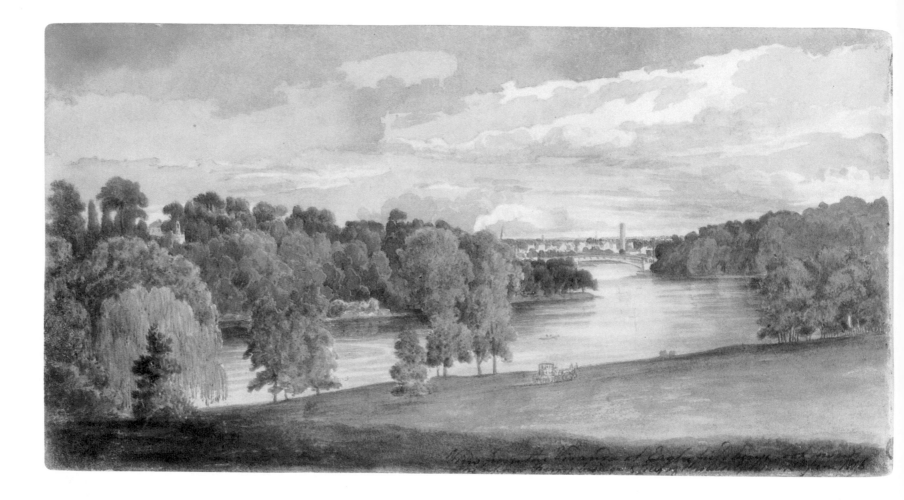

4. *View from the Veranda at Eaglesfield house look[ing] towards the Upper Ferry Bridge & City of Philadelphia 13th June 1816*
Watercolor over graphite (NY-133AB; see plate 14).

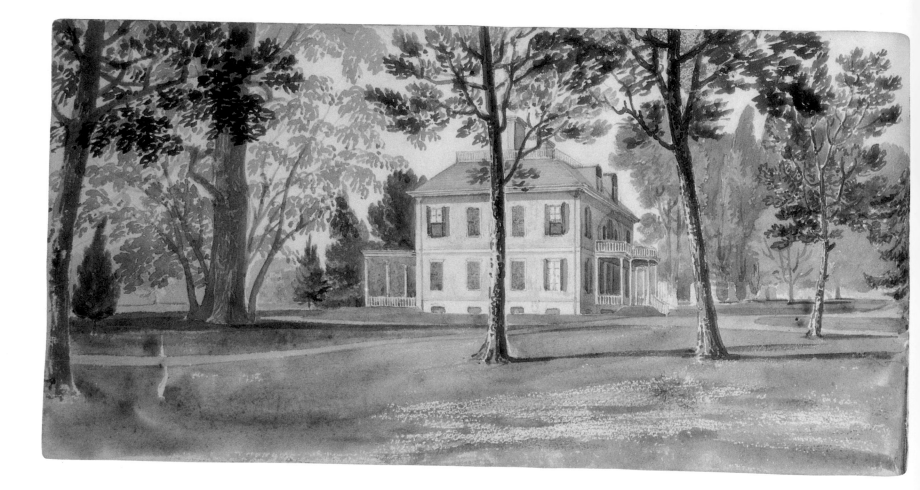

5. [Eaglesfield from the northeast] *May 11th. 1817*
Watercolor over graphite (B-43AB; see plate 16).

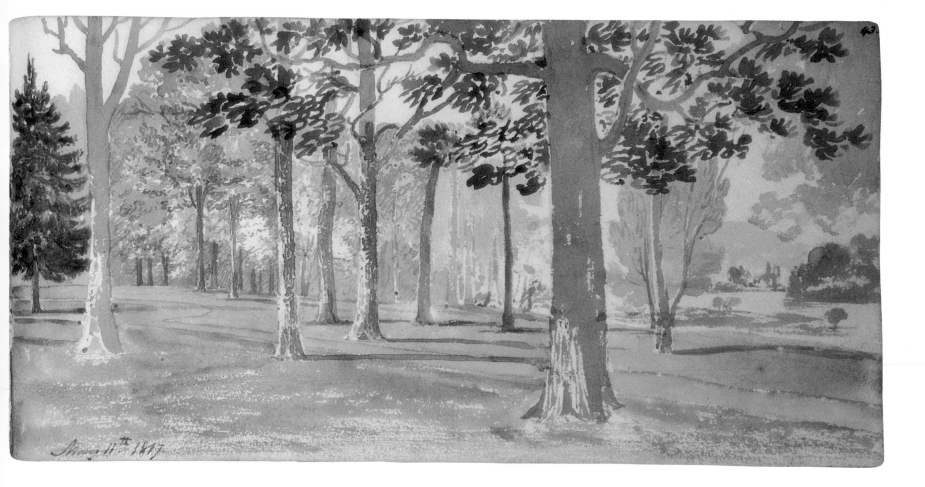

May 11th 1817

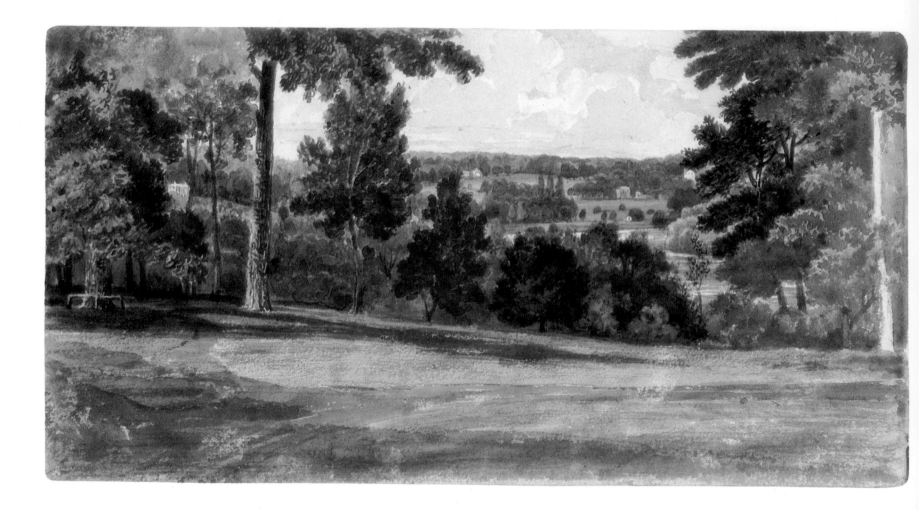

6. *Looking towards Bellmont from Eaglesfield 16 June* [1816]
Watercolor over graphite (NY-131AB; see plate 24).

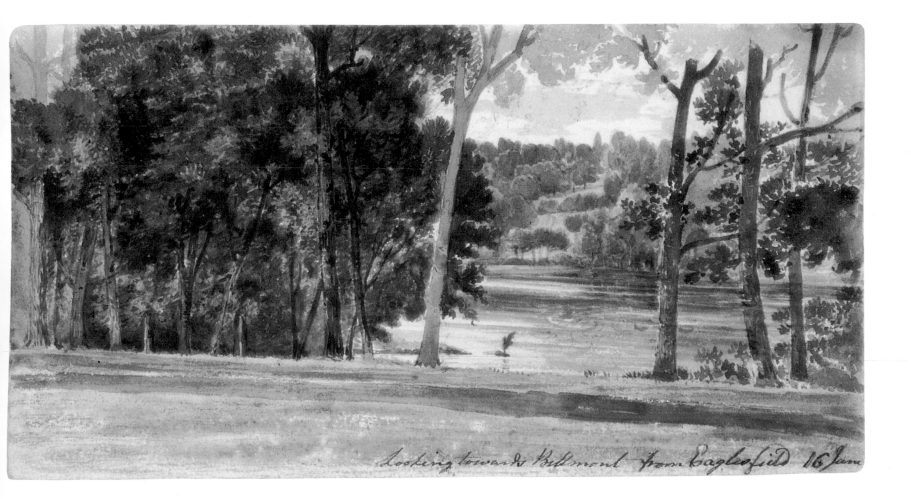

Looking towards Belmont from Eaglesfield 16 Jun

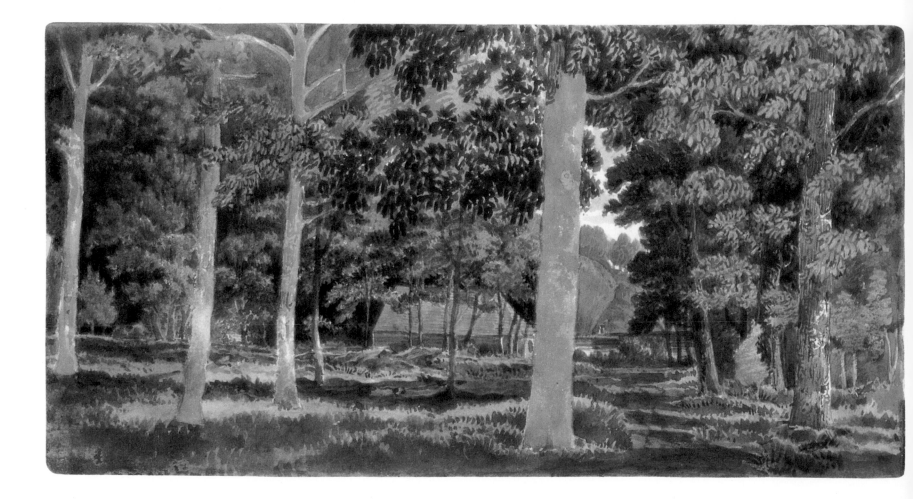

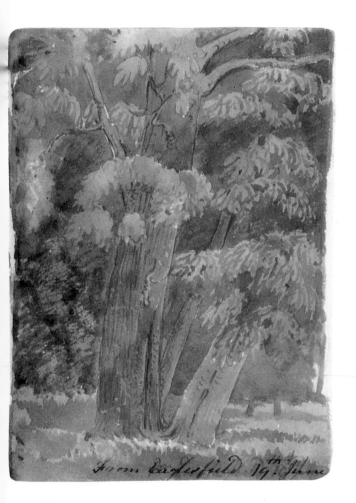

7. *From Eaglesfield 19th June* [1816; view through woods to river]
Watercolor over graphite (NY-130AB; see plate 21).

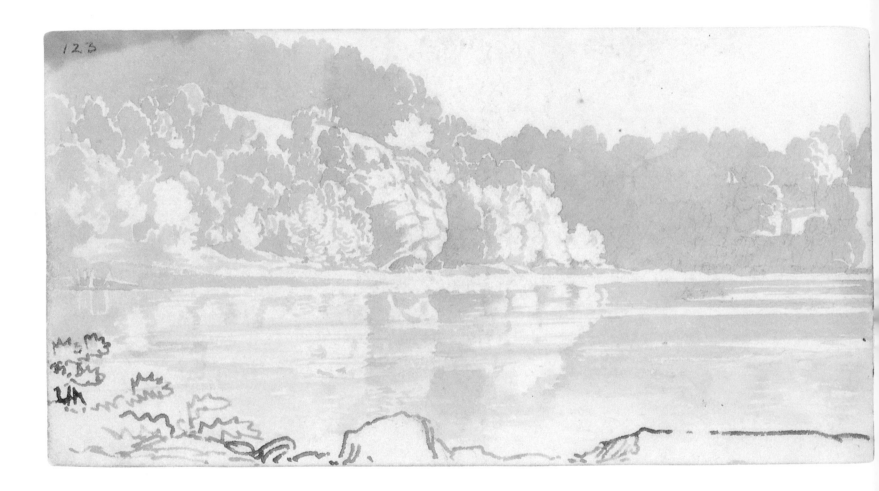

8. [River view, July 1816]
Pen and black and blue wash over graphite (NY-123AB).

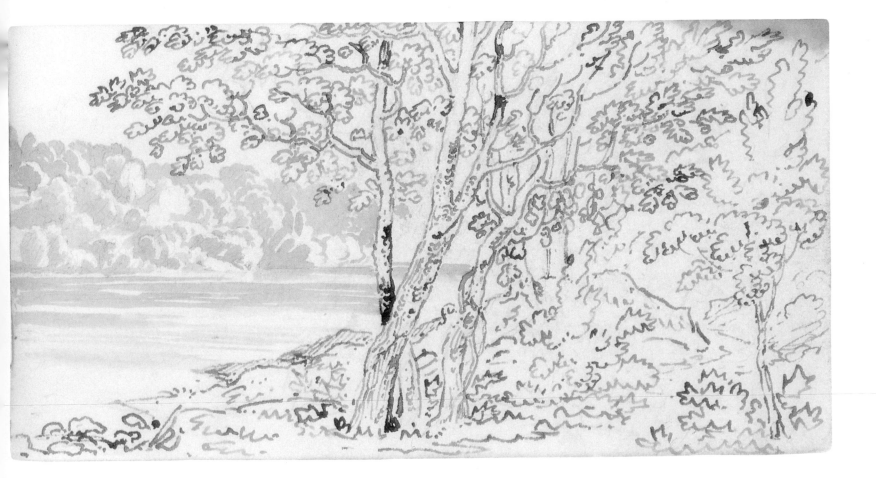

9. *The Lower Bridge on Schuylkill at Gray's Ferry 5 [—]ber 1816*
Watercolor over graphite (B-110A; see plate 4).

10. *View on the Schuylkill from the Old Water Works*, ca. 1816–17
Watercolor on paper, $20\frac{1}{8} \times 31\frac{3}{8}$ in., Atwater Kent Museum, Philadelphia.

11. *Banks of the Schuylkill looking down the River near the Ford below the Falls—4.th April 1817*; [steamboat; inscribed], *Memo The Indian name of the River Schuylkill was the Manaiunk—*
Pen and black and brown wash over graphite (B-74AB; see plate 27).

714

Memo The Indian name of the
River Schuylkill was the
Manaiunk —

Banks of Schuylkill looking down the River
near the Ford below the Falls — 4th April 1847

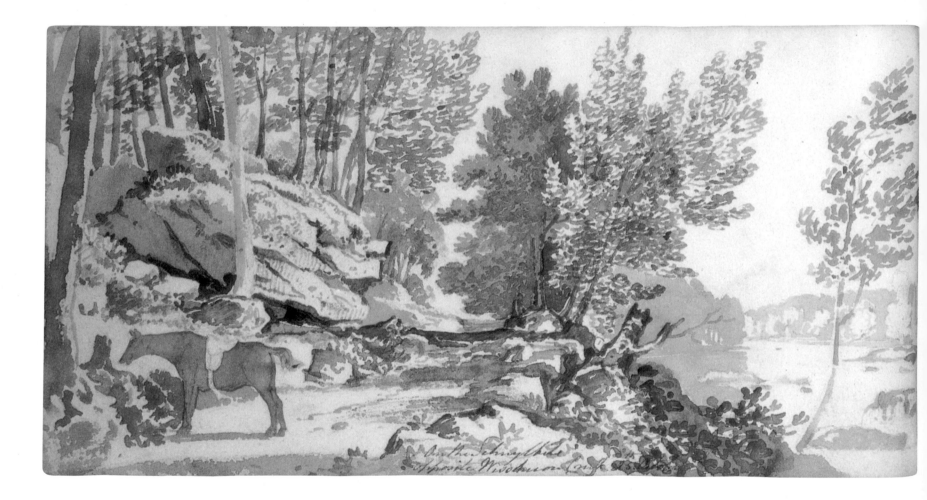

12. *On the Schuylkill opposite Wissihicon Creek 25th Octobr.* [1816]; *Looking up Wissihicon Creek 25.th October* [1816]

Black wash and watercolor over graphite (B-81AB; see plate 31).

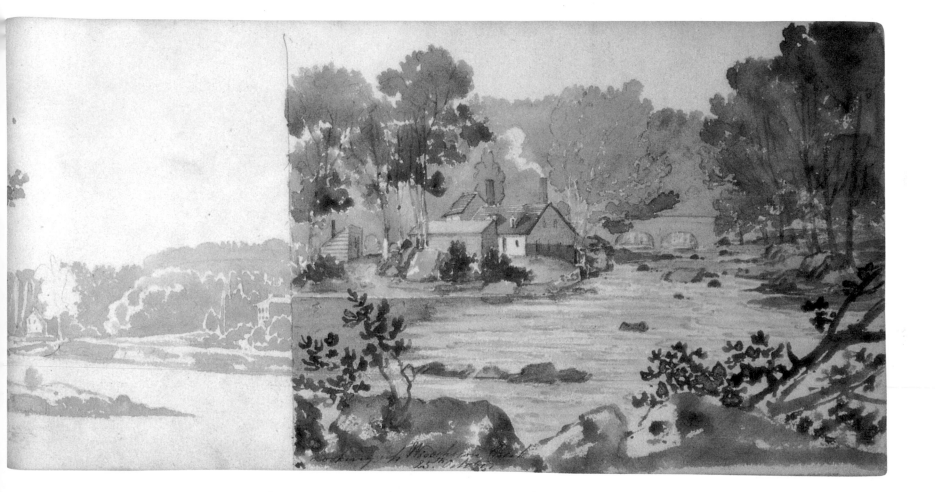

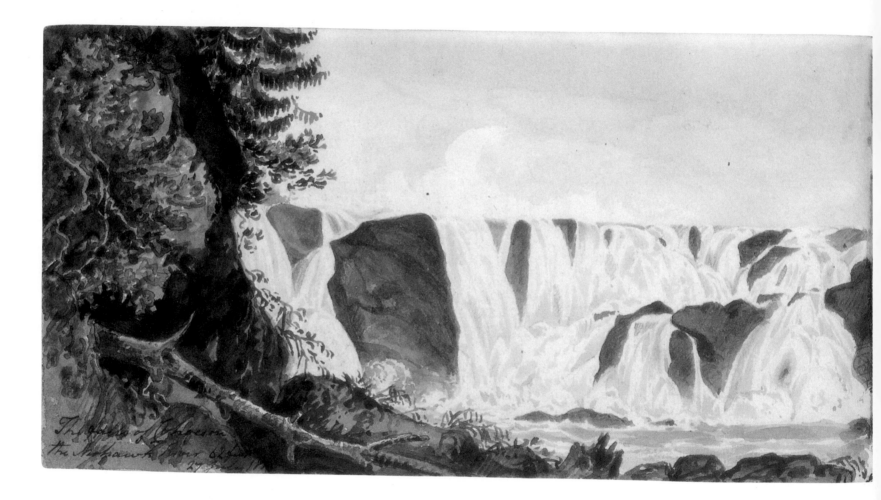

13. *The Falls of Cohoes on the Mohawk River 62 feet 27 July 1816*
Watercolor over graphite (NY-53AB; see plate 54).

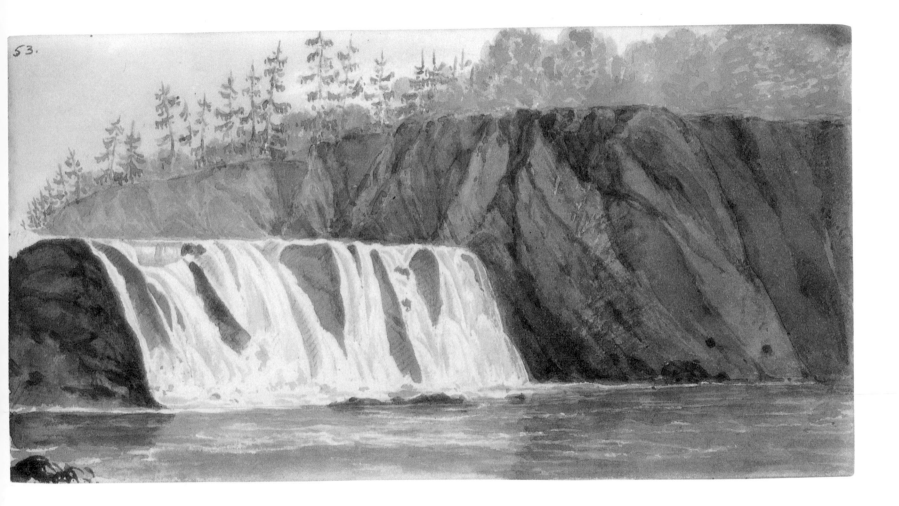

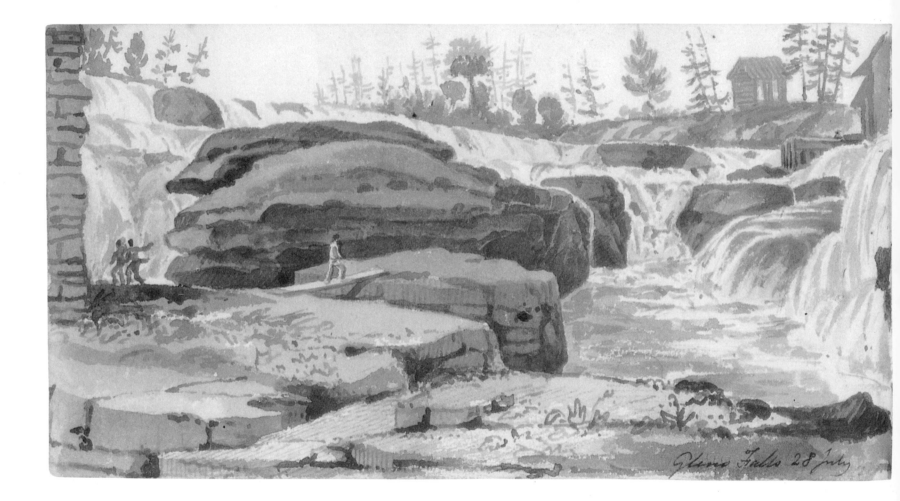

14. *Glens Falls 28 July* [1816]
Watercolor over graphite (NY-37AB; see plate 58).

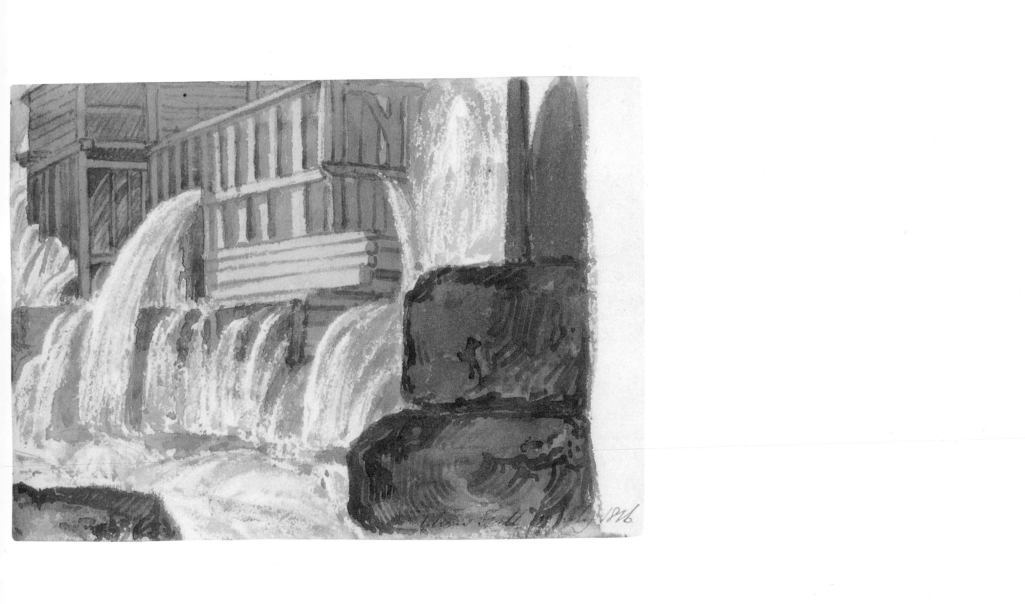

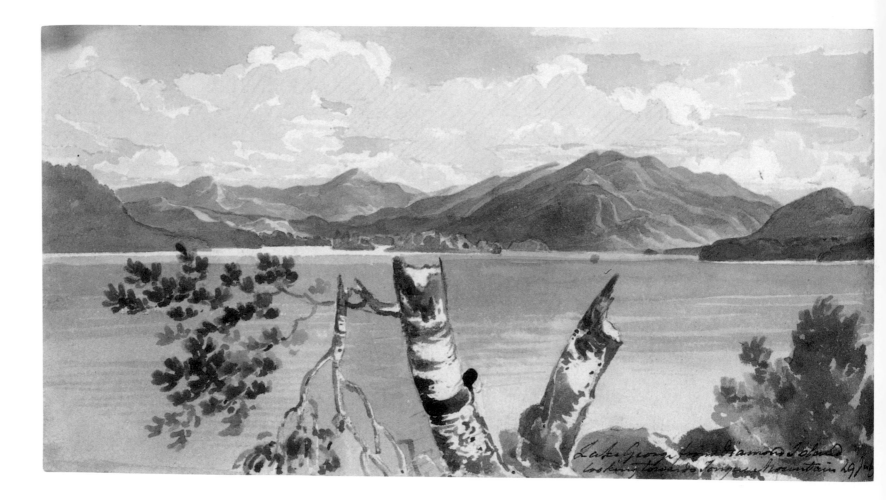

15. *Lake George from Diamond Island looking towards Tongue Mountain 29 July*
[1816]
Watercolor over graphite (NY-36AB; see plate 59).

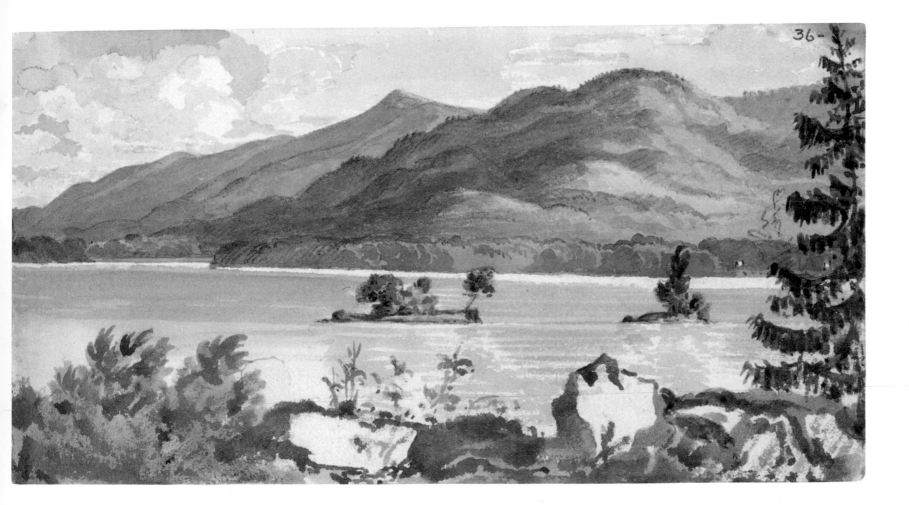

36.

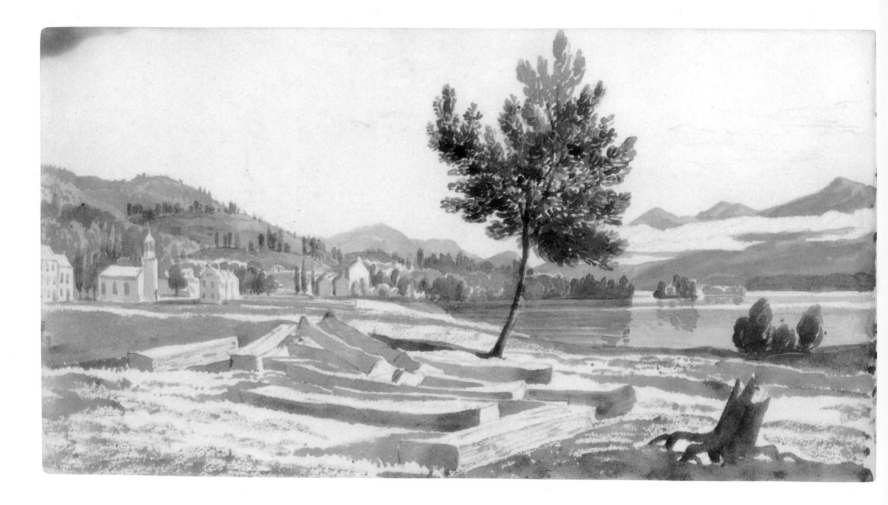

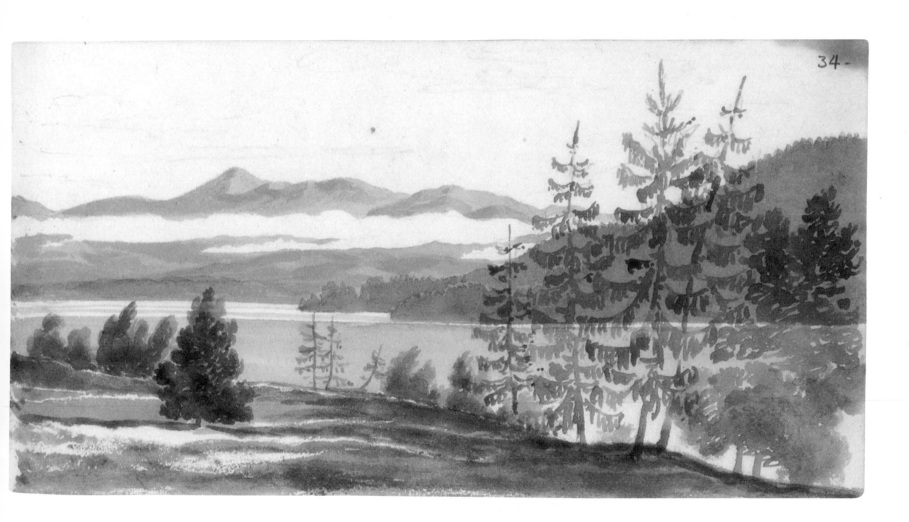

34.

16. [Caldwell, New York. Shores of Lake George, 29 July 1816]
Blue, brown, and black wash over graphite (NY-34AB; see plate 61).

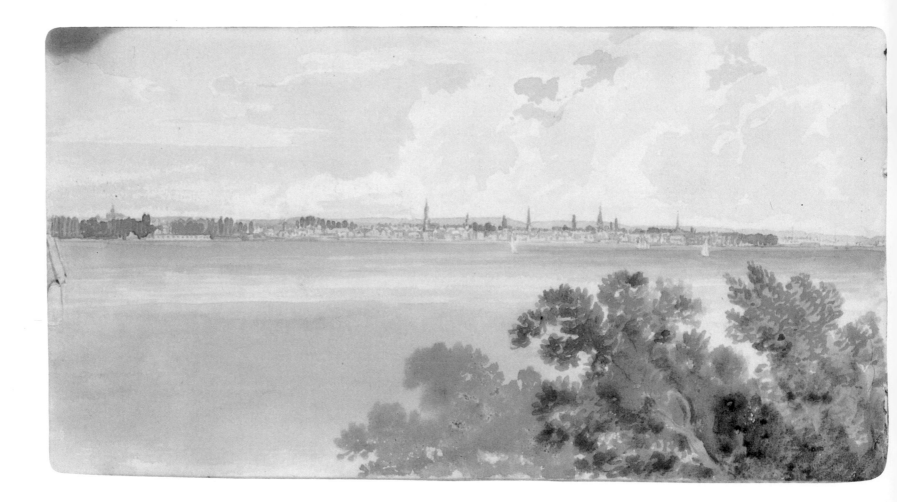

17. *New York from Whehauken [monument at the dueling ground] 19th August 1816*
J. R. Watson Delt.
Watercolor over graphite (NY-2″AB; see plate 73).

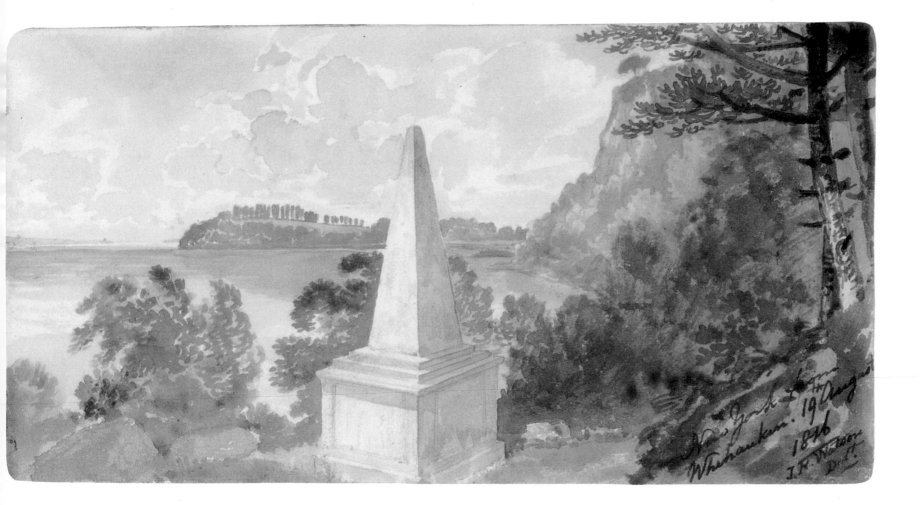

18. *General Washingtons Tomb at Mt Vernon [18 April] 1817*
Pen and ink and watercolor over graphite (B-62A; see plate 80).

The medium, scale, and subject of Watson's Devon views reconfirm his standing among that group unique to British painting: the gentleman amateur. Watercolor had been developed as an important modern medium by British artists in the eighteenth century, and by 1805, with the foundation of the first watercolor society exhibitions, the medium had become a source of pride and national artistic identity. The popularity of sketching in watercolors grew along with the taste for Gilpin's landscape tours. This reinforcing spiral of art, nature, tourism, and patriotism inspired popular watercolor painting of a widespread and frequently very accomplished order. In this golden age of British landscape painting, amateur status usually signified social class as much as artistic quality; at a time when artists were struggling to assert themselves as genteel professionals, the amateurs were usually securely stationed near the top of the class hierachy. The modest and diffident posture of the amateur, first exemplified by William Taverner and then adopted with various degrees of sincerity by others like Abbott, could mask condescension or failed hopes. But it did not necessarily mean that the artist was less practiced, less dedicated, or less inventive than the professionals. Quite the contrary, an amateur was free to experiment or imitate without criticism and, most important, free to choose subjects and styles without thought to marketability.

The promise of his rich, tightly organized Payne style was left undeveloped in America, where most of his work was in the speedy sketch manner described earlier. Occasionally he added an extra color or two to his standard palette of blue, brown, and gray, but only on a very few compositions did he work his sketches up to the density and color seen in his English views. The result in America is usually broader and brighter, without the daintiness and artifice of the Payne copies. Sometimes, the additional effort increased the impact, as in his view of Washington's sepulcher at Mt. Vernon (plate 80, color plate 18). On other occasions, the additional color seems heavy and unnatural, particularly when allied to a hackneyed motif like a Sandby-esque blasted tree (fig. 39). The inconsistency of effect in color seems to relate to infrequency of practice, as if the skill developed around 1803–1808 grew rusty while his facility with broader techniques advanced.

On one occasion in America, Watson undertook a finished, fully-

39. Joshua Rowley Watson, [Blasted tree] *27th Septembr 1816*, watercolor over graphite, Barra Foundation sketchbook, p. B-83A.

colored "exhibition piece": his *View of the Schuylkill from the Old Water Works* (fig. 40; color plate 10). More than a dozen times larger than his Devon copies, this view is unique in Watson's extant oeuvre; it may have been the largest work he ever painted. Surely it is the same watercolor exhibited at the Pennsylvania Academy of the Fine Arts in 1829 as no. 321, *View from the Porcelain Factory, near the Schuylkill, Permanent Bridge*; probably it served as the model for Cephas G. Childs' print, published in 1827 (see fig. 47).[28] This view is remarkable because of its size and its contribution to the iconography of Philadelphia. It is also important, however, as a display of

40. Joshua Rowley Watson, *View on the Schuylkill from the Old Water Works*, ca. 1816–17, watercolor on paper, $20\frac{1}{8} \times 31\frac{3}{8}$ in., Atwater-Kent Museum, Philadelphia. (see color plate 10)

Watson's competence at the scale and in the manner of his most professional contemporary colleagues. Closely based on drawings in his sketchbook (see plates 7, 8), this view establishes the pole of finish and elaboration in his American work, from which the relative completeness or separate expressiveness of his sketching style can be measured.

Watson's *View on the Schuylkill* has suffered from exposure to light, which has stolen some of the tints and distorted the color balance of the remaining pigments. The unsatisfactory quality of the sky, which seems to take up too much space to little effect, might be mitigated by the return of its original clean tints.[29] What can be analyzed in this work is Watson's sophistication of handling, unseen in his quicker sketches. Washes have been carefully overlaid and built up, highlights removed by lifting and scraping, textures evoked with sponging and dry-brush additions, to a beautiful effect, particularly in the water's surface. Knowing his subject well, Watson began with only the slightest pencil outlines; most of the forms are drawn entirely with the brush, with pen detail added in brown as a final touch on the distant figures. The final effect is crisp, delicate, and authoritative.

Looking to his sketchbook drawings of the same view, Watson's subtle manipulations of the scene for the sake of art become apparent. Although the topographic intentions of this picture limited his artistic license, Watson did his best to enhance the picturesqueness of the scene, adding a deeper foreground with more elaborate vegetation and linking three separate views taken from one point into a continuous panorama. Some of the figure groups in his sketches reappear in the larger view, with the notable exception of the foreground group in plate 8. His Devon views show a competent handling of such "staffage," so Watson must have eliminated them as too distracting or disruptive of scale. Certainly the water intake channel and settling basin for the old waterworks (whose pumping station is the chimneyed building at the far right) and the Market Street Bridge gain coherence and importance by the absence of such figures in the larger work. Since the waterworks, Beck's shot tower, and the two bridges are the major incidents in the picture, Watson's revisions seem astute. His choices also point to his purpose, which may

have been a gift to his uncle, Richard Rundle, whose estate lay up the river, just beyond the central feature on the horizon, the Colossus bridge and the new waterworks at Fairmount. This painting, based on sketches from the fall of 1816, may have been what occupied Watson in the cold months of 1816–17, when his sketchbooks record no activity.

Considering, now, the range of Watson's American work, from the quickest pencil notations in his sketchbook to his one large exhibition piece, a few characteristic tendencies emerge. Most striking is his interest in landscape, almost to the exclusion of other subjects. No portraits and only a very few figures and animals appear; still life is nonexistent. And, in the sweep of landscape possibilities, only suburban, rural, and wilderness scenery inspired him; the urban view finds almost no place in his sketchbooks, even though Watson had numerous opportunities to paint cities, especially Philadelphia, where he lived for at least eight months. His many drawings of country houses demonstrate his skill with architecture, but evidently the "magnificence" of Philadelphia struck him as unpromising material for a watercolorist. Perhaps it was too fresh and modern or too much like other provincial British cities he had known. The only urban views in his oeuvre, of Exeter (see fig. 38), feature medieval street scenes full of irregularity and historical associations that make them picturesque. Outside of Exeter, Watson sketched all other cities from afar, adopting the distant, shipboard perspective of his coastal profiles to show how the city, as a mass, emerged out of its surroundings. His few exceptions to this vantage focus on raw or marginal urban fabric: Washington, D.C., the capital so recently burned by the British, now undergoing rebuilding, or his large view of Philadelphia's western fringe (see plates 75, 76 and fig. 40). Otherwise, Watson found the novel and artistically memorable aspects of the United States outside of town, in the picturesque interaction of human settlement and natural beauty.

In this landscape, Watson looked first for water. A river, stream, or lake appears in almost every view, organizing the composition as well as human activity. Except for his sketch of Saratoga, which seems to have been done almost grudgingly in the face of the unpromising material (it is the only view that appears upside down in the normal

41. Joshua Rowley Watson, [Boulders in a wood], 1816–1817, brown wash over graphite, Barra Foundation sketchbook, p. B-86A.

sequence), there is no picture without water. Entranced by the wide sheet of the Susquehanna, he stayed sketching on its banks an extra day. Perhaps he was encouraged by writers such as Gilpin, or perhaps his own maritime culture drew him always to shorelines, but he used water consistently and well as the organizing principle in his landscapes.

Frequently, his central motif is a waterfall. A staple of Gilpin's picturesque tours and something of a specialty in Devon, waterfalls also appeared often in Watson's west country views (see fig. 37). Already a connoisseur, he missed few opportunities to draw them in America, gravitating to all the major cataracts in his vicinity: Schuylkill Falls, Passaic Falls, Falls of Cohoes, Glens Falls, Baker's Falls, Potomac Falls, and assorted rapids. Most often he combined water and waterfalls with bridges, his primary fascination among manmade artifacts. Watson painted every bridge on the Schuylkill several times, from all vantages, both bridges on the Potomac, and every major bridge he

crossed while traveling in Pennsylvania, New Jersey, New York, and Massachusetts. If he could not find a bridge to ornament his river view, he chose a house, an inn, or a mill to stand as a spatial marker or make a similar visual statement of human occupation and artificial form, in contrast to the ragged flow of nature.

Less often, Watson drew "unimproved" nature. His west country views show that he was avant-garde in appreciating the pictorial possibilities in raw moorland, landscape not yet seen as picturesque by most painters.[30] In America he preferred a mixture of cultivation or settlement and wildness, rarely painting wholly agricultural (or urban) landscapes or entirely uninhabited nature. His balance clearly tipped in favor of the less-developed landscape, however, particularly the "grand" untamed scenery of the Hudson Valley and western Massachusetts.[31] A storm at sea, a blasted tree, or gigantic tumbled boulders on the Schuylkill (fig. 41) absorbed his attention, all giving evidence of sublime force in nature. But in seeking unalloyed nature, Watson was more likely to end up in a quiet woodland spot on Wissahickon Creek (B-94, B-97, B-98) that gave instance of a mild and hospitable wilderness. Watson noted the severity of American "thunder gusts" and lightning in his diary, but he never tried to paint a scene more violent than the sunny aftermath of such a storm (see fig. 39). The record of his sketchbooks shows that he worked outdoors only in fine weather and warm seasons; unlike Turner, he had no interest in submitting to bad weather for the sake of art. Captain Watson had seen his share of storms, and he stayed home on rainy days.

These preferences display an Enlightenment taste for Claudian scenes of tranquility and control along with a Romantic willingness to enjoy selected wilderness on its own terms—exactly the mix of opinions one might expect from a progressive Englishman in 1816. Painters of the romantic landscape were still rare in the United States, but within twenty years they would be following Watson into the Catskills to paraphrase the exclamations in his diary and sketch similar blasted trees and boulders. Expressed in the work of another British provincial, Thomas Cole, Watson's taste in landscape would become part of the American national artistic identity.

The choice between sublime and beautiful aspects of nature formed one of the more complex binary oppositions in Watson's aesthetic. Simpler pairs, like the contrast of water and land, or human versus natural form, contributed to a repertory of visual oppositions that organized Watson's landscape into art. These devices, most of them already seen in his Devon views, included contrasting masses or planes of light and dark, such as the habitual foreground shadow or framing clump of trees, and oppositions of texture found in vegetation, water, or rock. The search for visual variety, irregularity, and contrast was fundamental to the experience of the picturesque, and Watson found the Schuylkill Valley a rich field for art, with its rolling hills, curving river banks and alternating patches of meadow and woodland, sprinkled with "gentlemens villas delightfully situated" (15 June).[32]

These diverse components of his landscape were controlled in space and on the page by a few simple compositional strategies that Watson employed repeatedly, with great success. Most frequent and effective was his use of a waterway, sweeping from one lower corner of the page in a "C" curve into the middle ground (see plates 22, 23, 27, 35, 55, 64, 88). The river (or roadway) organized in this fashion carves out a valley of space diagonally into the distance, along which the observer travels, from shadow into sunlight or from woodland to meadow, to all the delightful incidents of the landscape. Almost always the foreground inhabited by the artist is well established and rolls away invitingly along a clear path into the distance. Such simple means guarantee a sense of deep space despite the confined horizontal layout of his sketchbook. A master of this eccentric format, Watson understood that more complex spatial effects would be difficult within the restricted vertical dimension of his page. For the sake of speed and unity, he repeatedly depended on such simple organizations.

Watson liked rivers because they supplied a spatial and compositional spine for his drawings, but his attraction to water must make us remember the real function of these sketchbooks for the artist. Given the economy of Watson's means, the actual color and surface of the water could only be suggested. A few strokes of the pen or brush had to evoke the visual qualities of motion, reflection, and color and, by association, the noise and moisture, or the sense of "activity and bustle" recorded in Watson's diary at Glens Falls (color plate 14). His verbal description of the falls, which comments on the pleasant contrast of the blue limestone cliffs and the foliage, the "great crash" of the water, and the deleterious effect on the scenery of the nearby mills, reminds us that Watson was a tourist from a culture that had recently developed the concept of landscape viewing as an aesthetic experience. Travelers in late eighteenth-century England ranged about the countryside holding up "Claude glasses"—dark, convex mirrors or panes of tinted glass in small frames—in which they could discover and appreciate natural views constructed like Old Master paintings. As a taste for the sublime joined the earlier preference for the beautiful and the picturesque, the wilder reaches of Wales, Scotland, Devon, and Cornwall fell within the frame of landscape connoisseurship. In England, Watson was raised in the heyday of Gilpin's guidebooks, which suggested tours of the countryside encompassing the most rewarding views. Such books encouraged both tourists and painters. Artists found suggestions for appropriate subjects, and amateurs found encouragement to sketch the scenery as an exercise in disciplined observation, to help themselves see carefully and remember well later.

Aside from professional artists, most persons went on these landscape tours simply to thrill their senses with scenery. Today, in a society with many cameras, we sometimes confuse the act of photographing the view with the experience of the place itself; color photographs become the rationale and the trophies of travel. Preoccupied with the business of photography or betrayed by the camera's speed and ease, we do not always stop to see, feel, or hear the landscape as Watson did, much less describe it in words or weigh its picturesque merit. Watercolor sketches were the tourist snapshots of Watson's era, but the greater time and personal control invested in their creation make them much richer records of consciousness and intention. The diverse impressions in his diary tell us that Watson did not visit the falls just to make a sketch. He visited the falls to see what they looked like, and he drew the view to analyze and savor the en-

tire experience, recording visual clues in this sketchbook that would help him recollect the wider range of affiliated sensations later.

The by-product of this aesthetic moment was a watercolor. Watson was too accomplished and self-conscious as a draftsman to forget the niceties of composition and handling or fail to create a drawing that had a fresh aesthetic identity in its own right. But putting aside these pleasant surface qualities, the attractiveness of Watson's American drawings is based on his engagement with the landscape and his ability to suggest that experience, met by our ability to supply from our own memories qualities of space, movement, texture, and atmosphere only implied by his surprisingly abstract, nearly monochromatic system of line and wash. The challenge of communicating such elusive qualities in two dimensions has motivated European painters since the Renaissance, and especially English landscape artists of the romantic period. But Watson's amateur standing makes us reconsider this suggestive and naturalistic style in terms of his private purposes. Initially, the act of transcription was entirely for his own personal pleasure. Secondarily, he stood as his own audience, perhaps his harshest critic but also the one viewer able to supply "missing" effects or read incoherent passages with perfect ease. As delightful or useful as his sketches may be to us, their purpose as well as their richest realization lay in the tight circle of creation and recollection within the mind of J. R. Watson. As we study his sketchbooks for historical or topographical data or judge his pictures as art, we must remember that the pages now before us are souvenirs, shadows of the primary aesthetic event, which was Watson's encounter with the American landscape.

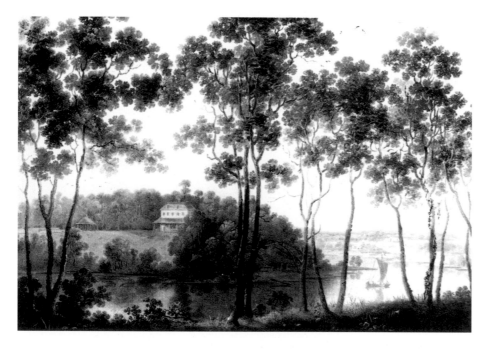

42. William Groombridge, *Fairmount and Schuylkill River* [with view of Eaglesfield], 1800, oil on canvas, 25 × 26 in., Historical Society of Pennsylvania.

The American Context

Captain Watson came to the United States at a time when there were few resident landscape painters and even fewer American-born practitioners of this genre. Four years would pass before Thomas Doughty (1793–1856) of Philadelphia would declare himself to be the first native-born landscape specialist. Until well into the nineteenth century American landscape art was largely in the custody of British emigrés, such as William and Thomas Birch, or British visitors, such as Watson.[33] The richness of the amateur class he occupied in England is quickly understood from an examination of professional work done in Philadelphia about the time of his arrival. The artists that he could have encountered and their work offer another context for Watson's art.

Portraits of the new estates along the Schuylkill were the special province of British landscapists such as William Groombridge (1748–1811), who painted Woodlands in 1793 and Eaglesfield in 1800 (fig. 42). Groombridge exhibited his work frequently in London be-

tween 1773 and 1790, and his professional experience prepared him to see the picturesque potential of the Schuylkill Valley as Watson did and to find beauty in uninhabited landscapes that resemble Watson's views along the Wissahickon a decade later. Groombridge lacked the disposition or skill to record detail with Watson's accuracy, and his views often have a dreamy, idealized quality that heightens awareness of his stylized foliage and compositional contrivances. Watson used these same artifices but with a varied and descriptive manner that reveals the increasingly naturalistic preferences of his generation. The fraternity of their compositional solutions, both in outright topographical views and in more fanciful scenes, unite Watson and Groombridge in the mainstream of English landscape painting of this period, despite their different drawing styles.[34] Groombridge, one of the first professional landscapists in America, had been gone from Philadelphia for a dozen years when Watson arrived; he moved to Baltimore in 1804 and died in that city seven years later.

In Baltimore Groombridge joined forces with the self-taught Francis Guy (1760–1820), another British-born emigré who had established himself as a painter of topographical landscapes, usually featuring country estates.[35] Less sophisticated than either Groombridge or Watson, Guy held his own in Baltimore and exhibited occasionally in Philadelphia at the Pennsylvania Academy. When Watson visited, Guy was about to move to Brooklyn, but his view of *Carter's Tavern at the Head of Lake George*, painted between 1817 and 1820 (Detroit Institute of Arts) indicates that he was touring on Watson's route about this time.

The death of Groombridge and the departure of Guy left Philadelphia to the Birch father and son, for the dominant figures in local painting—the Peales and Thomas Sully—were only peripherally interested in landscape.[36] Both Birches were born and trained in England, moving together to Philadelphia in 1794. Thomas Birch had painted an oil of Eaglesfield not long after it was built (see fig. 18) and a view to Eaglesfield from the bridge at Fairmount (see fig. 14). Both he and his father painted house portraits of Sweetbriar, next door, Sedgeley, across the river, and other local estates. Father and son also collaborated on two print portfolios depicting Philadelphia's urban attractions and many of the "country seats" in the area.

If Watson did not see their paintings, he probably knew these prints, for Richard Rundle was a subscriber to the first portfolio, *The City of Philadelphia*, who may have hoped to see Eaglesfield featured in the second suite, dedicated to American country seats.[37]

Well known for such landscape work, Thomas Birch had also made a name for himself as a marine painter, specializing in scenes from the recent war. Watson could have seen his *Capture of the Levant and the Cyane by the Constitution*, depicting a naval encounter in March 1815, displayed at the Pennsylvania Academy in the summer and fall of 1816. Since Watson saw the *Cyane* at the Brooklyn Navy Yard in July and probably met Commodore Bainbridge, captain of the *Constitution*, in Boston, he would have studied Birch's work carefully as both art and journalism. Birch was a practiced painter of the sea, but Watson could have faulted his landscape work for inaccuracy and distortion. Like Groombridge, both Birches were competent managers of the period's repertory of picturesque and beautiful forms, prone to manipulate the landscape and fudge detail for a general effect. Thomas Birch's painting of Eaglesfield twists the axis of the house in relation to the river, amalgamating different vantage points and ignoring architectural elements (windows, dormers, chimneys) at will. Clearly, Birch painted his scene in the studio, relying less on the outdoor sketching and disciplined observation that informed Watson's work.

Few others in Philadelphia were as interested in landscape as Watson and the Birches. The young Hugh Bridport (1794–ca. 1868), who mainly painted miniature portraits and taught drawing school with his brother George, arrived in Philadelphia in 1816 and exhibited a few watercolor landscapes at the Pennsylvania Academy in the spring of 1817, when the Society of Artists rallied to present their sixth annual exhibition. Charles Alexandre Lesueur (1778–1846) also landed in Philadelphia within weeks of Watson's arrival, but his elegant watercolors focused most often on topics of interest to scientists and naturalists.[38] William Strickland (1788–1854) was just entering the local field of landscape painting, exhibiting his watercolor view of Woodlands at the Academy in 1816 and 1817. The field, as Watson no doubt noticed if he visited the Academy's galleries those years, was not crowded.

Watson might have been interested in comparing his work with that of the resident artists, most of them provincial British painters like himself, but his strongest ties were not to the local professionals, whose scale, medium, and intentions usually varied from his own. Instead, his natural context arises among the other visiting amateur watercolorists who shared his background and interests along with his technique. Some of these visitors, such as Heriot, Latrobe, and Parkyns, stayed long enough to make a significant contribution to the local community. Others stayed more briefly but—like Watson, or George B. Fisher (1764–1839) or Pavel Svinin (1787–1839)—produced images that, translated into prints, made a lasting contribution to American iconography. Fisher's North American watercolors, published as a suite of aquatints in 1795, included a view of the Hudson River at Anthony's Nose that Watson might well have seen before he came. Spacious, luminous, and serene, Fisher's delicately modulated aquatints set a tone echoed twenty-five years later in William Guy Wall's *Hudson River Portfolio*. As Robertson has noted, these prints "were the first successful attempts to marry the unique qualities of the American landscape—its scale, light and wildness—to classical landscape conventions."[39] Svinin, a painter with academic training, joined the Russian foreign service and was posted in Philadelphia from 1811 to 1813. He preceded Watson at ten of the tourist sites on Watson's itinerary—such as Washington's tomb, the dueling grounds at Weehawken, Passaic Falls, and the Colossus bridge at Fairmount—using a softer, less varied touch in landscape subjects and showing a sharper eye for social life and the urban scene (see fig. 26). Both Svinin and Fisher had an interest in publication, however, and their work, like Watson's, circulated in engraved form long after their departure.[40]

Although briefly in residence, Watson shared stylistic affinities with a group of British amateur watercolorists who remained longer and contributed more: George Parkyns, George Heriot, and Benjamin Latrobe. Parkyns, whose work at Eaglesfield lay before Watson's eyes daily, has been discussed earlier in relation to his principles of landscape design as well as his own relatively rare prints and drawings (see fig. 19). Heriot and Latrobe, both about a decade older than Watson and just slightly more old-fashioned in style, left many more watercolors to posterity that allow us to judge the collegiality of their relationship with Watson.

George Heriot (1759–1834), the well-born Scotsman who became deputy postmaster of Canada, provides, along with Parkyns, an instance of the choices available, professionally and artistically, to gentlemen amateurs in Watson's day. Heriot gave up an unpromising start as an artist to join the civil service and the army, where he was employed as a draftsman. The opportunities for travel provided by his administrative posts in Quebec were turned to artistic advantage, as his watercolors found publication in Canada. When Heriot took a leave of absence to return to Britain in 1796–97, he—like Watson in America—spent his time touring and sketching; unlike Watson, he then submitted his work to the Royal Academy exhibitions and studied new aquatint techniques, developing an expertise in printmaking that later supported his illustrated travel accounts of Canada and the continent. Heriot preceded Watson along the Hudson and in Washington, D.C., by two years; just as Watson arrived in the United States, Heriot resigned his Canadian post and returned to England to begin a series of sketching tours. His career is worth comparing with Watson's because Heriot had a similar background but just enough more energy and ambition as an artist to consider both exhibition and publication of his work. Because Heriot's public career as a draftsman began with Royal Academy entries when he was thirty-eight and aquatints when he was forty-five, it is tempting to imagine what Watson, liberated from the navy at a similar age, might have done with his talent had he lived like Heriot to the age of seventy.

Heriot's style also makes a useful comparison with Watson's, because the two artists shared the tonal, transparent mode of the late eighteenth century. Heriot's thirteen-year advantage gave him a decidedly more old-fashioned style: more generalizing overall, with broad masses of tint; soft, dabbled foliage conventions; and Claudian compositions even more obvious than Watson's. Heriot's sketches (fig. 43) show habitual use of the brush, on the spot, in a broad style resembling the work of Gilpin.[41] More comfortable with this technique than Watson, Heriot seized atmospheric effects rapidly as he

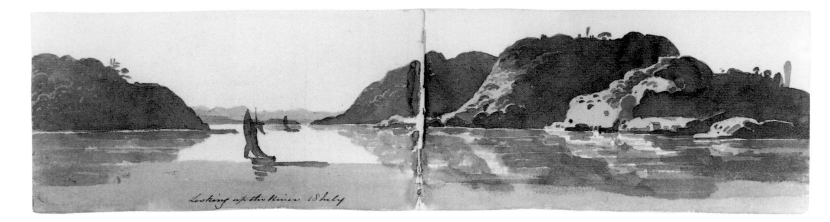

43. George Heriot, [West Point] *Looking up the River 18 July*, 1815, wash on paper, $4\frac{1}{8} \times 8$ in. (each page), from a sketchbook in the collection of the New-York Historical Society.

sailed down the Hudson in 1815, looking forward and back from the deck of the boat or from the shore, much as Watson did the following summer. Watson's daintier and more patient manner does not do much to disguise the fraternity of technique and picturesque instinct that embraced both men.

Watson and Latrobe

Sharing even more with Watson, as an artist and journalist, was Benjamin H. Latrobe (1764–1820), the English-born architect and engineer who came to America in 1796 and remained until his untimely death from yellow fever in 1820. Latrobe made a major contribution to the architectural landscape of his adopted country, alongside which Watson's observations bear little weight in terms of influ-ence. Even so, the two men held much in common, including close family ties between England and America (Latrobe's mother was born in Pennsylvania) that conditioned a sympathetic attitude unusual among British visitors in this period.[42] Even more striking is the near interchangeability of their artwork. Both were determinedly amateur as painters but typical of the most excellent class of such artists produced in Britain in this period. A study of their astonishing harmony of style enlarges our awareness of certain patterns in the art of their time, while it diminishes factors that seem — in artistic terms — to have been superficial differences in personality and professional accomplishment.

Both Watson and Latrobe were from provincial, genteel stock; both were cosmopolitan travelers, able administrators, and family men.[43] Latrobe had been raised for the ministry, like Watson's father, and he received an education appropriate to this calling. Always more intellectual and erudite than Watson, Latrobe displayed his literary bent in lengthy diaries, essays (including very relevant remarks on landscape painting), and public orations, such as his address to the Society of Artists of Philadelphia in 1811. Watson showed neither

Latrobe's contemplativeness nor his egotism, but he was interested in exactly the same topics: engineering, architecture, steam navigation, geology, botany, local customs, and landscape. Both, when crossing the Atlantic, whiled away the idle hours by drawing exotic fish and doll-like ships on unconvincing stormy seas. Latrobe's scholarly interests in natural history far exceeded Watson's occasional observations on skunks or grasses, just as Latrobe's technical knowledge of architecture and engineering surpassed Watson's experience on these subjects, but these basic interests were as attuned as their talents as draftsmen.

Given the small world of American gentlemen holding such identical lists of skills and interests, it is a wonder that, in a year's time, Watson neither met Latrobe nor mentioned his name. He encountered (and described) his work on all sides: in Philadelphia, the Bank of Pennsylvania, the old waterworks (see fig. 52), and Sedgeley (see fig. 22 and plate 12); in Washington, the Capitol (see plates 75–76), and the Navy Yard; in New York, the frigate designed by Latrobe's partner in steam engineering, Robert Fulton (see fig. 60). Latrobe had recently resigned his position as architect of the Capitol when Watson visited Washington in April 1817; his investment in steam navigation on the Ohio River was about to drive him into bankruptcy, which perhaps explains why he was not circulating much that spring. These personal turns may account for why the two men never met, but it remains puzzling that Watson, who knew many people who knew Latrobe (such as Samuel Breck), could have copied Latrobe's elevation of the Capitol without attributing the source or visited Sedgeley at least twice without remembering more than its designer was "a French architect." This inattentiveness says much about Watson's disinterest in fine art professionals, already noted; it may also hint at Latrobe's ambiguous identity in America, where architects were barely recognized as professionals anyway.

Failed personal connections aside, Watson and Latrobe shared a propensity for sketching and painting in watercolors that unites them historically more profoundly than any chance social encounter. Latrobe's work kept him busy as a draftsman, but he also kept diaries and sketchbooks for his own amusement, producing across twenty-five years a visual and literary record of American life and land-scape unmatched in the period. His fourteen sketchbooks, containing some 350 drawings, plus myriad individual watercolors and architectural renderings, were produced in scattered bursts of artistic activity, usually while traveling. Watson made two-thirds that number of drawings in the one year of his visit, offering a broad view within a confined period rather than Latrobe's scattered, long-term perspective. Given Watson's intense activity over a shorter time, his work is predictably more singleminded in both style and subject. Many things drew Watson's attention, but Latrobe's compass swung wider yet, including genre scenes, caricatures, literary illustrations, and trompe l'oeil still lifes. Latrobe could not draw figures well, but he persisted; Watson was not much better at figures and so turned relentlessly to landscape.

In the category of landscape, where their interests overlapped perfectly, the differences proposed by Latrobe's wider repertory and longer residency diminish to insignificance. Latrobe's discussion of landscape and art in his 1798 "Essay on Landscape" can be read as if it were a gloss on Watson's sketchbooks; his principles of picturesque-ness (based on Gilpin), his catalog of artistic "knacks" or "licenses" (foreground trees and shadows, figures, wagons, ships, and the like), his sense of the merits and pleasures of drawing, all speak for Watson as well. Drawing, for Latrobe, was done for personal delight and relaxation, for the instructive benefits in improving one's perception of nature, and secondarily for the possibility of communicating these observations to others or recollecting pleasures later.[44] Remembering these motives, it becomes clear why Watson, like Latrobe, rarely painted urban views and why neither felt any pressure to proceed beyond personal satisfaction to professional presentation or publication of their work.

Technically, their work is also alike, as it proceeds from pencil outlines to wash contours and shading, sometimes followed by broad transparent tints and finished with crisp pen detailing (see figs. 22, 44). Latrobe, with more time between sketching trips to reconsider his work, colored in his sketches more often, usually completing the effect with ruled ink margins to make a framing border. Watson never cropped his compositions in this manner, instead using the paper's edge self-consciously, both adapting to and exploit-

ing the odd proportions of his sketchbooks. Other such differences can be discovered, confirming differences in their personalities that are revealed in their writings, their career accomplishments, and in the testament of friends. But the search for the individual identity of each man is less provoking a task than confronting the stylistic brotherhood between them. Overall, their work unites in basic picturesque strategy, palette, and handling of contour and wash. This is remarkable not because they never met, but because each man's work resembles the other's more closely than it resembles any single British master of this period. Lacking tidy art historical "influences," we must look to a particular cultural climate that cultivated, independently, very similar expressions from two persons of similar class and experience. The popular sources of the British elite—schoolboy watercolor classes, Gilpin's tour books and their canon of the picturesque, contemporary aquatints, and Royal Academy landscape painting—here fell upon two very like-minded and talented sensibilities. Finding only such generalized sources uniting these remarkably similar creations, we must give credit to the wonderful vitality and coherence of Britain's "amateur" culture and refresh our sense of the powerful part it played in the nation's great age of landscape painting.

Given their common attitudes and techniques, it is no surprise to find Watson at Passaic Falls, sketching the view from a point no more than a few feet to the left of the position taken by Latrobe on his visit seventeen years earlier. Likewise, they sketched the same views at Mount Vernon and the capital, discovered similar perspectives on the Susquehanna around Columbia, sketched at Little Falls on the Potomac, on the Delaware below Philadelphia, on the Chesapeake near Havre de Grace, and on the banks of the Schuylkill. What may be more remarkable is the fact that their large oeuvres overlap *only* in these places. Watson's tour of the Hudson River and New England and his extensive series of views in suburban Philadelphia find no equivalent in Latrobe's sketchbooks. Latrobe, for his part, ventured farther south and west. It is as if these two kindred spirits collaborated to compose a single pictorial survey of America's eastern states, harmonious in style and intent, for the pleasure and edification of posterity.

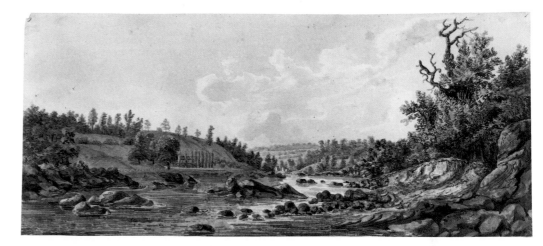

44. Benjamin H. Latrobe, *View of the Schuylkill, taken Augt. 31st 1799 . . .*, graphite, watercolor, pen and ink on paper, $8\frac{3}{8} \times 18\frac{11}{16}$ in., sketchbook V, Collection of the Maryland Historical Society, Baltimore.

Prints After Watson's Work

Watson hardly touched America's community of artists in the brief year of his residence, but after his departure his work was circulated in ways that allowed him a small part in the development of the national tradition in landscape art. Never an exhibitor in his own country, he made his debut in the United States ten years after his death, when two of his watercolors appeared in the Eighteenth Annual Exhibition of the Pennsylvania Academy of the Fine Arts, in May 1829. These two entries, from "Captain Watson, Royal Navy," were *View from the Porcelain Factory, near the Schuylkill, Permanent Bridge* and *View of the City of Exeter, Cathedral, and River*.[45] Both must have been lent by Maria and George Rundle, Watson's sister and brother-in-law, who had inherited all Richard Rundle's pictures in 1826.[46] The first view was probably the large watercolor (fig. 40,

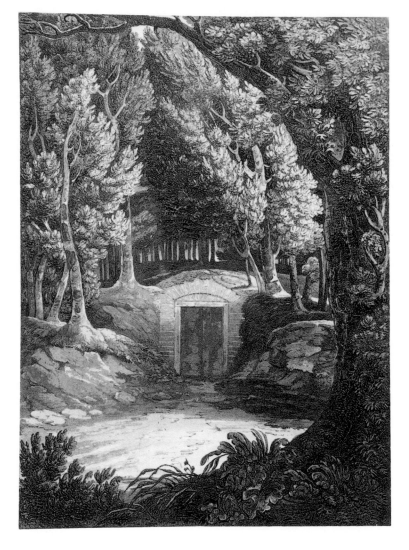

45. John Hill, after Joshua Shaw, after J. R. Watson, *Washington's Sepulchre Mount Vernon*, 1820, etching, engraving and aquatint on paper, 13 × 9½ in. (image), Pennsylvania Academy of the Fine Arts, bequest of the John S. Phillips Collection.

color plate 10) discussed earlier; the Exeter panorama has not been located.[47] The slender record of critical response from this period allows little speculation about the impact of these pictures on the local audience. Certainly Watson's views would have remained current and instructive, for there were few rival watercolorists of such skill, even by 1830, other than the newest generation of traveling British artists, such as W. J. Bennett and W. G. Wall.

Bennett and Wall both toured and painted American views with an eye to the possibilities of prints made from their sketches. They would have been among the handful of artists, all British born, who might have reacted with familiarity to Watson's name, for they all must have known the important prints after Watson's work that appeared in the decade following his departure. These three prints were part of two significant portfolios published in Philadelphia: *Picturesque Views of American Scenery* of 1819–20, and *Views in Philadelphia and its environs*, of 1827–30.

The first of these suites, mostly based on the work of the English-born Joshua Shaw (1777–1860) and engraved by another English emigrant, John Hill (1770–1850), has long been recognized as a landmark publication in the history of American printmaking.[48] Shaw arrived in Philadelphia in 1817, just as Watson was leaving. He drafted the project and then traveled widely, mostly along the eastern seaboard, sketching spots of historic interest or natural beauty and soliciting subscriptions for the portfolio. He was lucky to enlist Hill to make and print the plates, for there was no one else in America capable of such sophisticated aquatinting. A veteran of Rudolph Ackerman's publishing ventures in London, Hill had few peers on either side of the Atlantic, and his arrival in the United States in the summer of 1816, coincidentally just a few weeks after Watson landed, opened up new possibilities for the American book and print trade. Before encountering Shaw, Hill had produced two views of the spas at Ballston and Saratoga, based on sketches by C. A. Lesueur; the projected list of thirty-six subjects to be included in *Picturesque Views* included many such sites also visited by Watson in 1816–17. The suite was curtailed by the publisher, Mathew Carey, when only twenty plates had been printed, but the prints in circulation by 1821 did much to estab-

lish the itinerary of the American grand tour as Watson knew it, from Lake George to the Chesapeake.

All of the subjects in *Picturesque Views* were drawn by Shaw, with the exception of two, both by "Captain Watson R.N.": *Washington's Sepulchre Mount Vernon* (fig. 45) and *Falls of St. Anthony on the Mississippi* (fig. 46). Both of these views were exceptional and troublesome to Shaw, Carey, or Hill because of their anomalies. Shaw made a special selling point of his efforts to visit each site personally and make fresh, accurate delineations on the spot, so his inclusion of another artist's work immediately introduced inconsistency. However, *Washington's Sepulchre* was part of the first group of views published in 1819, so it surely belonged to the original concept of the portfolio, as imagined by Shaw or his first publisher, Moses Thomas. Clearly based on Watson's work (see plate 80 and color plate 18), the print must have been made from a replica—now lost—that Watson left behind in America when he departed (bearing his sketchbooks) in 1817. Who owned this view, and how Shaw or Thomas found it, remains obscure. Variations in the size, format, and detail of the print compared with the view in the sketchbook might be explained by this missing version, for Hill's plate is much larger and wider than the sketchbook page. However, the accompanying text admitted that the view had been embellished: "A *Painter's* license has been taken in regard to the number and size of the trees with which the hillock is covered, by anticipating what a few years will bring about," it began, although the title of the plate stressed that the artist (Shaw) had taken his subject "From A Drawing Made On the Spot By Captain Watson of the British Navy."

Perhaps the freedoms taken by the secondary artist or the engraver made Mathew Carey anxious as the rest of the portfolio developed along stricter lines, for he wrote to Shaw on 26 January 1820, asking that he "forward a good design to be instead of the Tomb of Washington." [49] Shaw objected to its withdrawal but volunteered an alternate view of Wissahickon Creek. By 3 March, Carey wrote to Shaw confirming work on a new plate with Hill, but he added that "we doubt however the necessity of changing the Tomb unless it is done in the whole of them." Because the exchange of letters between Carey and Shaw is incomplete, we can only imagine what Carey meant by "it" (taking artistic license?) or why he had misgivings but then decided to retain the plate. Something was irregular about *Washington's Sepulchre*. [50]

Perhaps Carey was uneasy about the impact of the subject itself. The dilapidation of Washington's modest tomb was a controversial topic in this decade, as travelers' accounts described the unkempt condition of Mt. Vernon and the unseemly, even grisly, spectacle of this national shrine with its door falling ajar to reveal tumbled coffins within. Latrobe took to the lectern in 1811 to criticize the "national disgrace" at Mt. Vernon, and Samuel Breck deplored the sorry state of affairs he and Watson encountered there in 1817. [51] Both Watson and Shaw produced images much tidier and more dignified than such accounts reported—a discrepancy that in itself may have worried Carey —so the text accompanying the plate addressed the issue directly:

This rude and decaying tomb of the most pure and faultless of patriots has long been the subject of reproach to his countrymen. "Shall any future patriot," it has ben asked, "hope to have his memory perpetuated while Washington lies neglected. Not a stone tells the stranger where the hero is laid. No proud column declares that his country is grateful. If but an infant perish, even before its smiles have touched a parent's heart, a parent's love marks with some honour the earth that covers it. 'Tis the last tribute which the humblest pay to the most humble." The true monument however of the patriot is his country. "Si quaeris monumentum circumspice," was inscribed on the tomb of a great English architect, and with equal propriety might it be said of Washington; if you would seek his monument look at the country he served, at the republican institution he loved and fostered, and at the humble farm to which he retired when ambition had no influence and power no charms.

Perhaps Carey or Shaw composed this text to explain the tomb to puzzled subscribers that they hoped to reach overseas. The reproach contained within the image might have been useful in galvanizing public opinion in the United States, but in Britain or France such a revelation was inexplicable and embarrassing. Among all the celebratory landscapes in the suite, the *Sepulchre* struck the only negative note. Both Carey and Shaw were anxious to produce images that sat-

isfied patriotic pride as well as curiosity, which may explain why they made the scene more lush and romantic, while interpreting the unpretentiousness of the site as a fitting emblem of Washington's virtue. In these two ways, the collaborators mitigated the irregularities of Watson's view within the larger context of the portfolio.

Falls of St. Anthony proved to be another problem. A thousand miles from Shaw's other views, it was far off the beaten track and difficult to verify in every way. Shaw's text made it clear that his knowledge of the site was secondhand; responsibility for the authenticity of the view was passed to Watson.

46. John Hill, after Joshua Shaw, allegedly after J. R. Watson, *Falls of St. Anthony on the Mississippi*, 1820, etching, engraving and aquatint on paper, 9½ × 13 in. (image), Pennsylvania Academy of the Fine Arts, bequest of the John S. Phillips Collection.

The Falls of St. Anthony on the Mississippi, were so called by father Hennepin, a French missionary who travelled in North America about the year 1680. The whole river, which at a short distance above is about nine hundred yards in width, is here compressed into a space of about two hundred yards, and falls perpendicularly about thirty feet according to Carver, and fifteen or sixteen according to lieutenant Pike. The descent continues through a succession of rapids to St. Peter's, a distance of eleven miles. The country around these Falls is said to be exceedingly beautiful. It is not an uninterrupted plain where the eye finds no relief, but is composed of many gentle ascents, which in the spring and summer are covered with verdure, and interspersed with little groves that give a pleasing variety to the prospect.

The view from which the annexed engraving is copied was taken and coloured on the spot by captain Watson of the British navy.

As our look at Watson's itinerary in America has shown, it is most unlikely that he visited the upper Mississippi.[52] Having access to one of Watson's Washington views already, Shaw may have borrowed a waterfall view from the same source (Samuel Breck?), embellished and obscured it with an elaborate foreground, and willfully mislabeled it. Just as likely, the drawing of some other artist could have been mistakenly or even purposefully attributed to Watson to gain credibility from his rank and lingering good reputation. In either event, the result does not look like St. Anthony's Falls or its surrounding landscape.

Fortunately for Shaw, very few people in the world knew any better. Nonetheless, this plate introduced a surprising and seemingly unnecessary risk into the enterprise. Since Shaw touted the freshness and accuracy of his views, he must have realized that any challenge to the authenticity of his sketches would discredit the whole project. Although few observers could dispute the appearance of the falls, there were several who might deny Watson's visit there or protest the fabrication of a false view. Perhaps Shaw calculated that such criticisms would be swallowed by Watson's genteel friends. Shaw himself was not known for reliability or good character, and as pressure mounted to produce and deliver an even barely profitable edition, the temptation to pass an exotic, fictitious view over the name of a reputable British officer must have increased. Someone does seem to have challenged the veracity of the view, for Shaw wrote defensively to an associate that "with regard to the Falls of St. Anthony, I am satisfied

that it is correct and have the best proof that it is so."[53] Because Shaw did not elaborate on the nature of that proof or his source, we are left with the same alternatives: he may have been convinced by genuine evidence lost to us now, misled by a misinformed person, or lying.

Shaw assessed his risks correctly, for his *Picturesque Views* were reprinted in his lifetime and ultimately recognized as an inaugural statement of a new era in American landscape art. The portfolio popularized the country's scenery in the most sophisticated contemporary terms and set Hill on the path of an ever more distinguished career. Just months after Carey ceased publication of his debt-ridden venture, Hill was approached by the young Irish watercolorist, William Guy Wall (1792–ca. 1863). Although younger than Watson, Wall worked in a more conservative style, adapting the broad and conventionalized manner of the early romantics to the American scene. Gracefully organizing the landscape into beautiful and picturesque panoramas, Hill and Wall collaborated on the *Hudson River Portfolio*, a publication that was to celebrate in a more formal and painstaking fashion the tour that Watson had taken so swiftly five years earlier. With Shaw, Hill, Wall, and William J. Bennett (ca. 1784–1844), all British watercolorists who arrived within a year of Watson's visit and shared his skill, style, and taste in landscape subjects, the great age of "picturesque America" dawned. Watson came first but made the least impression because he had no interest in promoting or publishing his work. Yet, by the agency of his friends, his views earned a lasting presence in this parental generation of the American landscape school.

Watson's friends and family must have again allowed his participation in a second posthumous publishing venture: Cephas G. Childs' *Views in Philadelphia* of 1827–30. His participation in this portfolio seems less problematic than his role in Shaw's, perhaps because the sketchbook source (see plate 8 and color plate 3) and the actual model (see fig. 40, and color plate 10) for Childs' print, *View on the Schuylkill, from the Old Waterworks* (fig. 47), are both known.

A consideration of the other images in Childs' portfolio shows Watson's view to make an original, but not eccentric, contribution to the whole, which was more tightly defined by its Philadelphia focus than Shaw's wide-ranging suite. Childs apparently felt it was time

47. Cephas G. Childs, after Capt. J. R. Watson, *View on the Schuylkill, from the Old Waterworks*, 1827, etching and engraving on paper, $2\frac{15}{16} \times 5\frac{7}{16}$ in. (image), The Library Company of Philadelphia.

to revise and refresh Birch's earlier *City of Philadelphia*, a publication that was still circulating in new editions, although most of its imagery dated back to 1800. Less ambitious in scale or technique than Birch's or Shaw's portfolio, Childs' publication was also less egocentric. With a format one-quarter the size of Shaw's, perhaps aimed at a more popular market, Childs turned to a number of different artists and printmakers to supplement his own skill as an engraver. Watson's work stood among views by Thomas Birch, Thomas Sully, Thomas Doughty, and some lesser-known painters, mostly from a generation younger than Watson. This kind of committee effort made Watson's inclusion less surprising than his earlier appearance in Shaw's portfolio, particularly after that publication drew attention to his work and to the local owners willing to lend it for reproduction. Childs must have been delighted to find Watson's watercolor, for it showed a stretch of the Schuylkill, its famous bridges and waterworks, from a previously unpublished vantage. Watson's view complemented Birch's perspective of the city from its Delaware shore, also in the suite, and led smoothly upstream to William Mason's de-

48. Thomas Sully (?), *On the Schuylkill from the Old Waterworks*, ca. 1827, black wash and graphite on paper, $3\frac{1}{2} \times 6\frac{5}{8}$ in. (image), The Library Company of Philadelphia.

49. George Strickland, *On the Schuylkill*, ca. 1827, brown wash on paper, pen and brown ink on paper, $3 \times 5\frac{5}{8}$ in. (image), The Library Company of Philadelphia.

piction of Eaglesfield (see fig. 3) and a final Schuylkill landscape at Manayunk, by Childs's partner, George Lehman.

Although Shaw and Hill seem to have enlarged Watson's "Mt. Vernon" view (or its replica), Childs had to work in the other direction. The original watercolor (see fig. 40), was thirty-five times the area of Childs' plate, requiring reduction in two phases, perhaps using two collaborating artist-translators. A set of monochrome watercolor or ink sketches made in preparation for Childs' engravings provides a rare look at this intermediary phase between a large drawing or painting and its petite engraved reproduction.[54] The small brush and ink *On the Schuylkill from the Old Waterworks* (fig. 48), signed in pencil "T.S." (and certainly in the style of Thomas Sully, who contributed a design of his own to Childs' group), reduced and simplified Watson's large watercolor, which was itself an expanded composite of his sketchbook views (see plates 7, 8). Sully cropped the vertical dimension of Watson's original by one-sixth, reducing the amount of sky and enlarging the impact of the horizon. He also redrew the smoke and cloud effects to give more weight to the upper half of the picture, where Watson's image was weakest. Perhaps using this sketch as a reference, the young George Strickland (1797–1851) made a more detailed version in brown wash (fig. 49), incorporating detail from the original watercolor into the new format and developing Sully's more energetic sky. Childs, as engraver, could have looked only to this version as he worked on the plate, for the finished print (see fig. 47) shows further simplification as well as a few new improvisations. In this labor-intensive fashion, the watercolor could have been copied without ever leaving the Rundle home.

George Strickland, nephew of the architect William Strickland, made his first important showing at the Pennsylvania Academy's annual exhibition in 1826, sending "A frame, containing nine views in Philadelphia now engraving for 'Childs' Picturesque Views of Philadelphia, and Company,'" mostly from his own designs. Thomas Doughty's two views of Fairmount, also engraved in the portfolio, appeared at the academy the next year, in 1827, and in 1828 George Lehman showed three Schuylkill landscapes, including two at Manayunk that may have played a part in Childs' publication.[55] Given this sequence of displays, it can be no coincidence that Watson's two watercolors appeared at the exhibition in 1829, conveniently anticipating the publication of Childs' portfolio the following year. Childs no doubt prevailed on the owners to lend the picture that year, drawing attention to Watson's good work and allowing Childs to use the exhibition for renewed publicity, as many publishers did in this period. This display may have been Watson's only public exhibition in the nineteenth century; the print was his last contribution to American iconography.[56]

A hundred years later, Watson's New York and Boston harbor views (see fig. 58 and plate 68) were discovered and copied in aquatint by Harold Wyllie (1880–?) and published in New York by A. C. and H. W. Dickins, Inc., in 1926. Wyllie, an English artist with a distinguished military record and a fondness for historical naval subjects, stood within a dynasty of marine painters much as Watson fell among sea captains.[57] His two images, although published for the American market, were probably made in England from watercolors in Watson's family's possession.[58] Stylistically, the prints speak more of Wyllie and the early twentieth century than they do of Watson and his period, showing the descriptive and nostalgic antiquarianism of Edwardian art, analogous to the colonial revival that filled American homes with Georgian-flavored furniture and Wallace Nutting's softly tinted photoengravings of eighteenth-century interiors. No less willing to embellish than Watson's two earlier publishers, Wyllie interpreted these images in ways useful to his own period's concerns. The present volume, marked by the taste of the late twentieth century, hopes to let Watson speak for himself at last.

Epilogue: Watson's Final Year

Watson's Return to England; His Final Year
in Exeter; the Sad Circumstances of His Death

"ON THIS DAY OUR WORTHY AND AMIABLE FRIEND Watson embarked on board the Rebecca Sims to return to England," wrote Samuel Breck in his diary on 14 June 1817. "I shall ever feel attached to this good hearted gentleman."[1] Two months later Watson arrived home. The sketches made on the ship as he approached Liverpool conclude his second sketchbook, and they seem to be the last extant watercolors from his hand. His leave of absence expired in August, and he returned to domestic life on half-pay, in and around Plymouth and Exeter.

The first page of Watson's new diary (fig. 50), begun 1 January 1818, opened with a declaration of hope and well-being:

I commence this year without a debt unpaid. My Dearly Loved Wife and six equally Dear Children in perfect health and myself certainly *much* improved and I thank my God for all his bounties to me and mine for the past, and I hope with confidence for the future.[2]

His health, as this statement implies, was not good. Periodically seized by debilitating headaches, Watson resorted to "physics," emetics, and leeches; after four or five days, sometimes spent in bed, these headaches would pass.

Otherwise, he was pleasantly occupied, his major business being a search for a house for his family in Exeter. Their old home in Topsham was rented out, and Watson took accommodations near his aunt Frances Burges and her husband, John Green. The Greens lived on the Barnfield Crescent in a house that seems to have harbored Watson's family earlier, when his second child was born. The Watsons were in and out of the Barnfield house almost daily, partly because his aunt Fanny was failing from an illness that would end her

50. Joshua Rowley Watson, Diary page, 1 January 1818, Collection of Elizabeth Burges Pope.

current mayor, Robert Sanders; and "Patch," probably the Reverend Gayer Patch, who had introduced Watson's work to Joseph Farington. Between visits to his friends and family, Watson ventured afield to Heavitree, Cowley Bridge, and Wandford to enjoy the "salubrious air" and the "delightful rides and walks in the vicinity" recommended by local writers.[4] He tutored his daughters, attended church services regularly (often twice on Sunday) at St. Sidwell's or St. Leonard's Chapel, and maintained his correspondence with friends and relations in Philadelphia. Dispensing directions to his banker to sell stock (probably to purchase his new house) and attending to various "businesses," Watson lived a pleasant, gentlemanly existence, marred only by the recurrent distress of his headaches. His diary mentions no sketching or painting this spring.

The preparation of his new house became the outfitting and provisioning of a final ship that Watson would never sail. After a few finishing touches on the evening of 24 May, the Watsons left their children in the new house, in the company of a servant, and returned to the Barnfield Crescent for one last night in the Greens' home. According to accounts in the local newspapers, Watson retired "in his usual health,"

life on 20 February. This sad event was countered by the discovery and purchase of a suitable house in March, at no. 6 Dix's Field, just north of the Barnfield Crescent. The back gardens of the two streets adjoined, giving a neighborly closeness to the two homes. Dix's Field was one of the newly developed streets opening out of Southernhay, along the medieval city wall.[3]

The Watsons spent the rest of the spring ordering fixtures for the house and contracting with painters and upholsterers to make what may have been a brand-new house ready for occupancy. Tasks related to preparing the house increased as the spring wore on; earlier that winter his social rounds—dinners, teas, "calls," and regular visits to Moll's Coffeehouse, where army and navy officers gathered—took up a large portion of almost every day. In January Watson mentioned encounters with thirty-six different people (in addition to his family and in-laws), many of them numerous times, at many different homes in Exeter. Predictably, this group embraced a large number of officers, including Admiral John Dilks; politicians, such as the

and about 2 o'clock he awoke under an impression that the house was on fire; he immediately got out of bed, and having ascertained that there was no cause for alarm, was returning to his room, when he suddenly dropped down at the head of the staircase and instantly expired. He was a gentleman of the most affable and friendly disposition, and has left a widow and six children to mourn the irreparable loss of an affectionate husband and father.[5]

A few days later Mary gathered her strength to write the Rundles in Philadelphia. The extant draft of her letter, crossed with strike out lines and charged with grief, painfully expresses the "sudden loss of my Hearts best Treasure":

to attempt to convey to you in language what my agony has been would be fruitless—I can only appeal to your remembrance of my beloved Husband's Virtues, your regard for him & your kno[w]ledge of the purity of his love for his Family & how he was idolized by them[,] to form a just idea of the present state of my feelings. . . . The many & frequent separations we have endured may induce many to imagine that the pangs of final parting wou'd be ameliorated, far otherwise, it only aggravates my grief. . . .

Taking solace in the conviction that she would be reunited in heaven with her husband, and praying for strength to live "in the path of religion," Mary embarked on her own description of "the circumstances that occur'd on that dreadful night":

We were delayed from occupying our house from the writings not being ready—much longer than we first had an idea of. . . . Monday 24th May we had been many hours at the house, myself engaged in making things ready for occupying the next day when the writings were to be signed. We did not leave it until eight o clock, my dearest W. having kiss'd the younger Children bidding them goodnight & saying that the *following one* we shou'd all be together under the same Roof, but *that* never came to him. We return'd to the Barnfield, took our tea as usual & retired about ½ past ten. The room we occupied was a back one which looked immediately across to Dixfield— our window curtain was undrawn & about ½ past one we were awaken'd with an appearance of fire from the adjoining unfurnished house to where our dear babies were sleeping in Dixfield. My Dr W. immediately got on his Clothes, went to the house while I call'd the domestics of Mr. Green—The manservant had just gone out of the Barnfield Gate when he met him— returning saying that all was quiet & that it was the moon shining thro a room that had a through light. dr W. had just gained the top of the staircase where I was waiting for him—saying as he came up don't be alarm'd it is only the moon—& desiring I would send the Servts to their beds—, which I was about to do when the Man Servt who had followed him up the stairs said Maam Capt Watson is faint—I flew to him & happily the servant [prevented] his falling down the staircase. He breathed once or twice after I came to him & I recollect I had the presence of mind to open his neck cloth (k)not & get some Hartshorn[?] the female Servt assisted me in supporting him whilst the man Servt ran to the nearest [—————] for medical assistance. it appeared an age before they return'd & in the Interval dear Mr Green had awaken'd by our screams [—————] imagine what his feelings were in the dreadful scene before him. My poor lifeless husband & myself in a state bordering on Frenzy—Mr. Morris the Medical man on his arrival saw that the vital spark had fled & therefore did not bleed him. from his looks I began to be awaken'd to the reality & when I told him he was not doing his duty to restore him to me his reply was Maam we do not live in the age of Miracles. this fully conveyed to me that all was over—still I had recollection enough left to me to request he would try to restore [—————] with [—————] bleeding in the [—————] was resorted to but all these efforts were fruitless—in one sad half hour my poor Watson had been awaken'd from a sweet sleep to be called into the presence of his God—It almost breaks my heart as I write yet I ought to for the satisfaction of those beloved kind friends whose love for him was little short of mine . . . dear Fanny [her 14-year-old daughter] was the only comfort at the time as poor

Mr. Green was obliged to go to his bed so agonized were his feelings . . . now little able to support ourselves after the recent loss we had sustained in [his wife] our beloved Aunty. this poor child endeavor'd to comfort me by saying Recollect my dr Mama that Papa is now in Heaven & free of those dreadful pains that he always endured.[6]

Later an autopsy revealed the source of Watson's "dreadful pains": a ruptured blood vessel was discovered in the brain, while "much disease appeared about the head & skull." What consolation such explanations might bring was added to the support of Watson's "numerous naval friends," who "fixed on the Cathedral" at Exeter as an appropriate funeral site.[7] Watson was interred in the precinct of the cathedral close on the morning of 1 June 1818, with a large company of brother officers in attendance behind his oldest son, the nine-year-old Rundle Burges Watson. Later a marker was installed in the floor of the south transept. The inscription read: Joshua Rowley Watson Esq., Captain of the Royal Navy, died the 26th day of May 1818, aged 46." This text, recently recut at the behest of his great-great-granddaughter, Pamela Burges Watson Brice, came at the head of a Latin inscription long since obliterated by the footsteps of the cathedral's visitors.

Mary Watson, widowed at the age of 38 with six children between the ages of 17 and 2, was not the only person heartbroken by Watson's death. In America, Richard and Mary Rundle had looked on him as a son; with no children of their own, they were desolated by this loss so late in their own lives.[8] "It would be needless for me to attempt to describe to You how the dear departed invited our love," wrote Rundle to Mary.

his Heart was good—so good that it seemed almost perfect—there was no Dross in it—his manners how pleasing—his conduct how correct— his Virtues conspicuous, splendid & brilliant—Friends & Admirers he had everywhere—Enemies he had none—for he knew not how to make one— such was the Man We have lost—for years ever since his Merits began to unfold themselves has he been to me a son the Son of my affection—had Nature given me one I doubt if could have loved him more.[9]

Rundle counseled Mary to comfort herself in God's grace and consider her blessings—six fine children—and her sacred duty to them. For their welfare, Rundle urged Mary to move the entire family to America. She had few "Blood Relations" in England, he argued, and

none capable of lending real assistance; few benefactors stood likely to offer "the uplifting hand of patronage." Without "Family Interest, Fortune and Powerful Patronage," Mary would find "settlement in Life and forming Connections" difficult. And, aside from the security of life alongside "nearest and dearest relations," America was less expensive. Investment opportunities were more lucrative. "This country is large & extensive & comparatively thin of inhabitants — it therefore allows Elbow Room for the Young & Enterprising to bustle in & affords better prospects of success. The Comforts of good living are much more easily attained here — & with much less expense." Rundle opened Eaglesfield to Mary and her children, and offered them all passage to Philadelphia on a Rundle-connected ship. He urged her

to convert her property into cash so that he could advantageously invest it for her. Mary's response can be deduced from Rundle's third letter to her after Watson's death, wherein he accepts her decision to remain in Exeter. Evidently her husband had spoken some wish — probably relating to the raising of the children — that they all agreed must be obeyed "like the Laws of the Meads and the Persians, never to be altered."[10]

Indeed, by remaining in England Mary Watson kept faith with the Burges family tradition. Young Rundle Burges Watson, left fatherless at almost the same age Joshua had been orphaned, was already poised to follow in Watson's footsteps. Three months after his father's death, he applied for a place at Portsmouth naval academy.[11] A hero in his youth and an able administrator in his maturity, R. B. Watson, C.B., repeated his father's pattern across a longer and even more distinguished career. His son became an admiral; his son's sons were a rear admiral and a commander. His nephews were navy lieutenants and army colonels. The longevity of the tradition, still alive in the twentieth century, would please Watson; certainly it vindicated Mary's decision to stay in England.

But Watson was not forgotten soon in America, at least while George and Richard Rundle lived. Certain phrases from the elder Rundle's letters to Mary reappeared in the death notice published in a Philadelphia paper that summer, making it likely that Rundle himself wrote the terse but emotional tribute that Watson received in the United States. In a small space, he expressed the sadness felt on both sides of the Atlantic at the loss of a talented and lovable man:

DIED, suddenly, on the 26th of May last, in his native city, Exeter (Eng.) aged 46, JOSHUA ROWLEY WATSON, Esq. Captain in the Royal Navy. This awful dispensation produced great grief to the inhabitants of that city, to all by whom he was known, and therefore by all beloved. His amiable deportment, gentlemanly manners, and brilliant virtues, gained the esteem of every one. Friends he had many, enemies none; for he knew not how to make one. Very many of our own citizens, who had the pleasure of being acquainted with Captain Watson during his short stay among us, some twelve months since, will participate in the feelings excited among his countrymen on this awful event; for here too he could only be known but to be loved. Homage is in all countries paid to virtue. His remains, attended by a great number of citizens, and all his brother officers in the city and vicinity, were deposited in the Cathedral on the 2nd of June last.[12]

51. Artist unknown, *Silhouette of J. R. Watson*, ca. 1817, ink on paper, Collection of Elizabeth Burges Pope.

Appendix A: Watson's American Diary, 21 April–3 August 1816

THE DIARY OPENS WITH A LIST prepared by Watson himself of friends and acquaintances in the United States. Not all these persons are mentioned in the diary, and other names appearing in his text are not included in the list. The meaning of these inconsistencies and the general character of Watson's circle of friends are discussed in Part 1, "American Family and Friends" and "Watson's American Diary." An annotated directory of persons actually mentioned in the diary follows the diary text; these names are italicized in the footnotes to direct the reader to these biographical entries. Please consult the index for full references to all names and places discussed in the diary.

The daily headings for the diary entries usually appear in the margin or at the top of the page, as in figs. 30, 55, and 68. Headings that indicate new entries are given at the beginning of that day's text; those that appear above or alongside continuous text are put in square brackets. Brackets also indicate a space left empty, an illegible word, an editorial insertion, or a cross reference to plates and figures in this volume. Slash marks (/) indicate line breaks in the original manuscript.

The diary was originally transcribed by Patrick Whinney, who has generously consented to its publication here.

Mr Sam¹ Breck Sweetbriar Hill
Mr. Geoᵉ Blight
His Excelᵞ Governor Brooks. Boston
Commodore Bainbridge U.S. Navy
Doctor Brun[?] N. Y[——] marᵈ to Capt. White's Sist.

Captain Biddle	U S. Navy	
Doctor Caldwell	Philadelphia	
Mr Crammon	Merchant Philadelᵃ	
Mr. Josʰ Dugan		
Commodore Dale	United States Navy.	Philadelᵃ
Captain Derby, U.S.N.	Boston	
Mr Davis	Boston	
Mr Davis	Philadelphia	
Mr. Dallas	late Secretary of ᵉ̱ᵧ Treasury	
Mr G. Dallas	his son	
His Excelʸ Monsʳ Daschkoff	Russian Envoy	
Commodore Decatur	U.S.N. Washington	
Monsʳ Ellisen	Russian Secretary Legation	
Mr Emlin	Merchᵗ Philadelᵃ	
Mr Jamˢ C. Fisher		
Mr Wᵐ. Fisher		
Lieutᵗ Finch	U.S.N.	1st Lᵗ of ᵉ̱ᵧ Independence
Mr Green,	Boston, Brothʳ of Mrs. Copeley	
Mrs Gapper	An English Lady of fortune	Philadᵃ
Marchal Grouchey		
Mr Jamˢ Hamilton,	Woodlands on the Schuylkil	
Alexʳ Hammond Esqʳ	N. York	
Mr Hoffman	ᶠᵐ Baltimore	now Philadelᵃ
Dr Hosick & his Brother	N.York.	
Captain Hull	U.S.N.	Commissʳ at Boston
Mr Hillhouse	of New Haven	Connecᵗ
Hopkinson Esqʳᵉ	Member Congress for Philadelphia.	
Mr H. Hollingsworth	Misc.[?]	Do.
Major Jackson, formerly Aid du Camp to Washington		
Monsʳ Ivanoff,	Russian Councelʳ of Legation	
Mr Ingersoll.	Lawyer	Philadelphia
Mr J. Keating	No. 183 Sᵗʰ Fifth Street	Philadelphia
Mr De Kantzow	Swedish Embasʳ	
Mr President Kirkland, Head of Cambridge		
Mr. Kimber, at Boston, now Baltimore.		
Mr T. Leaming of Philadelphia		
Mr Jamˢ Lysle	Brother in law to Mr. Hamilton	

Mr Fisher Leaming,	Brother to the above.	
Mr	Lloyd of Boston	
Mr. Murgatroyd		
Commodore Murry, United States Navy, now Commisʳ Philaᵃ		
Captain Morris U.S.N. now has the Congress.		
Mrs. Morris	Philadelphia	
Mr Jos. P. Norris	Philadelphia	
His Honor Judge Peters	Bellmont on the Schuylkill	
Mr Thoˢ Peters	Lawyer in Philadelphia.	
Mr Perotte	Philadelᵃ & Germantown.	
Mr. Ralpʰ Peters.	Near Philadelphia.	
Mr Parish		
Mr. G. Parish		
Mr Chief Justice Parker, Boston.		
Captain P	U.S. Navy	
Mrs. Phillips	Philadelphia.	
Mr Hayns[?] Powell	Philadelphia	
Lieutᵗ Page	U.S. Navy	
Mr. P. Pedersen	Danish Minister & Consul Genᵗ	
Mr Rawle	Lawyer	Philadelphia.
Mr Renguenete	Spanish Consul General.	
Colᵗ Raguet	1.st Regᵗ Volᵗ Pensilⁿ Militia	
Capt Read	U.S.N.	
Mᵗ General Ripley	U.S. Army	
Mr G. Roberts	Philadelphia	
{ Mr Jacᵇ Ridgway	Philadelphia	
{ Mr Rotch	his Son in Law	Philadᵃ
Mr Jnᵒ Savage.	Merchᵗ	Philadelphia
Mr Shoemaker	Philadelphia Lawyer	
Count Servilliers	Joseph Buonaparte	
Mr Clemᵗ Stocker	Merᵗ	Philadelphia
Colᵗ Thorndike, Boston.	Militia	
Mr Tilden,	Boston.	Is brother in law of Admᵗ Luigis[?]
Mr. Tenkate,	Chargé des Affaire	fᵐ Holland
Mr Tunis	Merchᵗ	Philadelphia.
Doctor Thornton,	Patent Office Washington	
Genᵗ Wells of the Masachutsets Militia.		

His Honor Judge Walton. Saratoga
Mr Vaughan Phil.ᵃ Cousin of Adm¹ Hollande & Portugese Consul.
Mr Alexʳ. Walker. Merch.ᵗ fᵐ England, now Phil.ᵃ
Mr. Wikoff—Philadel.ᵃ He has an astonishing <u>memory</u>
Mr C. Wistar. Philadel.ᵃ a man of ability.
Mr Winthrop, Boston. He is brother to Capt W.
The Right Revrand Bishop White of Pensilvania
Doctor Wistar M.D. Philadelphia.

1816 / Sunday / April 21st.
I got up at 4 OC. and at 6 AM embarked on board the American ship Mercury (364 Tons) of Philadelphia and bound to that Port. James Yeardsley Master. The wind ESE

The Crew consisted of the Master, 1 Mate a Carpenter and 12 hands and a Boy. The Mercury is a sharp built ship sails well, 10 Years old, & heretofore employd in the East India trade. Her topmast &.ᶜᵃ of the same dimensions, on her Fore and Main masts, and the Yards on each of these masts of the same squareness, and the sails to correspond. A Mr Keaton was also passenger, a young man of French extraction, of amiable manners, and good principles. After a most boisterous passage of 52 days from the Port of Liverpool, we struck soundings in 40. Fms. water off the River Delawar on the Morning of Tuesday 11th. June, & at 3 AM a Pilot Boat furnished us with a Pilot. We have had the winds from WSW to WNW for 36 days and blowing at times [1816/Tuesday/June 11ᵗʰ] very heavy gales of wind. The ship very leaky requiring to be pumped every half hour. My reckoning was right till we had passd the stream of the Gulf, and nearly approached soundings in Latitude 38.51, Longitude 74.5, when a strong Gale at WNW drove us again into the Gulf Stream, and tho we were by our reckoning making Westing, we were evidently drifting to the Ewd.

I strongly advise every Captain who has orders to go to any part of the Coast of North America, to furnish himself with one, or more, Thermometers, as they will at all times announce to him his approach to the Banks of Newfoundland and the Gulf Stream. The Ocean water is about 55° or 56°, it is therefore easy to discover your bearing on the Banks by the Quicksilver's falling, and should you be near Islands or Fields of Ice, the Thermometer will announce your danger by a fall of at least 5 degrees.

In approaching the Gulf stream the water then a dark Blue gets warmer & the Quicksilver rises by degrees to 61°. when it gets up to 65° the water becomes of an Azure Blue you are then getting into the stream and the Q[uic]k.silver will rise as high as 76° & even to 78°. The following are the actual remarks I made when in and drawing out of the Gulf Stream.

	Latitude	Hour	Thermometer		
			Water	Air	In ℮y⊙¹
May 31st	39° 17 N at	Noon	71°	66°	80°
June 1st	37 49 "	do	70	63	
" 2d	37 3 "	do	68	73	87
" 3d	38 18 "	8 AM	72	70	
		Noon	76	71	
		8 PM	68./2	61	
" 4th	38.51 "	8 AM	58	57	
		Noon	60	61	
		8 PM	60	58½	
" 5th	39. 0 "	7 AM	57	62	
		8 "	56	63	
		11 "	51	64	
		Noon	50½	66	
		4 PM	56	do	
		8 "	59	65	

We had been in the Gulf stream on the 31st of May & had drawn off it on the 4th June when a heavy Gale of wind at WNW drove us again into it, as will appear by the state of the Quicksilver, as follows [:]

We must at the time been <u>very near</u> Soundings

	Latitude	Hour	Water	Air	In℮y⊙
6th.	39°. 26' at	7 AM	53°	57°	
		Noon	57	do	
		8 PM	59	54	

7th.	37 . 48 ″	7 AM	63	53	
		9 ″	63½	56	
		Noon	68	57	
		4 PM	68½	56	
		8 ″	72	55	
8th.	37 . 9 ″	7 AM	72	62	
		9 ″	76		
		Noon	76½	65	
		8 PM	76½	59	
9th	37 . 17 ″	7 AM	75	58	
		9 ″	67	59	
		Noon	66	57	
		4 PM	64½	″	
		8 ″	63	55	
10th.	37 . 38 ″	7 AM	60	55	
		10 ″	59	59	
		Noon	57	60	85°
		4 PM	56½	56	
		8 ″	55	55	
11th	38 . 45 ″	6 AM	56½	53	
		8 ″	56	54	
		Noon	56½	60	
		8 PM	d°	57	

June 11

This day at 1 AM sounded in 40 F° water which made us about that distance from the shore, & it is to be observed that in general The distance from the shore on coming on soundings is denoted by the fathoms each fathom being that of a mile, except off Cape Hattrass & the Shoals of Nantucket. A Pilot Boat Schooner shortly after hove in sight, & by 3 OC. we got our Pilot on board, a well informed clever man. We made the Land of the False Cape at 10 OC. and soon after the Lighthouse on Cape Henlopen. The weather very fine with a Breeze at NEᵗ. At 3 PM we were abreast of the Ligt.house, & clearly saw Cape May on the Jersey shore; the breadth of the River Delaware at the Capes, appear to me to be about 17 m. The navigation is very critical, & after passing the Buoy on the Brown Bank, the channels between the shoals are narrow, & of course dangerous. The breeze freshened after passing the Capes, and meeting the first of the flood tide we had a fine run up as high as Reedy Island[2] where we anchored for the night at 9 PM.

Thermometer Noon Air Water
 60° 56½

June 12th.

We weigh'd at 3 AM with a light breeze at ENE. The Delaware at Reedy Island begins to contract itself, indeed from the Capes to this Island is call'd the Bay of Delaware. [see plate 1 and color plate 1] At Reedy it is about 8m broad. At 8 OC. we were abreast of a shoal rather critical calld the Pea patch,[3] at this place there is a low Island of the same name on which the American Government are erecting a strong Fort—its position is formidable, commands the channel, and you can't avoid passing within a Musket shot of it. We pass'd Newcastle at 11 OC. at this place we were boarded by the Custom house boat. This town is in the State of Delaware. At 1 PM we pass'd Wilmington, which stands very prettily on a rising ground about a mile fm. the river. At 2 OC we passd the small Town of Chester at which place Capt. Porter who commanded the Essex frigate has a nice house. At 4 OC. we were obliged to anchor abreast of the Lazaretto where we were visited by the Officers of the Board of Health; This establishment is situated about 15 miles below the City of Philadelphia and where all vessels from all parts of the World are obliged to stop—those from the Mediterranean West Indies &ca. haul in within the Island, and perform a strict Quarantine. There is a Lazaretto for unloading Ships if necessary, a hospital & two neat looking houses for the Phisician & Quarantine Master. We were not detained long and therefore weigh'd at ½ past 4 OC. At about 13m below the City Philadelᵃ we sailed over the Bar, which has only 18 feet water on it at high tides, Fort Mifflin[4] (formerly call'd MidFort, and which in the revolutianary war beat off ~~Albion 50~~ the Augusta 64 guns) It is situated on a low Island regularly fortified, and has on the Delawareside 25 guns of large caliber. There is also in the center of the river a Block house fort of 5 heavy guns $\frac{ch}{w}$ with those from regular fort commands the passage over the Bar and enfilades

$\frac{e}{y}$ whole range. The river at this place, I think, is about 2 miles broad but from shoals, you are abliged to pass close by the Forts. With light airs we pass'd Glouster Point at Sun set. At this place you first come in view of the City, and which, nothing can be finer — [see plate 2] The shores of the Delaware are from the sea very low, and were as high as Philadelphia a distance of 130m. it only has very gentle swells — the scenery however is both interesting & fine — Tho the hand of the cultivator has cleard much of the country, still there are great quantities of wood, such as the White Oak, Cedar Hickory, Ash, Black Walnut, Chesnut & the Tuliptree remaining, which gives the appearance of well laid out grounds, and a tolerably numerous population.

I landed at Philadelphia about 9 OC.PM. and by the assistance of a younster soon found my way to Locust Street, where my Brother & Sister live, and found them with my Niece [July (sic) 12th] quite well & expecting me. Their house is pleasantly situated & with every comfort.[5] [see fig. 15] I remained there the night. Philadelphia being so large and populous a City (100,000 souls acc$\frac{g}{}$ to $\frac{e}{y}$ last Census) gives full employment to the Country round about, the Delaware is therefore the means of conveying the supplies of all sorts to the Markets, and keeps the River in an active state from the numbers of sloop rig'd craft which are constantly sailing up & down, and take their loading from the Towns, Creeks & banks. There are also Steam Boats of large dimensions being 114 feet long [see plate 27], with <u>most excellent</u> accommodation for passengers, which ply daily from the City to Newcastle and others on a smaller scale which attend the Ferry from Philadelphia to the Jersey shore [see plate 3; color plate 2] — others again as large & convenient as those to Newcastle go to Trenton, but I shall have occasion to speak more fully on Steam Boats when I take a trip in them.
Thermometer Air 72°

June 13th.
I dispatched a note early in the morning to my Uncle[6] at Eaglesfield house, who arrived in Town by 10 OC. & delighted me with his affectionate & kind reception. After transacting business at the

Custom house[7] (The Officers of which are <u>particularly</u> attentive & polite) and writing a letter, & a duplicate, to my Dearly Loved Wife; I attended Mr Rundle accompanied by my Brother, Sister & Niece to his House about 3½ miles from the City. We left Town at 1 PM in his Chariottee, drawn by a very fine pair of Bay horses — We proceeded through a part of the City, which is built on a scale of magnificence I had no idea of, through Walnut Street to the Old Waterworks,[8] [fig. 52] which is in the center of the intended plan of the City at the head of Market Street, and so on to the Center or Permanent Bridge[9] across the river Schuylkill — [see fig. 40; plate 8; color plates 3, 10] This Bridge is built of wood on two stone piers, three arches and the whole covered in, so that in passing, you are sheltered in Summer from the rays of the Sun, in Winter from the severe cold, and the whole of the works of the structure protected

52. John Lewis Krimmel, *Fourth of July in Centre Square*, by 1812, oil on canvas, 22¾ × 29 in., Pennsylvania Academy of the Fine Arts, purchase (from the estate of Paul Beck, Jr.).

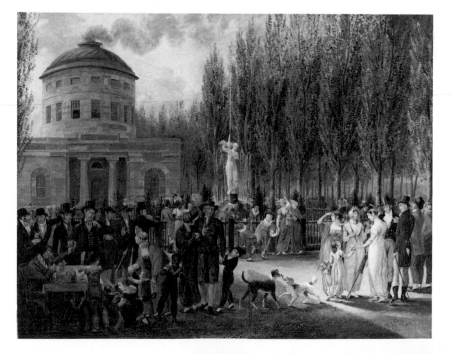

from the weather. On your approaching this Bridge, you come in view of the most beautiful and gigantic Bridge of One Arch in the World—It is thrown across the river Schuylkill at the upper ferry, and forms a most striking object—the span of the Arch is 340 feet $3\frac{3}{4}$ inches, it is also covered in, and finished in a most complete manner [see plates 8, 9, 13, 14; and color plates 3, 4, 10]. This masterly piece of workmanship & ingenuity was invented by Mr Lewis Wernwag, a German, self-taught. It was executed by him & Mr Joseph Johnson—It is composed of Wood with Iron braces, the arch springing from Stone abutments on either side the river.[10] On passing over the former we turned to the right along the banks of Schuylkill, to the Old ferryhouse, where we came close to the Lancaster Bridge, the road is prettily diversified by Country houses and small boxes laid out with good taste. I was all eyes looking out for a view of Eaglesfield,[11] but afraid to ask questions, tho we pass'd one or two places I thought might be it. By the approach through a good road with trees on either side, and the beautiful flowering plants, the wild Laurel and Rhodedendrums &ca. in great profusion, we enter'd the North Gate of Eaglesfield near the Dairyhouse and Bath [see plate 19]: and drove about 300 yards amidst fine timber trees of Oak, Cedar Hickory, Chesnut & Tulip, nor could I get even a peep at the house till we were close up to the door [see plates 15, 16]. On alighting, I was met by my Aunt,[12] who gave me a warm and affectionate reception, my Uncle welcom'd me to this beautiful abode, and announcing me at home. 'Tis now upwards of 12 years since I parted with them on their return to this Country; in that time, the general enemy, has made less alteration in their appearance than I could have expected: and in any part of the world they would be considered a handsome couple.[13]

Eaglesfield is about 3 miles from Philadelphia, situated on the right shore of the River Schuylkill [see figs. 3, 18; plates 15–20]. The estate consists of 130 acres of which 50 are wood, the rest in pasture and arable, including the Garden & pleasure ground. It is one of the most beautiful places, for its size, I ever saw, and the house has many conveniences. It is well situated on a rising ground, shelter'd from NW to NE by lofty trees, and commanding most pictoresque views up and down the river. You enter the house from a Piazza 25 feet long, with a porch in a half circular form, supported by pillars, into the hall, on the left of which is a breakfast parlor, on the right the stairs, and under them a door to the China & glass closet, and the stairs to the kitchen &ca which is underground; in the front are the drawing & eating rooms communicating with each other by large folding doors [see fig. 21]—the hall and eating room are decorated by some very tolerable pictures, the drawing room with our family picture and several drawings by me. The bedrooms are very good, 3 in number with a dressing room on the first floor, and good garretts over. The front windows of the eating & drawing rooms reach from near the top of the room to the floor, and open out on a spacious Piazza 46 ft long and 13 ft wide supported by 6 pillars, the whole front of the house [see plates 17, 18]. This is a delightful place, and affords shelter in the summer from the intense heat, and in rainy weather and winter, from damp and extreme cold. The view from it is beautiful, looking over a lawn of 25 acres, well planted with trees and shrubs down to the Schuylkill—the magnificent bridge of one arch fronts you, and over it, you see a part of Philadelphia, the shott manufactorys forming striking objects, and the distance closed by the Jersey shore [see plate 14, color plate 4]. The view from the back front is equally grand, but of a different discription—from it you get two peeps of the Schuylkill through the trees, and an interesting turn of the river, with views of the grounds of Landsdown, Bellmont and a small tho pretty house, belonging to a Mr Walln.[14] [see fig. 1; plate 24; color plate 6] Near the house is a pavillion with a Piazza all round it, it consists of two rooms and well situated for privacy [see plate 18]. By the river side is built a pleasure room with kitchen & store houses belonging to a Society of Gentlemen who meet during the summer months once a week—they stile themselves The Schuylkill Fishing Club. My Uncle has granted them permission to hold their meetings there, they acknowledging their privilage by presenting him annually on the [] June with a Yellow Perch, and stiling him their Baron.[15]

The Dairy house Cow house, Bath &ca are at a short distance from the house—in the former the pans of milk are placed in a cooler

in summer, through which a stream, issuing from a fine spring is constantly running. It also supplies the Bath and fills a pond for the Horses and ducks [see plate 19].
Thermoᵗ 2 PM 76°

14th.
I went into Town and transacted business at the Custom house, and got my luggage on shore from the Mercury. I paid my respects to Mr & Mrs. Murgatroyd — Mrs. M. reminded me much of Mrs. Manley, tho she is more lively in her talk and manner. They have experianced sad misfortune, haing lost all their Children in consumptions 7 in number. Mr M. accompanied by Mr Thos. Leaming called on me in the evening (this gentleman was engaged to be married to Miss Mary Murgatroyd before she died) Mr, Mrs. & Miss Perot dined with us — they enquired very particularly after Mrs. Green with whom they had been very intimate when my Aunt was in America. I found the season very backward, the weather cold and unsettled. I was informed that at Cambridge near Boston, they had Ice and Snow on the 7th Instant, and ever since my arrival, the mornings & evenings have been cold and the appearance of the weather very unsettled.[16]
Theomᵗ 2 PM 84°

15th.
After breakfast my Uncle took me a most interesting ride along the banks of the river, as high as the Falls of Schuylkill — every turn of the road brought new objects to my view; on either side innumerable gentlemens villas delightfully situated. At the falls, which is more properly speaking a rapid in the river through some rocks, there was a bridge, but which by the weight of Ice and Snow, has been carried away. There is at this spot a manufactory of Wire, the proprietor, a very ingenious Man, has constructed a Spider bridge across the Schuylkill to enable his workmen to go to & from their work — his name is White, a quaker.[17] [see fig. 30; plates 26–29]
The principle on which this very curious work is constructed, I look on as original; The horizontal line or footway is suspended on the segment of a circle made by two Iron wires, carried across the river,

and fastened at each end to the Manufactory on one side, and to a Tree on the other, at the height of about 50 feet from the water; To the main wires are fastened, at equal distances, perpendicular wires to which are afixed pieces of wood, on which the planks of the footway rest; and by another wire on each side, which keep the perpendiculars steady, there is a very secure railway made to assist the passengers in crossing the river.
The length of the footway is 407 feet the width of it 18 inches — Mr White informed me, he had placed 45 men on it at the same time, & that he thinks 50 men might cross at a time, if they walked steady. Such a flying bridge as this might easily be made out of two five inch hausers, with the necessary perpendicular ropes, and carried across a river in a <u>very</u> short time, so as to enable a body of troops to secure an opposite shore, and the whole of the apparatus might be so contrived that two waggons would carry it.

[Wire Bridge Drawing; see fig. 30]

Thermometer 8 AM 72°
1 PM 79
8 PM 66

June 16th.
The weather cloudy and damp — every person complaining of it as a most extraordinaary season — Messrs. Dugan and Walker of Philadelphia and Judge Peters honord me with a call — the latter is wonderful old gentleman, replete with wit and bon mots. He stayd dinner with us, and amused me much by his lively anecdote and information. He is the District Judge of Philadelphia, and also of the Admiralty Court; and during the Revolutionary War, was Secretary at War. I understand General Washington had a high regard for him, indeed no one can be in his company without being much gratified. He told me he considers it an honor done him to be a member of <u>our</u> general Agricultural Society, and that of Bath. He has done much good in America by promoting Societies of this sort, and written some clever things on that subject. He was <u>very</u> averse to the late war with England, and condemns the system of the present people in power. He thinks the people of the United States feel an inclination for War, tho he allows a few months more

of it, would have placed the country in a most awful state, so much so, that we might have had our own terms. I was much surprised at his expressing himself so strongly as to some remarks the Quarterly Review from time to time makes on America — indeed the old Gentleman appeard quite angry, and I find his feelings on this head are very general — I asked him if the remarks of the Qua^y Rev^w on Captain Porter's narrative of his cruise in the South seas was included in his general displeasure of that work. He candidly said "no, nor will you find a person in America in genteel walk of life, but speak of his conduct with horror".[18]
Thermo^r Noon 64°

17th.
My Brother Sister & Niece returned to Philadelphia — Fanny [see fig. 16] is a fine promising Girl, of quick comprihension. She is well grown, and regular fetures and promises to be a fine woman; she is rather retired, but which may be overcome by mixing in genteel company. In the evening I accompanied my Uncle over to Bellmont to pay my respects to Judge Peters — the House is finely situated and looks down on the River Schuylkill command a view of the grounds of Lansdown, Eaglesfield and the distance closed by the City & Jersies. [fig. 53; plates 24, 25] He show'd me his Gardens and Orchards

in the latter of which was a variety of Grasses, but I saw none of that sort which in England is commonly call'd Heaver. In the Garden he show'd me a Chesnut Tree which General Washington planted, the day he came out to take leave of his old friend; they never met afterwards. He has promised me some fruit from it, & a young tree of the same. Their last interview was on the []

This great man died at his Seat, Mount Vernon on the [] Aged [].[19]

I was also shown a grove of Pines in which the General used frequently to walk in and converse with the Judge. On one occasion, he was so absorbed in his subject, that he did not observe a snake in the path, and which he must have step't over several times. On the Judge's perceiving it, he step'd back and showd signs of great horror and fear — they kill'd the snake, it was a long Black one, & the bite not considered dangerous. Judge P. was a great deal astonished at the Generals showing his feelings so strongly, as he told me he had seen him, when all the terrors of the World, would not have moved a muscle of his frame.

Bellmont house is old, but is well built of stone and like all the

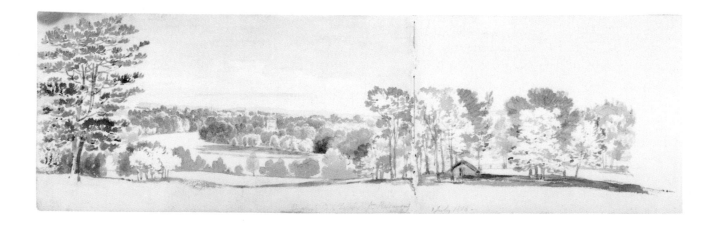

53. Joshua Rowley Watson, *Eaglesfield & [Philadelphia?] from Bellmont 1 July 1816*, blue and black wash over graphite, New-York Historical Society sketchbook, p. NY-128AB.

Country houses, has a Piazza in front. I dont see why those in England should not have the same, which would secure a fine airy walk in all weathers, besides being ornamental to the building.
Thermo.̣ 1 P.M. 62° NE.̣ Cloudy.

June 18th.
We had rain all the morning. I amused myself filling in two views I had made from this place, the one looking down the Schuylkill the other looking up. After dinner, the weather clearing up, my Uncle took me a ride round by Hamilton village [20] and on to the lower ferry bridge, which is formed of logs of wood connected together by rafters and the several parts moord out in the stream — the center of it has a sliding part on rollers which is opened with great ease to enable vessels to pass up and down. The scenery on either side is interesting and from it you have a fine view of the Woodlands, James Hamilton Esq.ʳᵉ [see plates 4–6; color plate 9]
Thamometer 5 PM 68° NE.ᵗ [/] rain

19th.
Fine weather tho the wind from the NE & E.̣ still continued. I made several sketches about the house, $\frac{ch}{w}$ furnishes a great variety. In the evening Mr & Mrs. R. drove over to see the family of the Rawle's — he is a Counsellor and a man of ability. The views from their place looking up the Schuylkill as high as the Falls, is interesting — you get a sight of Bellmont & Landsdown house on the other side of the river, and a peep of several gentlemens villas on the left bank. [see plates 27, 28] Mr & Mrs. Rawl have a large family, she was a Miss Shoemaker, they are Quakers, but it is not perceivable either from their dress or mode of speaking. We return'd over the Lancaster Schuylkill bridge.

	8 AM	—	63°	
Thamometer	Noon	—	75	fine
	8 PM	—	69	

June 20th.
We all went to Town. I returned the calls of Messrs Leaming, Dugan [,] Savage, Davis, Walker Vice Consul, Wᵐ Fisher[,] Keating and

Murgatroyd. I went to see the Banks and Athaneum [21]; those of the Old United States (now Girards) [22] and Pensilvania [23] are handsome buildings, the latter is after the plan of the Temple of Diana at Ephesus; it is built of white Marble brought from Quarries about 12 miles from the City, and is much used in the steps, door ways, and window frames of their houses. The Clay for making bricks in about Philadelphia is uncommonly fine, and their bricks particularly good — the neighbourhood also abounds with a light coloured grey granit and grey Marble, with such materials, and an abundance of the choisest woods for building, easy to be procured, 'tis no wonder that this City is the boast of its inhabitants. The Streets are all wide, and regular, running at right angles from each other from the Rivers Delawar across to the Schuylkill, and parallel with those streams. The houses are throughout the City built on the outside of squares and if I except the State hous garden, and the square of the Potters field [24] (formerly a burial place) there is no place for the public to walk in but the streets; all of which are very well paved with brick, and many of them shaded with trees, which in the summer months afford an agreeable protection against the heat.

The publick buildings, Churches [/] Meetings [?] and Houses are all so neat in this City, that it looks as if it was just out of the hands of the workmen. Market Street is the broadest in Philadelphia, and measures 100 feet across — in it are the principal markets; and when it shall be completed from the one river to the other, will be two miles long. In the center of it, is the Old water works, but which is no longer in use [see fig. 52] — the building which is a Rotunda, forms a good feture, but capable of great improvement, and being made a striking object in entering the City from the Middle Bridge.

June 20th.
The Hospital, Bettering house, House of Correction and Jail are all fine buildings,[25] the former of which is on a magnificent establishment; all of which I hope to have an opportunity of visiting. The State house, in which the Senate & Congress used to hold their sittings before they removed to Washington, is now fitted up for the Courts of Law, and a Museum collected by a curious and scientific

man of the name of Peal.[26] [see fig. 54] All the east side of the Town bordering on the Delawar is appropriated to Storehouses Wharfs & Docks, and the depth of water allows vessels of large burden to unload alongside of them. The trade of this City to every part of the World has been great in the extream, but the Merchants have been loosing ground from the commencement of the late War with England. The population of Philadelphia as now estimated amounts to 112,000 including about 12,000 Blacks. The Tonnage in Shipping out of Philadelphia in 1794 was 74,168 tons—in 1804 it was 81,163 tons, and the comparative payments into the Treasury of the United States from April 1801 to 1805 was $7,777,965.

I returned to Eaglesfield to dinner well pleased with the mornings drive the afternoon was well employd in a walk over the farm. It was a delightful day and the warm weather appeard to agree with me.
Thermomr. Noon 78° WSW.

21st.
We rode through most interesting scenery above the falls and I came in sight of Flat rock bridge on the river Schuylkill [see plates 36–38]—on our return we call'd on Mr Breck at Sweetbriar,[27] which adjoins Eaglesfield. 'tis a pretty thing with about 40 acres of land. From thence we calld on Mr Ralph Peters who is the elder son of the Judge.
Thermomr. 2 PM—75° fine

June 22nd.
I was occupied all the morning filling in some sketches I had made from Eaglesfield—the two views from the house looking up and down the river are fine. [see color plates 4, 6] In the evening I went to Town to spend the following day with my brother & Sister—Mr & Mrs. R. drove me in and took me to see Landreths nursery gardens[28] where we saw a very large Multiflora Rose tree in full flower, which covered one front of his house: seven sorts of the Magnolia, and many other native plants.
Thermor 2 PM—84°

23d.
Remained in Locust Street the whole day being sadly troubled with a Bile, but the time was fully occupied in conversation with my Brother and Sister, talking over the past, and about those we love in Old England.

This is the birth day of my Dearly Loved Wife—we have drunk her health with wishes for her seeing many happy returns of the day.
Thermometer 2 PM—86° fine

June 24th.
My good Uncle being unwilling to let me remain long absent from him, he came into the Town for me—We call'd on Mr. Baker, British Consul General, Dr Caldwell M.D. Mr. J. Smith, Mrs. Leaming, & the Murgatroyds; and got back to Eaglesfield to dinner. The weather extremely hott but I felt the better for it, and my head greatly relieved by perspiration—There is a something in the atmosphere in this climate, which is not experienced in England. Here you feel light and the spirits exhilarated; with us, the Thermometer at 72°, and we are oppress'd with heat, and the spirits relaxed and depress'd.
Thermometer 2 PM 86° Sly

25th.
Being still troubled with a Bile [,] I amused myself writing & drawing, indeed from the great variety, and new matter occuring every ride or drive I take, 'tis necessary to make good use of my time in filling in my sketches—A Reedpen makes quick work, and by using licquid Scipia for the front & second ground, and licquid Indigo for the distance, a good effect is produced and an easy sketch completed. I had frequently heard of the severity of the Thunder Gusts in America, and this evening I saw one which came on from the NW. with great fury—however, I find they are not more severe than what I have experienced in the West Indies & Mediterranean. The Lightning was vivid—I am told much mischief is at times done by it—for prevention, most houses & buildings in this Country have

conductors. The Indians in the Western country, when in the Woods hunting, and overtaken by a storm of this sort, look out for a Birch [Beech?] tree and if any are at hand consider themselves as perfectly safe under them; but quite the reverse under any other. It rained in torrents during the Gust—but it soon cleared off and my Uncle & self drove to Philadelphia to dine with Mr Savage—he had invited a party of his friends to meet me: amongst whom was Mr Parish, elder son of the great Merchant at Hamburgh—He has made a large purchase of Land to the Northw^d on the river St Laurance. A gentleman who resides at New Orleans, gave a more favorable account of the <u>Crevasse</u> at that place, than was generally understood—but some of the party thought he was making the best of a bad business.[29]
Thermo^r. 2 P.M. 78°.—

″ 26th.
The weather from yesterdays gust appeared quite altered the Thermo^r from 78° fell to 66°—I was glad to put on warm clothes. This Climate is very changeable and treacherous, and to be always prepared is the most advisable plan. I have always worn flanel in warm Countries and therefore have no sudden chills from over exercise, and avoid colds by that means. Mr. Hamilton of the Woodlands & his brother in Law Mr Lysle favord me with a call—the former is a man of considerable landed property in this neighbourhood & up towards Lancaster. Judge Peters calld and sat some time amusing us with his entertaining conversation.
Thermomé^r 2 PM 66 NE^{t.}

″ 27th.
The weather being unsettled with showers of rain I was in the house all the morning, and amused myself drawing—my good Uncle was not very well, we did not see him till late. He has a wonderfully good constitution of fine form and proportions—in height about 5/10 with a fresh rosey complexion, which this climate has not effected, and tho he is now 69 years old, he walks as erect as ever, and uses much horse exercise, and enjoys the amusement & interest of his farm.

In the morning I accompanied my Aunt to Town, who went to see her brother & Sister Murgatroyd. They are a melancholic instance of Parents outliving their Children—they had six Boys & Girls, most of whom lived to be adults, and one to be the father of a family—They are now no more, and the Green sod grows over their graves.

″ 28th.
This was the commencement of the hay harvest: my Uncle mow'd his Lawn, which promises well—It is a mixture of Clover and Natur.^l Grass. I am told the favorite grasses in the Country, are the Orchard grass & Timothy. They have the Fyonice [?] grass, which grows in a state of nature, as does the white clover; but the former is not cultivated. I have not seen any of our Meadow grass, and which in the W.^t of England is calld Heaver; nor do I think from what Judge Peters tells me, that they have any of it in America. They gett two crops of hay, and it has been known in very favorable seasons, on well dressd ground, to get three. The Grass of the second crop has a very strange effect on Horses and Cattle; it throws them, to all appearance, into a state of salivation, and the saliva runs from their mouths by quarts. This reduces them much, & of course weakens; It has not yet been discovered what is the cause of it—the remedy to stop its effect, is to feed them on Bran; two or three feeds will in a great measure take it off. In the Cow, it reduces her Milk, and what she gives is poor. The Grasslands is troubled with a weed, which grows in great profusion, call'd St. Johns wert—it throws out a Yellow flower which soon runs to seed—To the Cows it taints their Milk, and blisters their mouths—On the Horse it produces the latter effect, and takes the hair off their nose and makes it sore; when the hair grows again it invariably becomes white.
Thermo^r 2 PM 72°. NE^t

″ 29th.
The fineness of the day induced us to take a long ride—my Uncle took me through Turners Lane, which is to the Northw^d of the City—you get a good view of it, and a peep of the Delawar

Philadelphia at a distance does not make much show, and was it not for the Towers of the two Shott Manufactories and the Steaples on one of the Episcople Churches & Free Masons Hall, a stranger might enter it without knowing he was in Town.[30]

We went into Mr Symes's grounds[31] which overhang the E^t shore of the Schuylkill; The house appears comfortable, the Gardens & Grounds in good order — it commands a pretty view up the river and across, looking to Bellmont.

I returned the call of Mr Fisher whose Country house i[s] directly opposite to Eaglesfield.[32] [see fig. 22; plate 12] It is built in the Modern Gothic style of Cottages — A Villa would be more appropriate for buildings of this sort. The views from it are confined, and the Trees are allow'd to grow too near the house. The interior arrangements are good and the Bedrooms have each a dressing closet adjoining. There is a Piazza on two sides; It was built by a Mr. Crammond, who laid out on it $59,000. Mr. Fisher only gave $15,000
Thermo^r 2 PM 74°.

″ 30th.
We had, had several catching days, $\frac{th}{w}$ rain through the nights — there was much hay down, which if neglected would be lost: therefore, notwithstanding the day was the Sabbath, the people were seen busily employd throughout, at work. I have often lamented the loss of a fine day to our Farmers in England, in a bad season, when it fell on a Sunday; It surely would not be considered by the Almighty as a breach of the Commandments, were they to do the same: nor an impropriety of the Clergy, were they to grant permission on such occasions.

We drove over to the Woodlands to call on Mr Hamilton. [see plates 5, 6] It is a very good house on a large scale, the approach well laid out, and the Trees and Shrubberies fine — The view from it, looking down the Schuylkill is beautiful — near the house in a second ground, is the Lower, or Log Bridge, before noticed, — the river meandering below it, till lost in the marshes — in the distance you see

the river Delawar, Fort Mifling, the Vessels passing up & down that great river, and the Jersy shore finishes the picture.

We returned to dine with Mr Breck at Sweetbriar, who had some of his friends to meet us. I was introduced to his Lady, she was a Miss Ross of Philadelphia — they have a little Girl.
Thermom^r 2 PM 72°. North.

July 1st
I went into Philadelphia to take the necessary Oath, & get the Vice Consuls certificate, for my Half pay to forward to my Agent; this will be required every Quarter. After dinner we rode up by the Falls. I cross'd the Wire Bridge, before discribed [see fig. 30]; the vibration is great, and to a person not used to such sort of motion, the walking on it is attended with difficulty. We met Mr White the inventor and proprietor — it communicates with his Wire & Nail Manufactory — He is about commencing a sett of Locks to enable the Reading Boats to pass with safety down the Schuylkill with their Cargos and which, when completed, will prevent the necessity of their shooting the Falls, which is dangerous and the risk calculated at 1 P^rC^t.
Thermo^r 2 PM 70———

″ 2nd
I attended Mr R. to Town and went through the Markets — Most of them are situated in the Street of that name. They are full a quarter of a mile long & under cover — It is well, and abundantly supplied with Butchers meat of all sorts, Poultry, Fish (which is brought to Town in Carts with covers, and packd in Ice with Straw and Blankets, in high perfection.)

Vegetables and Fruit: and the whole kept in very nice order. The Season being uncommonly backward, every article of life is become very high in price — Butchers meat is now fm. 9 to 10^d P^r H^d Butter 1^s/6^d to 2^s/0^d P^r H^d and everything else in proportion.

We had a party to dinner & what is uncommon in this Country, Ladies formed a part of it. Mrs. Leaming & her two sons, Dr. & Mrs. Caldwell M.D. Mr and Mrs. Smith and Mr Murgatroyd with GR.[33]

Ice is in general use both in the Towns and Country, every house in the latter has an Ice house, in which they also keep their butter & meats in high preservation for a long time, indeed in a climate like this, Ice is become a necessary article of life, and in the Town, Carts are constantly going about with supplies; which is sold at a very cheap rate during the whole of the summer. All the drinks are Iced, and the butter and Fruits also.[34]

" 3d
We rode over in the course of the morning to Judge Peters, and had the pleasure of being introduced to his amiable daughter— she has a fine person, well formed, interesting countenance, and with a lively wit shows you a well cultivated & highly improved mind—I am astonished at this Lady's having remained so long single, tho I am informed, that she has refused some good offers, in order to attend on her Father who is now far advanced in Age. Such a sacrafice is rare, & is duly appreciated by him.

The Judge accompanied us in a ride through some lanes which brought us out on the Schuylkill above the falls—He amused us much with his puns and good sayings—his anecdote and information made this ride very agreeable—he show'd me some Oats which is a native of Chili in South America. It lookd very fine, and appeard to me very like the Potatoe Oat with us.

We returned home to dinner and in the evening walked to the Dairy house [see plate 19] to see the arrangement of the Milk in the Spring room. The water rising from a natural font is at a temperature of [] & remains so winter & summer. Its stream is so contrived as to pass round the room, into which the Milk in pans are placed, and kept in the nicest Order. An old Woman (in general calld Aunt Fanny) has the charge of this house, at which the People employd

on the farm reside. It is situated near the Northgate, and is a good object on entering the grounds on that side. At present there are 13 Cows on the farm—they supply excellent butter & cream the surplus, after the house is served, she takes to Market. The breed of Cattle are not good, and very far from handsome; nor are the Pigs in this part of the country of that sort most esteemed in England— Those I have seen are long headed and stand high on their legs.

" 4th.
This was a very fine day, and being the anniversary of American independence the whole population of the Country appeard to be in motion—those of the City forming parties into the country, and the Peasantry in groupes resorting to the Town [see fig. 52]. We rode to Philadelphia to see the procession of the Washington & Cincinatus societies. The former is founded to relieve its distressed members, each paying an annual stipend towards the fund—the Members are all Federal. The latter was established on General Washingtons retiring from Office & public life in the year 179[] It is composed of most of the Officers in the Army & Navy who served in the Revolutionary War & the leading men in the Country, whose politics were Federal—they wear a Blue & White riband surmounted with a Silver Eagle, as a badge of the Institution, & every new Member must be balloted for, before election. Both these Societies have branches throughout the United States.[35] On this day they both assembled together in the Washington Hall,[36] and being Marshald by their Officers, proceeded in procession through the principal streets of the City, attended by a Company of the Washington Guards of Philadelphia, a band of Music playing National airs (amongst which was Yankee doodle) and several highly ornamented banners, and emblematic decorations. On their return to the Hall they sat down to a dinner, prepared for the occasion. The several Companies & Troops of Volunteer's paraded, and at Noon fired a feu de joie. On the Schuylkill a number of people had assembled in boats, and went up the river in procession, & landing on an Island took their dinners and spent the time in jollity—on their return they fired guns under some of the Villas bordering on the river and gave three cheers, which was answered from the shore—This had a very interesting

effect, particularly at the Echo under Eaglesfield, where the Regatta stop'd some time. The evening was closed by the Boys amusing themselves with Fire works.

Thermo^r 2 PM. 70 WSW.

July 5

As we were all to dine with my Brother & Sister and being anxious to see more of the City, we went early to Town to the Athaeneum which is at present in its infancy.[37] they have a small collection of Minerals and take in most of the periodical publications from Europe — the Library is small and makes but a so so appearance — From hence we went to Peals Museum, which is arranged in the upper apartments of the centre building in the Old State house, and does the collector infinite credit, both in selection and arrangement.[38] [see fig. 54] It was founded in 1785. The Quadruped room contains 212 preserved Animals: amongst them are the Elephant Seal fmly Southsean being

54. Charles Willson Peale, *The Artist in His Museum*, 1822, oil on canvas, $103\frac{3}{4} \times 79\frac{7}{8}$ in., Pennsylvania Academy of the Fine Arts, gift of Mrs. Sarah Harrison (The Joseph Harrison, Jr., Collection).

9 ft. in girth & 11 ft. long, The Madagascar Bat, spreading 3 ft. 2.".s The long room contains Birds presented from every quarter of the globe to the number of 1240. The portraits of 136 characters distinguished during the American revolution. A splendid collection of Minerals & Fossils of 8000 artics. The Mammoth room exhibits the stupendous skeleton of that Animal, it was dug up by Mr C. W. Peal in the state of New York in 1801. it measure 18 ft. in length 11 ft. 5¦ in height. The Marine room contains 121 fishes 148 snakes, 112 lizards, 40 tortoises and turtles, and 1044 shells with cases of monkeys. In a private apartmt. a variety of Anatomical preparations. In the winter these rooms are lighted with Gas which is produced by Pitch and which is found to be less expensive.

In this collection they had a living Rattlesnake, two black & one Garter snakes. the former had destroyd a large Rat, which had been put into the cage, and a poor little terrified Mouse was in momentary danger of destruction.

Thermo^r 2 PM 73 N.W.

July 6th.

I made several sketches about Eaglesfield [see color plate 8], after which we went to Town and calld on Mrs. Shoemaker, (a Quaker lady) and was introduced to her daughter Mrs. Morris: they are both widows. My Sister & Niece accompanied us home & Rundle came to us in the evening. Fine weather.

Thermometer 2 PM 75° N W.

" 7th

We drove over the Upper Bridge to Mr Pratts [39] who has a large collection of plants and extensive Greenhouses & ca. [see fig. 14] His grounds are too much after the French manner of pleasure gardens. The view looking up the Schuylkill and over towards Eaglesfield is pretty. From thence we went to Mr George Blights. (He is the natural son of Mr Isac B — who was shot by Patch.) He has much to do — the country about him is flat & uninteresting. Hay making going on, tho Sunday.

Thermometer 2 PM. 72°. N.W.

July 8th

My Aunt took G.R. Maria & my Niece to Town. we rode and went some distance on the Frankford road, passing through Kensington I saw the stump of the Old Elm tree under which Mr Penn signed the treaty with the Indians by which they gave him possession of the land on which stands the City of Philadelphia.[40] The weather fine but it was cold for the season.

Thermor 2 PM 70o NW.

9th

We drove on the Baltimore turnpike road, it is 65 ft. broad and in very tolerable order—the center is much higher than the sides and so covered with stones as to be always hard—on either side of it is, what is call'd the summer road and which is easier for the horses feet in the fine weather. The rules of the road are different to ours, for in meeting you keep to the right, and in following you must take which ever side you can pass, for the Waggoners will not move aside to accommodate you, nor will they even in a narrow road without you speak to them in a civil requesting manner. We met many of their Lancaster Waggons all with excellent cattle; they appeard to be of the Flanders breed—The driver rides the near wheel horse and has a single rain to the near leader—they have at times six, but in general drive with four horses. The waggon is large and the whole set out, is in excellent order. In the winter they put Bear skins over the withers of their horses, to keep them warm and dry. In our way back we call'd at the Woodlands, James Hamilton Esqre it is a very pretty place, the situation of the house fine and the view down the Schuylkill extends to the Delawar and a peep at Fort Miflin & the Jersies [see plate 6] Mr H. has his grounds & gardens in excellent order & his conservatories contains some valuable plants—The house is well arranged and there are some good pictures—One by Gevr Dow. Mr H. is a bachelor, his Sisters, Mr Lyne (his brother in Law) and 2 Nieces live with him; his brother also when home (he is now in England). Mr H. has a fine fortune & in this country considered a very large one: having an Anl income of $45,000—

We spent the evening at Mr Brecks where the Woodland family joined us. Sweetbriar is the ajoining estate on the Northside of Eaglesfield and Mr B farms it himself—tis a small but pretty thing. He has some very large Lemon trees which are all the year round in full bearing. I think with a little care the Lemon tree would be a valuable domestic tree in all families in England: it is very hardy, and would only require shelter from the severe blasts of winter.

Thermor. 2 PM. 70o. N.

" 10th.

We rode over to Sedgley, James Fisher Esqre [see fig. 22 and plate 12] it is directly opposite Eaglesfield on the Schuylkill, pleasantly situated and built after the modern gothic. The grounds are confined. its view up the river is interesting. From hence we rode over to Lansdown which is on a large scale and the approach through the woods delightful in the warm weather. It belongs to the Binghams & is likely to be for sale when the young man becomes of age; [/] The house is large and fronts the river [/] the Piazza has a hanging gallery from the Bed rooms—and tho convenient does not add to the lightness. It was built by Governor Penn.

The Fishers came over to spend the evening and very unexpectedly Madame & the 2 Miss de Kantzow's with Madame Ranguinet drove up and walked over the grounds & garden. The De Kantzows are the Swedish Ambassadors family, and in Mme Ranguinet I found a near relation of my esteemed friends the Villavicencio's of Cadiz, her husband is the Spanish Consul at Philadelphia. she is a very interesting woman—Fine weather tho fog in the Morng

Thermomer. 2 PM 70°. Variable.

" 11

We went to Town & spent the day $\frac{th}{w}$ GR. & Maria—Judge Peters, Dr. Caldwell [/] Leaming, Smith, Breck, Blight, Walker & Mr Whycoff. I visited the Navy yard and went on board the Franklin 74 gun ship.[41] Lieutent Morgan showed me every part of her—She was finished last year, her timbers are principally of Live Oak and some of Cedar & Mahogany. She has no poop—her dimentions are;

Length of Gun Deck	186 ft	
Breadth —	50/8	
Depth of hold -	19	
Tons ———	1900	

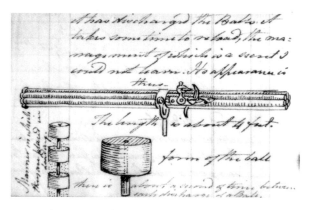

55. *Rudderhead*, pen and ink, from Watson's diary, 11 July 1816, Collection of Elizabeth Burges Pope.

She has 16 ports on a side on each deck 7 and an entrance port on the Quarter deck and 4 on the Forecastle. Her gangways are 12 ft. wide—She works her cables on the Main deck & a Capstan on a new construction on the Quarterdeck like our frigates—she falls home fm. the uppercell of the lowerdeck ports. Her rudder head is small her tiller being Iron, and which is secured by two bolts passing through the hole of the tiller, and secured to the same. [fig. 55]

She is to mount on [42]

the Gun Deck	30 Long	32.pns.
Main Deck	30 Short	32pns. 2
Quarter Deck	14 Car.l }	32pns.
	2 Long }	
Fore Castle	6 Cars }	32pns.
	2 Long }	

Intended compliment of Men and Officers	750 of which
there are to be	8 Lieutents
and Midshipmen	30

She is now along side the Jetty. On her slip was built the Guerrier,[43] the largest frigate of the American Navy

The Gunners' stores of the Franklin are arranged in a Store house in the Yard; amongst them I observed a 7 Barl Top Gun [44] of a curious construction, the invention of a Country man named []

It discharges 30 balls of a particular construction from each barrel, and which fires itself after the Trigr. has ignited the powder of the first ball—The lock is placed about two thirds on the barrel from e_y breech: it is fixed on a swivel and intended for the Tops or Boats—but when it has discharged the Balls it takes some time to reload, the management of which is a secret I could not learn. Its appearance is thus—[fig. 56]

Their boarding pikes are better than those in use in our Navy, and they have provided their Boarders with a leather Cap guarded with Iron, which I think clever. [fig. 57]
Thermometer 2 PM 74° fine

12th July
The weather very fine. I amused myself about the grounds. in the evening we observed a fire in the City and which appeared to rage

56. *Top Gun*, pen and ink, from Watson's diary, 11 July 1816, Collection of Elizabeth Burges Pope.

with some fury—I understand the young men of the different Wards of Philadelphia arrange themselves into fire companies, some to the Engine others to the supply of Water and strong parties to the saving of property from the building on fire and securing the same when saved. They are become so expert that you scarcely ever hear of more than the house in which the fire originates, being destroyd.[45]
Thermometer 2 PM 74° SW.

" 13th
We had fine showers almost the whole of the day, and which re-freshd the whole face of Nature, which had for some days required it. In the evening it felt raw and cold.
Thermometer 2 PM 68° SE

July 14th.
I drove into Town in the morning, on my return found Mr Leam-ing and Blight who dined with us, and we made arrangements for a Tour to the Northward.
Thermo. 2 PM 71° fine. NE.

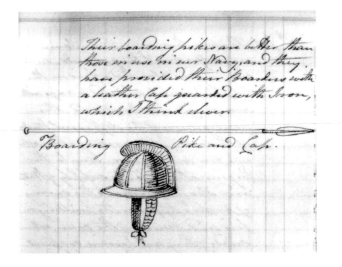

57. *Boarding Pike and Cap*, pen and ink, from Watson's diary, 11 July 1816, Col-lection of Elizabeth Burges Pope.

" 15
The day cloudy and unpleasant. I made some sketches of the house. We dined at Sedgley J. Fisher Esqr. [see fig. 22 and plate 12] It is opposite Eaglesfield on the Er. side of the Schuylkill and built after the plan of a Frenchman. it is well contrived, tho I can't say so much of the arrangement of the grounds. the Trees are too much trimed up and too many of them near the house. We had a pleasant party. Ourselves, Miss Wharton (sister of Mrs. Fisher) Judge Peters, Mr Hopkinson Membr. Congres for Philaa. Mr Morgan a Senator of the State of Pensilvania, Mr Jackson, formerly Aid du Camp of the Immortal Washington, Mr Leir [Levi?] & Mr Brown.
Thermor. 2 PM. 73 Cloudy SW.

July 16th
We had much rain during $\frac{e}{y}$ night and very sultry during the day: in the evening we had a severe gust which produced a fine effect at Sunsett.
Thermor. 2 PM. 79° W & NW

" 17th
Much the same sort of weather during the morning—Afternoon the wind suddenly shifted round to NW. and it became very cold. The Thermor. this day was curious
At 8 AM it was at 71°. At Noon 76°
At 2 PM 63° and at 10 OC. 59°

" 18th
We took a pleasant drive round by Bellmont, where we call'd, and on Mrs Wall's [Waln?]; delightfully situated for a summer resi-dence: indeed all along the Banks of the interesting Schuylkill are innumerable spots for building villas which might be laid out to great advantage: for Nature has done much. In the evening we drove to Town having made arrangements for setting out on a tour. I took leave of my friends.
Thermometer 2 PM 70 NNW

July 19th.
I got up early and after breakfast went on board the Steam Boat

Philadelphia at the Quay, where I met my friend Mr Thom.ˢ F. Leaming and left the City at 7 OC. This Boat or Vessel is 145 ft. long, 20 ft. broad; the power of the Engine that of 30 horses. The consumption of fuel is 4 chords of wood in her passage to Trenton and back to Philadelphia. The accommodation on board is excellent, being divided into two apartments, one for the Ladies, the other for the Men. You have refreshments of every sort & a regular table laid out for breakfast and dinner, for which you pay $\frac{3}{4}$ $ the passage up is 3$ being a distance of 40 miles which we completed in 5 hours including stoppages at the several landings [46]

We passd the pretty towns of Burlington, Bristol, White Hall and Burdentown (at this latter place Joseph Buonaparte has purchased a house and 30 acres of ground, for which he paid $15,000. It is about 20 miles from the City and in the State of Jersey; It was sold to him by Mr Sayre who was formerly Sherif of London.) [see plate 39]

On either side the River Delawar the Country is beautifully spotted with Gentlemens Villas and the face of Nature delightfully diversified by gentle undulations of the grounds all well wooded. The River has many low Islands, formed by the alluvial deposit, on some of which trees have grown up, and are very ornamental and picturesque to the scenery.

We got to Bristol, a distance of 20 m in 1ʰ 55ᵐ having the tide with us, and arrived at Trenton at Noon. The general rate of the Vessel is 8 miles an hour. You meet with a great mixture of company in this mode of conveyance, and the ease with $\frac{ch}{w}$ you get on, and the moderate charge, induces many families to be moving during the summer months from home, which before this improved plan was invented, confined them to a certain distance: But now for the small sum of $12 you can, in the course of 48 hours, be set down at the City of Albany in the State of New York on the River Hudson, with only a land carriage of 27 miles from Philadelphia, and with no other fatigue than is occasioned from being so long confined in the vessel, but which is relieved by the great variety of scenery and the company on board.

The Stages were in waiting for us, and had only time to make a sketch of the Bridge at Trenton, $\frac{ch}{w}$ is built on a peculiar construction, the arches, five in number supporting the road or platform over the river, which is <u>suspended</u> from them by chains. [see plate 40] The Delawar at this place is 600 ft. broad. The Town is the Capital of New Jersey and is pleasantly situated. The Courts of the State are held here. The Stages are amongst the worst contrivances in America, being <u>very</u> uneasy, they are open all round, have weather cloths to shelter you from the rain and wind — You enter at the front & each Stage accommodates 10 passengers. The horses were good and took us a journey of 27 miles over bad roads with ease to themselves — there were 4 of them.

The Country was by no means interesting — we passd through Prince town, where there is a College & a Theological seminary. [47]

At this place our 48th. Regiment greatly distinguished themselves after our defeat at Trenton in the Revolutionary War. Kingston is a small place where we watered our horses, and arrived in good trim at Brunswick, which is delightfully situated on the River Rariton. The Jersey is in general a light sandy soil — as you approach to Brunswick the country changes for the better, the woods larger & the Trees of a more considerable scantling — the soil, a deep red, the crops good and the lands well cultivated — the distance closed by the Kittateny Mountains.

This town is large and well built and as the Rariton empties itself into the Bay of New York, and large Sloops and Schooners come up to it, the inhabitants partake of the lucre of trade. It has a population of 6312 souls. There is a Wooden bridge over the river and the scenery on the banks on either side interesting. The Inn very tolerable — I made two sketches from it. [see plate 41]

July 20th.
The Steam boat for New York was ready to leave Brunswick at 5 OC. and we embarked at that hour — the Scenery on the Rariton river reminded me much of our Medway, tho not so wide as it. The salt

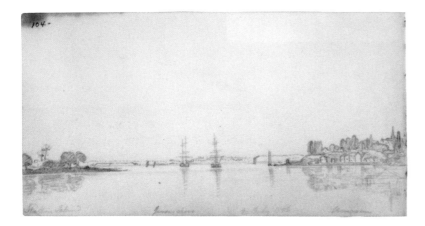

58. Joshua Rowley Watson, *Statton Island. Jersey Shore. 20 July 1816. Amboin*, pen and black wash over graphite, New-York Historical Society sketchbook, p. NY-104A.

marshes produce a heavy crop of coarse grass of which they make hay, but from the severity of the Mosquitoe's bite, they do not stork them. On passing Amboyne, you turn short to the left and pass through the channel that separates Statten Island from the State of Jersey.[48] [fig. 58; and see plate 42] We saw Elizabeth Town, & on

opening the Kill sound, get a fine view of Snakes Mountain from Newark Bay on the left, and soon after a magnificent view of the Bay of New York, the City, Governors Isl.d & Long Island in front: on either side of which is the North & East rivers: on the right are the Narrows, between Statten and Long Islands (which are very strongly fortified and the Bay is defended by heavy batteries on Govenors, Bedlow's & Ellises Islands, with a strong half moon battery at the South end of the City & Fort Gansevoort, at the upper end). The breadth at the Narrows is 1905 yards [fig. 59]

We landed at New York at Noon having run 47m. in 7 hours. This Steam boat was one of $\frac{s}{y}$. original ones—her length 120ft her breadth 15ft. her Engine has 18 horse power and works on a very simple principle.[49]

This City is on an Island of that name—uncommonly well situated for trade being at the confluence of the Rivers Hudson, Rariton and the channel $\frac{ch}{w}$ divides York & Long Island, from each other, commonly call'd the East river. It is already very large, and to prevent narrow street being built there is a plan laid out covering the whole of the Island, so that as new houses are built, they must follow the line of the intended streets or squares.[50]

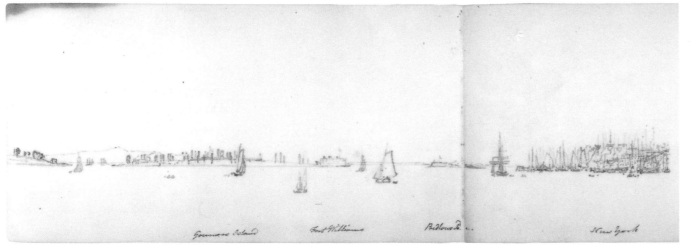

59. Joshua Rowley Watson, *Governor's Island Fort Williams Bedlows Isd. New York* [22 July 1816], pen and black wash over graphite, New-York Historical Society sketchbook, p. NY-94AB.

The present population is something more than 110,000. The streets are generally good: that of the Broad Way runs the whole length of the City, and would be considered a fine Street in any part of Europe. The Town Hall has a very imposing appearance, built of White Marble from Stockbridge in Massachusetts, but the proportions are bad. It is appropriated to the Courts of the State and City, with a suit of apartments for public festivals.[51] The Hospital is a fine establishment, and contains a separate building for Lunatic's: from the top of it is a most magnificent view of the City, the Bay and up the North & East rivers.[52]

The Shipping load & unload at the Quays, which are on each side [of] the town, they run out into the rivers and afford protection to the craft in winter from drift Ice.

At the Battery point the ground is laid out in walks shaded by Trees, in the Fort, they have a Telegraph $\frac{ch}{w}$ communicates with a station at the Narrows, & by Flag staffs each Merchant has intimation of the arrival of his own, or vessels consigned to his House.

From this Point a very formidable circular Castle on Governors Island is seen, it mounts 90 Guns, but can only bring 12 to bear on a given point. it has 3 tiers of guns, and in my opinion is a bad pland work. There is a Military establishment on that Isl.[53]

" 21st

Went to Church at St. James's,[54] a well proportioned pile in the modern style [/] the Congregation numerous & respectable were Episcopaleans. This City has a finer appearance than Philadelphia as most of the Churches have Towers & Steeple's, some of them very handsome.

The stone in general use here, is a Redish brown sandstone. they use it for steps, door, and window slabs, but it does not look either so neat & light as the white Marble in use at Philadelphia, nor are their Bricks so good.

" 22d

Mr. Hosick brother to the Doctor to whom we had a letter of introduction accompanied us to the Navy Yard at Brookland on Long Island—it is well situated and capable of being made a large Arsenal. The Vessels in Ordinary were the Cyane & Alert, taken from us, The Hornet, John Adams & a small Brig.[55] The Fulton Steam Frigate deserves particular notice, as the great powers of that engine is in full force, and not only applied to propelling the vessel forward, but to most destructive and dreadful purposes of attack, by the ejection of boiling water. She is built on a peculiar construction, being formed by the junction of two bottoms or vessels, on which her batteries rest, and her water wheel fixed in the center of her, and so secured that no shot can injure it from any direction. Her dimensions are 167ft. long, 60 feet broad, her sides 5ft. thick, of course

60. *Fulton's Steam Frigate*, pen and ink, from Watson's diary, 22 July 1816, Collection of Elizabeth Burges Pope.

is 50ft. broad within board, and has a traverse forward & aft 2ft. thick, and the casing of the water wheel is the same. The height of the Gundeck 7f/6i and under it an Orlop deck.[56] The Engine, which has the power of 120 horses is fixed on her StarBd side between the Orlop & Gun deck, and to it is affixed a cylinder 9 Ins diameter, and which by an apparatus for the purpose, throws out a column of boiling water with tremendous force if necessary. The Water wheel is 16ft. diameter & the same in breadth, and I was informed that her rate of going was from 6 to 7 knotts an hour.

She is rig'd with two Masts & two Bowsprits, with Lattine sails & Jibs.[57] Has two rudders to each bow, for she sails either way, and 'tis only necessary to secure the two rudders at that end which becomes the bow when in motion. She steers with wheels and very easy and very quick to her helm. She is well built, her knees secured by the bolts being screw'd, two plates placed over each Nut. Her Guns are very close together, and mounted on slides like Carronades. Her compliment of Officers & Men 350 [/] She mounts on her Gun deck 30, 32pnrs and 10 short Guns to throw 100 lb shot [/] calld Columbiads on the upper deck. When in action can only bring 10 guns to bear at a time—& at each end, bow or stern, 3 guns: There are no guns opposite the Water wheel, and the sides are something thicker in those places. This vessel was built after the plan [fig. 60] of the late Mr. Fulton and is named after him. she is intended as a protection to the harbor and narrows of New York and for which she is admirably calculated.

After going over this extraordinary floating battery, walking over the Yard and leaving my Card on Captain Evans the commanding Naval Officer at this Port, who was gone over to the City, we returned in the Steam Ferry boat, which is becoming in general use on all the large rivers. She is built on two bottoms, the water weel in the centre and the Engine on deck, with a round house over it: & has the power of 15 horses. These vessels are very convenient as they come close to their jetties, & Carts and Carriages drive into them as if going over a bridge.

On our return we visited the Accademy of Arts[58] when we saw two good picture by Mr Vanderlin a young American Artist lately returned from Paris where he obtained the Gold Medal as a prize for painting—the subject Caius Marius on the ruins of Carthage. He is supposd to be awaiting the answer from the Propretor Sextilius, then Govenor—I cannot say I admire the whole of this picture, the outline is good and the scenery and detail well managed, but there is a harshness in the flesh which by the reflected lights on the body give it the appearance of a copper figure [/] the countenance is well conceived and expressive of the character of Marius.

His painting of Ariadne is a most beautiful composition; was I a man of fortune I would try hard to become the possessor of this picture. [fig. 61] She is represented as yet unconscious of her misfortune, asleep amidst the shade and deep foliage on the Island, the drapery so managed as to display her beautiful form, and the contrast of the red and white clothes (on which she rests) with her lovely skin, is admirably managed—Mr. Vanderlin has been remarkably happy in his shadows, those from the face on the left arm &

61. John Vanderlyn, *Ariadne Asleep on the Isle of Naxos*, 1809–1814, oil on canvas, 68½ × 87 in., Pennsylvania Academy of the Fine Arts, gift of Mrs. Sarah Harrison (The Joseph Harrison, Jr. Collection).

shoulder, and from the right arm on the right shoulder, are very fine; and the reflected light on the chin throws the face well off the canvas. There is a great ease and eligance in the whole figure, and highly finished. It is a morning scene, and in the distance are seen the smoke of the sacrifice for a prosperous voyage, & the Bark which is bear Thesus from her.

From the Accademy we went to St. Pauls Churchyard to see the Monument erected by the Government to the memory of Captain Lawrence of the U.S. Frigate Chesapeak.[59] It is the shaft of a column with the capital broken off, and which lays at its base. [fig. 62] It is not well executed, & the Sculptor has not made the part of the column attached to the capital to correspond with the shaft. It is composed of American Marble, and two of the tablets at its base have the following inscriptions.

In memory of Captain James Lawrence of the United States Navy, who fell on the 1st. June 1813 in the 32d Year of his age in the action between the frigates Chesapeak and Shannon. He had distinguished himself on various occasions, but particularly when commanding the Sloop of War Hornet by capturing & sinking His Britannick Majestys sloop of War Peacock after a desperate action of 14 minutes. His bravery in action was only equaled by his modesty in triumph and magnanimity to the vanquished.

In private life he was a gentleman of the most generous and endearing qualities and so acknowledged was his public worth that the whole nation mourned his loss and the enemy contended with his countrymen who most should honor his remains.

On the other side
The Hero whose remains are here deposited with his expiring breath express'd his devotion to his country. Neither the fury of battle, the anguish of a Mortal wound, nor the horror of his approaching death could subdue his gallant spirit. His dying words were "Don't give up the Ship."

July 23
At 9 OC. AM. we embarked on board the Steamboat Firefly for Newburg, she is one of the largest, being 170ft. long 20ft. broad, draws 3ft. water and her engine that of 40 horses.[60] [fig. 63; see fig. 26] The accommodation excellent and our dinner good, we paid for it & our passage 2¾ dollars. there must have been upwards of 160 passengers on board and of all discriptions. I was so fortunate soon to get into conversation with Mr. Andw. Ellicot who is Profesr. of Mathemas. at the Military establishment at West Point, and Surveyor general of the State of New York. I soon found that his family

62. Joshua Rowley Watson, *James Lawrence* [Monument, 22 July 1816], pen and black wash over graphite, New-York Historical Society sketchbook, p. NY-95B.

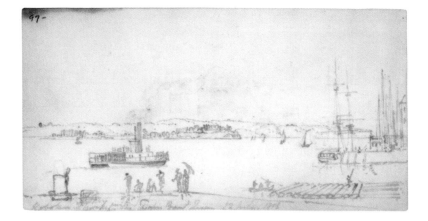

63. Joshua Rowley Watson, *Hoboken N. York [sic] from the Steam Boat Quay 22 July 1816*, brown wash over graphite, New-York Historical Society sketchbook, p. NY-97A.

had come from Devonshire & that his Mother was a Fox. he claimd relationship with the late R.! Honble Cha.! Fox. He had been much $\frac{th}{w}$ Genl. Washington and knew every point and spot on the River Hudson—I also got known to Mr & Mrs. Hammond of N.York with whom & their son we were much pleased.

The passage up the North or Hudson River is grand beyond anything I had ever seen before, and the varied beauty of its scenery requiring the pen of a Gray or a Eustace[61] to do justice to its discription. My humble attempt will fall very far short, and I fear will scarcely give an idea of what it really is. I connive the river to be about 1½ mile wide, the land on the York Island side well cultivated and spoted with Gentlemens villa's; that on the Jersy shore presenting a strong & opposite contrast, forming abrupt cliffs in vertical shafts from 250 to 300 ft. high of Basaltic rock; from their base to the water is a steep composed of fragments which have from time to time faln off from the cliffs; and trees with a variety of under wood having formed a soil, adds much to the picturesque beauty of the Palisado's—[see plates 43–46] This range of rock continues

for 18 miles up the river—At its commencement is Hoboken, a romanticaly interesting spot; but stained with the blood of one of Columbia's most able and best men, Maj Gen.! Hamilton. He fell in a duel with Col.! Burr at that place, where a monument is erected on the ground on which he was shot. [see plate 73]

On arriving opposite Niock you bring the long range of the Palisades with the shore of York Island into perspective and the view looking down the river takes in a reach of 23 miles. [fig. 64] A little above, both shores become the State of New York, the country is Mountainous, and the rocks stratefied.

At Verplanks Point (directly opposite to which is Stoney P.! and on which there was formerly a strong Redoubt)[62] the rocks all at once change from the Granit to Limestone—On turning the Point you become completely land locked, and so abrupt & deceiving is the shore, that you are at a loss to find out the passage through which you have to pass; but on arriving abreast of Peeks Kill, you turn short round a Point on the left, when the scenery becomes magnificent; [see plates 47–50] the ranges of Mountains hanging over the river to the height of 900 ft. in this reach calld the Horse race the

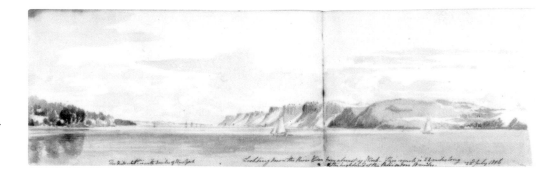

64. Joshua Rowley Watson, *Looking down the River Hudson from abreast of Niock . . . 23rd July 1816*, black and brown wash over graphite, New-York Historical Society sketchbook, p. NY-84AB.

Hudson becomes narrower and from Antonies Nose to West P.ᵗ I should not take it to be more than 900 Yards wide. The next reach to the Horse race opens out the Sugarloaf hill, and near which a house was pointed out to me as the one at which the much lamented and unfortunate Major Andrey used to frequent when carrying on the negotiation with the American General Arnold. (he was taken by three men near Singsing, which is farther down the Hudson, near the commencement of what is calld the Highlands.)

I lamented the day's fast approaching to its close (by the time we got up to Butter Milk falls at Leydiggs mills)⁶³ which prevented our enjoying the beauties of the grand scenery from it to Newburg. On passing West point we could scarcely distinguish the remains of Fort Clinton & Puttenham Castle⁶⁴—The Military Establishment is built on the ground of the former, and from its situation, admirably placed for study; no town is near it and the approach difficult, but by water. Here 300 Cadets study the Art of War, and the requisit accomplishmts. to fit them to make good Officers and well informed Men. There are Professors in the several branches of study, and a Company of Artillery and Engineers to practise them in Gunnery and Field Fortification.⁶⁵ I very much lamented not landing at this Point, having received a kind invitation fm. Mr. Ellicot—but hoping to get down the next day we declined it.

We arrived at Newburg by 9 OC P.M. having ran 70 m. in 12 hours, gliding along over the smooth surface of the Hudson like a Swan. This mode of conveyance is delightful and I hope will shortly become in general use on many of our Rivers & narrow Channels.

July 24th.
On landing at Newburg we took up our quarters at Cotters hotel and soon after set down to supper: the two meals of Tea & Supper are blended in one, and the traveller has no reason to complain of the fare—he will in general find some excellent fish, beef steaks, Mutton chops[,] eggs, grillade fowl's, with several sorts of preserves, a variety of cakes & good Coffee & Tea—Breakfast on most of the routs is served up in the same abundant manner. 'Tis necessary to examine your beds before you turn in, as they are not so particular

in furnishing them with clean linen. I had made up my mind to be roughly handled by Bugs, but I must say, in most of my nights lodging, I was agreably surprised to find I had been allowd to slumber in quiet.

This Town which only 12 years since had but 3 houses, is now growing fast into consequence, having at this time a population of 5000 souls, many good houses, and is well situated for the neighbouring Farmers embarking their produce to New York. Having been greatly disappointed in not getting either a Boat or a Carriage to take us to West Point, we amused ourselves in the evening in viewing the River from the upper part of the Town. A little above W.ᵗ Point the Hudson is confined between the Mountains for about two miles to the width of 900 Yards when it opens out to a fine wide expanse of water near two miles over, and has the appearance of a beautiful lake—the buildings on W.ᵗ Point closing the distance to the Southward, with Polypus Island in the Narrows & the high land on either side forming a fine outline of beauty—[see plate 50] On looking up, the scenery is very interesting, and the eye is carried over hills well diversified with woodland and cultivation as far as the Town of Poughkeepsie, where you loose the river in its Northern course. [see plate 51]

Opposite Newburg is the small town of Fish Kill (Kill in the Indian language signifying Creak) the land about it is well cleared and cultivated, and the farm hous appear good and comfortable—they are principally occupied by Germans.

Colonel M.ᶜ Clane, Ad.ᵗGen.ᵗ of the State of New York overtook us on the road, we had met him on b.ᵈ the Steamboat the day before, he invited us to his house, which is pleasantly situated about a mile from the Town, and commands the two views of the river before discribed.

″ 25th
As the Steam boat from New York to Albany passes in the night, we were obliged to get up by 1. OC—At 2 AM we embarked on board the Car of Neptune for that place, which from Newburg is 95 m, &

from New York 165m. This Boat is one of the finest on any of the lines, being 175 ft. long 20 ft. broad draws 3 ft. 2″ water.[66] The power of her engine that of 45 horses—she consumes 11 chords of wood in her passage up. The Richmond is 180 ft. long, and the fastest boat going. We went below on getting on board and took possession of a Bed place where I slept till 6 OC. by which time we had advanced up the Hudson some distance above Poughkeepsie. The river in this reach is about ¾ of a mile wide and continues so 'till you pass Esopus Island and reach the Meadow, where it opens into a fine wide reach, at the end of which turning short to the right, you come in ful view of the Cattskill Mountains, whose height I was informed by Judge Walton were near 3000 ft. [fig. 65] they form a striking object to the scenery till you get above the Town of Hudson. About a mile above this Town, the view looking down is very interesting as it includes the Town of Athens which is opposite Hudson on the W^tn shore at which Ships of large burden are built, and sent the the Southern Whale fishcry & to the W! Indies. When I passd there were 2 Ships & a Brig there. [see fig. 34]

The town of Hudson is fairly situated on a rising ground from the river; its main street appeard to be upwards of a 1½ in length

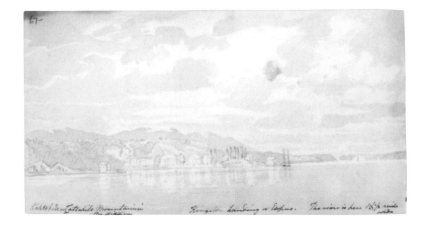

65. Joshua Rowley Watson, *Kingston Landing or Esopus* [25 July 1816], black wash over graphite, New-York Historical Society sketchbook, p. NY-67A.

it has a population of 6500 souls—the houses are of brick and look good & comfortable; the country about it cleard & cultivated and many gentlemens villa's near it. From Cocksackie landing the river begins to alter its character, and instead of Rockey and abrupt shores, it becomes flat and low; and many small but beautiful Islands tend to heighten the scenery—On some of them the Schad & Herring fishery is carried on to great advantage. They have a mode of drying their netts and keeping them in constant readiness for use which is very clever—they have large reels fixed on the shore, on which the netts are wound round, and the sun & air has full effect on them to dry and prevent their rotting. Until you arrive at Albany you are every mile or half mile passing Islands both them and the shore are well wooded and the meadows afford excellent pasture and hay. We arrived at that City by ½ pas 6 OC. after a most delightful days excursion, and found very tolerable accommodation at the Eagle Hotel.

Albany makes a very good appearance from the river; [see plate 52] the Capitol on the Hill, the State house, with its Churches and many Villas near the town, give it an air of consiquence: and when we reflect on its situation at nearly the head of the Hudson navigation, we are surprised at the rapid advances made by an industrious and high minded people, in overcoming the dreariness of the wilderness, and making the land smile with plenty.[67] We had some light rain early in the morning, but it cleard away and the Sun shone forth in all its glory. The weather for some days past had been very favorable to us, & every appearance of continuing fine. The Thermometer had varied from 72° to 80° since we left Philadelphia.

July 26th.
After breakfast we crossd over to the other side of the River, to the Town of Bath, it is but a small place and not likely to increase much, without the Military Post which is at Greenbush on the heights above, should in time give it consequence. The depot at Greenbush appears to be fortified—if it is not commanded by the ground to the North^wd of it my eye deceived me. We walked two miles down the river, and on my way back made a sketch of the City from a point fm. which you see it to the greatest advantage. In the evening we

took a more particular view of Albany: It is situated on the side of a hill from the river, the houses well built of brick and some of a dark redish brown sandstone, which in many instances has the appearance of having been in a state of fusion. The Capitol is placed at the head of the main S.t the Legislature of the State of New York hold their sittings in it: this with other public buildings and some good houses renders this Street very respectable; its width near 100 ft. — there is still remaining an old Dutch house with it gable turrated end to the Street, which forms a strong contrast to the modern style — I was much astonished to see so many houses building, and from the back of the Town on the high ground we had a very commanding view of all that was going on. This like all the American Cities & towns I have seen, has a degree of neatness and comfort, with which every European must be astonished, for they all have the appearance of being just put out of the hands of the Bricklayer & Carpenter.

The Inn is very tolerable — It is their general plan to have a public table, at which both Ladies & gentlemen assemble at Breakfast dinner and Supper — for a single man this is not unpleasant, as he has an opportunity of seeing the manners of the people, and from all thinking themselves on a level there is very little ceremony. The courteous traveller will at all times meet with civility, and tho the manners of these people are not very polished (I mean the Country people and the lower orders in large towns &ca) still by humouring them and appearing to request what you may want, they will be found to be a very diffirent character to what strangers in general have imputed to them. They are very inquisitive, accute, much cunning, quick in comprihension, ingenious, moderate in their living and laborious, and 'tis a mans own fault if he is not in easy circumstances. This is certainly the Country for the poor man, and those with moderate fortunes; but America is not the part of the World for the man of large fortune who delights in a certain style of life which Europe from its refined manners alone can afford. On this side the water allmost the whole are engaged in Trade and the population may be said to be divided into three classes, the Planter the Merchant and the Farmer.

Albany has a population of 12000 Souls[/] it is very likely to increase to a large City as it is well situated for communicating in time of Peace with the Canadas, and will become a grand point of junction, if the interior navigation by means of cannals, is carried into effect, by opening a communication from the Hudson to the Ohio by Canandaigua Lake Oneida and the Mohawk river. This grand undertaking would open an inland navigation from New Orleans to New York, taking and receiving produce from every part of the World, and passing through the States of Louisiana, Mississippi (Missouri territory) Tennessee [,] Kentucky, Illinois, Indiana, Ohio, Virginia [,] Pensilvania & New York.[68]

Having secured a Coachee at $8 Pr.diem to take us to Lake George, we went to the Bath's in the evening, which are very good.

July 27th.
We left Albany at 6 AM. and our way leading along the shores of the Hudson as far as the River Mohawk which joins it within a mile of Waterford. We passd by an Artillery depot opposite to the pretty town of Troy and which is the advanced station at present in front of Albany, at which, during the War, was their Head Quarters. [see plate 53] We went to see the Cohoes fall — their breadth 900 ft. and 72 ft. in height [see plate 54] — the Mohawk at this point falls in a fine mass of Water over a slaty bed of Rock — the River at the time was low, but there was quite sufficient to give us an idea of what it would be when full. We were told that some years since, an Indian th/w his Squa, in returning down the river from a merrymaking in his Canoe, had passd his proper landing from the darkness of the night; and was precipitated over the fall into eternity. We returned to the lower Mohawk bridge which is of wood & covered in, its length 916 ft. We were cautioned at the Toll Gate to drive slow as the vibration might endanger it. We breakfasted at Waterford a neat pretty town on the Hudson over which there is a bridge. Sloops come up as high as this. Our breakfast was served us by a very fine Girl noted for her beauty & her fame is as great in the State of New York as Mary of Baltimore — tho I hope her fate will not be so unfortunate.[69]

A few miles above this the Hudson becomes shallow passing over a bed of rock, but the scenery still continued interesting. We arrived at Fort Miller at 5 OC. PM. when we met Mr & Mrs. Hammond & family, and we agreed to go on to Fort George together. We had come 36m. They were on their way to the St. Lawrence through Vermont, but as they traveld for pleasure & not seen Lake George they determind on accompanying us & we increased our pleasure by their agreable society.

July 28th
Fort Miller is one amongst the many small Villages on the Hudson which from the great increase in population and the clearing of the land from wood are in time very likely to become large and thriving Towns—[see plate 55] Yesterday's journey took us through a well cultivated country and thickly settled with farms; the inhabitants a fine well grown healthy race of people, the women well looking tho not so beautiful as I had expected. As the waters were low, we saw a great deal of timber which was aground. it appeard to have been a large raft which in its way over the several falls farther up, had been seperated.

We got up early and left this place by 6 OC. crossed F! Miller Bridge & pass'd up on the left bank of the river. There are Saw Mills 2 miles up where the Hudson has a fall of about 8 or 10 ft.

Breakfasted at Kingsbury, the Scenery here is very beautiful, and the falls of Baker worthy notice—[see plate 56] there is a long wooden bridge over the river of 26 arches—The best view of the falls is on the opposite shore—they tumble over a dark rock with great force about 40 ft. part of the stream is turned off, and works a sett of Saw mills on either side. [fig. 66]

While making a sketch, a Man came up to me much agditated, who told me he had just saved a little Boy from destruction. The child had been playing on the bank with other children, and by accident slip'd into the river, which being very rapid would have taken him over the falls in a few minutes.

The view looking down from this spot is also pictoresque, the rocks in some places perpendicular, and the woods of Pine, Elm and Oak add much to its beauty. [see plate 57] I had ful amusement at Kings-

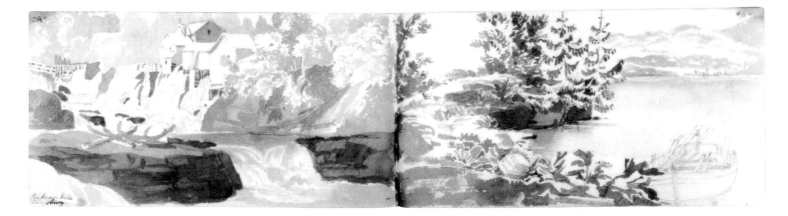

66. Joshua Rowley Watson, *Baker's Mills, Kingsbury* [28 July 1816]; *From Diamond Island, Lake George* [29 July 1816], black and blue wash over graphite, New-York Historical Society sketchbook, p. NY39A-40B.

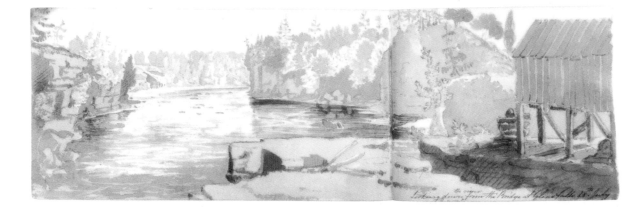

67. Joshua Rowley Watson, *Looking down the river from the Bridge at Glens Falls 28th July* [1816], watercolor over graphite, New-York Historical Society sketchbook, p. NY-38AB.

bury 'till past 12 OC PM, when we proceeded on for Glens falls through Pine barrens, and but so so roads, being a sandy soil—we got there by 1 OC.

I was greatly disappointed at this spot, having heard most exagerated discriptions of its scenery, and the height of the cateract. The bed of the river is of Blue lime stone, the Mass of rock in the center, and the Cliffs on either shore being the same, and overhang its waters—There is a Bridge over the Hudson, which in the center rests on the rocks, where they have a saw mill, and a large establishment of the same, on the left shore: but which requires so much of the water to work them, that the falls are lessened and the scenery far from improved by the buildings. [see plate 58]

The view from the Bridge is the best, and when the river is full, must make a tremendous crash. The fall at its greatest height does not exceed 60 feet, and there is no body of water that will form a greater fall than from 20 to 25f! I was much better pleased with the look down the stream, which is interesting & beautiful [fig. 67]— The height of the Cliffs are great, and the slate coulord Limestone shews off the foliage of the variety of forrest trees to great advantage, and the river rushing through with great force, gives a sort of activity and bustle to the scene. After making two sketches we proceeded on for Lake George, and arrived at the Hotel by 5 OC. We

had this day passed through a most varied & interesting country—the views on getting to the Lands height, looking back on Vermont is magnificent—the Mountains lofty & their outline beautiful—

The first peep we got of the lake was very fine, and I think the best we had of it from any point—indeed we only saw as far down as the Tongue Mountain, which space contains 7 Islands—Our friends the Hammonds had arriv'd some time before us & got dinner ready—We had a very fine Salmon trout $8\frac{1}{2}^{pds}$ which was excellent. In the evening we walked to the head of the Lake where the remains of the Old fort[70] shows how little was necessary at the first Settlement of the Country to secure it against the Indians.

July 29th Monday
After breakfast, having hired a Boat we embarked on the Lake with the intention of going down as far as the Narrows, where the traveller has a fine view of the whole expance of water— The wind getting up, we were very much disappointed in not being able to proceed farther than Diamond Island, where we landed, and my friends amused themselves in picking up from amongst the sand & gravel on the beach, crystallized quarts commonly calld Lake George Diamonds. [see fig. 66]

I made a sketch from the North end of the Island looking towards the Tongue Mountain [see plate 59]. In the Narrows, I was told, the

Islands are very numerous and the scenery interesting—On Diamond Island there is a small house in which a family live, and the Children and young people employ themselves collecting the crystals which they sell to the visiters. Finding we could not advance down the Lake without much inconvenience, we landed in our way back, on the Point under French Mountain so calld from the French forces having landed there from Canada when they advanced & took the Fort. [see plate 60] We also went on shore on a small Island near the Town on which a Mr Caldwell has built a pleasant summer house.[71] This Lake is 30m. long & about 6m. broad— it communicates with Lake Champlain which through the Sorel River becomes tributary to the St. Laurence.

There is some small patches of land in cultivation on the borders of the Lake and every encouragement held out by the proprietors to induce settlers from the Eastern states: but while the Ohio holds out so much better a climate and more productive soil, there is little chance of the population increasing hereabout, or the lands cleard. The Crop of Indian corn lookd very bad, & the Wheat thin. The Town of Lake George is situated at the Southern extremety of the Lake—it is but small—in it are two very good Inns, and which during the Summer seasons have great encouragement from the many who move about from the Southern and other States. [see plate 61] The Land is Mountainous and over grown with wood. A countryman informed me they were much infested by Rattlesnakes—he gave me the Rattle of one he had kill'd that morning. It is said that this Snake is very fond of music, and so overcome by it, as to follow the sound which appears to charm, and for the time to relax his venom.

Tuesday 30th.
We left Lake George at 5 OC. AM. and returned to the Town at Glens falls by the same road. I observed in the Woods a very pritty Orange Lilly. I was sorry it was not the season to collect its seed. The Country houses are in general built with wood, some in the Old style of Logs, placed over each other, & their ends locked in by a sort of mortice—they are plasterd inside or lined with plank

and are found to be very durable and warm—the chimneys are built of stone or brick: they have most of them sheds or piazza's with platforms. [see fig. 32]

After breakfast we very reluctantly took leave of our amiable friends the Hammonds, they taking the road to Vermont, we to Saratoga, where we arrived by 3 OC. having gone through a barren uninteresting country from Glens fall. (Saratoga is the place where Gen[l] Burgoyne & Army were made Prisoners by the American General Gage.)

Saratoga is a place in its infancy and has nothing attractive but the salubrity of its Mineral Waters.[72] [see plate 62] The two Hotels are on a <u>very</u> large scale; and people from all parts resort to this place to drink the Waters who are afflicted with Gout, Dispeptic or Bilious disorders. They are composed of Iron Sulphur & Magnetia with much fixed air: To my pallet these appeard to be Allumin thin [?]. They differ in strength; the well at the North end of the Town being much impregnated with Iron. The Congress spring is in most repute, the water drank early in the morning in $\frac{1}{4}$ pint tumblers, some taking so many as 6. They produce a gentle Cathartic and improve the appetite.

I was disappointed at not seeing much beauty amongst the Ladies—from their number, I had expected to have admird many. I cannot say there was one who would have been noticed for a Belle in any Country—Their figures were good, and in dancing Cotillons they moved with some grace. I remarked here as I have elsewhere in America, that the Ladies assemble together, and the Men in separate conversation lose the delight of female society, which so much improves the manners of those who mix much in their company.

Wednesd[y] 31st.
We left Saratoga after breakfast refresh'd our Horses at Bolstone and walked about this place which has been hitherto much frequented by invalids from the salubrity of its Waters they are much the same as those at Saratoga, but less powerful. The Country about has little

variety—there are a few small Lakes or Ponds as they are calld $\frac{ch}{w}$ in a more improved state might be made interesting.

After walking about the small Town we proceeded on for Albany: in our way we met a Mohock Indian, three Squaws and a Child. The man was dress'd in a short frock with blue leging which reached half way up his thigh's—the Women wrap'd up in blankets and all so filthy, they were disgusting to be look'd at. The Indian had a Bow & Arrow in his hand—their colour not so red as I had expected.

We took some refreshment at an Inn close to the Balston Mohock Bridge [see plate 63] The Hostess a young woman more beautiful than any I had seen in this Country, and being a Nurse, attracted my notice the more. We arrived in Albany by 6 OC. and after securing places for proceeding tomorrow for Boston, we each took a warm bath, which is a most refreshing thing in a Hot climate when the persperation is likely to be check'd in over exercise.

Aug.¹ 1 Saturday.
We left Alby at 2 AM in the Mailcoach and cross'd the River Hudson in a Schow: breakfast at the small Town of Chatham
we passd through Stockbridge (between it & Chatham runs the boundary of the States of New York & Massachusetts)

At this place are very valuable quarries of Grey and White Marble—it is sent to all the neighbouring States and works well for building and tombstones, but not sufficiently fine for statuary. It is a pretty Town and the inhabitants appear to be of a superior class of people—their houses good all with gardens & little shrubberys about them. Our road took us through Becket, Chester, Chester village (at this place there is a Glass manufactory, it is very likely to grow into a large town) Russel village, and Westfield. It is a large thriving town very pleasantly situated with excellent houses (tho most of them of wood) it is nearly on the banks of the Connecticut river over which we passd in a Schow, and ended our days journey at Springfield, where our Inn was most comfortable and everything good at the Indian Queen, Captain Burnet. I have been much

pleased with our days drive, tho the country was not so rich as I had expected—there is much rock interspersed among the fields————I was informed the soil is exausted. The increase of population is perceptibly greater than what I have seen in Pensilvania and State of New York—not a small Town but is fully inhabited and Children innumerable—each town has its school, at which the Boys and Girls are placed at an early age, and the propriety of their manners is very striking to strangers, for they all salute you by courtsies or bows as you pass—the elder ones setting the example to the younger, and arrange them in a line seeming proud to pay respect to travellers.

Such is the redundancy of population in the New England states that it is computed that from 20 to 25,000 people emigrate to the Ohio or Western States annually. We met a most interesting carrivan of 7 waggons, the two first drawn by 4 Oxen each, the others by horses, five of them were filld with household goods, each with an elderly man in the waggon, the two last were occupied by the women & children—several of the former very pretty. The Young men & Boys walked, the whole forming a pictoresque groupe, all bowing to us as we passd. they were getting on at about 2 miles an hour.

We had traveled 88 miles from Albany [/] the roads very tolerable and in many places the Country well cultivated and the Woods not too much cleard away—the rocks are principally Granet, tho there is Limestone near it. There are many stone enclosures, but the Worm fence[73] and trunks of trees laid one over the other is in more general use: we pass'd across many logbridges thrown over small streams—The road from Becket through the defiles of the River Agawam to Westfield is more beautifully grand than I can find language to give an idea of—the road in several places nearly overhanging the river, and precipices so grand and varied with wood scenery, that would occupy the time of an Artist for a week at least. I regretted much passing through it so quick. had I had an idea of this beautiful valley, I would have stop'd at Becket and gone on to Springfield at my Leisure—It passes through a part of the Green Mountains near Westfield, and closes in an uncommon fine style near that town. The Hills are covered with large timber trees rising magnificently

the English Manufactories has little to fear fm. their attempts at fine articles. The sums laid out in forming these establishments must have been enormous, and will soon become a dead letter, as the Markets are and will be so abundantly supplied from Europe with better articles and at a lower price.

″ 2d.

After a most refreshing nights sleep in a good bed & no Bugs to annoy us, and an excellent breakfast, we walked about the Town; there are some very good houses in it, but built of wood after elegant plans. I made a sketch of one $\frac{ch}{w}$ was for sale [see fig. 31]—they asked $8000 for it—the rooms of handsome dimensions with excellent out offices and good garden. Tis strange that throughout the states of New England most of the houses are built of these perishable materials particularly as they have such a variety of Marble Granit and other good building stones—and those in the greatest abundance and at hand. The wooden house does not last more than fm. 40 to 50 years. At Springfield the Government has a Manufactory and Depot of Arms.[75] I went through the workshops which at present employ 200 men and who turn out 1000 Muskets & Bayonets pr. month. they are made after the French plan and weigh 14Pd they have a very simple contrivance to prevent the bayonets comming of by any sudden jerk. I give the plan in the margin. [fig. 68] During the War they employd 250 workmen who made 1200 stand of Arms in the month. All the heavy work such forming the barrels and boaring is done at the shops worked by Water Mills established on the Connecticut river but not having time we did not visit them.

After taking an early dinner we left Springfield for Northampton in a small light Waggon call'd a Dearborn which is drawn by one horse.[76] [fig. 69] it will take 4 people with ease, and tho not suspend'd on springs, the seats are so elastic being on angular pieces of wood that the motion is not unpleasant. We drove along the shore of the Connecticut river for 21 miles, the country rather flat, but near Northampton it is mountainous the scenery rich and beautiful. [see plate 64] We arrived at this town by sunsett to be in readiness to go on in the Stage. It is prettily situated on a rising ground

68. *Bayonet Mounting*, pen and ink, from Watson's diary, 2 August 1816, Collection of Elizabeth Burges Pope.

on either side, and abrupt turnings of the road renders this one of the most romantic spots I have seen in America. There were scarcely a town that we passd through but had a Manufactory either of Woollen or Cotton. during the late War with England they were all in full work: but are now unemployd except here and there one, which turn out some of the coarse cottons. In this line they are likely to succeed particularly if the Government should encourage them by laying on an additional duty on what is imported[74]—but

near the river and is large, tho for some years it has not increased in size and its population, from emigration to the Ohio is decreasing—it now contains 2600 souls. Tho the soil near the Town is to appearance rich, being alluvial, the crops are but scant; the Wheat 15 Bushs pr. acre.

August 3d. Saturday.
Left Northampton by 4 OC. AM—the morning foggy and was much annoyed a few miles on the road by the very offensive smell exuding from a Skunk; this animal is between a Fox & Martin; its colour black with white about the neck and tail—it has the faculty of emiting a most distresingly offensive odour when pursued, and which obliges the fiercest dog to turn from him with a fright, and runs from it yellping.

We breakfasted at Belchertown—passd through the Towns of Western Brookfield, Spencer, Leicester to Worcester, where we dined. It is a large place and the houses good—indeed the appearance in every Town we pass'd all denoted comfort, contentment & ease, nor

did we see a begger or a person badly dress'd since we left New York. There is a Lake near the Town calld Worcester pond—it is 5 miles long, and its banks capable of great imbelishment. As we advancd the soil improved and the appearance of the Country altogether changes for the better. We next pass'd through Westown, Framingham, Waterford and so on to Cambridge University and arrived at Boston at 11 OC. at night much fatigued from the length of the journey (being a distance of 93 miles from Northampton) the uneasiness of the Stage coach & the cram, for it was quite full from Worcester. There is at Framingham another of those pieces of Water calld ponds, and several of them near Cambridge & Boston highly improved and elegantly laid out in pleasure grounds belonging to the respectable gentlemen of that City. [see plate 65]

August 4th. Sunday.
[Transcriber's note: The diary finishes here]

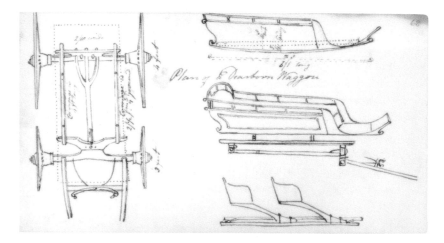

69. Joshua Rowley Watson, *Plan of a Dearborn Waggon*, pen and black ink over graphite, New-York Historical Society sketchbook, p. NY-68B.

Persons Mentioned in Watson's Diary

Names marked with an asterisk appear on the list Watson composed at the head of his diary text. His comments and variant spellings have not been repeated here. Italicized names within these entries have a primary entry elsewhere in this section. See the index for full page references to individuals mentioned elsewhere in this book.

John André (1751–80) of the British army was captured by American forces in 1780, shortly after negotiating the surrender of West Point with the traitorous American General Benedict Arnold (1740–1801). Arnold met Major André in the woods near Stoney Point and delivered over a description of the fortifications. Arnold escaped and found harbor with the British; André was hanged as a spy and buried at Tappan. His remains were removed in 1821 and reinterred at Westminster Abbey through the efforts of those on both sides who, like Watson, recalled André's many virtues and regretted the severity of his American judges.

William Bainbridge * (1774–1833) was one of the most senior captains in the U.S. Navy at the time of Watson's visit. In December 1812, as captain of the *Constitution*, Bainbridge captured and destroyed the British frigate *Java* off Brazil. In 1815 he sailed with *Stephen Decatur* and two squadrons to subdue Algiers. After successfully negotiating a treaty, he returned to establish a school for naval officers at the Charlestown Navy Yard, where Watson probably encountered him in 1816.

Anthony St. John Baker was serving as consul general to the United States from Britain during Watson's visit. Charles Bagot was at this same time minister plenipotentiary and envoy extraordinaire in Washington, where the legation was based. *Samuel Breck*'s diary notes that he and Watson met Bagot in Washington on 16 April 1817; Baker may have been on the scene in both Washington and Philadelphia.

James Biddle * (1783–1848) would have been well known to British naval officers. He served in the Mediterranean with Captains *Alexander Murray* and *William Bainbridge* in 1803 and earned laurels as lieutenant of the *Frolic* in its successful encounter with the British *Wasp* in 1812. Three years later Biddle won a congressional medal in recognition of his heroic action on the *Hornet* against the much larger British *Penguin*. During the summer of 1815 he narrowly escaped his third capture by enemy forces, surviving a four-day chase by casting all guns and metal fittings overboard. Appointed post-captain that year, Biddle was soon to be named supervisor of the Oregon Territory when Watson met him in 1816–17.

George Blight * was a gentleman farmer who also maintained various residences in center city Philadelphia. He joined *Judge Richard Peters* and others in 1785 to found the Philadelphia Society for Promoting Agriculture. Watson remarked that he was the "natural" son of Isaac Blight (or Bligh), whose murder by his Exeter business partner, Richard Patch, was the subject of a celebrated British trial in 1806. Richard Rundle's letters from England in March and April 1802 (HSP) mention Blight's trial and also his brother, P. Blight.

Joseph Bonaparte * (1768–1844), Napoleon's older brother, the former king of Naples and Spain, escaped in 1815 to America, where he lived a life of celebrity and ease. Taking the title of Comte de Survilliers from his estate in Switzerland, he established himself in New York, then moved to Philadelphia in September 1815. Briefly renting Landsdowne, near Eaglesfield, in the summer of 1816, Bonaparte soon moved to a large estate on the Delaware, Point Breeze near Bordentown, New Jersey, but maintained a home in Philadelphia at 260 South Ninth Street, just around the corner from *George* and *Maria Rundle*'s home on Locust Street. Both he and *Maréchal Grouchy* were together in town the entire year that Watson visited Philadelphia. Hospitable, gracious, and admired for his knowledge and good taste, Bonaparte was a popular figure. While in the United States, one of his closest friends and advisers was *Joseph Hopkinson*.

Samuel Breck * (1771–1862) lived on the Schuylkill River estate Sweetbriar, adjacent to Eaglesfield on the north, with his wife, Jean Ross, and their daughter Lucy (ca. 1807–28). Born in Boston and educated in France, Breck, like his father and brother, was a merchant, but his wife's inheritance allowed him to retire from business early. A liberal and civic-minded man of diverse interests, Breck held state and federal offices as a Federalist, in 1817. He promoted bridge and canal improvements on the Schuylkill and supported many educational institutions, particularly the School for the Blind and the city's public schools. Breck's diaries, published in excerpt by Nicholas Wainwright, mention his many contacts with Watson (HSP; see bibliography).

John Brooks * (1752–1825), a physician and soldier celebrated for his actions at the Battle of Saratoga, held many government offices after the conclusion of the Revolutionary War. Adjutant-general of Massachusetts from 1812 to 1815, he was elected governor in 1816 and reelected seven years in succession.

Dr. Brun * of New York does not appear in major American biographical dictionaries for the medical profession. His connection to "Captain White's sister" is obscured by the absence of a Captain White from the U.S. Navy lists. Probably, White and Brun were British.

Aaron Burr (1756–1836), Revolutionary War officer and Vice-Presi-

dent of the United States under Jefferson. See *Alexander Hamilton*.

*Charles Caldwell, M.D.** (1772–1853) was an eminent surgeon in private practice from 1796. A poet, biographer, and editor of the *Port Folio* from 1814, he was also a well-known orator with a pronounced Federalist bias. In 1799 he married Eliza Leaming, daughter of Thomas Leaming and sister of Watson's traveling companion, *Thomas Fisher Leaming*.

*William Crammond** (1754–1843), a wealthy merchant, bought the southern portion of Robert Morris's Schuylkill estate, the Hills, when it was auctioned in 1798. He built the gothic Sedgeley on this land in 1799, from designs by Benjamin H. Latrobe. Crammond sold the estate in 1806 to Samuel Mifflin, who sold it in turn to *James Cowles Fisher* in 1812.

*Richard Dale** (1756–1826) served as a first lieutenant under John Paul Jones on the *Bonne Homme Richard* in the famous action against the *Serapis* in 1779. After the Revolutionary War he married Miss Crathorne of Philadelphia and turned his maritime skills to the China trade. He continued to serve the navy, leading the American squadron to the Mediterranean in 1801, but retired from active service in 1802. Commodore Dale was president of the Washington Benevolent Society and a friend of *Judge Richard Peters* and *Samuel Breck*. In 1817 he was residing at 69 Spruce Street, in Philadelphia.

*Alexander J. Dallas** (1759–1817) came to the United States in 1783 from Britain. A lawyer and a rare Democratic leader at the Philadelphia bar, Dallas was appointed by Jefferson as U.S. attorney for the eastern district of Pennsylvania in 1801. Madison made him secretary of the treasury in 1814 and added the portfolio of secretary of war to his duties in 1815. In November 1816 Dallas resigned to return to the practice of law; two months later he died in Philadelphia. In 1780 Dallas married Arabella Smith in Alphington, a town near Exeter that Watson knew well. In 1817 his widow lived with her son *George Mifflin Dallas* at 100 South Fourth Street.

*George Mifflin Dallas** (1792–1865) was only twenty-four and recently married when Watson met him, but he was already a promising lawyer, diplomat, and Democratic politician, winning a seat in the Pennsylvania Assembly in 1817. Later deputy attorney general of Philadelphia, district attorney of the United States, and attorney general for the state of Pennsylvania, Dallas became mayor of the city in 1828, a U.S. senator in 1831, Vice-President of the United States from 1845 to 1849, and minister to England from 1856 to 1861.

*Andrew (André) de Daschkoff**, envoy extraordinaire and minister plenipotentiary of the Russian delegation in Philadelphia, resided at 109 South Third Street in 1816–17 but also worked at the embassy in Washington, D.C. Watson's list includes three members of the Russian legation (cf. *George Ellison, Theodore Ivanoff*) but not the consul general in Philadelphia, Nicolas Kosloff.

*Mr. Davis**, of Boston, may have been Daniel Davis (1762–1835), solicitor general of Massachusetts; or John Davis (1761–1847), a lawyer, scholar, and U.S. district judge in Boston; or Benjamin Davis, a Boston merchant in this period. Mr. Davis "of Philadelphia" has not been identified.

*Stephen Decatur** (1779–1820), the hero of an early naval victory in the War of 1812 when his *United States* captured the English frigate *Macedonian*, regilded his honors in 1815 when he and *William Bainbridge* led their squadrons against the beys of Tunisia and Algiers. Decatur was in Philadelphia in 1812 to receive a commemorative sword from the city, and he returned in late 1815, after concluding a favorable treaty in North Africa. One of the most senior captains in the navy by 1816, Decatur was appointed commissioner of the Navy Board that year and moved to Washington, D.C., in April 1817. Watson and *Samuel Breck* were twice entertained at Decatur's home that same month. Breck gave the portrait of Decatur that he owned to the Historical Society of Pennsylvania in 1861.

*Richard Derby** appeared in Boston's 1816 city directory as living at 5 Chauncey Place. He was made captain in the U.S. Navy in February 1799, without previous record of service, implying long experience in the merchant marine. Two years later he resigned, perhaps to return to commercial shipping.

*Joseph Dugan** (ca. 1766–1845) was a wealthy Catholic merchant, partner in the ship-owning and real estate firm of [*John*] *Savage* and Dugan. When Watson visited Philadelphia in 1816–17, Dugan's business was at 91 South Third Street. In 1831 Joseph Dugan cosigned the administration of the estate of Lucretia Rundle, *George Rundle*'s mother. From 1842 until his death in 1845, Dugan served as president of the Pennsylvania Academy of the Fine Arts. His shipping interests make it possible that Joseph Dugan was the same man who, with his wife, dined with Watson in Tortola in 1810. (Watson's diary, 1810; Pope Coll.)

Andrew Ellicott (1754–1820), a Pennsylvania-born Quaker and friend of Benjamin Franklin and David Rittenhouse, had in 1788 undertaken the first of many federal surveying projects, including the layout of the capital at Washington. He was appointed surveyor general of the United States by George Washington in 1792 and assumed his position as professor of mathematics at West Point in 1812.

*George Ellison** (or Ellizer), secretary of the Russian legation to the United States.

*Mr. Emlin** was probably the merchant Joshua Emlen, working at 17 South Wharves in Philadelphia in 1817; or William F. Emlen, of the firm of Emlen and Fullerton, 169 High Street, residing on Chestnut, near Tenth.

Captain Samuel Evans (ca. 1778–1824), was commander of the Brooklyn Navy Yard in 1816. Rated a midshipman in 1798, Evans made lieutenant in 1799, commander in 1806, and captain in 1812.

*William B. Finch** was first lieutenant on the *Independence*, one of the three largest warships in the American navy. He may have given Watson a tour of the ship when he visited the Boston (Charlestown) Navy Yard in August 1816. Commander four years later, Finch became a captain in 1831.

*James Cowles Fisher** owned an impressive mansion in downtown Philadelphia, at 277 Chestnut Street, as well as the estate Sedgeley, on the Schuylkill River opposite Eaglesfield. A merchant and a director of the Second Bank and the Philadelphia Insurance Company, Fisher purchased the estate in 1812 and used it as a summer home until 1836.

*William W. Fisher**, partner of *James Cowles Fisher* in the merchant firm located at 99 South Front Street in Philadelphia, lived on Walnut near Eighth Street in 1818.

Charles James Fox (1749–1806), English statesman, historian, and orator, is well remembered for his last motion in Parliament, which formed a few months after his death the basis for British laws opposing the slave trade.

*Susan M. Gapper**, a widow, was listed in Philadelphia city directories as residing at 218 Chestnut Street during the period of Watson's visit in 1816–17.

Frances (Fanny) Burges Green (1757–1818) was Watson's aunt, his mother's sister. She visited Philadelphia for nine years in the 1790s. In 1802, after returning to Devon, she married John Green of Exeter.

*Gardiner Greene** (1753–1832) married John S. Copley's daughter Elizabeth in 1800. Greene, a wealthy banker, had looked after his father-in-law's interests before the painter's death in 1815. The Greenes lived on Tremont Street in Boston in a lavish home adjacent to *James Lloyd*'s.

*Emmanuel de Grouchy** (1766–1847) was one of Napoleon's most successful field-marshalls, although he was to be most remembered for unaccountably arriving too late to help at Waterloo. He was in Philadelphia by April 1816 as secretary to *Joseph Bonaparte*, and he established his own residence at 245 South Sixth Street in 1817. The following year he lived at 244 Lombard Street. Restored to rank and favor in 1830, he died in France.

Alexander Hamilton (1757–1804), aide-de-camp of Washington, member of Congress, secretary of the treasury and the army, and the architect of Federalist economic policies, was killed in a duel demanded by *Aaron Burr*. The encounter took place 11 July 1804 at the "dueling grounds" on the Palisades near Hoboken, opposite 42nd Street on Manhattan (see plate 73).

*James Hamilton** (ca. 1765–1817) inherited his uncle's estate on the Schuylkill, the Woodlands, when William Hamilton died in 1813. The unmarried James maintained the house and its extensively landscaped grounds and art collection with the help of the family of his sister, Ann (1769–98), and her husband, *James Lyle*.

*Alexander Hammond**, his wife, and son, accompanied Watson on parts of his New York tour. He is not listed in New York City directories or census reports for this period.

*James Hillhouse** (1754–1832), a lawyer, Revolutionary War veteran, and state and federal officeholder for the Federalist Party, retired from the U.S. Senate in 1810 but continued to serve as treasurer of Yale College until his death. Watson also may have met his son, James A. Hillhouse (1789–1841), a poet and writer who made the family home, Sachem's Wood, the center of New Haven's literary circle.

*Mr. Hoffman** of Baltimore and Philadelphia may have been the merchant Samuel Hoffman, working at 11 Chancery Lane and 39 North Front Street in Philadelphia in 1816–17. The Baltimore Hoffman family included merchants George and Peter as well as the eminent lawyer and author David Hoffman.

*Henry Hollingsworth** was a merchant at 185 South Third Street in Philadelphia in 1818. Watson may have confused him with the venerable Federalist leader Levi Hollingsworth (1739–1824), who served in the Pennsylvania Assembly.

*Joseph Hopkinson** (1770–1842), son of Francis Hopkinson, signer of the Declaration of Independence, followed his father into law and public affairs, serving as a U.S. congressman from 1815 to 1820. A Federalist of aristocratic temper, Hopkinson actively supported cultural organizations such as the Pennsylvania Academy of the Fine Arts, which he led as president from 1813 to 1842.

*David Hosack, M.D.** (1769–1835) studied in Philadelphia under Benjamin Rush and in Edinburgh. Returning to the United States in 1794, he became a professor at Columbia University, a staff physician at New York Hospital, and an expert on yellow fever. Hosack attended the *Alexander Hamilton–Aaron Burr* duel in 1804. He may have introduced Watson to New York's American Academy of Fine Arts, an institution Hosack helped organize. He lived not far from St. Paul's, at 14 Vesey Street. A few doors away, at no. 47, lived the merchant *Alexander Hosack**, probably the man Watson listed as David's brother.

*Isaac Hull** (1773/5–1843) was captain of the frigate *Constitution*, responsible for the capture and destruction of the British *Guerriere* in the first major naval engagement of the War of 1812. By 1818 he was the ninth most senior captain in the navy, and a commissioner on the Navy Board, serving in Boston. That year he received a trophy from a group of grateful citizens of Philadelphia, including *George Rundle*.

*Jared Ingersoll** (1749–1822), delegate to the Continental Congress and the constitutional convention, later served as attorney general and judge of the U.S. District Court in Pennsylvania. He was an unsuccessful candidate for U.S. Vice-President in 1812, running for the Federalist party. Watson may have meant his son Charles Jared Ingersoll (1782–1862), also a lawyer, who lived next door to his father at 134 Walnut Street in Philadelphia but ran for Congress in 1812 as a Democrat.

*Theodore Ivanoff** served with *Andrew de Daschkoff* on the Russian legation to the United States at the time of Watson's visit.

*William Jackson** (1759–1828) was born in England, emigrated to South Carolina, and joined the revolutionary cause. His central role as secretary of the constitutional convention led to a position as *George Washington*'s aide-de-camp and personal secretary until 1793. A scholar and lawyer, Major Jackson married Elizabeth Willing in 1795 and enjoyed various government appointments in Philadelphia until the close of Washington's administration.

*Johan Albert (de) Kantzow** was envoy extraordinare and minister plenipotentiary from Sweden. Listed in Philadelphia's 1816 city directory as residing at the southeast corner of High and Twelfth Streets, the baron had a summer home near Bristol (Wainwright, "The Diary of Samuel Breck," p. 480). A different ambassador held the post by 1817.

*John Keating** appears in the Philadelphia city directories of 1816–17 at the address Watson noted, with no occupation given.

Mr. Keaton, a young man of French extraction bound for Philadelphia, encountered on board the *Mercury*.

*Mr. Kimber** "at Boston, now Baltimore," has not been located in the city directories of either city.

*John Thornton Kirkland** (1770–1840), minister, teacher and scholar,

led Harvard College into national prominence after his appointment to its helm in 1810. His gentlemanly style and popular touch made him one of Harvard's most beloved presidents.

David and C. Landreth operated a nursery garden on Federal Street in South Philadelphia, near Gray's Ferry Road.

James Lawrence (1781–1813), whose dashing actions won him rapid promotion in the U.S. Navy, was the commander of the New York Navy Yard in 1813, from whence he set forth in the *Chesapeake* and rashly challenged the much larger British *Shannon* on 1 June 1813. Captain Lawrence was dead and the ship lost, despite his dying wishes, in a matter of fifteen minutes.

*Jeremiah Fisher Leaming**, younger brother of *Thomas Leaming*, was also a merchant, with offices at 27 High Street and a home at 35 (or 53) Pine. He married Rebecca Waln.

Rebecca Fisher (Mrs. Thomas) Leaming (1757–1833), mother of *Thomas F.*, *Jeremiah F.*, Eliza, and Lydia *Leaming* (Mrs. *James Somers Smith*).

*Thomas Fisher Leaming** (1786–1839), the eldest son of Thomas Leaming and *Rebecca Fisher Leaming*, was a merchant like his father and an officer in the Philadelphia City Troop during the War of 1812. Engaged to *Richard Rundle*'s niece, Mary Murgatroyd, daughter of *Thomas Murgatroyd*, before her untimely death in 1810, young Leaming married Mary's niece Susan Murgatroyd (1800–1823) in 1819. Thomas Leaming accompanied Watson on his New York and New England trip in 1816.

*James Lloyd** (1769–1831), the wealthy senator from Massachusetts (1808–13, 1816–26), married *Samuel Breck*'s sister Hannah (1772–1846) in 1810. Lloyd was in Philadelphia in February 1817 (Wainwright, "The Diary of Samuel Breck's," 27 Feb. 1817), when he surely visited Breck at Sweetbriar. Watson could have encountered Lloyd the previous summer, at his elegant home in Boston adjacent to the mansion of *Gardiner Greene*.

*James Lyle** (1767–1825), a merchant, married Ann Hamilton (1769–98), the niece of William Hamilton of the Woodlands in West Philadelphia. When the estate was inherited by Ann's brother, *James Hamilton*, Lyle and his two daughters, Ellen and Mary, continued to live in the house.

Colonel McClane, "Adt. Genl. of the State of New York," resided north of Newburgh.

Benjamin R. Morgan (1764–1840), a Federalist senator in the Pennsylvania state assembly from 1812, became judge of the district court in 1821. At the time of Watson's visit, he resided at 41 Mulberry Street in Philadelphia and was a director of the Bank of North America.

Charles W. Morgan, a lieutenant on the U.S. Navy list in 1818, lived at 59 Spruce Street in Philadelphia when Watson visited.

*Mrs. Morris**, widowed daughter of *Mrs. Shoemaker*, was one among six Morris widows listed in the Philadelphia directory of 1818.

*Charles Morris** served as a lieutenant under *Isaac Hull* on the *Constitution* when it sank the British *Guerriere* in 1812; he received a prize from the citizens of Philadelphia for his part in this action. By 1816 he was captain of the *Congress*, which Watson sketched at the Boston Navy Yard (plate 39).

*Thomas Murgatroyd** (1746–1817) held mercantile offices at 244 High (Market) Street in Philadelphia next door to the counting house of *Richard Rundle*, who married his sister, *Mary [Murgatroyd] Rundle*, in 1772. Rundle and Murgatroyd shared business operations in the 1790s, but the partnership dissolved about the time that Rundle left for a long stay in England (ca. 1799) and Murgatroyd suffered bankruptcy in 1802. Misfortune dogged the family, leaving Mrs. Murgatroyd (née Sarah Phillips) a widow bereft of husband and all six of her children by July 1817, a month after Watson's departure. Watson remarked similarities between Mrs. Murgatroyd and his wife's mother (or aunt) "Mrs. Manley" (Diary, 6/14).

*Alexander Murray** (ca. 1754–1821) was the most senior captain in the U.S. Navy at the time of Watson's visit, having supervised much of the action at sea during the war of 1812. By 1815 he was stationed in Philadelphia, in charge of the Navy Yard.

*Joseph Parker Norris** (1763–1841), president of the Bank of Pennsylvania, was residing at 140 Chestnut Street in Philadelphia in 1818. His son, Joseph Jr., an attorney, lived at 108 South Street.

*Benjamin Page** (ca. 1795–1858), a lieutenant in the U.S. Navy according to the 1818 navy list. Made midshipman in 1810, Page had

just won his lieutenant's post in 1816. He became a commander in 1835 and a captain in 1841.

*Mr. Parish** may have been Isaac Parish, a gentleman residing in Philadelphia in 1818; or David Parish, a merchant at 293 Spruce Street (or Walnut and Columbia) after 1817. No G. Parish* appears in Philadelphia directories of this period.

*Isaac Parker** (1768–1830), chief justice of Massachusetts from 1814, lived on Summer Street in Boston in 1816.

Charles Willson Peale (1741–1827), student of Benjamin West and the founder of a dynasty of artists, was the senior painter in the city of Philadelphia and the proprietor of his remarkable museum, housed in the long gallery on the second floor of the State House since 1802 (see fig. 54). Ever the innovator, Peale had installed gas lights in his gallery just before Watson arrived in June 1816. That same month Peale had pressed the city managers to undertake responsibility for the museum, in consideration of its importance and his own advanced age. The city did nothing, and the museum collections moved to Baltimore or were dispersed after the artist's death. Many of Watson's statistics were enumerated in advertisements for the museum in this period.

*Peter Pedersen**, minister and consul general to the United States from the Court of Denmark, was described by Harriet Manigault as "a self-important fussy personage, and a somewhat conspicuous member of the Diplomatic Society of Philadelphia" (Diary, p. 143). He was based in that city, at 393 Arch Street, above Tenth, according to a Philadelphia directory of 1818.

*Mr. Perotte** was most likely one of the many merchants in Philadelphia's Perot family. Charles, John, and Joseph held offices at 297 High (Market) Street, not far from *Richard Rundle*; Elliston, James, and Sansom Perot all worked next door at 299 High or at 41 North Water Street in 1818. Watson's aunt *Frances Burges Green* had been friendly with this family during her visit to Philadelphia about 1797; his uncle mentions John and Elliston Perot in correspondence from England in 1802 (HSP).

*Ralph Peters** was the elder son of *Judge Richard Peters*. He lived near his father's estate (Belmont) at Mantua Farm, about a mile northwest of central Philadelphia.

*Richard Peters** (1744–1828) was a friend of George Washington's and secretary of war during the American Revolution. He attended the Continental Congress, served in the Pennsylvania State Senate, and was appointed judge of Philadelphia's U.S. District Court in 1792, a position he held for thirty-seven years, specializing in maritime jurisprudence. Peters headed the company that erected the first permanent bridge over the Schuylkill at Market Street, and he sought the improvement of American agriculture by conducting experiments on his own farm, Belmont. His pamphlet on clover and other grasses revolutionized American pasturage after 1797. Famed for his wit and hospitality as well as his accomplishments, Peters was beloved and respected by his contemporaries. He had six children with his wife, Sarah Robinson, whom he married in 1776; after her death in 1804, one of his daughters became hostess of Belmont.

*Thomas R. Peters**, younger son of *Judge Richard Peters*, was living at 61 South Seventh Street in Philadelphia in 1816–17.

*Mrs. Phillips** may have been the mother of Sarah Phillips Murgatroyd (Mrs. *Thomas Murgatroyd*).

David Porter (1780–1843) became a hero during the U.S. Navy's campaign against Tripoli (1801–5). He returned to marry a Chester heiress who brought as a wedding present the estate Greenbank overlooking the Delaware. Porter was made captain of the *Essex* in 1812 and took the first prize ship of the war. In peacetime he took charge of the steam frigate *Fulton*, which Watson visited in New York. Appointed a naval commissioner in 1815, Porter was living in Washington, D.C., by 1816.

*Mr. Hayns(?) Powell** was probably Colonel John Hare Powell (1786–1842), nephew and adopted son of Philadelphia's mayor Samuel Powel. In 1818 he was residing at 172 Chestnut Street and at Powellton in West Philadelphia.

Henry Pratt (1761–1838), a wealthy merchant, owned Lemon Hill, just above Fairmount on the east bank of the Schuylkill.

*Condy Raguet** (1784–1842) became a colonel during the War of 1812, when he commanded his own company of volunteers. Later a minister to Brazil and a Pennsylvania state legislator representing the Federalist party, he occasionally contributed articles

to the *Port Folio*. He founded the Philadelphia Savings Fund Society in 1816, an organization that included many of Watson's acquaintances on its Board (*Breck, Biddle, Hollingsworth, Peters, Stocker*).

William Rawle * (1759–1836), a Quaker, was admitted to the English bar but returned to the United States in 1783. A scholar, poet, artist, and philosopher, Rawle was a founder of the Pennsylvania Academy of Fine Arts. He served as district attorney for the United States under *George Washington* from 1791 to approximately 1799. Rawle's business address at 260–62 High (Market) Street was several doors from the *Rundles'*, and his country residence, Harleigh (now the site of Laurel Hill Cemetery), was upstream across the Schuylkill from Eaglesfield. Letters to Rawle from *Richard Rundle* in England (HSP; 1799–1802) show that Rawle held power of attorney over Rundle's affairs during his absence abroad. Their friendship may have been cemented by his wife Sarah's connection to the Burges and Bailey families, who were closely related to both Watson and Rundle.

George Cambell Read * (1787–1862) was third lieutenant under *Isaac Hull* on the *Constitution* when it overcame the British *Guerriere* in 1812. Made master-commander in April 1816 (after which he could be addressed as captain), Read later earned the rank of post-captain and became head of the Philadelphia Navy Yard. Watson may have met him in Boston in 1816.

Bartholomew Rengunet * Spanish consul, held offices at 62 Dock Street in Philadelphia in 1816. His wife was related to Watson's friends in Cadiz, the Villavicencios.

Jacob Ridgway * (1768–1843), a merchant, moved to London during the War of 1812, then served as American consul in Amsterdam before returning to manage his real estate investments in Philadelphia.

Eleazar Wheelock Ripley * (1782–1839) turned from his seat in the Massachusetts legislature to lead the American army on its attack on York (Toronto) in 1813. Made brigadier general in 1814, he fought at the battles of Chippewa and Niagara and was wounded at Fort Erie in 1814. He remained in the service after the war, from 1815 to 1820, before returning to politics.

George Roberts *, a gentleman, resided at 252 Chestnut Street, Philadelphia, according to city directories in 1800 and 1825. He may be the "G. Robertson" identified as Philadelphia's resident British consul in Watson's period.

Mr. Rotch *, married a daughter of *Jacob Ridgway*.

George Rundle (1772–1859), a Philadelphia merchant, married Watson's sister *Maria Watson Rundle* in Devon in 1801. Their only child, and Watson's only niece, was Frances Rundle (1805–27; see fig. 16), who died before her prospective marriage to Dr. Joseph Togno.

Maria Watson Rundle (1773–1852), Watson's younger sister, married *George Rundle*.

Mary Murgatroyd Rundle (1751–1823), married *Richard Rundle* in 1772 at Christ Church, Philadelphia. She was the sister of her husband's business associate, *Thomas Murgatroyd*.

Richard Rundle (1747–1826), referred to as Watson's uncle, was actually his wife's (Mary Manley's) uncle and Watson's distant cousin. A merchant and real estate investor, he was a director of the Bank of North America and a manager of the Pennsylvania Hospital (1787–89). In 1810 Rundle purchased Eaglesfield, an estate on the Schuylkill River a mile and a half northwest of center city Philadelphia. Baptized and married at Christ Church, Rundle was buried there with his uncle and aunt (Daniel and Ann Rundle); his wife, Mary; and his niece Frances Rundle in the family vault just outside the south door.

John Savage * (1765–1834), a Philadelphia businessman active in trade, banking, insurance, and real estate, was partner to *Joseph Dugan*. Savage hired Robert Mills to design blocks of rowhouses on Ninth Street ("Franklin Row") and Locust ("Rittenhouse Range"; see fig. 15) in 1809–10 and followed the success of these developments with the still-extant "Portico Row," nearby at 900–930 Spruce Street, based on designs by Thomas U. Walter. These new townhouses were owned by urban professionals such as *George and Maria Rundle*, who acquired their home at 921 Locust from Savage in 1817. Savage was married to Jane Allen White; he lived in this same neighborhood, on the northwest corner of Eleventh and Spruce Streets.

*Mr. Shoemaker**, a Philadelphia lawyer, may have been Thomas Shoemaker, a member of the State in Schuylkill present at a dinner at the Fish House 8 May 1817 when Watson was on hand.

Mrs. Shoemaker, the mother of the widowed *Mrs. Morris*, may also have been the mother of *Mr. Shoemaker* and the widow of Benjamin Shoemaker, a merchant who had worked several doors away from *Richard Rundle* on Market Street.

James Somers Smith (d. 1861), a lawyer and city councilman in Philadelphia, married Lydia Leaming, the sister of *Thomas F.* and *Jeremiah F. Leaming*. A son of James and Lydia was baptized Richard Rundle Smith (1817–1903), indicating a close connection to *Richard Rundle*, who named Smith as an executor of his will.

*John Clements Stocker** (1786–1833), son of John C. and Mary Stocker of Philadelphia, was, like *Richard Rundle*, a director of the Bank of North America. A merchant, he was also a director of the Mutual Insurance Company.

*Survilliers** (or *Servilliers*), *Comte de*. See *Joseph Bonaparte*.

Mr. Symes, probably the merchant Joseph Sims, owner of a Schuylkill villa on the site of the present Laurel Hill Cemetery. Sims also lived in downtown Philadelphia at Chestnut and Seventh Streets; his counting house was at 155 South Water Street.

*J. W. Tenkate** (or *Ten Cate*) was chargé d'affaires from Holland, serving on the legation in Washington, D.C.

*Colonel Thorndike** may have been Andrew, Jonathan, or Israel Thorndike (1757–1832), all Boston merchants active in 1816. Israel and *Gardiner Greene* were both directors of the Boston Bank and the New England Maritime Insurance Company, making it likely that Watson encountered these men together. Israel, a man of great wealth and generosity, was also a state senator.

*William Thornton** (1759–1828) was supervising the Patent Office in Washington, D.C., when Watson and *Samuel Breck* visited him on 19 April 1817. Dr. Thornton had drafted the winning design for the U.S. Capitol, although its construction, with revisions, was at that time under the control of Benjamin H. Latrobe.

*Joseph T. Tilden** (d. 1853?) was a director of the Massachusetts Bank and the New England Marine Insurance Company in Boston in 1816. He lent his support to several of the city's historical and scholarly institutions.

*Mr. Tunis**, perhaps Richard Tunis, a merchant who appears in Philadelphia's city directory in 1800; or Jehu R. Tunis, listed in 1817.

John Vanderlyn (1775–1852) had helped purchase casts and paintings for the new American Academy of Arts when he was studying in Paris in 1803. In France, thanks to the sponsorship of *Aaron Burr*, Vanderlyn won a medal from Napoleon for *Marius Amidst the Ruins of Carthage* (de Young Museum, San Francisco), exhibited at the Salon of 1807. As Watson seems to have noted, *Marius* was painted from Roman statuary. *Ariadne Asleep on the Isle of Naxos* (see fig. 61), finished in Paris in 1814, was studied from a live model, with more vibrant effect. Vanderlyn returned to New York in 1816 and displayed both paintings in the rooms newly offered to the academy. His exhibition was displaced by the academy's group show in the fall, and Vanderlyn left, insulted by suggestions that his nude paintings were unseemly. He built his own "rotunda" gallery nearby and later toured the country with his work, seeking the note of appreciation sounded in Watson's remarks. Such touring, assisted by a masterful engraving by Asher B. Durand, eventually made *Ariadne* the most celebrated American nude figure painting of the century.

*John Vaughan** (1766–1841) came to Philadelphia about 1790 from England. By 1818 he was acting vice consul for Portugal, but better known for his intellectual guidance as the secretary and librarian of the American Philosophical Society. Curator of the Academy of Natural Sciences (1825–27) and an active director of the Pennsylvania Academy of the Fine Arts, Vaughan was a much-loved pillar of the cultural community. His legendary hospitality to foreigners made some visitors conclude that he held an official post dedicated to such activities.

*Alexander Walker** appears in Philadelphia city directories as a merchant at 122 South Fourth Street in 1818 and as British viceconsul in 1817. He may have been the father of the journalist Alexander Walker (1818–93).

*Judge Walton** may have been a New York state official, as no one by this name appears in the records of the federal judiciary. Since Watson met him at Saratoga, a place frequented by tourists, he could have been from much farther afield.

George Washington (1732–1799), always "General Washington" or "the immortal Washington" to Watson, was very much alive in the memories of Philadelphians such as *Andrew Ellicott* and *Judge Richard Peters*. Washington resided in the city during his two terms as president of the United States, inhabiting a mansion at Sixth and Market Streets.

*General Wells**, of the Massachusetts Militia, may have been Benjamin T., Samuel A. (a merchant), or William Wells (a banker), all active in Boston in 1816.

Miss Wharton, sister of Mrs. Fisher, may have been Rebecca Shoemaker Wharton (1795–1846), the daughter of Isaac Wharton and Margaret Rawle, who would marry Jacob Ridgway Smith in 1817.

Josiah White (1781–1850), a merchant, manufacturer, inventor, and canal builder, developed the area just above the Falls of the Schuylkill. A chain bridge at the Falls collapsed in 1816, and White and his partner Erskine Hazard, proprietors of the mills and a wire factory on the site, replaced it with a temporary wire suspension bridge (see fig. 30), the first of its kind in the world.

*William White** (1748–1836) was the first Protestant Episcopal bishop of Pennsylvania. Born in Philadelphia and ordained in London, he became rector of Christ Church, Philadelphia, in 1779 and held that post until his death. In 1787 he was consecrated as one of the two first American bishops; in 1797 he became presiding bishop of the Protestant Episcopal Church. His home at 309 Walnut Street is maintained by the National Park Service.

*Mr. Wikoff** of Philadelphia may have been Isaac (a gentleman, at 34 Sansom), Jacob C. (at 35 High Street), or Peter (a merchant, at 146 South Tenth), all listed in the city directory for 1817.

*Thomas L. Winthrop** appears in the Boston city directory of 1816, living at 2 Hamilton Place. His brother, Captain Winthrop, was not on the American navy list at any time; he may have been a merchant captain or in the British navy.

*Caspar Wistar** (1761–1818) was, as Watson noted, a "man of ability." Trained at the University of Pennsylvania and in Edinburgh, Wistar joined the staff of Pennsylvania Hospital and earned a reputation as a professor of anatomy and chemistry at the university. He was president of the American Philosophical Society at the time of Watson's visit and well known for his hospitable entertainments at the Shippen-Wistar house, still extant at the corner of Fourth and Locust Streets. Wistar's adopted daughter married *David Hosack*, the celebrated New York physician. Since two entries appear on Watson's list (Mr. C. Wistar; Dr. Wistar, M. D.), another "C. Wistar" may also have made his acquaintance.

James Yeardsley, master of the American ship *Mercury* that brought Watson to Philadelphia in 1816.

Appendix B: Complete List of the Views in Watson's American Sketchbooks

THE PAGE NUMBERS GIVEN HERE reflect the inconsistent numbering found on the images, in ink. Some, but not all, blank leaves were numbered, and some numbers were mistakenly repeated; these pages have been distinguished by superscripts (104′, 104″). "NY" preceding the number indicates the New-York Historical Society's sketchbook; "B" refers to the Barra Foundation's sketchbook. The letters "A" and "B" refer to the left and right sheet of a two-page spread. The drawings are listed from back to front of each sketchbook, roughly following their order of execution. All the drawings are in graphite, with additions as noted. The captions have been transcribed from Watson's annotations, recording his spelling and punctuation; editorial description or insertion is in brackets.

NEW-YORK HISTORICAL SOCIETY SKETCHBOOK

Each page $4\frac{1}{2} \times 8\frac{1}{2}$ inches (11.4×21.6 cm), on off-white paper with the watermark "J. Whatman 1813"

PAGE	PLATE, FIGURE, OR COLOR PLATE (CP)	INSCRIPTION (OR SUBJECT), MEDIUM
Inside rear cover, A		*Memo. Trees X.ca.* [list of 21 tree names]
Inside rear cover, B		[Machine] *for Sausages*, pen and ink; inscribed: *On this Spot/ Fell/ July 11. 1804/ Major General/ Alexander Hamilton.*

PAGE	PLATE, FIGURE, OR COLOR PLATE (CP)	INSCRIPTION (OR SUBJECT), MEDIUM	PAGE	PLATE, FIGURE, OR COLOR PLATE (CP)	INSCRIPTION (OR SUBJECT), MEDIUM
NY-141A		[Ship at sea], black and blue wash			view from east bank of Schuykill], pen and black wash
NY-140A		[Ship at sea], *May 25th, 1816*, watercolor			
NY-139A		[Cloud forms], *May 29th, 1816*, watercolor	NY-121A		[Figures in woods], watercolor
NY-138A		[Flying fish], watercolor	NY-120AB	Pl. 6	[The Lower Bridge at Gray's Ferry from the lawn of Woodlands, 9(?) July 1816], blue and black wash
NY-137A		*11 June 1816 Light house on Cape Henlo[pen]*, [illegible inscription], black wash			
NY-136A		*The False Cape 11th June 1816 Cape Henlopen + Lt.house SSW 6m*, black wash	NY-119AB		[River landscape with grazing cattle]
			NY-118A		*Look down the R. Delawar on Philadelphia fm. Pt. no Point July 19th* [1816], black wash
NY-135A	Pl. 1/CP 1	*On The River Delawar Looking up to New Castle 12th. June* [1816], pen and blue and black wash	NY-117A		*Looking down from Dunkers Ferry 19th July 1816*, pen and black wash
NY-134A		*New Castle on the Delawar 12th June* [1816], black wash	NY-116A		*Bristol. Burlington. R. Delawar* [19 July 1816], pen and black wash
NY-133AB	Pl. 14/CP 4	*View from the Veranda at Eaglesfield house look[ing] towards/ the Upper Ferry Bridge & City of Philadelphia 13th June 1816*, watercolor	NY-115A		*Looking down the R. Delawar fm. Penns Mansion* [19 July 1816], watercolor
			NY-114A		*Point Breeze Bordentown White Hills, R. Delawar* [19 July, 1816], pen and brown wash
NY-132A	see Fig. 21	[Floor plan of Eaglesfield], with measurements and annotations indicating "all 13 ft in height"	NY-113AB	Pl. 39	*The landing at/ BordenTown with Point Breeze now belonging to Joseph Buonaparte./ U.S. Frig.te Congress at Boston/ Mr. Sayre,* [19 July 1816], black wash
NY-131AB	Pl. 24/CP 6	*Looking towards Bellmont from Eaglesfield 16 June* [1816], watercolor			
NY-130AB	Pl. 21/CP 7	*From Eaglesfield 19th June* [1816; view through woods to river], watercolor	NY-112A		*Bileses[?] Point & Island July 19 1816*, black wash
NY-129AB		[Schuylkill River meadow with grazing cattle], brown and black wash	NY-111A		[Two views of bridge at] *Trenton R. Delawar 19 July* [1816]; [illeg. graphite inscription in sky], pen and black wash
NY-128AB	Fig. 53	*Eaglesfield & [Philadelphia?] from Bellmont 1 July 1816*, blue and black wash	NY-110AB	Pl. 40	*Trenton Bridge/ Delawar River 19th July 1816*, black wash
NY-127AB	Pl. 15	*Front [at?] Eaglesfield 4 July* [1816], green and black wash	NY-109AB	Pl. 41	[Two views of] *Brunswick 19th July 1816 Kittateny Mountains*, black and blue(?) wash
NY-126AB		[Eaglesfield from veranda lawn, 6 July 1816], watercolor			
NY-125A		[Trees on riverbank; distant shot tower, July 1816], black wash	NY-108AB		*Looking down the Rariton River from/ the Ferry house Brunswick 19 July 1816*, black and blue wash
NY-124A		[Schuylkill River bank, below Eaglesfield, July 1816], blue and black wash	NY-107A		*20th July 1816 Martin's Dock R. Rariton*, pen and black wash
NY-123AB	CP 8	[River view, July 1816], pen and black and blue wash	NY-107B		*A Jersey Home*
NY-122AB		*Eaglesfield from Mr. Pratt's 7th of July* [1816,	NY-105A		*Perth Amboy. Statton Island. July 20th 1816 Highland of Newsink*, pen and black wash

PAGE	PLATE, FIGURE, OR COLOR PLATE (CP)	INSCRIPTION (OR SUBJECT), MEDIUM
NY-104A	Fig. 58	*Statton Island. Jersey Shore. 20 July 1816. Amboin*, pen and black wash
NY-103A	Pl. 42	*Point from whence the American Army crossed over to Statton Island to attack the British in the the Revolu.n War. Statton Island/ 20th July* [1816], black wash
NY-102A		*Birgen Pt. Kill Sound with Long Island in the distance. Statton Island* [20 July 1816], pen and black wash
NY-101AB	Pl. 43	*The highland at the entrance of the North River Powles[?] Hook Ellis Isd. Bedlows Isd. New York from Kill Sound 20th July* [1816] *Williams Battr & Governors Island. Land of Long Island in the distance.*, pen and black wash
NY-100B		[Sailboat], pen and black wash
NY-99A		*Narrows, New York Bay Fort Richmond/& signal Staffs Pt. of Stattens Isld.*, with graphite inscription, obscured by pen: *the narrows are 19 . . .* , black wash
NY-98B		[Pennsylvania-German type house with porch], pen and black wash
NY-97A	Fig. 63	*Hoboken N. York from the Steam Boat Quay 22 July. 1816*, brown wash
NY-96B		*The front of K. G. Otis Esqr house/ near Boston 8 Augt./ 1816*, pen and black ink
NY-95B	Fig. 62	*James Lawrence* [Monument, 22 July 1816], pen and black wash
NY-94AB	Fig. 59	*Governor's Island Fort Williams Bedlows Isd. New York* [22 July 1816], pen and black wash
NY-93AB	Pl. 44	*Hoboken Pallasades Fort Gansewert.* [Gansevoort; 22 July 1816], blue and black wash
NY-92A		*Looking down the Hudson, or North River from a little/ above Fort Gansewert and Powles Hook to The Narrow in New York Bay. 23 July* [1816], blue, brown and black wash
NY-91A NY-90A	Pl. 45	[The Palisades, 23 July 1816], watercolor *Commencement of the highlands of the/ Pallisadoes on the River Hudson. 23 July* [1816], watercolor
NY-89A		*Part of the Pallisadoes, on The River Hudson from [] 23rd July* [1816], watercolor; inscribed (89B): *Lord Courtney's Grounds* [House on highlands]
NY-88A NY-87B	Fig. 31	*1st. August 1816 House Springfield/ Connecticut*, pen and black wash, inscribed: *Kitchin/ 2 Bedrooms over it with passage and back stairs. Closet- Hall- Closet- Eating- Drawing/ Pantry- Stairs- Back kitchen & servants room over it*
NY-87A		*Pallisadoes 23rd July* [1816], black wash
NY-86A		*Part of the Palisades 23 July* [1816]/ *Their height is from 250 to 300 feet*, blue wash; inscribed (86B): *Height from the River 250 ft.*
NY-85AB	Pl. 46	*Part of the Pallisadoes with the highlands of the Hudson in the distance. 23rd July 1816.*, watercolor
NY-84AB	Fig. 64	*The distant Pt. is with 3 miles of New York Looking down the River Hudson from abreast of Niock. This reach is 23 miles long./ The highland of The Pallisadoes 18 miles. 23rd July 1816*, black and brown wash
NY-83A		*Looking back on the highland of the Pallisadoes from Tarry Town. Nyack* [23 July 1816], blue, brown and black wash
NY-82AB	Pl. 47	*23 July* [1816] *Looking from Sing sing to the highlands*, watercolor
NY-81A		*Stoney Pt. Virplanks Pt. at which place the Granite rock ceases and the Limestone begins* [23 July 1816], pen and black wash
NY-80AB		*Limestone rock Granite Rock Virplank's Pt. opposite Stoney Pt. on the Hudson 23 July 1816*, pen and black wash
NY-79AB		*Point of the Horse race 23d July* [1816] *Peeks kill*, pen and black wash

PAGE	PLATE, FIGURE, OR COLOR PLATE (CP)	INSCRIPTION (OR SUBJECT), MEDIUM	PAGE	PLATE, FIGURE, OR COLOR PLATE (CP)	INSCRIPTION (OR SUBJECT), MEDIUM
NY-78AB	Pl. 48	*The reach, calld The Horse race/ 23 July [1816] Antonies Nose 935 ft. in height.*, black wash			[1816], black wash, inscribed (A): *Catskill Mountains State of N. York 3000 ft high Athens. Hudson July 25th* [1816]; pen and black ink, inscribed: *5 to 6000 ship of heavy burden come up.*
NY-77A		*Sugar Loaf Hill, a Little below/ West Point, on The Hudson, 23 July* [1816], black wash	NY-64AB		
NY-76A		*Ludigg's[?] Hills or Buttermilk Falls. 23d July [1816]. West Point*, black wash	NY-63AB	Fig. 34	*Hudson looking down the river. July 25th. 1816 Athens Cattskill Mountains/ Kaatskill M*, pen and black ink
NY-75AB	Pl. 49	*Looking down The Hudson through the/ Narrows to West Point— from the/ Ferry— 24 July* [1816], black wash	NY-62A		*Cocksackie Landing July 25* [1816], pen and black ink
NY-74AB	Pl. 51	*Looking up the Hudson from Newburg at/ Butter Hills towards Poughkepsie 24 July* [1816], black wash	NY-61B		*View near Cocksackie Landing* [25 July 1816], pen and black ink
NY-73AB	Pl. 50	*Looking down the Hudson from Newburg at Butter Hills/ Through the narrows to Pollipero[?] Island, with the Military Establishment on West Point in the distance 24th July* [1816], black wash	NY-60A		*The Islands just above Cocksackie Landing July 25* [1816], pen and black ink
NY-72A		*Looking down the river to Poughkepsie/ 25 July* [1816], pen and black wash	NY-59B		*Some miles below Albany* [25 July 1816], pen and black ink
NY-71AB		*Looking up the river Hudson some miles above Poughkepsie/ Esopus Island in the center/ 25 July* [1816], pen and black wash	NY-58B		*Islands in the Hudson a few miles below Albany* [25 July 1816], pen and black ink
NY-70A		*Kaatskill or Catskill Mountains/ 3800 feet Esopus Meadows 25th July* [1816], pen and black wash	NY-57A		*The appearance of Albany when first seen* [25 July 1816], black wash
NY-69A		*25 July [1816] Kaatskill. Rinesbeck or Woods Dock/ Cattskill Mount. in cn. distance*, pen and black wash	NY-56AB		*Albany 25th July* [1816; distant view], black wash
			NY-55AB	Pl. 52	*City of Albany, taken on the Bathside of the/ River 26th. July.* [1816], black wash
NY-68B	Fig. 69	*Plan of a Dearborn Waggon*, pen and black ink; inscribed: *Carriage is 4 feet long/ 2½ ft. fm cn. Ground*	NY-54A	Pl. 53	*Military depot of/ artillery. Town of Troy, this view is taken near the depot 27 July* [1816], pen and black wash
NY-67A	Fig. 65	*Kaatskill or Cattskill Mountains in the distance Kingston Landing or Esopus. The River is here 1½ miles wide* [25 July 1816], black wash	NY-53AB	Pl. 54/CP 13	*The falls of Cohoes on/ the Mohawk River 62 feet 27 July 1816*, watercolor
			NY-52B		*Villa near Boston* [H. G. Otis house?; 8 August 1816], pen and black wash
NY-66AB		*Looking down the Hudson from a little above Kingston* [25 July 1816], pen and black ink	NY-51A		*Cohoes Bridge 916 feet across the River Mohawk (Mohocko R.)/ This view is taken near the falls, looking down* [27 July 1816], pen and black wash
NY-65AB		*Cattskill Kaatskill M. Mountains on the Hudson River from Upper[?] Red hook 25th July*	NY-50B		[Coach]
			NY-49A		*Cohoes falls taken/ from the Bridge 27 July* [1816]. *Mohocks River*, blue and lavender wash
			NY-48B		*A Dearborn Waggon*

PAGE	PLATE, FIGURE, OR COLOR PLATE (CP)	INSCRIPTION (OR SUBJECT), MEDIUM
NY-47A		*View 2 miles above Waterford, on/ Hudson July 27* [1816], watercolor
NY-46A		*View at The Shallows of the Hudson/ with the highland of Willard and Swain in the distance* [27 July 1816], pen and black wash
NY-45A		*Northumberland with Fort Miller Bridge in the distance 28th July* [1816], pen and black wash
NY-45B		[Bridge trestle?]
NY-44AB	Pl. 55	*Fort Edward or/ Millers Falls/ 28th. July* [1816], black wash
NY-43AB		*Kingsbury Bridge and the/ rapids 28th July* [1816], black wash
NY-42AB	Pl. 56	*Bakers falls, Kingsbury/ 28th. July* [1816], watercolor
NY-41AB	Pl. 57	*Looking down the Hudson from the hill over Bakers Fall, King[s]bury, 28th. July.* [1816], blue and black wash
NY-40B	Fig. 66	*From Diamond Island, Lake George* [29 July, 1816], black wash
NY-39A	Fig. 66	*Baker's Mills, Kingsbury* [28 July, 1816], black and blue wash
NY-38AB	Fig. 67	*Looking down the river from the Bridge at Glens Falls 28th July* [1816], watercolor
NY-37AB	Pl. 58/CP 14	*Glens Falls 28 July* [1816], watercolor
NY-36AB	Pl. 59/CP 15	*Lake George from Diamond Island/ looking towards Tongue Mountain 29 July* [1816], watercolor
NY-35AB	Pl. 60	*Lake George & Islands from the Point of Land under Frenchmens Mountain 29th July 1816*, watercolor
NY-34AB	Pl. 61/CP 16	[Caldwell, New York. Shores of Lake George, 29 July 1816], blue, brown and black wash
NY-33AB		[Lake George from highland, 29 July 1816], watercolor
NY-32B		[Figures in a wagon]
NY-31B		[Tree]
NY-30AB		*Glens Falls from near the Saw Mills/ 30th July* [1816], *Saw Mill Glens Falls*, black wash
NY-30B		*Saw Mill Glen Falls* [30 July 1816], black wash
NY-29AB	Pl. 62	[Saratoga. 30 July 1816], black wash
NY-28AB	Fig. 32	*Cottages in the Northern parts of [the] State of New York*, pen and black wash
NY-27AB		[Mohawk(?) River from bridge. 31 July 1816], black wash
NY-26AB	Pl. 63	*Bolston Turnpike Mohawk Bridge/ It is 93 ft over, & has 9 arches* [31 July 1816], black wash
NY-25A		[River gorge]
NY-24A		[Landscape with farm houses]
NY-23A	Pl. 64	*View on Connecticut River about 8m/ below Northampton/ 2d. August. 1816*, black wash
NY-22AB		*Northampton/ Connecticut/ 2d Aug.t 1816*, black wash
NY-21AB	Pl. 65	*Charles Town & Navy/ Yard Cambridge University The Statehouse The City of Boston from Walnut Grove/ near Watertown. E Preble's Esqr. 8 Augt./ 1816/ Gloucester heights Rocksbury*, black wash
NY-20AB	Pl. 66	*Boston from the Road under Dorchester heights/ 10th. August 1816*, black wash; inscribed (B): *Williams Island*
NY-19AB	Pl. 67	*Roxbury—Boston fm Church 10th Augt.* [1816], black wash
NY-18AB	Pl. 68	*Boston from the/ Navy Yard at/ Charlestown/ 10th. Augt.* [1816], black wash
NY-17B		[USS Independence. August 1816]
NY-16A		*The U.S. Ship Independence 74/ Comr. Bainbridge - Capt. Ripley* [August 1816], pen and black ink
NY-15AB	Pl. 69	*Charlestown Boston from/ The Wt. Bridge/ 11th August* [1816], black wash
NY-14AB		*Little River Bridge near Middleburg on the/ River Connecticut 13 August 1816*, pen and black wash
NY-13AB	Fig. 27	*Town of Middletown on the River Connecticut/ from Little River Bridge- 13th Augt. 1816*, pen and black wash

PAGE	PLATE, FIGURE, OR COLOR PLATE (CP)	INSCRIPTION (OR SUBJECT), MEDIUM
NY-12AB	Pl. 70	*New Haven with the high lands of the Et. & Wt. Rocks 15th. August 1815* [1816], black wash
NY-11AB	Pl. 71	*View from the Top of the Museum at New Haven with the East Rock/ & Mill River 14th August 1816 Quennipack River*, black wash
NY-10A		*Gates Et. River 15 Augt. 1816*, black wash
NY-9AB		*Long Island Battery Passing Through Hell Gates 15th August 1816 Mill Rock distance is York Island*, black wash
NY-8A		[Bridge]
NY-8B		*Distance/ Long Island Blackwell Island City York Island* [15 August 1816], black wash
NY-7AB		*On The Passaic River/ 15 August 1816*, watercolor
NY-6AB		*Passaic River near/ The Falls looking down* [ca. 15 August 1816], black wash
NY-5AB	Pl. 72	*Passaic Falls* [15 or 16 August 1816], black wash
NY-4AB	Fig. 28	*Patterson 16 Augt.* [1816], pen and black wash
NY-3AB		*Upper[?] Fall of the Passaic/ 17th Augt.* [1816], black wash
NY-2"AB	Pl. 73/CP 17	*New York from / Whehauken [monument at the dueling ground] 19th August/ 1816/ J. R. Watson/ Delt.*, watercolor
NY-2'A		[Weehawken] *Aug 19 1816*, blue and black wash
NY-1A		[Map of Hudson Valley]
Inside front cover, A		*J.R.W. . . . 1816.*; inscribed in pen: *Springfield new mode of/ fixing the bayonet to prevent/ its coming off in a charge*; in graphite: notes on distances, routes from New York to Philadelphia; waterfall heights.
Inside front cover, B		inscribed: *35,000 Souls return a member to Congress/ 70,000 Inhabitants [are] necessary [to] a state/ In Virginia 5 slaves are as 2 whites . . .* [remainder illegible]

BARRA FOUNDATION SKETCHBOOK

Each page $5\frac{3}{8} \times 10\frac{1}{2}$ inches (13.7 × 26.7 cm.), on off-white paper with a watermark of "Ruse and Turner/1813."

PAGE	PLATE, FIGURE, OR COLOR PLATE (CP)	INSCRIPTION (OR SUBJECT), MEDIUM
Inside rear cover, B		Inscribed: *Joshua R. Watson/ La Favorita/ Guernsey*
B-110A	Pl. 4/CP 9	*The Lower Bridge on Schuylkill/ at Gray's Ferry 5 [—]ber 1816*, watercolor
B-109AB		*View from Eaglesfield near Philadelphia/ 14th. September 1816*
B-109B		[View from Eaglesfield to Fairmount, 1816], pen and brown wash
B-108AB	Pl. 10	*Looking up the Schuylkil from the Upper Bridge/ 9th October 1816*, pen and black wash
B-107A	Fig. 20	*Front of Eaglesfield. 20th September* [1816], black wash
B-106AB		*Back Front of Eaglesfield 22d. September.* [1816], black wash
B-105A	Pl. 5	*5th October [1816]/ The Woodlands from the/ Rocks at Grays Ferry, with the Lower Bridge*, pen and black and brown wash
B-104"AB	Pl. 8/CP 3	*View of the Middle and Upper bridges on the/ River Schuylkill taken from the Old Waterworks/ Philadelphia 5th October 1816*, watercolor
B-104'A	Pl. 7	[West bank of the Schuylkill below the Market Street bridge] *3d. December 1816*, pen and black wash
B-104'B	Pl. 7	*The Shot tower [illegible]/ December 1816*, pen and black wash
B-103AB	Pl. 23	*Looking up the Schuylkill from the Hutt 24th September 1816*, pen and black wash
B-102AB	Pl. 26	*Looking down the R. Schuylkill towards/ Eaglesfield— from Kennedys house 24th Septembr.* [1816], black wash
B-101AB	Pl. 28	*Looking up the Schuylkill to the/ Mills at the*

PAGE	PLATE, FIGURE, OR COLOR PLATE (CP)	INSCRIPTION (OR SUBJECT), MEDIUM
		Falls from the Fishermans Hut Alphington[?]/ 24th. Septembr. 1816, black and brown wash
B-100AB	Pl. 29	*Falls of Schuylkill/ 19th. October. [1816]*, pen and black wash
B-99A	Pl. 30	*The Road from Philadela./ to Robisons Mills/ 18th Septembr. 1816*, pen and black wash
B-98A		*Looking up the/ Whissihikin Creek/ from the Bridge at/ Robisons Mills/ 18th Septr. 1816*, blue and black wash; inscribed: *Wisshicon*
B 97A		*On the Whissihikin Creek a little/ above Robissons Mills. 18th Septemb. [1816]*, blue and black wash
B-96A	Pl. 34	*At the Paper Mills/ Whissihikon Creek/ 18th September 1816*, pen and blue and brown wash
B-95A	Pl. 33	*Rittenhouses Mill on/ the Whissihiken Creek/ 18th September 1816.*, pen and blue and brown wash
B-94A		*Looking down from Rittenhouses Mill/ Whissihikon Creek 18th. Septbr. 1816.*, pen and black wash
B-93A	Pl. 32	*Look[ing] up on Whissihicon/ Bridge from the Iron Mills/ 4 October [1816]*, pen and black wash
B-92AB		*Looking up the Schuylkill a little below/ Whissihicon Creek 4th. October [1816]*, pen and black wash
B-91A		[Bull], pen and brown ink
B-90A		*Flat Rock Bridge on/ the R. Schuylkill/ 4th October/ 1816*, pen and black wash
B-89A	Pl. 38	*Looking up the Schuylkill from the Hill above Flat/ Rock Bridge-4th. October. 1816.*, pen and black wash
B-88AB	Pl. 37	*Flat Rock Bridge on the Schuylkill/ looking down the River 25th October [1816]*, pen and black wash
B-87AB	Pl. 35	*On the Schuylkill a mile/ above Wissihicon*
		creek 25th. October [1816], black and brown wash
B-86B		[Chipmunk], pen and brown ink
B-86A	Fig. 41	[Boulders in a wood, 1816–1817], brown wash
B-85B		[Boats] *On the Manaiunk or Schuylkill*
B-85AB		*View on Schuylkill just above the Falls 19th. October. [1816]*, brown wash
B-84A		[View down a road] *27th Septembr./ 1816*, pen and black wash
B-83A	Fig. 39	[Blasted tree] *27th Septembr 1816*, water-color
B-82A	Pl. 25	*Bellmont The Honble Judge Peters/ 23d. October 1816*, black wash
B-81B	Pl. 31/CP 12	*Looking up Wissihicon Creek/ 25.th October [1816]*, watercolor
B-81AB	Pl. 31/CP 12	*On the Schuylkill/ opposite Wissihicon Creek 25th Octobr. [1816]*, black wash
B-80AB	Pl. 36	*View Looking up Schuylkill to the Flat Rock Bridge/ 25 October 1816.*, black wash
B-79AB		*The Flat Rock Bridge 25th October 1816.*, black wash
B-78A	Pl. 12	*Sedgley— J. Fishers Esqr. opposite Eaglesfield/ 28th. October. [1816]*, pen and black wash
B-77B	Pl. 13	*Solitude Jno. Penn Esqr./ 28th. October [1816]*, pen and black wash
B-77A	Pl. 13	*Upper Bridge with the Waterworks/ on Schuylkill fm Solitude 28.th October [1816]*, pen and black wash
B-76A	Pl. 9	*This View looking up the River Schuylkil is taken from/ the top of the West Shot tower at Philadelphia. 3rd Decembr./ 1816.*, pen and black wash
B-75AB	Fig. 1	*From Eaglesfield looking up the Schuylkill. 1817-*, pen and black wash
B-74B	Pl. 27/CP 11	[Steamboat], pen and black ink; inscribed: *Memo The Indian name of the/ River Schuylkill was the/ Manaiunk-*

PAGE	PLATE, FIGURE, OR COLOR PLATE (CP)	INSCRIPTION (OR SUBJECT), MEDIUM	PAGE	PLATE, FIGURE, OR COLOR PLATE (CP)	INSCRIPTION (OR SUBJECT), MEDIUM
B-74A	Pl. 27/CP 11	*Banks of Schuylkill looking down the River/ near the Ford below the Falls- 4.th April 1817*, pen and black and brown wash			[18 April] 1817, pen and ink and watercolor
B-73AB	Pl. 22	*Banks of Schuylkill looking up the River/ 4th. April 1817—*, pen and black wash	B-61AB	Pl. 79	*Looking down the River Potomac/ from the Summer house at Mount Vernon 18th. April 1817*, pen and black wash
B-72AB		*Banks of Schuylkill Looking down the River/ 6th April 1817*, black wash	B-60AB		*View looking up the Potomac River from Mount Vernon 18th. April 1817—; Fort Washington*, black wash
B-71AB		[River scene: view from Woodlands? ca. 1817]	B-59AB	Pl. 78	*Mount Vernon. Virginia/ 18 April 1817.* pen and black wash
B-70AB	Pl. 11	[View up the Schuylkill toward Eaglesfield, from the west bank opposite Sedgeley Point; April 1817], black wash	B-58AB	Pl. 76	*The Capitol Washington as it is to be/ from the Bridge over/ Tiber Creek 18th. April 1817.*, pen and black wash
B-69B	Pl. 2	*Philadelphia 14 April(?) 1817*, black wash	B-57AB	Pl. 82	*Bridge at the Lower [Little] falls of Potomac/ 21st. April 1817*, pen and black wash
B-68B		[Conestoga wagon], brown wash			
B-68AB		*Looking up the Elk River from/ Oldfield Pt 15 April 1817*, pen and brown and black wash	B-56AB	Pl. 81	*From the Gun Foundry near Washington/ on the River Potomac. 21st. April 1817.*, pen and black wash
B-67B		*Entrance of the Susquehannah/ from Turkey Point* [15 April 1817], watercolor			
B-67AB		*Looking down into the Chesapeak from/ the Elk river at Turkey Point 15th April 1817*, watercolor	B-55AB	Pl. 86	*Looking down the Susquehannah from the end of the Town of/ Columbia- 24th. April 1817.*, pen and black wash
B-66AB		*North Point— The Entrance into the Patapsco River/ 15 April* [1817], black wash	B-54AB		*Looking down the Susquehannah from/ Columbia Bridge at the Island over which it/ passes 25th April 1817*, black wash
B-66B		*Virginia Negroes Hutt* [April 1817], black wash	B-53AB		*Looking up the Susquehannah fm. Columbia Bridge/ at the Island on which it passes over. 25th April 1817.*, black wash
B-65AB	Pl. 74	[Two views of the] *Entrance into Baltimore between/ Battery Island and Love Point/ 15th. April 1817.*, black wash; [inscribed in sky (65B)]: *St. Paul's Courthouse*	B-52AB	Pl. 84	*View of Columbia Town & Bridge over the Susquehannah/ looking down the River— 25th April 1817.*, black wash
B-64B	Pl. 75	[Washington D.C.: Pennsylvania Avenue from Capitol Hill; Elevations of the U.S. Capitol, after drawings by B. H. Latrobe, April 1817], pen and black wash	B-51AB	Pl. 83	*Looking up the Susquehannah from the Point below Cryts Creek/ with Columbia Bridge of 51 Arches being 1 mile & 25 Rods long 25th. April 1817*, black wash
B-64A	Pl. 75	[Washington D.C.: Pennsylvania Avenue from Capitol Hill, April 1817]	B-50AB	Pl. 85	*Looking down the Susquehannah fm Wrightsville ferry/ 25th April 1817*, pen and black wash
B-63A	Pl. 77	*18th April 1817. Looking down the Potomac from the War Office at Washington*, black wash	B-49AB	Pl. 88	*Halfway houses near/ Chickeys Rock— On the Susquehannah 26th. April 1817.*, pen and black wash
B-62A	Pl. 80/CP 18	*General Washingtons/ Tomb at Mt Vernon/*			

PAGE	PLATE, FIGURE, OR COLOR PLATE (CP)	INSCRIPTION (OR SUBJECT), MEDIUM
B-48AB	Pl. 89	26th. April 1817. Mill at the Half way Houses/ near Chickeys Rock on the Susquehannah, black wash
B-47A		Chickeys Rock 26th April [1817], black wash
B-46AB	Pl. 90	26th. April/ 1817/ View looking down the Susquehannah/ from under Chickeys Rock., pen and black wash; inscribed: Pale Ash Clouds throughout
B-45AB	Pl. 87	Looking up the Susquehannah/ a little above Columbia Bridge— 26th. April 1817., pen and black wash
B-44AB		[Pavilion and garden at Eaglesfield, May(?) 1817]
B-43AB	Pl. 16/CP 5	[Eaglesfield from the northeast] May 11th. 1817, watercolor
B-42AB	Pl. 19	Dairy House. May 11th. 1817, pen and black wash
B-41AB	Pl. 3/CP 2	View of Philadelphia from Keans Ferry/ on the Pontuxat or Delawar River/ 12th. May 1817., pen and brown wash
B-40A	Pl. 18	From the Piazza looking towards the Pavilion/ 21st May 1817—, pen and black wash
B-39AB	Pl. 20	Stables & Barns 21st. May 1817—, pen and brown wash
B-38AB	Pl. 17	From the Piazza Eaglesfield looking towards Mr. Morris's/ 29th. May 1817, pen and brown and black wash
B-37A		Manaiunk or Schuylkill [illegible] Wisshicon Creek June 1st 1817. [Road curving into forest], brown wash
B-36A		On the Banks of the Manaiunk or Schuylkill/ near the Falls 1st June 1817., brown wash
B-35A		From the Breakfast room Eaglesfield/ 5th June 1817, watercolor
B-34B		Fort Mifflin Delawar River/ 15th June 1817, brown wash
B-34AB		River Delawar Fort Mifflin 14 June 1817, brown wash
B-33A		Flying Fish taken on bd Rebc.a Sims/ 23 June 1817. Lat 39.30 Long 5530, watercolor
B-19 to B-32		blank
B-18A		Helwick Head Dungaroon Bay Highland of Dungaroon 14th July 1817, black wash
B-17A		Skerries Lighthouse & Carmels Pt Holly Head 16th July 1817, black and brown wash
B-16AB		Little Orms Hd Great Orms Head Conway Bay Returning to Liverpool/ from America Pinmanmoor July 16th. 1817 Priest Island & table land entrance/ into Baumaris & Bangor, black and brown wash; inscribed: Water darker than the land
B-15A		The Rock [?] Liverpool from Back of the [oil?] 17 July 1817, black wash
		blank
B-11 to B-14		[Two Terriers] Eaglesfield Tip & Flirt 31 May 1817, black and brown wash
B-11A		
B-6 to B-10		blank
B-5B		[Man walking]
B-4B		page cut out
B-3B		[illegible sketch]
B-2B		[Machine, side view, with] Cog Wheel 8 in. diameter the teeth 3½ long 10 in Number [1816–17], inscribed with measurements
B-2AB		[Machine with] Knife at an Angle of 30 [1816–17], inscribed with measurements
B-1B		A float or raft of lumber- 25th April 1817; [Pistol]
Inside front cover, A		Inscribed: R[illegible]n/ Favorita/ Guernsey

Notes

Introduction: Discovering Captain Watson

1. See George C. Groce and David H. Wallace, *The New-York Historical Society's Dictionary of Artists in America, 1564–1860* (New Haven, Conn.: Yale University Press, 1957), 665; Anna Wells Rutledge, *Cumulative Record of Exhibition Catalogues: The Pennsylvania Academy of the Fine Arts 1807–1870* . . . (Philadelphia: American Philosophical Society, 1955), 244.

2. Philadelphia: Philadelphia Museum of Art, 1976, cat. 198, pp. 239–40. Sewell also included the sketchbook in his 1988 exhibition, "The Fairmount Waterworks, 1812–1911," Philadelphia Museum of Art, 23 July–25 Sept., 1988; see *Philadelphia Museum of Art Bulletin* 84 (Summer 1988): 10.

3. William R. O'Byrne, *A Naval Biographical Dictionary* (London: J. Murray, 1849), 1258, under the entry for his oldest son, Rundle Burges Watson (1809–1860).

4. *The Annual Report of the New-York Historical Society for the Year 1958* (New York: New-York Historical Society, 1959), n.p.; and Richard J. Koke, *American Landscape and Genre Paintings in the New York Historical Society* (New York: New-York Historical Society and G. K. Hall, 1982), 3: 250–51. "The album of exceptionally well-drawn studies is one of the most interesting items in the society's collection of early nineteenth-century pictorial Americana recorded by foreign visitors."

Part I: Watson's World

Raised in the Navy

1. Letter of 3 Feb. 1780 to "Mrs. Burges. At Mrs. Coleman's/ Ewell, near Epsom/ Surrey." Collection of Elizabeth Burges Pope (hereinafter Pope coll.).

2. Will of Thomas Watson, Pope coll. His letter of 3 Feb. (ibid.) remarks that his "brother" is a lieutenant on the ship. Thomas Watson had no brothers; Rowley was a distant cousin.

3. Rowley's journal of the *Resource* indicates that the ship was at sea, with no mention of new crew members, the day the boys "joined the company." Public Record Office (PRO); ADM 51/4309. I am grateful to Pamela Brice, who first alerted me to the practice of "paper" service. See also N. A. M. Rodger, *The Wooden World: An Anatomy of the Georgian Navy* (Annapolis, Md.: Naval Institute Press, 1986), 320–21, for a discussion of the dubious benefits of this deception.

4. J.R.W., "Memorandums of myself and family," undated ms., after 1806; Pope coll. Parish records in Topsham show his baptism on 11 May 1772.

5. Watson's passing certificate records his age as 21 years 5 months, his true age when awarded a lieutenant's commission on board the *Hannibal* in August 1793. PRO, Lieutenants' Passing Certificates, ADM 107, vol. 14, p. 63.

6. See Michael A. Lewis, *A Social History of the Navy 1793–1815* (London: Allen and Unwin, 1960), 22–26. This percentage from service families was increasing in Watson's day. Among the forty-one counties in Britain, Devon contributed a disproportionate share (10 percent) of naval officers. See also Rodger, *Wooden World*, 253, 276, 292, on the typical background of naval officers.

7. J.R.W., "Memorandums of myself . . ."

8. T.W., "Will" of 1780. Sir William Rowley's wife was either the sister of Thomas Watson's great-grandmother or the sister of his grandfather, Joshua Smith. The Rowley and Watson families joined when they were neighbors in Tendringhall, Suffolk.

9. Thomas Watson was born in Ennis in 1737; commissioned lieutenant 6 Sept. 1759; commander Dec. 1779; captain 17 Jan. 1780; died 27 May 1780 from wounds received 15, 17 or 19 May; buried at the Vighi, St. Lucia. PRO, ADM 9/2; 6/91; 107.

10. The entry for "Topsham" in *Pigot and Cos. Royal National and Commercial Directory and Topography* (1844) remembers Thomas Watson as the town's hero.

11. From R. R. Burges's obituary in the *Gentleman's Magazine* (1797), quoted in D. M. Morris, "At Your Service Captain Burgess Sir!" *Devon Life* (Sept. 1967): 22. I am grateful to Pamela Brice for sharing this source. Burges entered the service in 1775 under Joshua Rowley. He was made lieutenant in 1779 (or 21 Nov. 1780); commander, 7 Dec. 1782, captain 21 Sept. 1790; died 11 Oct. 1797 at the Battle of Camperdown (Kamperduin).

12. Of Auchins Academy, I have discovered no trace; Watson's attendance there is recorded in a memorandum written by Mary Manley Watson, outlining her husband's career. Pope coll.

13. Watson's enrollment at the Chelsea Military School from 1783–85 is documented in Mary Manley Watson's memorandum, Pope coll. Information and quotations come from *Rules and Regulations of the Maritime School, on the Banks of the Thames, near London. Instituted in MDCCLXXVII. with a view to qualify scholars to serve as officers in the Royal Navy. Preferring the sons of sea officers for the greater part* (London: 1781), 52, 100–106. The name of the school's drawing master is not given. This manual explains the founding principles of the school by noting the dearth of preprofessional educational opportunities for middle-class boys interested in naval careers. The only other relevant school at this time was the Royal Naval Academy at Portsmouth, founded in 1730. Small, expensive, and burdened with a reputation for "indiscipline and vice" in this period, Portsmouth saw few scholars from naval families like Watson's. Older than Chelsea's students, Portsmouth's graduates often found themselves disadvantaged by going to sea late, even though (as at Chelsea) their school years counted as sea time for promotion. When Portsmouth was reorganized and expanded in 1806 it gradually became the source of the navy's professional elite. Watson's son, Rundle Burges Watson, was enrolled there in 1821, at the age of twelve. From this, and from the absence of further news about the school, we can imagine that Watson's alma mater had been superseded. See Rodger, *Wooden World*, 265. Watson's letter to his grandmother, dated 4 July 1785, is in the Pope coll.

14. Mary Manley Watson's "Memorandum" annotates the year 1786: "In France went there in Febur?" and 1787: "Left France in Feby for Engd. November joined the Savage." Since official records show he joined the *Savage* in July 1786, his French trip must have fallen between January and June 1786.

15. Watson's own record of ships and service, jotted inside the flyleaf of his first American sketchbook, begins with the *Savage*, as does his wife's biographical memorandum; see note 14. "Captain's servant" was the designation for all unrated boys, regardless of their education or birth.

16. The *Savage*'s logs are PRO ADM 51/835; *Porcupine*, 51/687, 52/2429.

17. Lieutenants' Passing Certificates. PRO, ADM 6/91.

An Officer's Life During the Napoleonic Wars

18. The sketchbook is in the Pope coll. The drawings in this book appear in random chronological order and are interspersed with the watercolors made after ca. 1830 by his son, Rundle Burges Watson, who did not share his father's talent as a watercolorist.

19. Mary Watson's "Memorandum."

20. Watson also drew this ship in his first sketchbook; see "H.M.S. Queen, Capt. Hutt/ R. Adl. Gardner 1793," Pope coll.

21. William R. O'Byrne, *A Naval Biographical Dictionary* (London: J. Murray, 1849), 1258. Watson served on the *Queen* until 29 May 1793 when he was transferred to the *Winchelsea*, under Lord Garlies, until November 1794. His lieutenant's commission was won at the time of this transfer. Mary

Watson's "Memorandum" notes that he returned briefly to Portsmouth late in 1793 and then sailed again for Ireland and Gibraltar, returning to the West Indies in early 1794, for the siege of Martinique.

22. "Journal of the Proceedings of his Majs Ship Lively . . . Commencing 8th Day of November 1794 and ending the 31st Oct. 1795." PRO, ADM; Lewis, *Social History of the Navy*, 85.

23. Pope sketchbook; see "H.M.S. Spy 1795." Also from this period is a watercolor view in the Pope sketchbook of the spectacular conflagration of the HMS *Boyne*, a huge warship that accidentally burned in Portsmouth harbor on 1 May 1795.

24. Certificate of command, 13 Oct. 1795; Pope coll. Mary Watson's "Memorandum" indicates sojourns in London and Ireland in mid-1795, perhaps connected to the receipt of prizes or orders, and the transfer of *The Spy*. Her notes read: "1795 Made Comd Portsmouth Plymouth Ireland Plymth London Plymth Ireland."

25. Pope Sketchbook. In the same book, see "H.M.S. Unicorn Capt. J. W. Williams"; and "On the coast of Ireland" [Battle scene at night, the *Unicorn* and *La Tribune*].

26. "Minutes of the Proceedings of a Court-Martial" on board HMS *Cambridge*, Hamoze harbor, 20 Aug. 1796; ADM 1/533b. Letter of commendation from Vice Admiral Kingsmill, 24 July 1796. ADM 1/613, L175.

27. Mary Watson's "Memorandum." Watson was in Bath in June, according to a letter he received there at 36 Milsom St., dated 30 June 1797, from his uncle Richard Rundle Burges; Pope coll.

28. Banks (1735–1805) created the Burges memorial as the first of his two commissions in a series of monuments for national heroes in St. Paul's. T. S. R. Boase, *English Art 1800–1870* (Oxford: Clarendon Press, 1959), 130. The Pope collection also contains an engraving of Shee's portrait miniature (see Fig. 4) with the following inscription below the image: "RICHARD RUNDLE BURGES ESQ.r/ Captain of His Majestys Ship Ardent/ who so gloriously fell in the Battle of Camperdown/ October 11, 1797. Posthumous Tribute arranged by his family."

29. The quotations are from an undated letter from Robert Bayley to Hannah Bayley, ca. Oct. 1798; Pope coll. In the navy, sons or near relations were frequently given sympathetic consideration for promotion following the death of a senior officer; see Rodger's discussion of "legacies to service," *Wooden World*, 292. A pencil and pen drawing of *La Legère* appears in the Pope sketchbook, dated 1798.

30. Statistics from *Steel's Original and Correct List of the Navy*, April 1794, reprinted, with additions through 1799, in Otto von Pivka, *Navies of the Napoleonic Era* (Devon and New York: David and Charles, Ltd., and Hippocrene Books, 1980), 160–71. On seniority, see Lewis, *Social History of the Navy*, 51.

31. Mary was born in 1780. Their marriage is recorded in the parish records of 1798 (no. 335, p. 112.) The Rev. James Carrington officiated, with Watson's younger sister, Maria, and Mary's father (or uncle) William Manley recorded as witnesses.

32. Joseph Farington, *The Farington Diaries*, ed. James Greig. 8 vols. (London: Hutchinson, 1922–28), 6: (1810–11), chap. 54, pp. 191–92. In 1827, when establishing her claim against her uncle's estate before the satisfaction of other creditors, Mary Watson stated that "I was not only the late Mr. Rundle's nearest relation (as niece) but was adopted by him, from the early age of eight years, he paying the expenses of my education until I was seventeen," because her parents were very poor. According to Mary, Rundle promised her a sum at marriage and an annual income thereafter, which was raised after the birth of their fourth child in 1809 to three hundred pounds per year. Mary felt sure that Watson, whose "affections were engaged to another lady, more equal in Age," would never "have thought of me," being so much younger, without the inducement of the "large fortune from my uncle." See Mary Manley Watson to General Thomas Cadwalader, 4 Feb. 1827 and 12 July 1827; Cadwalader papers; legal files, Rundle Estate; Historical Society of Pennsylvania (HSP).

33. Coates to Rundle, 10 March 1802. HSP. Watson returned to Liverpool in 1817 only a few weeks before West's painting was shipped to America. See Helmut von Erffa and Allen Staley, *The Paintings of Benjamin West* (New Haven, Conn., and London: Yale University Press, 1982), cat. no. 338.

34. See Robert Bayley to Richard Bayley, 2 May 1800; Pope coll., and Watson's "Memorandum." George and Maria's wedding is sometimes given as 1800, or as 6 March.

35. On the bread riots in Exeter in 1795 and 1800, see Rev. George Oliver, *The History of Exeter* (Exeter: R. Cullum, 1821; rev. ed. 1861), 240. Watson was living on half-pay at this time, not a grand income even with his wife's annuity from Richard Rundle (see note 32), so we may guess that he received some support from his grandmother, Mary Rundle Burges, or her daughter, Frances Green. When he returned to England after his American visit, he purchased a new house outright with money from the sale of stock. He personally packed his new cellar with "66 doz 10 bottles" of wine and "4 doz. & 10 bottles of spirits"; diary, 6 May 1818; Pope coll. Such details, along with the record of silver, jewelry, miniatures, and linen in the will of Frances Green (proved in Exeter, 28 July 1818; see Inland Revenue Wills, 583), help measure Watson's standard of living. In an era of high infant mortality and an average family size in Exeter of 4.5 persons, Watson's family of eight (not including two children lost at birth) was itself a testament to his affluence. See W. G. Hoskins, *Industry, Trade and People in Exeter 1688–1800* (Manchester: Manchester University Press, 1935; repr. University of Exeter, 1968), 129. On the upper class "rage for making tours," see Michael Clarke,

The Tempting Prospect: A Social History of English Watercolours (London: Colonnade Books, 1981), 31.

36. From Watson's diary, June 13, 1816. On Leakey's and Exeter's art world, see Part III, "Watson's Art." The attribution to Leakey is based on a description of this painting, naming the artist, in Richard Rundle's will proved in Philadelphia in 1826 (Registry of Wills, Will Book 8, no. 83, p. 591) and correspondence dealing with the estate, such as George Rundle's letter to Mary describing the "Family Picture of yourself, Watson and the dear Girls Mary and Fanny, painted by Leaky of Exeter" (George Rundle to Mary Manley Watson, 12 June 1826, Cadwalader Papers, HSP). Rundle left the painting to Watson's children, but George Rundle kept it until his death in 1859, when his will left instructions for the return of the picture (along with other family miniatures by Leakey) to the surviving children in England. Philadelphia Registry of Wills, File 278, Will 42, p. 267. The arrival of the Rundles in Philadelphia is documented in *Passenger Arrivals at the Port of Philadelphia* (Baltimore: Genealogical Publishing Co., 1986).

37. See Watson's log on the *Inflexible* 21 March 1807–4 Feb. 1808; ADM 51/1686.

38. Most of these houses were built between 1790 and 1820. In design and ambition, they are much like the home occupied by George and Maria Rundle in Philadelphia at this same moment (see Fig. 15). The Barnfield Crescent was leveled by air attacks in World War II. See Hoskins, *Exeter*, 149. Watson's view of Southernhay is in the Pope coll.

39. Lewis, *Social History of the Navy*, 64–66.

40. The chronology is from the ship's log; ADM 51/2121; the quotation is from a private diary kept on board the *Alfred*, 2 May 1810; Pope coll.

41. Log of the *Alfred*; ADM 51/2121, no. 2.

42. Diary, 1810; Pope coll.

43. "Court martial proceedings of 6 March 1810," PRO, ADM 1/5403. I am grateful to William Foot of the PRO Search Office for his interpretation of these proceedings, which he judges to have been inspired by a conflict of personalities and authority when Watson attempted to discipline the marines on his ship.

44. *Farington Diary*, vol. 6 (1810–11), chap. 54, "Captain Watson of the Navy," 191–92.

45. Diary, 1810.

46. Watson sketched the *Implacable* about this time; his drawing is in the collection of Pamela Brice. The ship survived until after World War II, one of the last of her generation.

47. Related views are in the family's collection. See discussion of these drawings in Part III, "Watson's Art."

48. On the "Great Slump" following the Napoleonic wars, see Lewis, *Social History of the Navy*, 48, 64–73. The navy's roster of ships fell from a high of 979 (1809) to 121 (1818). Ninety percent unemployment among officers persisted until 1842.

49. Watson was referred to as "Esquire" in his naval logs, a term that implies land-owning status, although this may have been just polite address. His salary as superintendent of sea fencibles off Ireland in 1806 had been £638.15.0 per year. Ten years later, allowing for seniority, his 'half-pay' (which was usually more than half) would have been about four hundred pounds annually. Although not a handsome income, it was still far more than most seamen and noncommissioned officers made full time. See Lewis, *Social History of the Navy*, 212. Watson and his sister also received a small annuity of twenty pounds as orphans of a captain.

50. Pope coll. His aunt, Catherine Watson, was still living at Ennis in this period. The Pope sketchbook contains nine other views from the Plymouth area, dated from July 1814 to April 1815.

The American Trip

51. Watson's sketchbooks and his diary hold no news for British naval intelligence; see "Watson's American Diary," below.

52. *Views and Visions: American Landscape Painting Before 1830* (Washington, D.C.: Corcoran Gallery of Art, 1986), 190.

American Family and Friends

53. Persons mentioned in this section are individually profiled in Appendix A. See also "The List of Names" below, which discusses the nature of the roster of Watson's friends at the head of his American diary.

54. Watson's wife noted in 1827 that Frances Burges (Green) had spent nine years in Philadelphia; see Mary Manley Watson to Thomas Cadwalader, 4 Feb. 1827; HSP. "Fanny" was in Philadelphia by the late spring of 1797, according to a letter from Richard Rundle Burges to Watson in Bath, 30 June 1797; Pope coll. She may have had St.-Mémin prepare her profile portrait in 1799, before returning to England to join the Rundles by 1800. See Ellen G. Miles, *Saint-Mémin and the Neoclassical Profile Portrait in America*, ed. Dru Dowdy (Washington, D.C.: National Portrait Gallery and Smithsonian Institution Press, for the Barra Foundation, 1994) no. 110, p. 258. Fanny remained attached to the Rundles and remembered them affectionately in her will (see note 35). She was herself a beneficiary of Daniel Rundle's will (proved in Philadelphia in 1797; see Register of Wills, File 171, Book X, p. 256; or "Pennsylvania Gleanings in England" [Daniel Rundle's will of 1795], *Pennsylvania Magazine of History and Biography* 29 (1905): 207–8. Richard Rundle Burges, Watson's uncle, reminded Watson in his letter of June 1797 (cited earlier) to continue sending "the weekly newspapers to our friends in America."

55. A handful of manuscripts at the Historical Society of Pennsylvania identify Daniel Rundle's many interests. Although involved in the West Indies slave trade by 1762, the Rundles owned no slaves by 1790, according to the U.S. Census of that year. Daniel belonged to the Sons of Saint George and helped found St. Peter's Church and the Pennsylvania Hospital in Philadelphia, good works that imply his activity in the city in the 1750s and sixties. By 1780 his taxable estate was assessed at $170,000, making him much more than a millionaire in today's terms; see "Effective Supply Tax Rolls, 1780," *Pennsylvania Magazine of History and Biography* 15 (1891): 201, 237, 318, 336. On his will, see note 54.

56. Daniel Rundle was listed among those "supposed to have gone to join the enemys of this state upon the frontiers," *Pennsylvania Archives* 13 (series 6, 1907): 464. He was summoned to appear before the Supreme Executive Council of the state to answer charges of willingly aiding and assisting the enemy. Rundle surrendered himself and was discharged. "Minutes of the Supreme Executive Council," *Pennsylvania Archives* 3 (series 4, 1900): 775–77, 943; 9 (1902): 444.

57. George Rundle, born before 1725 and deceased before 1790, was described as "of Devonshire" in his brother Daniel's will. No birth or baptism for George or his son Richard have been found. Another George Rundle, perhaps a son or nephew, matriculated at the University of Pennsylvania in 1761.

58. The Rundle-Watson genealogy is outlined in Alfred Rudolph Justice, *Ancestry of Jeremy Clarke of Rhode Island and Dungan Genealogy* (Philadelphia: Franklin Printing 6, 1927), 145–47. For Watson, these redundant ties were tightened by the two successive brother-sister pairs in his family that married into the Rundle-Burges clan. In the preceding generation his father, Thomas, and his father's sister, Mary, wed the cousins Mary Burges and Richard Rundle; twenty-five years later Watson and his sister Maria wed the cousins Mary Manley and George Rundle. The presence of two sets of "Uncle Richard" and "Aunt Mary" in Watson's life demonstrates the confusion in the family history caused by a proliferation of Richards, Georges, Marys, and Franceses in the eighteenth century; there may be as many as six different Richard Rundles in this period. Compounding the problem of repetitious names and transatlantic roving is the old-fashioned tendency to call respected friends, distant relatives, and in-laws "sister," "brother," "aunt," or "uncle," while using the term "friend" as a generic term for all relatives. I am indebted to Pamela Burges Watson Brice, who has energetically studied her family's history and generously donated fact and speculation to my study of this genealogical stew.

59. *Poulson's Advertiser*, 31 May 1826; from the papers of the Fairmount Park Commission. Rundle served in the First Battalion, company of Captain Charles Syng (1777), later commanded by Captain John Davis (1780), and the Second Battalion of the Philadelphia Militia, sixth company (1786). *Pennsylvania Archives* 1 (series 6, 1906): 37, 85, 87. After the war, he established himself in his uncle's "triangle trade" with the West Indies and England. By 1780, Rundle was taxed as a "gentleman" with an estate valued at $8,800 in addition to control of assets of Daniel Rundle in the amount of $84,000; 15 (series 3, 1897): 201. Later, Thomas Murgatroyd, referred to as "cousin" in Daniel Rundle's will of 1795, joined their counting house, remaining a partner until at least 1795. The partnership of Rundle and Murgatroyd appears in Philadelphia city directories at 96 North Front Street (1790, 1791) and 13 Walnut Street, six doors from the Delaware (1795). They appear as "Rundel and Miergatroyd" in the account book of George Washington, who did business with the firm while he was in Philadelphia. See *Pennsylvania Magazine of History and Biography* 30 (1907): 469. Although divisions and new alliances took place after Daniel Rundle's death in 1797, the two men kept business addresses side by side at 244 and 246 High (now Market) Street between Seventh and Eighth after 1800, maintaining a relationship bound by Richard's marriage to Thomas's sister, Mary.

60. Daniel, his brother George, and George's son Richard Rundle all owned hundreds of acres of land in Northampton County, Pa., purchased before 1776. Richard purchased another eight hundred acres in 1784 and 1793. See "Warranties of Land," *Pennsylvania Archives*, 25 (series 3, 1897): 156, 279, 283, 754, 780. Richard's several center city properties can be traced in his multiple entries in the city's real estate registers for this period.

61. On the State in Schuylkill, see plate 18 and diary entry for 13 June 1816.

62. The house at 921 Locust was given to Watson's sister in her uncle's will of 1826; Richard Rundle purchased the house for (or with) her in 1817. On these houses, see Watson's American Diary, note 5, in Appendix A.

63. From an obituary clipped from a newspaper dated 2 August 1859; bound in Thompson Westcott, *Biographies of Philadelphians*, Vol. 2, Part I, Book C, p. 122; HSP. George Rundle shared his uncle's involvement in local bridge and canal ventures, such as the Schuylkill Permanent Bridge and the Susquehanna Bridge. He supported the Pennsylvania Academy of the Fine Arts and served on a commission to build Philadelphia's insane asylum in 1841.

64. During the months of June and July covered in his diary, Watson mentions attending church only once: St. James in New York City. An Episcopal chapel in Mantua and St. Peter's downtown would have been closest to the Rundle residences, although Richard Rundle was a member of Christ Church. After returning to Exeter, Watson recorded regular church attendance in his diary.

65. Breck's diary shows that he owned portraits of Napoleon and Maria Louisa and welcomed Joseph Bonaparte in Philadelphia but also cele-

brated the return of the Bourbons; his sister, Hannah, was painted by Saint-Mémin, the favorite portraitist of the French expatriates in Philadelphia; see Miles, *Saint-Mémin and the Neoclassical Profile Portrait in America* (1994), no. 83, p. 253; and Nicholas B. Wainwright, "The Diary of Samuel Breck, 1814–1822," *Pennsylvania Magazine of History and Biography* 102 (Oct. 1978): 470–508. Wainwright's introductory biography of Breck describes some of the celebrated visitors entertained at Sweetbriar.

66. Breck had known Decatur since 1815. See "Diary of Samuel Breck," p. 487.

67. "Diary of Samuel Breck," 10 August 1816.

68. On the striking similarities between Watson and Latrobe, see Part III, "Watson's Art."

69. See Linda Bantel et al., *William Rush: American Sculptor* (Philadelphia: Pennsylvania Academy of the Fine Arts, 1982).

70. "Diary of Samuel Breck," 14 June 1817. According to Breck, "Capalano" worked in Spain while Joseph Bonaparte was king. He was active in the United States from around 1815 to 1827, mostly working on the Capitol.

Philadelphia

71. See E. P. Richardson, "The Athens of America, 1800–1825" in Russell F. Weigley, Nicholas B. Wainwright, and Edwin Wolf, eds., *Philadelphia: A 300 Year History* (New York: Norton, 1982), 208–257.

72. George Rundle owned stock in the Pennsylvania Academy, as did many of the men on Watson's list of acquaintances. Hopkinson and Vaughan were very active Academy directors.

73. J. Thomas Scharf and Thompson Westcott, *History of Philadelphia, 1609–1884*. 3 vols. (Philadelphia: L. H. Everts, 1884), 587.

74. Scharf and Westcott, *History*, 589.

75. Scharf and Westcott, *History*, 589.

Eaglesfield

76. The Warner patents were received from William Penn in 1684 and 1702. Particulars about the estate before 1867 can be gleaned from the HSP's *Printed Briefs of Title*, vol. 11, and Philadelphia Record Office Deed Book. Ken Finkel discovered among the papers of the Fairmount Park Commission an undated survey of the property ca. 1794–98, showing a barn and two unidentified buildings at the river's edge, perhaps the barn glimpsed in plate 21 and the "Castle" of the State in Schuylkill. A survey map of the property prepared 3 May 1824 for Richard Rundle by Joseph H. Siddall is owned by Alfred Borie of Wyndmoor, Pa.

77. The attribution to Parkyns comes from Cephas G. Childs' text accompanying the etching of Eaglesfield (see fig. 3) in his book *Views in Philadelphia and its environs, from original drawings taken in 1827–30* (Philadelphia: C. G. Childs, 1830). The Warner family retained land to the west of Eaglesfield; their original farmhouse stood near 45th and Westminster.

78. Deed Book EF, No. 3, 189ff. Not long after Rundle's purchase the estate was drawn by John G. Exilious, who exhibited *Eagle's Field, the Seat of Richard Rundle, esq.* (present location unknown) at the Pennsylvania Academy in 1813.

79. See *Views and Visions*, 276–77; and Eleanor M. McPeck, "George Isham Parkyns, Artist and Landscape Architect, 1749–1820," *Quarterly Journal of the Library of Congress* (July 1973), 171–82; and William H. Adams, ed., *The Eye of Thomas Jefferson* (Washington, D.C.: National Gallery of Art, 1976), 328.

80. William R. Birch, "The Life of William Russell Birch, Enamel Painter, Written by Himself . . ." (typescript, HSP), 47. According to Birch, "Mr. Rawl told me he had [the prints] in his possession." Watson knew Rawle, who was an old friend of the Rundles, so he may have seen Parkyns's views. The portfolio is at present unlocated. Birch's reference could mean that Parkyns worked for Greenleaf on Landsdowne, a neighboring estate to the north. However, this property was already well "layed out" and Greenleaf's bankruptcy in 1797 chilled any renovations. See also McPeck, "Parkyns," 176. She cites this passage in Birch's memoir to propose that Parkyns designed Woodlands, although this estate was complete before Parkyns came to America.

81. See McPeck, "Parkyns," 175–76. The prospectus was issued in 1795. All four of the prints were of the Washington area. Parkyns also executed four aquatints for William Winstanley, including a Watsonesque *Morning View upon the Schuylkill near the Commencement of the Canal*; see McPeck, "Parkyns," 177.

82. Private collection. See *Philadelphia: Three Centuries of American Art* (Philadelphia: Philadelphia Museum of Art, 1976), cat. 49.

83. *Six Designs for Improving and Embellishing Grounds* (London: J. Taylor, 1793); see *Views and Visions*, 154, and McPeck, "Parkyns," 172–73, and note 10.

84. Wainwright, "Diary of Samuel Breck," 479.

85. Possibly, Parkyns remodeled an older house on the site, adding stylish new window detailing. However, I have seen no earlier maps or views indicating a house on this spot; see note 76. The attribution to Griffith and Parkyns given by Childs in 1830 (see note 77) and the coherence of effect visible in Watson's views must remain the basis of assumptions that Eaglesfield was built afresh in 1798. The Franklin Fire Insurance Company survey of Eaglesfield made 19 Jan. 1832 describes the house as a "two-story stone mansion house with basement story rough cast," "marble water table and ashlar" exterior stairs to the basement. Much detail about material and fit-

tings of the house can be learned from this survey and a later one from 22 Nov. 1832, which describes the barn-stable complex. I am grateful to Jeffrey Cohen for bringing these documents to my attention. Such masonry construction was typical in southeastern Pennsylvania.

86. Barra Foundation sketchbook B-35A reproduces a northerly view sketched from a window in the "Breakfast Room." Watson's plan does not correctly record the fenestration that appears in his elevations.

87. Rockland, built in 1810, survives as a modest version of Eaglesfield, sharing its conservative taste, stuccoed stone construction, and parlor with four floor-to-ceiling windows that open on a riverfront veranda.

88. The importation of this form is signaled by Watson's use of words borrowed from sunny locales—"verandah" from India and "piazza" from the Mediterranean—but transformed by English speakers to refer to a roofed and colonnaded porch rather than an open public space. Common in all classes of homes in the American South wherever contact with Africa and the West Indies was made, the veranda form moved northward throughout the eighteenth century. Its growing popularity in the mid-Atlantic states among middle- and lower-class builders was met, at the turn of the next century, by the arrival of the neoclassical taste for porticoes and temple fronts. Confirmed by and merged into cosmopolitan vogue, the veranda was then accepted by even the most affluent and fashion-conscious persons. I am grateful to Henry Glassie for his conversations on the social and architectural history of the veranda.

89. From *Six Designs* of 1793, cited in McPeck, "Parkyns," 173.

90. Watson reiterated this opinion on 10 and 15 July. He recollected only that Sedgeley was built "after the plan of a Frenchman." Watson also disliked the effect at Lemon Hill, (see fig. 14), where the grounds were laid out "too much after the French manner of pleasure gardens" (9 July), but he approved heartily of Woodlands, which followed English practice (30 June; 9 July). Latrobe was not satisfied with Sedgeley either; on his opinions and the history of the house, see R. A. Lewis's essay on Thomas Birch's "Southeast View of 'Sedgeley Park,'" in *Fifty Years on Chestnut Street* (Philadelphia: Schwarz Gallery, 1993), cat. 1. As in Latrobe's watercolor (fig. 22), Eaglesfield is clearly visible in the distance of Birch's painting.

91. *Views and Visions*, 137.

92. Rundle left behind a reputation for "Honor, Integrity and usefulness, with the community at large." George Rundle to Mary Manley Watson, 12 June 1826; General Thomas Cadwalader papers; legal files; Rundle Estate, HSP. See also the obituary cited above, note 59.

93. Philadelphia record of Wills; proved 30 May 1826, includes George Rundle's estate accounts. The legal files of the Cadwalader Papers also include Rundle's estate correspondence.

94. George Rundle to Mary Manley Watson, 12 June 1826. See also Rundle and James Somers Smith to Thomas Cadwalader, 15 July 1828; HSP.

95. See caption to plate 16. The house is credited to Borie in Joseph Jackson, *The Encyclopedia of Philadelphia*, 4 vols. (Harrisburg, Pa.: National Historical Association, 1931–33), 4: 1219. Borie's 1832 insurance policy with the Franklin Fire Insurance Company, is cited earlier in note 85. The policy's plans and descriptions of the house and splendid three-story barn, both in good condition, document a value of four thousand dollars and two thousand dollars. Also from the Borie era is William Mason's etching (fig. 3), which was preceded by two drawings dated October 1829; Library Company of Philadelphia.

96. After 1834 the land was owned by an investment consortium. In this period, Augustus Kollner included Eaglesfield in two etchings from a portfolio of *American Scenery*, published in 1846; see *Opposite Fairmount* and *Country Seat near Philadelphia*; HSP. A daguerreotype of Fairmount with Eaglesfield in the distance was made by William Southgate Porter, 22 May 1848, Sipley Collection, George Eastman House, 77:503:1–8. Eventually, the parcel north of Girard Avenue was incorporated into Fairmount Park in 1869, while the southern portion of the estate was subdivided into blocks and urban housing plots. Eaglesfield survived only in the name of a street running parallel to Girard Avenue until this neighborhood was absorbed by the Philadelphia Zoo.

97. Pennsylvania Academy of the Fine Arts. A sketchbook page from Charles Bregler's Thomas Eakins Collection.

98. Ken Finkel discovered this petition, which bears forty-two signatures, among the papers of the Fairmount Park Commission. Another view of Eaglesfield by David J. Kennedy, sketched in 1869, notes that the house was demolished in 1870; HSP.

Travels in the United States

99. On the development of the American grand tour, see Bruce Robertson, "The Picturesque Traveler in America," in *Views and Visions*, 187–209. An interesting earlier comparison is the ten-month visit of William Strickland, Baronet of Boynton (1753–1834) in 1794–95. Strickland's journals, sketchbooks, and papers, now in the New-York Historical Society, cover the landscape between Albany and the Carolinas with an eye to agricultural practices. Oddly enough, his journal also stops abruptly, as does Watson's in Boston, after only two months of entries. See *Views and Visions*, 293–94, and William Strickland, *Journal of a Tour of the United States (1794–95)*, ed. J. E. Strickland (New York: New-York Historical Society, 1971).

100. On Heriot, see "Watson's Art"; and *Views and Visions*, 96. C. B. J. de Saint-Mémin did not sketch en suite, but he did make a drawing and a print ca. 1810–14 of Fulton's *Clermont* on its way to Albany; see Ellen G. Miles, *Saint-Mémin and the Neoclassical Profile Portrait in America*, 190.

101. On the development of tourism on the Hudson, see Raymond J.

O'Brien, *American Sublime: Landscape and Scenery of the Lower Hudson Valley* (New York: Columbia University Press, 1980).

102. Thanks to Lila Goff of the Minnesota Historical Society, who shared other views of St. Anthony's Falls in this period and remarked the oddness of the "Watson" view of the scene.

103. Wainwright, "Diary of Samuel Breck," 15 and 16 June 1816. All the quotations concerning the Washington trip are from this source. Breck wrote his account later, after returning to Philadelphia, which may explain why his sequence of events occasionally disagrees with the dates recorded on Watson's sketches.

Watson's American Diary

104. Current members of Watson's family have no recollection of an earlier diary. Since so many of his personal effects (including two diaries) were carefully saved by his descendants, this draft must have disappeared long ago.

105. Minutes of the State in Schuylkill, 5 Sept. 1816 and 8 May 1817; HSP.

106. Wainwright, "Diary of Samuel Breck," 488.

107. Latrobe, quoted in Edward C. Carter II, John C. Van Horne, and Charles E. Brownell, *Latrobe's View of America, 1795–1820* (New Haven, Conn.: Yale University Press, 1985), 11; on the usual attitude of British visitors, see *Views and Visions*, 40.

108. From Rundle's statement of 1818, quoted at greater length in the Epilogue.

109. A rare note on American government appears inside the cover of his first sketchbook: "35,000 souls return a member to Congress/ 70,000 Inhabitants [are] necessary [to] a state/ In Virginia 5 slaves are as 2 whites . . . [illegible]."

110. Watson's sense of history, perhaps pressed upon him by his own illness or the deaths of family members, also inspired him to jot down his "Memorandum of myself & family" at about this time.

111. References to the topics summarized in this section can be found in the index.

112. See Part I, "American Family and Friends."

113. 31 July; 3 August.

114. Exeter Diary, 9 Feb. 1818. A list of American trees appears on the inside cover of his second sketchbook.

PART II: SELECTIONS FROM WATSON'S AMERICAN SKETCHBOOKS

Note numbers in this section refer to plate numbers.

1. For other views of Cape Henlopen and Newcastle, see NY-137A, 136A, 134A. See Edward C. Carter, II, John C. Van Horne, and Charles E. Brownell, eds., *Latrobe's View of America, 1795–1820* (New Haven, Conn. and London: Yale University Press for the Maryland Historical Society), pp. 254–55.

2. All quotations in the captions, unless otherwise noted, are from Captain Watson's diary; see Appendix A. Other near-contemporary representations of the Philadelphia waterfront include a watercolor attributed to John James Barralet in 1796, "Philadelphia from Kensington," reproduced in Martin P. Snyder, *City of Independence: Views of Philadelphia Before 1800* (New York: Praeger, 1975), p. 197. This and Thomas Birch's "Penn's Treaty Tree," ca. 1800, were the first to include both tree and port. For the Birch painting, see Nicholas B. Wainwright, *Paintings and Miniatures at the Historical Society of Pennsylvania*, rev. ed. (Philadelphia: Historical Society of Pennsylvania, 1958), p. 293. Related views include "The City & Port of Philadelphia, on the River Delaware from Kensington," frontispiece in William Russell Birch, *The City of Philadelphia . . . as it appeared in the year 1800* (Springland, Pa.: W. Birch, 1800); "Philadelphia, taken from Kensington," by Samuel Seymour after Thomas Birch, frontispiece in James Mease, *The Picture of Philadelphia, Giving an Account of its Origin, Increase and Improvements in Arts, Sciences, Manufactures, Commerce and Revenue, with a Compendium View of its Societies . . .* (Philadelphia: T. Kite, 1811; reprint New York: Arno Press, 1970); and "Philadelphia from Kensington," frontispiece engraved in 1828 by J. Cone after Thomas Birch for Cephas Grier Childs, *Views in Philadelphia and its environs, from original drawings taken in 1827–30* (Philadelphia: for C. G. Childs by Clark & Fraser, 1827–1830). Although the prospect from Kensington persisted after the Treaty Tree blew down in a storm of 5 March 1810, the view from the south gained in popularity. See the aquatint of 1836: "From the Ship House in the Navy Yard looking up the river Delaware," painted by J. W. Hill, engraved, printed, and colored by J. Hill (New York: published by James E. Betts). Also see the lithograph of 1837, "View of the Launch of the U.S. Ship of War Pennsylvania./ From the Navy Yard at Philadelphia, July 18, 1837," by George Lehman, printed and published by Lehman & Duval. Both are at the Library of Congress.

3. Peter Cooper's painting is at the Library Company of Philadelphia; the large Scull and Heap panorama is at the Historical Society of Pennsylvania; see Edwin Wolf 2nd and Marie Korey, *Quarter of a Millennium: The Library Company, 1731–1981* (Philadelphia: Library Company of Philadelphia, 1981), p. 138 and Sewell et al., *Philadelphia: Three Centuries*

of *American Art* (Philadelphia: Philadelphia Museum of Art, 1976), pp. 56–59. The Delaware ferries are described in Joseph Jackson, *Encyclopedia of Philadelphia* (Harrisburg, Pa.: National Historical Association, 1931–33), 3: 648–51.

4. *Columbian Magazine*, May 1789, pp. 282–83. Two engravings of this site appeared in that publication: "An East View of Gray's Ferry, on the River Schuylkill" by Charles Willson Peale, engraved by J.T. [James Trenchard] in the issue of August 1787 and, by the same artists, "An East View of Gray's Ferry near Philadelphia; with the Triumphal Arches & c. erected for the Reception of General Washington, April 20th. 1789" in the issue of May 1789. See Snyder, *City of Independence*, pp. 149, 150, 152. Snyder also reproduces James Peller Malcom's watercolor of 1792, "View of Philada. from the Hill above Gray's Ferry," pp. 170–71.

5. James Peller Malcom also made a watercolor in 1792: "Woodlands the seat of W. Hamilton Esqr. from the Bridge at Gray's Ferry"; see Snyder, *City of Independence*, pp. 170–71. William Groombridge painted it in 1793 (Santa Barbara Museum of Art, Preston Morton Collection). William Birch included the house in his *Country Seats of the United States* (Springland, Pa.: Designed and Published by W. Birch, 1808); see Richard J. Webster, *Philadelphia Preserved: Catalog of the Historic American Buildings Survey*, 2nd ed. (Philadelphia: Temple University Press, 1981), p. 195; and Richard J. Betts, "The Woodlands," *Winterthur Portfolio* 14, no. 3 (Autumn 1979): 213–34.

6. Letter in the Historical Society of Pennsylvania, "Woodlands," Miscellaneous Collection, [June 15, 1788] by a woman, L.G., reprinted in Betts, "The Woodlands."

7. On the genesis of the Childs engraving of 1827, see Part III, "Prints After Watson's Work" (figs. 47–49). This image reappeared in a wood engraving, probably by George Gilbert, entitled "View of the Schuylkill, from the Old Water-Works," published in Samuel C. Atkinson, *Casket or Flowers of Literature, Wit and Sentiment* (February 1828), opposite p. 75. See Sewell et al., *Philadelphia: Three Centuries of American Art*, pp. 239–40; Edward J. Nygren with Bruce Robertson, *Views and Visions: American Landscapes Before 1830* (Washington, D.C.: Corcoran Gallery of Art, 1986), pp. 100–101. For a discussion of the Childs *Views*, see also *The Annual Report of the Library Company of Philadelphia for the year 1987* (Philadelphia: Library Company of Philadelphia, 1988), pp. 29–34.

8. Mease, *Picture of Philadelphia*, p. 347; [Samuel Hazard], *Facts in relation to the progressive increase, present condition, and future prospects of Philadelphia* (Philadelphia: J. Sharp, 1838), p. 13.

9. Thomas Birch's engraving was published in *The Portfolio* 8, 6 (December 1812), opposite page 643: "N. W. View of Mr. Paul Beck's Shot Tower near the Schuylkill."

10. For a general account of the houses along the river, see Marion Willis Martin Rivinus, *Lights Along the Delaware* (Philadelphia: Dorrance, 1965).

11. Mease, *Picture of Philadelphia*, pp. 351–52. A reproduction of number 73 of Charles Alexandre Lesueur's sketches at the Société Géologique de Normandie, Musée d'Histoire Naturelle is on file at the American Philosophical Society in Philadelphia. See R. W. G. Vail, "The American Sketchbooks of a French Naturalist, 1816–1837," *Proceedings of the American Philosophical Society* n.s. 48 (20 April–19 October 1938). Also see the lithograph printed and published in 1838 by J. T. Bowen, "A View of the Fairmount Waterworks with Schuylkill in the Distance Taken from the Mount," in Nicholas B. Wainwright, *Philadelphia in the Romantic Age of Lithography* (Philadelphia: Historical Society of Pennsylvania, 1958), #8, pp. 95, 97.

12. William Birch included Sedgeley in his *Country Seats of the United States*, as did Childs in *Views in Philadelphia and its environs*.

13. "The Diary of Samuel Breck, 1814–1822," *Pennsylvania Magazine of History and Biography* 102, 4 (October 1978): 485–86. For other views, see "The Solitude near Philadelphia," engraved by William Byrne after R. F. Pine, in John Penn, *Poems* (London: W. Bulmer and Co., 1801), opposite p. 38, and Birch, *The Country Seats of the United States*.

14. For another view, see B-109AB.

15. See Part I, "Eaglesfield," for a fuller discussion of Parkyns, the house, and the estate. A copy of John Soane's *Sketches in Architecture* (London: For John Taylor, 1978), with Parkyns's *Six Designs* as an addendum was on the shelves of the Library Company of Philadelphia by 1800. The Historical Society of Pennsylvania's painting by William Groombridge, often identified as a Schuylkill River view, is the earliest image of Eaglesfield (see fig. 42). It was purchased by the Society July 28, 1913; no earlier provenance is known. I identified the subject as Eaglesfield based on visual evidence of the house and its setting.

16. Sidney George Fisher's diary was edited by Nicholas B. Wainwright, *A Philadelphia Perspective: The Diary of Sidney George Fisher covering the years 1834–1871* (Philadelphia: Historical Society of Pennsylvania, 1967). One of the last images of the house while a hotel is entitled "Ice Houses on the Schuylkill" (fig. 24), located under "Schuylkill" in the large boxes of the Penrose Collection at the Historical Society of Pennsylvania. The Mutual Assurance Company's surveys of Eaglesfield, house, stable, carriage house, and dairy house (policy numbers 3650, 3651; survey numbers 2251, 2252) were kindly located by Carol Wojtowicz Smith. The "Petition to Preserve Eaglesfield Mansion," dated 3 July 1869 and presented "To the Park Commission of Philadelphia," was brought to my attention by Amy Freitag of the Fairmount Park Commission.

17. The site of The Cliffs was proposed in 1911 for a new Convention Hall: see newspaper clippings in the Campbell Collection, vol. 24, p. 125; a

watercolor by David Johnson Kennedy, after William L. Breton (KII-6); and a watercolor by William G. Mason (Bc61 M412), all in the Historical Society of Pennsylvania. The house stood empty after 1968 and burned February 22, 1986; only the ruins of its charred walls remain.

18. See Wainwright, *The Schuylkill Fishing Company of the State in Schuylkill 1732–1982* (Philadelphia: The Company, 1982).

19. The "Survey of Richard Rundle's House," among the Mutual Assurance Company's surveys of Eaglesfield, includes a description, dated May 1815, of the dairy house (policy number 3650; survey number 2251).

21. Watson's Eaglesfield watercolors were done during two stays, at the beginning and at the end of his American tour. For a discussion of these views, see Part III, "Watson's Art."

22. Accounts of the freshet in 1853, see Charles A. Poulson Scrapbook at the Library Company of Philadelphia, 2526.F, vol. 7, p. 117.

23. William Birch included Landsdowne in *Country Seats of the United States*. A photograph that seems to be "the Hut" was made by Robert Newell, ca. 1870: "Oldest House in Landsdown, Philadelphia Park," Library Company of Philadelphia, P. 9062.63a (Brenner).

24. "The Diary of Samuel Breck, 1814–1822," pp. 503–4; Richard Peters, *A Discourse on Agriculture* (Philadelphia: Johnson and Warner, 1816).

25. Keyser, *Fairmount Park and the International Exhibition at Philadelphia* (Philadelphia: Claxton, Remsen, and Haffelfinger, 1876), pp. 77–78; Vaux, "Extracts from the Diary of Hannah Callender," *Pennsylvania Magazine of History and Biography* 12 (1888): 454–55. A related watercolor of Belmont, $7\frac{1}{2}'' \times 13\frac{1}{2}''$, signed "J.R.W.," is owned by Ralph F. Peters. See *Belmont Mansion: Historic Structures Report*, prepared for the Fairmount Park Commission by Martin Jay Rosenblum, R.A. & Associates, January 1992.

26. For Robert Kenedy, see Charles V. Hagner, *Early History of the Falls of Schuylkill, Manayunk . . .* (Philadelphia: Claxton, Remsen, and Haffelfinger, 1869), pp. 39–41.

27. See Campbell Collection at the Historical Society of Pennsylvania, vol. 81, which contains an article on steamers on the Schuylkill River published in the *Philadelphia Record*, 11 September 1916.

28. See Hagner, *Early History of the Falls of Schuylkill*, pp. 22–30.

29. Benjamin Henry Latrobe made a similar view of East Falls seventeen years earlier: Carter, Van Horne, and Brownell, *Latrobe's View of America*, pp. 232–33. Also see Charles Peterson, "The Spider Bridge, a Curious Work at the Falls of the Schuylkill, 1816," *Canal History and Technology Proceedings* 5 (22 March 1986): 243–62; Joseph Neef, *Sketch of a Plan and Method of Education founded on an Analysis of the Human Faculties and Natural Reason, suitable for the Offspring of a Free People* (Philadelphia: For the author, 1808).

30. Mease, *Picture of Philadelphia*, p. 352; the Duke de la Rochfoucauld Liencourt's account appears in the *Germantown Independent Gazette,*

7 July 1911. See clippings in the Historical Society of Pennsylvania, Campbell Collection, vol. 101.

31. Mease, *Picture of Philadelphia*, p. 352; Jackson, *Encyclopedia of Philadelphia*, 3: 1201.

32. See the lithograph: "Railroad Depot at Philadelphia," printed by Kennedy & Lucas, 1832. Copies at the Historical Society of Pennsylvania and the Library Company of Philadelphia, reproduced in Wainwright, *Philadelphia in the Romantic Age of Lithography*, no. 305. The *Second Annual Report of the Commissioners of Fairmount Park* (Philadelphia: King and Baird, Printers, 1870) contains a detailed "Map of the survey of Wissahickon Creek from its mouth to Paul's Mill Road."

33. John Holmes' poem of 1696, "True Relation of the Flourishing State of Pennsylvania," is reproduced in T. A. Daly, *The Wissahickon* (Philadelphia: Garden Club of Philadelphia, 1922), p. 22. Also see Susan Oyama, *Walk on the Wild Side: The Wissahickon Creek, 1800–1840, An Exhibition at the Library Company of Philadelphia, October 18, 1993–March 18, 1994* (Philadelphia: Library Company of Philadelphia, 1993); Horatio Gates Jones, "Historical Sketch of the Rittenhouse Paper-Mill," *Pennsylvania Magazine of History and Biography* 20, 22 (1896): 315–33; and Horace Lyman Weeks, *History of Paper-Manufacturing in the United States, 1690–1918* (New York: Lockwood Trade Journal Co., 1916). The first Rittenhouse mill was destroyed in a flood not long after 1700 and the site stayed in family hands until it was acquired by Fairmount Park in 1868.

35. Daniel Bowen, *A History of Philadelphia with a notice of villages in the vicinity* (Philadelphia: Daniel Bowen, 1839), p. 134.

36. Hagner, *Early History of the Falls of Schuylkill*, p. 81.

37. Hagner, *Early History of the Falls of Schuylkill*, pp. 72–73. For another view of the Flat Rock Bridge, from downstream, see B-90A; from the west bank, B-79AB.

38. Mease, *Picture of Philadelphia*, pp. 352–53.

39. Francis Bazley Lee, *History of Trenton New Jersey* (New York: Publishing Society of New Jersey, 1895). A quick pen sketch of Point Breeze and Bordentown from the river, NY-114A.

40. Two quicker, more distant views of the bridge and town, NY-111A.

41. Richard Beale Davis, *Jeffersonian America: Notes on the United States of America Collected in the Years 1805–6–7 and 11–12 by Sir Augustus John Foster, Bart.* (San Marino, Ca.: Huntington Library, 1954; reprint Westport, Conn.: Greenwood Press, 1980), p. 278; NY-108AB; other sketches of Raritan, Perth Amboy, and Staten Island, NY-107A, 105A, 104A.

42. Francis Bazley Lee, *New Jersey: As a Colony and as a State* (New York: Publishing Society of New Jersey, 1892), pp. 324–26; Charles Leonard Lundin, *Cockpit of the Revolution: The War for Independence in New Jersey* (Princeton, N.J.: Princeton University Press, 1940), p. 415.

43. William Cullen Bryant, *Picturesque America or the Land We Live*

In (New York: D. Appleton and Co., 1841), p. 545; Horation Gates Spafford, *Gazetteer of the State of New York* (Albany: H. C. Southwick, 1813), p. 53; Adam Hodgson, *Letters from North America, Written During a Tour of the United States and Canada* (London: Geoge Smith, 1824), p. 109. See NY-8AB (Long Island, Blackwell's Island), NY-9AB (Long Island, Battery, Hell Gates), NY-10A (Gates, East River); other views of New York Harbor: NY-99A (Narrows, Ft. Richmond), NY-94AB (Governor's Island).

44. Other views of Palisades: NY-90A (Palisades highlands with steamer), NY-97 (see fig. 63), 89A, 87A, 86A.

45. *Nelson's Illustrated Guide to the Hudson and its Tributaries* (New York: T. Nelson and Sons, 1860), pp. 18–19; Raymond J. O'Brien, *American Sublime: Landscape and Scenery of the Lower Hudson Valley* (New York: Columbia University Press, 1980), p. 247.

46. Paul Wilstach, *Hudson River Landings* (Indianapolis: Bobbs-Merrill, 1933), p. 215; Watson also sketched the view downstream from Nyack, along the Palisades to New York: NY-84AB, 83AB.

47. For other sketches between Stony Point, West Point, and Peekskill, see NY-81A, 80AB, 79AB, 77A, 76A.

50. Wilstach, *Hudson River Landings*, p. 248.

52. Jacques Gerard Milbert, *Picturesque Itinerary of the Hudson River and the Peripheral Parts of North America*, translated from the French and annotated by Constance D. Sherman (Ridgewood, N.J.: Gregg Press, 1968), pp. 40–42. See also NY-72–60 (related sketches); NY-57A, 56AB (other views of Albany).

53. Lossing, *The Hudson, from the Wilderness to the Sea* (Troy, N.Y.: H. B. Nims, 1866), pp. 113–15.

54. Milbert, *Picturesque Itinerary of the Hudson River*, p. 46; see also NY-51A, 49A (related views).

55. Milbert, *Picturesque Itinerary of the Hudson River*, p. 48; Spafford, *Gazetteer of the State of New York*, p. 112; see also NY-45AB (Northumberland and Fort Miller bridge).

56. Spafford, *Gazetteer of the State of New York*, 219; William Guy Wall, "Baker's Falls," in John K. Howat, *The Hudson River and Its Painters* (New York: Viking, 1972; Penguin Books, 1978), plate 93. Wall's watercolor for the *Hudson River Portfolio*, plate 8 shows mills at the falls. Wall's plate 7 in the same portfolio (Howat, plate 94) shows the rapids at Sandy Hill seen in Watson's NY-43AB. See also NY-43AB (Kingsbury bridge and rapids) and NY-39A (fig. 66) for view of mill buildings carefully avoided in NY-42.

57. Milbert, *Picturesque Itinerary of the Hudson River*, p. 62.

58. Milbert, *Picturesque Itinerary of the Hudson River*, p. 67. See William Guy Wall, "Glens Falls," plate 6 of the *Hudson River Portfolio*, for a complete view of the bridge and the toll house (Howat, *Hudson River and Its Painters*, plate 95). On his return to Glens Falls on 30 July, Watson sketched the falls adjacent to the sawmills; see NY-38AB (fig. 67), 30B.

59. See also NY-40B (fig. 66).

60. Milbert, *Picturesque Itinerary of the Hudson River*, p. 72n.

61. Spafford, *Gazetteer of the State of New York*, p. 24. See also NY-28AB (fig. 32).

62. Valentine Seaman, *Dissertation of the Mineral Waters of Saratoga* (New York: Collins and Perkins, 1809; orig. ed. 1793); Milbert, *Picturesque Itinerary of the Hudson River*, p. 50.

63. Seaman, *Dissertation of the Mineral Waters of Saratoga*, p. 79; Milbert, *Picturesque Itinerary of the Hudson River*, p. 87.

66. Walter Muir Whitehill, *Boston: A Topographical History* (Cambridge, Mass.: Belknap Press of Harvard University Press, 1959), pp. 3, 47, 75, 76.

67. Whitehill, *Boston: A Topographical History*, p. 86.

68. Whitehill, *Boston: A Topographical History*, pp. 79, 82. For Watson's sketches of the *Independence*, see NY-17B, 16A.

69. Whitehill, *Boston: A Topographical History*, p. 78; Milbert, *Picturesque Itinerary of the Hudson River*, pp. 207–8.

70. See also NY-13AB (fig. 27); Milbert, *Picturesque Itinerary of the Hudson River*, p. 251; John C. Pease and John M. Niles, *Gazetteer of the States of Connecticut and Rhode-Island* (Hartford: William S. Marsh, 1819), p. 100.

71. Milbert, *Picturesque Itinerary of the Hudson River*, p. 252.

72. Carter, Van Horne, and Brownell, *Latrobe's View of America*, pp. 160, 167; Frances Jean, Marquis de Chastellux, *Travels in North America: In the Years 1780, 1781, and 1782*, trans. and ed. Howard C. Rice, Jr., 2 vols. (Chapel Hill: University of North Carolina Press, for the Institute of Early American History and Culture at Williamsburg, Va., 1963), vol. 1; Frederick Marryat, *Diary in America with Remarks on its Institutions*, ed. Sidney Jackman (New York: Knopf, 1962), pp. 52–53. See also other Passaic views, NY-7AB, 6AB, 4AB (fig. 28), 3AB.

73. I. N. Stokes, *The Iconography of Manhattan Island, 1498–1909*, 5 vols. (New York: Robert H. Dodd, 1915–28; reprint Arno, 1967), 5: 1425, 1451–52, 1587; 3: 877.

74. "The Diary of Samuel Breck, 1814–1822," pp. 487, 488; *A Complete Historical, Chronological, and Geographical American Atlas* (Philadelphia: H. C. Carey and I, Lea, 1822), "No. 20 Maryland."

75. Breck recorded his 14 June 1816 visit to the Capital (see "The Diary of Samuel Breck, 1814–1822," p. 483), during which he met Latrobe and Lane. The following year, Breck and Watson met William Thornton at the patent office. Thornton's designs for the Capitol had won the Federal competition in the 1790s, but it was Latrobe's new and revised plans that were now being followed. Thornton was "excessively civil" to Breck and Watson and may well have shared Latrobe's plans with them. Jeffrey Cohen pointed out that Latrobe's was the source for Watson's drawing. For the compromise where the site of Washington was selected, see Constance McLaughlin

Green, *Washington: Village and Capital, 1800–1878* (Princeton, N.J.: Princeton University Press, 1962), p. 8.

76. Green, *Washington: Village and Capital*, pp. 3–7, 14–16, 32, 39. A half-finished but working Capitol constructed under Latrobe's direction but based on the designs of William Thornton was burned in 1814. Latrobe returned to supervise the second building campaign, from 1815 to 1817, with his own revisions. See Latrobe's own sketch of 1813, from north of Pennsylvania Avenue in Edward, Van Horne, and Brownell, *Latrobe's View of America*, no. 119, p. 297.

77. "The Diary of Samuel Breck, 1814–1822," p. 487; James N. Goode, *Capital Losses: A Cultural History of Washington's Destroyed Buildings* (Washington, D.C.: Smithsonian Institution Press), p. 293. Thanks to Henry H. Glassie Sr. for his advice on this view.

78. "The Diary of Samuel Breck, 1814–1822," p. 487; Paul Wilstach, *Mount Vernon: Washington's Home and the Nation's Shrine* (Garden City, N.Y.: Doubleday, Page & Co., 1916), pp. 254–63.

79. See also Watson, B-60AB (looking up the Potomac River from Mt. Vernon); Peter Cunningham, *London in 1853* (London: Murray's Modern London, 1853); Mount Vernon Ladies Association, *An Appeal for the Future Preservation of the Home and Grave of Washington* (Philadelphia: T. K. and P. G. Collins, 1855).

80. For more on Joshua Shaw see Part III, "Prints After Watson's Work."

81. Wilhelmus Bogart Bryan, *A History of the Nation's Capital* (New York: Macmillan, 1914), 1: 491; 2: 4.

82. "The Diary of Samuel Breck, 1814–1822," p. 488.

83. Svinin's watercolor, "A Ferry Scene on the Susquehanna River at Wright's Ferry, just above Havre de Grace" is at the Metropolitan Museum of Art. See also an aquatint by T. Cartwright after George Beck, "Wright's Ferry on the Susquehanna, Pennsylvania," ca. 1808 (New York Public Library). The "Cryts Creek" in Watson's legend is identified in Latrobe's survey of the Susquehanna (1801–2) as "Kreutz' Creek"; see Roger B. Stein, *Susquehanna: Images of the Settled Landscape* (Binghamton, N.Y.: Roberson Center for the Arts and Sciences, 1981); fig 24, 12; Joshua Gilpin, "Journal of a Tour from Philadelphia through the Western Counties of Pennsylvania in the months of September and October, 1809," *Pennsylvania Magazine of History and Biography* 50 (1926): 75; H. M. J. Klein, ed., *Lancaster County Pennsylvania: A History* (New York and Chicago: Lewis Historical Publishing, 1924), 1: 309.

84. When Watson visited, there were two grist mills and two tanneries. The town was between newspapers. The *Susquehanna Waterman* had folded in 1815 after only five years; a second, *The Columbian*, would begin publication in 1819; Carl Carmer, *The Susquehanna* (New York: Rinehart, 1955), pp. 198, 207, 442.

85. J. Lee Hartman, "Pennsylvania's Grand Plan of Post-Revolutionary Internal Improvement," *Pennsylvania Magazine of History and Biography* 65 (1941): 449; Jonathan Williams Condy, *A Description of the River Susquehanna, with observations of the Present State of its Trade and Navigation, and their practical and probable improvement* (Philadelphia: Zachariah Poulson, Jr., 1796), pp. 21, 32; 21, 32; Turner Camac, *Facts and Arguments respecting the great utility of an extensive plan of Inland Navigation in America* (Philadelphia: William Duane, 1805), pp. 8, 12; Carter, Van Horne, and Brownell, *Latrobe's View of America*, pp. 190, 194.

86. Gilpin, *Pleasure and Business in Western Pennsylvania*, p. 76.

87. Condy, *Description of the River Susquehanna*, pp. 18–19; "The Diary of Samuel Breck, 1814–1822," p. 488. See plates 88–90, B-47A.

88. Russell F. Weigley et al., *Philadelphia: A 300 Year History* (New York and London: W.W. Norton for The Barra Foundation, 1982), p. 266.

89. William Strickland, *Reports on Canals, Railways, Roads and other Subjects* (Philadelphia: H. C. Carey and I. Lea, 1826); Klein, *Lancaster County, Pennsylvania*, 1: 308.

90. See B-47A (Chickies Rock); "The Diary of Samuel Breck, 1814–1822," p. 488.

PART III: WATSON'S ART

Inventing a Personal Style in Watercolors

1. On Watson's childhood training, see Part I, "Raised in the Navy, 1772–1790." I have discovered no general text on the subject of military drawing, perhaps because it is so difficult to isolate from the eighteenth-century mainstream; a survey of this tradition, with examples from North America, can be gained from Bruce Robertson, "Venit, Vidit, Depinixit, the Military Artist in America," in *Views and Visions: American Landscape Painting Before 1830* (Washington, D.C.: Corcoran Gallery of Art, 1986), 83–102. As Robertson admits (102), the records of the Royal Military Academy at Woolwich do not describe the drawing curriculum in any detail. Paul Sandby's teaching can be deduced from the experience of Watson's exemplar, William Payne (see figs. 36 and 37) who was also trained in the "Drawing Room" of the Ordnance Board; see David Japes, *William Payne: A Plymouth Experience* (Exeter, Devon: Royal Albert Memorial Museum, 1992), pp. 6–9; and W. A. Seymour, ed., *A History of the Ordnance Survey* (London: W. Dawson, 1980). See also Martin Hardie's classic three-volume study *Water-colour Painting in England* (London and New York: Barnes and Noble, 1966–68) or monographic works on influential painters and teachers such as Paul Sandby. The blend of military (scientific) and artistic impulses in Watson can also be understood as part of the epistemology of topographical drawing in this period; see Barbara Maria Stafford, *Art, Science, Nature, and the Illustrated Travel Account, 1760–1840* (Cambridge, Mass. and

London: MIT Press, 1984). On the braided influence of artists, drawing masters, printmakers, topographers, amateurs, tourists, and literary figures, see Michael Clarke, *The Tempting Prospect: A Social History of English Watercolours* (London: Colonnade Books, 1981).

2. 16 June 1810; Pope collection.

3. All Watson's known profiles are in his family's custody; they include views of the coasts of Spain, France, Italy, and the Mediterranean islands he visited in 1811–12. Although this was a period when the eastern Mediterranean was being systematically surveyed by the Admirality, the Hydrographic Department of the Navy contains no Mediterranean coastal profiles signed or ascribed to Watson. However, the collection's curator, D. Mann, who kindly searched the records, noted that many views are unsigned and most are cataloged by subject, according to their original purpose. The coastal survey was generally made in conjunction with other hydrographic charts by specialists whose work was rapidly professionalized during the period of the Napoleonic wars, when accurate charts were in demand. See George S. Ritchie, *The Admiralty Chart: British Naval Hydrography in the Nineteenth Century* (New York: American Elsevier, 1967) and Adrian H. W. Robinson, *Marine Cartography in Britain: A History of the Sea Chart to 1855* (Leicester: University of Leicester Press, 1962). The king of North American hydrography in Watson's era was J. F. W. des Barres (1722–1824), whose charts Watson surely knew; des Barres' rare coastal views, from a generation earlier than Watson, show a distant relationship to Watson's work. See G. N. D. Evans, *Uncommon Obdurate: The Several Public Careers of J. F. W. des Barres* (Salem, Mass. and Toronto: Peabody Museum and University of Toronto Press, 1969).

4. See, for example, Towne's *Coniston Lake, Lancashire*, 1786, Yale Center for British Art, reproduced in Louis Hawes, *Presences of Nature: British Landscape, 1780–1830* (New Haven, Conn.: Yale Center for British Art, 1982), 117; or *A Panoramic View of Plymouth*, Museum of Art, Rhode Island School of Design, reproduced in *Selection II: British Watercolors and Drawings from the Museum's Collection* (Providence: Rhode Island School of Design, 1972), no. 15. Vanderlyn's panorama is at the Metropolitan Museum of Art.

5. Breck praised Watson's work in his diary; see Nicholas Wainwright, "The Diary of Samuel Breck, 1814–1822," *Pennsylvania Magazine of History and Biography* 102 (October 1978): 469–508; see 18 Sept. and 19 Oct. 1816; and 14 June 1817. Farington's remarks are cited below, note 27.

6. On Heriot, see *Views and Visions*, 266–67.

7. "Any cadet with artistic talent and ambition studied with private drawing masters." Robertson, "Venit, vidit," 91. As a result, he notes the vagueness of Sandby's influence on his students at Woolwich.

8. Robertson, "Venit, vidit," 91. Watson occasionally evoked Sandby's characteristic tunnel composition, as in his *View down a country road*

near Plymouth, from the Pope Sketchbook, or *View down a road, near Eaglesfield*, 27 Sept. 1816, Barra 84A.

9. On the Peales, see "The American Context" below. On Davies (ca. 1737–1812), see *Views and Visions*, 249–51; and R. H. Hubbard and C. P. Stacey, *Thomas Davies* (Ottawa: National Gallery of Canada, 1972). Davies's portfolio of six prints, published from his watercolors in 1768, featured North American waterfalls. If Watson was not aware of these prints, their emphasis nonetheless shaped the iconography of America, directing his attention to the same or similar views.

10. The term "neutral tint" was used widely in the drawing manuals of this period to describe a grayish wash mixed by the artist or made from a composite pigment cake marketed for this purpose, for example, "Payne's grey." Watson used several base tints, usually watered black, blue, or brown. Marjorie B. Cohn describes the development of this tint and its modification into cool and warm values (as in Watson's work) about 1800, in *Wash and Gouache: A Study of the Development of the Materials of Watercolor* (Cambridge, Mass.: Fogg Art Museum, 1977), 41–42.

11. Because these pencil sketches are pale and sometimes abraded, they are difficult to reproduce. An early example, *View from Eaglesfield near Philadelphia/ 14th. September 1816* (B-109AB), depicts the view down the Schuylkill to Fairmount, also seen in plate 14 and color plate 4). The same view in "neutral tint" only appears on the facing page (B-109B).

12. Americans were slow to appreciate outdoor sketching in watercolors, although British colormakers fielded a variety of portable equipment by mid-century. The development of watercolor materials is well described in Cohn, *Wash and Gouache*. The shift in American attitudes, directly related to the formation of the American Watercolor Society in 1867, is traced in my doctoral thesis, "Makers of the American Watercolor Movement: 1860–1890," Yale University, 1982.

13. See 18 June, evidently in reference to views made on the 13th (plate 14, color plate 4) and 16th (plate 24, color plate 6); 22 June, 27 June. Except on these occasions, it is impossible to know how far apart the two phases of drawing and coloring came. The date given on the page always seems to be the moment of the initial sketch.

14. Wainwright, "Diary of Samuel Breck," 486.

15. His early sketchbook contains memoranda interspersed among sketches dating from 1793–96: "For a very fine green take verdigrise and boil it with Argle [Agol, or Tartar] and Water in a Pipkin," he notes. (As Cohn remarks in *Wash and Gouache*, 42, unstable greens were a problem for watercolorists until the late nineteenth century; Watson, for his part, used greens rarely.) "To use Carmine add four drops of Hartshorn of Salmoniack [sal ammoniac; ammonium chloride] as soon as the Carmine is extracted or the Colour diluted add water," Watson wrote, and then added a chemist's address in South Hampton where carmine could be purchased. More

suspicious is a recipe for "Asphaltum diluted in turpentine" to "pen in your drawings with." He also noted the use of an ox-gall solution on the paper, before "shading," to cover greasy spots in the paper or admit oil colors into the work along with watercolor. Watson's entire palette in 1816 included no more than nine colors, including the sepia, indigo, and black mentioned earlier. Although no chemical analysis has been done of his pigments, it appears that he also had a transparent yellow (gamboge?), a naturally opaque ochre, burnt sienna (?), brown-pink (?), green, and a transparent red (probably madder or the carmine mentioned above.) Although his color became more complex in his larger finished work, the sketchbook pages preserve his palette better than the "exhibition" pieces, which seem to have lost some of their color to sunlight. All of Watson's organic pigments were fugitive (indigo, carmine, madder, gamboge).

16. Most of these watercolors are in the possession of Watson's descendants; I have not examined or photographed them all, so some are speculatively attributed to a Payne source based on size and title alone. From 36 to 38 items seem to be after Payne's work in the Swete albums (see note 18). Only one of Payne's views is dated (*Maristow*); Watson's copy of this subject shows "JRW/1803" substituted on the sail of a boat where Payne had painted "WP/1793." Although Payne occasionally signed these works, no signatures appear in the copies. An additional 5 watercolors of the same size and general character may be from other sources in Swete's collection, or other collections of Payne's work. Two slightly larger watercolors (*Cleve Cottage* and *Powderham*, dated 1802, each ca. $5\frac{1}{2} \times 7\frac{1}{2}$"), also may be from this series of copies.

17. Very popular in his day, Payne's reputation fell in the nineteenth century and little has been known (and much misinformation repeated) about his career until the publication of David Japes, *William Payne: A Plymouth Experience* (Exeter: Royal Albert Memorial Museum, 1992).

18. In 1790 Swete crowed over the acquisition of a group of Payne's views, "reduced" for inclusion in his albums; by this time he owned at least a dozen items by Payne; see Japes, *William Payne: A Plymouth Experience*, rear cover and p. 20. On Swete, see Sir Leslie Stephen and Sir Sidney Lee, eds., *The Dictionary of National Biography* (Oxford: Oxford University Press, 1917), 19: 200. Swete's albums remained in his family until the twentieth century; they are now in the custody of the West Country Studies Library in Exeter. All 87 views appear in Peter J. Hunt, *Payne's Devon: A Portrait of the County from 1790 to 1830 through the Watercolours of William Payne*, (Exeter and Newton Abbott: Devon Books, 1986). Passages from Swete's diaries have been published in Peter J. Hunt, ed., *Devon's Age of Elegance: described by the diaries of Rev. John Swete [and others]*, (Exeter and Newton Abbott: Devon Books, 1984).

19. Joseph Farington, *The Farington Diaries*, ed. James Grieg, 8 vols. (London: Hutchinson, 1922–28), 5: 254, September 23, 1809. Additional evidence that Watson worked from Payne's watercolors while they were mounted in Swete's album rises from the pattern of items chosen to copy: he painted almost three-quarters of the views in vol. I, skipping over routine estate portraits and views of places close to (and including) Oxton House; in volume II he copied eleven of the first thirteen views and then stopped. Japes lists the contents of these two volumes in *William Payne: A Plymouth Experience*, Appendix V. Watson kept these watercolors in albums of his own, to judge from the evidence of earlier mounting on the versos; the will of Mary Watson Bayley (dated 1871; Pope coll.) also describes her father's "book of Devonshire views."

20. See Hoskins, *Industry, Trade and People in Exeter, 1688–1800* (Manchester: Manchester University Press, 1935; repr. University of Exeter, 1968), and *Two Thousand Years in Exeter* (Exeter: James Townsend and Sons, 1960).

21. I am indebted to Samuel A. Smiles for sharing a copy of his thesis, "Plymouth and Exeter as Centres of Art: 1820–1865" (doctoral dissertation, Cambridge University, ca. 1982). His chapter three, "Development of Art Institutions in Devon," outlines the first years of the two art organizations. Smiles notes that the bombing of local libraries and archives during World War II has impeded research on the founding of these institutions, for the earliest extant catalogs are from after Watson's death. Watson's residence in Plymouth prior to his American trip is particularly tantalizing, because of the greater energy of its artistic community and its stronger ties to London. See Smiles, 20–25.

22. Devon and the west country were a last frontier for adventuring English painters, especially during the Napoleonic wars, when much of the continent was off limits. On this period in Devon's art, see Trevor Fawcett, *The Rise of English Provincial Art* (Oxford: Oxford University Press, 1974), 187–91; and Smiles, Chapter 2, "The Social and Aesthetic Background," especially p. 24 and notes 47, 48.

23. On Leakey, see Smiles, 238–39, and many references passim.

24. Orias Humphrey, in Adrian Bury, *Francis Towne, Lone Star of Water-colour Painting* (London: C. S. Skilton, 1962), 101; see Smiles, "Plymouth and Exeter," 41. Towne seems to have been resident in Exeter from 1769 to 1780 and from 1795 to 1800, in addition to briefer visits. After his death in London he was buried near Exeter, in Heavitree churchyard, a spot Watson visited regularly. By the early 1820s Exeter claimed only six resident artists and Plymouth, five; Smiles, 104. The painters of Watson's era in Devon were also late-bloomers on the national scene; most did not exhibit at the Royal Academy until after 1814.

25. Although published in 1798, Gilpin's book was based on a tour made in 1775. Payne's work in the 1780s was thus in advance of widespread appreciation of Devon's scenery, although the example of Gilpin's earlier

tours and publications must have encouraged Payne's work. On Gilpin's influence on taste, see Graham Reynolds, *Concise History of Watercolors* (New York: Abrams, 1971), 71; and Malcolm Andrews, *The Search for the Picturesque: Landscape Aesthetics and Tourism in Britain, 1760–1800* (Stanford, Ca.: Stanford University Press, 1989). Andrews' account does not discuss the "West Country," the last territory within the United Kingdom to be explored by tourists and artists in search of the picturesque.

26. See "Introduction," note 1, and note 45 below. A view of Broadgate, Exeter, is in the Brice collection; four views of the city gates and Rougemont castle, all undated, are in the Pope collection, including fig. 38. A pen sketch of Southernhay in Exeter (in the Pope sketchbook) is dated 1808. Other undated sketches from the Pope collection include views of the Plymouth area, Torquay, Sheerness harbor, and many unidentified coastal landscapes.

27. Farington, *The Farington Diaries*, 6: 191–92. Farington was even more taken by the story of Mary Watson's "powerful affection and feeling" recounted in Part I. Patch, whose name appears frequently in Watson's diary of 1818, had a sizable collection of contemporary watercolors, including work by Payne; he could have supplied models for other copies by Watson after sources not in Rev. Swete's albums. See Smiles, 41. No further references to Watson appear in the eight volumes of Greig's abridged version of Farington's diaries. Evelyn Newby, who is preparing a complete edition of the diaries (held in the Royal Archives, Windsor Castle) was kind enough to examine the texts that had been transcribed (through 1816), but found no additional references to Watson.

28. See "Introduction," note 1; the Childs print is discussed in "Prints After Watson's Work" below; see figs. 47–49. Topographically, Watson's view makes a useful pendant to J. J. Barralet's better-known (but often misread) view, *Bridge over the Schuylkill (Market Street Bridge)* of around 1810 (HSP), which shows the same stretch of shoreline looking south, under the bridge, with the old waterworks on the left.

29. The reddishness of the clouds may be the result of staining from an acidic mount or sunburning, with the loss of cooler tints. Even with this alteration, Watson's palette appears to be the same here as elsewhere in his sketchbooks.

30. An untitled watercolor in the Brice collection depicts a tor on Dartmoor, a progressive subject (perhaps copied from Payne) for the period around 1800. Smiles notes that Gilpin hated moorland scenery, and it was not until the generation of David Cox and Constable that English painters grew to love the heath. See Smiles, 11, quoting Gilpin's *Observations on the Western Parts of England.*

31. See Watson's diary, 23 July and 1 August 1816; and analysis of the diary text in Part I.

32. The literature on the picturesque is large, but its principal issues and theorists are introduced in the *Views and Visions* catalog, particularly Bruce Robertson, "The Picturesque Traveler in America," 187–210. A well-organized bibliography of primary and secondary sources concerning the aesthetics of this period can be found in Hawes, *Presences of Nature* (1982).

The American Context

33. An invaluable survey of this period's art is contained in the Edward J. Nygren's *Views and Visions: American Landscape Before 1830.* (Washington, D.C.: Corcoran Gallery of Art, 1986). The many illustrations and bibliographies in this catalog make it an excellent place to begin further study of Watson's contemporaries. I am particularly indebted to the essays by Bruce Robertson, "Venit, Vidit," and "The Picturesque Traveler in America"; and Edward J. Nygren's introductory statement, "From View to Vision."

34. Groombridge's view of Woodlands is in the Santa Barbara Museum of Art. See *Views and Visions*, 262, for an overview of his career with relevant examples of his work, such as *English Landscape* (1811; plate 182), which bears comparison with Watson's Devonshire watercolors. The structure of Groombridge's *View of a Manor House on the Harlem River* of 1793 (plate 181) echoes Watson's *View on the Schuylkill* (see fig. 40).

35. On Guy, see *Views and Visions*, 264–65; and S. T. Colwell, *Francis Guy* (Baltimore: Maryland Historical Society, 1981).

36. Charles Willson Peale was, like Watson, galvanized by the Hudson River: "The grand scenes . . . so enraptured me that I would if I could have made drawings with both hands at the same instant." Peale's sketches, made on a trip up the Hudson in 1801 (American Philosophical Society) represent the earlier, wiry pen style of the eighteenth century, discussed previously. On the Peale family's landscapes, see *Views and Visions*, 279–81; and E. P. Richardson, *Charles Willson Peale and His World* (New York: Abrams, 1982), 95.

37. Birch's *City of Philadelphia*, with its list of subscribers, has been reproduced with modern views of the same sites and notes by S. Robert Teitelman (Philadelphia: Free Library and University of Pennsylvania Press, 1982). The second suite is described by Martin P. Snyder in "William Birch: His Country Seats of the United States," *Pennsylvania Magazine of History and Biography* 81 (July 1957): 225–54. As Ken Finkel remarked to me, Birch's decision not to include Eaglesfield in this portfolio, notwithstanding his usual practice of engraving his and his son's oils (see fig. 18), may have contributed to the later neglect and obscurity of the house. On the Birches, see *Views and Visions*, 238–41; and William H. Gerdts, *Thomas Birch (1779–1851): Paintings and Drawings* (Philadelphia: Philadelphia Maritime Museum, 1966).

38. Lesueur produced many landscape sketches in a rough pencil manner quite different from his polished scientific illustrations. His many American views, held in the museum of natural history that he founded in Le Havre, are informative but generally graceless. Although his circle of friends rarely overlapped Watson's, he did record the view of the Schuylkill above Fairmount, centered on Eaglesfield; see sketchbook 40, no. 40085, Musée d'Histoire Naturelle du Havre (copy at the American Philosophical Society). See Robert W. G. Vail, "The American Sketchbooks of Charles-Alexandre Lesueur 1816–1837," *Proceedings of the American Antiquarian Society* (April 1938), no. 73. Other examples of his work, with additional bibliography, can be found in Patricia Tyson Stroud, *Thomas Say, New World Naturalist* (Philadelphia: University of Pennsylvania Press for the Barra Foundation, 1992).

39. *Views and Visions*, 95, 258.

40. See Avrahm Yarmolinsky, *Picturesque United States of America, 1811, 1812, 1813, Being a Memoir on Paul Svinin, Russian Diplomatic Officer, Artist and Author* (New York: Rudge, 1930). All the watercolors in Yarmolinsky's book are now in the Metropolitan Museum of Art, New York. Among them, plate 33, "General Moreau's House," has been misidentified since Svinin's day; Watson's remarkably similar view of the Woodlands (see plate 5) suggests the correct title. By contrast, Svinin's depiction of Washington's tomb (Yarmolinsky, plate 43) is remarkably different in detail from Watson's image. Another Svinin sketchbook, containing smaller versions of the Metropolitan's watercolors and many new images that await correct identification, is reproduced in Yevgenia Petrovna, *Traveling Across North America, 1812–1813: Watercolors by the Russian Diplomat Pavel Svinin*, trans. Kathleen Carroll (New York: Harry Abrams; Saint Petersburg: Izokombinat, 1992).

41. *Views and Visions*, 266–67, 95–96, where Heriot's work is labeled Gilpinesque. See also Gerald Finley, *George Heriot, Postmaster-Painter of the Canadas* (Toronto, Buffalo, and London: University of Toronto Press, 1983).

Watson and Latrobe

42. My work on Watson has been both assisted and inspired by the excellent work of Edward C. Carter II, John C. Van Horne, and Charles E. Brownell, *Latrobe's View of America, 1795–1820* (New Haven, Conn.: Yale University Press, 1985). On Latrobe's tolerant attitude, see p. 11, also cited above in "The Character of the Text," note 107.

43. Both men were raised in the London area, and their families may have shared acquaintances, since Sir Charles Middleton, First Lord of the Admiralty, was a close friend of the Latrobes. See Carter, "Benjamin Henry Latrobe (1764–1820): Architect, Engineer, Traveler, and Naturalist," in *Latrobe's View*, 5.

44. See Charles E. Brownell, "An Introduction to the Art of Latrobe's Drawings," in *Latrobe's View*, 20–26. Brownell analyzes Latrobe's "Essay on Landscape," reprinted in Edward C. Carter II et al., *The Virginia Journals of B. H. Latrobe, 1795–98* (New Haven, Conn.: Yale University Press, 1977), 2: 455–531.

Prints After Watson's Work

45. Rutledge, *Cumulative Record*, 244, nos. 321, 322.

46. See Part I, "After the Golden Age," on the history of Rundle's estate. George Rundle was a Pennsylvania Academy of Fine Arts stockholder.

47. Both large watercolors were in the possession of Rear Admiral Fischer Burges Watson in 1926. Evidently, they were sold at the same time as the two American sketchbooks, the first of which surfaced at the New-York Historical Society in 1958.

48. The history of this portfolio, along with an extensive bibliography, is given by Stefanie Munsing in *Philadelphia: Three Centuries of American Art* (Philadelphia: Philadelphia Museum of Art, 1976), 249–51.

49. Carey Papers, HSP. See also his letter of 28 Jan. 1820. I thank Stephen Edidin for drawing these letters to my attention.

50. Carey Papers; 8 Feb. 1820 and 3 March 1820; HSP.

51. See captions to plates 78–80 for the story of the rescue of Mount Vernon and the tomb; see also Latrobe, "Anniversary Oration. Pronounced before the Society of Artists . . . on the 8th of May 1811," *The Portfolio* 5 (1811):26.

52. See Part I, "Travels in the United States."

53. Shaw to unknown person, 13 Sept. 1821; Carey Papers, HSP.

54. Two of these preparatory drawings are owned by the Historical Society of Pennsylvania; eighteen are in the Library Company of Philadelphia, including the preparatory wash for Mason's *Eaglesfield*, fig. 3. On these drawings see Kenneth Finkel's remarks in *Annual Report of the Library Company of Philadelphia* (Philadelphia: Library Company, 1987), 30–34.

55. Rutledge, *Cumulative Record*, p. 216, no. 424; p. 63, no. 97, 99; p. 125, no. 211, 231.

56. Ken Finkel has noted to me that Childs evidently shared Watson's image with Samuel C. Atkinson, the publisher of *The Casket*, who printed a wood engraving of this scene, "View of the Schuylkill, from the Old Waterworks," in the February 1828 issue of the magazine, p. 74. Watson's image traveled back across the Atlantic to find itself painted on a panel of a porcelain vase, manufactured in France about 1870. Finkel identified this source in correspondence with Joe Goddu, of Hirschl and Adler Galleries, New York, who brought the vase to Finkel's attention.

57. Wyllie, son of the better-known marine painter William Lionel Wyllie (1851–1931), was a member of the Royal Society of Marine Painters. He lived much of his life in Portsmouth and found his work collected by military institutions along the English Channel. Coincidently, he was active in the restoration of HMS *Implacable*, Watson's last command.

58. An inscription on the prints dates their publication to 1 December 1926, at 665 Fifth Avenue, New York. Pamela Brice has shared photographs of these prints with me; they may be color aquatints or hand-colored. According to Mrs. Brice, they were based on watercolors owned by Admiral F. B. Watson, (see note 47) who sold them "to an American." Since the two views resemble sketchbook harbor views (NY-104A, see fig. 58; and NY-18AB, see plate 68), it is not clear whether Watson made more detailed replicas, or Harold Wyllie embellished the views extensively.

EPILOGUE

1. Nicholas B. Wainwright, "The Diary of Samuel Breck, 1814–1822." *Pennsylvania Magazine of History and Biography* 102 (October 1978): 469–508.

2. From his 1818 diary in the Pope collection. All other citations in this year are from this source.

3. Watson purchased his home from Matthew Nosworthy, the builder who put up the houses on Dix's Field beginning about 1808. The two rows of houses facing a small green were largely obliterated by air raids in 1942. See W. G. Hoskins, *Two Thousand Years in Exeter* (Exeter: James Townsend and Sons, 1960), 139.

4. George Oliver, *The History of Exeter* (Exeter: R. Cullum, 1821), vii.

5. "Naval History of the Present Year," *Naval Chronicle for 1818* 39 (Jan.–June 1818):498. Watson's obituary is remarkable in this periodical for its unusual length. This notice is identical to those published in the *Exeter Flying Post* (28 May 1818), the *Exeter and Plymouth Gazette* (30 May 1818), and the *Alfred* (2 June 1818). I am grateful to Mr. Ellis, the Area Librarian of the Devon and West Country Library, for drawing these notices to my attention.

6. Pope collection. A bit later Mary entered a more composed account in her husband's 1818 diary. Another, condensed version of the story was published as a footnote to Joseph Farington's account of her unexpected meeting with Watson at Plymouth, cited above in Part I, note 33, and in Joseph Farington, *The Farington Diaries*, ed. James Greig, 8 vols. (London: Hutchinson, 1922–28), 6:191–92. This note, supplied by Watson's great-grandson, Fischer Burges Watson, about 1925, emphasizes Mary Watson's "highly strung" nature and offers different details; in this account, a reflected sunset alarmed her, and Watson collapsed after the sudden exertion of his "weak heart."

7. 1818 Diary, Mary Watson's postscriptum.

8. Rebecca Leaming wrote to her son (or husband) J. Fisher Leaming in Canton, China, on 23 September 1818, bearing the news of Watson's death. "Our friends at Eaglesfield have met with a severe loss in the death of Captain Watson[.] he broke a blood vessel in his head and expired immediately[.] they are under very heavy affliction." Spicer-Leaming papers, HSP.

9. Dated at Eaglesfield, 3 August 1818; Pope coll.

10. Dated at Eaglesfield, 2 February 1819; Pope coll. Richard Rundle's estate papers show that he sent her annual stipends in addition to income earned from the investment of Captain Watson's estate. These funds were supervised by George Rundle long after Richard Rundle's death. Rundle's will of 1826, cited above in Part I.

11. Evidently Rundle was too young, for he was not enrolled until three years later. Perhaps his premature application hoped for special consideration, following his father's recent death, or early placement on a waiting list. When he actually matriculated in 1821, he had to furnish proof of four years tuition from a private tutor at Dawlish (ADM 1/3513). R. B. Watson inherited his father's interest in watercolor, if not his skill, as shown by several marine views by his hand in Watson's early sketchbook in the Pope coll.

12. From an undated clipping, ca. July 1818; Pope coll.

APPENDIX A: WATSON'S AMERICAN DIARY

1. In the sun.

2. Reedy Island stands in the Delaware River opposite Port Penn, about ten miles below Newcastle. A mechanical telegraph or semaphore was installed there in 1809 to announce the arrival of ships bound for Philadelphia, some forty miles upstream.

3. About six miles below Wilmington, Delaware, opposite Salem, New Jersey, the Pea Patch was fortified during the War of 1812; it is currently Fort Delaware State Park.

4. The old "Mid-Fort" on Mud Island, just south of the junction of the Schuylkill and Delaware Rivers, was begun by the British in 1772 and nearly leveled by their own gunfire in 1777. Renamed in honor of Pennsylvania's governor, Major General Thomas Mifflin, the fort was rebuilt in the 1790s from designs by the French architect, Pierre-Charles L'Enfant. The site can still be visited, or surveyed from the air by travelers using the adjacent Philadelphia International Airport.

5. *George*, *Maria*, and *Frances Rundle* (see fig. 16) lived at 124 Locust or "Locust above Ninth," an address that changed to 921 Locust when stan-

dardized house numbering was adopted in the 1850s (see fig. 15). George died in this home, a widower, in 1859; the site is now a park adjacent to Will's Eye Hospital. When Watson visited in 1816–17, this neighborhood west of Washington Square was full of new brick row houses. Their home was in "Rittenhouse Range," a suite built by the developer *John Savage*, from designs by Robert Mills. Finished in 1813, their home was purchased from Savage in 1817; they may have been renting it when Watson arrived in 1816. The last surviving Mills house from this development, built at 228 South Ninth (on the same city block but around the corner from the Rundles, in "Franklin Row") has been moved to the southwest corner of Eighth and Locust Streets. Both Maria Rundle and *Richard Rundle* also owned houses in Franklin Row. Two similar houses remain en suite in the 900 block of Spruce Street.

6. *Richard Rundle.*

7. In the eighteenth century, Philadelphia's custom house moved frequently, usually following the residence of the customs officer. In 1802 it settled in Carpenter's Hall, at 320 Chestnut Street, where it remained until 1 Jan. 1817, under the supervision of customs collector John Steele and the presiding naval officer, Samuel Clarke. During Watson's visit in 1816–17 a grander edifice was proposed, and a site on Second Street below Dock was chosen. The new building, designed by William Strickland, was finished in 1819. In 1844 the offices moved into another Strickland building, the vacant Second Bank of the United States (1819–24), which eventually became known as the "Old Custom House."

8. The Centre Square pumping station (see fig. 52), at the intersection of Broad and Market Streets, had been abandoned only the year before. From 1801 until 1815 the engine house distributed water pumped in from the Schuylkill, enacting an innovative system designed by Benjamin H. Latrobe in 1799 to improve the quality of the city's water supply. In 1812 the source was moved upstream and work began on a new pumping station and reservoir at Fairmount that went into action in September 1815. The old building was converted into an observatory by the American Philosophical Society in late 1817 and remained an ornament of the park until it was demolished in 1828.

9. Foundations for the "Center Bridge" at Market Street, the Schuylkill's first permanent bridge at Philadelphia, were begun in 1798; work on the superstructure began in 1800, with the deck opened in 1805 and the wooden cover finished a year later. The design as well as the campaign to finance and construct the bridge came from the initiative of *Judge Richard Peters.*

10. The Upper Ferry Bridge, leading to the Lancaster Turnpike and the Schuylkill River Road, replaced a ferry that crossed the river just below Fairmount. Designed, invented, and built by Louis Wernwag, a local engineer, the "Lancaster" or "Fairmount Bridge" was also known as the "Colos-

sus" because of its astonishing single arch of 340 feet—almost 100 feet longer than any previous single-span bridge. Built between 1809 and 1812, with an elegant exterior design by Robert Mills, the bridge was a major feature of the view from Eaglesfield and an important link to the city for all the northwestern suburbs. The structure burned in 1838 and was replaced by a suspension bridge and, much later, by the present Spring Garden Street bridge.

11. On the history of Eaglesfield, see Part I.

12. *Mary Murgatroyd Rundle.*

13. *Richard* and *Mary Rundle* were in England from approximately 1799 to 1804; during this sojourn they visited friends and relatives, and attended the wedding of Watson's sister, Maria, to *George Rundle.*

14. Landsdowne, the largest and most lavish of the Schuylkill mansions, was built by Governor John Penn in 1776. William Bingham owned the house later and made it famous for extravagant hospitality. After Bingham's death in 1804, the house was occasionally rented out (as to *Joseph Bonaparte*, several weeks after Watson's arrival in the summer of 1816) and often stood empty. The mansion burned in 1854 and the grounds were added to Fairmount Park in 1866. Ten years later the estate became the site of the principal buildings of the centennial exhibition, including the present Memorial Hall. Belmont, adjacent to Landsdowne on the north, was the home of *Judge Richard Peters*. His father, William, had built a house on the site in 1745. Richard expanded the house and made the estate into a model farm. Acquired by Fairmount Park in 1867, the house continues to command a sweeping vista of the river and city skyline. North and east of Belmont stood Ridgeland Farm, owned by the Quaker merchant and Federalist legislator Robert Waln (1765–1836) and his heir, also a politician, Jacob S. Waln (1776–1850). The house, built between 1790 and 1810, joined Fairmount Park in 1868.

15. Conceived as a tiny independent domain on an island in the river, the Colony in Schuylkill was founded in 1732, becoming the first English social organization in the country. Renamed the Fishing Company of the State in Schuylkill after the Revolutionary War, the group met to eat, drink punch, and unwind, presumably after fishing. The owner of the property on which their river bank Castle stood received rent of 3 fish per annum and an entrée to their famous parties (The castle is visible in fig. 22 and perhaps in the distance of plate 19). *Richard Rundle* enjoyed the privileges of "Baron" until the club's fishing grounds were ruined by the dam at Fairmount (in 1822), and the castle was moved to various new sites, finally settling in 1887 at Andalusia on the Delaware.

16. The year 1816 was remembered in New England as the year in which there was no summer. Ten inches of snow fell on 6 June.

17. The chain bridge collapsed in January 1816, after which *Josiah White* installed his temporary suspension bridge, "one of the great curiosi-

ties of the time" (Scharf and Westcott, 584). The best extant description of the bridge survives in Watson's sketch and notes. See Charles E. Petersen, "The Spider Bridge, a Curious Work at the Falls of Schuylkill," *Proceedings of the Canal History and Technology Symposium* 5 (1986):243–59; and Norris Haskell, *Josiah White, Quaker Entrepreneur* (Easton, Pa.: Canal History and Technology Press, 1992), 35–36. White's bridge was replaced about a year later by a permanent structure designed by Louis Wernwag, the engineer of the Colossus at Fairmount (cf. 1 July).

18. *David Porter* cruised in the Pacific during the War of 1812, tormenting the British whale fishery and adventuring. Captured by the British in the neutral port of Valparaiso, Porter escaped, disparaging the honor of his British captors. His *Journal of a Cruise Made to the Pacifick Ocean in the U.S. Frigate 'Essex' in 1812–'13–'14*, illustrated with his own drawings, was published in two volumes in Philadelphia in 1815.

19. Washington died 14 December 1799, aged 67. As with other deliberately empty spaces in the text, we can conclude Watson intended to fill in these facts later. Thomas Birch painted the same view from Belmont in 1808; see Edward J. Nygren, with Bruce Robertson, *Views and Visions: American Landscape Before 1830*. Washington, D.C.: Corcoran Gallery of Art, 1986, plate 170.

20. In 1804 William Hamilton, the uncle of *James Hamilton*, laid out a neighborhood of streets and small lots in West Philadelphia, north of his estate, the Woodlands. Designed as a summer retreat from the city, with villas more modest than the mansions along the river, Hamilton Village was rapidly settled after the opening of the Market Street ("Permanent" or "Center") Bridge in 1805, which fed the Lancaster Road nearby.

21. See 5 July.

22. Built between 1795 and 1797, the First Bank of the United States at 120 South Third Street, between Chestnut and Walnut, is the oldest bank building in America. It became Stephen Girard's private bank in 1812, after its national charter elapsed. The architect, Christopher Myers, modeled it on the Dublin Exchange and produced Philadelphia's most stylish and imposing Palladian-style edifice. Girard's Bank held the building until 1926; it is now owned by the National Park Service.

23. The Bank of Pennsylvania on Second Street above Walnut was the other distinguished banking building in Philadelphia at the time of Watson's visit. It was designed by Benjamin H. Latrobe and built between 1799 and 1801. Latrobe's pride, as well as the great influence of this design, did not save the bank from demolition.

24. The State House, or "Independence Hall," tightly enclosed by buildings in this period, overlooked a walled garden to the south that was popular with strollers. In the seventeenth century, William Penn had envisioned five public parks symmetrically distributed on the city's plan, but by 1816 Philadelphia had only grown enough to embrace two. The southwestern square had been used as a common pasturage and a pauper's burial ground, or potter's field, until late in the eighteenth century. Many casualties of the Revolutionary War "camp fever" and victims of the yellow fever epidemics twenty years later were buried there in mass graves. Penn's vision began to be realized in 1816, when the area was fenced and a new name proposed: Washington Square.

25. The Hospital was surely Pennsylvania Hospital, an institution *Richard Rundle* had supported as a director. One of the prides of the city, the hospital had been founded in 1751 on pleasantly suburban ground between Eighth and Ninth Streets on Pine Street. Built in stages, the final component—the center pavilion—had been commenced in 1804. The Bettering House or Almshouse was located in the next block on Pine, above Tenth. Food, shelter, and employment were offered there to the destitute; in 1810 the two L-shaped buildings housed almost thirteen hundred persons, most of whom were employed spinning and weaving. The Walnut Street Jail, at Sixth Street overlooking Washington Square, had been built in 1773. Old-fashioned and overcrowded by the turn of the century, it was supplemented by a new prison at the corner of Broad and Arch, begun in 1803 and constructed during the next decade.

26. Independence Hall, completed in 1756, had been the center of provincial, state, and federal government until 1799. Site of the second Continental Congress and the constitutional convention, it served as Congress Hall until 1800, when the capital moved to Washington, D.C. Thereafter it held the state's Supreme Court and, upstairs, *Charles Willson Peale*'s museum, described by Watson on 5 July.

27. Built in 1797 by the newlywed Brecks, who sought a country refuge from Philadelphia's yellow fever epidemic, Sweetbriar was the first Schuylkill mansion on the west bank to be inhabited year-round. Although not the largest in the neighborhood, the forty-acre estate became a showplace for its gardens, farm, and cosmopolitan hospitality. The salubrious air of Sweetbriar was ruined by the new dam at Fairmount, built in 1822, which submerged the farm's meadowland and encouraged the spread of fever that killed Breck's beloved twenty-one-year-old daughter, Lucy, in 1828. Disheartened, Breck sold the estate and moved into town. Fairmount Park acquired the property in 1867. The elegantly detailed house, with many of Breck's possessions on view, is open to the public. Restored by the Junior League in 1929, it has been maintained by the Modern Club since 1939.

28. See *David Landreth*.

29. A French term for a break in the levees containing the Mississippi around New Orleans.

30. Turner's Lane ran southwest to northeast, along the course of the present Sedgley and Greenwood Avenues. From this vantage about three

miles northwest of the city wharves on the Delaware, the skyline featured Spark's shot tower at Second and Front Streets. The first in the United States and now one of the last, Spark's tower—like its competitor, Beck's, at Twenty-first and Cherry—was built in 1808. The Episcopal church that Watson saw was Christ Church, at Second and Market, with its steeple built in 1753. The Masonic Hall on Chestnut Street, between Seventh and Eighth Streets, was begun in 1809 from designs by William Strickland. A spire was added, at "the suggestion of several respectable citizens who," like Watson, "regretted our deficiency in an article of embellishment so essential to the beauty of a great city." James Mease, *The Picture of Philadelphia* . . . (Philadelphia: T. Kite, 1811), 335.

31. Probably Watson refers to the country estate of the merchant Joseph Sims, sold in 1836 to form the first portion of the present Laurel Hill Cemetery. Another estate, also known as Laurel Hill, stood about a mile below on the east bank of the river; acquired by Fairmount Park in 1869, it is now known by its long association with the Randolph family.

32. Sedgeley was built for *William Crammond* in 1799 after designs by Benjamin H. Latrobe. The first Modern Gothic cottage in America, it burned in 1857. The porter's lodge remains on the grounds, now within Fairmount Park.

33. The members of this party were united by their affiliation, by birth or marriage, to the Leaming family.

34. That summer (1816) Turner Camac had proposed icehouses for the city's new fish market; as Watson was writing, fishing vessels began to put to sea from Philadelphia with ice in their holds for packing the returning cargo.

35. The Society of the Cincinnati was formed in 1783 by officers of the American army who hoped to follow the model of patriotic behavior seen in the Roman farmer Cincinnatus, who left his fields to serve his country and then returned to his plow in peacetime. George Washington, "The American Cincinnatus," was elected president-general in 1787 at the second general meeting of the state societies, and he remained in this role after his retirement from public office in 1796 until his death in 1799. Six of the state societies had been dissolved by 1804 for fear of the establishment of a military aristocracy, but the parent chapter in Philadelphia remained strong. Many members of the Society of the Cincinnati also joined the Washington Association of Young Men, formed in 1811 to honor the memory of the first president. Both of these groups in turn fed the membership of the Washington Benevolent Society, a mutual benefit association organized in 1813 that operated much like an insurance company. Predictably, all these groups shared Federalist politics and contained a high percentage of military men. The Benevolent Society met annually on Washington's birthday and Independence Day, often in conjunction with the other two groups.

36. The Washington Benevolent Society built Washington Hall (and Hotel) in 1814–16 on the west side of Third Street, above Spruce, from designs by Robert Mills. Watson may have attended the annual ball there on 22 Feb. 1817, for he knew many of the principal organizers of the event, including *Major William Jackson*, *Commodores Richard Dale* and *Alexander Murray*, *Captain James Biddle* and *Judge Richard Peters*. *Condy Raguet* and *Charles Caldwell* both delivered orations at the society's celebrations during this period.

37. A proprietary library, the Atheneum was the newest such club in the city, having opened its subscription lists in 1814. Its reading rooms, specializing in new books and periodicals, were above Mathew Carey's bookstore at Chestnut and Fourth until May 1817. Under the presidency of Watson's friend *Samuel Breck*, the Atheneum acquired grander quarters: its present building on Washington Square was built in 1844 after designs by John Notman.

38. See *Charles Willson Peale*.

39. In 1799 the merchant *Henry Pratt* bought the northern half of Robert Morris's estate, the Hills, when it was sold at auction to satisfy Morris's creditors. One of the first Schuylkill Valley summer retreats for urban gentry, the Hills was replaced that year by a Federal-style mansion and lavish gardens named Lemon Hill in honor of Morris's extraordinary greenhouse. The mansion still stands in Fairmount Park, maintained by the Colonial Dames of America and administered by the Philadelphia Museum of Art. Watson would have been interested to learn that Pratt's father, Henry, had been a portrait painter and student of Benjamin West.

40. Tradition tells that William Penn met with the local Indians in 1602 beneath the branches of an elm tree close to the bank of the Delaware at Shakamexunk, now Kensington. This venerable tree blew down in a storm 3 March 1810, but the stump remained visible for years, sending off shoots that were planted in the courtyard of Pennsylvania Hospital.

41. The *Franklin* had been launched on 21 August 1815, while a crowd of some 50,000 persons looked on. See "Breck's Diary" (21 Aug. 1815), p. 480.

42. The abbreviations in Watson's table of artillery probably refer to the range of the guns (long, short, and carronade, for close operations) and the weight (32 pounds) of their shot.

43. The *Guerriere*, named after the British ship captured and burned by Isaac Hull in 1812, was launched two months before the *Franklin* on 20 June 1814. (See Wainwright, "Breck's diary," p. 475 for an account of the event.) She remained at the Philadelphia Navy Yard until the conclusion of the peace treaty in 1815.

44. The repeating gun that Watson described was intended for mounting in the top-castle platforms on the ship's masts. Although innovative, this

kind of muzzle-loading gun proved unreliable; true machine guns would rely on the easier breech-loading design, developed by Americans in the mid-19th century, and leading to the invention of the Gatling gun—which resembles Watson's "top gun" in some respects—in 1862.

45. Fear of citywide fires inspired Benjamin Franklin to organize Philadelphia's first fire-fighting brigade in the 1730s, adding in 1750 a component of insurance company protection. These companies promised trained and speedy response to fires, and their strict building codes for insured properties inspired the city's uniform brick-and-marble texture.

46. Although steamboat service on the Delaware River had been seen as early as 1788, with John Fitch's experimental boats, the complexities of patent rights restricted expansion until 1816, when Robert Fulton's patents were acquired for navigation above and below Philadelphia. The *Philadelphia*, built in Baltimore in late 1815 for the Chesapeake routes, may have been the ship Watson and Leaming sailed; another *Philadelphia*, built in 1813, plied the New York–New Jersey link earlier. The frequency of catastrophic fires made most of these boats short lived, but they proliferated nonetheless. On 13 August 1818 Samuel Breck exclaimed that there were seven steamboat departures daily from Philadelphia, excluding Sundays (Wainwright, "Breck's Diary," p. 495).

47. Princeton College was founded in 1746. More recent was a Presbyterian school, the Princeton Theological Seminary, founded in 1812. The Battle of Princeton (Jan. 3, 1777) was an important American victory.

48. Perth Amboy and South Amboy flanked the mouth of the Raritan. The steamboat passed up the Arthur Kill and out the Kill Van Kull, below Bayonne, into Upper New York Bay. While less direct than the route around eastern Staten Island, this channel was protected from rough Atlantic weather.

49. Five of Robert Fulton's original steamboats were still in operation in 1816; Watson probably sailed on one of the two oldest ones, the *Raritan* or the historic *Clermont*, both built in 1807.

50. The state commissioned John Randel, Jr., to survey Manhattan and project a grid of streets and parks upon the landscape above Houston Street. A map based on this survey, drawn by William Bridges and engraved by Peter Maverick, was published in 1811 to guide future development.

51. Watson no doubt preferred the proportions of Old City Hall, or Federal Hall, at the intersection of Broad and Wall Streets, renovated by Pierre-Charles L'Enfant in 1790. The expanding city soon demanded a larger edifice farther uptown, one that was begun in 1803 from designs by Joseph Mangin and John McComb and finished in 1812.

52. The original New York Hospital, chartered in 1771, was burned before its completion and rebuilt to serve as a barracks during the Revolutionary War. Opened as a hospital in 1791, its staff included *David Hosack*,

who may have shown Watson the view from its main building, which stood west of Broadway between Duane and Worth Streets, where Thomas Street now runs. Like Pennsylvania Hospital in Philadelphia, New York Hospital was at first on the suburban fringe, amid fields and ponds. Overtaken by the city, the Lunatic Asylum moved farther into the country (to Broadway and 116th Street) in 1818–20.

53. The military presence at the Battery ceased when the last traces of the seventeenth-century Fort Amsterdam and eighteenth-century Fort George were razed in 1790 to build Government House amid a pleasant park. The resulting defenselessness of the lower city inspired the building of Castle Clinton just off the Battery in 1808; other fortifications on Governor's Island and elsewhere in the harbor were added at the time of the War of 1812. In peacetime the playful air of the Battery returned, and the fort became a theater, Castle Garden.

54. St. James Church was consecrated in 1810 in the three-year-old suburban development known as Hamilton Square, at Lexington Avenue and 69th Street. That church was demolished in 1870 to be replaced by the present structure. Watson's attendance at St. James implies that he and Leaming were visiting friends who lived, like the Rundles in Philadelphia, in "villas" at the bucolic edge of town.

55. The Brooklyn Navy Yard, on the East River at Wallabout Bay, was New York City's major naval base after 1802. The *Cyane* (20) had been taken by the U.S. *Constitution* in March of 1815; the *Alert* (16) was taken by the *Essex* under *David Porter* in August, 1812. The U.S. *Hornet*, with *James Biddle* and *James Lawrence* on board, had captured the British *Penguin* in 1815.

56. The anxiety of the War of 1812 inspired the defenders of New York harbor to build Robert Fulton's novel "floating battery," first known as *Demalogos* (Voice of the People) and then as *Fulton the First*. Launched at Crown Point in October 1814, this first steam man-of-war was laid up almost immediately and destroyed by fire in 1829 before seeing action. Watson must have regretted the recent death of Fulton (1765–1815), for the two shared interests in painting, engineering, and naval warfare. Fulton had worked in both London and Devon as a portraitist.

The orlop was always the lowest deck on a ship, immediately above the hold. Like a typical battleship of this period, the *Fulton the First* had three decks: orlop, gun, and upper, this last being entirely open and without the superstructures fore and aft (forecastle and quarterdeck) of conventional warships.

57. Lateen (from the French *latine*) or Mediterranean triangular sails.

58. The New York Academy of Fine Arts, the first such establishment in the city, was founded in 1802 to house the casts sent back from Paris by the American ambassador, Robert R. Livingston. By 1816 it was known as the American Academy of the Arts, with a state charter and a board of di-

rectors, mostly businessmen and professionals (such as *David Hosack*), save only the painter John Trumbull (1756–1843), who served as its first vice-president and, after January 1817, as president. When Watson visited the academy it had just received new quarters in the New York Institution (the old Almshouse) facing City Hall Park. The new space, supervised by the "keeper," John Rubens Smith, was about to be installed with the permanent collection and the "annual" (albeit irregular) loan show. In the meanwhile, *John Vanderlyn* was using the rooms to exhibit his own work. The American Academy was superseded in 1825 by the artist-organized National Academy of Design.

59. St Paul's, on Broadway between Vesey and Fulton, just across City Hall Park from the American Academy of the Arts, had been built in 1766 from designs by Thomas McBean; the spire and portico were added in 1794–96 with Pierre-Charles L'Enfant's guidance. The monument to *Captain James Lawrence* was actually in Trinity Churchyard, a few blocks farther south on Broadway. Erected by the New York Common Council shortly after his death in 1813, its construction was no better than its design. Crumbling already in 1825, the column was replaced by the present brownstone monument, which carries only the second part of the inscription recorded by Watson. Stokes' *Iconography of Manhattan* records only one engraving of the first monument, made long after it had begun to deteriorate.

60. The *Firefly* was one of Fulton's original steamboats, built in 1812.

61. Although the pre-Romantic poetry of Thomas Gray (1716–71) remains well known, the power of Watson's exclamation has been somewhat diluted by the present obscurity of John Chetwold Eustace (1762–1815), author of *A Tour Through Italy* (1813).

62. Stony Point became an American "Little Gibraltar" in 1779 when its small British garrison was successfully stormed by the American troops under General Anthony Wayne.

63. At Highland Falls, on the west bank of the Hudson, below West Point.

64. Fort Putnam, built on the west bank in 1777 under the supervision of General Israel Putnam, had once been a major stronghold on the river, inspiring Benedict Arnold's subterfuges to bring it into enemy hands. Known as the "Gibraltar of North America," it overlooked West Point Military Academy on the plain below. By 1800 the fort was already in ruins, local builders having robbed much of the original stone work for new purposes.

Fort Clinton stood at the water's edge, south of the Academy; another, earlier Fort Clinton was about seven miles downstream.

65. West Point had been central to the string of fortifications along the Hudson, laid out in 1775. The United States Military Academy was founded there in 1802.

66. Another of Robert Fulton's original steamboats, the *Car of Neptune* was built in 1808.

67. Albany was one of the oldest settlements in the colonies. Founded in 1614 by the Dutch, it was not declared the capital of New York State until 1797. The capitol was built in 1807.

68. After exploration of a route from the Hudson to Lake Erie, begun in 1810, the New York legislature approved in 1817 the building of a canal from Albany along the Mohawk River valley to Buffalo. Work on the Erie Canal, which intersected Lakes Oneida and Canadarago on its way west, commenced 4 July 1817 and was completed in 1825. This new artery benefited Virginia, which then encompassed the territory of West Virginia that would profit from connecting traffic on the Ohio and Mississippi Rivers.

69. According to the ballad scholar Kenneth S. Goldstein, no song about "Mary of Baltimore" has survived in British and American published collections or song-title indices.

70. Fort William Henry.

71. The village of Caldwell at the southern end of the lake, named after the major landowning family in the area, was renamed Lake George in 1904.

72. The healing springs at Saratoga and Ballston (six miles away) were known to colonists in the eighteenth century, but few accommodations existed nearby until 1801, when Gideon Putnam opened the Grand Union Hotel at Saratoga.

73. A "worm" or "snake" fence, laid without posts in a zigzag pattern, could be built of split rails, branches, or tree trunks.

74. As Watson foresaw, a round of protectionist tariffs was imposed by the U.S. government in 1816, sponsored by textile manufacturers such as Robert Waln.

75. The Springfield armory was established in 1794.

76. The comfort of this wagon was owed to Benjamin Dearborn (1755–1838), the inventor of the spring balance.

Select Bibliography

THIS BIBLIOGRAPHY LISTS ONLY THE MOST important sources consulted for this book and those most useful to a reader interested in the local context of Watson's art. No attempt has been made to survey sources on British and American social, political, or naval history of this period or to list all the standard art references. A few books offer good entrance points to these larger topics, such as N. A. M. Rodger, *The Wooden World: An Anatomy of the Georgian Navy* (1986), which explores the structure of the navy and provides a lengthy annotated bibliography. British landscape painting and the aesthetics of Watson's period are lucidly introduced by Louis Hawes in *Presences of Nature* (1982), and the history and bibliography of British watercolor painting has been surveyed in splendor by Andrew Wilton and Ann Lyles in *The Great Age of British Watercolours 1750–1880* (1993). A superb introduction to the Anglo-American background of Watson's art can be found in Edward J. Nygren et al., *Views and Visions: American Landscape Before 1830* (1986), which includes wide-ranging bibliographical references to the artists and aesthetics of this period. Likewise, students of Philadelphia in Watson's day should begin with Edgar P. Richardson's "The Athens of America, 1800–1825" in Russell F. Weigley, ed., *Philadelphia: A 300 Year History* (1982). Another valuable crossroads of information exists in the encyclopedic catalog of an exhibition orchestrated by Darrel Sewell at the Philadelphia Museum of Art, *Philadelphia: Three Centuries of American Art* (1976). Full citations for all these publications appear below.

Most of the early nineteenth-century primary sources consulted for this study, such as manuscripts, city directories, naval lists, maps, prints, drawings, and periodicals, came from four places: the British

Admiralty's Archives at the Public Record Office, Richmond, Kew (Surrey); the Historical Society of Pennsylvania, Philadelphia; The Library Company of Philadelphia; and the personal papers of the Watson family, held by Patrick and Maria Whinney until 1995 and now in the custody of Elizabeth Burges Pope, who plans to deposit them at the Portsmouth Royal Naval Museum. Other period materials were found at the Athenaeum of Philadelphia, the Philadelphia City Archives, and the Devon and West Country Library, Exeter. See the notes for more detailed references.

Adams, William H., ed. *The Eye of Thomas Jefferson*. Washington, D.C.: National Gallery of Art, 1976.

Allodi, Mary. *Canadian Watercolours and Drawings in the Royal Ontario Museum*. 2 vols. Toronto: Royal Ontario Museum, 1974.

Bantel, Linda et al. *William Rush: American Sculptor*. Philadelphia: Pennsylvania Academy of the Fine Arts, 1982.

Birch, William Russell. *The City of Philadelphia . . . as it appeared in the year 1800*. Springland, Pa.: W. Birch, 1800.

———. *Country Seats of the United States*. Springland, Pa.: Designed and Published by W. Birch, 1808.

Bowen, Daniel. *A History of Philadelphia with a notice of villages in the vicinity*. Philadelphia: Daniel Bowen, 1839.

Breck, Samuel. "The Diary of Samuel Breck, 1814–1822." Ed. Nicholas B. Wainwright. *Pennsylvania Magazine of History and Biography* 102, 4 (October 1978): 469–508.

Bryan, Wilhelmus Bogart. *A History of the Nation's Capital*. New York: Macmillan, 1914.

Bury, Adrian. *Francis Towne, Lone Star of Water-colour Painting*. London: C. Skilton, 1962; 1974.

Caldwell, John and Oswaldo Rodriguez Roque et al. *American Paintings in the Metropolitan Museum of Art*. Ed. Kathleen Luhrs. Vol. I. Princeton, N.J.: Metropolitan Museum of Art in association with Princeton University Press, 1994.

Carmer, Carl. *The Susquehanna*. New York: Rinehart, 1955.

Carter, Edward C. II, John C. Van Horne, and Lee W. Formwalt, eds. *The Journals of Benjamin Henry Latrobe, 1799–1820: Philadelphia to New Orleans*. New Haven, Conn. and London: Yale University Press for the Maryland Historical Society, 1980.

Carter, Edward C. II, John C. Van Horne, and Charles E. Brownell, eds. *Latrobe's View of America, 1795–1820*. New Haven, Conn. and London: Yale University Press for the Maryland Historical Society, 1985.

Chastellux, François Jean, Marquis de. *Travels in North America: In the Years 1780, 1781, and 1782*. Trans. George Grieve. 2 vols. Dublin: Colles, Moncrieffe, White et al., 1787.

Childs, Cephas Grier. *Views in Philadelphia and its environs, from original drawings taken in 1827–30*. Philadelphia: for C.G. Childs by Clark & Fraser, 1830.

Clarke, Michael. *The Tempting Prospect: A Social History of English Watercolours*. London: Colonnade Books, 1981.

Cohen, Jeffrey A. and Charles E. Brownell. *The Architectural Drawings of Benjamin Henry Latrobe*. New Haven, Conn., and London: Yale University Press for the Maryland Historical Society and the American Philosophical Society, 1994.

Cohn, Marjorie. *Wash and Gouache: A Study of the Development of the Materials of Watercolor*. Cambridge, Mass.: Fogg Art Museum, 1977.

Colwell, S. T. *Francis Guy*. Baltimore: Maryland Historical Society, 1981.

Condy, Jonathan Williams. *A Description of the River Susquehanna, with observations of the Present State of its Trade and Navigation, and their practical and probable improvement*. Philadelphia: Zachariah Poulson, Jr., 1796.

Cooke, W. Martha E. *W. H. Coverdale Collection of Canadiana: Paintings, Water-Colours, and Drawings (Manoir Richelieu Collection)*. Ottawa: Public Archives of Canada, 1983.

Cosentino, Andrew J. and Henry H. Glassie. *The Capital Image: Painters in Washington, 1800–1915*. Washington, D.C.: Smithsonian Institution Press, 1983.

Davis, Richard Beale, ed. *Jeffersonian America: Notes on the United States of America Collected in the Years 1805-6-7 and 11–12 by Sir Augustus John Foster, Bart*. San Marino, Ca.: Huntington Library, 1954; reprint Westport, Conn.: Greenwood Press, 1980.

Dunbar, Seymour. *A History of Travel in America*. New York: Tudor, 1937.

Dwight, Timothy. *Travels in New England and New York*. Ed. Barbara Miller Solomon with Patricia M. King. 2 vols. Cambridge, Mass.: Belknap Press of Harvard University Press, 1969.

Erffa, Helmut von and Allen Staley. *The Paintings of Benjamin West*. New Haven, Conn. and London: Yale University Press, 1982.

Farington, Joseph. *The Farington Diaries*. Ed. James Greig. 8 vols. London: Hutchinson, 1922–28.

Fawcett, Trevor W. *The Rise of English Provincial Art*. Oxford: Oxford University Press, 1974.

Finkel, Kenneth. *Nineteenth-Century Photography in Philadelphia: 250 Historic Prints from the Library Company of Philadelphia*. New York: Dover, with the Library Company of Philadelphia, 1980.

Garvan, Beatrice B. *Federal Philadelphia 1785–1825: The Athens of the West-*

ern World. Philadelphia: Philadelphia Museum of Art, distributed by the University of Pennsylvania Press, 1987.

Gerdts, William H., ed. *Thomas Birch, 1779–1851: Paintings and Drawings*. Philadelphia: Philadelphia Maritime Museum, 1966.

Gibson, Jane Mork. "The Fairmount Waterworks, 1812–1911." *Philadelphia Museum of Art Bulletin* 84, nos. 360, 361 (Summer 1988).

Gilpin, Joshua. "Journal of a Tour from Philadelphia through the Western Counties of Pennsylvania in the Months of September and October, 1809." *Pennsylvania Magazine of History and Biography* 50 (1926): 64–78, 163–178, 380–382.

Goode, James N. *Capital Losses: A Cultural History of Washington's Destroyed Buildings*. Washington, D.C.: Smithsonian Institution, 1979.

Green, Constance McLaughlin. *Washington: Village and Capital, 1800–1878*. Princeton, N.J.: Princeton University Press, 1962.

Hardie, Martin. *Water-colour Painting in Britain*. 3 vols. London and New York: Batsford, and Barnes and Noble, 1966–1968.

Hartman, J. Lee. "Pennsylvania's Grand Plan of Post-Revolutionary Internal Improvement." *Pennsylvania Magazine of History and Biography* 65 (1941).

Hawes, Louis. *Presences of Nature: British Landscape, 1780–1830*. New Haven, Conn.: Yale Center for British Art, 1982.

Henry, John Frazier. *Early Maritime Artists of the Pacific Northwest Coast 1741–1841*. Seattle and London: University of Washington Press, 1984.

Hodgson, Adam. *Letters from North America, Written During a Tour in the United States and Canada*. London: George Smith; Liverpool: for Hurst, Robinson; Edinburgh: A. Constable, 1824.

Hoskins, W. G. *Industry, Trade and People in Exeter, 1688–1800*. Manchester: Manchester University Press, 1935. Reprint. University of Exeter, 1968.

———. *Two Thousand Years in Exeter*. Exeter: James Townsend and Sons, 1960.

Howat, John K. *The Hudson River and Its Painters*. New York: Viking Press, 1972; Penguin Books, 1978.

Howat, John K. et al. *American Paradise: The World of the Hudson River School*. New York: Metropolitan Museum of Art, distributed by Harry N. Abrams, 1987.

Jackson, Joseph. *The Encyclopedia of Philadelphia*. 4 vols. Harrisburg, Pa.: National Historical Association, 1931–33.

Klein, H. M. J., ed. *Lancaster County Pennsylvania: A History*. 4 vols. New York and Chicago: Lewis Historical Publishing, 1924.

Koke, Richard J. *American Landscape and Genre Paintings in the New-York Historical Society*. 3 vols. Boston: New-York Historical Society with G. K. Hall, 1982.

Kouwenhoven, John A. *The Columbia Historical Portrait of New York*. Garden City, N. Y.: Doubleday, 1953.

Lewis, Michael A. *A Social History of the Navy, 1793–1815*. London: Allen and Unwin, 1960.

Looney, Robert F. *Old Philadelphia in Early Photographs 1839–1914: 215 Prints from the Collection of the Free Library of Philadelphia*. New York: Dover and the Free Library of Philadelphia, 1976.

Lossing, Benson J. *The Hudson, from the Wilderness to the Sea. and the Peripheral Parts of North America*. Translated from the French and annotated by Constance D. Sherman. Ridgewood, N. J.: Gregg Press, 1968.

Manigault, Harriet. *The Diary of Harriet Manigault (1813–1816)*. Ed. Virginia Armentrout and James S. Armentrout. Rockland, Maine: Colonial Dames of America, 1976.

Marryat, Frederick. *Diary in America with Remarks on its Institutions*. Ed. Sydney Jackman. New York: Knopf, 1962.

McPeck, Eleanor M. "George Ishams Parkyns, Artist and Landscape Architect, 1749–1820." *Quarterly Journal of the Library of Congress* (July 1973): 171–82.

Mease, James. *The Picture of Philadelphia, Giving an Account of its Origin, Increase and Improvements in Arts, Sciences, Manufactures, Commerce and Revenue, with a Compendium View of its Societies . . .* Philadelphia: T. Kite, 1811. Reprint New York: Arno Press, 1970.

Milbert, Jacques Gerard. *Picturesque Itinerary of the Hudson River and the Peripheral Parts of North America*. Translated from the French and annotated by Constance D. Sherman. Ridgewood, N. J.: Gregg Press, 1968.

Miles, Ellen G. *Saint-Mémin and the Neoclassical Profile Portrait in America*. Ed. Dru Dowdy. Washington, D.C.: National Portrait Gallery and the Smithsonian Institution Press for the Barra Foundation, 1994.

Nelson's Illustrated Guide to the Hudson and Its Tributaries. New York: T. Nelson and Sons, 1860.

Nygren, Edward J., with Bruce Robertson. *Views and Visions; American Landscape Before 1830*. Washington, D.C.: Corcoran Gallery of Art, 1986.

Oberholtzer, Ellis Paxson. *Philadelphia: A History of the City and Its People*. 4 vols. Philadelphia: S. J. Clarke, 1912.

O'Brien, Raymond J. *American Sublime: Landscape and Scenery of the Lower Hudson Valley*. New York: Columbia University Press, 1980.

O'Byrne, William R. *A Naval Biographical Dictionary*. London: J. Murray, 1849.

O'Gorman, James F., Jeffrey A. Cohen et al. *Drawing Toward Building, Philadelphia Architectural Graphics, 1732–1986*. Philadelphia: University of Pennsylvania Press for the Pennsylvania Academy of the Fine Arts, 1986.

Oliver, George. *The History of Exeter*. Exeter: R. Cullum, 1821; rev. ed. 1861.

Oyama, Susan. *A Walk on the Wild Side: The Wissahickon Creek, 1800–1840. An Exhibition at the Library Company of Philadelphia, October 18, 1993–March 18, 1994.* Philadelphia: Library Company of Philadelphia, 1993.

Pease, John C. and John M. Niles. *A Gazetteer of the States of Connecticut and Rhode-Island.* Hartford, Conn.: William S. Marsh, 1819.

Richardson, Edgar P. et al. *Charles Willson Peale and His World.* New York: Harry Abrams for the Barra Foundation, 1982.

Ritchie, George S. *The Admiralty Chart: British Naval Hydrography in the Nineteenth Century.* New York: American Elsevier Publishing Co., 1967.

Robinson, Adrian H. W. *Marine Cartography in Britain: A History of the Sea Chart to 1855.* Leicester: University of Leicester Press, 1962.

Rodger, N. A. M. *The Wooden World: An Anatomy of the Georgian Navy.* Annapolis: Naval Institute Press, 1986.

Royal Albert Memorial Museum and Art Gallery. *Loan Exhibition: Three Exeter Artists of the Eighteenth Century: Francis Hayman, R.A., Francis Towne, John White Abbott.* May 8—September 22, 1951. Exeter: the Museum, 1951.

Scharf, J. Thomas and Thompson Westcott. *History of Philadelphia, 1609–1884.* 3 vols. Philadelphia: L. H. Everts, 1884.

Sewell, Darrel et al. *Philadelphia: Three Centuries of American Art*, Bicentennial Exhibition, 11 April–10 October, 1976. Philadelphia: Philadelphia Museum of Art, 1976.

Smiles, Samuel A. "Plymouth and Exeter as Centres of Art: 1820–1865." Doctoral dissertation, Cambridge University, 1982.

Smith, Philip Chadwick Foster. *Philadelphia on the River.* Philadelphia: Philadelphia Maritime Museum, distributed by the University of Pennsylvania Press, 1986.

Snyder, Martin P. *City of Independence: Views of Philadelphia Before 1800.* New York: Praeger, 1975.

———. "William Birch: His Country Seats of the United States." *Pennsylvania Magazine of History and Biography* 81 (July 1957): 222–54.

Spafford, Horatio Gates. *A Gazetteer of the State of New York.* Albany: H. C. Southwick, 1813.

Stainton, Lindsay. *British Landscape Watercolours 1600–1860.* Cambridge: Cambridge University Press, 1985.

Stapleton, Darwin H., ed. *The Engineering Drawings of Benjamin Henry Latrobe.* New Haven, Conn. and London: Yale University Press for the Maryland Historical Society, 1980.

Stebbins, Theodore E., Jr. *American Master Drawings and Watercolors.* New York: Harper and Row, 1976.

Stein, Roger B. *Susquehanna: Images of the Settled Landscape.* Binghamton, N.Y.: Roberson Center for the Arts and Sciences, 1981.

Stokes, I. N. Phelps. *The Iconography of Manhattan Island, 1498–1909.* 6 vols. New York: Robert H. Dodd, 1915–28. Reprint Arno, 1967.

Strickland, William. *Journal of a Tour of the United States (1794–95).* Ed. J. E. Strickland. New York: New-York Historical Society, 1971.

———. *Reports on Canals, Railways, Roads and other Subjects.* Philadelphia: H. C. Carey and I. Lea, 1826.

Stroud, Patricia Tyson. *Thomas Say, New World Naturalist.* Philadelphia: University of Pennsylvania Press for the Barra Foundation, 1992.

Tatum, George B. *Penn's Great Town: 250 Years of Philadelphia Architecture Illustrated in Prints and Drawings.* Philadelphia: University of Pennsylvania Press, 1961.

Teitelman, Edward and Richard W. Longstreth. *Architecture in Philadelphia: A Guide.* Cambridge, Mass.: MIT Press, 1974.

Teitelman, S. Robert. *Birch's Views of Philadelphia: A Reduced Facsimile of "The City of Philadelphia . . . as it Appeared in the year 1800": with Photographs of the Sites in 1960 and 1982.* Philadelphia: Free Library of Philadelphia, 1982; University of Pennyslvania Press, 1983.

Van Horne, John C., ed. *The Correspondence and Miscellaneous Papers of Benjamin Henry Latrobe.* 3 vols. New Haven, Conn. and London: Yale University Press for the Maryland Historical Society, 1984–1988.

Watson, John Fanning. *Annals of Philadelphia, and Pennsylvania, in the Olden Time; . . .* 3 vols. Revised and enlarged by Willis P. Hazard. Philadelphia: Edwin S. Stuart, 1877, 1899.

Webster, Richard J. *Philadelphia Preserved: Catalog of the Historic American Buildings Survey.* Second edition. Philadelphia: Temple University Press, 1981.

Weeks, Horace Lyman. *A History of Paper-Manufacturing in the United States, 1690–1918.* New York: Lockwood Trade Journal Co., 1916.

Weigley, Russell F. with Nicholas B. Wainwright and Edwin Wolf II. *Philadelphia: A 300 Year History.* New York and London: W. W. Norton for the Barra Foundation, 1982.

Westcott, Thompson. *The Historic Mansions and Buildings of Philadelphia, with some notice of their owners and occupants.* Revised and enlarged. Philadelphia: Walter H. Barr, 1895.

———, comp. "Biographies of Philadelphians." Clippings scrapbooks, Historical Society of Philadelphia.

Whitehill, Walter Muir. *Boston: A Topographical History.* Cambridge, Mass.: Belknap Press of Harvard University Press, 1959.

Wilstach, Paul. *Hudson River Landings.* Indianapolis: Bobbs-Merrill, 1933.

Wilton, Andrew and Ann Lyles. *The Great Age of British Watercolours, 1750–1880.* London and Munich: The Royal Academy and Prestel-Verlag, 1993.

Winslow, Stephen N. *Biographies of Successful Philadelphia Merchants.* Philadelphia: James K. Simon, 1864.

The WPA Guide to Philadelphia, compiled by the Federal Writers' Project of the Works Progress Administration for the Commonwealth of Penn-

sylvania. With a new preface by E. Digby Baltzell, and an introduction by Richard J. Webster. Philadelphia: University of Pennsylvania Press, in cooperation with the Pennsylvania Historical and Museum Commission, 1988.

Yarmolinsky, Avrahm. *Picturesque United States of America, 1811, 1812, 1813, being A Memoir on Paul Svinin, Russian Diplomatic Officer, Artist, and Author, Containing Copious Excerpts from his Account of his Travels in America* . . . New York: William Edwin Rudge, 1930.

Photo Credits

Atwater Kent Museum: fig. 39, color plate 10

Barra Foundation (Rick Echelmeyer): figs. 2, 20, 39, 41; plates 2–5, 7–14, 16–20, 22, 23, 25–38, 74–90, color plates 2, 3, 5, 9, 11, 12, 18

Michael Cavanagh and Kevin Montague: figs. 3, 18, 36, 37

Fairmount Park Commission (Philadelphia Museum of Art): fig. 22

Houghton Library, Harvard University: fig. 5

Historical Society of Pennsylvania: figs. 23, 24, 42

Library Company of Philadelphia: figs. 47, 48, 49

Library of Congress: fig. 19

Maryland Historical Society: fig. 44

Metropolitan Museum of Art: fig. 26

National Gallery of Canada: fig. 35

New-York Historical Society (Glenn Castellano): figs. 3, 27, 28, 31, 32, 34, 43, 53, 58, 59, 62–67, 69, plates 1, 6, 15, 21, 24, 39–73, color plates 1, 4, 6–8, 13–17

Pennsylvania Academy of the Fine Arts (Rick Echelmeyer): figs. 14, 45, 46, 52, 54, 61

Philadelphia City Archives: fig. 15

The author, with Henry Glassie (prints by Michael Cavanagh and Kevin Montague): figs. 1, 4, 6–13, 16, 30, 33, 38, 50, 51, 55–57, 60, 68

Index